"Ahead of the curve...A gem."
—**J.J. ABRAMS**

"The first spotlight for Asian American artists that didn't pigeonhole us as Asian American artists. If you know, you know."
—**DAN THE AUTOMATOR** • Music Producer

"Totally honest, fucked up, and funny."
—**JON MORITSUGU**

"The world would be just a little more boring and oppressive without *Giant Robot*."
—**KATSUYA TERADA** • Artist

"Mags like *Giant Robot* were the internet. You really needed great editorial to find out about neat, new things and expand your perspective and tastes. Or if you were lucky, you already had cool friends. But that's what *GR* was, like a really cool friend."
—**BEN CLARK** • *GR* Photographer

"They paved the way for many of us. Platforms like NextShark would not exist if it wasn't for the work of Eric Nakamura and Martin Wong."
—**BENNY LUO** • Founder, NextShark

"[A] touchstone for the invisible."
—**ROY CHOI** • Chef and TV Producer

"I can't express in words what it meant to me as an Asian American to see our community and the diaspora represented here in ways I had never seen...both embracing and rejecting Asian traditions and American mainstream culture."
—**TEENA APELES** • *GR* Contributor

"I remember others of my ilk kind of shrinking away from their Asian-ness, not so much hiding it—which was near-impossible racially—but reconfiguring it into something harmless, an absence instead of a presence, not a problem, nothing to see here. Which of course means personal disfigurement. *GR* seemed to say in a flatly Californian accent: 'Fuck all that.'"
—**ROLAND KELTS** • Writer

"This hilariously bratty magazine seemed to zero in on something kindred!"
—**CASSIA LUPO** • GR Store Manager and Curator

"It was unadulterated Asian cool. Unapologetic, with a deep sense of joy and pride, unwilling to varnish the pain or silences."

—CAROLINE FAN

"*Giant Robot* wasn't afraid of letting people get their 'geek' on, while also giving a peek at certain sections of the zeitgeist that were under the radar of the Wonderbread American vantage point."

—TRAVIS LOUIE • Artist

"In punk rock, there were no zines that covered art culture through the DIY lens of an Asian American. Throw in skateboarding, articles about donut shops and Chinese food, Margaret Cho on the cover, art by Yoshitomo Nara, and you had everything I ever wanted in a zine."

—MIKE PARK • Founder, Asian Man Records

"When *Giant Robot* first appeared on the stands, it connected the dots between different scenes, helping lay a common ground—with music, art, food, and film all under the same covers."

—AARON COMETBUS • Creator of *Cometbus*

"I think it says a lot about the community it has fostered over time, encouraging artists who are young, emerging, or older and established, mixing us all up and saying we're all allowed and encouraged to be friends."

—GARY BASEMAN • Artist

"It's easy to jump on the bandwagon of someone or something successful, but what *Giant Robot* did was build stars. *GR* is its own category."

—JON LEE BRODY • Producer/Director/Actor

"*GR* is a reminder to just be fucking humble and enjoy art, whether it's yours, mine, or someone else's. Get out of your head, share opinions, and be cool, man."

—JAMES WERNER

"*GR* was the light at the end of the tunnel. Candy and soda was served."

—MATT FURIE • Cartoonist

"*Giant Robot* entices you and lets you dream. You just can't help but want to be involved."

—CONNOR NGUYEN • Artist

"Unpretentious and irreducible."

—PAUL WEITZ • Filmmaker

Giant

Robot

THIRTY YEARS OF DEFINING ASIAN AMERICAN POP CULTURE

edited by
Eric Nakamura,
Francine Yulo, Tracy Hurren,
Megan Tan, and Tom Devlin

designed by
Megan Tan and Tracy Hurren

DRAWN & QUARTERLY

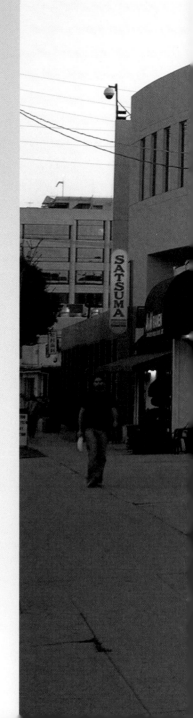

Drawn & Quarterly would like to thank Wendy Lau, *Giant Robot*'s designer from issue 18 onwards, for creating the base style for the magazine that inspired the design of this retrospective.

Published by Peggy Burns // Additional production by Mélina Lopez-Racine, Reid Urchison, Shirley Wong, and Lucia Gargiulo // Marketed and administered by Julia Pohl-Miranda, Gabrielle Cole, Alison Naturale, Trynne Delaney, and Rebecca Lloyd

drawnandquarterly.com // giantrobot.com

ISBN 978-1-77046-713-2 // First edition: September 2024 // Printed in Malaysia // 10 9 8 7 6 5 4 3 2 1

Cataloguing data available from Library and Archives Canada

MIX
Paper | Supporting
responsible forestry
FSC™ C005748
www.fsc.org

Published in the USA by Drawn & Quarterly, a client publisher of Farrar, Straus and Giroux // Published in Canada by Drawn & Quarterly, a client publisher of Raincoast Books // Published in the United Kingdom by Drawn & Quarterly, a client publisher of Publishers Group UK

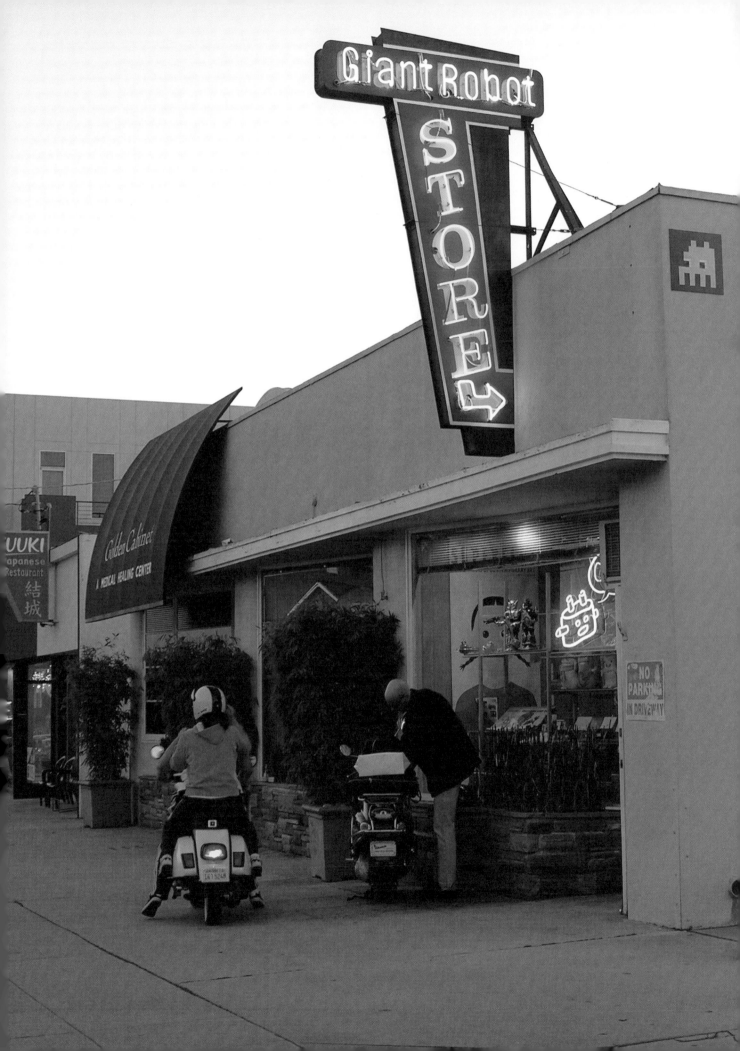

(left to right) Martin Wong, Claudine Ko, and Eric Nakamura in front of the Giant Robot Store in Los Angeles, early '00s.

RENEE TAJIMA-PEÑA ● Director, *Skate Manzanar*: I moved back to LA from NYC in the same year *GR* was founded. Not only back to

ONCE UPON A T/ME ON SAWTELLE BOULEVARD

words
Claudine Ko

People have projects that they have been working on for ye a r s, but because of work, laziness, school, girl/boyfriend, or lack of cash, they never get done.

It's like talking about fixing up that old Datsun 510 into a true rice grinder, but never getting around to it, and then to find out later that body rust is everywhere and the interior is infested with the stench of mildew. Most everyone has a dormant project tucked away somewhere that's just waiting to get worked on, **and that's how Giant Robot *was born.***

—ERIC NAKAMURA, founder of *Giant Robot*, *GR #4*

I.

As usual, Eric Nakamura and Martin Wong needed to fill pages. On ski trips to Mammoth Mountain, Martin's family would often drive past the Manzanar incarceration camp, where more than 120,000 Japanese Americans were imprisoned during World War II. Rising from the desert off Highway 395, he would see the abandoned watchtowers once used by armed guards, but never stop. So for *GR #7*, he decided it was time for a visit. Eric had personal ties to the story since his father, Bob, had spent three years as a child imprisoned at Poston in Arizona. But Martin, a Chinese American, came up with the story, so he would be the writer.

This was business as usual: Whoever thought of the idea got the assignment. For the entire run of the magazine, there was never much editorial back-and-forth. "It was just, 'That sounds rad, you should do that,'" Martin says. "And that was it." So early one morning in late 1996, Eric and Martin packed a couple of skateboards with off-road XT wheels, a camera, and set off on a road trip up the 395.

In the resulting article, "Return to Manzanar" (p. 50), Martin sardonically sets the scene as a place where "Japanese Americans hung out" in the 1940s, before revealing its cruel legacy—barbed wire, guns aimed at the detainees, and orders to shoot to kill anyone who tried to escape. "We wrote about movies and punk rock," Martin says. "Writing about history was something different." In the meantime, Eric's job was to take photos that were as impactful as the words.

Back then, there was no thoughtfully curated museum with multimedia presentations, no junior ranger program. Manzanar was just a dusty wasteland with a lone monument, and Eric and Martin were there to capture what you couldn't read about in history books. Like how the California Historical Landmark plaque describing its significance as a "concentration camp" had been vandalized by a "veteran who doesn't think former Japanese and Japanese American internees at Manzanar deserve any sympathy." Or how the rusty tin cans and kitchen appliances riddled with bullet holes were both tetanus traps and warning signs to Asians from gun-toting locals who weren't too crazy about their kind. And that the north end of the dried-up reservoir, originally designed to sustain prisoners, was now a great place to drop in on a skateboard.

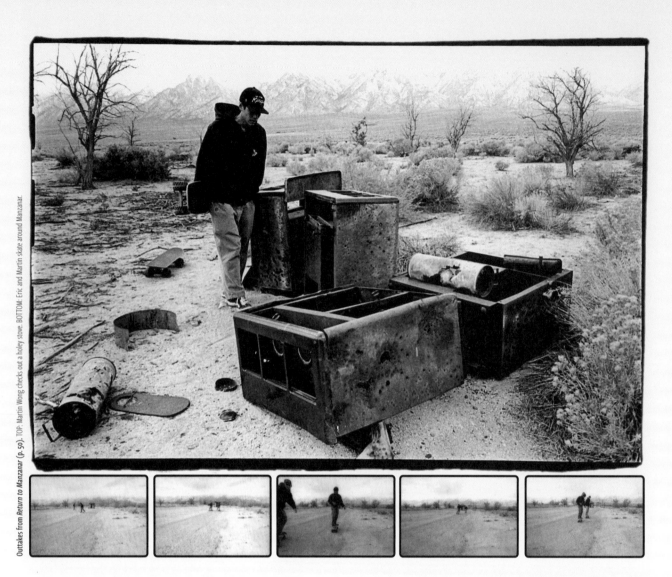

The article's opening image, which shows Martin mid-air, skating off the concrete obelisk in the camp cemetery, was controversial (p. 52). Though staged, the photo was alarming to some, including preservationists, who viewed it as disrespectful. But for Eric, it captured an act of defiance. "The *Giant Robot* way is what's really there—the shit that's behind the scenes, stuff the tourist guides won't show you—the dirty," he says. "It's taking ownership of an otherwise fucked-up place. Those stories are important."

II.

The first cover was a black-and-white close-up image of a sleeping sumo wrestler (p. 448). Hair slicked back, chubby cheek pillowed against chubby hand, he looked as if he had passed out after gorging on chankonabe with extra sides of rice. It was a thick, 64-page zine, copied, folded, stapled, and placed on the shelves of record stores and bookshops on the westside of Los Angeles. The coverlines teased, "Sumo Wrestler Gets 6″ Implant in Head! Filmmaker Disposes of Raw Beef Parts! Boredoms, Exotica, Twinkies, Fevers, Trash, TV, and More!" Across the top in Helvetica Bold typeface, it read: *Giant Robot*, issue no. 1 1994 made in the USA $2.

In the early 1990s, if you were looking for an Asian American magazine, there were a handful to be found, with names like *Jade*, *Rice*, and *A*. They often perpetuated the model minority myth, spotlighting high-achievers with coverlines such as "Top 10 Asian American Entrepreneurs Under 40" and ads from luxury brands—BMW, Chivas Regal, Chanel, and others looking to leverage the fast-growing, affluent demographic. Meanwhile, Eric, a third-generation Japanese American, had scored 400 on his SAT verbal, attended Santa Monica College, and lived at home with his parents. Those were not the magazines for him.

In spring 1991, Eric transferred to San Francisco State University, took classes with American scholar Lane Hirabayashi, who focused on the wartime incarceration of Japanese Americans, and became immersed in Asian American studies. Then he met directors Gregg Araki and Jon Moritsugu while they taught a "Guerrilla Filmmaking" workshop at the National Asian American Telecommunications Association (now the Center for Asian American Media), where Eric was an intern. Both were creating what Eric describes as "really weird and strange" movies. Gregg was making queer films on tiny budgets at a time when gay sex was still a criminal offense in

JON MORITSUGU: Eric was a young college kid in Frisco (sportin' totally looooong grunge/stoner hair) who told me about his idea of starting a zine with a

half the country. Jon would create a garden composed of 800 pounds of raw beef for a "meat climax" during the production of *Mod Fuck Explosion*.

"They were the outlaws," Eric says. "They were both not part of the Asian American social norm, whatever that is. They were on the outside, and I felt I was always on the outside." Eric interned full-time all summer for Gregg's production of *Totally F***ed Up*. It was the first movie in the filmmaker's *Teenage Apocalypse* trilogy, telling the story of queer, nihilist Los Angeles students in a homophobic society during the AIDS crisis. Eric saw Gregg take frugality to astonishing heights (e.g., arming producer Andrea Sperling with a quarter and directing her to only use it if a meter maid approached), bootstrapping the production in a way that Eric later applied to his own creative endeavors. "He was smart and really talented," Eric says. "He gets what he wants done."

In fall 1991, Eric transferred to the University of California, Los Angeles (UCLA), even though an Asian American Studies major didn't exist there yet, and moved back home. Some of his friends booked concerts for the school's Campus Events group, and he began volunteering as a photographer. He became a fixture at local underground venues like Al's Bar, Jabberjaw, Macondo, and Raji's. "He was always the one in the crowd taking photographs," says Minju Pak, a fellow student who played in her own band. "I did not know a lot of Asian kids. In fact, that scene was not filled with Asian kids. It was a bunch of white kids, Eric taking photos, and then me." There was an implicit acceptance among those who pored through the *LA Weekly* tracking bands and showed up at Al's. This was before Napster unleashed digital music, before Spotify algorithms generated song recs. It was a lifestyle that "you really worked at," Minju says. "You had to put yourself out there."

Right after graduating in 1993, Eric was hired on contract by *VideoGames: The Ultimate Gaming Magazine*, part of Larry Flynt's eponymous publishing house. He worked as an associate

RANDALL PARK: I came up in Los Angeles during the '80s and '90s—a time when there seemed to be a great push in making Asians synonymous with achievement, hard work, and quiet humility—we were deemed the "model minority"—and I just hated that.

There were very few Asian faces in American popular culture. Pat Morita and Margaret Cho were great, but most of the time, we were cast way off to the side—decor in a white protagonist's surroundings. Oftentimes, we were the punchline. When I was really young, I thought little of it. But as I got older, I came to hate that shit.

I graduated from Hamilton High School in Los Angeles, the same year as the riots, where the TV news seemed to revel in images of Korean storeowners on rooftops, defending their stores—with guns—against mostly black and brown looters. There was hardly any regard for the complexities of the lives of anyone involved. I hated that too.

Here were the things that I loved at that time: comic books, drawing, Public Enemy, Polo by Ralph Lauren, the comedy stylings of Garry Shandling, Mexican food, and antiquing (I've always loved old things). I attended college at UCLA, where I added writing, performing, and a bit of Asian American activism to this ever-evolving idea of who I was. I was a true Asian American Angeleno mishmash, trying to figure out my place in this world.

Around this time, *Giant Robot* emerged, and I remember being immediately drawn to the aesthetic. Everything, from its zine days and beyond, felt purposefully imperfect—handmade, photocopied, assembled with scissors and scotch tape—and to me, that was so damn cool.

Within its pages were some of the things that I loved—articles on folks like hip-hop producer Dan the Automator (p. 216), legendary activist Yuri Kochiyama (p. 62), Margaret Cho—along with things that I had no interest in at all—Hong Kong action films, punk rock, skateboarding, snacks...(Note: I have since become a strong advocate of snacks from Asia.) Regardless, it was all a compendium of cool shit from this unique Asian American perspective.

Asian Americans were so thoroughly in the margins that much of our collective struggle seemed to be in trying to prove our worthiness to a mainstream culture that had little use for us. Yet here was a magazine that said, fuck that—we're already cool, and here's why. The idea of an alternative Asian American magazine, at a time when it was hard enough being Asian American basic, was thrilling, audacious, so fiscally irresponsible...And I just loved that.

In that way, *Giant Robot* had a profound influence on me. It helped me reconcile with the sides of myself that never quite fit into any mold—the sides of myself that wanted to pursue a life in comedy and performing and storytelling at a time when opportunities were few and the mere thought was an audacious one. In fact, it was at the Giant Robot Store on Sawtelle Boulevard where I first discovered Adrian Tomine's graphic novel, *Shortcomings*, which many years later would wind up becoming my feature directorial debut.

Giant Robot showed me that there are cool Asian things all around us—within the margins of the margins, overseas, and even within myself. And those things are worthy of documentation, mass publication, and celebration. 🐱

Randall Park is an American actor, comedian, writer, and director. He was born and raised in Los Angeles, California, to Korean parents. Park graduated from UCLA with a bachelor's degree in English and Creative Writing, and continued his academic pursuits at UCLA's graduate program for Asian American Studies. He lives in Los Angeles with his wife and daughter.

Wendy Lau asks Martin Wong to take a look, circa Y2K. Pryor Praczukowski is in the background, focusing his Pryorvision.

WENDY LAU: I first encountered *Giant Robot* when my friend and co-worker Ryan Yokota showed me issue #2 with Martin as Hello Kitty on the cover (p. 448). I pored over it and was struck by the bold writing and images, and continued to pick up issues now and then.

Years later, I finished art school and Mike French, one of my instructors, introduced me to Eric, who wanted to redesign the Giant Robot website. Mike thought I'd be a good fit and I knew enough HTML to re-skin the site, but what really interested me was the magazine! It was 2000 and most design jobs, including my day job, were digital. Everyone was saying print was dead and I relished the opportunity to be part of an awesome print project!

Giant Robot had gone from a DIY cut-and-paste aesthetic to a supercharged frenetic design that I thought distracted from the content. Unlike glossier mags, *GR* had an extremely high word count and fans loved the dense articles, top 10s, and book, movie, and music reviews. I stripped everything down, made templates, and built it back with the idea of highlighting the content, whether it be words or artwork or photos. All 88 pages were jam-packed and full of energy, yet clean and readable. It was way more challenging but infinitely more fun than any of my typography lessons in art school.

The atmosphere of the magazine office was super inspiring, too. Eric's tiny, cluttered garage was where the magic happened. Four—and eventually six—times a year, everyone in the Giant Robot orbit showed up during deadline to help. Martin and Eric oversaw content and I made sure the layout was legible and fun. Pryor and his "Pryorvision" color-balanced every image to perfection. Susan (the most stylish person I'd ever met), Hane (the drollest), and Kim (former professional ballerina turned English major) were copyeditors extraordinaire. Other regular readers included Michelle and Bill from the store, our ad guy and resident martial artist Kiyoshi, and a revolving mix of volunteers, interns, friends, and family. Even though the entire magazine staff were trained professionals, we had a very DIY approach to making the mag. Our work didn't rely on focus groups or design by committee. We just charged forward and did what we wanted. After our day jobs, we gathered in the garage to work late into nights and weekends because we believed *Giant Robot* was the greatest publication in the world.

Like our readers, Giant Robot gave me a family and community. Martin and I got married, and he keeps life super fun and interesting. Even though the magazine isn't around anymore, we still live the Giant Robot lifestyle by surrounding ourselves with inspiring music, art, movies, and people. Our child Eloise grew up surrounded by musicians, artists, writers, and other creative people who live by the Giant Robot DIY ethos, as well. We started "Save Music In Chinatown," DIY punk shows to raise funds for the music program at Castelar, Eloise's public school in LA's Chinatown. Those shows eventually led to The Linda Lindas, who continue to shape pop culture and beyond.

When I look back at my 11 years designing *Giant Robot* from issues #18 to #68, I am extremely proud of our work. I am grateful for the experience and feel privileged to have contributed to a touchstone in Asian American pop culture and subculture that meant so much to so many readers. Martin and I still randomly meet fans who tell us how *GR* changed their lives. Besides introducing them to cool stuff, it made them feel like they weren't the only artsy weirdos in town, and proud and excited to be who they are. I felt the same and still do to this day. ✍

Wendy Lau is an art director and graphic designer. She crafted Giant Robot *magazine's visual identity from 2000 to 2011, and went on to help start and design for the "Save Music in Chinatown" DIY punk shows and do design work for The Linda Lindas.*

editor, or what he describes as a "low-ranked writer," playing video games, interviewing, and writing reviews. Larry Flynt Publications, or LFP, was infamous for its porn mags *Hustler* and *Barely Legal*. But it also published titles like *Rap Pages* and *Film Threat*, as well as a fleet of mainstream magazines about maternity fashion and computers. It was a well-tread landing pad for recent grads who were friends with existing employees and needed a job. "You either worked there or knew of someone who did," says Minju, who was employed at *Hustler* after college and is now an editor at *The New York Times*. "It was six degrees of separation from Larry Flynt."

Less than a year later, Eric quit. There were fun aspects to the job, but his boss yelled a lot. Perhaps the most important thing he learned from LFP was that it doesn't take a lot to put out a monthly magazine. He was still living at his parents' and working as a busboy at his mom's sushi restaurant. "I wasn't doing much at the time creatively aside from photography," says Eric, who occasionally landed pictures in album art or in *Fiz*, the LA-based alternative-music mag. "I wanted to do something different and new."

III.
In the '90s, everybody had a zine. But Eric couldn't find one that spoke to him, something that encapsulated indie rock, Hello Kitty, kung fu movies, Japanese candy, and Tokyo, so he decided to make his own. He came up with the name "Great Mazinga Z," based on a super robot from a 1970s manga and anime TV series by the artist Go Nagai, and invited friends to help. They'd hang out at his parents' house talking about story ideas, and he'd tell them, "Just write it."

Martin was game. He graduated from UCLA in 1990 with a degree in English, and eventually met Eric through the free shows held at the campus' coop pizzeria. He was already writing for a number of zines and editing textbooks for McGraw Hill by day when he wrote about the "God of Manga," Osamu Tezuka, and

ANTHONY BATT • Technologist & Entrepreneur: Eric and I were roommates and I helped him fold the first paper version of *GR* at our house in

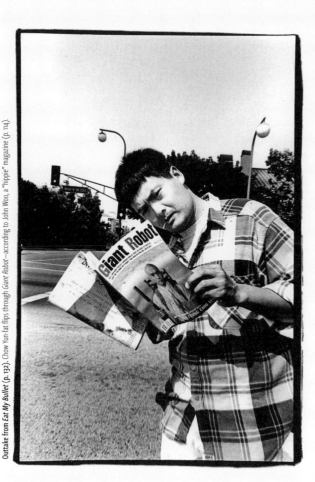

Outtake from *Eat My Bullet* (p. 132). Chow Yun-fat flips through *Giant Robot*—according to John Woo, a "hippie" magazine (p. 114).

Hong Kong film fanzines, and reviewed books about kung fu movies for *GR* #1. Lynn Padilla, a Filipina American who majored in art at UCLA and booked shows at Campus Events, wrote a handful of essays from the perspective of an Asian American woman in LA at a time when, she says, Asian American pride was rare. Especially for Filipinos, "it was unheard of," she says. "[We've] been colonized so many times, there's this real wish to just lie low and fit in."

The stories couldn't be cribbed from Wikipedia. "We were just writing about stuff we liked," Martin says. "We weren't trying to define anything or change anything. In retrospect, it was just happening, whether we tried to or not. As a result, it was very honest and pure." The articles were mostly first-person and full of attitude, often told from the field, both as observer and participant. They had titles like "Life As a Twinkie," "Penis Envy?," and "I Was a Cat" (p. 100). The humor could be crude, the captions were worth reading, and the tiny fonts pushed the edge of legibility. Throughout the magazine's run, this editorial ethos persisted.

There was no grand plan. Contributors would print stories at their home or work and hand-deliver them to Eric, who would resize them on a copy machine. At the last minute, he changed the name to *Giant Robot*, inspired by a Japanese TV series that aired after school on KTLA 5, about a kid named Johnny Sokko and his flying robot. *Giant Robot* sounded better and was easier to remember. He made 240 copies at a small print shop a couple blocks from his mom's restaurant on Wilshire Boulevard in Santa Monica.

Many helped staple and fold. It was followed by a second printing of 400. Additional runs were surreptitiously made after hours by friends on copy machines hijacked from employers like Xerox Corporation, MTV, and Geffen Records.

Giant Robot launched in September 1994, the same year Hollywood released its portrayal of Gen X, *Reality Bites*. Like the movie's main characters, 25-year-old Eric and his friends were navigating their post-college lives, tolerating day jobs while trying to maintain their integrity and obsessions with music and pop culture. But this was not Houston, and these kids were not white. These were Asian Americans living in LA, where the rent was also affordable, but the census counted more people of Chinese, Filipino, Korean, Japanese, and Vietnamese descent than in any other metropolitan area in the United States. Eric and Martin were deeply entrenched in Hong Kong cinema, which featured Asian actors, something that didn't exist in the West.

"It was a dream world of insane fiction—think *John Wick* 30 years ago and romantic leads via *Chungking Express*," Eric says. Actors like Tony Leung (p. 116), Maggie Cheung (p. 122), and Chow Yun-fat (p. 132) were easy enough to land for a *Giant Robot* story because no one in mainstream American media cared about them yet. "They were just excited that someone in the US was interested," says Martin, who was balancing trips to Jabberjaw with pilgrimages to the San Gabriel Valley numerous times a week to catch $5 double features at the Chinese movie theaters.

It was the last days before the internet posed any threat to print media, when email barely existed, and Google was just a couple of computer science nerds. Top editors at major publishing houses had big expense accounts and the power to launch entire careers. Meanwhile, a trove of cult indie mags debuted. In 1993, the Beastie Boys published *Grand Royal* magazine, named after their record label. The next year, *Ego Trip* ("the arrogant voice of musical truth") in New York, Dave Eggers's *Might* in San Francisco, *Punk Planet* in Chicago, and *Vice* in Montreal came to be, along with *Giant Robot*. *Bust* and *Bitch*, for third-wave feminists, also emerged during this time. They were anomalies in an ocean of mainstream media that controlled the narrative of what was "worth covering."

The publishers of these titles were young, defiant, and energetic, doubling as editors, writers, designers, and more, putting out nationally distributed magazines on low to no budgets. Instead of totally selling out to the hierarchy of corporate America, these so-called disaffected slackers figured out an alternative way of working: DIY—as did many of their peers across filmmaking, music, art, and fashion.

"Right away, we got people excited about the stuff we were talking about," Eric says. Seth Friedman gave *Giant Robot* a positive review in *Factsheet Five*, then known as the bible of the alternative press. The early zines made it across the United States and around the world, eliciting letters to the editor from Sherman Oaks, Austin, Honolulu, Kyoto, and more—attracting a mostly white, male, and punk-indie audience. Female and Asian American readers

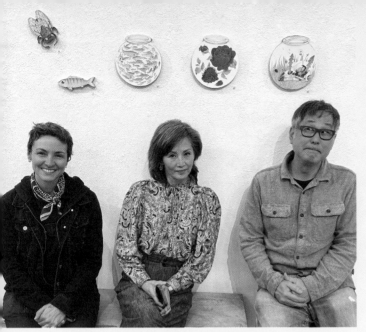

LEFT TO RIGHT: GR Store Manager Cassia Lupo, Tamlyn Tomita, and Eric at GR2 Exhibit for *Original Assembly*, art by Cassia.

TAMLYN TOMITA: I saw the rise and fall of other Asian American publications, but *Giant Robot* always stood out. It was authentic, down, and dirty. I read my first issue off the racks of the old 24-hour newsstand on Cahuenga Boulevard in Hollywood. *GR* bridged how Asian Americans should be considered as Americans. It was not the shiny spotlight; it was about an attitude. Eric and Martin weren't delving into the secret lives of celebrities like the rest did. They documented with blood, sweat, and tears, writing articles about what turned them on, what they thought was cool.

I was never a subject. They knew that I was already a known entity—the sweet Okinawan girl in *The Karate Kid Part II*, the bitch in *The Joy Luck Club*. I didn't need to be amplified, and they didn't need me, but we continued to support each other in the worlds that we occupy. They wanted to uplift artists that hadn't been paid attention to by mainstream media. That proved to me how cool they were because they didn't buy into celebrity. They never kissed my ass, especially in the '90s, when it was all about the sexualization of Asian females. For me, it was a sign of total respect. They saw me as the dork and lover/fan of the art and music they wanted to put out. For them, the purpose of art was a way to communicate fresh ideas of how to relate to the world, and how to reflect the world.

Then the store opened, this homegrown third-generation Asian American store where people can literally walk into what it means to be Asian and Asian American. We had known Sawtelle as a lane of mom-and-pop shops, forged in the aftermath of our concentration camps when Americans of Japanese descent returned to West LA. To see non-Asian people bring in their kids, flip through the magazines, check out the T-shirt with Bruce Lee DJing, and figurines written in Japanese kanji, Chinese, and Korean was so affirming. Our stuff is cool because people come in the store and buy it, and they don't look like us.

To this day, Giant Robot is an integrity-filled art space that people can come to for inspiration. It will go forward, and it will absolutely transform itself decades from now. But it will always be a steady, safe space and foundation for artists. 🐱

Tamlyn Tomita is an actor, singer, and writer.

didn't really catch on until it graduated from its zine phase, growing to a standard 8×11 size and going glossy.

In *GR* #2, Martin wrote a first-person essay about dressing up as Hello Kitty for the Sanrio Festival in Sherman Oaks (p. 100). He grew up in Anaheim Hills, was familiar with cosplay from being a Jungle Cruise skipper nearby at Disneyland, and instinctively knew this would make a good story. At the time, the mouthless feline, with her granny glasses, hair bow, and tiny backpacks, appealed to the indie scene. Wrapped in layers of styrofoam and fabric, Martin sweated his way through the festival, experiencing both physical demands ("I can barely see or maintain my balance"), as well as psychological taunts ("Get a life," "Your mom must be so embarrassed," "I hate you"). Eric regards the piece as the quintessential *Giant Robot* article. "It's super active," he says. "Martin wears the costume, becomes a famous character, and then writes about it—the good and bad of it all. That's rad."

IV.

Around the same time, Wendy Yao and her older sister, Amy, were living in the San Fernando Valley with parents on the verge of divorce and not a lot of supervision. "I was a dork with no friends," Wendy says. "We were in the outskirts of LA, we were some of the only Asians, and there was a lot of social isolation." Starting in middle school, the sisters would spend hours on the floor of the local Tower Records sifting through the classifieds in the back of indie music magazines, writing down addresses for anything that looked interesting. Amy would mail-order seven-inch records from labels like K Records and Sub Pop, sending repurposed lunch money in an envelope. Then they studied the liner notes for clues as to who to listen to next. "It was a really fun and awesome treasure hunt back then without the internet," Wendy says.

They moved to the Orange County suburb of Irvine for a year in 1992 and met high school classmate Emily Ryan. Together, they hung out at all-female punk shows at UC Irvine, like Bikini Kill and the Red Aunts, attended riot grrrl meetings, and ultimately formed the band Emily's Sassy Lime.

Outtake from "I Was A Cat," c. 1995. Angelyn De La Garza (née Wong) poses with friend Yvonne Ng and brother Martin in costume as Sanrio's finest.

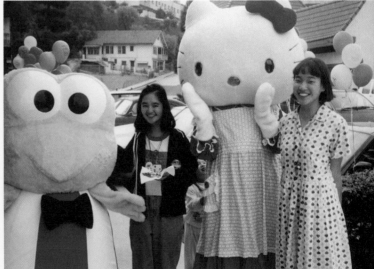

In the second issue of her *Girl Power* zine, Bikini Kill singer Kathleen Hanna urged readers to claim being a dork as cool, an idea that resonated with the three. After the Yao sisters moved back to the Valley, they would bum rides to Jabberjaw, the independent coffeehouse and gathering space on Pico and Crenshaw, where Eric and Martin were regulars. Its founders, Michelle Carr and Gary Dent, curated a stunning roster of emerging bands, including Nirvana, Hole, and Green Day, making it one of the most important venues in the underground music scene. There was no backstage and no liquor license. Paintings by the artist Margaret Keane hung from the walls, ice cream was sold along with $1 coffee, while a topless female mannequin wearing satan horns over a dark wig gazed at the scene from a cabinet top.

"We stood out as the youngest people there," Wendy says. "It was mostly college-aged people, and we were shrimps." Between sets, the crowd would disperse to the back garden to hang out with the musicians, smoke, and buy fanzines from people selling them out of Kinko's boxes. Here they met Gabie Strong, a musician and UCLA student who self-published the zine *Kitten Kore.* "We were like, 'This is so cool,'" Wendy says. "She was this really gentle, welcoming, inclusive person who was older than us." Gabie asked if they had heard of *Giant Robot* and recommended they check it out. They picked up *GR #1* and immediately connected with it. "Maybe our interpretation of [the riot grrrl's dork=cool] was through the stereotypes of being an Asian

nerd," Wendy says. "*Giant Robot* was also nerding out on culture. It's not a dichotomy where you're dorky or you're cool, but both are part of the same continuum."

The first time the sisters met Eric, Wendy says, "I was 15, so he looked like an old-as-fuck dinosaur—he was probably, like, 19 [actually closer to mid-20s —eds]. I remember them specifically making fun of me because I wasn't even old enough to apply for a driver's permit." But Eric and Martin automatically took to Emily's Sassy Lime, publishing a free-form Q&A with the band in the next issue. The teens talked to Eric about curfews and alibis for sneaking out to shows, along with a myriad of other disjointed topics, obfuscating the turmoil of their troubled home lives. When the indie record label Kill Rock Stars released the trio's first vinyl LP, *Desperate, Scared, But Social*, in 1995, the band asked Eric and Martin to make a subscription flier. The slips of paper were inserted in every copy of the record, describing *Giant Robot* as "Emily's Sassy Lime's Favorite Magazine." Four issues were priced at $15; foreign airmail cost $42. The girls were thanked under the *GR* masthead as "partners in crime."

In the evenings and on weekends, Martin would head over to Eric's to produce the zine. For *GR #3*, Eric asked Martin, who had also helped by getting the issues into shops, particularly around Orange County, to be co-editor. Martin kept that role for the rest of the magazine's run, and his name became synonymous with *Giant Robot* and Eric. Along with the new editor came a fresh look: *GR #3* was full-sized and had a new tagline: A magazine for you (p. 448).

CLAUDINE KO: *I picked up the first issues of* Giant Robot *in 1994, when I lived in Berkeley, California, and frequented record stores on and off Telegraph Ave. But unlike so many people who had an instant connection with GR, after skimming a few pieces, I'd put them back on the display. I didn't care much for sumo wrestlers or anime, let alone giant robots. Certain stories did resonate: I loved* The Doom Generation *(Gregg Araki) and* Terminal USA *(Jon Moritsugu), and also interviewed both filmmakers in the early '90s, for the weekend "Film Close-Ups" show at K-ALX 90.7 radio. And who doesn't like Hello Kitty or John Woo movies? When GR grew to a standard magazine size, I'd take note of the colorful covers and flip through the pages, but the connection was still fleeting. It was not until GR #10, when I saw Jenny Shimizu (p. 324) looking butch, hot, and badass on the cover that I got hooked. Imagining her wondering whether or not to Bondo her car, and then coming out of the gates and calling Eric a "bitch" in the first paragraph of the article was a revelation. The story took off and kept flying. At that point, Giant Robot wasn't just a magazine I needed to read, but one I needed to write for, too. I paid for it, brought it home, and read the story again.*

Emily's Sassy Lime. LEFT TO RIGHT: Eric with the riot grrrls Emily Ryan, Amy Yao, and Wendy Yao; Wendy on drums against a Barry McGee backdrop; Amy thrums the bass.

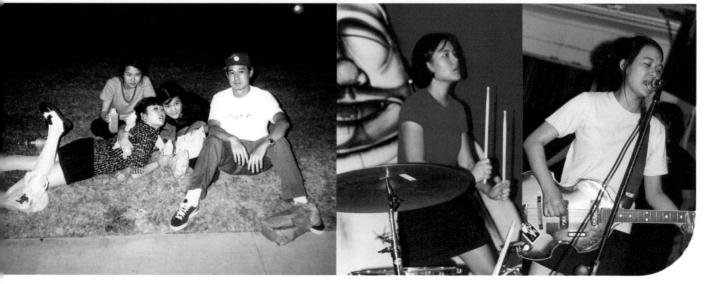

"We were pretty focused compared to a lot of other zine makers that are more personal and soul-searching," Martin says. "We really embraced the idea of not being pros but just going for it. That's the punk rock side. You just keep going, make tweaks and get better as you go. You build a community the same way a band might make friends with other bands, and you come up together." Minju wrote about sangapul (double eyelid) surgery and why the indie rock band Sebadoh attracted so many Asian female fans. "The Asian people I knew were snobs," Minju says. "It was just like, we're cool, we know about cool things, and we want to write about it. That's what I liked about it."

For Dylan Robertson, who discovered *Giant Robot* when he was an undergrad at Yale in the mid-'90s, the arrogance felt important. "In a world when Asian American culture was seen as less than, to have somebody say, 'This isn't just as good as everything else, but better than anything else out there' was a strong statement," says the LA native whose family on his dad's side is from Hawaii, where he spent a lot of his childhood. "That arrogance was always balanced with openness. Anyone can partake. You just have to come to us." Readers who couldn't get to the LA shops carrying *Giant Robot*—places like Golden Apple Comics, Rhino Records, Top Shelf, and Aron's—mail-ordered issues by sending carefully wrapped bills.

Letters to the editor were just starting to trickle in when Eric contacted the "patron saint of zines," Doug Biggert, who ran magazine distribution at Tower Records. Doug had a soft spot for underdogs (and photographing hitchhikers) and agreed to put the first issues of *Giant Robot* in Tower, which, at its peak, had more than 200 locations in 18 countries. In an interview on MarkMaynard.com, Doug, who passed in 2023, said, "We wanted to show people something they'd never seen before, something odd and wonderful." Tower, which went bankrupt and closed most of its stores in 2006, expanded the *Giant Robot* audience around the world, particularly in Tokyo, where many designers, artists, and other creatives would await new issues. The Shibuya branch still exists today.

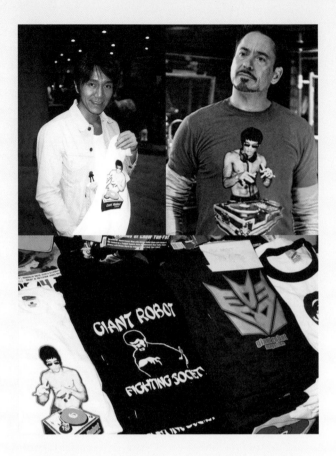

V...

By 1996, *Giant Robot* was coming out four times a year and, according to its promo material, was in "every bookstore, record store, and magazine rack that matters." Advertisers were starting to take interest, and Eric, who was almost 30 and still living with his parents, began to turn the magazine into a career. At a release party, he met Nate Shimizu, who was interested in helping with the business side of things, and, after *GR #6*, the two signed a lease on a loft in an industrial pocket of Downtown LA now known as the Arts District. Back then, the area was artsy, and more importantly, rent was cheap. "GR was always where I lived," Eric says. The masthead said official business hours ran from 9:00 a.m. to midnight, but he often kept going much later. He lived and breathed the magazine.

Somewhere along the way, Eric taught himself how to use QuarkXPress, a desktop publishing software, to design more sophisticated layouts, followed by Adobe Photoshop to make original branded merchandise. The first Giant Robot T-shirt design, Bruce Made Tapes, was based on a picture

of a shirtless Bruce Lee wearing aviator sunglasses slightly askew. Lee's hands jutted out in front of him, which gave Eric the impression that Bruce could have been scratching records like a DJ. So he superimposed a Technics 1200 turntable to the image, added the text "Giant Robot magazine," and sold the shirts for $12 a piece, plus $3 postage and handling. It was the first design he made in Photoshop, and, he says, "It was lightning in a bottle. If there's such a thing as a T-shirt hall of fame, that would be in it." In 2015, Robert Downey Jr. wore a version of it as Tony Stark in *Avengers: Age of Ultron*. Though Eric has since made numerous T-shirt designs, Bruce Made Tapes—later also referred to as Gung Fu Scratch—remained the top seller in the history of Giant Robot.

The magazine continued to gain traction in spite of its shoestring budget. Throughout the entire run of *Giant Robot*, a steady stream of devoted volunteers and interns would dedicate their time, energy, and skills to write articles; proofread; taste-test Asian soft drinks, snacks, and packages of ramen; model T-shirts; take photos; set up booths at Comic-Con in San Diego; and more. Nobody was getting paid, unless you counted the occasional free stickers or T-shirts. "Everyone had a real job somewhere else," Martin says. "They would come in because they liked the magazine and wanted to help."

Giant Robot also continued to grow because it was at the right place at the right time, covering the rise of anime (pp. 146–150) and Hong Kong movies (pp. 114–145), Hello Kitty proliferating across the malls of America, the crossover of street art to high art (pp. 414–420), and more. "Everyone came through LA—all the directors, all the cool bands. We didn't have to go anywhere,"

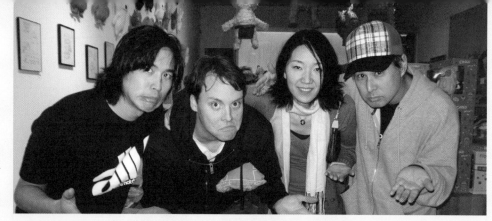

CLAUDINE KO: *Not long after I read the Jenny Shimizu issue, I cold-pitched Eric over email. Turns out we had a mutual friend who had moved from California to New York, like myself. Plus, I was already a working journalist and had a deep interest in street photography. My first GR stories—guides to San Francisco and New York Chinatowns (pp. 91–93), when coconut cream buns were 60 cents and I could easily pin down categories like "best skate spot," "best place to buy carved-off pig faces," and "stinkiest alley"—appeared in issue #12. I kept contributing for another 10 years or so, the last few mostly blogging for the website. I always lived on the East Coast, so I was never part of the Los Angeles GR community, but we had the same affinity for* Giant Robot, *and we knew how to hustle. I pulled all-nighters and reported on my days off from my full-time job as a staff writer/editor for* Jane *magazine, which just barely afforded me the ability to write for Eric and Martin for free. In exchange,* Giant Robot *gave me license to walk the streets of Soho, photographing and chatting with Maggie Cheung and Wong Kar-wai (p. 128); dine with Cibo Matto; ask Kazu of Blonde Redhead point blank if she was dating one of the twins; run around the Natural History Museum with Margaret Yang (a.k.a.* Rushmore *actress Sara Tanaka); and so much more.*

As I researched and wrote the history chapter of this retrospective you're reading, connecting with so many GR people I had never met or hadn't spoken to in years, the all-in affair reignited. The process was not much different than making deadlines for Giant Robot *decades earlier. My current job as an editor at* The New York Times *is also very demanding, so there's not a lot of room in my days for side work. I socially isolated myself and started pulling all-nighters again to finish multiple drafts. Of course, when I saw Martin in fall 2023, for the first time in person in 15 years, he gave me shit again for filing my magazine stories late.*

DAVID HORVATH & SUN-MIN KIM: We came to Los Angeles in 2001 with the dream of making toys that could tell stories. We both had recently graduated from Parsons School of Design in New York and moved around the corner from Sawtelle. The neighborhood had been dead for a good two decades. There was a supermarket at the end of the street, a hardware shop, a make-up place—and that was about it. Out of nowhere comes the Giant Robot Store, a place that felt like we were walking into the pages of the magazine. It even smelled like magazines. Before, we had no idea where to find things like a plush dog-shaped-like-a-house toy, which had been featured in a tiny corner of a page somewhere. It was the physical manifestation of everything that Eric had been building. The store injected life into the whole street; and then eventually into the art scene in Los Angeles and around the world.

When 9/11 happened, Sun-Min's mom called from Korea and told her, "You are coming home right now." She moved back to Seoul, and that was that. One day, David went to the store to brag about a stuffed doll that Sun-Min had handmade for him as a gift from Korea, based on a drawing he had doodled at the bottom of a letter. It was the first thing that she had ever sewed, and she wanted to call it Uglydoll. Eric thought David was pitching him and ordered 20. As soon as he said it, David agreed. He figured we could have them at Giant Robot and even though no one would buy them, we would figure out what to do from there.

The worst thing you can do when you're in the character business is marketing. It's really critical to always be a source of discovery, and the Giant Robot Store was the perfect storm of walking into a place and just being completely wowed by what you were seeing. What an amazing thing to be on the shelf right next to a Murakami plush, a Nara ashtray, and an Otamatone, a big plastic musical note that sings. It lumped us into their same universe.

Sun-Min made a batch of Uglydolls, and we named it Wage. We also made a handful more of a friend, Babo, and David dropped them off on a Friday afternoon. By Sunday, Eric emailed, asking for more. David was horrified because he hadn't even had a chance to take pictures. We were sure someone from a big toy company had brought them home to dissect and include on a moodboard for their next work meeting. The second order we dropped off also sold out in one weekend. Eric promised individual customers were buying them and said we could monitor all the transactions from the store's web camera through the Giant Robot website. So after the next delivery, David ran home and watched for the whole weekend.

It was as if a group of people were instructed to act a certain way. The customer would pick it up, read the tag which includes a short story we wrote. They were probably thinking how funny the name Uglydoll was in contrast to what they really look like, which is weird but also cute and relatable. And then they would put it under their arm and head to the register. Every single time. A year and a half after returning to Seoul, Sun-Min was able to move back to California. Meanwhile, the Sawtelle location filled up one of its storefront windows with Uglydolls for about 15 years.

Eric ran a couple stories in the magazine on us (p. 385). He even mentioned our blog through the homepage of the Giant Robot website and invited us to be in a few group shows, and then a couple solo shows in that first two-year period. He opened up GR2, then Silver Lake, San Francisco, and New York, so we grew with him. Thanks to Eric, we started receiving orders from small independent shops all across the country, Canada, and even in Europe. Many of our retailers had never physically gone to the Giant Robot Store but signed us up because they had found us in the magazine. They understood GR as the church of the designer toy movement. 🐱

David Horvath and Sun-Min Kim are the husband-and-wife team behind the Uglydoll character brand.

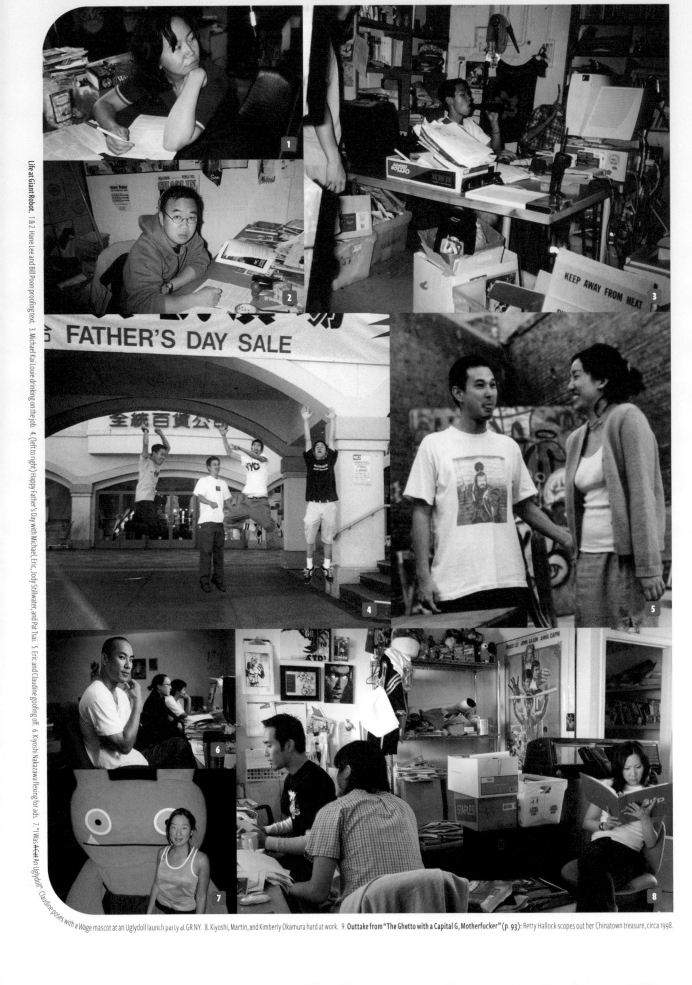

Life at Giant Robot. 1 & 2. Hane Lee and Bill Poon proofing text. 3. Michael Kai Louie drinking on the job. 4. (left to right) Happy Father's Day with Michael, Eric, Jody Stillwater, and Pat Tsai. 5. Eric and Claudine goofing off. 6. Kiyoshi Nakazawa flexing for ads. 7. "I Was A Cat An Uglydoll". Claudine poses with a Wage mascot at an Uglydoll launch party at GR NY. 8. Kiyoshi, Martin, and Kimberly Okamura hard at work. 9. Outtake from "The Ghetto with a Capital G, Motherfucker" (p. 93): Retty Hallock scopes out her Chinatown treasure, circa 1998.

(left to right): Michael in a helmet, Wendy, Martin, and Susan Cho. 17. **Outtake from "The Famous Hot Sauce Factory Tour"** (p. 310): (left to right) Chantal Acosta, Jayson Sae-Saue, Angelyn, and Martin before embarking on the hot sauce taste test. 16. **Outtake from "Crunch Time" in GR #10, Winter 2000:**

(13) featuring canned coffee taste testers Raina Lee and ad intern Jessie Mann; (14) drummer Bill Stevenson (of ALL, Black Flag, and Descendents); (15) Raina, Martin, and Angelyn let their pug friend sniff the goods. 13–15. Outtakes from "Need for Speed! Asian Iced Coffees reigned Supreme" in GR #12, Summer 1998:

10. **Outtake from "Super Relaxed" (p. 241):** Margaret Cho preps for her Cibo Matto interview, circa 1996. 11. Eric snaps pics of wrestlers warming up. 12. Martin shakes a luchador's hand at the World Wrestling Peace Festival, June 1996. 13–15.

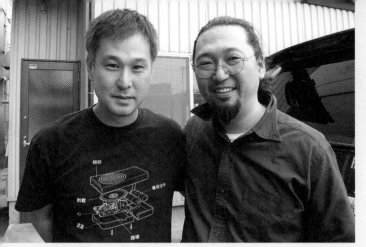

Eric with Takashi Murakami.

TAKASHI MURAKAMI: I presume that the
launch of *Giant Robot* was a project that Eric Nakamura did simply because he wanted to make it happen, not because he was aiming for financial success or anything. I am truly grateful that he pulled it off, specifically in that era.

Japan is in the end a monoethnic-minded country, and the tone in the media starts with the assumption that people understand each other's cultural backgrounds. I think the major difference was that *Giant Robot*, in introducing Asian culture in America, carefully explained the history and context behind each of the works and artists.

I cannot imagine how Eric's work has been perceived in the Japanese community within the US, but I can speak for myself that it was such a tremendous relief for me, as a Japanese studying art in New York City, to see otaku culture explored in-depth by an American in an English-language magazine.

Around the time of the rise of *GR*, Mike Kelley was active in the LA art scene with a band called Destroy All Monsters, which was the title of a Toho Godzilla movie. I think Eric and his friends have created a bridge that connects the worlds of expression along the Pacific Rim by describing the mechanism of cultural exchange from a geeky perspective that unraveled the mystery, for example, of why such confusion had invaded the world of high art.

When Yoshitomo Nara and I became visiting professors at UCLA and stayed in LA for three months, Eric was very kind to us. I don't think there was a gallery in his store at that time, but soon after, he opened the gallery and started introducing artists working in alternative genres. In other words, Nara and I were two such budding alternative artists, and I think it was a praiseworthy activity to provide opportunities to present, critique, and support the activities of artists who were not quite yet contemporary artists.

At the time of my ©*MURAKAMI* exhibition held at MOCA Los Angeles in 2007, I believe that a significant percentage of the audience that crowded into the venue to see the show were *GR* readers.

They had read the feature article (p. 435) that digested my standing position in art and therefore tried to understand me more deeply, which created positive reactions. I am grateful. 🐱

Takashi Murakami is a multidisciplinary artist whose work challenges the boundaries between fine art and pop culture. His aesthetics draw upon tradition while showcasing contemporary Japanese culture.

Martin says. "We were there for the tail end of the Golden Age of Hong Kong movies. John Woo (p. 114), Chow Yun-fat (p. 132), and Jet Li came after the handover in '97." The music scene was integral as well, particularly the increasing influence held by bands from Japan. They featured the pop-punk trio Shonen Knife [*GR* #6] and the Boredoms [*GR* #1], both from Osaka and signed by American labels in 1992, with Reprise Records quickly releasing the latter's *Pop Tatari*. The next year, the noise-rock band shrieked and moaned its way across America on a self-funded tour, all the way to Lollapalooza '94, where they performed alongside Shonen Knife.

"It was that turning point where everything Japanese was cool," says Anne Ishii, who blogged for the *Giant Robot* website in the early aughts. On one end, there was the retro-future pop band Pizzicato Five (debuting its first American EP, *Five by Five*, with Matador Records in 1994). On the other was Guitar Wolf, a self-proclaimed "jet rock" band decked out in motorcycle jackets, skinny leather pants, and dark sunglasses (releasing its first vinyl LP, *Wolf Rock!*, in 1993, on US label Goner Records). Japanese rap was also catching on. Music producer and fashion designer Hiroshi Fujiwara (p. 338) and Nigo, who founded the streetwear brand A BATHING APE, were doing early collaborations that were coveted in hip-hop culture.

More importantly, *Giant Robot* helped expand Asian pop culture and bring it to curious readers without coming off as Japanophile creeps. "Part of it was that Eric and Martin were ineffably cool," Anne says. "They were looking in the right direction." Around the same time, Tom Devlin was working at the Cambridge, MA, comic shop The Million Year Picnic in Harvard Square. "We were selling so many GR shirts and reordering the magazines no matter what the newsstand date was," he says. Tom, now executive editor of Drawn & Quarterly, remembers *Giant Robot* being a "non-shameful" conduit for a cool Asian culture fix. "All Asian pop culture was previously brought to us white nerds by these very creeps—white dudes who were a little too obsessed with anime, tentacle porn, *Star Blazers*, Asian girls in uniforms, whatever," he says. "Invariably many of us were not going to go to the Anime Club at university because of these guys. *GR* didn't cater to white people, but it was inclusive, and it was authentic and cool in a way that none of those *Sailor Moon* fan clubs could be."

The covers shifted from Asian to Asian American personalities around *GR* #8. The Japanese American model/actress/mechanic Jenny Shimizu, famous from CK One ads and being shot by fashion photographers around the world, appeared on the cover of *GR* #10 (p. 449), along with cover lines for stories about the Yellow Power movement (p. 60), rice (p. 288), ping pong, and Hong Kong film. The shoot was a disaster, according to Pryor Praczukowski, who photographed her. "The pictures were out of focus," he says. "I was like, 'Dude, I'm so sorry.' Eric rolled with it. We had a fun time shooting her again at her house." Jenny didn't hold it against them. She later said, regarding the magazine, "The writing was incredible, and that's why I read every single story. I didn't even care what it was about because you guys are so funny and fucked up and rad."

Eric had asked Pryor, a six-foot-two Irish Polish art director for magazines like *Gun Dog*, *Wildfowl*, and *Bowhunter*, to help out a few issues back. Born in Boston, raised in Seattle, Pryor was a fan of 1940s to 1960s Japanese cinema—the films of Akira Kurosawa, Nagisa Ōshima, Yasujirō Ozu. "Eric's good at recruiting people with skills when he's got a project," Pryor says. The two met in the mid-'80s working at the same photo lab; Eric was in high school volunteering in exchange for free darkroom hours before getting hired. In the print world, a prepress technician who can color-balance art files is the key to making pictures look good. Within the *Giant Robot* garage headquarters, Pryor's touch on every image was coined "Pryorvision." One of his biggest highlights wasn't when Eric finally cut him a nominal paycheck, but instead, how honored he felt when Eric asked him for a headshot so that his tiny face could live on the spine with the rest of the core staff members.

By *GR* #14 in 1999, the magazine was publishing six times a year and had a new tagline (p. 449), "Asian pop culture and beyond." "You'd say, 'I'm into Asian American culture.' What does that mean?" Dylan says. "And there was the shorthand, 'I read *Giant Robot*.' And you knew what that meant." Julia Huang, founder and CEO of InterTrend Communications, says, "To see an Asian American magazine that was not focused on [Asian Americans as a model minority] was very appealing to us as an advertising agency." InterTrend consulted with brands to reach the Asian American market, and although Eric and Martin were skeptical about working with them at first, it helped connect *Giant Robot* to brands like Toyota. Eric would go on to collaborate on Scion × Giant Robot cultural events for a few years, with Jeri Yoshizu hooking him up with the gig. "*Giant Robot* woke us up," Julia says. "If we want to target Asian America, yes, language is very important, but culture is very, very important."

VI.

Before the turn of the century, *Vice* received $4 million from a Canadian investor and moved their operations to New York. *Giant Robot* never received outside funding like that, but was taking more meetings with advertisers. Eric and Martin started getting invitations to speak at colleges and ad agencies. In many ways, the possibility of turning a real profit complicated things, and soon, Eric had a falling out with Nate. Overnight, Eric moved out of their Downtown LA loft back to his parents' house on the Westside.

Eric's grandmother lived off Sawtelle Japantown, an area initially settled by Mexican and Japanese farm laborers. After World War II, Japanese Americans returned from the prison camps and opened up dozens of plant nurseries along the street. At one point, it was all Japanese-owned businesses—a plumbing store, a fishing supply, a bank, a hair salon, many restaurants, and some small Japanese markets—but still few retail shops. It is the neighborhood where Eric's parents first met and where he attended daycare, Japanese school, and Buddhist temple. He ultimately moved there and, from his detached garage, continued to operate *Giant Robot*.

In 2000, the boba tea craze had taken hold of Los Angeles, from the San Gabriel Valley to Brentwood. Everybody seemed to be walking around sucking chewy tapioca balls through fat straws. It was happening on Sawtelle Boulevard, too, signaling a new type of clientele: college students, young expats, and hipster professionals.

During trips to Japan, Eric walked the streets of districts like Ura-Harajuku, Aoyama, Daikanyama, and Nakameguro, checking out stores. He also visited ones in New York, including the Japanese design-toy-book shop Zakka. He had started selling hard-to-procure products featured in the magazine, as well as Giant Robot-branded merchandise online. The inventory grew to the point where he needed extra storage space. Ultimately, he was inspired to open a brick-and-mortar store for fans to buy the obscure items they read about. "The problem with the '90s," Dylan says, "to get a vinyl toy, you had to navigate Hong Kong websites. To order anime from Japan, you had to read Japanese."

In 2001, a retail space became available a few blocks away from Eric's house, in a strip mall on Sawtelle. The real estate brokers rejected his application because, as Eric recalls, "they thought that we were going to bring a bad element" to the neighborhood. "What did they think, like a motorcycle gang? What is this bad element that Hello Kitty will bring to Sawtelle? Weeaboos? People wearing costumes?" Fortuitously, another opportunity opened in the onetime Naramura Realty space, which was then a defunct print shop, and the landlord, Mrs. Naramura, who was friends with Eric's grandmother, offered him a good deal.

The Giant Robot Store had a soft opening in August 2001, stocked with T-shirts, Yoshitomo Nara watches, Adrian Tomine comics, Michael Lau vinyl toys, art books from Japan, zines, and more. Like the magazine, the shop was a hybrid of cultures. The only publicity for the soft opening was through email and word of mouth, and Eric was already worried about making rent. But on the first day, customers showed up—far more than he had expected. "I was like, 'Oh shit, people are coming here to buy stuff,'" he says. "It was exciting."

A couple weeks later, the 9/11 attacks hit, and the street went quiet. The Saudi Arabian Consulate General was a few doors down and was getting so many threats that bomb squads had to be called in. Consulate security stood

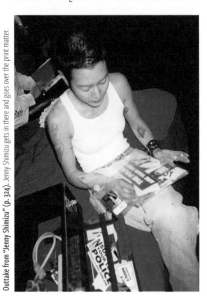

Outtake from "Jenny Shimizu" (p. 334). Jenny Shimizu gets in there and goes over the print matter.

CLAUDINE KO: *For the GR #14 Sex issue, I wanted to write about an Asian American male porn star. This was 1999, when it was still hard to procure Asian films on US-compatible VHS tapes. I realized after a visit to then-iconic video store, Kim's, down on Saint Mark's, that it wouldn't be as easy as finding a name on the back of a box and reaching out for an interview. There simply weren't any Asian male porn actors. And that's when it turned into a full-blown investigation, where I eventually found exactly one: "Brandon Lee," who was known for being a gay top with a "10-inch egg roll" and had already quit the business. Ultimately, after a follow-up story in 2005 (GR #36) with the actual "Brandon Lee," I was finally able to meet him in person and have a satisfying finish to the story.*

guard on the rooftops. SWAT bomb squads arrived daily, roping off a section of the block. Thankfully, the tension cleared right at the end of the month, when the store had its official grand opening, as people got tired of staying home and watching the news. Hundreds of customers showed up, with a mix of punk rockers and hipsters lining down the block. Cate Park, whose headshot also lived on the spine of the magazine with the core staff, remembers being at the store when the khaki-clad brokers showed up and overhearing them discussing their regret over not renting to Eric. "It was packed on a weekday in the middle of the day," she says. "They said, 'Man, we blew it.' Instead of bringing a bad omen, it would have brought a good element. It would have brought a lot of business to their tenants."

What was Giant Robot's best selling item? The magazine, particularly after a new release. After that, T-shirts, Be@rbricks collectible toys, and Uglydolls (which got its start right there in the store after David Horvath, a fan and friend, brought his then-girlfriend Sun-Min Kim's original design to show Eric). "That curatorial aspect of GR meant something to a lot of people," says Adrian Tomine, whose comic books have been regularly stocked on the shelves since the beginning. "I'm sure there were many artists and publishers who would've loved to buy some real estate on the shelves of the GR stores, and the fact that it wasn't for sale made the endorsement that much more meaningful."

The bottom line was that if the product didn't meet Eric's cool meter, it didn't make it in the store. "I couldn't put my finger on it," says Michelle Borok, the former Sawtelle shop manager. "If you asked Eric, how do you make these decisions? It's not a hard-set written-down formula. It's just an ingredient he knows and a recipe he has in his head."

V.II. ...
After high school, Wendy Yao moved to Palo Alto to attend Stanford University. One day,

while on campus, she felt a tap on her shoulder, and when she turned around, there was a couple she didn't recognize. They asked, "You really snuck out of your house and told your parents you were studying for math when you were playing shows?" It was Margaret Kilgallen and Barry McGee (p. 416), artists within the Beautiful Losers and Mission School art movements. In the early '90s, they covered the Bay Area with their graffiti art under various aliases, usually META/Matokie Slaughter and Twist, respectively. They were featured in *Giant Robot*, where they had also read about Emily's Sassy Lime. "We weren't introduced by Martin or Eric, but through the magazine we had known of each other," says Wendy, who founded the LA Chinatown art, books, music, and clothing store Ooga Booga in 2003. (It exists today as a webshop and an occasional pop-up.) "*Giant Robot* was a meeting place for kids who might have felt out of place for liking things that didn't quite fit into the mainstream cultural narrative." Margaret was earning her MFA at Stanford, and the three of them became friends, occasionally collaborating as artists. Several days after graduating, Margaret died of cancer.

Indeed, *Giant Robot* wasn't just a place to learn about the Cambodian "doughnut cartel" (p. 300), Vietnamese nail salon workers, or the gay pornstar who went by the stage name Brandon Lee (p. 106). It was also a connection point. "Sawtelle Boulevard, between Giant Robot and GR2, became my real-life version of the sitcom *Cheers* on the weekends," says David Horvath, who now lives with his Uglydoll cofounder and wife Sun-Min and their children in Texas. "A cast of characters would just show up, and as the years went [by], that cast of characters grew. My favorite thing on TV wasn't on TV, it was on Sawtelle." He argues that without the same "secret ingredient," the stores that copied

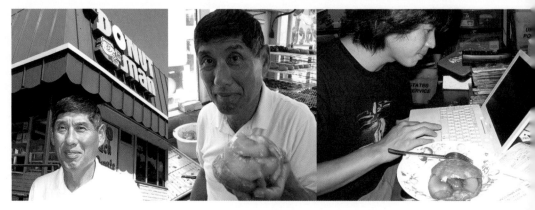

Outtakes from "Holy Man: Circle of Life" in *GR #44, October 2006.* One of GR's many love letters to California's doughnuts. Jim Nakano, founder of Donut Man in Glendora, CA, best-known for their fresh fruit doughnuts since 1972; RIGHT: Martin dares to eat a peach doughnut.

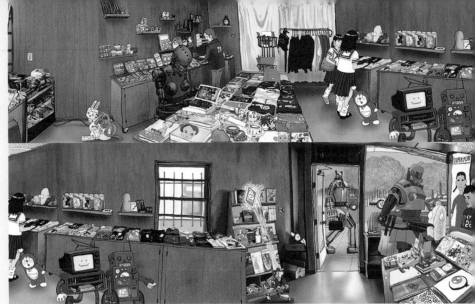

Giant Robot likely have not survived. "The human component is what has kept customers coming back for years."

The GR Lounge was a message board on the magazine's website that had its own robust online community and fostered smart, progressive, and/or silly conversations about cross-cultural topics. Anne Ishii had learned about the magazine through the Robot Lounge when she was living in New York in the early 2000s. She had majored in music at UC Santa Cruz and, on a friend's recommendation, came to the Lounge to learn about new music, particularly Asian musicians. "It would be random, like, 'Did you know the bassist for Man or Astro-man? is Asian?' Or discussing if [Kazu Makino from] Blonde Redhead was really Asian or if she's half." Lounge members (nicknamed "bots") planned meet-ups at the GR stores and galleries, movie theaters, restaurants, and elsewhere.

"I was learning about things I couldn't possibly have found on my own," Anne says. "It was like, let's just exchange as much information as we can. Like Dan the Automator—to know that there was a producer out there who had touched all these other musicians, and he was related to *Giant Robot*. It was cool to be proximate to somebody who had access to the music industry like that."

Like Anne, some bots on the chat boards didn't realize there was a magazine at first. "Every once in a while an issue would come out and someone would talk about an interview or something, and they'd be, 'Where are you reading this?'" says Michelle, who was an active bot living in Minneapolis before moving to Los Angeles. "It was a whole scene. You had strong personalities, and then everybody else was just dipping in and out." People who met on the boards were kindred spirits who forged friendships, dated, and occasionally ended up getting married and having kids. Romance even happened inside its offices.

Just before *GR #18*, Wendy Lau, a graduate of both UCLA and ArtCenter College of Design, joined the crew to help with the website. "*Giant Robot* was something that everyone in the

KOZYNDAN: In 2001, a few months after the original Giant Robot Store opened on Sawtelle, we decided to check it out. This was around the same time when the magazine had started to change and you could tell their interest in illustration and art was exploding. We were about to graduate from Cal State Fullerton and had started doing extremely detailed panoramic illustrations. The first one was a depiction of our apartment, and the second one was of an intersection on Melrose Avenue. The store was perfect for the project—we liked the aesthetic of how packed it was. So, as strangers, we asked Eric, who was running the register, if we could take pictures to make an illustration. He said, "Yeah, sure. Let me see how it comes out." We drew all of the individual merchandise, the 2K T-shirts, the GASBOOKs, the shelving, and even Eric standing there scratching his head. We titled it, "Domo Arigato, Mr. Nakamura" (see above, far right).

Around March, Eric asked us to do some illustrations for the magazine. Then we showed him some more of our projects, and he invited us to have an exhibit at the store a couple weeks after our graduation, in June 2002. Eric did everything punk rock. He didn't give us any instructions. He promoted it only by sending out invites to his email list. He didn't even know the typical gallery cut was 50 percent—he only asked for 10 percent.

Opening night was packed even though we were unknown artists. People came just because Giant Robot was having its first art show. We had brought all of the panoramic images we had made, as well as some small paintings and drawings. It was summer, so when it got too crowded inside, people milled around outside on the sidewalk to cool off. We met all these creative people that we hadn't had access to during school. It was a blast, and such a great way to have our first real show—we didn't know it would be any other way. We just thought, "Life is amazing."

Soon after, an art director working on a Weezer EP cover hired us for our first paid illustration job. We also got a call from a vice president at Disney who asked us to come in for a meeting to see if we wanted to pitch an animated TV show. It was a wild ride for us to graduate college in Orange County, have this show in LA, do a cover for Weezer, and then drive to the Walt Disney Studios, literally going to where the seven dwarves hold up the building's arches. We basically had a career going forward. To this day, we cater to people like us: young art students and people who can't afford hundreds of dollars on high-end artwork.

The same summer, we moved to Los Angeles, and for the next decade, made so many good friends through Giant Robot. After we got the cover of the magazine, more galleries approached us from all over the country and around the world. Eventually, we sold our prints and posters not just through Giant Robot, but many other stores as well. Basically, Eric is responsible for starting our careers without us having to struggle to get our work seen. He's never asked for exclusivity, something a lot of gallerists want. He has always been supportive of us to be happy and successful. He just liked the art and wanted to help some young artists get their work out there.

kozyndan are husband-and-wife multidisciplinary artists Kozue and Dan Kitchens. Their commercial work includes everything from album covers, to clothing lines, to Sony PlayStations.

CARIN ADAMS: In 2014, I was excited to work with Eric on the Oakland Museum of California *SuperAwesome* show, which coincided with the 20th anniversary of *Giant Robot*. As a practicing artist, and then later, a curator, I've always thought about art in the context of daily life. There are multiple art worlds, and I'm often moving around in those adjacent spaces where art is in conversation with other aspects of culture—so I felt a kinship with the magazine. Also, my mother is nisei, and I grew up in a neighborhood full of other Japanese Americans. *Giant Robot* spoke to me in a way that was unique, to have an intentionally Asian American place that intersected with all these other alt realms.

The museum entrance is on Oak Street, which is actually the top floor of the three-level building. There were many artists that participated in smaller ways, but about 15 created new work—graphic novels, illustrations, photography, portraiture, sculpture, large-scale installations, and more—for the exhibition. We tried to make sure the artists had a strong California connection. Just outside, there was an enormous Andrew Hem mural titled, "I think that possibly maybe I've fallen for you." The installation was paired with a group of color-coordinated lounge chairs so people could relax and socialize in the plaza.

Once inside, visitors would walk down the stairs to the second level, go down a long hallway that had a case full of about 100 customized vinyl toys, ephemera, and different original artworks scanned from early issues of the magazine, which sped rapid-fire through its milestones. There was a sense of moving down a tunnel with the flashing light of the publication's history pulling you in, a beacon surrounded by all these interesting small objects. If you keep going, the ceiling in the next space is only about nine feet, and the lights are dim. This is where the original Giant Robot Scion xB car-turned-gaming-station sat. Eric's design was inspired by the Nintendo Famicom gaming console and fabricated by Len Higa. People took turns getting inside the convertible to play. Past a threshold, the ceiling goes up to 30 feet, and that was the main art space, which included a zine-making area. People sat in an area where we had Eric's personal zine collection, stapling their own zine coloring books, talking to one another, and listening to a soundtrack that he put together. We revamped gumball machines, and he filled them with different small artists' projects, something that he had already been doing for a long time at his stores.

Rob Sato's beautiful watercolors were monumental in scale. He made them in a tiny studio surrounded by his materials and his sketchbooks, so we refurbished a turn-of-the-century library book and manuscript case, and had Rob do an installation of his materials: sketchbooks from his years of practice, a baseball from his little league days. It was his artistic history, presented in an archival ephemera installation in conversation with these large-scale recent pieces. That was a revelation. Kozyndan spent a lot of time in our natural science gallery and were inspired by all of our taxidermy. They made an immersive work called *Ode to California*, where you walked onto an ocean floor and were surrounded by naked figures frolicking in a fantasy landscape. Adrian Tomine, who was living in Oakland at the time, included elements from his graphic novel *Shortcomings*. It was all anchored on one end by David Choe's mural, a silhouette of a woman emerging out of an actual spray can that he physically embedded in the wall. He had painted at night, and we constructed a giant bubble in the gallery to keep the fumes from escaping into the HVAC system.

It was busy and definitely not the same crowd we got at, say, a Dorothea Lange exhibit. It was younger, different, and exciting, and the show definitely injected life into the museum. The artists understood so much more than the museum did about how to use social media to promote the show and their work. There were people who normally wouldn't have come to a show, people who came because they knew the magazine or the store, or were fans of the artists. It felt like a social space. People would come in, hang out, and have an experience inside the exhibition. That's something that we've carried forward. Also, having so many artists simultaneously making new work for an exhibition of that scale changed how we operate; it made the museum much more adept at working with contemporary artists.

SuperAwesome felt personally important and remains one of the highlights of my career. I still pay attention to who Eric's showing, to learn about artists. 🐱

Carin Adams is the Senior Curator of Art at the Oakland Museum of California.

design community had heard of," she says. "I wasn't that cool, I wasn't in the punk rock scene. I liked art, and I was interested in getting into design. What attracted me was the energy of the place. It was inspiring to be in an environment like that." On the side, she had a full-time digital design job. Meanwhile, Martin had become full-time co-editor at *Giant Robot*, after being laid off twice during the dot-com boom. Even though the magazine still wasn't making significant money, the store was doing well enough that Eric had the means to pay Martin a modest salary. As more dot-coms went out of business, *Giant Robot* furnished its garage office through liquidation sales, collecting miscellaneous Aeron chairs, file cabinets, computers, a fax machine, and even free cases of paper.

Wendy Lau eventually migrated from the website to designing the print magazine, where she had more interest and felt there was a need. "I loved clean typography," she says. Aside from prescribing the general magazine structure, Eric and Martin gave Wendy free reign to revamp its look and feel. She created a template for the page layout and tried to streamline the large number of stories and high word counts. Mainstream magazines at the time coveted white space and concise articles. "We were like, 'Let's just throw the kitchen sink at this,' which I actually liked as a reader," she says. "And as a consumer, that's why you love *Giant Robot* as well, because you get a lot out of this little package."

Hane Lee volunteered as a proofreader for *Giant Robot* from late 2001 to 2005. "It was the opposite of what my other magazine jobs had been, which were super stressful and just soul-crushing and a pain in the ass," she says. "It was a pleasure to be there." There were nights when they'd all work until 10:00 or 11:00 p.m., but nobody was getting yelled at or impatiently standing over shoulders waiting for copy. Sometimes they'd take a break and play Scrabble. Pizza would be served. Everyone was friends. Eric and Martin were "both pretty goofy," Hane says, "but Eric's sense of humor was more crass. Martin was more articulate whereas

PAT CASTALDO, Buyolympia: That's what GR is—a center of cool people doing things. Whatever cool means or is, the Giant Robot

Eric tended to blurt out whatever popped into his head. They're super funny, super smart, really easy-going. I just loved both of them."

For Wendy Lau, the atmosphere "was electric. Eric, Martin, Pryor, and all the contributors were at the top of our game," she says. "We were firing on all cylinders, working super late and churning out tons of awesome content that was fun and meaningful." In particular, her bond with Martin grew, and the two began dating about a year after she started. Eventually, they married and had a child named Eloise. Hane remembers the couple as "super chill. You wouldn't know they were a couple."

The chemistry between Eric and Martin was more overtly dynamic. "When they would bounce ideas off each other in the office, it was very passionate, energetic," Wendy Lau says. There was never a big fight between them. They would talk on top of each other, but in the end they'd agree. There were some mishaps, like when they had to reprint the Margaret Kilgallen cover for misspelling her name. "That was not fun," she says.

Wendy's first cover featured a color photo of Patricia Lee, an actress who played the Pink Power Ranger. That would be the last photographed portrait *Giant Robot* would ever use on its cover. The next issue, *GR* #19, featured cover art by Barry McGee, kickstarting a new era (p. 450). "If you want it to be unique it just seemed natural to go towards art," Wendy says. "You could commission artists to do custom original work that's not going to be on any other cover." Many artists who were featured at the start of their careers in *Giant Robot*—Seonna Hong, James Jean, KAWS, Saelee Oh, Ryan McGinness, Souther Salazar, Deth P. Sun, and others—went on to be successful.

In early 2001, Eric met the artist Takashi Murakami, who had gotten his first issue of *Giant Robot* in New York in the 1990s. "He knew the magazine better than I knew him," Eric says. Murakami had organized 19 Japanese artists for Superflat, the inaugural exhibit at the MOCA Pacific Design Center in West Hollywood. Opening night was massive, manifesting the craze for Asian and especially Japanese pop culture in the West. "Superflat was the first exhibition that was close to what I could understand," Eric says. "I was like, 'I get this. This is for me.'" Shortly after, Murakami debuted on the cover of *GR* #21 with a full-bleed image from what would become his *Jellyfish Eyes* series and an interview inside (p. 435). Eric wrote that he was "emerging as one of the most influential artists of the decade."

Martin sees a similarity between the artist and the magazine. "Murakami will say that he's connecting pop culture to high culture," he says. "He's removing all those barriers. That was *Giant Robot*, too—an example of popular culture becoming cool culture becoming high culture. And then hopefully Asian culture going from being dorky or exotic to being cool and important."

V.III.

In 2002, Kiyoshi Nakazawa met Eric and Martin at a zine fest in downtown Los Angeles. He was a student at the ArtCenter College of Design who moonlighted as a bouncer. He hated the job. "I'm a skinny Asian dude," he says. "I'm not a natural visual deterrent the way larger security guards are, so I had to rely on different types of social skills. It was stressful work." *Giant Robot* had just lost its advertising guy, and Eric asked Kiyoshi to pinch-hit. He had no advertising experience and had never used Microsoft Excel, but he liked comics and made his own zine. Plus, it was part-time

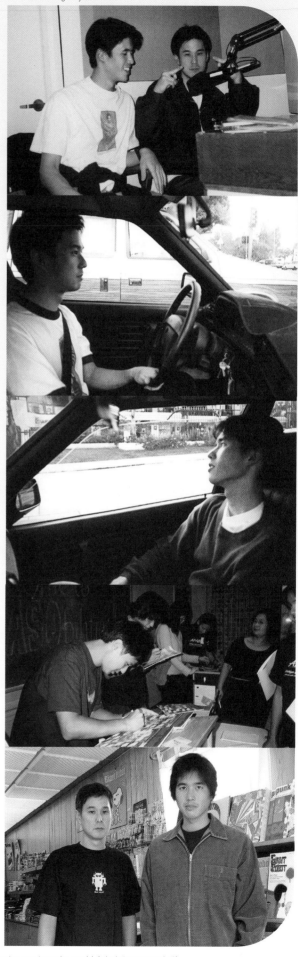

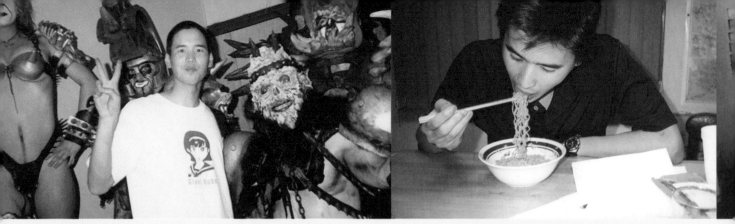

LEFT TO RIGHT: Martin gets some downtime with GWAR after their hot sauce taste test, circa 1997; Never too busy for a bowl of noodles; Unloading fresh pages; Appraising crack seed.

MARTIN WONG:

When *Giant Robot* ran its course in 2011, I was philosophical. Sixty-eight issues over 17 years was a damn good run for a DIY publication. Advertising was drying up, distributors kept biting the dust, paper was getting more expensive, and so was shipping. The age of print was coming to an end and everyone was going online—getting their culture fixes way faster and easier. Maybe our readers didn't need us anymore.

I had met Eric at punk shows. He and I were among the handful of Asians who went to dives like Jabberjaw, Raji's, Al's Bar, and, probably mostly the Cooperage pizza parlor at UCLA that hosted a lot of cool shows. We joked that since people often confused us for each other, we either had to become allies or mortal enemies. We chose the former and, besides going to the same shows, we had a lot of the same friends and both contributed to punk rock fanzines, Eric as a photographer and me as a writer.

The first issue of *Giant Robot* came out in 1994 after Eric told me he wanted to make a zine about Asian stuff. I said, "Me too!" So we applied our energy and collective experience contributing to *Flipside*, *Fiz*, *Fear of GrownUps*, and other lowbrow publications (plus Eric had a job working at a photo studio and I was editing high school textbooks) and the earliest issues featured garage rock and robot toys from Japan, Hong Kong movies, manga and indie comics, junk food from Asia and Hawaii, and other stuff we were into, plus travel pieces that read more like scene reports, and editorials about Yellow Fever. It's hard to believe any of that was considered underground back then, or that when the cover of the second issue featured me wearing giant cat head and dress for a part-time gig at a mom-and-pop Sanrio store, that there were people out there who weren't familiar with Hello Kitty.

We came to feature big-time artists, pro skaters, and respectable authors, as well, and the publication evolved from a stapled-and-folded photocopied digest into glossy magazine with international distribution and a handful of shops and galleries across the US. But to me, *Giant Robot* was always a punk zine with intensely personal and subversive subject matter intended to infiltrate and uplift culture. Featuring Yellow Power activists alongside punks like J Church, Emily's Sassy Lime, and Channel 3; and underground artists like Barry McGee, Jon Moritsugu, and Shizu Saldamando; and iconic (to us) actors and filmmakers like Maggie Cheung, Wong Kar-wai, Takashi Miike, and Park Chan-wook made perfect sense to us. So did having friends like Hong Kong movie star Daniel Wu, indie rock royalty Naomi Yang, or post-riot grrrl dynamo Thao Nguyen as readers and correspondents.

Mixing and matching subjects insured that we never got bored, and maybe punkers would get turned onto movies, art weirdos

would get into comics, and so on. And Asian American culture would be mixed up with Asian stuff, and we'd document and share everything because we thought it was important. There was an unspoken sense of pride that AAPI readers could grasp and everyone else would absorb it. We could go to a college campus and stoke Asian American student groups but then have a booth at Comic-Con and geek out with readers from around the world.

The magazine grew up and so did we. I was in between jobs when Eric opened the first Giant Robot Store and shared that I could stop sending out applications because I would start getting paid for my work on the magazine. The team got bigger when Wendy began designing the magazine starting with issue #18, and a year or so later we started hanging out. "Only if you're serious," she warned me, not wanting to lose the gig if our relationship flamed out. After years of dating, we got married. Eric gave a speech and took credit for hiring her out of ArtCenter. I knew we'd coexist if I could be her production assistant while being editor. Plus, who else but someone on the spine (Ever notice the faces hidden down there?) could possibly understand the long hours and amount of energy we poured into it? It was more like a lifestyle than a job—obsessing over stuff we loved every single moment and just happening to write about it.

By the time *GR* magazine ran its course, Takashi Murakami's art was on Uniqlo shirts, which were at the mall, and K-drama was even bigger than manga, which was already in every public library. Hong Kong movies were being mimicked by Hollywood and anime wasn't screened at midnight anymore. Asian chefs and street food were everywhere. We couldn't take credit for mass enlightenment, but the world looked pretty different from the garage behind Eric's house. BTS was selling out stadiums across the US! Maybe, for the first time, it was not uncool to be an Asian American kid?

And because Wendy and I had Eloise, who was now a three-year-old, it seemed like an okay time for us to stop. I never would have walked away from *Giant Robot*, and it was getting harder to dedicate ourselves 100 percent to the magazine while growing as a family. Our mission, to champion and grow Asian culture, was clearly over, and I was ready to retire from the world of kung fu—like the monks, swordsmen, and pugilists in Martial Arts Theater used to do.

A few years later, Wendy and I returned to punk rock, where it all began, by starting the Save Music in Chinatown series of DIY matinees to raise money for the music program at Eloise's public elementary school. The idea was that we'd carry on the historic neighborhood's punk tradition of the old Hong Kong Café (p. 88) and it was exciting to make something happen in real life after

BARRY McGEE, on his favorite GR memory: Asians taking over graffiti and the hardcore music scene, especially the women.

sharing culture on paper for so long. We became locals in the Japanese American neighborhood of Sawtelle, where the first Giant Robot Store, gallery, and, for a while, restaurant were located, and it was almost poetic to start something where my immigrant grandparents and Wendy's immigrant parents hung out, where we had our wedding banquet, where Eloise was now going to school.

Joining *Giant Robot* pals like Money Mark, Channel 3, Dengue Fever, and Carsick Cars, we became friends with lifers Alice Bag, Adolescents, and Alley Cats, as well as newer bands like The Schizophonics and Slaughterhouse. A community grew out of the shows, and it was multigenerational, with veterans of the scene and little kids from Chinatown pogoing and eating cookies from the bake sale side by side. Eloise not only attended every show, but made flyers and did some guest singing. Her cousins Lucia and Mila would go, too, and eventually formed their own band, whose official debut was a Save Music in Chinatown show that was also my fiftieth birthday. (The Linda Lindas are another story for another book.)

When COVID came around and canceled what should have been our twenty-first show over seven years, it also wiped out any idea that things were better off for us Asians in America. They were worse: Asians were more victimized than ever by hate crimes, scapegoating, and alienation. As a person who celebrated Asian culture in print, got ingrained in the historic LA neighborhood where my immigrant grandparents hung out, and was a parent of an Asian kid in America, it was totally demoralizing. Did all that time toiling on the magazine amount to anything? Should have we done more?

But if punk rock has taught me anything, it's that life isn't some jock sport that is scored with points. The coolest songs don't make a dent in the charts. The best gigs are never the biggest ones. The ugliest artists can make the most beautiful art. And you're probably doing it right if hardly anyone has heard of your zine!

Regardless of its impact, I needed *Giant Robot*. I never got rich or famous but I only worked with friends and only wrote about what I loved and had no regrets. Today I can go to almost any city across the country and meet up with someone who contributed to the magazine, or was featured in it, or was a hard-core reader that I became friends with. Ripples made by *Giant Robot* bounce back all the time, usually when I least expect it.

When we started making *Giant Robot*, being Asian and Asian culture weren't cool. But it was cool to us. It still is. And I still contribute to zines (mostly *Razorcake*) and go to a ton of punk shows, film festivals, art openings, and book signings. I see a clear, straight line from the magazine to Save Music in Chinatown to The Linda Lindas. *Giant Robot* was the starting point and there is no end.

It's the same for Eric, who still holds down the fort with the shop and gallery on Sawtelle, as well as for so many of the *Giant Robot* contributors and readers that I know are out there. As the anagram said, GRAB ONTO IT. And let's see how far we can go. 🐱

Martin Wong contributed to punk zines like Flipside *and* Fear of Grownups *before editing all 68 issues of* Giant Robot *from 1994 to 2011. He went on to start the "Save Music in Chinatown" DIY matinee shows inspired by the historic LA neighborhood's punk past to support the local elementary school's music program, and still contributes to zines to this day (mostly* Razorcake*).*

work for a magazine he loved, with a regular paycheck and health benefits.

Eric showed Kiyoshi the spreadsheet of advertisers, how to email them and make cold calls. "It was kind of like battlefield learning," Kiyoshi says. "I probably shouldn't have had that job." For Eric, Kiyoshi was a good fit with his deftness in diplomacy, honed by dealing with drunk, belligerent club goers. "What better skill set does one need to talk to potential advertisers," Eric says. "It's conversational jiujitsu mixed with friendliness, and all that is a gift."

When Kiyoshi first came to the *Giant Robot* office, he was surprised. "I didn't think that it would be in a converted garage with three computers," he says. Once, a young Asian American technician from ADT came to work on the alarm system. "He knew what *GR* was and looked disappointed when he realized the garage was the office," Eric says. People envisioned a fancier workspace because the magazine was glossy and had Adidas ads. "You walked in, and there was just crap everywhere—CDs, magazines, books, toys, all kinds of shit," Hane says. "It was like a really messy boys' dorm room." The aesthetic matched the magazine's energy, which at times felt like a "boys' club" to her. "A lot of the content was sometimes very dude-centric," she says.

The front inside covers always had video game advertisements or apparel. There were also anime ads, record labels, even casino ads. The only ones rejected were from a cigarette company, and once, a man wanting to place a personal ad. From *GR* #4 to *GR* #51, Hook-Ups skateboards, owned by Jeremy Klein, had a monopoly on the back cover despite other advertisers continually requesting it. The Hook-Ups ads were controversial; some readers found the images, often provocative female anime characters, to be sexist. "Jeremy's the one that we rode in on so I'm not going to boot out the person who supported us from the beginning," Eric says.

"At the same time, it was obvious that Eric and Martin were very supportive of women," says Hane, who continues to work as a copy editor

for various publications today. One of her idols back then was Jenny Shimizu, and when she saw her on that cover, she was blown away. "It was an amazing interview, she was so funny," Hane says. "It was a tell-all of the modeling industry, which was enlightening and interesting."

In *GR #26*, Eric wrote a story about how manpurses had become trendy in Japan. It left such an impression on Hane that when she interviewed the lead singer of the Japanese psych-rock band Acid Mothers Temple, her last question to him was whether or not he owned one. "It was something I never would have asked were the interview for anyone besides *Giant Robot*. He was like, 'What? No!'"

Some advertisers asked if they could get a positive review in exchange for business. *Giant Robot* had a straightforward policy: No pay for play. The editors covered what they covered, they wrote what they wrote, and if they hated something, they might say they hated it. But it was exactly this honesty that appealed to advertisers, many of whom bought pages even if the numbers didn't make sense. Jason Sturgill, whose main client was Nike when he worked at the ad agency Wieden+Kennedy from 2000 to 2004, says, "I knew that if I were to share something that I found out about in *Giant Robot*, most people in the room at Wieden would not have heard of that thing. It definitely made me more valuable. I don't even know where else I would have looked to find out about Asian culture and artists from Japan, Be@rbricks or Pocky, toys and stuff from Japan. They were the gateway to all of these things."

The business spreadsheet showed the magazine's upward trajectory. "It's a combination of what society wanted and the fact that the internet hadn't blown up yet," says Kiyoshi, who has since pivoted his profession to nursing. Then it leveled off around 2005. At its peak, the magazine had a circulation of 27,000. Higher figures floated around, including something called a "pass-along rate," which reflects an estimate of the number of times an issue is shared beyond the original buyer. "That's an advertising thing, some a-holes out there added a digit or more to their circulation," Eric says. "*GR* was a magazine that you shared with many people, so our actual circulation was more than what we printed—at least I hoped so and believed so."

IX.

Kozy and Dan Kitchens, jointly known as kozyndan, were a young artist duo studying at Cal State Fullerton. In 2002, they drove up from Orange County to check out the new Giant Robot Store. Not long after meeting Eric behind the register, he invited them to be the first artists to show their work at the shop the following summer. Afterward he realized that even though he wanted to support artists, he knew it was not suitable for the retail business model. If art was taking valuable shelf space, it disrupted the store's economics. "But having a gallery space," he says, "that changes everything." He found a junky, narrow retail space, but it had high ceilings, a skylight, affordable rent, and a convenient location right across the street from the store.

That spring, Eric asked the artist David Choe, a longtime contributing writer and illustrator for the magazine, to do a solo exhibit. Titled "Immaculate Collection," it was a huge

success. In addition to the artwork, it featured *Cursiv*, a "book of dirty drawings," which was published and sold by Giant Robot—the first of many exclusive artist collaborations. Hundreds of people hung out in and around the gallery. The art shows became all-night sidewalk parties because, at the time, there was a lack of art shows to go to in Los Angeles. "*Giant Robot* was an intellectual hub in that you would read these magazines, and then it became a physical hub through the store and particularly the gallery," says Dylan Robertson, who directed the KCET/PBS episode of *Artbound*: "Giant Robot," in 2022. "It really impacted our lives, for a whole group of us living in Los Angeles."

For Naomi Kageyama, who served with Eric on the City of Los Angeles's Sawtelle Japantown Neighborhood Council, Giant Robot elevated the street's energy. "Giant Robot and Eric are significant influencers for Sawtelle Japantown," she says. "He was always welcoming to everybody. Where else could somebody feel comfortable walking into an art gallery?" Dan thinks of Eric as the "Godfather of Sawtelle," granting the neighborhood cachet with his businesses. "It started to attract people who also wanted to open cool stores and then cool restaurants," he says.

Inevitably a slew of shops selling Asian pop culture-inspired products proliferated around the world: Kidrobot, ROBOTlove, Dragatomi, Rotofugi, Tiny Robot, Toy Tokyo, and more. Marketing companies and large-format stores would send reps to scout the merchandise. "When you could only find this stuff on Sawtelle, that brought in a certain customer, and it kept them really loyal," Michelle says. "But when stuff starts popping up in the San Gabriel Valley, they don't have to come to Sawtelle anymore." Again, Eric would leverage his relationships with his artists to keep ahead of the competition. Giant Robot continued to develop custom collaborations of exclusive merchandise that would sell out: skateboard decks, limited-edition T-shirts, pins, blankets, cups, etc.

Then there was The Post-It Show. In 2004, Eric went to an opening at Junc Gallery, eventually the next-door neighbor of the Giant Robot satellite store in Silver Lake. It featured a wall of the 3×3 sticky notes, each individually drawn by 25 artists and priced at $10. The curators, Mark Todd and Esther Pearl Watson, had been inspired by an exhibit they'd seen in New York. But after that first Junc show, they decided it was too onerous to run. So Eric volunteered to take it over with the pair staying on to curate.

"On a good year, we're cataloging 3,300 pieces of art, but we don't sell 100 percent," Eric says. "Think of all the leftovers. What do you do with that? You got to return it all. That job is hell. It took a lot of tweaking to figure it out." Held annually in December, it continues to be one of the most popular GR2 exhibits. Today the art openings are more tame than the earliest ones. "Other galleries started to open [in the vicinity]," Eric says. "Everybody comes and goes because there's other art shows."

🤖 [SF]

The same year Eric opened GR2 on Sawtelle, he returned to the Bay Area and opened his first store outside of Los Angeles. "I was hustling," Eric says. "It was the time to do

JESSICA HENWICK: The Post-It Show was full of so many incredible artists, I could have wandered for hours. It also felt like a great entry point for someone who

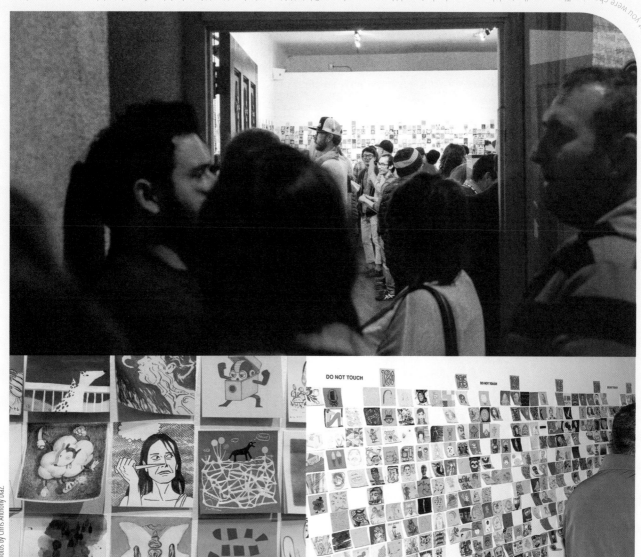

Photos by Chris Anthony Diaz.

it, I had the energy to do it, so I was doing it. That felt like my speed." San Francisco was a natural fit: The punk rock, zine, and Asian American communities were all strong, and there was a large friend and fan base, including Lance Hahn (p. 247) from pop-punk band J Church, Jawbreaker drummer Adam Pfahler, artists like Margaret and Barry, as well as Adrian Tomine, who lived in Berkeley at the time.

"It always felt like we had a home there," Eric says. "A lot of people to this day think *Giant Robot* was made in San Francisco. I would be recognized more in SF as the Giant Robot guy than in LA." The store was in Upper Haight, originally at 622 Shrader Street, just off the main drag. It was a busy area, and the shop was so successful, he soon moved it to a larger space a couple doors down. That storefront, at 618 Shrader, was previously occupied by the FTC skateboard shop owned by Kent Uyehara, a fellow UCLA grad. The new location had a separate room to hold art exhibitions.

Luke Martinez, who had graduated from San Francisco State with a political science degree and no prior work experience in art or toys, was hired to manage the Haight store in 2008. He had grown up in Los Angeles and worked his way up from

dishwasher to manager at Buster's Ice Cream and Coffee, a longtime independent South Pasadena community shop. "Maybe it gave me some legitimacy in Eric's view, that I came from such a cool place," Luke says. Two months in, Eric asked him if he had any ideas for art shows and let him start curating.

The gallery showed younger artists with street cred, as well as a connection to the Bay Area, which helped attract locals. Art openings happened about once a month, and as usual with any of the GR locations, the crowd would overflow onto the sidewalk and take over the street. "You finished up and for the rest of the night, there were remnants of [the party] on Haight Street," Luke says. "You'd go to the Caribbean restaurant across the street, everybody in there just came from the show. Go to a bar, there's some people in there. It was wonderful times."

The actor Robin Williams regularly shopped at the Shrader Street location, picking up comic books, graphic novels, and an assortment of toys, including blind boxes—the mystery art-toy collectibles sealed in unspecified packaging. "He was *the* celebrity for San Francisco," Luke says. "Every month, the staff and I would discuss the book that he thought was

PAMELA ADLON: The Post-It Shows blew my mind. I took my youngest daughter to the show and she just was as obsessed as I am. Sifting through the post-its during the show was like finding diamonds. You never knew which artist you were choosing. They were all priced the same—25 bucks. It could be an art student or Edwin Ushiro, or Andrew Hem! I have had them framed. And they give me so much joy.

might not have bought art before. **DANIEL DAE KIM:** Post-It Show! What a great way to bring the communities of artists and collectors together. To experiment, take chances, and have fun.

Giant Robot a hip business success

CREATORS OF TREND-SETTING MAGAZINE AND STORE WILL APPEAR AT CAMPUS EVENTS' super*MARKET CONVENTION

By Rhea Cortado
dB MAGAZINE CONTRIBUTOR
rcortado@media.ucla.edu

WARNING

The following material contains graphic content. May not be suitable for readers comfortable with the status quo.

GRAPHIC CONTENT

*Jordan Crane's illustrations, "Melee" (above) and "Nails" (right), will be featured at super*MARKET.*

Where did East meet West? In L.A.

By Heseon Park
Special to The Times

'Giant Robot 10 Years'

SPATIAL GAZER: *Mark Ryden's "Pinkie" is included in a group exhibition celebrating the magazine's 10th anniversary.*

What: Group exhibition by artists whose works have inspired Giant Robot magazine, such as Yoshitomo Nara, Gary Baseman, Mark Ryden, Uglydolls, Clare Rojas, Seonna Hong, Ai Yamaguchi, kozyndan, Luke Chueh, Jordan Crane and Adrian Tomine.

Where: GR2, 2062 Sawtelle Blvd., L.A.

When: Opens Saturday. Reception 5-10 p.m. Saturday. Ends Aug. 4.

Contact: (310) 445-9276 or www.giantrobot.com

Heseon Park can be reached at weekend@latimes.com

THE NEW YORK TIMES, MONDAY, JULY 5, 2004

10 Years of Spotting and Setting Asian-American Trends on a Shoestring

Asian-American Trendsetting On a Shoestring

By RANDY KENNEDY

Continued From First Page

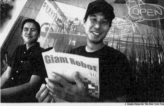

Martin Wong, left, and Eric Nakamura, founders of Giant Robot, a force in Asian-American pop culture.

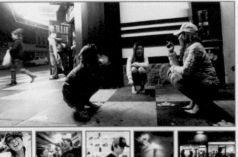

We're way past sushi

EDITORS' CHOICE

Our picks of the month. These aren't the "best" zines (there isn't a "best" in the zine world) they're just the ones that grab our attention. Recent new discoveries and enjoyable new issues by old friends.

GIANT ROBOT
A Magazine for Now

interesting or something weird he got for his daughter."
Once, the artist Matt Leines, who regularly showed at both
GR NY and SF, was having a signing at RVCA a few blocks
away and had run out of his books. "He came down, apolo-
gized, and asked if he could get some of the books from us,"
Luke says. "We're like, of course. He came back later and
brought me and all the staff signed books, you know, 'To
Luke, thank you for saving the day.' All those guys came
to our shows. We'd go to their art shows. We're all friends."

Like the other GR galleries, the art was more illustrative, less
abstract than what could be found in fine art galleries. "We
were personable and accessible," says Luke, who still works
in the toy industry. "I'm not selling medicine. I'm selling stuff
that people don't need. But art can connect with people in
different ways, more than a licensed toy. People can identify
with it and be like, 'I don't know what this is, but I have to
have it.' And it's awesome when you have those connections."

🤖 [gr/eats]

Growing up, Eric's mother, Margie, who owned Santa Monica
sushi spot Hakata, would tell him, "Don't open a restaurant."
He didn't listen, and in early 2005, he opened gr/eats. It was a
small space, located between the store and the gallery, with
a parking lot out front. Eric's father, Bob, and Pryor helped
with construction and design, and the artist Ai Yamaguchi
created custom artwork to hang on the walls. Eric says, "I
was thinking, 'I have a lifetime of experience, my mom
owned a restaurant for 32 years, I can do this'—which is kind
of stupid." Initially, he had hoped to hire a young, ambitious
chef to help build something "creative, different, modern, not
from, like, 1980." But he couldn't find the right person. Margie
came out of retirement to handle operations and brought in
one of her former chefs, Nelson Magana, who was from El
Salvador and had worked with her for years. The menu was
a mix of American, Japanese, and Salvadoran comfort food.

It was exciting at first, and the restaurant would regu-
larly copromote with Giant Robot. For example, when they
offered a special Uglydoll set meal, diners would pack the
place. "If I came in to get my miso soup and rice, and they
were swamped, I would quickly bus the tables," Michelle
says. When there were GR2 events, the gallery was able to
use the parking lot that the restaurant shared with George's
Hardware. "The Giant Robot energy made it work, but if it
stood on its own, I don't know if it would have," Eric says.

The restaurant operations ran on an entirely different
wavelength than the magazine or the stores. "You wake up and
everything's fine, and then you find out the dishwasher quit,"
he says. "Or the power was cut off and all the food spoiled in
the freezer. Brand new things break down. Fifty percent of
the people who quit just disappeared. They didn't say anything,
they just didn't show up again. It's out of your control and
almost catastrophic in a restaurant." Once, when the dishwasher
went MIA and he didn't have time to find a replacement, Eric
washed dishes for three days straight. "It was harsh," he says.

In February 2012, he closed gr/eats. Perhaps diners could
not appreciate that it was a Giant Robot-styled restaurant,

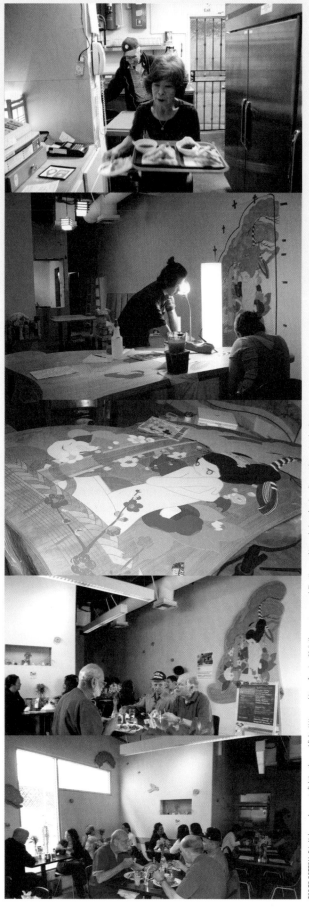

TOP TO BOTTOM: Eric Nakamura's parents fighting the good fight. Ai Yamaguchi transforming GR #6's cover to a mural. Tiny Yamaguchi murals dot gr/eats's walls, complementing the showstopper.

one that offered an eclectic diversity of delights. "We ended up having really great moments, but then ultimately, people didn't quite get it," Eric says. "It wasn't weird, but it wasn't ramen. We'd probably do really well if we just did ramen."

During those seven years, Sawtelle saw an influx of trendy new Asian eateries and earned a reputation for its "Ramen Row." What remains are Ai's artwork, which Eric has in his home, and this *LA Weekly* review by Jonathan Gold, who often came in with his family to eat:

> This small, chic café is furnished with Eames shell chairs and the sort of harsh, glowing light one expects to find in Prada boutiques. The densely packed hamburgers are made with Angus beef, and the mango-garnished fish tacos are pretty good. A platter of French fries includes crunchy banana shavings and squishy sweet-potato fries along with the usual shoestring potatoes; an occasional special of fried tofu comes hip-deep in a dashi-based sauce that will be familiar to anybody who has ever eaten a single dinner in a Japanese American home. The food at gr/eats is re-contextualized Asian American home cooking: bland Thai shrimp curry and Japanese omelet rice; a mild Salvadoran seafood stew served over a yellow rice "paella" and slightly clumsy Vietnamese spring rolls wrapped in rice paper.

🤖 [N Y C]

The same year gr/eats opened, Eric expanded to include satellite store locations, including the aforementioned Silver Lake, and across the country in Manhattan. The latter was actually two adjacent storefront slivers on E. 9th Street, one to focus on merchandise, the other a gallery. Located at the border of the East Village and Alphabet City, the New York store could fit about 20 visitors. "But it was always a really good time," says Anne, who had a full-time job but worked the register on the weekends, basically to hang out with like-minded souls.

Again, the opening nights for the group shows were quintessential GR: a big party attended by a mix of skater cool kids and arty nerds that spilled outside onto the sidewalk. The grand opening showcased sculptures by Eishi Takaoka, whose work was put on the cover of the Haruki Murakami book *Kafka on the Shore*, after the graphic designer Chip Kidd discovered it through *Giant Robot*. Once, during an event for the cartoonist Jeffrey Brown, Ira Glass walked in. Jeffrey was friendly with the host and producer of the radio show *This American Life*, and thanked him for taking the time to stop in. Ira, who had been out walking his dog, told him he had no idea about the signing until he passed by. Anne recalls he said, "I just came in because I thought the store looked cool."

The gallery spaces had a pivotal role in giving new artists exposure. In her early days as an illustrator just out of the Rhode Island School of Design, Julia Rothman would make trips to the city to see art with friends and fellow alums like Matt Leines, and the Giant Robot Store was a requisite stop. In 2009, she was invited to present her work at the Paths Less Traveled group show. She remembers feeling, "I'm not a person who gets a show here, it's for people cooler than me," and appreciating the unpretentious crowd (dressed down in

indie band T-shirts, awkward, hunchbacked, "like people who spend all day hunched over, drawing.") She went on to participate in larger group shows, such as Dime Bag, which also included graphic designers, filmmakers, photographers, product designers, and others, and for which she created a miniature "change of clothes"—cutouts of a pair of socks, folded shirt and underwear. "Giant Robot gave illustrators a place to show work," she says. "There's not a lot of galleries that give illustrators shows. It makes art accessible to everyone—$200 and you can have a piece of art in your house."

🤖

"2007 to 2008 were amazing years for Giant Robot," Michelle says. By now Eric had eight leases—including the locations in Sawtelle, Silver Lake, San Francisco, and New York—and 35 employees. And the opportunities kept coming. In fall 2007, Clement Hanami of the Japanese American National Museum (JANM) in Little Tokyo had a gap to fill in programming. He knew Eric over the years and had just seen the Scion × Giant Robot To the Masses show curated by Eric in Scion Space Culver City. He thought, if Giant Robot could put on shows in these alternative spaces, why not a pop-up at the Japanese American National Museum?

It is highly unusual for a museum to hand over curation to an outsider. Shows can also take years of preparation. But Eric was able to organize 10 artists in a fraction of the time, mostly based on who could be ready in three months. He also wanted to find a cohesive group that could encapsulate Giant Robot, and that meant incorporating paintings, photography, illustration, and comics. The final roster included Adrian Tomine, Eishi Takaoka, Pryor Praczukowski, David Choe, Seonna Hong, Saelee Oh, Souther Salazar, and Masakatsu Sashie. David planned to spray paint a mural across an entire inside wall, which had never been done before at JANM. Part of the building needed to be closed over a weekend, the doors left open for ventilation. "Literally overnight, he did this whole mural," Clement says. "It was amazing."

Before the opening, Eric gave a presentation to the museum trustees, including Senator Daniel Inouye of Hawaii, who was about to marry the museum president and CEO Irene Hirano, and Norman Mineta, who had just retired as US Secretary of Transportation. Both politicians were champions of *Giant Robot*, just two examples of how it appealed not only to its own generation and younger readers but to an older demographic as well. Still, Eric had to convince the museum marketing team to allow guests to use their phones to take photos for sharing on social media. At the time, JANM had signs all around forbidding photography.

On the November 2007 opening night for Giant Robot Biennale: 50 Issues, Eric left his everyday skater attire at home and wore a suit and tie. Attendees broke museum records, with a headcount of roughly 3,000 (counted by a single staffer holding a clicker). The staff was astonished. All of a sudden the historically smaller JANM crowds multiplied exponentially (though not quite reaching the blowout numbers next door at the Museum of Contemporary Art for

TRISHA AND DARREN INOUYE: For Giant Robot to be established and continue to operate in Los Angeles for 30 years in the art world is impressiv

the Takashi Murakami retrospective, which had opened five days earlier). "We never had this type of audience, a lot of young people, young teens with hoodies—that wasn't our scene," Clement says. "It was mostly older, nisei, 60-, 70-year-olds. I remember that night having a conversation with a 45-year-old. I asked him, 'How did you get here tonight?' He goes, 'It's so weird. I used to come here 10 years ago with my parents, but they've since passed. Now I'm here because my kid is a *Giant Robot* fan.'"

Giant Robot partnered with the museum on four more Biennales (most recently in 2024), inspiring others to invite Eric to curate more GR shows: a pop-up show for the Smithsonian Asian Latino Festival (2013), SuperAwesome at the Oakland Museum of California (2014), Samurai! at Worcester Art Museum outside of Boston (2015), a pop-up show for Contempo #ArtShop at the Honolulu Museum of Art (2015), and Silent Wonderment at the Vincent Price Art Museum at East Los Angeles College (2016). Various galleries started inquiring if they could curate museum shows like Giant Robot, but for directors like Clement, the answer was no. "This is Giant Robot, it's different," he says. "There's a whole history behind it. They're not just trying to sell a bunch of art."

XI.

In New York, the epicenter for the Great Recession of 2008, store sales began to dip and then suddenly they plummeted. Eric sublet one of the GR storefronts for the final year of its lease to an apparel brand. In retrospect, he realized all his employees who had lived in Manhattan had moved to Brooklyn, where housing was more affordable. "What would have been the right move? Move to Brooklyn? Maybe or maybe not, but that's a time where staying where we were was not going to be a good idea," he says. Things were changing everywhere. In San Francisco, Haight Street was no longer the tourist destination it once was. Real estate prices had surged and a Whole Foods Market opened on the next block from the store. "Haight Street was not where I even wanted to visit although my shop was there," he says. "That's the least fun place to go."

Eric shuttered New York in 2010, and the following spring, the Haight store was gone, too. "We ended up crawling to the finish line on the leases," he says. In San Francisco, he borrowed a friend's car, spent many days loading it with store detritus and dumping it in public trash bins late at night. He repurposed store shelves for his home in LA and left the rest for scavengers on the sidewalk in front of the store. Then the magazine started to crumble.

With every issue, circulation and advertising dropped. Hook-Ups had stopped buying the back page after *GR #51*. Eric's consulting gigs with brands like Toyota Scion had dried up, and those paychecks could no longer help the business. He knew he needed to change something or it was not going to work. "Everything that had been built was being dismantled," Michelle says. Ironically, *Giant Robot* featured articles about the very trends that helped kill it: *GR #51* ran a piece called "Tubers," highlighting Filipina comedian Christine Gambito a.k.a. HappySlip, musician David Choi, and Urban Ninja Xin Sarith Wuku; *GR #49* talked about Justin Kan of Justin.tv and who

Eric and Martin, c. 2010, near the magazine's end.

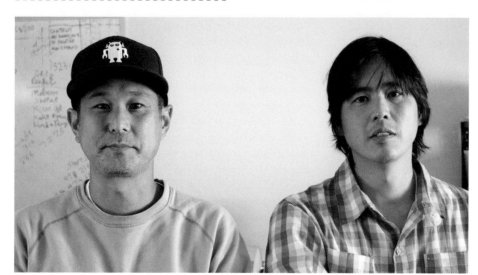

In many ways, I think a magazine/store/gallery like GR can only happen in LA, because it's a city where so much creativity and culture come together. Giant Robot does not come with pretense. It's like home.

later co-founded the streaming platform Twitch; and *GR #55* profiled KevJumba, another prominent YouTube personality. While they foresaw the trend, Eric and Martin were unable to catch the wave and make the transition to video themselves.

"Being on the cusp of young and old is a difficult place to navigate," Eric says. "What was *GR*? A magazine for younger people or a magazine that aged with its audience? Or was it both?" At some point he realized he didn't know anybody who bought magazines anymore, including himself and his entire staff, so why publish one? After a number of site updates by various web designers, the Robot Lounge ultimately stopped working. Some bots moved to a Facebook page, but the community was never the same.

Eric thinks the magazine went longer than it should have. "I was concerned about it for a year," he says. "Everything's going down, and we weren't making any changes. If we don't do anything different and everything's going down, how are we going to expect to save ourselves?" He blames part of the downfall on the distribution system. Publishers would send issues through distributors with the expectation to get paid 210 days later. This plagued the magazine's entire run. "We're shipping thousands of copies, waiting two-thirds of a year and by then a distributor can go out of business owing you for two or three issues in a row that they can't pay back," he explains. "That could be like $25,000 or $30,000. You would think we would have learned, but we didn't. It just kept happening over and over."

Meanwhile, the first Kindle e-readers had been released in 2007, selling out within five hours. Soon the internet flatlined print media. Magazines were dying left and right. Everyone was scrolling through Facebook and reading online articles for free. But the death spiral had begun long before. Craigslist, which started in 1996, had become one of the world's most popular websites, wiping out revenue from classified ads for a slew of alt weeklies across the country. By 2010, both Pinterest and Instagram launched, the latter gaining 25,000 users on its first day, close to *Giant Robot*'s entire circulation. The next year, Borders Books and Music, the second largest bookstore chain in the United States with nearly 20,000 employees, filed for bankruptcy.

"There was no GoFundMe scene," Martin says. "We were groveling to people, putting up video testimonials asking for donations, trying to get people to subscribe and buy or advertise." At the end of 2010, with next to zero ads coming in, Eric made the call. Martin was in Europe with Wendy for a family wedding when he got Eric's message: "We need to talk. This is really important." Over the phone, Eric told Martin that the issue they were still working on would be the last. "It sucked having to say, 'Hey, dude, we're all done,'" Eric says. "It wasn't planned ahead of time. It was literally, 'Today's the day.'" There was no announcement about the closure in the final issue, which remained on stands in 2011. "It's hinted at in the intro," Martin says. "There's contracts and ad fulfillment, and you just don't want to put it in print for people to find out that way." So after 16 years and 68 issues, it vanished.

"There's no goodbye," Eric says. "The magazine ends right there."

Martin remembers calling people to share the news. "Also because I needed a job," he says. "My job description was really weird—editing a zine." He continued contributing to punk zines and freelanced for InterTrend but put most of his energy into being a father and a husband. He took Eloise to the beach, art shows, and concerts, and volunteered at their preschool, as well as organized the "Save Music in Chinatown" series of DIY punk shows in Chinatown with Wendy, who still had her day job when the magazine folded. "Looking back, I realize that I was part of something magical that happened at a very specific time with a very specific combination of people," Wendy says. In a way, Eloise continues the couple's GR legacy as the bassist of the punk band The Linda Lindas. In 2018, Martin was hired by a former *Giant Robot* contributor to work as a marketing administrator for an arts and humanities initiative at the University of Southern California.

Julia of InterTrend has always hoped Eric would find a trustworthy business partner and scale Giant Robot. "From the get go, they were very suspect of us because we weren't necessarily speaking the same language," she says, nodding to Eric and Martin's skepticism of the ad agency world. "[Eric] could have been Tyler Perry, especially now when content is king. They had such a pipeline of content, good taste, and all of that...It's not too late."

Anne Ishii, now Executive Director at the Asian Arts Initiative, saw Giant Robot and Vice Media on parallel tracks early on: "two art misfits in outlier regions, artistically speaking, investing a lot of energy into subcultures." But, she says, "It's a wonderful thing that GR didn't turn into a bigger thing than it actually is. GR did this thing of giving outlier Asian creative people permission to have a little dignity and not have to sell up. This is our scene. You don't have to be into it. It's for us."

XII.

After shutting down the last of the magazine operations in 2011, Giant Robot took a hit with the final printing bill. There was debt, and creditors chased it. Eric even sunk into his personal savings, which "went away like dust." He shifted *Giant Robot* content to a blog on the website. "It was a feeling of shrinking and accepting that ASAP," he says. "Gone was a sense of fame if you had that at all. Did anyone care about the blogs we were writing? It didn't have the same feeling of importance." But there was still the store and the gallery on Sawtelle. He kept those because in a sense, they were home to him. He worked in the shop ("I learned where every cent came in and every cent went out") and started to make big changes at GR2, including a remodel of the space.

Luke Chueh (p. 439), the artist whose work appeared on the cover of the final issue, also helped Eric transition to a magazine-free existence, showing him how he could work with new artists on different kinds of projects. Comic-Con 2011 was approaching, so Luke asked artist friends to customize toy figures to sell at the Giant Robot booth. They physically painted or sculpted them, transforming $30 toys into $500 pieces of art. And it worked. The pieces weren't pretentious or stuffy, and people took to them. "It was communicative and

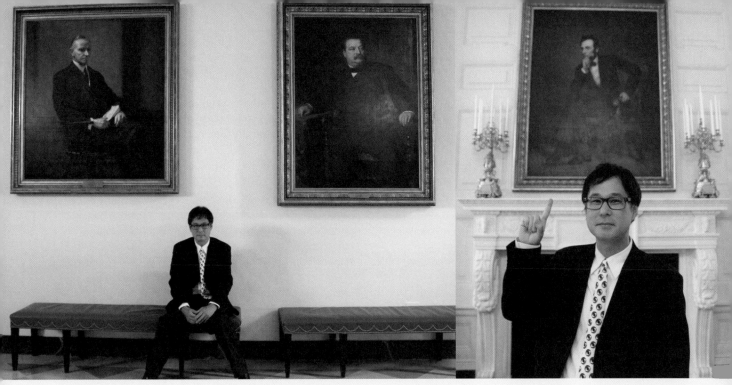

Eric Nakamura gets multiple sweet 1600s—his second visit captured above, and the first on pp. 284–85.

it was emotive, and it borrowed from the kinds of media that we grew up with," Luke says. Eric would later include some of those same custom figures in museum exhibitions, including the JANM biennales and the Oakland Museum of California.

It was another education for Eric: learning about new artists in a subcategory of art that he was both familiar and unfamiliar with. During this period, the GR2 shows became more cohesive, and his vision of what artists to work with—and how—became more clear. This meant exploring styles that were more painterly, crafty, or sculptural. It also pushed him to take things beyond just showing art: inviting artists for podcast interviews, public talks or workshops; collaborating with local groups and individuals to put on comedy, drawing, and video game nights; book reading and signings; and poetry events.

When the artist Yoskay Yamamoto signed on with GR2 for its Year of the Rabbit Lunar New Year group show in 2011, he had just ended his relationship with a different gallerist. "Eric always tells me one man's trash ends up being somebody else's treasure," Yoskay says. "A lot of artists end up facing a situation where they feel like they've been taken advantage of because they're so desperate to make it. But working with Eric, I never felt that way."

Eric would later invite artists like Lauren Tsai, James Jean (p. 398–406), and Katsuya Terada to use his home studio, where they could create enormous paintings that would not fit in their own spaces. After Eric's father passed away, Eric even allowed Yoskay to use his dad's workshop. "Giant Robot has its own community and its own fan base that's a little separate from the other galleries," Yoskay says. "Everybody's there to genuinely enjoy the show or support the community."

During the Obama administration, Eric was invited to the White House as a representative of Asian Americans in arts, as well as small businesses (p. 284). In 2013, he was asked to come for his fourth visit, but this time forwarded a list of artists he admired and worked with over the decades to be invited instead: Adrian Tomine, Barry McGee (p.414), kozyndan, Andrew Hem, and Shizu Saldamando (p.421).

"When you have an experience on that level, it feels like any adjective you use to describe it runs the risk of sounding kind of glib," Adrian says. "I remember people asking me about it, and I'd say, 'It was really cool,' and then they'd say something sarcastic like, 'Oh yeah, just a trip to the White House. No big deal.' But it was indeed cool, as well as surreal, uncomfortable, gratifying, and hard to believe. Like so many other lucky breaks in my life, my connection with Giant Robot felt like I got to be a part of something I was a fan of, which has always been the unspoken goal of so much of what I've done."

Just out of art school in 2013, Cassia Lupo joined the retail staff at GR2. It was not like other galleries she had been to; it was influenced by people her age with similar interests. "It's a cool brattiness, but I liked that style," she says. "There's usually an animal or a character, and something happening in the picture." She eventually became general manager and helped relaunch exhibits at the original store, bringing it back to its roots. Each year she curates roughly 12 shows. "I'm always trying to define what we're looking for," says Cassia, who grew up in the San Fernando Valley. "It's like a Venn diagram of storytelling, illustration style, skill, and someone who is nice and easy enough to work with."

GR2 began hosting Art Konbini ("convenience store" in Japanese), involving select artists who sell their own merchandise and prints, keeping all the profits without paying any fees. "It nourishes the relationships that we have with our artists and builds our community," she says. "Punk to me is when you just do the thing and don't worry about being a perfectionist. You figure out how to make it and do it. A lot of that is making sure that your community is good because they are the ones that help you."

an oversized plastic bag from Blick filled with drawings, protected by two pieces of cardboard and held together by masking tape. I was filled with excitement and nervousness to show my work to James and Eric like this.

Meanwhile Eric was also busy building Giant Robot into a multimedia brand, collaborating on a series of artist-profile videos with Ashton Kutcher's Thrash Lab YouTube channel, producing various podcasts (from as early as 2006) featuring interviews with artists, actors, toy makers, and more. Yet, for Eric, not even *Robot and the Bear*, the 80-plus-episode art and pop culture podcast he started with Luke Chueh in 2019, lives up to the influence of writing an article and having it in print. "The magazine had more lasting power," he says. "We're still talking about it."

Eric even co-taught a course at Pitzer College about Asian American zines for a few years, and with his students, established the Claremont Zine Fest. The first event was held on campus before moving to a public location where it is now managed and run by the artist-owned non-profit Curious Publishing. This complemented his own zines: *Whatever Falls in Between*, a collection of his pictures shot on film in 2016 and 2017; *From the Pit*, which features photos from long-ago punk rock shows; and a couple of collaborations with Katsuya Terada, coinciding with his solo GR2 shows in 2018 and 2019. "In a roundabout way, zines are back as a result of the internet," Eric says. "People want to touch print again."

In 2018, Eric asked Lauren Tsai, who has over a million followers on social media and starred in the popular Netflix

reality series *Terrace House*, to be part of a group show at GR2. Opening night, a line formed outside and went so far down the block it looked endless. "It was eye opening to see the power of a young artist who has an audience larger than most from a different genre," he says.

During the pandemic the storefronts closed. But this time Eric quickly adapted by holding sidewalk sales, hosting night-market-like events, and live-streaming "indie QVC" sale events, which often ran 30 hours a week. Eric would walk around the shop and gallery, and stream from his phone, inviting guest artists and celebrities for interviews. It kept the Giant Robot spirit alive. "Many thought it was like watching reality TV," he says. Occasionally viewers would spontaneously send him take-out sushi.

XIII.

Nearly all the venerated indie publications that emerged in the mid-'90s—*Bitch*, *Ego Trip*, *Grand Royal*, *Might*, *Punk Planet*—are long gone. *Vice*, which expanded into a multimedia and broadcasting company with 3,000 employees and 35 global offices, finally filed for bankruptcy in 2023 after over a billion dollars of outside funding throughout the decades. Facebook, YouTube, and Instagram continue to dominate media, clocking roughly one to three billion users each. The lens for what is rad and "worth covering" has, for better or worse, become a more democratized process.

GR Silver Lake storefront, photo by Chris Anthony Diaz

Over the years Eric has been asked if he would ever relaunch the magazine. "Could *Giant Robot* exist today? Yes, I think so, in some capacity," he says. "It would need to have the same energy but, at the same time, transcend print." Magazines aren't what they used to be. Comparable titles that sit closer to the legacy of *Giant Robot*—fewer issues per year, limited runs, quality over clickbait, tiny staff—are pricey and often treated as collectibles. It is not lucrative business by twenty-first-century standards, but when was *GR* ever? "Since the magazine's departure, we've rode down a timeline of bloggers, YouTubers, and TikTokers who ripple the water with an occasional post," he says. "Most of the time, it's like a turtle poking its head out and then hiding again. I'd like to think that *Giant Robot* magazine had potency."

In October 2022, JANM premiered the hour-long KCET/PBS *Artbound* episode "Giant Robot: Asian Pop Culture and Beyond." After the screening Clement moderated a discussion panel, which included the episode's director Dylan Robertson, artist James Jean (p. 398), Academy Award nominated filmmaker Renee Tajima-Peña, actor Daniel Wu (p. 252), Eric, and Martin. An audience member—author/journalist Eva Katz who'd featured GR in many publications—took the mic to thank Eric and everyone on the stage, some of whom were teary-eyed: "My kids grew up at Giant Robot so I really just feel like a part of this community," she said, adding how artists have embraced it. "It's beautiful and moving and touching." In typical fashion, Eric deflected the praise before saying, "I didn't grow up with art galleries. When I was a little kid, it was not accessible. The idea is to make it more accessible." And then Martin, seated next to him, chimed in. "Hopefully this empowers people to just go for it, do the stuff you love and to share it and grow culture. Make it happen."

In 1996, Eric finished the *GR #4* launch letter by writing, "Get rid of the crap that holds you down. If you don't take a risk, then you'll be in the same place bitching about the same things. You'll never fix that Datsun 510 and your life will never change." Nearly 28 years later, in 2023, Eric got his dream car. It was an early 1970s two-door Datsun 510, in Safari Brown—a true rice grinder in great condition. All it needed was a new set of tires. 🐱

Claudine Ko grew up in Orange County, California, where she started stringing for the *Los Angeles Times* at age 15. After moving to New York City, she got a full-time job as a writer/ editor for *Jane* magazine, the same year she began writing and taking photos for *Giant Robot*. Over the next decade, she worked nights and weekends to report stories for *Giant Robot*, including investigations into male circumcision, lactose intolerance, and Asian body odor, as well as profiles of filmmakers, actors, musicians, and artists. She currently works for *The New York Times* as Culture Editor of T Brand Studio.

Giant Robot Store *(see indicia for photo)*
2015 Sawtelle Blvd
Los Angeles, CA, 90025

GR2
2062 Sawtelle Blvd
Los Angeles, CA, 90025

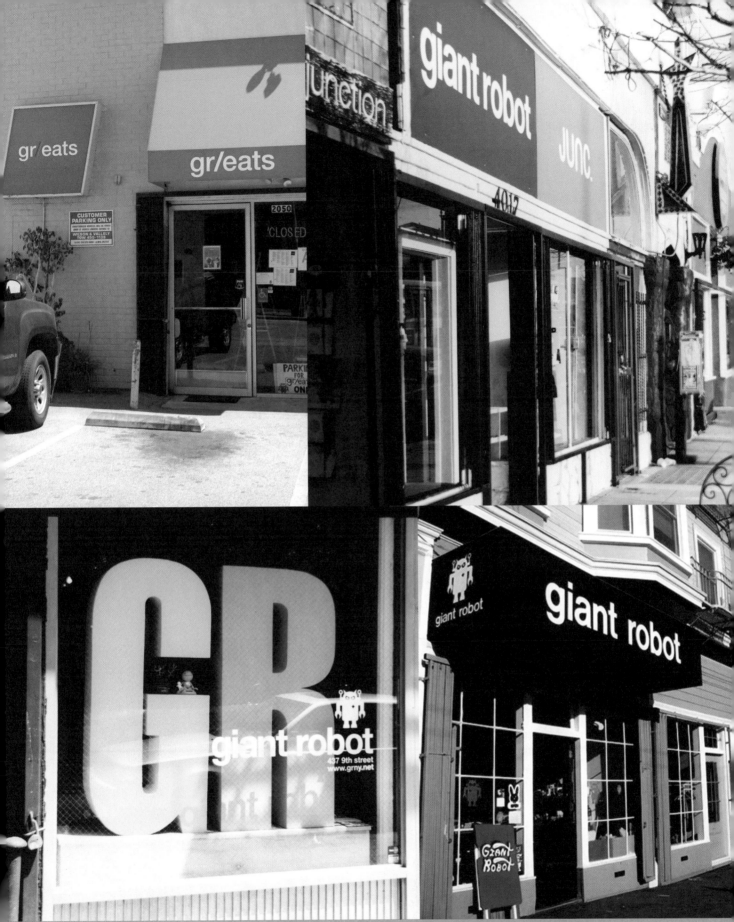

photos of GR2, GR Silver Lake, GR NYC by Chris Anthony Diaz

CLOSED LOCATIONS
(*top row*) gr/eats, Giant Robot (Silver Lake location in Los Angeles)
(*bottom row*) Giant Robot NYC, Giant Robot San Francisco

GIANT ROBOT X GOOD SMILE COMP

BIG BOSS R

BIG BOSS ROBOT
DAI LO 大佬 12 COLORS

BIG BOSS ROBOT
DAI LO

BIG BOSS ROBOT
DAI LO

BIG BOSS ROBOT
DAI LO

Barry McGee zine (2006)
Out of Print low stock
$25

Margaret Kilgallen
$45

James Jean
Signed

words | Eric Nakamura
picture | Chris Anthony Diaz

I've iterated that contemporary Asian pop culture began with *Godzilla* in 1954. It was a decade after World War II when Japan began to get reestablished, and allegories of nuclear devastation could sneak into fantastic cinema. My mother moved to Northern California from Japan around then, and my father, who was born in a Steinbeck-esque California farm town and then interned at Poston, Arizona, eventually found themselves in Southern California. In due time, Godzilla becomes the GOAT of monsters and leads a worldwide influence in Neo Asia, including West Los Angeles. An early memory puts me in a fake velvet seat at the Nuart Theatre, my eyes fixed on Godzilla thrashing Tokyo. It was the mid-'70s, and the crowd laughed at the monsters' campy moves, but I was as transfixed and awed as if it were *Jaws*.

We spoke English at home, and I attended Japanese school, Buddhist Temple, and helped occasionally at the family business—a Japanese restaurant called Hakata. I was shy as a kid and sat in the backs of classes, not wanting to participate. Later, I studied photography, drew a little, and began run-on sentence writing that became a zine. I became a publisher and co-editor.

The '90s were confusing as music tastes expanded from one niche to nearly every niche. Hong Kong movies came from a tiny island and influenced cinema worldwide, and conformity to the previous generations was already out. We weren't doing what our parents did, but I still lived in a mix of filial piety and punk rock. At first, *Giant Robot* zine encapsulated the passion and energy of what excited my small world of friends. It spoke of our intersections, whether it was identity, Hello Kitty, or Sumo wrestling, and it spoke to others as well.

Giant Robot woke up a thirsty audience and later changed people's lives. Stories came from readers telling us about their artistic career paths and thanking *GR* for it. A new esoteric future was possible and was far from being a model minority. Your dreams could become your vocation and not just a vacation. I was doing it, and so could you.

I wasn't the best at anything, and worked tirelessly with a protean attitude to make highlights throughout my career. The zine slowly grew into a solid bi-monthly magazine on newsstands near everyone. Our subject matter matured to interviews with underground celebrities who acted, painted, or skated. Taste tests of ramen packs and obscure Chinese alcohol preceded food blogs. You'd see *GR* next to *Vogue* or *National Geographic*, and sometimes next to the packs of grey healthy gum at Whole Foods checkouts. In the 2000s, Giant Robot shops with gallery spaces opened in LA, SF, and NY. A restaurant happened as well.

Then, years later, almost all of it went away. Time ran out on the magazine as print died and blogs, vlogs, and e-books rose. The economic crash doomed almost everything in 2011, but it gave way to a denouement. It marked a time after publishing 68 issues, speaking at Ivy League colleges, and traveling hundreds of thousands of miles to visit the shops that I finally figured it all out.

The free Nikes, the multiple White House visits, and being a prototypical influencer no longer mattered. Who should give a shit about your shit? What did count was the hard work—often known as the "process." Ask any artist. The ride to get there is personal and everything. It's possible that life is about the stories behind the stories, and that's what keeps GR moving along.

Today I work with experience and efficiency, with an understanding of what's good or what works. It's also tempered with my own "talents" or "eye" for details, art, and products. The grind I felt during the magazine years is no longer. The hours today could be long, but they're mostly smooth, refined, and continue with the team.

Only recently have I heard of the descriptor, "Giant Robot Artist," which is an honorable and maybe adorable category in our galaxy of art. The hundreds of artists we work with support us and are the friendliest group of misfits lost in their sketchbooks. I only hope that Giant Robot continues to represent them well.

I'm most likely to liken Giant Robot to a small gear that spins with many other gears to create a better world. I'd rather downplay my career, but for the sake of this book, I'm louder than my typical self and celebrating what's happened thus far. If I really wanted to go all out, I could say that we started contemporary Asian pop culture by documenting it piece by piece and putting it all together in the pages of *Giant Robot*. My friend Godzilla perhaps being the starting point, and without an ending, and continuous chapters never-ending. We then created a new retail niche of toy figures and design goods, and later, in coda to the legacy: formed a category of art.

You're holding a marker that embellishes the accomplishments of GR up to now, and this book project was born from a single pitch that was a few sentences long to my old friend and Drawn & Quarterly's executive editor, Tom Devlin. It went to his wife, Peggy Burns, the publisher, and within a few minutes, her response was: "We would love to do this!!!" They didn't require a "deck" to prove our worth. Instead, they brought out their personal copies of *Giant Robot* to get this project rolling out of Montreal. It was a reverse ultimatum: "No them, no book," and it worked.

The output of over 6,000 pages, hundreds of curatorial projects, and retail locations in three cities is like a burning obelisk of creativity. The tributes herein by a range of maverick experts, artists, and friends speak to the importance. Yet, Giant Robot remains an underdog story and seldom gets the credit it deserves. I've heard some utter thoughtlessly and nasally, "something else would have taken its place." But after a quick thought. No. Giant Robot. Is. It. I've learned to accept that the GR stench is the silent but deadly kind. Nothing has ever come close, nothing should, and nothing will, and it's why this book exists.

IDENTITY

As a kid in the '90s, I could hardly have dreamed of the place where our culture has landed: currently, whiteness is straight-up uncool. (Sure, it remains dominant, ubiquitous, festooned with advantage, et cetera, and the fact that it's increasingly regarded as tacky and/or boring is one of many discursive smokescreens masking unchanged and/or worsened material reality—but still!) You'd think that, under the circumstances, writing on identity, Asian American or otherwise, would feel especially unfettered, unpredictable, ungoverned. But more often it feels dutiful—respectful and respectable. And as a result, these excerpted pieces from *Giant Robot*, some of them 30 years old, can at times feel fresher than most anything you'd find today.

For this we give it up for the creators and writers of the magazine, first and ultimately. But we might also consider the way that *Giant Robot*, like its peers in zine-core and alt-weekly spaces, was free from a set of coercive factors that have come to dominate the plague-ridden playland of identity discourse. Corporate encroachment, for example, and Instagram in general, and the fact that the representation conversation has left the realm of the everyday and the material for an airless echelon of narrowly conceived celebrity and commerciality. Most of what currently passes as public conversation about negotiating identity transpires on mediums that have been orchestrated to produce the simplest possible reactions: approval or disapproval, anger and ostentatious righteousness. On the algorithmic internet, stuff is corny and punk is dead. The conditions are not exactly conducive to the kind of writing you'll find here—blunt, ambivalent, meandering, unpolished, self-aware but not self-conscious. "What is my point?" Lynn Padilla asks, in a piece about hot Asian girls dating ugly white guys. "Do I need a point?"

We need this spirit—of doing things, of writing, for no particular reason—especially badly at a time when everything, even identity itself, has been forced into a framework of instrumentalization; a time when everything is expected to have not just a point but some point of profit, too. Free of that pressure, these pieces flow loose and easy. Writing about being pursued mostly by white guys who like Asian girls, Margaret Cho writes, "I think they see in me the face of what they want and the spirit of something else entirely." It's fine, she notes—any kind of love is fine: "It's your hate that you have to watch." That little key twisted in the lock, that absence of weight in such a loaded topic—no section break followed by a turgid vignette or a capsule history of colonialism—it's nice! We find ourselves grateful for tossed-off idiosyncrasy! Martin Wong wears a Hello Kitty costume for ten days and comes out with no conclusion other than it was kind of funny. ("When asked if I knew the Power Rangers, I posed in a karate stance.")

JIA TOLENTINO

The piece that most exemplifies the *Giant Robot* ethos, in this section, may be Martin Wong's "Return to Manzanar," a sidelong-then-straight-on view of history as seen from a skateboard. The skate trip places ephemerality and aimlessness where they'd never be otherwise—in a concentration camp site. (Though, Wong notes, someone chipped the "c" off the "concentration camp" sign in protest.) Internees' names are carved into the walls; one person wrote, simply, "I Love Myself." Wong notes that the reservoir in Manzanar is "rough, pebbly and rideable only if you have the XT wheels," and that if you can't find them, "order them direct and tell them *Giant Robot* sent you." Wong adds that you won't be able to ollie in these wheels, but you can ride on "dirt, rock, trees, cars, and roadkill without a hitch."

But the centerpiece of this selection is "Yellow Power," by Eric Nakamura and Martin Wong, a series of interviews with Asian radicals that feels, today, 62 years after SNCC was founded, like a treasure chest stuffed with bootleg firecrackers and detonated bombs. "Inevitably," Nakamura and Wong write, "some of you will say 'But you forgot this...' or 'This isn't true,' but we don't care, so don't waste your time telling us what we missed." They add, addressing the former activists who didn't respond to their queries, "We're sure your ex-movement group will thank you for being a pussy." Interviews with Yuri Kochiyama, Lee Lew Lee, Vicci Wong, Mo Nishida, and many others are coded with tallies for how many times each person mentions Mao, Malcolm X, Che, and MLK. Lew Lee notes that many assimilation-minded Asian Americans considered Asian radicals to be traitors and communists: "Of course, the more somebody calls you a communist, the more you want to become one." He exhorts readers, "Think in a new way. Organize in a new way." (My mind wandered, cringing, to #StopAsianHate infographics formatted for Instagram Stories.) Wong remembers helicopters showering students with pepper gas during the Third World Liberation Front Strike. Nishida considers the "power elite" Asians who "think they represent all of Asian America." "These motherfuckers," he says. The "only way the human race is going to survive is if we take them out by any means necessary."

These pieces left me with a reminder that the Asian American radical lineage includes and depends on not just militancy but aimlessness—beautiful aimlessness. Both of these qualities are methods of resistance to a world of instrumentalization. Both give us the space to see each other, to see ourselves, to reject received ideas of identity and forge something potent and new.

Jia Tolentino is an essayist, screenwriter, and the *New York Times* bestselling author of *Trick Mirror*.

RETURN TO MANZANAR

words | Martin Wong
pictures | Eric Nakamura

In the early 1940s, there was a spot in central California, between Sequoia National Park and Death Valley, where Japanese Americans hung out. Coming from each of the Western states, they gardened, painted pictures, published newspapers, composed poetry, made babies, and played volleyball and baseball there.

🤖 **ERIC:** This photo might be the most iconic image ever published in *Giant Robot*. It's a historical monument; we

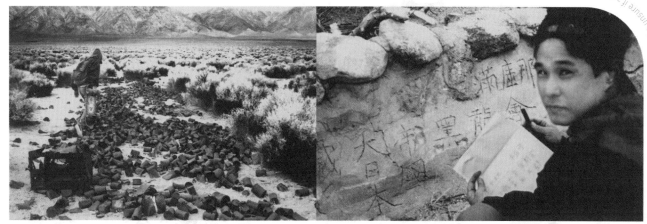

LEFT: When you recycle cans, they get dumped in Manzanar. So if you need some change, you know where to go. RIGHT: The wall basically says, "Die American white man!"

For some reason, even with all those activities, visitors couldn't wait to get the hell out. Perhaps it was the guns that were pointed at them or maybe it was the barbed wire that surrounded the complex. You see, Manzanar was one of ten internment camps in the United States where Japanese and Americans of Japanese descent were "relocated" during World War II.

Today, there's not much left where the "camp" used to be. But that doesn't mean Asians or any other minority group can't be rounded up and screwed over at any given time. The popularity of California's Proposition 209, with its thinly veiled hatred toward Hispanics, and the swelling controversy about whether or not the CIA introduced crack into the predominately African American neighborhoods of South Los Angeles, are just two current situations that show how brotherman still has a big, fat target tattooed on his ass.

Like any self-respecting militia group, we at *Giant Robot* want to be ready when the shit hits the fan. So, Eric and I decided to go to Manzanar. Not knowing what to expect, we tossed a few survival tools into our backpacks and equipped our skateboards with off-road XT wheels. Then we hit the road.

IN LONE PINE

Stepping out of the newly re-tinted Honda after a three-hour drive, the first thing we did was freeze our asses off. We thought the desert would be hot, but the first snow of

the season was settled on the mountains and a tundra-like wind was blowing through the air. There was probably black ice between the parking lot and the Lone Pine Visitor Center, too, but miraculously we managed not to slip.

Lone Pine is located about 10 miles south of Manzanar on SR-395. The burg's main function is to allow fishers, hunters, and campers to fill their gas tanks and unload their bowels. To further accommodate such camouflaged mountain men and hippy-dippy hikers, there's a visitor's center that tells which roads are closed, where the fish are biting and the deer are playing, and what the weather's like. They also have books and maps for sale.

Walk into the building and turn right. On the bottom right of the facing shelves, there is an entire row of books on Manzanar. Most were useless to us—interviews with local non-Asians about their views of the internment, lists of government press releases, and so on. But do pick up the 50-cent pamphlet. It's just a bunch of crudely cut-and-pasted mimeographed pages that aren't even stapled, but it lists self-guided tours with information that can't be found anywhere else. That, along with the free brochure (on the rack to the left of the front door) will take you where you want to go.

Stepping out of the heated building and into the frigid desert was a pain. But armed with our new information, we were ready to move on. By now, it was 9:30 a.m.

The following names were etched into the reservoir walls by vandal Manzanar internees who felt the need to tag.

1943 NOV OGAWA	**TOM M**
CONSTRUCTED BY CHOPO 8 INC. NOV 9 '43	**NOV 12 1943 MANZANAR WALL**
NOV 1943	**1943 Y&T KOBATA**
MANZANAR, CALIF	**T KAI**
KAZ OGAWA	**K OWGAWA**
TOMMY M 1943	**I LOVE MYSELF**
JACK YOSHINAGA	**TOMMY MIYAOKA**
TOMMY MIYAOKO	**JIRO MATSUYAMA 11/24/43**

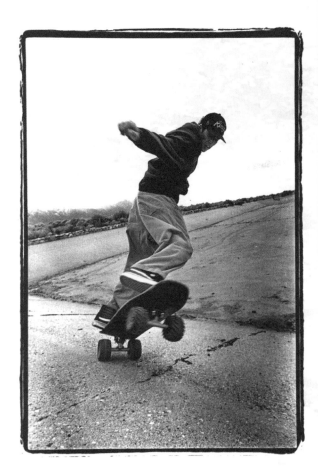

→ **SUE EMBREY**

Every year on the last Saturday of April, a few hundred people make a pilgrimage to Manzanar. Last year, on the 50th anniversary of V-J Day, a few thousand went. The number of pilgrims fluctuates, but you can count on Sue Embrey to make the trip. An internee at the age of 18, she's been organizing the trips for nearly 30 years.

So you organize these pilgrimages?
SUE EMBREY: This year was our twenty-seventh and generally we get about 300 people. It's a one-day program, and most people go on their own. We used to have buses, but the city stopped giving us money.

Do more students than interns come?
Yeah. One, the interns are getting older and don't like to travel. It's about four hours from Los Angeles. Two, they figure it's in the past and they don't want to talk about it. They got their redress money and I think they just feel that things should just be left alone. We would like to continue on. **Survivors of the Holocaust are worried that their story won't be told and we have the same feeling.**

Some World War II veterans argue that the Relocation wasn't such a big deal.
They want the exhibit in Independence to be taken down.

After hiking a mile from the parking area, we hit the empty reservoir that was in beat-up shape. We thought it was going to be a big bust, but we were wrong. The banks at the reservoir are rough, pebbly, and rideable only if you have the XT wheels. Look for these knobby rubber-coated tires at your local skate shop. They come with tall risers, hardware, and a disclaimer in case you wipe out and break a tooth. If you can't find them, then order them direct and tell them *Giant Robot* sent you. You can't ollie in them since you're too high up, but you can pull off old-school tricks like 360s and manuals. You can also ride on dirt, rock, trees, cars, and roadkill without a hitch.

BRICK HOUSE

Enter the Manzanar area, and the first things you'll notice are the stone houses. Placed between two tall structures that once supported gunmen, the stone houses were once occupied by armed guards. Now they're empty and boarded shut.

On the front of the first building is a plaque that relates Manzanar's history. Notice that the first "c" in "concentration camp" has been chipped off by some veteran who doesn't think former Japanese and Japanese American internees at Manzanar deserve any sympathy. Don't get too close to it, though. One disgruntled vet drove two hundred miles to pee on it.

Above the plaque, there's a shelf which holds a large collection of offerings that includes candy, stuffed animals, Budweiser, Martinelli's Apple Juice, make-up, homework, a comb, crackers, Lifesavers, a box of raisins, an onion, a hot dog, a nicely framed photograph, a pack of Marlboro Lights, a plum, and an AT&T credit voucher. We added a pack of ramen seasoning to the altar and skated in.

SKATE OR DIE

On maps, Manzanar is divided into a grid. Weeds, animals, and erosion, however, have eliminated most of its distinctions. What's left to guide you are a few tracks left by off-road vehicles and rows of dying trees. We skated as much as we could on overgrown paths, but often got stuck in sandy spots.

Upon entering the compound, turn to the right and you'll see the only structure that still stands at Manzanar—the auditorium. Until 1996, this building was still used as a garage by Inyo County for roadwork vehicles. Now it's been acquired by the Parks Department and will eventually be turned into a Manzanar museum. [Although Manzanar was recognized as a National Historic Site in March 1992, the Visitor Center would not officially open until 2004. A Junior Ranger program began in 2007, and today, a virtual museum supplements in-person programming led by park rangers.]

From the auditorium, turn left and skate toward Mt. Whitney. Under the trees, you should be able to find some fallen logs to practice rail slides and 50-50s on. Animals to look out for include roadrunners, owls, and jackrabbits. Don't step on the rusty tin cans and kitchen appliances. Yes, they are artifacts that should not be moved, but they are also tetanus traps. Interestingly, many are riddled with bullet holes, and shells are scattered around them.

Spotting evidence of firearms activity isn't exactly what you want to see when you're lost in a desolate wasteland, especially if some locals aren't too crazy about Asians. **Officially, it was**

They want the National Parks Service to fire the Superintendent, Ross Hopkins, because they said he was sitting in his office doctoring photographs. They went after Bill Michael, too. But everyone's pretty much stood their ground.

Is much research being done?
Archaeologists have been out there about three times in the last two years. There's a report coming out soon, and Jeff Burton from Tucson, Arizona is preparing a slide presentation called *Three Farewells to Manzanar* because the Native Americans were evicted by white settlers. Then they were evicted by the City of Los Angeles, who wanted to use the land for water. Then we were evicted from our homes and relocated to Manzanar.

No wonder there are rumors that the area is haunted.
Well, a number of people have told me that. I met with Bruce Babbitt, the Secretary of the Interior, and there was a man from Redondo Beach who, when we mentioned Manzanar, said, "That place needs to be protected because it's really important for us Americans history-wise." Later, he came up to me and said, "I walked around Manzanar and, you know, that place is haunted. You could feel the ghosts." I said, "I know, people say that."

Have you seen ghosts?
A local channel did a paranormal program. We went up there and they interviewed us and everything. I wasn't there at night, but they claimed that they stayed up real late and they said at the cemetery area there was a ghost. They claimed they took a shot of it, and it shows very lightly on the screen, but I didn't believe that. Other people have seen the show and they really think there may be ghosts there.

What's your opinion?
I feel that and I agree with that, but I don't actually know. People said there was some kind of occupation there, remnants of people probably still kind of wander around. I don't know.

Who do you think it was: displaced Native Americans, whites, or Japanese Americans?
They claimed it was an internee. It's possible. Japanese believe in ghosts.

It's hard to get to the cemetery, though.
Right after the rain, you can drive through there before the sand really gets loose. Other times, you can get stuck.

Does the aqueduct get filled when it rains?
They stopped filling it up because Water and Power are worried that someone might drown there. Young kids go up there and have beer parties. But it's very pretty when water's in there. 🐾

The vast expanse of reservoirness waits for your arrival next summer.

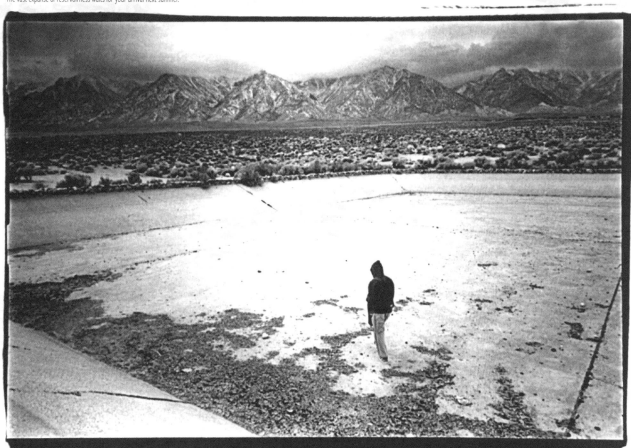

encourage more skaters to go out there and deface the monument made famous by the Ansel Adams photos. In response, I wrote a long, polite letter detailing how we were trying to inform and affect different audiences and generations like she was. I happened to run into her at a coffee shop, introduced myself, and was relieved when she told her colleagues about the article and how wonderful it was. Whew!

If you go to Manzanar, you'll come out with more questions than answers. What happened to the internment houses? Where did those rusty cans come from? Do ghosts really haunt the camp? Ask Bill Michael, director of the Eastern California Museum. It's based five miles north of Manzanar in the town of Independence. Both Michael and the museum have been threatened by certain bitter veterans who think the Manzanar exhibit is unpatriotic, but he hangs in there and answers questions for people, like us, who want to know.

Do a lot of people visit Manzanar? It looked pretty desolate.
BILL MICHAEL: It looks pretty desolate, but there are almost always cars parked in front. I've lived by here for 10 years, and any time you drive by, there are cars. Most people probably don't make it past the front gate. In the park, some actually find their way to the cemetery and the reservoir.

What are all those rusted tin cans?
At the west end of the camp is where the dumps were, from the town of Manzanar that was there in the '20s. So when you see a big pile of tin cans, that probably goes back to before the camp.

Is there controversy about the site and the museum?
Well, in this area and other places, there are some World War II vets, among them are people who were in Japanese POW camps, who are still fighting the war, and have it misplaced enough to think that Manzanar has some relationship to their experience.

Has anyone actually followed through with their threats on Manzanar or you?
No. That's just hot air, but they certainly mean more than hot air. I have some empathy for them. **They're angry and their hurt is misplaced, but these are guys who suffered in a war. Of course, there's some basic racism involved, but there's some of that everywhere.**

One Los Angeles Times *article described a man who drove two hundred miles to urinate on the plaque.*
There is a guy who said that. One of the people, Lillian Baker, who has written a couple of books on the subject, claimed there were no guard towers and there was only a fire watch tower. She managed to spend over 20 years in the National Archives. She found enough documentation so that everything she said would have an element of truth in

pheasant season, but every time we saw an off-road vehicle drive by, we wondered if the riders were taking aim at us. If they shot us, our bodies wouldn't be found for months.

We breathed a sigh of relief when the monument was finally in sight. That wasn't until we got past the trees, and we were three-quarters of a mile across the barren camp.

CITY OF THE DEAD

The cemetery itself is rather small...about the size of a fat basketball court. A sign hangs from a torii (a Shinto symbol that's basically a doorway) on the outside, but whatever was written on it has been eaten away by erosion. Judging from the harshness of the wind, dust, and cold, the paint could have been stripped in a day or two. Just behind the openings in the barbed wire stands a monument.

The tower isn't that big, maybe 15 feet tall. It reads, "Tower of Memory." People have left coins, stones, paper cranes, and hearts on it. The hearts are made from paper clips, barbed wire, and other found material. Behind the monument, Eric found a small kewpie-style figure made from wire with colored string wrapped around it. We placed it behind some rocks on the monolith.

Scattered mostly around the perimeter of the cemetery are 19 graves. Only a few are marked with carved stone, but each has coins, hearts, and paper cranes scattered in front. The loss of any life is fucked up, but don't pass up the two graves located in the left rear. The corner

marker is the oldest in the cemetery. To its right, sits a replacement marker for three-month-old Jerry Ogata.

When you're done paying your respects (we put up some extra change and upped the total amount of change distributed around the cemetery by $2.90), step out of the barbed-wire fence and notice the tie-dyed handkerchiefs that are securely knotted here and there. What do they represent?

RESERVOIR DOGS

As you leave the cemetery, make a left at the dirt road. Yes, you're walking away from the entrance and your car, but you don't want to miss the reservoir. Keep walking down the path until you see a torii marking a path that leads to the left, up toward the mountains. Walk that way.

You'll have to traverse your way past a lot of rocks, some more rusty cans, and maybe a rabbit or two, because the path is sandy and slopes slightly uphill. Skateboarding won't work no matter how big your wheels are. The path will turn to the right, left, and right again before you see the rocky "coping" of the reservoir. When you peek over the edge, you'll know the half-mile hike was worth it.

Built in 1942 by prisoners, the reservoir was designed to hold 600,000 gallons of water, enough to serve the 10,000 or so interns being held there at any time. Today, it's dry and suitable for off-road skateboarding—not unlike an empty swimming pool. (Tar-filled cracks and dirt make it too bumpy for regular wheels.) At the north end of

it. She wasn't dumb. She was very clever. She recently passed away, but she was the hub of a network of people who have been protesting since the state made it a landmark in 1973.

Would you say most people in the area are against that?
No. There are some people who are, but there are also schoolteachers up here who use the site every year and teach the topic to their students.

How many people go to the museum?
We get 25,000 people a year, and Manzanar is the most talked-about exhibit we have. We are a small out-of-the-way history museum, but the most commented and talked-about exhibit we have certainly is Manzanar, both by casual visitors and people who have come looking for it.

The auditorium still exists. Aren't bulldozers and plows stored there?
Not anymore—there were until six months ago. The City of Los Angeles owns the whole site. Except for the building, they own the land. Inyo County owned the building until about six months ago when the Park Service purchased it

from the County. Then the County moved the bulldozers out of there. That building will get restored and turned into some sort of visitor center. They will probably put up a couple of barrack buildings back on the site near the auditorium. The Park Service's general management plan calls for putting at least one guard tower up somewhere.

Weren't the tar-paper barracks auctioned off after the war?
Yes, in 1945 and '46. It was good building material. They dismantled them and built houses out of them. The auctions had a veterans' preference, and for guys who came back from the war or didn't have a place to live, it was a pretty good deal. I believe it was 350 bucks or something.

Are there ghosts in Manzanar?
There was a show out there, *The Paranormal Borderline* on the UP Network, and they did a segment and claimed to have filmed a ghost in the cemetery area. They sat out there and got pretty cold out there. I think they doctored the film a little, but people have had some unusual experiences out there. I myself have not. 🐱

the reservoir, notice where the run-off channel enters the reservoir. That's a great place to pick up speed and drop in.

Follow the run-off channel and you'll find a low bank (good for skating) and a basin wall (good for sitting). On the wall is some interesting Japanese graffiti that reads: "Long live the Great Japanese Empire—Manzanar Black Dragon Association Headquarters," and "Knock over England and America." There's also graffiti etched in English further up the channel. Most of that consists of names and dates, though. Don't dawdle too long; we spotted a giant turd there that must have come from a gigantic beast.

By the time we finished reading the graffiti, skating the channels like snake runs, and perfecting our manuals in the reservoir, the clouds had darkened and descended upon us. We had been shivering for four hours straight and it was time for us to leave.

The best way back to the parking lot is to skate all the way down the road with the torii. You'll wind up a couple blocks away from where you parked, but the ride on this moderate slope is the longest in the camp. After skateboarding on sand and dirt, the short cruise on the highway feels smooth, like you're the Silver Surfer. It's also fun to watch people who drive by in cars freak out at the sight of skateboarders in the middle of hell.

THE END

There's a lot of Manzanar that we didn't see—the Hospital Area, the Children's Village, and the Judo Dojo, for example.

That's okay because those spots probably look a lot like the rest, with the tar-paper structures gone and the overgrown jumbo desert weeds. **Just about all that's left are cement foundations, some plumbing, and the cold, dry, and dusty wind. This would be a shitty place to live, even without 8 guard towers and the military police armed with 21 rifles, 6 machine guns, 21 submachine guns, and orders to shoot to kill anyone who tried to escape.**

Revisionist historian Lillian Baker claimed that the internees at Manzanar and other relocation camps stayed by choice, and that they were free to leave once they proved their loyalty. Anyone who visits the area will know the truth. The weather is harsh, the land is sucked dry, and the living conditions are, at best, oppressive. The free education and food, which Baker suggests actually benefitted the prisoners, were not worth leaving a home or a business, or even wasting time in relocation. We hiked and skateboarded Manzanar, but the place should never be confused with a summer camp. 🐱

MARTIN: Looking back at this article is pretty exciting. It was active, informative, and funny, and really different than anything else I had written. I wonder what I was thinking? The most similar thing was probably the Hello Kitty piece. But right away, this one felt important and it was very cool to put it right next to cool movies and music. History, identity, and pride should be cool, too, right?

NINETEEN AND LIFE
SKID LO

words + pictures | Eric Nakamura
polaroids | Massachusetts Correctional Institute

After a long day at work, a 30-year-old guy might pitch in a recreational softball game, grab a beer and a burger on the way home, and then unwind on the couch and catch an episode of *Gilmore Girls*. On another night, he might wail like Skid Row's Sebastian Bach in an '80s hair-metal cover band, en route to hookin' up with groupies. For many, this is the American Dream, and for Wayne Lo, it is his life—except that he'll never again drink beer, make out with a female, or walk freely. Wayne has been a prison inmate since he was 19.

WAYNE'S WORLD

In 1992, Wayne murdered two classmates and injured four more in a 20-minute shooting spree at Simon's Rock College (SRC). **The seriousness of his crime cannot be quantified, and I don't intend to over-dramatize it, underestimate it, or even attempt to strike a happy medium in my portrayal of him; I just want to share my experience of getting to know him.**

The Massachusetts Correctional Institute is not far from Norfolk, a tiny New England town steeped in American history, with visits from George Washington and Paul Revere. Almost every house is over 100 years old, the businesses are small, and nestled among the trees is a public skate park. There are a few other prisons nearby, including Walpole, the maximum-security joint where Wayne entered the system. About three hours away is Great Barrington, a resort town filled with theaters and antique stores, and the home of Wayne Lo's alma mater. Voted the number-two gay-friendly college by gay.com in 2000, it is usually rated among the top small liberal-arts schools in the US, Simon's Rock enrolls 400 students a year with alumni including Joel and Ethan Coen.

Wayne is the son of working parents who reside in Montana. He was a violin prodigy who was so eager to leave home that he enrolled at Simon's Rock since they take tenth- and eleventh-grade students. Wayne was not religious, but as a sophomore he suddenly felt that God was telling him to perform the shootings. He ordered a rifle and had ammunition sent to his dorm. **The school's dean knew about it, but chose not to intervene because he felt it would have been a violation of privacy. A report filed by another student resulted in no action.** On December 14, Wayne Lo became a killer. After his insanity plea failed, he was sentenced to life without parole.

WAITING ROOM

I became familiar with Wayne's crime and started corresponding with him after he wrote a letter to *Giant Robot* last year. Right away, he suggested that I read a book about the incident, *Gone Boy: A Walkabout*, by Gregory Gibson. The author, the grieving father of Galen Gibson, one of

the students Wayne murdered, goes on a soul-seeking investigation of what led to the shooting, who was at fault, and what could have prevented it—ultimately helping him regain his life. It's well-written and does the trick when it comes to supplying the facts. Even so, I have my own questions about the incident, and arrange to visit the Institute.

The day I arrive, the prison's visiting hours are delayed due to a fight among inmates, which leads to a lockdown. Sitting with visitors in what could easily be a bus station waiting room, the conversations run like those in a support group. An African American woman says with authority, "The first holiday is bad, but wait until the second and the third." A younger white girl tells me, "You're a newbie. It's hard the first time you come, then it gets easy." Another woman asks a volunteer nun, "You can get married in here? How many guests can come?" It goes on and on, and it's actually comforting. The guards are surprisingly professional, helpful, and pleasant.

The visiting room is pentagon-shaped and features vending machines stocked with Blimpie sandwiches, chicken fingers, chips, candy, fruit, and soda. Visitors purchase armloads of treats for the inmates while the machines are still loaded. Most are women visiting their significant (or maybe insignificant) others. Reunited couples are happy and chatty—at least at first—some exchanging quick kisses and hugs, while others play with their kids.

Sporting an oversized short-sleeved denim top and ill-fitting jeans, Wayne enters the room and takes a seat, which he is not allowed to

ERIC: After this came out, Wayne sends it to Gibson. What were you thinking, Wayne?! Not printed here is the

n's Killer
Learn
Happened

 not sure he'll ever get." She was
sted in reading Mr. Lo's letter.
-mail message forwarded by her
lia said she would prefer not to talk
ter. She cares about Galen and her
e said, but "during this time of my
e been thinking about lots of other

said he was not sure his father's
ould ever end. "My dad," he said,
ellectual guy who is trying to figure
he rest of his life why his son is

ly conversations with a reporter
 in January, Mr. Gibson said that,
e energy for his investigation came
y that he focused largely on the
ation of Simon's Rock. Just before
ought the used semiautomatic rifle
t a gun shop in nearby Pittsfield, he
ed, over the telephone, 200 rounds
nition from Classic Arms, a North
arms supplier and brusquely de-
he package be sent to him, via next-
t the college. "I have to have it by
," an agitated Mr. Lo barked at the
rk, according to police reports.
time, Massachusetts law provided
 an out-of-state resident wanted to
le in the state, the gun laws in the
home state governed. The law in
where Mr. Lo's parents lived,
 18-year-olds to buy rifles with no
eriod so Mr. Lo had.
had slipped the rifle onto campus in

Alan E. Solomon for The New York Times

Police officers in Great Barrington, Mass., escorted Wayne Lo to an arraignment on murder and assault charges after a shooting on the campus of Simon's Rock College in December 1992. Two people were killed and four were wounded in the attack.

a lifting of clouds. It happened gradually and, from what he said, it appeared that much

This fall, Wayne asked his mother to have a copy of Mr. Gibson's book sent to him. In

leave. Guards stand on both sides. In reference to the crime, he says nearly under his breath, "I'm such an asshole." Finally, I'm face to face with Wayne and can have a conversation with him about his crime, his punishment, and anything else that comes up.

FACE TO FACE

Gibson and his book seemed excessive to me.
WAYNE LO: I can't believe you thought the book was too much. If you thought it was, it's only because what happened was indeed that crazy! I thought it was excellent—not at all overboard. He spoke his mind, he led us though his journey, and it was sad. I doubt anyone would have the same courage to confront what happened the way he did, so maybe that surprised and overwhelmed you.

How did the book affect you?
Before the book, I was like, "I killed two and injured four. So what? I'm still alive." That was all that mattered! I was in denial. I didn't think about the victims; I thought I was the victim. Gibson's book gave me a new outlook because I finally saw things from the victims' point of view. And, man, it really kills me that I've caused so much pain for so many people. I mean, **to the families that I've hurt, I'm worse than bin Laden. I must live with this burden, and it is my burden to carry.** And I'm not saying it with arrogance; I'm saying that people try to shed their burdens, but I won't.

Can you recall the event?
I can recall it pretty well, but I don't think about it unless I'm asked or something jars my memory. I'm certainly not proud of it, because it was truly a cowardly act. I randomly shot people out of anger. It's truly fucked up. I wish I could go back and miss all the people. I wish my aim were terrible. I wish the gun blew up in my face. The people who died were great people. I mean, sure, all the papers said I was talented, but nobody said I was a good person, which was completely accurate. Galen was a great guy—the most beloved kid on campus. He died on his way to help others. Isn't it ironic that the hero dies and the coward lives? I want to be the hero, but I'm the coward. That's what I think. If there's any proof that there is no God, just look at what happened.

If you were diagnosed as a paranoid schizophrenic, why is it that you don't get treatment? Or do you?
Yes, my defense attorneys and our "expert" shrinks said I was schizo, even though they had three different diagnoses from three different shrinks. Not an exact science is it? But I never believed I was. In fact, I told my lawyers I did not want to plead insanity, but there was no other plea possible. I am not getting treatment. Those shrinks have never visited me after the trial, so obviously they didn't really believe in my psychosis, either, right? Shouldn't they follow up? Isn't it in the Hippocratic Oath or something?

Wayne Lo "dollhouse" that one can cut out and make. These "cute" things made Gibson upset and critical. I refrained from writing back harshly. In retrospect, I felt bad since out of anyone in the world, he was the one person who'd get offended. It's like getting hit yet again after so many years.

How do you know you're not schizophrenic anymore? And what was God's appearance and voice like?

I don't think I was ever schizo. The whole God thing did happen, but it's a bit complicated: I never heard God's voice or saw a vision. People say that because they assume that's what happened. I basically had a feeling, and by that I mean like déjà vu—when you just know something inside you.

Are you religious?

I went to a Catholic high school, but I was never religious. I'm an atheist. And even if someone can prove God to me, I won't believe it because I choose not to! But I had a great deal of anger because I felt ostracized and persecuted at SRC. My outlook was a bit conservative compared to the extreme liberalism there. I hated the school so much that I was willing to believe that I was down with God—something I didn't even believe in. So if that's mental illness, then I may have been impaired for a while. But I wanted it that way, so I am still the one responsible. Religion sucks, and I think all those who fight and kill in the name of religion are basically in the same state I was, just making things fit their own agenda. I mean, I had this crazy notion that *Revelation* was written for me, because it mentioned Asia in it, and I'm Asian! I became like a fundamentalist Christian, distorting the Bible to fit my agenda just because it was the antithesis of SRC. I don't believe any of that anymore, but it doesn't mean I shed responsibility for what I did. I am responsible 100 percent.

Where did the right-wing thoughts come from?

Right-wing thoughts were more or less imprinted on me. I mean, being Chinese was strike one. Moving to and living in Montana, strike two. And then landing at SRC, no doubt one of the most liberal spots on the planet, strike three. **I wasn't able to adjust. I mean, it's not as if I'm a bigot. It's just that as a young kid you always rebel against what people tell you to be. So when left-wingers attacked,**

I basically tried to repel them with ridiculous right-wing thoughts. That's how an immature person acts. It wouldn't be like that now, because I don't mind what the hell anyone says. It was just stupid, ego shit.

Do you think going to college made that much of a difference?

I doubt I would have done anything violent if I'd stayed in Montana and gone to some normal university. At SRC, I was the freak show, and being isolated set me off. I think many things could have stopped me, and the fucked-up thing is that everything went so seamlessly. I was able to buy a gun like I was buying a Hershey's bar. I ordered bullets and they were delivered to me. My room was searched, but I had all the stuff on me. **I could have been stopped so many times but wasn't, and that only reinforced my thinking that I was doing what I was supposed to do.** I didn't even have to hide the gun. I bought it the afternoon of the shootings and walked around in broad daylight with a long box under my arm. The campus was pretty empty because everyone was taking finals.

What about your freedom?

Prison is limiting, but I am thankful to be alive. What I did could have resulted in the death penalty in another state! So I could've been killed, but I was not. It is a responsibility, too: to live the best that I can now. It doesn't mean I should become an activist. I mean, **I believe the victims of my crime will live comfortably knowing I'm behind bars, so I'm not going to start saying that I deserve a pardon because that will only hurt them again.**

What can you do to be productive?

I'm not really into all this "keep out of trouble" stuff because I think the best way to learn is to get in trouble. I want to show people how I can excel in prison, and then say to them, "If I can do well here, imagine how well I could do as a free person?" Sort of a reverse psyche on their ass. I'm not a preacher, but if people will listen to me, then great.

How do you deal with your sentence?

You've got to come to terms with your sentence. Many never do. They keep dreaming about the day their verdict is reversed or they get a parole or commutation. They put everything into that dream, and when it is not realized, they crumble. **I'm aiming very low.** I have no aspirations of ever getting out. Would I want to? Sure, but I keep it real. I work on how to make the most of my narrow future.

Can you have a girlfriend or get married?

Of course, "girlfriend" may not be the exact term, because obviously there will not be the normal intimacy that free people enjoy, but letters, calls, or maybe even visits and holding hands would mean a lot to me!

Did you have one before?

I've never had a long-term, steady girlfriend, but I was not a virgin when I came here. That's a good thing and a bad thing. Good, because I won't die a virgin, but bad because I'll spend the rest of my life missing it! I wasn't Don Juan or anything, but I sometimes wonder how those women are doing now. Would you feel weird if you've slept with a convicted murderer? Do you think you'd try to repress it, or would it be good conversation piece?

Does anyone inspire you?

Guys who have been in prison for many years do give me a sense of awe. We've got guys who've been in for 30-plus years. Imagine people who've been in jail since the moon landing! One day some kid will say to me, "You've been in since before 9/11?"

What's the prison like?

This place is medium security. It's really not that scary at all, even though there are 1,500 felons here. There's a lot of stuff to do—sports, education, a music program, visits, work—so people get involved with various things and keep busy, and the violence is pretty dissipated. When I was in Walpole, I saw some crazy shit.

 ERIC: Admittedly we had fun with the article, and it all fit Wayne's personality. He's a funny person. ● Yes, there are productive Asian Americans

One time, I was walking back to the block from the dining hall and heard a metal clang behind me. I just kept going. I found out later that someone had been stabbed. But I have yet to get into a bad situation. As bad as it sounds, people not fucking with you is one perk of being a famous murderer. I rank pretty high in this hierarchy, and the more time I do, the higher I climb because being an old-timer raises your status even more.

Are you friends with any guards?
No, but there are a couple of cops that I've known for a while. It's easier to ask them for things. I don't think they hate us. We're more or less animals to them, but zookeepers don't hate the animals. They just need to contain them and not get bitten.

On the day of the shooting, you wore a Sick of It All T-shirt. Are you still into punk rock?
I'm not punk rock at all. I'm actually a classical violinist and was pretty good when I was 10 or 11. I was number one in Taipei and number five in Taiwan's national competition. I went to the Aspen Music Festival at 14, and studied with Dorothy DeLay, who taught at Juilliard and was the most famous teacher in the US at the time. I went to a few hardcore shows with my friends, saw Sick of It All a couple of times, and got their T-shirt. It was a total coincidence that I wore it that night—a sick coincidence, absolutely not planned. I like glam metal.

I think Bon Jovi and hair metal is weak.
I am a musical prodigy! How can you argue music with me? Music died when grunge emerged. Real bands that actually had some musical talent got the shaft. I don't really like Bon Jovi, either, because they never died off, and that kind of makes them sellouts in a way. Plus, they are trying to distance themselves from the hair metal genre. Fuck them! But Warrant, Skid Row, Europe—come on!

JUST DESSERT

Our afternoon ends with a lot of joking around. Wayne's a pop culture junkie, and he's actually very knowledgable about film, TV, books, and magazines, as well as anything Asian American. For a person without the internet, he's well-versed in "our" interests. We also talk about softball—Wayne is a pitcher and a team captain. Then we discuss TV—he loves *Gilmore Girls*—and he tells me about his hair metal band, Skid Lo, in which he sings and plays keyboards on covers of '80s rock songs.

Wayne asks me to bring him some ice cream from the vending machine because he doesn't usually get to eat it. I don't understand why, and he reminds me, **"This is prison. It's punishment!"**

ERIC: Sometimes when you get to an old article, you think, "Oh wow...This is one of them." Wayne Lo is—to this day—still an occasional pen pal and a younger brother who was relentless in comebacks. There's a mini tub of the letters he wrote to me that I think I shouldn't reread and are probably unprintable. He said he had to destroy the ones I wrote to him since he could get into trouble. Through this, I visited him once in prison and it was weird. It's prison. He was friendly and nice, and I didn't know that I should have bought more vending machine credits since what's in those machines are a delicacy there.

Room drawing by Wayne Lo

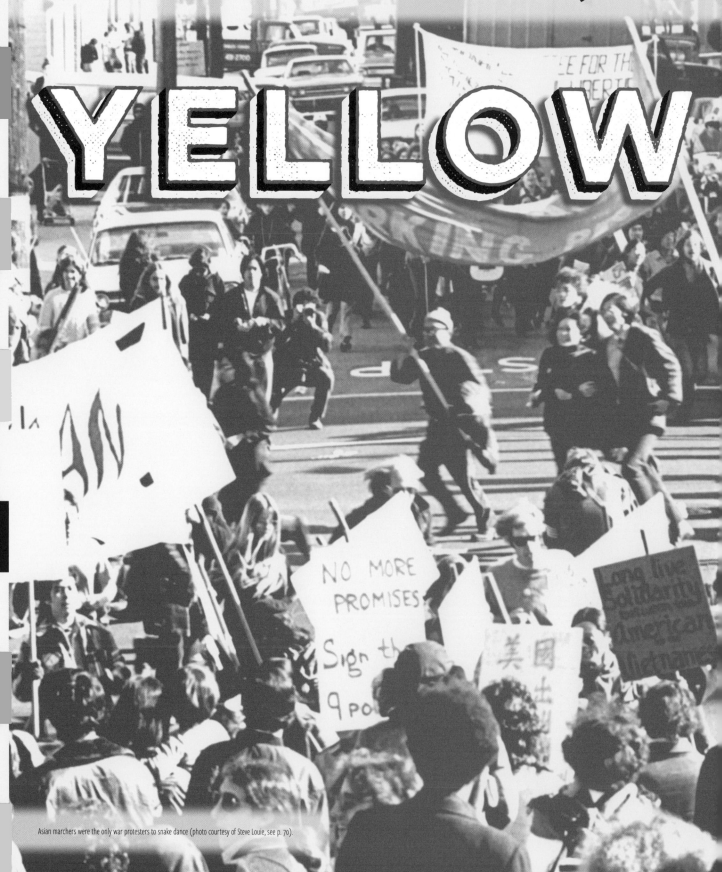

During the late 1960s and early 1970s, the Black Panthers rose to the battlefront for the oppressed people in America.

MANY ASIAN AMERICANS WERE RIGHT THERE, TOO.

YELLOW

Asian marchers were the only war protesters to snake dance (photo courtesy of Steve Louie, see p. 70).

YURI KOCHIYAMA
LEE LEW LEE
GANG OF FOUR
NOBUKO MIYAMOTO
MO NISHIDA
ART ISHII & GUY KUROSE
GEORGE WOO
ALEX HING

+ EXTRAS!

POWER

The Panthers set the stage in the late 1960s and were the unofficial leadership for the American revolt against The Man. A lot of people probably have no idea that this movement included Asian Americans that supported, joined, and participated with Black Panther-inspired groups. Yes, Asian Americans were badass and fought oppression in the forms of drugs, racism, and injustice.

In our quest to make sense of this period, we interviewed a bunch of people who participated in various organizations from LA to Seattle to New York who were part of the worldwide movement during this turbulent and exciting period of protest in America. Most of the people we talked to said that the Yellow Power movement ended when the Black Panthers were split in the early 1970s. The end of the Vietnam War was also cited as an end to the massive protest, but most of the individuals we met are still active and waiting for the next big revolt so they can kick The Establishment's ass.

Inevitably, some of you will say "But you forgot this..." or "This isn't true," but we don't care, so don't waste your time telling us what we missed. We wrote about what we thought was accessible and interesting. We did the best we could with the people who responded to our inquiries. And then there are those Yellow Chickenshit Charlies who held back or wouldn't respond at all. You know who you are, and we're sure your ex movement–group will thank you for being a pussy.

To our knowledge, this is the biggest, fattest, and most informative collection of articles written in a non-academic magazine about this topic. But take it for what it is—a series of interviews that describe a bigger story of movement and revolution around the world. The individuals aren't as important as the entire picture. If you're an Asian American, a history buff, or a person who gives a shit about society, then these pages are for you.

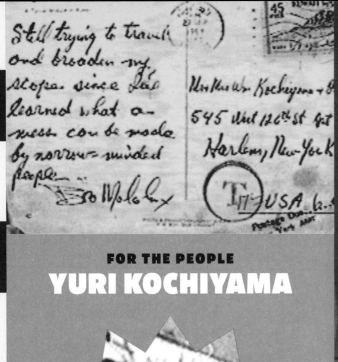

Still trying to travel and broaden my scope since God learned what a mess can be made by narrow-minded people... —Bro Malcolm X

Mr. Mrs. W. Kochiyama + ?
545 Wel 126th St. Apt
Harlem, New York
T/7 USA 62...

FOR THE PEOPLE
YURI KOCHIYAMA

ANGEL OF HARLEM

words + picture | Eric Nakamura
video images | Rea Tajiri

WE ARE KEEPING TABS ON HOW MANY TIMES THESE FOLKS ARE MENTIONED

MAO	X	CHE	MLK
2	17	0	4

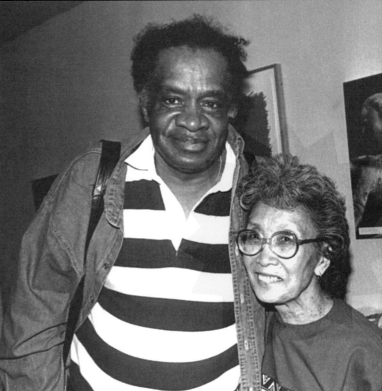

TOP: (right) Donald Byrd hanging with Yuri. LEFT: A letter from Bro Malcolm X to Yuri's husband (see p. 65).

Looking through an old copy of *Life* magazine, you might come across the photographs from Malcolm X's death. In the smoke-filled Audubon Ballroom, he was slain from 16 shots to the chest, face, and hands. If you look closer at the black and white photograph, you'll see Malcolm's lifeless head resting on the lap of an Asian woman who's wearing cat-eye glasses.

Living by herself in her Harlem project apartment, Yuri Kochiyama is still active in numerous causes from the Mumia Abu-Jamal defense to protecting Affirmative Action. Rea Tajiri (who made *Passion for Justice*, the Yuri Kochiyama documentary) and I be-came two more visitors to add to the Kochiyama's long list of friends who range from Malcolm X to legendary jazz man Donald Byrd—who happened to be there when we dropped in. As we came through the door, Yuri soon whisked the jazz man out to make space and time for us in her teddy-bear-filled apartment.

NISEI SOLDIERS LETTERS

Perhaps the first level of her involvement to make life better was to start a letter-writing campaign to World War II Nisei (Japanese American) soldiers. This began during her assembly center days in Santa Anita and followed her into her concentration camp days at Jerome, Arkansas.

Tell me about your letter-writing campaign.
YURI KOCHIYAMA: I had a Sunday School class. The class grew to about 60 in the Santa Anita Relocation Center and then we were sent to different camps. Then five of the camps started their own groups. In 18 months we were writing to 13,000 soldiers. People would ask, "How did you do it since you didn't have much money?" But you have to remember, we were doing it with penny post-cards, so with $2 that's 200 people you could write to.

ERIC: I remember mentioning Kochiyama to filmmaker Rea Tajiri, who

MALCOLM X ASSASSINATION

How did you get so close?

It happened right across from where we were. Two guys jumped up and one said, "Get your hands out of my pocket." Every eye looked at them. Then two or three guys in front went right up to Malcolm and he was a clear target. I ran up on stage as soon as he got shot, when all the shooting started and the smoke bombs and all that were going off. People were screaming and yelling. This guy came right past where I was and I thought, "Gee, this guy knows how to get to the stage," so I followed him right up there and I put Malcolm's head on my lap. When I went to see him he had about 13 shots. I was hoping he was going to make it, but he didn't make a sound. I don't think he could have survived it. It was all over. The hospital sent a rep who said that Malcolm had passed away. You could just feel how it hit the people. When I got on the subway, they announced over the loudspeaker that Harlem leader Malcolm X was just shot down in the Audubon Ballroom. I'd gone with my 16-year-old son Billy. It hit him hard. Since that assassination, so many things are still unanswered. The people put on the stand weren't even at the Audubon. They did 27 years except one who's still in. The one caught there is quietly in one of the small prisons in Harlem. They only got him because one of Malcolm's bodyguards got him. He asked his bodyguards not to have weapons so as to not frighten children and their mothers. I think he thought something was going to happen. Everyone thought something was going to happen.

Prior to Yuri's entry into concentration camps, she didn't care about politics. Living in San Pedro, she lived the life of an average high school student, eating hot dogs, going to the Friday night game, and having fun. The concentration camp experience changed her outlook.

I came to know Japanese people and I felt very proud of how they took the evacuation and how they worked in camp without letting it overwhelm them. I think as soon as you finish school and you go into the working world, you face racism trying to get a job. I think my first and only job before I went to camp was at Woolworth's. **Woolworth's never hired an Asian before. But I saw a Mexican working there so I asked her if they would take me. She was the first Mexican, so she said, "Why don't you try?"**

After being released from the concentration camp, Kochiyama worked for the USO in Mississippi, went to Minnesota, then returned to the camp. After the war, she went back to California and began to raise a big family with her husband, Bill, whom she met when he visited the camp as a soldier. They later relocated to NYC, and that's where the activism ball started rolling.

We had a group called the Nisei-Sino Service Organization during the Korean War, from 1950 to 1960. We worked with girls between 16 and 25, and we said, **"Here are all of these Asian American soldiers, they have nowhere to go and they don't feel welcome in the regular dance places." Chinatown came right in and helped and we had these young girls organize dances in Chinatown, Midtown, YWCA, and churches.** In that way we helped many Asian American soldiers.

LIVING IN HARLEM

Harlem was such a motivating place to be. Everything was happening. It was 1960, the Civil Rights Movement was coming up north and there was a Black Liberation Movement already going on. **I didn't realize there was a big difference between the Civil Rights Movement and the Black Liberation Movement, but here in Harlem you could see both and the different tendencies.**

I worked with CORE (Congress of Racial Equality) for the Civil Rights group, but at the same time I joined Malcolm's group, the Organization of Afro-American Unity. The first group my husband and I joined was the Harlem Parents' Committee and the major issue there was quality of education. In 1953, all of New York City had massive, massive picket lines in front of every school, to improve education. Also, we had demonstrations to get traffic lights on every block. You know if it's down in the white town, it's there on every corner, but not up here.

There were two major leaders. There was Martin Luther King who was for integration, and Malcolm X who was for separation, or self-determination. **I'm glad we were involved in both, because you have to get a taste of both to get an idea of what was needed in the Black community.** Malcolm X thought we must separate from the power structure, and develop our own group. Martin Luther King was propped up there as a national leader, whereas Malcolm X was demonized as being excessive and anti-American. But I think when you see what was happening in the world—the African countries were fighting to free themselves from colonialism, from the Western powers—you could see why Malcolm chose the direction he did. There was no way Black people could really be free by becoming part of the

power structure. **We felt Malcolm was doing the right thing. Not that Martin Luther King wasn't;** Martin Luther King was carrying the mass movement. But there needed to be another kind of movement that would challenge those in power, and the only way you could do it was by being your own leader and by determining your own programs.

How did you go from an Asian American community group to working with an African American community group?
It was gradual. In the mid-'50s, there was Little Rock, Arkansas, where they were desegregating the schools. We were watching that, and were encouraging Asian Americans to keep an eye on what was happening in the South. So it was a transition, but as we saw the Civil Rights Movement getting major play by the media, we felt that was one of the most important things happening in the country.

ON HAVING GUESTS

We had speakers. Every time someone interesting would come in, like people who had been down south, we would invite them. And then we would invite them to our homes. It wasn't difficult to locate people like that because the newspaper would give their phone number and address.

Did you do that in the '60s and the '70s?
Oh, from the time we first got married, I guess. We've had literally thousands of people stay with us. But this is a good way to meet people. In my condition, now that I've had the stroke, I can't go out that much, and so I have a good excuse: "I'm sorry, I can't walk well enough to meet you outside. Could you come here?"

ON MEETING MALCOLM

When did you meet Malcolm?
During the summer of '63, one of the biggest things in Civil Rights was getting construction jobs for Blacks and Puerto Ricans. **We used to go to Brooklyn where they were building hospitals, and I used to take the four little ones, they were four, six, eight, and eleven, and we would hold hands and go on the subway to the demonstration. Eventually, by the end of that summer, more than 600 people were arrested, including my 16-year-old son.** Then the hearings began. In October of '63, Malcolm came to the court, and that's where I met him.

I remember when he walked into the foyer of the court, all the young Blacks ran down and they circled him and they were shaking his hand, but since I wasn't Black, I didn't feel like I should go down there. There was that article a few months before in *Life* magazine where a white gal came into Harlem and saw Malcolm at the Shabazz restaurant and said, "What can I do for you, Malcolm?" and he just said, "Nothing," and she went away crying. I thought, "Wow, that could be me making the same mistake." But as I saw all those Blacks around him, I kept thinking, "Gee, doggone it," I wanted to meet him so much and I asked one of the court leaders, "Do you think there's any chance of meeting him?" and he said, "Why don't you try and see? All he can do is tell you to go away." So I went slowly down there until I was 15 feet away, watching them, and then all of a sudden—just in one instant—he looked up, almost looking like he was wondering, "What is this old Asian woman doing?" But I thought it was now or never, so I went right over there and said, "Malcolm, can I shake your hand?" "Of course," he said, "For what?" And I said, "Oh, I want to congratulate you." And he said, "What for?" I said, "Well, for what you're doing for your people." **He asked, "What am I doing for my people?" and I had to think of a quick answer and said, "You're showing direction." And all of a sudden he just looked up and he smiled and he came out of the circle onto the other side and shook my hand.**

But I said something stupid—I didn't know anything about civil rights or the Black Liberation Movement—I said, "I admire the things you say, but I disagree with you about some things." To show what an open guy he is, he said, "What do you disagree with me about?" I said, "Your harsh stand on integration." And he said, "Well, I can't give you a two-minute stand on the pros and cons of integration. Come to my office and we'll discuss it." I couldn't believe it. I said, "You mean I can go to your office and talk with you?" He said, "Yes, but you probably won't know where I am." I said, "Oh yes, I live in Harlem on 126th Street and your office is on 125th." And so he said, "Get an appointment with my secretary." Of course, it never happened because the next month he made that statement about the "chickens coming home to roost," when Kennedy was killed on November 22, and then he was taken out of the Mosque, so I thought I'd never never see him again.

HIBAKUSHA IN HARLEM

When the Hiroshima-Nagasaki Peace Study Mission started to come in, they wanted to meet Malcolm. When they found out that we were Japanese living in Harlem, they asked us if we could get in touch with him. So I started writing letter after letter, not knowing if he was even receiving them or if he would even come if he did. And then—I couldn't believe it—on the day we had the reception he came. He came here June 6, 1964, and half a year later, he was killed.

What did he talk about that day?
There were three major things. One, he thanked the Japanese Hiroshima Nagasaki Hibakusha for coming to Harlem, because Harlem was holding its "World's Worst Fair." Harlem activists got one of the worst streets in Harlem and they just opened it up for people to come and look at. There, you could see clogged bathtubs and toilets that wouldn't flush.

They put them out on the street?
No, no, no! You go right into those buildings, and you see all those broken windows that the landlords didn't fix, all the garbage on the streets, and the Hiroshima-Nagasaki group had only been to the nicest lunches, church events and schools, but had never gone to Black communities. Especially not these poor communities, and so I thought it was great that for the first time they saw something different.

They spoke English?
No, they had translators. They knew very little English. He (Malcolm) thanked them, he said, "You have scars on your body, but you have seen scars in our community, you know these broken-down places and all." And he said, "We were hit by a bomb too, and that bomb was racism." Then he mentioned how much he admired Mao, because Mao tackled three problems: feudalism, corruption in the government, and foreign incursions. Then on the Vietnam War (which hadn't started yet—this was 1964), America was sending advisors to Vietnam. Here, all the people were Civil Rights activists, he said if America decides to go to Vietnam, you progressives should be protesting it, and it's too bad he didn't live long enough to see how big that protest became. He also made remarks like, "The reason that Japan has never been attacked is because Japan never had anything to offer other countries, they didn't have resources." Vietnam had resources, all of the other countries that Europe went into had resources, but Japan did not. It just showed how much he knew about the world. He said, "What I gained out of prison was reading everything I could get hold of." And he knew so much about Asian history. Everyone was so impressed by him.

Did he come alone?
No, but it was done in such a way that we didn't even notice who his bodyguards were. He had three, but then the place was jam-packed. We couldn't get everyone in here. Everybody was filled in the kitchen hallway, jammed. When he spoke, you could almost hear a pin drop because everybody kept so quiet when he spoke. The Japanese said we don't want any translation since we don't want to stop him at every sentence. They said they could catch on to him, plus they thought they could get him through his vibe. He was so gracious. The white people were surprised. He was as warm to them as to the Blacks. There were no radicals, no Muslims, no nationalists...

Was that after he broke off?
It was only three months after, and there were so many rumors that he was going to be killed, that's why everybody told us, "Malcolm won't come to your place, he doesn't know you. Why would he come here?" It was so dangerous, but he came.

What did you think of the movie?
Spike followed the book and spent a lot of time when Malcolm was young and jitterbugging. He didn't put in the parts with the African leaders that he met. You know why? The book has chapters missing. One is the chapter on Africa, one is on sister Ella. It's sad that before sister Ella died no one saw her. She has both of her legs amputated. She was a half-sister and more like a mother or sister to him. His real mother was in an asylum. Before he was killed he was happy that he got her out of there. I think they got along so well that she and Betty [Shabazz] never got along.

When did you get involved with the later Asian American Movement?
I joined Asian Americans for Action shortly after I Wor Kuen (IWK) started. The Nisei were really ahead because they have been active from way before. They were active since the '30s... not only against the Vietnam war, but against the US-Japan SEC Treaty. Every year they renewed it, so we would speak out against it. When the Hiroshima or Nagasaki dates came, we would do a program about it. It was mostly an anti-war and peace movement. We took a stance for the workers.

After spending a couple of hours at Yuri's place, and being her last visitors of the day, we took off having learned a lot. She showed us the postcards that Malcolm X had sent to her husband while he traveled the world to find his roots and to study. **One of the postcards read: "Still trying to travel and broaden my scope since I've learned what a mess can be made by narrow-minded people." And he signed most everything "Brother Malcolm X."** But aside from her relationship with the late political leader, Kochiyama has gone on to work with almost every group that she feels she can make a difference to. 🐱

ERIC: *I'm glad to have met Kochiyama—who I might say would be on the Mt. Rushmore of Asian Americans. I was green, and way out of my league interviewing her, but to have this interview appear in a magazine issue that also might talk about skateboarding and poop helped take Kochiyama out of pure academia and into popular culture.*

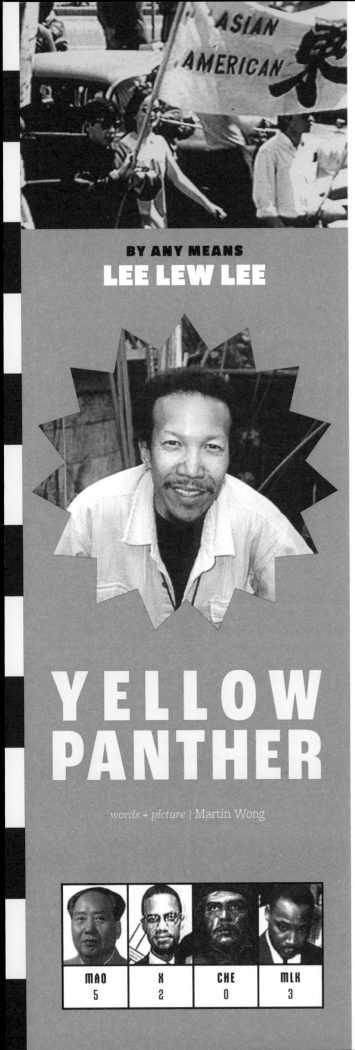

TOP: Video image liberated from Lee's two-hour documentary *All Power to the People! The Black Panther Party and Beyond*. (1996) STAR: Lee is currently working on *Downwinders*, a new documentary about nuclear pollution.

Lee Lew Lee is a Chinese Jamaican who would rather talk about how his grandparents were scholars in China than say what it was like to interview Geronimo Pratt, Leonard Peltier, and Mumia Abu-Jamal in prison.

Likewise, he would rather recount how the I Wor Kuen and Young Lords teamed up to resuscitate New York's Gouverneur Hospital than describe meetings with Jackie Robinson, Haile Selassie, and the Dalai Lama. After several lengthy discussions with Eric and me, the LA-based filmmaker took me to his secret book source and provided more contacts than I'll ever be able to dial. Lee's humble, generous, and playful personality belies the fact that he belonged to radical Asian Power groups as well as the Black Panther Party, and is a fierce revolutionary to this day.

KING COMMIE

I had a scholarship to go to the Cathedral of St. John the Divine choir school. When I was in the eighth grade, Dr. King came and gave his first anti-war speech. I was one of the three students chosen to meet him and he was very kind. Then he sat opposite me in the cathedral. He was staring at me. At first I thought I was imagining it. Then I looked around and noticed that I was the only person of color up in the choir on that side of the cathedral. When he gave the sermon, he began talking about the Vietnam War.

Basically he asked, "How can we ask for civil rights in this country when we deny other people their human rights?" That was a profound statement in 1967. The whole cathedral was silent, and then in about 30 seconds there were 5,000 people crying. I've never seen 5,000 people cry again, even to this day.

I thought to myself, "This is a dangerous thing to say; they're going to kill him." And of course, a year and two months later, he was killed. I think it was a month after the sermon that he offered himself as a peace candidate to stop the Vietnam War. In fact, the day after the sermon, all the New York newspapers labeled him, "King Commie," and you could see the campaign to demonize him.

When Dr. King died, I was in school in upstate New York. I saw the reaction of the white kids there and the reaction of the people in the community. There was a riot. I dropped out of school and joined the movement. I'd already been going to movement things for a year and a half before that, but after Dr. King was killed, I joined the Ahmed Evans Defense Committee. Ahmed Evans was a political prisoner in Milwaukee, a brother in the ghetto who dared shoot back at the Klan. So we got together a defense committee.

ASIAN AMERICAN ACTION

When I was 16, I joined the Asian Americans for Action (AAA) in the end of 1968 and the I Wor Kuen (IWK) in 1969. When I was going back and forth from school I would go to meetings. It was not uncommon to belong to more than one organization.

ERIC: I'm only going to add, "This guy is cool."

BY ANY MEANS
LEE LEW LEE

YELLOW PANTHER

words + picture | Martin Wong

MAO	X	CHE	MLK
5	2	0	3

THREE TAPES THE HARD WAY

words | Eric Nakamura

To get you into the mindset of revolution to fight against your oppressors. Sure, there are tons of videos out there that might represent fighting back, but this is a great little collection that ranges from the fake and funky to the hard and real.

THE FBI'S WAR ON BLACK AMERICA (50 min.): This documentary by Denis Mueller and Deb Ellis has great select footage from Malcolm X, MLK, and some Black Panthers. It traces the COINTELPRO, the FBI, police, and the KKK who were out to destroy the Black revolutionary movement by killing the young and outspoken Fred Hampton, X, and MLK, among many others.

THE BLACK GESTAPO (90 min., d. Lee Frost): No name recognition on this tape like Dolemite or Shaft, but you do get a Blaxploited view at how power gets corrupted. A Black man—Rod Perry as General Ahmied—wants to start a Watts Black army and he gets it going, but then it splinters off in a bad angle. The People's Army Group square off with cheesy white racketeers who have the gambling, prostitution, and drug market cornered. The army takes over with violence and gets too fat, they get a training compound with swarms of big-breasted white women and are living like Idi Amin. General Ahmed gets word of this and it's up to him to set everything straight. Meanwhile the whiteys get driven out of town. With gun battles, freebies breast shots, pimp slaps, and militant uniforms, shit goes off in this film. There aren't exactly any Black Panthers in this film, but it's a satire on how local armies get started.

BROTHERHOOD OF DEATH (90 min., d. Bill Berry): No city folks here. *Brotherhood of Death* starts off with Black Vietnam War soldiers who come back and end up in the South. A local Black woman gets raped, her boyfriend gets beat up, and the three white perpetrators walk around strutting. The ex-soldiers decide that going to the church and talking about it is no longer good enough. Alongside the funky music score, they fight back and beat the shit out of one of the men. But after the nice local sheriff gets murdered by the Klan while investigating the murder of a Black man, the locals get organized to fight back and beat the shit out of the Klan, and they do it with force and brains. I'm not sure if Black Panthers were plentiful in the South, but this brotherhood was solid enough to take care of The Man.

Taking a cue from Yuri Kochiyama and being a multi-racial person, I tried to help people organize, to bring all these different groups together. I would tell the IWK what the Panthers were doing in Harlem and what the Young Lords were doing in East Harlem. I spent a lot of time with the Young Lords.

The IWK was like the Black Panther Party, the Young Lords, and the Red Guards. It was a Maoist organization run by two engineers from Mainland China, Yu Han and Yu Man. They were the best ideologists because they were here in the United States doing graduate work. They decided that these poor kids in Chinatown didn't know how to organize, so we studied the *Red Book* a lot.

On the East Coast, we knew about Alex Hing (p. 82) and the Red Guards. The IWK was patterned after the Red Guards. It was one-upsmanship. They were the Red Guards. But what was the IWK? The Boxer Rebellion. You can't get better than that. The movements were very connected. The real problem was that we didn't have fax machines. We sent letters, but many times the letters were intercepted, so people got in airplanes.

THE PANTHER DAILY GRIND

I started becoming involved with the Panther Party in June 1969, when I dropped out of school. I got closer and closer to the Panther Party and joined in December 1969. When I joined the Panther Party, I talked to Afeni Shakur and Bashir Saunders. **I told Bashir I had been in these other organizations and could I be a contact between the Harlem Branch of the Panther Party and the IWK and AAA. For a little while, I tried to do that, but I got totally subsumed by all the things I had to do with the Panther Party.**

I knew the *Red Book* better than anybody. I spent two years reading it. I also read Marx, Stalin, and Hegel. In the Panther Party there was really very little time to read. The Panthers were basically a daily grind. **There were no part-time Panthers. You couldn't just join.** You had six months on probation, gradually getting initiated deeper and deeper into the party. The things I remember the most clearly were the different programs we had, especially the breakfast program and anti-drug program. **We had a**

health complex in the South Bronx on Boston Road. We had free clothing, a free food program, all these things. Most importantly, we went door-to-door, organizing strikes, things like that from 5 o'clock in the morning.

The Panthers stopped wearing the black beret and leather jacket in the end of 1968. People think that went on and on, and it didn't. We stopped that because it made it easy for people to infiltrate. That all stopped before the Panther 21, I think. I came in after the Panther 21.

The good thing about the Panther Party was that it brought the idea of socialism. Let's look at this (Mao's) revolutionary ideology from China and bring it into the African context. And then take it into the American context, understanding that we are colonized as people of color in the ghettos of America. Chinatown is a ghetto. IWK said the same thing.

So we began to look at neocolonialism, Marxism, Ho Chi Minh, and these different ideologies and how to bring them together in the context of the United States. For example, if Mao had his barefoot doctors, we would have our barefoot doctors and our health centers. We didn't believe in Western anything, so if you were going to be a barefoot doctor, you were going to learn acupuncture. If Mao had his People's Revolutionary Army, we would have our People's Revolutionary Army in the sense that the Panther Party would defend the Black community against the racists. **The IWK or the Red Guard would defend the Asian community if the racists wanted to take people of Asian descent to concentration camps.** That was a real threat back then.

There was a lot of training. We learned how to break down rifles and guns. We learned military strategy. For example, what did Mao mean when he said that "force had to be 2-to-1?" You cannot win a shoot-out if you have less than a 2-to-1 advantage. You have to understand what a fire zone is, how to apply what Mao said in *Selected Military Writings* to the actual reality if you have to fight in the ghetto, and how to make Molotov cocktails.

HARLEM VS. CHINATOWN

One of the differences between the African community and the Asian community was that the IWK couldn't just come out and walk down the street. If you came out all the time and did a lot of propaganda, you would get into some very

serious fights. A lot of people were very skilled in martial arts and at the time, the Kuomintang was very strong in New York's Chinatown. They controlled all the family associations and they would send goons to beat you up, like the Flying Dragons, White Shadows, and people like that.

To be in the Panther Party in Harlem was much easier because they had much greater community support. You didn't have to worry about going down the street and being beaten up so much as having cops trying to kill you. Mao said, "To be effective you have to be like a fish among the people." The Panther Party was much more effective in grassroots organizing than the IWK.

The truth is that the historic conditions did not exist at the time in Chinatowns in the United States. The United States was at war with Vietnam and here we were walking around supporting the Viet Cong. They didn't allow any Asian Americans to become citizens in 1965, and a lot of people wanted to become American citizens. A lot of people considered us to be communists and traitors. Of course, the more somebody calls you a communist, the more you want to become one.

INTERNATIONALISTS

The Black Panther Party had a political and a military wing, as did any socialist revolutionary organization of the time period. The Panther Party followed the same command structure of the liberation movements overseas. The Panther Party, the Student Nonviolent Coordinating Committee (SNCC), the IWK, the Red Guard, the Young Lords, the Brown Berets, the White Panther Party, the Young Patriots—all these organizations saw themselves as part of a worldwide youth revolution. The Panther Party in particular sent people to the Middle East and to socialist

above us would be *Gidra*, and that mountain would have only those two peaks.

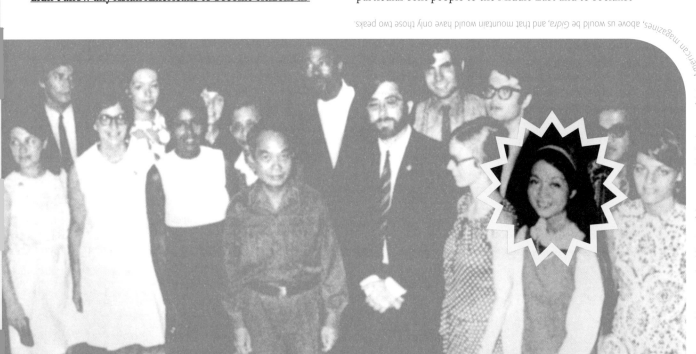

PAT SUMI MET THE NORTH VIETNAMESE GENERAL *words* | Eric Nakamura

Pat Sumi was one of the individuals we wanted to interview for this article. But as we were getting our editorial minds up-to-date, Pat passed away, stricken with cancer. According to Lee Lew Lee, she wanted a copy of the photograph of the delegation to Asia before she passed away. Eldridge Cleaver, who had the neg, never made a copy for her. This image you see above was liberated from Cleaver's book, *Soul on Ice*.

Pat grew up in East LA, admittedly a model Asian getting good grades and, to quote Mao, "a frog at the bottom of a well." She traveled throughout the US to get a glimpse of how

life really worked outside of her home. She went to Africa in 1965 and learned that the people there have elements in common with Asians. After college, she traveled to the South, where she saw poverty and racism firsthand. This is where she realized that her life was going to change. After attending grad school, Sumi moved back west and joined a hippie commune in 1967.

Later, she helped set up a coffeehouse near Camp Pendleton in San Diego to talk to GIs about what the heck they were doing and what was going on. "When you start messing with

the troops, you're messing with the power that The Man has to control most of the so-called 'free world,'" said Sumi in a 1971 *Gidra** interview. Her group helped organize the Movement for Democratic Military, which sounds like on oxymoron. Although she admits that they did some good, they also messed some soldiers' minds up. In recognition of her work, Sumi was invited to join the Anti-Imperialist People's Delegation on their trip to North Korea, North Vietnam, and China. (Alex Hing, who joined the delegation as a member of the Red Guard Party, talks about the trip on page 84).

ERIC: *Perhaps one mistake was that we didn't get more folks from *Gidra* in this mini opus. *Gidra* was a strong influence into the formation of *Giant Robot* magazine,

however different our topics are. I later met more than one contributor to this esteemed publication. If there were a Mt. Rushmore of Asian American magazines,

countries like Cuba for training in military affairs, guerrilla warfare, and other things. This occurred around 1970. You began to see quite a few people going overseas to be trained in East Germany, Czechoslovakia, Palestine, and Ireland. At that point, people were preparing for guerrilla war. Our idea was always to have a mass struggle and to organize as many people as possible to guard what we now call "human rights."

Every city in the country had what they called a "Red Squad." Chicago, New York, Los Angeles—their intelligence units used to spy on anybody who was against the war in Vietnam, anyone who was talking about civil rights, affirmative action, union organizing, or student unions. It is estimated that the CIA actually had spied upon 24,000 Americans and opened 30 million pieces of mail during that time period. There was good reason to be paranoid. Sometimes people were actually assassinated.

GOING UNDERGROUND

We had a song: "Hold your heads high/Panthers marching by/We won't take no jive/Not from a regular 45/Free Huey, free Bobby/Goddamn, we gotta free Eldridge." **All they had to do was arrest our leaders and the whole thing fell apart. Cult of personality was the worst thing, and it destroyed the movement. We mustn't have hero worship again.**

I quit the Black Panther Party in 1970 when all the slaughter started to happen in Harlem. I went underground. Hearing the stories of how my grandmother, my grandfather, my mother, and my aunt survived the Japanese Occupation taught me a lot about how to survive. It's a sad reality when you're in your own country and you haven't broken any laws. I didn't kill anybody. I didn't even commit any felonies. But I had to go underground. I continued living: went to college and everything. It was a futile reality, though. You realize that you're not going to change the system from within it.

ALL POWER TO THE PEOPLE

I had been a photographer before I was in the Black Panther Party. I set it aside for the party, because they didn't want a photographer coming off the streets. It was kind of suspicious. I picked it up again because of Gordon Parks's book, *A Choice of Weapons*. Later, I became friends with Gordon. I credit him with saving my life, actually. He gave me direction. **When you're in the mode of revolution and you're thinking that you're going to kill the enemy, and then you find that there's a way to change society without having to kill people, that's quite liberating.**

The film, *All Power to the People*, is an organizing tool to help people in the Black community say, "Look, Asians are not your enemy." Originally, in the film we wanted to have one part about the Asian movement, one part about the Latino movement, one part about the African movement...but the mandate we got from German TV was to do the Panther Party, so we had to focus on that. But we still tried in the context of the film to make people see the much bigger picture. I'm not advocating that we overthrow our government, but I think in the future this system will collapse on its own. People ought to be aware and ready to replace it in the future.

ORIGINAL GUERRILLAS

People turn on the TV today and see Bobby Seale selling barbecued spare ribs. They don't realize that 30 years ago he wasn't selling barbecued spare ribs. They look at Geronimo Pratt and think, "Oh, he's OG." He's beyond OG. OG ain't shit. He's an old guerrilla, that's what he is. **The youth has nobody from our generation in the mainstream that's telling the truth.** Jesse Jackson has sold out. All these other so-called leaders you see on TV—Sharpton, Young, even Farrakhan—they're all bought out. They're not going to give you an hour on TV to talk about them. It costs $400,000 an hour. It's misinformation. Propaganda, communication, and public opinion—that's how they run the media. They make people think the '60s were a time of free love, free this, free that, *Steal This Book*, and Abbie Hoffman. Abbie Hoffman and Yippies were clowns. The real revolutionaries were hard-core revolutionaries who got killed on a daily basis.

When Timothy Leary said, "Tune in, turn on, drop out," most of us didn't agree with him, either. Leary worked for the government at Harvard, doing LSD experiments on people. The more serious revolutionaries didn't do heroin, cocaine, or any drugs at all. Anybody who did drugs, we expelled. The Panther Party was anti-drug. The Panther Party, the Young Lords, and maybe the IWK on the East Coast used to go out, grab the drug dealers, and beat the crap out of them. If one came back, you'd go get a gun, put it to the guy's head, and say, "If you come back here, you're fucked." And the cops had a program going in New York, San Francisco, and Los Angeles because drugs were coming in through the military. They found out in the Vietnam War that a lot of brothers came back and said that drugs were being sent in body bags to the ghettos. We realized drugs were a way they were destroying the revolution.

THE WAY TO SURVIVE

I am insignificant. And **I don't pretend to speak for the entire movement, but I can speak honestly about those that I knew.** We were willing to sacrifice our own lives if need be for our fellow human beings and our people in the ghetto who might even hate us. **Everybody was 17, 18, 20—nobody thought they'd live to be 30. Everybody thought they would be dead. I think for the 21st century, Maoism isn't going to make it. Marxism and Leninism aren't going to make it. People are going to have to make a new kind of ethic.** Malcolm said, "Think for yourself." You don't need anybody to tell you what to do. Malcolm never saw a fax machine or the internet. This stuff is new. Think in a new way. Organize in a new way. That's the way to survive. 🐱

A GANG OF FOUR

RICHARD AOKI
HARVEY DONG
STEVE LOUIE
VICCI WONG

BERKELEY
AND BEYOND

words + picture | Martin Wong

MAO	X	CHE	MLK
2	0	0	0

A ton of e-mails and phone calls led me to the Asian-owned, movement-rooted Eastwind Books shop on Shattuck Avenue in Berkeley. That's where I met with **Richard Aoki** (charter member and Field Marshal of the Black Planthers and spokesperson of UC Berkeley's Asian American Political Alliance (AAPA)), **Harvey Dong** (worker and tenant organizer), **Steve Louie** (member of Wei Min She and worker organizer), and **Vicci Wong** (a founding member of UC Berkeley's AAPA, involved with Student Nonviolent Coordinating Committee, and worker organizer). Eastwind was too small for all of us, so we procured a corner booth at a nearby Burger King. It was weird to talk to a bunch of political radicals in a corporate death-burger joint, but sometimes the most dangerous place is the safest place.

PART 1: STEVE LOUIE

"The Asian Movement was tremendously liberating," says Steve Louie, sifting through his collection of slides, prints, and radical newspapers from the early 1970s.

The third-generation American Born Chinese (ABC) first became involved with Asian activism in 1969 when he was studying sociology at Occidental College in Los Angeles. When he received a scholarship for independent study, he used it to travel the Bay Area, Boston, New York, and across the country where "groups were coming up like weeds."

He settled in San Francisco, where he made contacts during his travels. At this time the International Hotel was a center of Asian American activism, with elderly Filipinos and Chinese living in the upper stories and community groups renting out the basement. [See: *The Fall of the I-Hotel* (1983), d. Curtis Choy]

Louie joined the Wei Min She (WMS), an anti-imperialist and pro-worker group whose name can be translated into "Organization for the People." Louie explains, **"We were trying to organize people to take things into their own hands and become politically conscious."**

Unionizing the Lee Mah electronics and Jung Sai garment workers was one of the group's big struggles. Both battles ended bitterly when the electronics owners struck a deal with the union and fired the workers. The garment workers walked out and Jung Sai went out of business.

When the Vietnam War ended, so did WMS. "As the war started to wind down in 1972, the more politically aware groups began to embrace more revolutionary ideals. Struggling against the war and understanding the nature of the enemy caused a lot of us to gravitate toward Marxism and find inspiration from Mao. That's the direction I went in."

PART 2: RICHARD AOKI

By the time Richard Aoki involved himself with Asian American activism, he had been active in three political movements:

1. "Picking strawberries is the worst thing I've ever done in my life. While I was getting my toes wet being a proletariat, I ran across militants in the unions. All these militants were communists! These communists seemed to have some good ideas."
2. "You could look at the Civil Rights era as the beginning of the Black Liberation struggle, but the Nationalist Movement with Stokely Carmichael, Student Nonviolent Coordinating Committee (SNCC), and other younger organizations that sprung up all over the country attracted me."

MARTIN: I can't believe I interviewed these activists at a Burger King!

3. "When the Black Panther Party (BPP) for Self-Defense sprung up in Oakland, it seemed like a good thing. I was at the first organizational meeting and they said, 'Who wants to step forward to join?' I stepped forward and was made branch captain and then elevated to field marshal, of which there were only six in the history of the BPP."

Upon promotion to field marshal, Aoki (who grew up with BPP co-founders Huey P. Newton and Bobby Seale in West Oakland after returning from the Topaz Concentration Camp) transferred from Merritt College to Berkeley and "went underground to look into the Asian Movement to see if we could develop an Asian version of the BPP." There, he joined the Asian American Political Alliance (AAPA) and became the spokesperson.

"We protested against the security pact signed by the US in Japan. We participated in anti-war and BPP demonstrations, especially to free Huey Newton, the co-founder who was in jail at the time. Technically I was a representative of AAPA. Privately, I was still making reports to the Panther organization. I'd say, 'This is what's happening, etc.' They'd ask, 'How can we help?'"

"AAPA was the first Asian group at Berkeley that had such a diverse ethnic background. We had Chinese, Japanese, Filipinos, and Koreans. **Pan-Asianism really was something that we never thought of at the time. We were so glad to see another Asian.**"

And not all members were students: "Bob Rita was a founder of the Farm Workers Union. He was at Berkeley organizing and I was able to talk to him and see if he was interested in AAPA. It was a natural thing for him—he was Filipino and he had been an agricultural worker all his life. He was a labor organizer, yet he joined AAPA because of our stance on the exploitation of workers."

In Fall 1968, the SFSU branch of AAPA joined the Third World Strike. The Berkeley chapter followed in the spring.

PART 3: GANG OF FOUR
THE THIRD WORLD STRIKE

Why did the Asian Americans for Political Action and other groups in the Third World Liberation Front strike at Berkeley and SFSU?
VICCI WONG: What we were striking for was not ethnic studies but an autonomous Third World campus, which never happened. We got tremendous community support, despite what people have said about our movement being an isolated group of militant students.

What was a typical strike day like?
HARVEY DONG: A common day involved helicopters flying above, shooting pepper gas at the students. The police would sweep the campus with these machines spraying gas. All that repression forced neutral elements to take sides.
RICHARD AOKI: I saw how changes occurred in consciousness when 147 of us were arrested. We had a mass arraignment and I was sitting in the classroom. I saw a blond-haired, blue-eyed sorority-type girl walk before the judge with a big-time attorney. So I said, "What are you doing here?" She was coming out of one of the buildings and her boyfriend, a hippie, got his head beaten in. All she could do was recite one of our slogans: "Pigs off campus! Pigs off campus!" They arrested her. You don't think she had an attitude change?
WONG: It was the bloodiest and costliest strike in history. We had to come up with these actions and tactics because people in power were violently against the Third World College, against the Third World people uniting.

LEFT, TOP: I-Hotel eviction notice burning with Steve Louie taking a photo in the right bottom corner (photo courtesy of José). BOTTOM: I-Hotel protesters including bespectacled Harvey Dong on far left (photo courtesy of Steve Louie). RIGHT: Richard Aoki decked out in full Panther gear (photo by Nikki Arai).

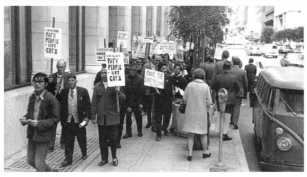

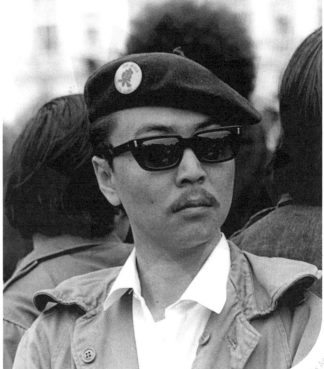

AOKI: After three months, the violence got out of control. Reagan called the Alameda County's Sheriff's Department, which brought an atmosphere of terror to our campus. Things happen in a reign of terror. The largest auditorium at the university caught fire.

What made the Third World Strike different from previous demonstrations?

WONG: People like Richard who had direct military experience. Also, we took inspiration from worldwide struggles, most notably the Zengakuren in Japan. They had very unusual tactics, very mobile and fast actions. We would start really early, break up into small groups. By the time campus officials got there, we were gone. Before they'd just seen big, massive demonstrations.

STEVE LOUIE: The Free Speech Movement used very massive, immobile, easy-to-find groups.

DONG: The strike was a combination of direct action with education. In the evenings we went to dormitories, fraternities, churches, community groups, and stuff like that.

WONG: It wasn't just a local thing or just for our own little group in college. **We identified with the struggles of the oppressed peoples of the world, of all of the struggles that were going on then. We fought harder because we didn't see it as just our own fight.**

DONG: After the Third World Strike, we felt that we had to carry out our rhetoric, so we started setting up field offices in the community.

CHINATOWN CO-OP

How did the Chinatown Co-op start?

DONG: It began as a research project. There was a lot of research on the problems of garment workers and **we didn't want to be "poverty pimps" who did research, filed reports, and that was it.** They were trying to get into the union. I was involved in two union drives. **The problem was that there wasn't much democracy within the union, so we looked more toward the idea of developing a cooperative.** The Co-op lasted about four years.

Was it hard to get workers involved?

WONG: We were fortunate enough to recruit one of the top workers, Mrs. Lum, who was making a lot of money for a garment worker back then. She tested us for a while, but after the third meeting she decided to join. She helped recruit other workers.

Did they freak out when you asked them to sew Chinese worker-style jackets?

WONG: No. That was a big moneymaker. It became a famous thing among international labor movements. We would get people visiting us from Iceland and Canada.

DONG: And they all brought home Mao jackets. It was kind of unique. This whole concept of alternative institutions was part of the whole movement going on at the time. Eventually, it shut down, but we were able to make new links with immigrant workers and provide things like English classes. Later, when there were other labor disputes and strikes, some workers from the Co-op came to the Asian Community Center for help in their struggles.

WONG: Every day, people would come down and say, "Can you help us?" Electronics workers, garment workers—they had no place else to go. Some of them felt intimidated. Busboys would say, "I shouldn't be here." We said, "You have every right to be here. This is supposed to be a public university."

THE I-HOTEL

What was the International Hotel?

DONG: The hotel was owned by Walter Shorenstein, one of the real estate barons in San Francisco. The tenants (elderly Filipino and Chinese men) organized a union that opposed eviction. They got a lease extension, then a fire was set in the building and several tenants died. Shorenstein said, "See? I was right." Just around the time the Third World Strike was winding down, tenants of the I-Hotel contacted AAPA for support.

LOUIE: When I first saw it I thought, "Holy shit! What a tuberculosis breeding pit!"

DONG: That's when all the former SF State strikers, AAPA from Berkeley, and the Filipino community converged. The Co-op was a part of that. The Asian Community Party was part of that. The Asian Legal Services set up shop there. The Red Guards opened there.

WONG: You had the Financial District that was Moneybags City. Then here was one block, totally the opposite in the way they dressed with paintings, murals, and all these banners saying, "Get the rich off our backs." **The community started to see this was their center. All these different groups operated out of there. On paper it looks good: young and old, unite! It was a real lesson in democracy.** We argued, but we kept the place going when they were going to tear it down.

What was eviction night like?

LOUIE: It went beyond the Asian community. Five to six thousand supporters came from all over the city. They went there because we were fighting for something that we thought was important. **There was a landlord-tenant aspect of the struggle, but when they wiped out the block, they wiped out a center of activism in the Asian community.**

WONG: Not just the Asian American Movement. It became a center for The Movement.

DONG: Although you can't prove it, we see the eviction as being political. It's not a landlord-tenant dispute; it's an attempt to destroy the Asian American impact that was going on. 🐱

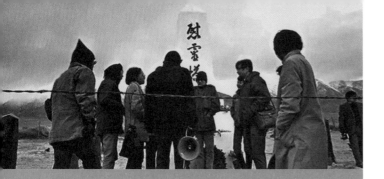

HARD-CORE
MO NISHIDA

HARD-CORE ASIAN AMERICAN

words + picture | Eric Nakamura

MAO	X	CHE	MLK
3	1	1	0

You might not notice the person walking around wearing a shade of fatigue green who cleans up after your empty soda cans, condom wrappers, or nail clips. But one of them at a popular mall is waiting for the Revolution of the APEs (Asian Pacific Ethnics). Mo Nishida is an ex-member of the Asian American Hard Core, a small group that formed after the Black Panthers during the revolutionary late '60s. The friendly man who maintains the grounds you might be walking on is waiting for the wave of change. The greatest thing about this man isn't his past, it's his truthfulness and openness to the entire subject.

On the Asian American Hard Core?
MO NISHIDA: I think the idea was percolating around because of the notoriety of the Panthers. Looking at places where our people were concentrated, you could see what the hell was going on with the young people. Quite a few were going in and out of prison and stuff like that. And when the Panthers came forward, the idea of trying to get some of our people back from the other side of capitalism came up, so some of us talked about needing to form a group like that. We developed a crash pad over on 23rd and Vermont. A doctor owned the apartment and let us stay there. We used to get people who were just out of prison or referred to us from parole officers and from there, with the Panthers as a model, we could serve the people. Christmas programs, working with seniors, helping with projects, and different kind of things. We did that for a few years. The Core was three or four to half a dozen. The rest were helping out.

The crash pad?
The crash pad was for people to detox and have a place to stay. We did some political education and took people out into the community. People were trying to get straight and they wouldn't take any bullshit. We didn't tie people up (some

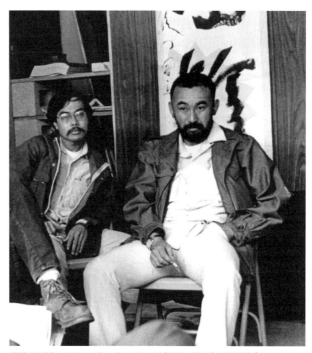

ABOVE: Mo Nishida gets serious at a heavy-duty meeting in LA (photo by Nikki Arai). LEFT, TOP: The first organized Manzanar Pilgrimage on December 27, 1969 (photo courtesy of Evan Johnson Collection and National Park Service). STAR: Mo Nishida now.

GIDRA

words | Eric Nakamura

In a communal house, a group of Asians decided to put together a publication that was going to be cool, funny, and politically conscious at the same time. It was named after the Japanese Godzilla foe, the three-headed beast, Gidra. **With a revolving staff who smoked sticky green pot (if they could get it), they put together what some say was a predecessor to the mag you're holding. This was in '69 when things were going off in the world.** They used the word "fuck," to the dismay of the rightist tightasses, but they got the job done for five years. Funded by donations, a bunch of ads, and whatever sales they could put together, they put this sucker out once every two weeks. One of the early staffers, Eddie Wong (also a member of the Asian Radical Movement, a small group of five or six folks) recalls, "We were getting high and there was a lot going on. It was a great experience, it was fun, it was life or death for some people, since every day brothers and sisters were getting killed in Vietnam. The LAPD were vicious motherfuckers. They were cracking down on protests. Things were changing in the world. We had fun, man." Later on, many staffers found out that one of the hangers-on was an FBI informant. Posing as a photographer, he probably could only report that people smoked pot.

folks did do that). There were always enough people around to babysit. If they acted up, we held them down. **We were dealing with more mature people, so we didn't want to mess with them too much or else they would try to kill your ass.**

What kind of drugs were they doing?

Reds or Seconal, downers. People were gangsters. They were going to jail for all kinds of stuff, mostly drugs. Most of the Hard Core were doing hard drugs like heroin. They were in prison for drug-related incidents and raising rent.

Were you a gang member?

You had to be part of a gang in the '50s and '60s. I was in one called the Constituents. We were from the Westside on Crenshaw. There were gangs from before the war. The Japanese Americans were no different than other people.

What did your gang do?

See who was the baddest, go to the dances and act funny, and get drunk.

Did you fight against yourselves?

It's usually like that. You fight against your own group, then everybody got together and participated in the race riots and went after the white man.

Did you work with others, like Chinese Americans?

Those other communities have to develop their own thing. People are talking about this Asian American stuff—it's a political term, not real. The real Asians are hurting. These so-called Asian programs are helping non-Asians. We got some real oppressed communities now. Some of those people don't have a pot to piss in. So they have to go the other route, the backside of capitalism. Shit, nobody ain't doing nothing about them. It's the straight up betrayal of the Asian Movement.

Did you wear paramilitary outfits?

Some wore fatigues and a red beret. We wore it sometimes at certain demonstrations.

ON THE END

Some of us took on a more political process. This was after the Panthers got wasted by COINTELPRO, so there was disillusionment about the political line of the Panthers. The proletariat was supposed to become the leadership of the people. But they couldn't protect themselves from the fuckin' cops. And what a lot of us were waiting for was for the word to come down from Huey, Bobby, and them. The Panther Party was the basic acknowledged leadership in the Revolutionary Nationalist Movement. They set the whole stage. When they couldn't respond to the killings by the police, it fucked everybody's minds up.

Did you dissolve?

There was the AA Hard Core and New People's Hard Core. There was a deviation from Mao to the classics like Marx, Engels, Lenin, and Stalin. So we went into studies, the NPHC stayed with the old way. They kept it going in the old direction. We studied—and tried to apply—Mao. We stayed at the level of *The Red Book* and didn't get into his philosophical stuff.

ON THE MOVEMENT

There was a conference called "Are You Yellow?" in the late '60s to bring together the younger people who were trying to figure out what was going on. They knew about Asians getting jacked up, so they wanted to know what was up. People were saying, "Fuck the Man." **We were sick and tired of them telling us what we were supposed to be, we were going to develop our own identity. We wanted to build a real democratic system that had no racism.**

Did you meet the Black Panthers?

I met Eldridge and Bobby. We were small potatoes compared to those guys. We are talking about a real small operation, but we never felt that way. We weren't petty bourgeoisie nationalists who thought we were the center of the world. We thought we were part of the

ERIC: Mo Nishida is truly a badass and is still working in Little Tokyo and is still part of advocacy groups. The last I heard about Mo was when I met

revolutionary stream that was going on at that time around the world. Che said we were like the fingers of a hand. We all do our bit; one finger can't develop a grip. If you get them all working, you can fuck The Man up.

You still get active?
I went through being a drug addict in the '80s. Part of my recovery was to go back to The Movement again. I hope young people get into looking at themselves, looking at what kind of things we stood for, and see where you hook up. It's coming. This thing is getting ready to rock and roll. The '60s and '70s ain't shit compared to what's gonna go down now. The reactionary motherfuckers are tightening the screws on everything. There's the stratum of Third World people who moved up since the civil rights movement to become the power elite...quite a few Asians in there. They think that they represent all of Asian America. Those motherfuckers are going to get knocked out. They are upholding a system that is unjust. Everything is based on greed and what's best for them.

Did they sell themselves out?
That's what it looks like. They're all nice people if you talk to them; they have liberal sentiments. But what do they stand for and what do they do? How can five percent of the population consume 40 percent of the resources and make 20 to 30 percent of the greenhouse gases and pollution? The only way the human race is going to survive is if we take them out by any means necessary. **The first person you work on is yourself. We didn't do that in the '60s and '70s. All we thought we needed was an identity. But looking like a Buddhahead isn't enough. We have to learn who we are and then we can accept other people and share ourselves with them.**

What's going to happen?
The revolutionary storms in the Third World are kicking up. People are clear to what the US government is doing in South Africa and Indonesia, they don't give a fuck; there's no getting along with this son of a bitch. Western Imperialism doesn't benefit most people. All over the world, you can use the internet. That's the only thing that's not controlled. Fuck TV, fuck newspapers. You can't pick up shit on the bourgeoisie media. Chairman Mao teaches "wherever there's oppression there's resistance," and there's oppression all over the world. If you have spiritual strength then suffering is part of the game. If you can turn suffering into challenges, to turn you into a loving human being, then shit, when you die it's like the Indians say, "It's the best time to die," so you won't have regrets.

Were you into the armed struggle?
Malcolm teaches that you get ready by any means necessary. When we say by any means necessary, and Mao teaches that you fight with two hands—not one behind your back—that should be sufficient. The whole thing is about the human race now. Another 100 years and forget it. Look at the dumbshits in Indonesia setting forest fires. For what? The most important thing to realize is that the struggles of the '30s, '60s, '70s, and '90s and the coming millennia show a lesson. As if they think we started on a level playing field, now they want to knock out affirmative action. And then look at the top, it's "Charlie." What we have to do as APEs, Asian Pacific Ethnics, is the key question. All classes of people in the ethnic communities need to recognize the working class. Shit, I don't want to buy a big house and I don't need anything. Little Tokyo is a big parking lot. We got thrown out, they destroyed the housing. If you want political power you need people concentrated. I'm waiting for the young people to come back and say, "I'm tired of this shit; let's build something." I want to live in a Buddhahead community. Right now I can't trust anybody, including other Buddhaheads. I grew up in camp; being in a village with 10,000 others is a pretty cool experience.

→ WHERE DO THESE WORDS COME FROM?

words | Eric Nakamura

The funniest use of the word, "Charlie," sneaked out of Mo Nishida's lips. But after thinking about it, what does "Charlie" really mean? I've heard it in many of the incredibly popular 1980s Vietnam War films, and after looking in an Oxford English Dictionary, which weighs in at about 20 pounds with three-point-font text that you literally use a magnifying glass to see, the answer was revealed:

CHARLIE
Charley, Charlie—there are many definitions, the origin is unknown.
 6 A fool, simpleton, esp. a proper, right Charley. *slang.*
 7 A white man. *US Negro slang.* 11 Jan. 1967, *Guardian,* Stokely Carmichael was there promising "Mr. Charlie's" Doomsday.
 8 US Services Slang. The North Vietnamese and Vietcong, esp. a North Vietnamese Soldier or Vietcong soldier. e.g. M. McCarthy, Vietnam, 'If he called them Charlie'...he was either an infatuated civilian, a low-grade primitive in uniform, or a fatuous military mouthpiece.
 9 Used as adj.: afraid, cowardly, esp. in phr. to turn Charlie. *slang.* 1954 'N. Blake' whispered in "Gloom You," 'turn Charley and we'll do ya.'

Here's another word. This word seems like it originated from the Vietnam era, but there are traces of it from much earlier.

GOOK
Origin unknown. Used as a term of contempt: a foreigner; spec. a colored inhabitant of Southeast Asia or elsewhere.

To summarize, the word has been around since the '30s to signify an Asian who speaks Spanish, particularly a Filipino, but it is also used to slag the Koreans, Japanese, and Vietnamese.

a grain of sand
landing in the belly
in the belly of the monster

and time is telling
only how long it takes
layer after layer
as its beauty unfolds
until its captor
it holds in peril

a grain
a tiny grain of sand

a grain of sand

MUSIC FOR ALL

NOBUKO
MIYAMOTO

GRAIN OF
SAND

words | Eric Nakamura

MAO	X	CHE	MLK
0	5	0	0

Nobuko Miyamoto gave up the glamour of being top-billed in Broadway stage shows such as *Les Girls*, *Kismet*, and *The Flower Drum Song*, and in Hollywood blockbuster movies like *The King and I* and *West Side Story* only to get her home ransacked, searched, and pillaged by The Man.

One day while scouring a used record bin, I stumbled across a 1973 LP called *A Grain of Sand* that featured three Asian names: Charlie Chin, Chris Iijima, and Nobuko Miyamoto. It was subtitled "Music for the Struggle by Asians in America" and song titles included "Wandering Chinaman," "Yellow Pearl," and "Somos Asiaticos (We Are Asians)." For $1.99, it was a steal. The clerks working at this collector's shop had no clue, much less gave a shit that this was the first album of Asian American songs.

Last year, the trio reunited for a show that was filled with old friends and college students who were there as a class. Nobuko sits across from me in her LA home with a stack of photocopied essays that the students had to write up about the reunion gig. Many were taking notes during the show, but after a few songs, the notebooks went back into the packs. Nobuko then handed me some proof sheets of college students looking like they were having some supreme flashbacks.

She started dancing at four and then got scholarships to some of the best schools before landing her first pro job at 15 in *The King and I*. From there, she went on to do much more on Broadway and on the silver screen...and then she gave it all up. **"I was actually sort of disgusted with the limitations within that business. I would go to audition with these TV variety shows, and they would come up to me and say, 'You're great, but we can't use you since you stick out.'"** The dancing was one thing, but the acting was another. I knew they would want me to have a fake accent. And I would ask, 'Why would this person have an accent?' I would confront this, and that's why I went to singing."

While Nobuko was singing in a Seattle nightclub in 1968, she checked out the political scene and was later approached by an Italian filmmaker who was making a documentary on a young man who becomes a Black Panther member. "It was like a docudrama so we were with this guy who was actually in the Black Panther Party. We moved around with the BPP, went to demonstrations, and met a lot of people." During a film shoot at the Young Lords' (the Puerto Rican radicals) churches, she met Yuri Kochiyama and gravitated into the Asian American movement.

At the time, Miyamoto was in another band called Sequoia, a jazz-rock fusion thing that was close to signing with A&M records. But the climate was expanding her mind and the band became a memory. **Finding that she would rather pass out flyers and leaflets, go to demos, and volunteer her time, she moved on to a new part of her life.** And after going to a meeting in Chicago between West and East Coast Asians in 1969 and performing in a new group with Chris Iijima and Charlie Chin for the first time in front of an entirely yellow-faced crowd, she felt something different. "It was a mind-blowing experience, just to put your

ERIC: The stories continue in this epicness and each person we met

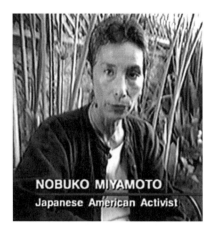

NOBUKO MIYAMOTO
Japanese American Activist

A GRAIN OF SAND: A hot album that you will most likely not find. But it will be on CD on Nobuko's label BINDU RECORDS

YOKOHAMA, CALIFORNIA: Courtesy of Ron Kane. If you have this, then you're a real collector. This came out later in 1977, but it's a Yellow Power album for sure. Some songs are hilarious.

comes in and says, 'Well, it's just a couple of lines. Can't you fudge the words a bit?' I don't know what happened to me. All of a sudden I lost it and I pointed at this guy (the producer) and said, 'You were put in concentration camps and now you're saying that we can't play this song?' I don't know who did this, but it was me. I started walking away, and they said that we could do the song. It went on national TV."

ON GETTING RANSACKED, BUSTED, AMBUSHED

"Later, a couple of my friends got busted for having guns in their house. And when they were going to trial, police broke into my house. I didn't know what it was about until much later when I learned that the trial was beginning and Hirohito was coming through town. They were trying to say that it was a conspiracy to kill Hirohito. Ten years later, my brother was reading a script written by an ex-member of the FBI Asian Tactical Squad. In this script, the ex-cop (who wanted to be a Hollywood writer) wrote a scene about a Japanese singer who was plotting to kill Hirohito. He described breaking in to my house and at the end of the scene he looked around and he said, 'It looked like a n———'s pad.' That's chilling. I don't know why I returned the script. This was evidence."

"And sometimes, the Panthers would stay at my house and make a call to Algeria, and the next day the police would come. That's why the FBI knew who I was. And **I just narrowly escaped being arrested many times through association.**"

"I was married to someone before, a Jewish man. But I was never married to Attila, the father of my son. He was close to Malcolm X when Malcolm was with Elijah. When Malcolm left Elijah, Attila left with Malcolm. And when Malcolm got killed, Attila went in many different directions. He went downhill and went into drugs. Finally one day, he woke up and thought, 'Would Malcolm want me like this?' So when he got out he started a detox program at the Lincoln Hospital in the Bronx, which was the center of the BLA (Black Liberation Army). And so when the Imam (spiritual leader) came back to America, he called the followers to come back. In the process of meeting, they were ambushed by other Muslims, so he died defending his Imam. Four died, two on each side, and no one was convicted."

A lot has happened since the turbulence of the '70s. Nobuko now lives in a cool pad in Los Angeles. She went on to record more albums, is still performing a one-person play, and is working with musicians. She's part of the Bindu record company where she records, produces, and releases music. Check Bindu's Website, and if you're lucky, you may someday find a copy of *A Grain of Sand*...but don't count on it.

two feet on the ground. Then I knew I couldn't go back any more."

The band played shows up and down the coasts, crashing on couches. Trying to figure out what the scene was like, I asked if these events were cool. Nobuko came back with, "It was the best party in town. It was political, but it was the party. It was the 'in' thing to do. It was rebellious, there were a bunch who came for the party. There were a lot of posters, flyers, and there were dances with light shows. We used to fill the UCLA Grand Ballroom."

The trio played everywhere, including prisons. At one prison gig in Chino, CA, they played to a multicultural crowd only to come out to find their cars had flat tires. Perhaps it was the KKK not digging the fact that Asians were playing shows to unite the ethnic prisoners. Nonetheless, Miyamoto laughingly remembers that they passed out *The Red Book* in prisons! The trio's biggest show was at the Madison Square Garden, for Puerto Rican Liberation Day...where they sang in Spanish!

The highlight was the trio's performance on the *Mike Douglas Show* on the week that John Lennon and Yoko Ono hosted a week of programming. "We met them at their loft in the Village. We went with them to Philadelphia in a limo and on the way to the show we thought it was surreal. We got there and rehearsed and the director comes forward after he hears, 'Watching war movies with the next-door neighbors and secretly rooting for the other side,' and asks us what other songs we have. They said there were a few lines there that housewives in the Midwest would think were subversive. Then Lennon

PREVIOUS PAGE, TOP: Artwork from *A Grain of Sand* LP. STAR: Nobuko on the *Best of Both Worlds* LP. THIS PAGE, TOP LEFT: Nobuko today (liberated from *All Power to the People*). BELOW: (left) Nobuko on *Newsweek*; (right) Nobuko in motion (liberated from *Gidra's* 20th anniversary issue).

WESTSIDE CONNECTION

ART ISHII
GUY KUROSE

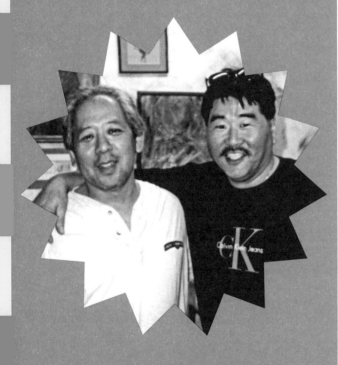

PANTHER
BROTHERHOOD

words + picture | Martin Wong

MAO	X	CHE	MLK
0	0	0	0

Art Ishii was a gangbanger who became one of the Yellow Brotherhood, which was the first group of Asian activists in Los Angeles. Guy Kurose was a Black Panther who became an Asian activist in Seattle. Today, both run their own dojos, teaching karate to at-risk kids in their respective cities. When Guy was in LA for speaking engagement (he's a spokeperson on race and gangs), I met both of them in a Silver Lake coffeehouse to talk about their experiences in the Asian American Movement.

How did a Japanese American kid from Seattle become a Black Panther?
GUY KUROSE: I was raised in the Black community and listened to these songs: "Say it loud, I'm Black and I'm proud." I wanted to be there, too. Also, the Black Panther Party had a strong anti-war line. **My perspective of the anti-war movement was "I'm not going to fight no Asians."**

What was it like being in the Party?
KUROSE: We did what we wanted. I was a renegade Panther. We were what Bobby Seale called "jackanapes," kids that had good intentions but were relating strongly to hoodlumism. He said we were good guys, but we always wanted to do something crazy.

How did you find out about the Asian Movement?
KUROSE: When Mo Nishida (p. 73), Victor Shibata, and Warren Furutani came from the Japanese American Citizens League (JACL) to speak in Seattle, I was introduced to them. I was 16 and I was a member of the Black Panther Party. I had basically said, "I don't need to talk to no Japanese motherfucker who thinks he's white, man. So fuck you!" I was a kid. I was telling him what was going on with the Party up there. My perception of other Asian Americans was that they weren't very hard.

Why did you think Asian Americans were soft?
KUROSE: A lot of that was due to the camps and the way the community had become very insular about it. There was a fear. I tell people I'm a product of the concentration camps my parents went to. I was born a few years after they got out. I felt all this injustice.

Did you read **The Red Book?**
KUROSE: The Panthers took *The Red Book* and broke it down into how it affected the community in a real direct sense. I was a Panther, I got a *Red Book*, I said, "This motherfucker's Asian." I got an identity thing out of that.

How long were you a Panther for?
KUROSE: I stayed in for three years until I was 18. Then I entered college and became involved in the Asian Student Coalition. We had demonstrations on campus. I was into rioting. We'd cause wild stuff. We'd all end up in jail because we'd fight the police and fuck up all the buildings.

What sort of support did you get in the Asian community compared to the Black community?

KUROSE: As Panthers, we were heroes in a lot of communities. In the Japanese American community, **everything our parents knew culturally and through their camp experiences for the most part was to be quiet.** I'm proud of the activists' search for identity that resulted in the Redress Movement. Some people back then would have called it bourgeoisie counterrevolutionary. I don't agree with that. It's wonderful it happened for, if nothing else, psychological reasons. I see so many Niseis out there and you know they're traumatized. They're hypersensitive or hyperapologetic. We picked up some of that.

ART ISHII: That's why the Yellow Brotherhood was so controversial. We weren't hyperapologetic. We weren't like, "Let's keep it hush-hush."

KUROSE: We were told to out-white the white, and groups like the YB and me said, "Fuck the whites. Fuck that shit."

How did you meet the Yellow Brotherhood?

ISHII: I came to LA to meet the Movement people. Some of them were from the middle class, espousing philosophical and ideological kinds of things. Then I heard about the YB and I liked that. I was in the BPP, but I knew I wasn't Black. There was this quest for belonging. I didn't want to be like the stereotype of our own people. I said, "Yeah, man, fuck wearing glasses and becoming dentists and lawyers. Fuck that, I'm with the people; struggling for the cause."

What was the Yellow Brotherhood?

ISHII: We were way before all those other groups, late 1969. We had just gotten out of prison or the service. We realized all these young next-generation gangsters respected us. We thought that we could turn all that respect into something positive. **That's how the concept of the Yellow Brotherhood started. It was anti-drug, anti-gang, and pro-school.** We were at the forefront of the Asian Movement. Most people from those days will acknowledge that the YBs were the first ones talking shit and kicking ass.

What was it like being in the YB?

ISHII: Unlike the Panthers, we weren't heroes. We really struggled with denial, particularly among the Nisei. Their thing after the camps was to out-white the whites and don't rock the boat. So many of my generation, my classmates, were doctors, lawyers, pharmacists, and optometrists. That's typical of the baby boomers. But there was also a minority who became gangbangers: the Ministers, the Shokashus; those groups were like a hidden part of the community. **People wouldn't acknowledge that we had a problem with gangs and drugs.** *The Rafu Shimpo*, the Japanese American newspaper, reported day-in and day-out in the obituaries, 15 and 16-year-old kids dying of heart attacks. They had such denial. We were the ones who put the ugly statement out. We went to parents and their kids would be drugged-out and drooling on the rug. But they were in denial that their kids had drug problems.

words | Eric Nakamura

FARM WORKING TO ORGANIZING

Traveling to where the crop needs to be picked is the life of a migrant farm worker, and so is living in a farm camp that doesn't have toilets or running water. **Philip Vera Cruz** did this for years, living through injustice, racism, and poor living conditions. Being a migrant farm worker and Filipino was tough, since many Japanese and Chinese had already come through and been the subjects of hatred from landowners, public figures, and the general citizenship. The Filipinos were the next-hated farm group.

"I remember him talking about the need for working people to fight racism and the need to fight for the rights of immigrants. He said that someday, the capitalists were going to fight scapegoat immigrants for political power," explains Fernando Gapasin, who now teaches at UCLA's Center for Labor Research Education and is a nephew of the late Vera Cruz. "Philip was a progressive guy."

Also raised on a farm until the first grade, Gapasin recalls, **"I learned what 'take out' meant at many restaurants: Mexicans and Filipinos eat outside. We couldn't stay at most hotels. There were signs that read 'No Mexicans, Filipinos, or Dogs.'"** On September 8, 1965, 1,300 Filipinos stopped work in Delano, starting the Great Grape Boycott. The group that organized this event was the Agricultural Workers Organizing Committee, of which Vera Cruz was an active member. Following the lead of the 1,300 strikers, 11 days later, Cesar Chavez and his National Farm Workers Association joined in and together they formed the United Farm Workers. The original UFW board had three Filipinos on it, including Vera Cruz.

"It was Gandhian," explains Gapasin. "What Cesar was doing was portraying the UFW as victims. It worked and they gained nationwide sympathy... especially because of the picture of the cops and Teamsters whipping the farm workers' asses." The strike was non-violent, but they would picket daily on farms. Many had to get jobs to support their own strike, like washing dishes. "The strike benefits were something like $5 a week. They used winos from Skid Row, and bussed them out. It had a demoralizing role. They would take them in and out on a bus."

Philip Vera Cruz worked for years as a second vice-president of the UFW. He left in 1977 when he felt the focus begin to shift away from undocumented workers and Filipinos. Today, Vera Cruz is no longer with us and the work of the Filipino farm workers is largely unrecognized, but the Grape Boycott continues and the Filipino workers' struggle lives on. 🐾

What types of drugs were people taking?

ISHII: We had this epidemic in LA and all over the Coast of barbiturates and heroin. They had to turn to guys like the YB and say, "Help us save our kids." I think one year there were more than 30 funerals of Japanese American kids. Groups like AADAP write articles patting themselves on the back about how they salvaged the cities and talk about how their predecessors (and they could only be talking about the YB) used to be barbarians. Part of that was true. We weren't academic. We were people from the community working in the community, as opposed to outsiders with their Nikon cameras and 280Zs.

Was the Yellow Brotherhood political?

ISHII: Very political people would come into the Yellow Brotherhood house and espouse *The Red Book*. Gangsters didn't give a shit about *The Red Book*; they cared about red pills. **We were political in terms of what we did, but we were very reluctant about grandstanding.** There was actually a lot of internal struggle in our meetings about just how political we were going to be.

What about other groups in LA?

KUROSE: There was Asian American Hard Core, Joint Communications, and and there were small groups geographically.

Did people belong to more than one group?

ISHII: Pretty much one, but we networked a lot.

What was Eastwind?

KUROSE: Eastwind was a Marxist-Leninist group. They were more political. People in Eastwind called themselves "comrades" and they'd go, "You said that Lenin said this, so you're a revisionist." It was so bizarre. They wanted to start attacking other people. They were all my friends, but when they'd talk about purging people, I'd say, "Yeah. Whatever, man." They were pretty elitist.

How did it all end?

ISHII: There's a time and place for everything. The same problems weren't as apparent. Also, mobilization reached a critical mass and a transition. **As we got older, my friends started having kids. There was a transition and we tried getting younger guys to assume leadership positions. But you had to find the right people and the right dynamics. With the YB, you couldn't be just the most intelligent guy, because you also had to be bad. People had to respect you. The transition was the demise of all of those organizations, carrying on those ideals.**

Was there a stronger sense of Asian community during the Movement?

KUROSE: It was really splintered. There was this group called the Movement, but then you had the Asians outside and you wonder if they even knew about it.

ISHII: I grew up in a predominantly Black neighborhood. All my time in the service was with Blacks. So I've always socially gravitated toward the Black culture, just like my peers in East LA gravitated toward Chicano culture. But **one of the negative things about all this Black Power, Brown Power, and all this togetherness as social ethnic neighbors, is that it divided us.** The first time I ever heard a Black call me Jap, I was shocked. The polarizing started then and it continues today.

What's the most lasting effect of the Asian Movement for you?

ISHII: I went to a function and ran into a kid I hadn't seen for 25 years. I remember him as a high school kid. That kid voluntarily came up to me and said, "You know what man? You guys really made a difference in my life." This guy was very high-risk. If it was one isolated incident, it would've been worth it, but there were more. Too much press goes to how many people died.

KUROSE: To articulate, the Panthers—I have this huge identity behind them. "Former Black Panther" and all of that stuff. But what if they said "Former Asian Movement participant?" People would say, "What the fuck is that?" I don't like that because I am proud of our involvement, our trying to empower the community, trying to get young people to see their identity.

ACUPUNCTURE

words + picture | Eric Nakamura

In his office, Tatsuo Hirano proudly shows me a diploma dated 1981. It looks like most any other certificate except it has a black pyramid logo with a yin and yang symbol! **He tells me that I will probably never see one of these again. Hirano was the only Asian person in the area to be a student in the Black Acupuncture Advisory Association of North America (BAAANA), the first acupuncture school in America.** The New York school was built by people who were tied to political organizations such as the Black Panthers, Black Liberation Army, Young Lords, and White Lightning. A Canadian doctor and a Hong Kong doctor helped them with their studies alongside an American MD, Richard Taft, who made their studies "legitimate."

Unfortunately, on the day representatives from the National Institute of Mental Health were visiting the center to evaluate it for government funding, Taft was killed. He was found dead in a closet, injected with heroin in an attempt to cover up his murder. Fortunately, the BAAANA was able to find a replacement and the program continued. Hirano continued on his six-year residency/student journey. "The first day I was doing acupuncture, I was doing it to myself, my friends, and my family. The results were effective. People would come in irritable and aggressive; some came with bats. It was a tough area and you had to be tough there to survive, but within 10 minutes everyone would be quiet. Auricular acupuncture was the main program at that time. It was a lounge with people sitting in a circle so there was no mystery; you could see

STAR: George Woo, circa 1970 (photo by Nikki Arai).

GEORGE WOO: SFSU STRIKE

words | Martin Wong

"I'm too chicken to be revolutionary," says George Woo, a San Francisco State University (SFSU) **professor who earned his position through community action and takes pride in not having a PhD.** "I'm not dedicated enough to give up my life and everything. I also realize that is not the efficient way to go about things."

He may not be revolutionary, but he's no chicken either. George Woo moved to SF's Chinatown from Hong Kong in 1963 at the age of 15, did time in the Navy, and shot photos for *Sunset* magazine before he started hanging out in a coffeehouse frequented by Wah Ching gangsters.

Two things happened there: "One, I became aware of the gang activity. I had an expensive camera, so I decided to get to know them so they wouldn't take it. Second, I empathized with them. One thing led to another, and I started to work with them."

Instead of crime and idleness, Woo suggested that gangbangers organize a town meeting to publicize the community's problems. When members of the Chinese establishment, City Hall, and media got in, the hoods locked the door and told the audience off.

"That blew everybody's minds." he says. "As I worked with them, I emerged as their spokesman. People started looking at me as a gang leader. I didn't give a shit or worry about the establishment."

Woo's work in the Chinese community led to involvement with SFSU's Chinese student group. "We came up with Free University for Chinatown Kids, Unincorporated (FUCK U). At the time, the Chinese student group had a basement, so we had a slide show and talk. Tom Wolfe was doing a story for *Esquire* and I was prominently in it. He said that I had a silver-tipped umbrella. Shit, man, that was a tin-foil tip!"

When students were forming the Third World Liberation Front, demanding a curriculum and system that reflected and respected the community's cultural diversity, Woo was called on to raise community support.

"It was a war. No classes went on because demonstrators would go from class to class and challenge teachers who were still holding classes. To stop the bookstore, we would fill a shopping cart with books and go to the check stand. We'd say, 'Oh, I'm not going to buy these,' and walk out. To break classes, we'd make noise, throw a chair. People threw cherry bombs down the john and pushed people around. The students who participated had violent tendencies, but they were out-gunned, outsmarted, and out-manned by the police, who were very, very violent."

At the rallies, the predominantly Japanese Asian Americans for Political Action (AAPA), ICSA (the Intercollegiate Chinese for Social Action), and Pilipino Action Collegiate Endeavor (PACE) joined with La Raza, the Black Student Union, and supportive white students. This was the first time Asian groups worked together.

"We instigated the Yellow Power slogan here. Of course, one of reasons why it never stuck is because we included the Filipinos. They said, 'Look at us, we're not yellow.' So I said, 'You're right. Asian Power!'"

To Woo, the Third World Strike was the beginning and end of the Asian American Movement. "The student movement did not last that long once the strike ended and an ethnic studies program began." Then he adds, "I don't think there was a movement, because no one really sat down and planned out everything. People would like to think so. If they want to claim credit, so be it."

After the strike, he went back to school despite advice from his friends in the La Raza community. They said the revolution would be over in two years and his response was that afterwards, people would have to pick up their books. Now George Woo is a member of the faculty he struck against.

"They tend to see me as a one-dimensional hellraiser. If that's the role they assign me, then I have to take advantage of it."

the person come in and get worked on. You could see that person relax and get comfortable. The whole place would be quiet. That neighborhood wasn't typically quiet; it was very impressive. People would come in shaking and sick. The medicine works, but whether you quit or not is another question. Some would come since they were in trouble with the law and some would come so they could cut their addiction down so it wouldn't be so expensive." Hirano actively participated on the West Coast in anti-drug organizations such as "Go For Broke," and also helped at the Asian Joint Communications in New York City, which had a detox house and organized Asian American prisoners according to Leftist and collective philosophies. After getting burned out on the Asian American movement, Hirano turned to something that he felt would fix the imbalances and the internal problems within all people: Chinese medicine.

After talking for about an hour about reasons why the Movement ultimately didn't work out due to inner-movement conflict, I came out with the feeling that Hirano is at peace with himself. He mentions that a meeting or a conference needs to be organized to get everything aired out and healed. Friendships were lost and people are still angry to this day. Hirano believes that the key link, as quoted by Mao, is "change internal, then society has to do the same." That's why Hirano treats everyone. He says, "I'll check out anything that comes through that door."

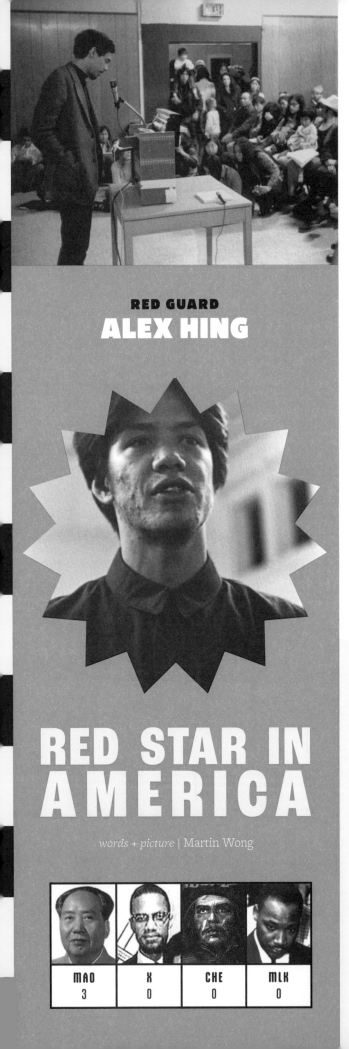

RED GUARD
ALEX HING

RED STAR IN AMERICA

words + picture | Martin Wong

MAO	X	CHE	MLK
3	0	0	0

San Francisco's Red Guard Party was named after Mao Zedong's young squad of private property burners, but patterned more closely after the Black Panther Party. Initially gaining inspiration and guidance from the Panthers across the Bay in Oakland, the Chinatown-based Red Guards formed in 1969 to uplift their community and create social change. Minister of Information Alex Hing was one of the co-founders. Now a cook, union organizer, and Tai Chi instructor in New York City, Hing remains politically and socially active. When I called him from the Marriott Marquis in Times Square to arrange a meeting, he informed me that his group was boycotting that particular hotel because it was non-union. Then he invited me over to his Chelsea flat for morning tea and conversation.

ON GUARD

What were some of the Red Guard's accomplishments?
ALEX HING: One of the first things we did was make it acceptable for political forces other than the KMT to exist in Chinatown. That's important because **prior to the Red Guards, Democratic Party liberals would be branded as communists, and it made it very hard for them to have any political influence. When we came out and said, "We're communists," we established ourselves as the real Left.** We participated in the movements for China's gaining a UN seat and also for the United States to have a relationship with Beijing. We created that pull in Chinatown, to make it okay for people to talk about Beijing as China, and not just Taiwan.

We also accomplished some small reforms. The federal government wanted to cut down a tuberculosis testing center in the community, although at the time Chinatown had the highest rate in the country. We demonstrated to keep that TB testing center functioning. They wanted to close the traditional Buddhist temple, to turn it into a parking lot. We demonstrated support for the temple so they didn't tear that down. We did a number of those kinds of reforms.

→ ONE-WAY TICKET TO CUBA

March, 1969: The Red Guard newspaper reports that "four pigs" bust Tyrone Won on "trumped-up charges" when he walks out of the Red Guard headquarters with a disassembled rifle. Out on parole in July, Tyrone has a distinctive tattoo removed from his left arm by a doctor in a back-alley operation. (A lot of doctors were supportive of the movement.) Then Tyrone, his girlfriend, and a Black Panther who is also on the run, drive to Texas where they possibly rob a bank before driving to Mexico and hijacking a plane to Cuba. This is the last we hear of the Panther.

August, 1970: Upon returning from his trip to North Vietnam with the Panthers, Red Guard Minister of Information Alex Hing receives a frantic phone call from Tyrone's girlfriend informing him that Tyrone had hung himself in his Cuban jail cell. In disbelief, Alex asks Eldridge Cleaver (who had lived in Cuba) to find out more. Eldridge writes a letter to Alex stating that Cuban authorities reported that Tyrone hanged himself

We worked in what we called the Asian Legal Services that had a branch of the Asian American Draft Help Center. We had 1,000 cases of people who didn't want to go to the military and kept them out. We actually got four people who were in the military out. So we were quite successful in establishing an anti-war base in the community. I think that we opened up Chinatown for more progressive politics.

What about the breakfast program?
The Panthers set up a Free Breakfast for Children program. We tried that, too. The kids who came were African Americans who lived in the projects of Chinatown. So we re-thought it and had an afternoon lunch program for senior citizens. **We tried to model ourselves after the Panthers. When it didn't work, we gave it our own characteristics.**

Was that food ever stolen?
Liberated. You know, in Chinatown they make these deliveries, just dropping stuff off in front of restaurants. It's just there.

How many people were in the Red Guards?
The high point was 200, right when we opened up in 1969. That's not an exaggeration, but that didn't last long. You can only take so much police repression before people stop coming around. We dwindled down to a hard-core base of around 50.

What was the average member like?
Early 20s. Our youngest member was like 13. We were American-born, but we were actually able to unite with immigrants and take up the struggle for immigrant rights. You hear one immigrant group think that they're better than a more recent immigrant group: they talk funny; they're dirty; they make the community more this, more that. It's really not right. So we then had some old-timers, too. Old pro-China people.

Did you ever go out wearing Mao jackets and all that?
Oh yeah. We'd wear army field jackets and berets. Sometimes we'd wear armbands during public demonstrations.

How long was the Red Guard Party together for?
The phenomenon was very short-lived, two and a half years. The main reason why it broke up was political police repression. We couldn't stay in that office if the landlord kept on quadrupling the rent. We couldn't walk down the streets without being put up against the wall, frisked, and asked for ID.

They knew who was involved?
Oh yeah. And our offices were being constantly raided. They didn't need a pretense. They were just looking for stuff.

Did you ever have an arsenal full of guns?
We were armed. In California it's legal to possess arms. Let's leave it at that.

Did you ever have to use them?
It wasn't quite a shoot-out, but one of our members had an armed standoff with the police. The brother was on parole at the time, Tyrone Won, and they went after him. He wound up hijacking a plane to Cuba. He passed away in Cuba.

ON BEING IN ASIA WITH THE PANTHERS

What was the relationship between the Red Guards and Black Panthers?
It was as close as it could be given the circumstances. The Panthers were absorbed in their own problems. The police waged an unrelenting onslaught against them. They had to spend so much time fighting off that attack.

words | Martin Wong

and that Tyrone's girlfriend was engaged to a Cuban. When Alex tells the girlfriend's parents all the details, they give the Red Guards a care package full of clothes to send to her.

Sometime, 1978: Alex Hing is practicing martial arts in a park after work when he hears someone say, "Alex?" It's Tyrone's girlfriend. During the Carter administration, he and her son were among the Americans who were allowed to return from Cuba. They're waiting for her husband. She tells Alex that she learned to sew while in prison (all American hijackers were imprisoned because they could be CIA agents), went to school, and then joined a factory. She has two criticisms about Cuba: (1) She disapproves of the country's involvement in the Angolan war because it is not popular among the people, and (2) it is too reliant on the USSR, which is social-imperialist, and not truly socialist. Then she goes on to say that she is still socialist and revolutionary, but doesn't want to get in touch with her old friends because she has to get her life together

and because she's afraid her phone is tapped. Alex goes back to the park in the weeks that follow, but never sees her again. 🐦

 CASTRO TIME *words* | Eric Nakamura

Why in the fuck would a hijacker want to go to Cuba? At the time in the late '60s and early '70s, Cuba became the hottest place to go. Perhaps the best reason for this is because it's only 85 miles from Florida, and the place is run by Fidel Castro, who's looked upon by some as a badass revolutionary. But a lot of the fools who hijacked planes and went to Cuba were into the fact that hijacking a plane to Cuba served as an embarrassment to the US. **Prior to 1973, people didn't get their bags checked!** So guns, knives, and bombs were easy to get on board. But once a hijacker got into Cuba, in many cases, he or she got screwed. Meeting them at the airport

Where were you when the Panthers' split started?
I was in China with Eldridge Cleaver. In 1970, I went on this trip to North Korea, North Vietnam, and China. How did it happen? Eldridge Cleaver, who at that time was based in Algiers, hooked up with North Koreans. At that time Kim Il Sung was still alive, the economy of North Korea was fairly strong, and Koreans wanted to have more public relations. So they invited Eldridge to North Korea and he sent a small delegation there. The North Koreans really got behind the Black Panther Party. Basically, they said that the Black Panther Party was the revolutionary vanguard in the United States. They had the Panthers set up an embassy in North Korea.

Did any other countries do that?
Algeria did that. The Panthers had an office in Paris. Eldridge was in Cuba. At that time, there was this movement of what was called the "non-aligned countries" that was led by Cuba, North Vietnam, and North Korea. They were the leaders. Somehow, people felt that China was too big. So **the Panthers ordered a subsequent delegation of American leftists to go to North Korea and they wanted a fairly broad cross-section of the American movements.** An 11-member delegation went and David Hilliard asked me if the Red Guards wanted to be represented. So I went.

We went first to North Korea. One of the first things we did was sit around with the North Koreans to plan an itinerary. And they said to all of us in the delegation, "What would you like to see?" I said, "I want to visit the Chinese embassy." You know, I'm a Chinese American, we're the Red Guard...Well, everyone in the delegation, their mouths dropped. The image was that North Korea was kind of like a junior China, and they were very sensitive to that. So we weren't supposed to talk about China, but I'm a Chinese American, and I didn't care. So the North Koreans arranged for just me to go to the embassy. The limo comes in to pick me up, and Eldridge asks, "Where are you going?" I say, "The Chinese embassy." He says, "You're not going by yourself," and we all went to the Chinese embassy together, all 11 of us.

Also, while we were in North Korea, the North Vietnamese wanted to meet us. We also wanted to meet them. So they

invited us to go to Hanoi because the war was still going on. We couldn't turn that down. So it became complicated because this was supposed to be a big PR thing for North Korea. Then we got invited to go to Hanoi and to China. So we spent three weeks in Korea, three weeks in Vietnam. Coming back through China we would have had an extended trip, but that was the time Huey got released from prison, and Eldridge had to deal with all this inter-party stuff. So our trip to China got cut off and we went to Algiers with Eldridge. That's exactly when the split happened.

We were in North Korea when the whole shoot-out at the Marin County Courthouse happened. So Eldridge had to get back to the Panther headquarters in Algiers. When the rest of us got back to the US, the party was in shambles. At the same time the Red Guards had suffered from a lot of political repression, so we dissolved. Basically, we merged with other Asian American leftists, and became a part of another organization. When the Red Guards dissolved, we actually merged with the IWK, which became a national organization with chapters in New York and San Francisco. A lot of ex-students went into the working class. We sought out working class jobs where we could organize and work in unions. That's how I became involved in unions.

With the collapse of the Soviet Union, and the kind of repudiation of Communism, Marxism, and Leninism, a lot of us have had to rethink our politics. Basically, that's where I'm at now: retrenching, trying to make my contributions where I can. So I'm involved with the Asian Pacific American Labor Alliance, involved in unions and organizing. That's what I do, plus I teach Tai Chi.

Most people who take classes like that seem to be non-Asian.
Yeah. Mainly it's because Asians are falling into their own stereotype. **I think a lot of youth now are basically computer nerds, and not really into studying the traditional stuff. Whereas people in Western society are getting fed up with Western values and are beginning to explore this big growth industry in alternative, or what they call "Oriental," medicine.** So a lot of people are taking martial arts, Tai Chi, acupuncture, transcendental meditation, yoga, all that stuff. If you go to any of those events, you'll find very few Asians.

were security guards and police who would put these revolutionaries into jail for their crimes. The African Americans who hijacked their way into Cuba got fucked, as they were left to be nothing but low-class citizens once they got out of jail. But the fools who were fugitives running to Cuba got more fucked since Castro didn't want fugitives in Cuba.

One publication mentions that there was a $25,000 fee that a hijacker would have to pay, which was most likely wrong, but another mentions that Castro would collect $2,500 to $3,000 per plane load. For some reason, Castro would let the hijacked plane fly back to the US, but would make the passengers stay in Cuba. He would arrange to have them

taken on a tour of Cuba, have them eat good food, give them Che Guevara propaganda. The US would have to pay the fine quickly or else their plane could possibly get impounded.

In 1980, Castro's Cuba opened its borders for outbound refugees. So tons of people got on boats and landed in Miami. But Castro did better, he let folks out of prisons and mental institutions and sent them out to the US, too. This led to shit like what you see in *Scarface*. Those that didn't want to stick around tried to hijack planes to go back home.

Before you hijack a plane, check out: *Terror in the Skies* (1987) by Captain Thomas M. Ashwood or *The Sky Pirates* (1972) by James A. Arey.

FROM THE *RED GUARD COMMUNITY NEWS*, VOL. 1, NO. 2, APRIL 9, 1969
RECOMMENDED READING LIST:

1. Edgar Snow | *RED STAR OVER CHINA*
2. *MALCOLM X SPEAKS*
3. *THE AUTOBIOGRAPHY OF MALCOLM X*
4. Eldridge Cleaver | *SOUL ON ICE*
5. Felix Greene | *VIETNAM! VIETNAM!*
6. Régis Debray | *REVOLUTION IN THE REVOLUTION?*
7. Che Guevara | *GUERRILLA WARFARE*
8. *DIARY OF CHE GUEVARA*
9. Che Guevara | *REMINISCENCES OF THE CUBAN REVOLUTIONARY WAR*
10. *CHE GUEVARA SPEAKS*
11. *HO CHI MINH ON REVOLUTION*
12. Giap | *PEOPLE'S WAR, PEOPLE'S ARMY*
13. Myrdal | *REPORT FROM A CHINESE VILLAGE*
14. *SELECTED MILITARY WRITINGS OF MAO ZEDONG*
15. *SELECTED WORKS OF MAO ZEDONG*
16. K. Marx and F. Engels | *COMMUNIST MANIFESTO*
17. Vladimir Lenin | *THE STATE AND REVOLUTION*
18. C. Wright Mills | *THE POWER ELITE*

CULTURAL RENDERING

What were you into when you were growing up?

I think that some of these traditional Asian variety acts are amazing: contortionists, jugglers, magicians. But I loved Bob Dylan. I like Bob because his lyrics are so right on. No one has a command of English and images quite like he does. He had a profound effect on my consciousness. And Bruce Lee, of course.

What about Bruce Lee?

When he was alive, I was very critical of him because he played Kato. Being an ultra-leftist, I felt, "Oh, here's Bruce Lee playing the servile role and fighting for this white guy. We've got to get off of that." It wasn't until he passed away that I began to appreciate his contributions. He played a major role in having a more positive view of Asians out there. To be that good of a martial artist, you've got to put in a lot of work. Maybe it's easier to say let's break out of that and do something easier! If we had a homegrown Jet Li from the US, we'd all be flocking. We wouldn't put that down.

MAKING HISTORY

Do you miss the days of liberating food and standing up to pigs?

I wouldn't do that now and I don't miss it. But I still believe in most of that stuff. Either you're part of making history, or you're not. I think we made a lot of history.

How can people make history now?

I think it's impossible to liberate others without first liberating yourself. **People have to be open to different ways of thinking. I'm supportive of everything that moves things forward. If you look at the yin and the yang, there's theory and there's action.** There's a time for theory and there's a time for practice. I think we're in a mode now for ideas. More of a retreat.

As Mao showed in the Long March, sometimes a retreat can be turned into an advance. There's no stigma attached to retreating. It's a natural process. People are beginning to understand what was not-so-correct about the past, and to take some of the good things and try to go out and have more practice and add their own generation's stamp to some of our experiences.

I think people should be revolutionary. People should break out of the old mode of things and not accept things as they are. Unfortunately, it takes a system to fall apart in front of your face before people start to look for alternatives.

What type of framework did you envision?

We were going to reclaim our heritage. We were going to break every stereotype that they put in our way, and we were going to show them that we are here to stay and they'd better come to some reconciliation with us. That's the attitude that I still have and I don't let anybody mess with me. I'm still surviving. I still plan to fight and still believe that I'm fighting. We'll see what happens.

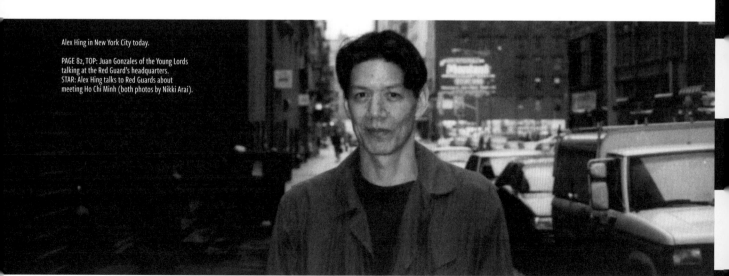

Alex Hing in New York City today.

PAGE 82, TOP: Juan Gonzales of the Young Lords talking at the Red Guard's headquarters.
STAR: Alex Hing talks to Red Guards about meeting Ho Chi Minh (both photos by Nikki Arai).

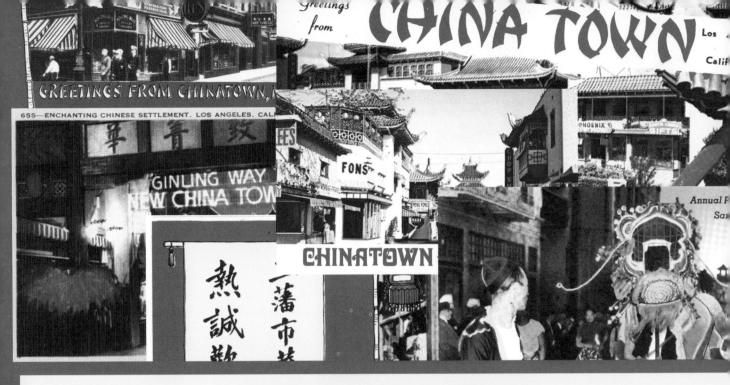

CHINATOWN

In the 1800s, the Chinese came to America, first to build railroads and then to mine gold. The coolies' work ethic was noted, respected, and feared by the White Man. So was their funky dress and language. As a result, when the final spike was hammered and the last prospector gave up, the Chinese found safety by clustering in major cities. These became the touristy and trashy Chinatowns of today.

There are lots of reasons why Chinatowns are generally crummy. One is that they're crammed in the inner-city. Often, they took over the ghetto of another minority, such as the Italians, who moved up when Chinese people started arriving. Another reason why Chinatowns get run down is that legislators tend to ignore them. Whether the Chinese are seen as godless heathens, Fu Manchu villains, Commies, or the model minority, there always seems to be a reason for the government not to reach out to them.

We cased out three Chinatowns: Los Angeles, San Francisco, and New York City to bring you the best and worst of each place.

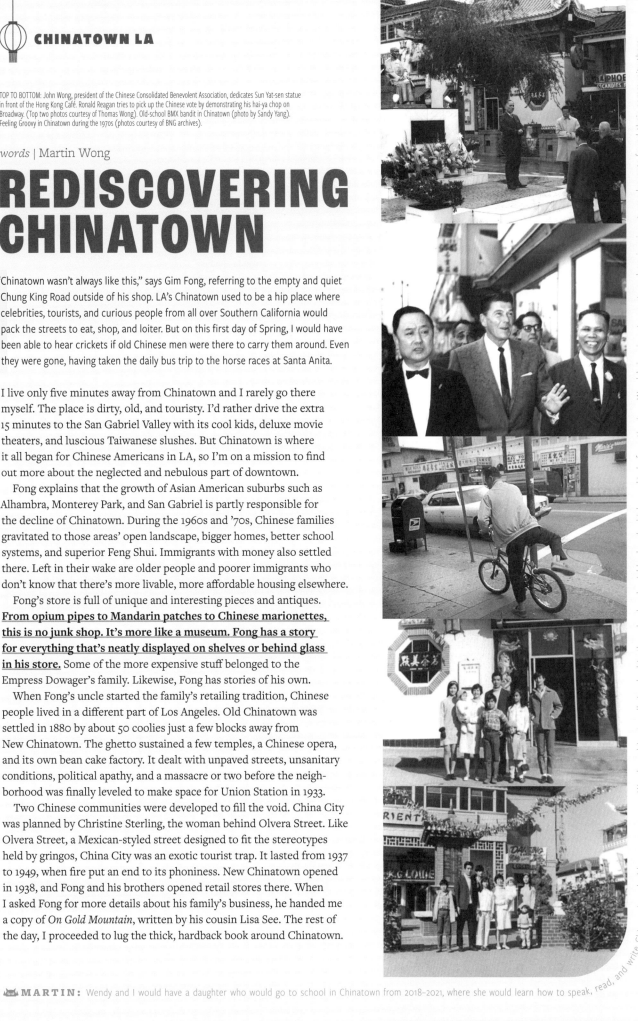

TOP TO BOTTOM: John Wong, president of the Chinese Consolidated Benevolent Association, dedicates Sun Yat-sen statue in front of the Hong Kong Café. Ronald Reagan tries to pick up the Chinese vote by demonstrating his hai-ya chop on Broadway. (Top two photos courtesy of Thomas Wong). Old-school BMX bandit in Chinatown (photo by Sandy Yang). Feeling Groovy in Chinatown during the 1970s (photos courtesy of BNG archives).

words | Martin Wong

REDISCOVERING CHINATOWN

"Chinatown wasn't always like this," says Gim Fong, referring to the empty and quiet Chung King Road outside of his shop. LA's Chinatown used to be a hip place where celebrities, tourists, and curious people from all over Southern California would pack the streets to eat, shop, and loiter. But on this first day of Spring, I would have been able to hear crickets if old Chinese men were there to carry them around. Even they were gone, having taken the daily bus trip to the horse races at Santa Anita.

I live only five minutes away from Chinatown and I rarely go there myself. The place is dirty, old, and touristy. I'd rather drive the extra 15 minutes to the San Gabriel Valley with its cool kids, deluxe movie theaters, and luscious Taiwanese slushes. But Chinatown is where it all began for Chinese Americans in LA, so I'm on a mission to find out more about the neglected and nebulous part of downtown.

Fong explains that the growth of Asian American suburbs such as Alhambra, Monterey Park, and San Gabriel is partly responsible for the decline of Chinatown. During the 1960s and '70s, Chinese families gravitated to those areas' open landscape, bigger homes, better school systems, and superior Feng Shui. Immigrants with money also settled there. Left in their wake are older people and poorer immigrants who don't know that there's more livable, more affordable housing elsewhere.

Fong's store is full of unique and interesting pieces and antiques. **From opium pipes to Mandarin patches to Chinese marionettes, this is no junk shop. It's more like a museum. Fong has a story for everything that's neatly displayed on shelves or behind glass in his store.** Some of the more expensive stuff belonged to the Empress Dowager's family. Likewise, Fong has stories of his own.

When Fong's uncle started the family's retailing tradition, Chinese people lived in a different part of Los Angeles. Old Chinatown was settled in 1880 by about 50 coolies just a few blocks away from New Chinatown. The ghetto sustained a few temples, a Chinese opera, and its own bean cake factory. It dealt with unpaved streets, unsanitary conditions, political apathy, and a massacre or two before the neighborhood was finally leveled to make space for Union Station in 1933.

Two Chinese communities were developed to fill the void. China City was planned by Christine Sterling, the woman behind Olvera Street. Like Olvera Street, a Mexican-styled street designed to fit the stereotypes held by gringos, China City was an exotic tourist trap. It lasted from 1937 to 1949, when fire put an end to its phoniness. New Chinatown opened in 1938, and Fong and his brothers opened retail stores there. When I asked Fong for more details about his family's business, he handed me a copy of *On Gold Mountain*, written by his cousin Lisa See. The rest of the day, I proceeded to lug the thick, hardback book around Chinatown.

MARTIN: Wendy and I would have a daughter who would go to school in Chinatown from 2018–2021, where she would learn how to speak, read, and write Chinese in a dual language program. Wendy and I got really involved in the school and neighborhood, which was kind of poetic since Wendy's immigrant parents and my immigrant grandparents found their community there.

"It's like a movie set," says Gene Moy, a charter member of the Chinese Historical Society of Southern California (CHSSC). Standing in the middle of Gin Ling Way, he points to the fading, chipping, and ornate facades of the chop suey joints and curio shops that surround the statue of Dr. Sun Yat-sen in the Central Plaza. **The crumbling, curved roofs are nothing but decoration, not to mention the cracked red and gold pillars. "These were built by the same people who built movie sets," he explains.** Chinatown is in various states of decline, and the CHSSC is trying to promote and document its history with weekly tours and a planned museum.

In its prime, during and after World War II, New Chinatown was always crowded. Lo Fan (white) tourists converged from all over Southern California for supper and shopping. The paparazzi would spot movie stars watching the stage show at The Rice Bowl.

But Noah Woo and Kenneth Wong, an immigrant and an ABC who worked there in the 1950s, note that the ornamental new restaurants on Broadway were only for tourists. Woo says, "They served chow mein and chop suey, and Chinese don't eat that." Wong continues, "We would go to holes-in-the-wall and greasy spoons on Spring Street. You'd be eating there and a guy would be dragging a garbage can past you."

"My father owned stock in the Jung May restaurant," remembers Sing Wong, who grew up in nearby South Central. That particular Chinese American café was popular with the Chinese community because it was open late and had gambling in the basement. As part-owners of the business, her family would receive checks from Jung May every year. Eventually, the checks got smaller as tourism waned and the Chinese moved further east in Los Angeles County.

Since the 1970s, commerce in Chinatown has experienced a long and steady decline. The restaurants my family used to frequent for wedding and birthday banquets—the Golden Palace, Golden Dragon, and other joints with live fish in front and private rooms in back—have changed owners multiple times. The only large parties in Chinatown restaurants are tourists off the bus or people having dim sum at Empress Pavilion.

As Gene Moy guides me through Chinatown's streets and alleys, it's empty and quiet except for the occasional shuffling and slapping of mahjong tiles by old men in second-floor benevolent societies. Today, the action is in the newer malls filled with Vietnamese pho joints, bootleg clothing stands, and karaoke shops. The signs are in Chinese, Vietnamese, Thai, and Spanish. Tons of new ethnic Chinese from all over Southeast Asia have been immigrating since the late 1970s, but even their shopping centers are practically empty on this Friday afternoon. (They would be on Saturday, as well.)

→ CHINESE ROCKS

Twenty years ago on any given Friday or Saturday night, the courtyard in LA's Chinatown was full of leather jackets, mohawks, and safety pins. See how it was by renting the first *The Decline of Western Civilization* movie or wait to see a Hollywood version in the *Darby Crash* movie that's in the works. Better yet, talk to the punks who were there:

JOHN ROECKER (You've Got Bad Taste)

"Punk rock in Chinatown started in 1978 and only lasted about two years. Madame Wong's was the first to have punk rock bands. I think it was after the Bags show that she stopped. Then the Hong Kong Café started having punk bands like Black Flag, X, The Germs, The Circle Jerks, Wall of Voodoo, B-People, and The Plugz. It was amazing. I'm thinking it was Madame Wong who put the stop to the punk rock. She had a fit when people were loitering (in the punk rock days it wasn't cool to see the opening band) and would call the police. We called this the "Chinatown War."

EXENE CERVENKA (X, Knitters, Auntie Christ)

"Madame Wong thought punk bands with women in them—like Alice Bag and me—were causing all the problems. So she only booked shows like 20/20 and Oingo Boingo. New wave stuff. She hated punk rockers so much. Punk rockers destroyed their club, tore out their seats, and loitered in the courtyard.

MARTIN: In 2023, PBS SoCal made a documentary called *Chinatown Punk Wars* about the

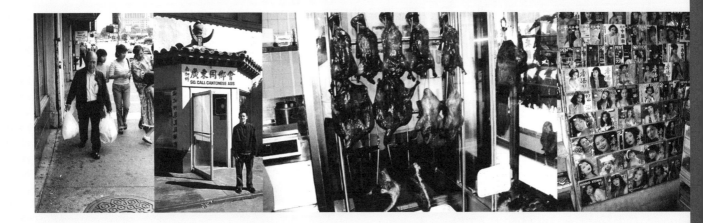

What will it take to resuscitate Chinatown? Safe parking would be a good start. Car break-ins are the number-one crime in the neighborhood. The development of more community-based businesses would also help. But most businesspeople don't think about community enrichment or long-term growth, according to Gim Fong. They just want some quick bucks, so they sell touristy trinkets and mediocre food. As a result, if you've been to a couple of the businesses in Chinatown, you know exactly what the rest of them are like.

One aberration is located on Gin Ling Way in the Central Plaza. **In 1978, Madame Wong's booked new wave bands and the Hong Kong Café took on punk bands. This rivalry lasted for about two years, and was documented in early issues of magazines like _Slash_ and _Flipside_.** When the punk rock scene briefly revisited the Hong Kong Café in 1992, I caught Bikini Kill (it was packed) and Rancid (McCall and Lint's first post-OPIV gig in LA), but it wasn't quite the same.

Standing in the Central Plaza, I look up into the foggy windows of the Hong Kong Café's second floor, trying to spot punk graffiti. The closest thing is "Shaolin Manifest" tagged on an adjacent gate. Like frolicking movie stars, families on outings, and bustling business in general, the punk rock is gone, so I soak in the tourism trade that remains.

I throw some change into the wishing well, try on a coolie hat, buy some Bruce Lee memorabilia, and toss some snaps around. Then I spot the Hill Street coffee and cigar store, newly opened on the first floor of the Dragon Gate Inn motel.

The trendy venture stands out from the area's more traditional fare, such as manicures, flowers, and pornography. It's probably got the only pinball machine in Chinatown (five balls for a quarter!). The owner, Peter, says that the upscale shop was intended to serve businesspeople staying at his motel because they had nothing to do after their meetings downtown. An unexpected windfall, he says, has come from ah bocks

So the Hong Kong Café started having punk bands. It was crazy. At an X show, I had to stand on a chair and hold on to the ceiling because everything was being pushed over."

KEITH MORRIS (ex-Black Flag, ex-Circle Jerks, ex-Buglamp)

"When I was in the Circle Jerks, Lucky Lar, Greg Hetson, and myself, we'd gone to just see a show. But because the three of us showed up, the owner of the Hong Kong Café thought the band was playing that night. This is no prejudicial slur or anything like that, but he said, "No play! Free egg roll, no play!" We had played there probably two or three times before and any time we played there it got pretty wild and the kids got pretty riled up. There were kids taking bus trays—those metal trays with wheels on them that they put dirty plates on—and pushing each other around on them. They had gone so far as to set a table on fire and throw trays through plate glass windows. It was all-ages and it was no-holds-barred. So the Circle Jerks played three or four times and that was the extent of that. He didn't want it in his place."

PLEASANT GEHMAN (ex-Screaming Siren, punk writer)

"Me and Belinda Carlisle used to get completely bombed out of our minds and go to the Hong Kong all the time.

She just called and reminded me of a story. We were swing dancing there, I think to The Blasters, and every time she swung me around, I'd spit on the people around us. Another time, we trimmed all our pubic hair, kept it in a matchbox, and put it in people's drinks! We did lots of filthy things there. I always had a great time." 😈

X at the Hong Kong Café, 1979. Photo by Debbie Leavitt, courtesy of You've Got Bad Taste.

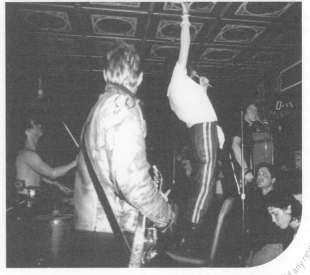

Hong Kong Café and its rivaly with Madame Wong's, the new wave club across the plaza. I'm in the movie, which you can stream on YouTube, and totally forgot that I did any research or writing about it!

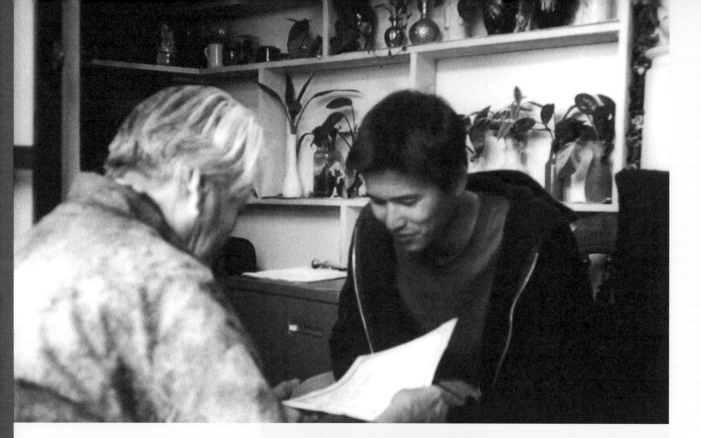

(grandfathers) who like to puff on $4.99 La Fontanas while playing mahjong.

Back at the Central Plaza, I decide to hit up the It Pun Fortune Readings booth. I fork over $10 and tell my date of birth to an older Chinese man who proceeds to read my palm and my face. He coolly describes my health and fortune in Cantonese and his female partner relays the information to me with volume and spittle. In terms of luck and love, this is a bad year for me, she yells in my ear. (She's right.) But it will get better. I've got a good heart and sometime between the ages of 41 and 51, she adds, I will be making $880,000! She informs me that I can improve my fortunes by sleeping with my head facing north.

If LA's Chinatown had a definite birthday, distinctive face, and clear direction, perhaps its fortunes would be as easy to predict as mine. With its layered history, cheap facades, and lack of leadership, its future is not so clear and not so easy to change. As the sun sets, I continue to take pictures, buy junk, and try not to bother the locals who wonder what I'm doing there. **Chinatown is touristy, cheap, and possibly obsolete, but it's also a cool place that may not be around tomorrow.** 🐱

→ **CHINESE RUBBLE**

Roberta Greenwood is an archaeologist who has been on call for Los Angeles's Metropolitan Transit Authority since 1987. One of her latest projects involved excavating the Old Chinatown when they were digging subway tunnels by Union Station. She found stuff like opium pipes, ceramic monkeys, and dominoes. Because the Metro Rail is partially funded by the federal government, she had to keep technical reports, which she turned into a deluxe book, *Down By The Station: Los Angeles Chinatown 1880–1933*.

Were you surprised by what you found from Old Chinatown?
ROBERTA GREENWOOD: It was deeply buried more than 14 feet below Union Station, which made us think it would still be intact. It was. There was a layer of rubble and all the evidence was under it. When they knocked down the buildings, they left everything there. It was more than we expected.

Did you find evidence of Chinatown tunnels?
This has pretty much been discounted. There were tunnels under the nearby Pueblo, but they were normal basement utility tunnels. They had been filled in as early as the 1930s, so there's no way we can prove one way or another if they went across Alameda (to Chinatown). I would really doubt it.

I understand a lot of artifacts were found in toilets.
You have to understand that there were no municipal trash services. There were no sewers and the streets were not paved. So they had to either dig trash pits or fill natural depressions in the ground.

Is it still stinky 60 years later?
Not at all. 🐱

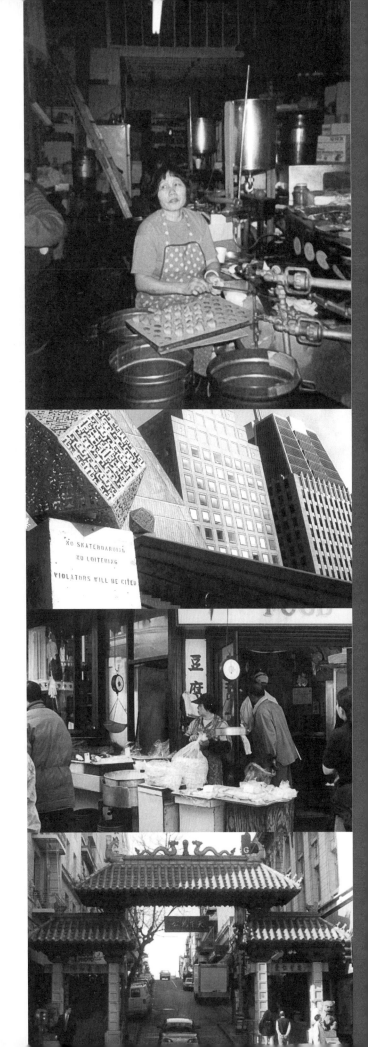

words + pictures | Claudine Ko

THE OG OF AMERICAN CHINATOWNS

"Little China" originated in the late 1840s on the Southern edge of San Francisco. In 1853, "Chinatown" was coined by "the press." 33 stores, 15 pharmacies, 5 restaurants. The first Chinese residents lived on Sacramento Street. They came, as did thousands of other immigrants, mainly because of gold fever at Sutter's Mill, but generally worked as cooks, laundrymen, carpenters, and servants. They were allowed to take old claims only after white miners had abandoned them. Within 25 years of the Gold Rush, California's Chinese population jumped from 54 to 116,000. By 1905, there were already six Chinatown Benevolent Association companies, a handful of Chinese Exclusion Acts, several cases of the bubonic plague, and 40,000 Chinese confined to a six-block radius around Portsmouth Square, the city's original center.

An 1885 municipal survey reported alleys bursting with barbershops, drugstores, pawnshops, and locksmiths. Opium dens and gambling houses were simply called CP: Chinese Prostitution. A description of Spofford Alley, a one-block street in the heart of the ghetto, said: "Every house there is a direct violation of all sanitary and police regulations and fire ordinances. Filth, stench, smoke, overcrowded habitation, houses of prostitution of the vilest sort, courtyards covered with slime, etc., abound there, in contradistinction to all civilization."

In 1906, the earthquake hit and Chinatown fell to pieces. Although city authorities had been trying to get rid of Chinatown for years, they finally began making plans to relocate Chinatown from its original land—between Nob Hill and the Financial district—to Hunters Point, just outside of the city in San Mateo. As the Chinese fled to Oakland and other East Bay cities, newspapers wrote false stories about a subterranean-Chinatown labyrinth over 10 stories deep, spreading more xenophobic fear.

However, Her Majesty the Empress Dowager of China firmly opposed this relocation and sent 100,000 taels to aid the city, and 40,000 taels for the relief of the Chinese residents. Ultimately, because of Her Majesty's insistence—and because San Francisco did not want to lose its trade with "the Orient"—the city began reconstructing the original site. The gweilo architect came up with an "Oriental" motif, replete with pagoda buildings and crazy dragon lanterns, so that the new Chinatown would attract tourists. It worked. Today, Chinatown is second only to the Golden Gate Bridge in visitor popularity. Tourism is the area's main source of income and 16 million visitors each year pour into Chinatown for all the pork buns and chow mein they can eat. 🐱

SOURCES:

Chinese Historial Society for America, Calvin Fung (Administrator)

The San Francisco Tourist and Convention Bureau

Philip Krayna, "The Backstreets of San Francisco," *Metropolis* (Sept. 1997)

Museum of the City of San Francisco's website, sfmuseum.org

San Francisco Chinatown's website, sanfranciscochinatown.com

→ MR. BING'S COCKTAIL LOUNGE

I like Mr. Bing's mostly because of the bar itself. It's in the shape of a "V" since the place sits on a sharp street corner. This way, you can check out other people at the bar or make conversation without hurting your neck or looking shifty-eyed. It also has a squishy black-vinyl rim around the edges—helps if you pass out and slam your chin into the counter. Then there's a jukebox and an old-school tabletop Pac-Man game. Plus, the bartender is really nice. He said that the cocktail lounge was opened 31 years ago. Before that, it was a topless club. You can still see vestiges of the old place, like the metal ring attached to the ceiling for the curtain where the naked girls would dance.

ROBERT H. GRANT, BARTENDER FOR 9 YEARS:

BEST TIPPERS:
"The regulars. Tourists are really bad tippers usually."

MOST-COMMONLY-ORDERED DRINK:
Crown Royal (the regulars).

SHOOT-OUTS:
"I've seen fights, but never a shoot-out. The fights are mostly goofy people off the street."

MOST POPULAR/LEAST POPULAR NIGHT:
Friday/Monday.

MOST POPULAR SONG PLAYED ON THE JUKEBOX:
"Tiny Bubbles"

HOW DO YOU SHAKE YOUR MARTINIS?
"Depends if they want it up—if it's up, I use a circular motion. I don't use a shaker. They're kind of a pain, you have to pop the thing off and everything."

OLDEST CLIENT:
"I had one that just died off, he was 87." (Some of the clientele have been regulars for 20 years!)

WEIRDEST DRINK ORDER:
Tequila, Jägermeister, and orange juice. "Three tourists probably from the midwest...it came out this really funky, burnt orange color."

ROBERT'S NICKNAME:
Tequila. (He used to drink a lot of shots with his friends.)

WHY IT'S CALLED MR. BING'S:
"Mr. Bing's my dad. That's his nickname." 🐱

For the record, Mr. Bing's is still open and was granted historical status in 2023.

CHINATOWN NYC

THE GHETTO WITH A CAPITAL G, MOTHERFUCKER

words + pictures | Claudine Ko

Chinatown, NYC, doesn't fuck around. Everything about it is fierce: street traffic, durian fruit prices, ladies working in sweat shops, the train station at Canal Street, ugly-ass Versace rip-offs, and the guy sitting behind you at the Music Palace. Even hanging in Columbus Park is an experience like no other.

It didn't start with gold like the West Coast; most of the Chinese didn't get there until the late 1870s. Many of them were former laborers on the transcontinental railroad (1864–1869), pushed out by unemployed, angry white men. And it didn't get any easier when they changed coasts, with more Exclusion Acts of 1882, 1888, 1902, and 1924, and the dearth of job opportunities. Most were forced into shit-paying jobs and lived on Mott Street, the earliest residence of the Chinese. There's a record of a man named Ah Ken who moved there in 1858, and the city's first Chinese grocery store, Wo Kee, established in 1878.

The Tong Wars pretty much raged from the early 1900s, and only recently have begun to slow down, at least according to the papers. Before, they battled over the opium trade and gambling control along the elbow-shaped street of Doyers near Pell, where the Hip Sing Business Association is located (16 Pell St.); now it's gambling, heroin, and prostitution. It has been said that more people have been killed on this "bloody angle" than any other intersection in America.

New York's Chinatown was once six blocks of segregated streets between Bowery and Mulberry, Canal and Worth. Today, it stretches as far east as the FDR highway, as far West as Thompson St., as south as Church, and as north as Spring St. It is very, very big. If you ask the librarian at the Chinatown library in SF about stats on the community, she will automatically hand you a few binders with census records neatly compiled. If you go to Chatham Square Library on East Broadway, the librarian will look concerned and say that it's really hard to get accurate information like that in this China-town. Income? Age? No, it's just really difficult, she repeats.

Yet, what was once described as the "worst pigsty of all" by social reformer Jacob Riis is now home to four brand new Shiseido boutiques, a hair salon that gives $20 dollar cuts, and rent prices that have shot up to $2,400 for a three-bed-room dive on Broome St. It smells in Chinatown, but it's not just the salty fish and dry piss emanating off of Canal. 🐱

SOURCES:

Peter Kwong, *The New Chinatown* (1996)

Christiane Bird, "Exploring New York's Chinatown, Little Italy, and the Lower East Side," *New York City Handbook* by Moon Travel Handbooks.

THE MEANING OF SQUAT!

words + pictures | Manami Kano

Toilets and toilet rituals are not universal. That's what I found out when I came to Japan 15 years ago with the American idea of what a toilet was and had to adapt to squatting. I first encountered the Japanese style "squat" toilet (ceramic oblong basins in the floor that generally flush) at my grandparents' home. At that time, I wasn't very adept at squatting, my balance a bit suspect in the plastic toilet slippers, but I managed. Private homes and public restrooms then almost exclusively had squatters, and finding a toilet seat was a challenge.

Coinciding with the 1980s economic boom and the Euro-Americanizing of Japan, the so-called Western toilet (which shall be referred to as the "sitter" from hereon), became commonly used in Japan only in the last 10 to 15 years. **The sitter is one of the concrete—or shall I say ceramic—manifestations of Western imperialism and "modernization" in Japan.** The assertion that Western sitters are a form of cultural imperialism may seem strong for something as basic as a toilet. Because toilets are such ubiquitous and mundane appliances, we are less apt to question their significance, particularly as a mode of cultural transmission. The fact that even talking about toilets and our bodily functions

ERIC: Toilets in the US have made puny strides to modernization. Here's how. 1) A Squatty Potty basically makes you squat like the Asian squat

is seen as crude by most Americans (who refer euphemistically to the toilet as the "bathroom," "powder room," "restroom," or "little girls'/boys' room" in polite company) also makes it difficult to discuss it as a cultural ritual.

However, in the same way Western art, music, and literature were embraced by (and to some extent mandated by American forces through public education) a post-war Japan wanting to Euro-Americanize, the sit toilet tagged along with these "modernizing" efforts. **The sitter has become a symbol of civilization, of sanitation, a way to get Japanese noses out of their shit.**

A Japanese colleague of mine, who first used a sitter only 10 years ago, speculates that sitters were popularized as a space-saving device, a two-in-one toilet. Before the widespread use of sitters, Japanese homes generally had two toilets, a squatter and a urinal, in separate rooms. Early toilets were often built outside the house or adjacent to it to keep out the smell before toilets had flushing capability. However, even now, some portions of Japan still don't have flush toilets or modern sewage disposal. In parts of southern Osaka, you can still see the "dump" trucks going from house to house, sucking out the waste through big hoses. If you get stuck behind one of those trucks, the stench will hang in your nose all day.

The technical differences between the sitter and squatter reflect deeper opposing ideals and attitudes. The main contrast between Japanese and Western notions about the toilet is the amount of shame associated with the body and its functions. Americans inherited Victorian attitudes from the British toward their bodily outputs and how to disguise them.

From the days of Queen Victoria and Thomas Crapper (the man who

perfected the modern throne, the "pull-and-let-go cistern"), Western civilization was measured by the amount of distance you could keep from your feces. **The Victorian Era was the heyday of toilet design in terms of trying every possible way to disguise its use as a feces receptacle.** In 1969, scatological expert Wallace Reyburn noted, "Having the courage to bring the toilet out into the open, the Victorians saw to it that it was a thing of beauty. Or perhaps it was that they

This chrome alloy, lowered toilet has hydraulic jacks.

were rather self-conscious about it and felt that it should be camouflaged.

The body, and by extension, its excretions, signified shame and needed to be hidden, particularly for women. Reyburn added, "Sensitive females, such as maiden ladies and girls entertaining a new boyfriend, know it is no good announcing, 'Excuse me a minute, I'll see if the scones are done,' merely to have the sound of the flushing toilet proclaim to everybody

in the house, 'I have been to the loo.'" In keeping with the concept of virginal women immaculately conceiving, "good" women don't shit, either; their waste should immaculately disappear. (The Victorians would have appreciated the Japanese invention, otohime, a recording of a toilet flushing which women could use to cover up the sound of urination or defecation in public restrooms.)

Nevertheless, Japanese people still have a more matter-of-fact attitude towards the toilet. When I discussed with a group of young Japanese women about euphemisms they have for the toilet, urination and defecation, they couldn't think of any, preferring straightforward yet polite terminology (e.g. "Excuse me, I'm going to the toilet.").

In general, discussing bodily functions is less shameful or embarrassing for the Japanese than for Westerners. It wouldn't be unusual for a close friend to ask you how your dump was that morning. There is even a cartoon, *Dr. Slump*, in which one of the characters eats feces—this is family entertainment. Without Christianity or other rigid religious doctrine dictating Japanese attitudes on a day-to-day level, there is less association of vice and shame in the body.

The public bath, sentō, is an example of this more relaxed attitude. The first time I went to a sentō, even though the male and female sections were, and are, usually separate, I was a bit mortified (must be all that American puritanical indoctrination) showering and bathing with a bunch of naked women who were not the least bit self-conscious. Back in the old days when not everyone could have their own bathtub, the sentō was a necessity, as well as a community meeting place. You could relax and unwind

with your friends in the ofuro without the sleaze associated with the contemporary hot tub clubs or bathhouses in the United States.

Although American puritanical values haven't been embraced by all Japanese folks, the sit toilet has swept the country. While public restrooms usually have one sitter for every ten squatters, sitters have become the choice for home use. Toilet manufacturers such as Toto and Inax have been redesigning and innovating sitters to be ultimate havens for relaxation and comfort, elevating the toilet experience to a whole new realm of pleasure.

The French bidet was immediately embraced by the Japanese who could afford it, adjustable sprays and driers at the touch of a button. Electric seat warmers, protecting the user from the shock of an ice-cold seat during winter, is a given in any home. Almost every flush toilet in Japan, both sitter and squatter alike, comes complete with a spout on top which gushes out water with each flush so the user can wash his or her hands over the toilet (toilet and sink built into one). I personally have never gotten used to washing my hands while flushing, even after being reassured the water hadn't been recycled from what I had just flushed.

There is no conclusive evidence of the health benefits of squatters vs. sitters. However, Japanese folks seem to believe that squatters build character as well as muscles in your haunches; that squatters are more sanitary because you come in no physical contact with any part of the toilet; that squatters are an essential part of the Japanese heritage. **One thing I've discovered from traveling through different parts of Asia and trying every sort of squatter, every sort of hole in the ground (and sometimes wall or cement cubicle) with varying squatting methods, is you become significantly closer to your bodily functions. (Gravity also seems to accelerate the excretion process as well, leading to a speedy delivery.)**

Throughout Asia, the tradition of the squatter has been passed along from generation to generation. When first introduced to Japan by Americans, sitters had to come with directions such as, "Don't stand or squat on the seat," "Use with seat down," and "Flush after use." Even the toilet in my apartment has a sign with an illustration and directions for use, and this is a relatively new building.

The squatter, like the sitter, has evolved over the years, particularly in terms of sewage disposal. Nevertheless, because of how the sitter has been marketed in Japan, squatters cannot represent modernization the way sitters do. Would Japan have embraced the sitter so wholeheartedly had it not come with all its cultural implications?

By calling the squatter "washiki" in Japanese, meaning "Japanese style," there is a recognition of Japanese tradition in the squatter. Although few things should be kept only for the sake of tradition, Japanese people should reexamine the impact of the Euro-American influence on their lives and, specifically, decide if squatters are really something they want to give up.

In a larger sense, Japanese people need to determine what kind of identity they want to create for themselves, whose traditions to continue, and whether to ally themselves with the white First World or the developing nations of Asia. The rise in Japan's economic power coincided with the spread of sit toilets, whereas this has not occurred in most other parts of Asia for economic reasons. As Japan has become more affluent, Japan's desire to be like the US and Western Europe has expanded beyond industry and technology to aspects of cultural life. The sit toilet may be another barrier Japan can raise between itself and the rest of Asia. Is the sitter such an advanced form as it professes to be?

Nonetheless, the use of squatters won't be eradicated any time soon. As public facilities go, squatters are cheaper to install and maintain, easier to clean, and more sanitary in the minds of ordinary Japanese folks. For the time being, squat toilets will remain a part of Japanese life. 🐱

SMELL

I'm not saying my shit doesn't stink. I'm saying people I'm around tell me, "You never smell bad." What do you want me to say?
—**CHRIS,** 29, Chinese American

I never used to smell my armpits before, but for the past five months not only have I been trying to get a whiff of what goes on with my axillary glands, I've also been accosting many an unsympathetic friend in the name of BO research. Multiple sniffs and three victims later, I've learned nothing—nothing new, that is. You see, I'm Asian and my pits don't smell.*

This is not to say that all Asians lack BO. **It has been scientifically proven that Asian people tend to have smaller or no sweat glands in their armpits while European and African descendants have the most.** In one study, it was estimated that 10 percent of Japanese, 2 to 3 percent of Chinese, and 50 percent of Koreans have odor.

HOW IT WORKS

Asian people most definitely smell better than most. I'm sure you can think of one or two exceptions, but that's the exception... Non-Asian girls smell more, but that is a good thing, that sweet, that gushy, that nasty funky shit. —**DAVE**, 25, Korean American

Humans have two kinds of sweat glands: eccrine and apocrine. It's the latter ones that cause the stink, and they're the ones that cluster in your pits, your crotch, and around your head. George Preti of the Monell Chemical Senses Center explains that along with sweat, apocrine glands secrete fats and proteins that decompose in the recesses of your body, inspiring all kinds of aroma. Hairy people have a proclivity to smell more because fat absorbs odor, and hair,

MY ARMPITS

words | Claudine Ko
pictures | Eric Nakamura

with all its grease and shit, sucks it up. If you haven't noticed, Asians also tend not to have as much body hair as others. Wait, let me clarify: East Asians don't smell as bad. According to Preti, "I have to say we haven't really looked at Asian men; I've looked at Indians, and they have good old-fashioned armpit odor."

There are other theories as to why people of different cultures smell the way they do, from diet to native climate. However, I don't know if I believe them because I eat more meat and crap than anyone else I know and my essence is still clean. And if a hotter climate causes inhabitants to develop bigger or more sweat glands, why the hell doesn't the entire humid Pacific Rim reek?

My first experiences of body odor take me back to when I was a little boy studying karate under my longtime mentor and teacher of life, Tenzan Hirakawa. I was his number one at the time and practice was very long and grueling. I remember as a young Japanese kid trying to resist being slammed to the ground by a grown yakuza-looking Japanese guy. When I sparred with the other kids I didn't notice it as much, but when it was time for me to withstand sensei—it smelled like a sushi restaurant, like rice and vinegar. Only later, when I smelled this odor coming from myself, did I realize that this smell was actually body odor. —MIKE, 25, Japanese American

In *A Natural History of the Senses*, Diane Ackerman writes, "At one time, body odor could disqualify men from military service" in Japan. And doctors of Oriental medicine attribute physical body odors to internal diseases like liver cirrhosis, diabetes, and/or bladder problems. "In most of Asia, it's considered a disease," says Preti. "There's a surgery to remove apocrine glands from the axilla. I think it's done on both sexes." In fact, some cosmetic surgeons in Japan say they perform hyperhydrosis (excessive sweating) operations almost every day. After discovering a substance that causes BO in people over 40, Shiseido, Japan's largest cosmetics company, launched the Care Garden line of shampoos, lotions, and deodorants targeted at middle-aged men. It was one of their most successful lines ever, predominantly bought by businessmen in their 50s.

The best kind of deodorant is white sticky thick chunks, like LL Cool J on MTV Unplugged. —DAVE

I don't use deodorant. I got a free sample in the gift box I got for moving into the dorms. I felt compelled to use it since I was sharing my room with a deodorant-using white girl, but once it ran out, that was that. No one in my family uses it either and, except for one freak day in the history of my dad's life, none of us smell. While people have been trying to cover up their odor since the age of antiquity (taking perfume baths in Egypt, dousing their nasty wigs with scented powders, etc.), the first deodorant product was invented by some guy in Philly in 1888. It was called "Mum" and later, in 1931, Bristol-Myers bought it up and began marketing it all over the country and, eventually, in Britain. It was very successful. As of last year, the US had the largest deodorant market in the world, followed by the UK, Germany, France, Italy, Japan, and Spain. One major difference is that while almost 80 percent of deodorant sales in the States are in solids, the other countries sell over half the products in spray form.

IT'S ALL GOOD

The issue of body odor has always been one-sided in my relationships. I'm aware that they have it and they're aware that I don't. I know someone who's half-white and half-Japanese and she claims to have BO in only one armpit. I definitely notice it among white men. You go out for a while and get back in the car and it's like, geezus. If you're emanating odors, you're desensitized to them. It's like if you've never farted and then someone does. You're like, "This is disgusting." —DAN, 27, Japanese American

It's been said that once, when Napoleon was returning home after a long time away, he messengered a letter to Joséphine that read, "I'm coming home. Don't bathe." Smell is sex. So don't freak about it unless you really do have a serious BO disease, like hyperhydrosis.

I can't stop smelling my armpits. It's the spice that will get you going for whatever task it is in front of you. Just like when Kevin Kline sniffs his armpits before he has sex in A Fish Called Wanda. I would never dream of extinguishing these delightful pleasures in life with a stick of soap that you rub on your armpits to conceal the odor. But then again, I'm Asian and Asian BO smells good. —MIKE

*Once, after not bathing for four days straight and going on a three-night bar fest, I came home and my roommate said I stank. Oh, and a boy I went camping with once said I smelled like red wine and Camembert cheese, which is what we had been eating and storing in our bags for the week.

ERIC: The funniest part of this article is that it may have manifested into smelly Asian-Americans thinking that they don't smell bad.

G 97 R

ODORAMA

AARON CHAN

1. Speed Stick.
2. No.
3. I have no idea.
4. Sometimes, depending on the person.

MABEL KO

1. Secret.
2. I shaved for this photo.
3. Wouldn't you like to know?
4. I don't think so.

JASMINE ONG

1. Crystal spray. Almay Stay Dry Hydro solid.
2. Shave.
3. Light, leaning to moderate.
4. Not particularly, but it could be.

SOPHIA CHANG

1. Generally none.
2. I Nair—three-in-one!
3. Nice, I could sniff my pit all day.
4. It depends on whose, but generally no.

CINDY LIU

1. No deodorant.
2. I shave and tweeze out ingrowns.
3. Faint musky odor after a workout.
4. Hell no, it's not sexy! I'll run the other way!

MELISSA COATS

1. Dove anti-perspirant/deodorant.
2. None!
3. Like candy...durian candy.
4. Nope!

MICHAEL KAI LOUIE

1. Unisex Sure; men's gives me a rash.
2. No, but I shampoo it once a week.
3. Sassy and alluring.
4. In the right places.

PATRICK PARK

1. Almay hypoallergenic fragrance free.
2. Hell no.
3. Very, very light unshowered—not so fresh.
4. Hell no.

TONY HONG

1. Old Spice Sea Breeze.
2. None of the above.
3. Tantalizing and refreshing.
4. No, but I prefer it over bad breath.

ALEXIS CHING

1. Secret Platinum.
2. Shave.
3. Fruity. I have fruity shower gel.
4. Not if it's stale or overpowering.

UYEN LY

1. Ban.
2. Epilady.
3. Like ketchup and fried eggs.
4. Not really.

MICHAEL IDEMOTO

1. Speed Stick.
2. Shave.
3. Lighter than a fart, heavier than halitosis.
4. BO is not sexy.

BARRY HAMAGUCHI

1. Natural Crystal Deodorant.
2. No.
3. Tamales, like Mexican food.
4. If it's the right potency and right person.

EUGENIA YUAN

1. Dove Deodorant Original Scent.
2. Shave.
3. I don't have BO.
4. I don't find BO sexy.

SELENA MA

1. Secret.
2. Shave, ugh.
3. Piquant.
4. Depends on the situation.

NELSON KUO

1. Right Guard Spray.
2. No.
3. Sour.
4. In an intimate relationship, yes.

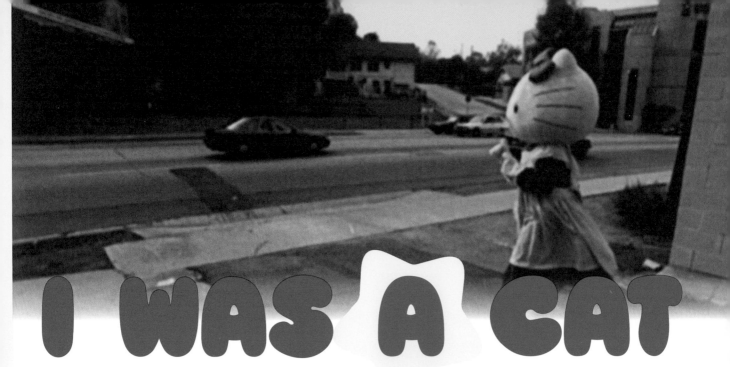

I WAS A CAT

words | Martin Wong *pictures* | Eric Nakamura

In January 1905, Natsume Sōseki published the first installment of *I Am A Cat* in the Japanese literary journal, *Cuckoo*. There, and in nine subsequent chapters, Sōseki examined the foibles of humanity through the eyes of an anonymous feline narrator.[1]

Almost 90 years later, through a strange, anthropomorphic, gender-bending turn of events, I was hired by a Sanrio proprietor to be a part-time Hello Kitty for 10 days or so. At first, I just thought it would be fun to be a symbol of cuteness and idol for children everywhere. Now I think it's kind of a drag, especially for minimal wages.[2] Yet I go back for more. How's that for a human foible?

Physically, being Hello Kitty is quite demanding. I wear a thick styrofoam vest, fancy dress, huge red patent leather Mary Jane shoes, furry gloves and leggings, and three layers of unvented cat head. Plus, the outfit is as impractical as it is uncomfortable; I can barely see or maintain my balance. As a result, even though I look like a seven-foot tall embodiment of charm on the outside, on the inside I'm panting, sweating, and teetering—just like Darth Vader in his hermetically sealed bodysuit.

There are also less apparent challenges, most of them psychological. For example, **after a day of greeting and hugging children, it becomes automatic. This must be quelled. Such friendliness is acceptable when you're a cuddly cat; it's creepy when you're a scruffy guy driving around in a dirty, rickety car.**

Also, when Hello Kitty isn't being adored, she's being insulted: "Get a life," "Your mom must be so embarrassed," "I hate you."[3] For me, the most stressful part of the job is being an expressionless entity.

One would think that people wouldn't ask Hello Kitty questions because she doesn't have a mouth. Of course, they do. Certain adults feel compelled to demonstrate their well-honed skills of discernment ("Is it hot in there?"). Rebellious teens, perhaps responding to Hello Kitty's ultra-innocent airs, attempt to taint her purity by bringing up sex ("Are you

a boy or a girl?"). Young children ask the most alarming questions of all ("Do you know Barney?").[4] All I can do in response is shrug, dance, or nod. Who would have thought that being Hello Kitty would help me to identify with Stephen Hawking or Muhammad Ali?

There are also times when I feel invincible inside the Hello Kitty outfit. Warned only by the patter of saddle-shoed feet, packs of children hug my furry legs from out of nowhere. Other times, parents take pictures of Hello Kitty holding their infants—not knowing how precarious her furry paws are. And there's nothing like being gazed at by little kids with their eyes as big as silver dollars as if you're a dream come true.

It could be argued that even Charles Manson would look cute in a Hello Kitty costume, but I don't think he'd like her. To appreciate Hello Kitty means having an affinity for the cute and the cuddly. It also requires a suspension of disbelief—an ability to enjoy something that's fabricated and sold. I personally don't find it unhealthy to believe so strongly in such a product—millions of people celebrate Christmas every year even though they don't believe in God or Santa. It's fun.

Do I play God or Santa when I'm dressed as Hello Kitty? Sometimes it's hard to tell. Either way, wearing the outfit can lead to religious experiences. Sometimes I feel charismatic. Kids want to take Hello Kitty home, invite her to school with them, and ask for her autograph. Other times, at the end of a long shift when the air gets thin inside the cat head, I have out-of-body experiences. Dehydrated, dizzy, and detached from reality, I spy a co-worker dressed as Keroppi and I'm instantly transported to Puroland, Sanrio's version of Disneyland.[5]

However, when I take off Hello Kitty's stuffy stuffed head, it's as clear as the sweaty nose on my face that Sanrio isn't a religion. It's big business. Like the Disney company, Sanrio boasts a theme park, animated features, and licensed products. Unlike Disney, Sanrio sold the products before it dabbled in the rest. One legend suggests that the eternally youthful kitten was designed for the family-owned company by an

engineer. Another gives credit to a designer (p. 383). Regardless of Hello Kitty's origins or nature, Sanrio's evolution from a kiddy cult leader to a mass-marketer involves two distinct eras: the pretty, pastel years and the populist, primary years.

When the first Hello Kitty stickers, stationery, and pencil boxes hit America's store shelves in 1976, Sanrio targeted young females almost exclusively. The marketing is especially apparent when considering the other early mascots included Little Twin Stars, My Melody, and Tuxedo Sam. All are cuddly creatures commonly surrounded by hearts, flowers, stars, and rainbows in various pastel shades. And even in red, the ubiquitous Hello Kitty personified sweetness and light.

Many early Sanrio retailers underscored their products' gender-specific nature by dividing their stores in half. One side of the usually Asian-owned shop would feature Sanrio products for girls, the other, Kaizo Ningen toys, for boys.[6] This yin-and-yang relationship lasted about a decade.

Appropriately, Sanrio leapt into the next era with help from a frog. Arriving in 1988, Keroppi differed radically from the rest of the Sanrio pantheon. An athletic, bright green bachelor, he was the first gender-neutral mascot. He was a huge hit. Keroppi's splash cleared the way for subsequent non-feminine mascots Pochacco and Pekkle in the following years.

Sanrio's successful transition from feminine frills to cartoon cuteness has allowed retailers to expand from Asian mini-malls into the mainstream. Today, nearly every mall in California features a Sanrio store. Simultaneously, Hello Kitty and friends pervade punk rock fashion. The recent introduction of the "riot grrrl"—styled Rururugakuen and resurfacing of the "grunge" plaid Winkipinki suggest that Sanrio is playing up its crossover appeal.[7]

As Sanrio spreads from Little Tokyos to major malls, new mascots pop up like kittens in a litter. Not all succeed—the ill-conceived and controversial Sambo character, for example—but newcomers such as

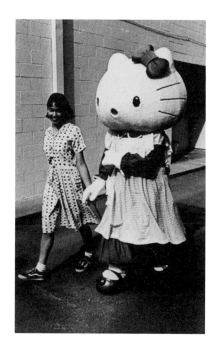

Pippo or Picke Bicke could be the stars of the future.[8] Meanwhile, established mascots are revamped every season. With a bounty of goods available in Asia yet unseen to most Americans and new merchandise in the works continually, the Sanrio craze is growing and slowly working its way inward from the West and East Coasts.

The question is not if Middle America will accept Hello Kitty, but when. Consider the following connections between cartoon cats and American culture: Krazy Kat romping in the surreal '20s, Tom chasing Jerry in a '50s dream house, Kliban's cats "being themselves" in the me-decade '70s, and Garfield indulging himself in the epicurean '80s. The simple, elegant Hello Kitty epitomizes the back-to-basics attitude that Americans purport to have in the '90s. Plus, she's cute. That's something that needs no translation to embrace. What would the anonymous narrator of I Am a Cat think about my unique employment by the Sanrio company? Even though I'm quite satisfied with my placement and personality as a human, I'm still willing to masquerade uncomfortably as an enormous feline for insignificant wages. Sōseki's alter-ego probably would approve. In his view, cats own humans and are in fact superior to them. After being Hello Kitty, I'm inclined to agree. 🐱

NOTES

1 A very well translated English edition of Sōseki's I Am A Cat has been published in three volumes by the Charles E. Tuttle Company. Also, Osaka residents Shonen Knife perform a song by the same title on their Let's Knife LP.

2 However, I enjoyed a generous discount on Sanrio merchandise.

3 Interestingly, all verbal abuse took place in a San Fernando Valley mall. In the San Gabriel Valley, I was unequivocally given royal treatment. This may have to do with the San Gabriel Valley's predominantly Asian population, which has had a longer (and more reverent) relationship with Hello Kitty.

4 When asked about Barney, I shook my head. When another child asked me if I knew the Power Rangers, I posed in a karate stance.

5 At Sanrio Puroland, visitors enjoy rides, shows, and encounters with their favorite mascots. Why not book a flight to Japan and see it for yourself?

6 Generally, the Kaizo Ningen aesthetic entails robots, rangers, and monsters.

7 The Riot Grrrl movement involves equal parts of do-it-yourself feminism, fanzines, and punk rock. Grunge entails flannel, coffee, and Seattle.

8 The Sambo mascot received much deserved criticism for being insensitive to Blacks. However, when confronted with African Americans' concerns, Sanrio immediately recalled all related merchandise and established several cultural awareness programs on both sides of the Pacific.

MARTIN: I was contacted by Sanrio's lawyers, who basically said not to use Sanrio stickers and art—which was in the original layout—in our magazine anymore. I said, sure, and then asked if they had any corrections or reactions to the article itself, and they said everything seemed right. The footnotes are a result of me being really into David Foster Wallace at the time—specifically his articles about going to the state fair and going on a cruise.

loud and at the same time, full of information about his experience.

G 101 R

BEAUTY AND THE BEAST

words | Lynn Padilla

No, this is not the story of a lovely girl who falls in love with a prince who is trapped in the body of a beast, but just a commentary on couples who, on a superficial level, seem mismatched.

Okay, granted, maybe living in la-la-land makes me more attuned to surface traits, but I have asked others about this phenomena and it's not just my opinion, but something that is often seen and I don't know how often it's discussed. Anywho, here it is: why do we often see a beautiful Asian girl or a handsome Asian guy with a not-so-physically-attractive Caucasian person? It's not just true of Asians, you can see attractive African Americans and attractive Latinas/os with not-so-stunning Anglo Americans. But, since this is an Asian fanzine, and I happen to be Asian (or Pacific Islander or "other") I think I better talk about this in terms of Asians or just what I happen to notice.

For those of us who grew up in America, the idea of what is beautiful/attractive/desirable comes mainly from the media—television, movies, magazines, etc. There is this unrealistic standard of beauty that many of us ("us" being used in a figurative sense, of course) try to live up to and of course fail miserably because no matter what we do, we can't suddenly be taller, our dark hair won't turn blond, and our brown/black eyes won't be made blue like Crystal Gayle's country song. Oy vey! What's a girl/boy to do?

Welp, maybe the next best thing to being "it" is to try to have "it" alongside you. Never mind that beauty is much more than what's on the surface and totally subjective. Never mind that having blond hair and blue eyes does not a hot babe make! **I'm sure at any given moment we can remember someone describing someone they had a crush on/lusted after/were seeing and when we asked what s/he looked like they would say, "Oh gorgeous! S/he is tall, has blond hair and blue eyes." I mean, that tells me absolutely nothing. There are many people who fit that bill who would not be considered model material or even remotely appealing.** I only say this because growing up I was made to feel that since I was none of the above I must be muggly. I also had the problem of relatives only considering the light-skinned family members as attractive. They would say things like: "She's so beautiful because she's so fair." Yee. It's not a good idea to try to be white when you're not. Just think of a certain very famous entertainer who now looks like a very bizarre kewpie doll or something.

Naturally, not all interracial relationships fall into a B/B category. But do you notice the ones that do? Okay. Often there are couples where we look and think, "Gee, he must have money" or something like that. But when you see a couple that looks like a real couple and wonder where the disparity comes from, I wonder if it stems from this

YELLOW FEVER

words | Eric Nakamura

Yellow Fever isn't in any medical journal, but it exists and can be likened to a disease. A definition of a person with the Yellow Fever is one who makes a project out of scoping an Asian person out for a relationship. Does this sound familiar?

There are many non-Asians who study Asian culture and have interests in only Asian women. For this article, I will call this Type I. Most of the time, it is a white male searching out Asian females to have dreams about anime and cuteness. This is Type II. Sometimes, it's an old white man scoping out young Asian girls to fulfill his Oriental dreams that he probably saw in some old Suzy Wong type of movie. This is Type III. I have no problems with interracial couples since many happen naturally without any kind of "fever," but making a project out of attaining Asian "girls" is unjustifiable.

Since I was an East Asian Studies major, I've run into many who were not Asian, yet were studying Asian language, politics, history, and culture like mad people. I've met a few who will even start to speak Japanese to me! They have little interest in anime, but are more interested in literature and movies, etc. I call these people Type I and "egg." Although some may be not vocal of their female preferences, for many, it is usually Asian. They must figure that to make their package of knowledge complete, they need to have the Asian woman. I haven't seen this kind of behavior in women, although it's probably out there.

Working in the video game industry, I've been exposed to hoards of people who are into Japanese video games, animation, and magazines. Some of them have a fetish for Asian women who have the look of some of the characters. In actuality, any Asian will suffice since many think that most Asian woman can have the anime look, although Japanese

media-influenced view of beauty. Sometimes I think people have lower standards when they date outside of their race, like it's a status thing to have a white partner. I know with some of my relatives, they seem to find practically anybody who is white attractive and I just think, "Huh?" Because I see them being much more critical of "our relatives" (I mean this in the sense of our mutual ethnic background).

Granted, people fall for people for many different reasons, but it seems like some attributes, depending on who has them, are seen as admirable while on others they are deplorable. And, I often see a lot of people picking only a certain race to date and falsely placing "negative" stereotypes on Asians, etc. while falsely placing "positive" stereotypes on others. Prime random examples of given stereotypes: smart, emotionally distant, more passionate, more intuitive, more virile, more subservient, more shy, more aggressive, boring, interesting, blah blah blah. While at times you may see certain characteristics as being apparent in certain groups of people, usually "grouping" is created by a preconceived notion and not a reflection of the actual person being judged. I know we all have preconceived notions, but I think we end up limiting ourselves if we generalize a whole race of people, because for every rule there are many exceptions.

So what is my point? Do I need a point? I just wanted to spread awareness of what I observe. While it seems like I'm talking about mismatches that are only physical, naturally I'm referring to loser/winner combinations since beauty is in the eye of the beholder. My words for women who start feeling desperate is: Don't believe the hype! That's a man-made invention used to fuel the dating industry (ads, dating services) and to perpetuate the patriarchy in full force around the world. For you guys out there, please note that most women are not attracted to a guy who reeks of desperation. And for everybody: beauty and beast often come in the some package, so watch out... 🐱

LYNN: *This commentary (rant?) was inspired by all of the oddly-matched couples out there, but the disparity seemed particularly glaring with Asian/white couples. Attending UCLA, since there are so many Asian students, it was rudely coined "University of Caucasians Lost Among Asians." People have a hard time guessing my background, even other Filipinos, so I've had to hear the "I've always wanted to meet a beautiful Chinese, Japanese, Hawaiian, etc." girl, which was a further reminder that it was never about who I was as a human being, just that I was a stand-in for whatever fetish they might have had. A lot of the thoughts I've expressed way back then are still with me today.*

seems to be at the top. The look includes the schoolgirl style including the outfit, the Dirty Pair look, and the basic big eye look which is part of all the anime females. This is Type II of Yellow Fever. One white male I have spoken with says the best thing about Japan is the girls. He boasts he met a bunch of 14-year-olds and even got Sailor Moon outfits for him and his girlfriend. This may be an extreme, but this behavior exists.

But **what I don't understand is why I don't see mouth-foaming Asian-scoping anime freaks who are also Asian.** On the flip side, I don't see white females chasing after Asian anime-looking males. Perhaps it's because Asian males aren't in the comics enough. Perhaps guys like *Robotech*'s Rick Hunter or *Street Fighter*'s Ryu don't turn people on while *Robotech*'s Minmei is an anime fantasizer's dream. However, I have heard reports of Yellow Fever in France after the film *The Lover* was shown.

Some old white males also have Yellow Fever thinking they know about Asian culture while telling Asian and Asian American people that they know more about how "we" Asians should act and think. This is Type III. In the film *Rising Sun*, Sean Connery's character was probably a Type I in his youth and then became a Type III in his older age. A lot of these old perverts want only Asian women because of their "cuteness, subservience, and quietness," while some want the Connie Chung exotic, wild-jungle bush woman. One friend told me that an old white man told her that in the world, there are only four good types of women. These are South American, Australian, Canadian, and Oriental! Explaining about old closed-minded perverts is a waste of time, but I hope you've seen what I've seen and know what I am talking about. Undoubtedly, there are more versions and types of Yellow Fever that I have never seen but this is page one in my new medical journal. 🐱

White Guys that

words | Margaret Cho

White guys that like Asian girls. I know so many. They are nice guys. They are also jerks. They can be fun. They can be a real drag. There are many different kinds. They are my friends. They are my, gulp, lovers. They are and have always been a big part of my life. Sometimes they say funny things like, "Korean girls are pretty, the Chinese have the best legs, Japanese girls are romantic, and Filipinas know how to have fun." What a strange mantra!

I'VE NOTICED A FEW THINGS ABOUT WHITE GUYS THAT LIKE ASIAN GIRLS.

A. They almost always have more than a passing interest in photography.

B. They usually have spent time in Asia during their formative years; many have spent a year abroad studying at an Asian university.

C. They are usually way more Asian than me!

A CULINARY EXPERIENCE

This one white guy who likes Asian girls took me to a restaurant that was so Asian I didn't like it. It was one of those places where you can cook your own food at the table in a big pot of boiling water. It was not just any Asian restaurant, it was super Asian. No English on the menu, and there was a big buffet where you get the raw food that you can cook yourself, and things like rice and soda. They kept the squid next to the chocolate cake. Not to say that I mind when things are really Asian. It's cool, I'm just not that used to it. And **it surprised me that he took me there. And he liked the place so much! I was taken aback by that. Is that racist of me?** I mean, he wasn't taking me to impress me. He goes there a lot. He really liked it, and he wanted to share that with me. And it wasn't like he was saying, "Oh little Lotus Flower, so lonesome for your homeland, I will take you to a place where you can eat the food of your people." It wasn't like that at all. He was a white guy who liked Asian girls and knew how to cook his own tripe.

BRAVE AND WHITE

I think that white guys that like Asian girls are really brave. Not as brave as say, white guys that like Black girls, but still pretty brave. I think we can be an incredibly intimidating group sometimes. One guy told me that he went with this girl to Chinatown late at night. They went to this nightclub that was exclusively for Asians, and when he walked in with her everything stopped and turned hostile as all the people in the club were going, "What's he doing here!" He stepped backward onto the street corner, smiling and sweating just like anyone would, and this girl tried to get him to go back in. She was pulling his arm and her purse fell on the ground and when he went to pick it up for her, her gun fell out! White guys that like Asian girls have to be brave because we can be very dangerous. Growl!

THEY ARE SO GOOD

I don't want you to think that I only date white guys. There are many Asian girls that only date white guys, and I think that is weird. Asian guys are so hot. And personally, I like all kinds of guys. They are all so good, how could you pick just one! I tend to be pursued most by white guys that like Asian girls. I think they see in me this wonderful mix of the face of what they want and the spirit of something else entirely. Sometimes, they can't deal with me. They get mad and run away. But mostly they are pretty good sports. When I was growing up, my family would have huge gatherings, and there would always be tons and tons of Asians, and the one white boyfriend walking around, trying to make conversation: "Hey, jellyfish. Just like Mom used to make." And everybody is ignoring him.

ANDREW McCARTHY IS YELLOW HUNGRY

I think Andrew McCarthy is the ultimate white guy that likes Asian girls. I don't know anything about his personal life, and I am not basing this on the fact that he played Rosalind Chao's husband in *The Joy Luck Club*. (However, casting him was a brilliant decision!) I was in a political science class in high school covering the McCarthy Era. This Asian girl sitting next to me wrote "Andrew McCarthyism" on the top of her paper. I thought that was quite profound. **Andrew McCarthy is everything Asian girls like about white guys. Quietly handsome, not overly masculine, sweaty-palmed, neatly dressed in blues and grays, and when we want, really good at looking bewildered.**

THE SUMMATION

When I do stand-up, the audience is always filled with couples, white guys with Asian girls. It seems to be the

ERIC: It's weird how this continued to be an issue that spanned from when I was in college, to post-college,

like Asian Girls

Yellow Fever Symptoms

words | Lynn Padilla

1. You were a member of the Chinese, Japanese, Filipino, Vietnamese, Korean (etc.) Student Unions, or all of them, but you are none of the above.

2. You only date Asians, and all of your ex-mates are Asian, too.

3. If alone with a person of Asian descent and you know any words in "their" language, you feel compelled to show your knowledge—or lack thereof.

4. You've decorated your home as an "Oriental Love Den" complete with futon, lacquer, red lanterns, scrolls, lazy susans, Hong Kong movie posters, and Asian calendars.

5. You have a lot of toys in your car, and/or have stuffed toys on the shelf space behind the back seat of your car because your friends do that.

6. You go to every Hong Kong (and other Asian cinema) film at least three times each. You even buy them when you can, whether or not they are subtitled or dubbed.

7. If you're a straight guy, you believe Asian women are just "more understanding and sympathetic to your needs."

8. You have your own Asiaphile web page.

9. You are reading this list and see yourself.

10. You probably give me the creeps and don't know it!

hot ticket for them. I think that is really nice. I am not at all making fun of this pairing. It is part of who I am. Asian guys tell me that it is hard for them because there aren't enough of us to go around. But you can't get mad at white guys for that. Or us even. My point is, I guess, **any kind of love is fine. It's your hate that you have to watch.**

An anime girl full-body pillow may get added to Lynn Padilla's list of Yellow Fever Symptoms. But on average, are people less sensitive today? Do people care anymore and has being hapa taken over with no end in sight? I'm honored by her trust. for her opinions and for that I'm honored by her trust. Robot magazine as a forum for her opinions and for that I'm honored by her trust.

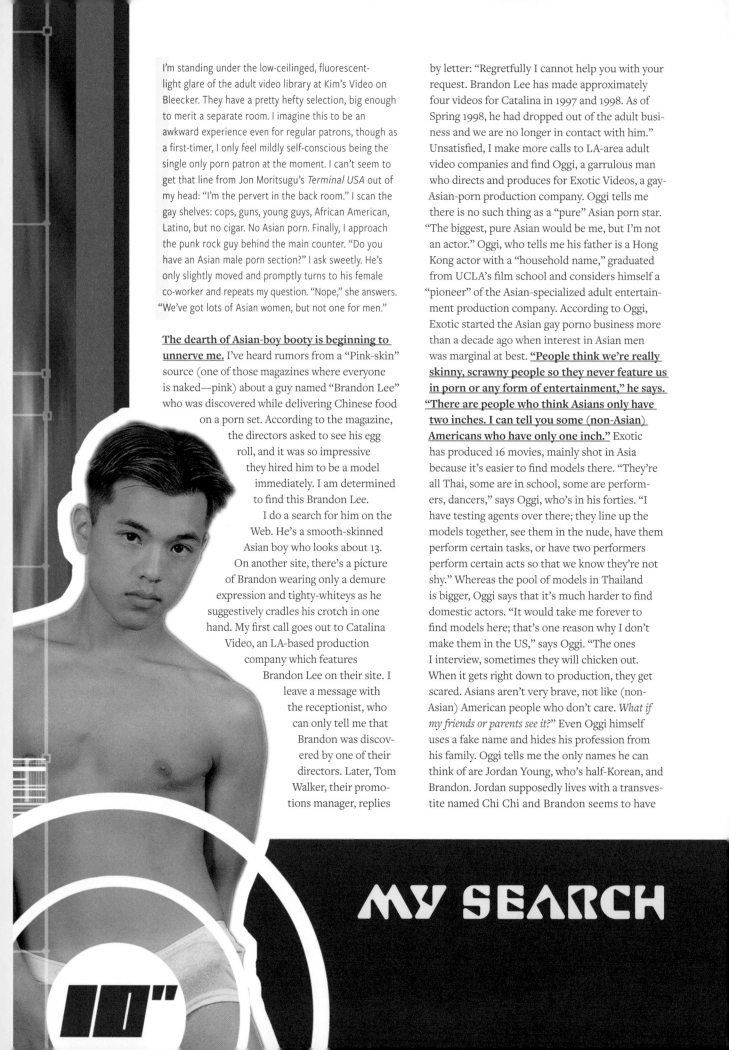

I'm standing under the low-ceilinged, fluorescent-light glare of the adult video library at Kim's Video on Bleecker. They have a pretty hefty selection, big enough to merit a separate room. I imagine this to be an awkward experience even for regular patrons, though as a first-timer, I only feel mildly self-conscious being the single only porn patron at the moment. I can't seem to get that line from Jon Moritsugu's *Terminal USA* out of my head: "I'm the pervert in the back room." I scan the gay shelves: cops, guns, young guys, African American, Latino, but no cigar. No Asian porn. Finally, I approach the punk rock guy behind the main counter. "Do you have an Asian male porn section?" I ask sweetly. He's only slightly moved and promptly turns to his female co-worker and repeats my question. "Nope," she answers. "We've got lots of Asian women, but not one for men."

The dearth of Asian-boy booty is beginning to unnerve me. I've heard rumors from a "Pink-skin" source (one of those magazines where everyone is naked—pink) about a guy named "Brandon Lee" who was discovered while delivering Chinese food on a porn set. According to the magazine, the directors asked to see his egg roll, and it was so impressive they hired him to be a model immediately. I am determined to find this Brandon Lee.

I do a search for him on the Web. He's a smooth-skinned Asian boy who looks about 13. On another site, there's a picture of Brandon wearing only a demure expression and tighty-whiteys as he suggestively cradles his crotch in one hand. My first call goes out to Catalina Video, an LA-based production company which features Brandon Lee on their site. I leave a message with the receptionist, who can only tell me that Brandon was discovered by one of their directors. Later, Tom Walker, their promotions manager, replies

by letter: "Regretfully I cannot help you with your request. Brandon Lee has made approximately four videos for Catalina in 1997 and 1998. As of Spring 1998, he had dropped out of the adult business and we are no longer in contact with him." Unsatisfied, I make more calls to LA-area adult video companies and find Oggi, a garrulous man who directs and produces for Exotic Videos, a gay-Asian-porn production company. Oggi tells me there is no such thing as a "pure" Asian porn star. "The biggest, pure Asian would be me, but I'm not an actor." Oggi, who tells me his father is a Hong Kong actor with a "household name," graduated from UCLA's film school and considers himself a "pioneer" of the Asian-specialized adult entertainment production company. According to Oggi, Exotic started the Asian gay porno business more than a decade ago when interest in Asian men was marginal at best. **"People think we're really skinny, scrawny people so they never feature us in porn or any form of entertainment," he says. "There are people who think Asians only have two inches. I can tell you some (non-Asian) Americans who have only one inch."** Exotic has produced 16 movies, mainly shot in Asia because it's easier to find models there. "They're all Thai, some are in school, some are performers, dancers," says Oggi, who's in his forties. "I have testing agents over there; they line up the models together, see them in the nude, have them perform certain tasks, or have two performers perform certain acts so that we know they're not shy." Whereas the pool of models in Thailand is bigger, Oggi says that it's much harder to find domestic actors. "It would take me forever to find models here; that's one reason why I don't make them in the US," says Oggi. "The ones I interview, sometimes they will chicken out. When it gets right down to production, they get scared. Asians aren't very brave, not like (non-Asian) American people who don't care. *What if my friends or parents see it?*" Even Oggi himself uses a fake name and hides his profession from his family. Oggi tells me the only names he can think of are Jordan Young, who's half-Korean, and Brandon. Jordan supposedly lives with a transvestite named Chi Chi and Brandon seems to have

MY SEARCH

disappeared. "I want to work with Brandon, but someone said he moved to Florida," Oggi tells me. "I would imagine some wealthy man hooked up with him and wanted to be his boyfriend and asked him to live with him in Florida."

In a quest to locate Jordan Young, I find Chi Chi LaRue. Chi Chi, as it turns out, is one of the biggest names in Hollywood's gay porn industry. He calls me from San Francisco—he no longer rooms with Jordan, who has closed off all contact and refuses to discuss his involvement with the industry. So I ask Chi Chi if he knows of any Asian male porn stars. "It's a question of what's a star?" says the veteran drag queen/porn director and producer. "In my mind, anyone who fucks or sucks on camera is a star."

"The popularity of Asian men is a given," he continues. "Whenever I use a white lead, they prefer someone that's a little softer, like a cute, nice Asian man. But it's still an untapped market in the adult industry."

In another fortunate twist of events, Chi Chi reveals that it was actually he who discovered Brandon at a Los Angeles bathhouse a few years ago. **"He was just a patron playing around. I was like, 'That Asian man over there is fabulous, gorgeous. He's got a huge dick.' So I brought him to Catalina Video and they signed him to a contract."** Brandon was only 18 when he got into the business. He's 20 or 21 now. He also wasn't in school, had a regular job, a steady boyfriend, and according to Chi Chi, was packing a 10-incher. Studies reveal that only one in every 10,000 men wield that much. Although Chi Chi didn't make any films with Brandon at first, he eventually directed him in the 72-minute hump-de-force, *Fortune Nookie*. "Brandon Lee was very popular because he was very good-looking and a fierce top. He could fuck really good," Chi Chi says.

I call Catalina again so I can watch young Brandon in action, and this time, I get Tom Walker on the phone. I ask him why there aren't more Asian leads. "Maybe because it is so new to them, some of these actors are scared and didn't want to do it again," offers Tom. "[Brandon] was disillusioned and very young. It looks fun, but he decided it wasn't for him. That happens with a lot of the guys. It's really not a wise career choice. There's the reality of growing older and your looks going." Chi Chi agrees: "I always say: Don't quit your job to be a porn star, that money goes quickly."

"Now it's very hard to find Asian models," Chi Chi says. "They're very private. I think maybe they're worried, maybe their culture doesn't condone this kind of thing, maybe Asian guilt, like Catholic guilt. That's why they'll come and do one or two films and they'll disappear."

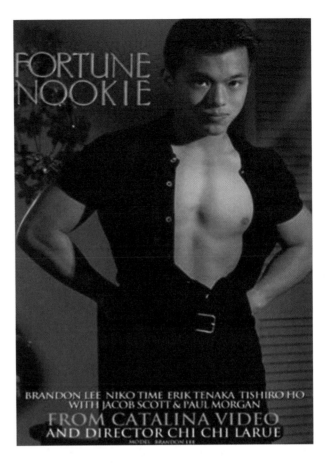

BRANDON LEE NIKO TIME ERIK TENAKA TISHIRO HO
WITH JACOB SCOTT & PAUL MORGAN
FROM CATALINA VIDEO
AND DIRECTOR CHI CHI LARUE
MODEL BRANDON LEE

WHAT REALLY HAPPENED TO BRANDON LEE?

Brandon actually made seven movies for Catalina Videos during his short-lived career, from 1997 to 1998: *Asian Persuasion I* and *II*, *Harley's Crew*, *Big Guns II*, *Fortune Nookie*, *Throat Spankers*, and *Dial S for Sex*. In his debut in *Asian Persuasion*, your typical wham-bam-and-slam video, Brandon plays a charming yet philandering real estate agent. Brandon is no bear (big, overweight, hairy man). **He reminds me of my first college crush: a Chinese American pretty boy with a penchant for The Smiths, bleached hair, and as I learned later to my dismay, other boys.** In Chi Chi's film, *Fortune Nookie*, Brandon is manipulated by a shady lawyer into giving sexual services for litigation fees. But Brandon blows the notion of the submissive Asian out of the water. He never takes it in the ass, let alone in his face. He's a top through and through. So what really happened to the 10-inch egg roll? Drug addiction? Prostitution? Downward spiral? "Brandon's happy," says Chi Chi. "He's in a nice, happy relationship and they live in Miami. It's funny how people think they quit the business because they found a rich sugar daddy, but it's not true."

FOR BRANDON LEE

words | Claudine Ko

STEVEN DRE
Bust A Move
YOUNG MC
Box ♫ 2 ♫ Mr. Pibb

COLUMBENE JENNER
In the Year 2525
ZAGER & EVANS
Box ♫ 1–2 ♫ Pocky and Wigs

LILLIAN LAI
Top of the World
THE CARPENTERS
Box ♫ 3–4 ♫
Hot Krispy Kreme Donuts

ANGELYN WONG
We Belong
PAT BENATAR
Box ♫ 1–2 ♫ Hi-Chews

AUDREY EDNALINA
That Thing
LAURYN HILL
Home ♫ 2 ♫ Lumpia

BILL POON
Killing Me Softly
ROBERTA FLACK
Box ♫ Random ♫
Duck with Rice

LEONARD NG
Three Times A Lady
THE COMMODORES
Home ♫ 1 ♫ Prayer

TRANG LAI
Anything Goes
COLE PORTER
Box ♫ 2 ♫ Dried Fruit

AUDREY "KAIA" LEE
Close To You
THE CARPENTERS
Box ♫ 1 ♫ Granola

YVONNE NG
You're So Vain
CARLY SIMON
Box ♫ 1–3 ♫ Standing Up

WEI HUNG*
I Don't Want to Wait
P. COLE
Bar ♫ 3–4 ♫ Moutai & A fat blunt

CINDY WONG
Bridge Over Troubled Water
SIMON & GARFUNKEL
Home ♫ A lot ♫ Coca-Cola

BILLY SHIN
Mack the Knife
FRANK SINATRA
Box ♫ 2 ♫ Beer

VIV CHIA
Superwoman
FAYE WONG
Box ♫ 5 ♫
Oolong Tea & Marlboro Lts.

TED LAI
My Way
FRANK SINATRA
Box ♫ 2 ♫ Bottled water

TONY LEE
Summer Wind
FRANK SINATRA
Bar ♫ 2 ♫ Sake and Beer

MASAKI MIYAGAWA
Our House
MADNESS
Box ♫ 1 ♫ Gin and Juice

MICHELLE LEONG
Hotel California
THE EAGLES
Box ♫ 1 ♫ Nestlé Crunch

MIKE LOCKE
Sweet Child O' Mine
GUNS N' ROSES
Home ♫ 17.3 ♫ Sour Patch Kids

KELLY O' SULLIVAN
Thank God I'm a Country Boy
JOHN DENVER
Box ♫ 1–5 ♫ Velvet Finger Rolls

DAVID MOSS
My Way
FRANK SINATRA
Box ♫ 1 ♫ Roscoe's
Chicken & Waffles

SILAS LAW
Girl From Ipanema
A. GILBERTO
Bar ♫ 2 ♫ Midori Sour

JOSEPH BARIBEAU
Ring of Fire
JOHNNY CASH
Bar ♫ 1–2 ♫ Jägermeister

WING HO
My Heart Will Go On
CELINE DION
Box ♫ 1–2 ♫ Oolong Tea

KAH-RAH-

TIFFANY NG
I Swear
BOYZ II MEN

Home ♫ 2 ♫ Lychee Jelly Cup

MICHELLE CABALU
Secret Lovers
ATLANTIC STARR

Box ♫ 1 ♫ Lemon Soju
& Banana Chips

CATHY YOO
Shake Your Love
DEBBIE GIBSON

Box ♫ 8 ♫ Pokka Iced Tea

RICHARD CHIA
Spice Up Your Life
SPICE GIRLS

Box ♫ 1 ♫ Spice

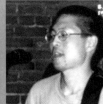

SOO YOUNG PARK
My Sharona
THE KNACK

Box ♫ 1 ♫ Beer

LUONG QUANG
I'll Be There
JACKSON 5

Box ♫ 1 ♫ None

GREG WONG
Faith
GEORGE MICHAEL

Box ♫ 1-3 ♫ Cracked Seed

MONTI LAWRENCE
Wannabe
SPICE GIRLS

Bar ♫ 2 ♫ Beer

JEE HYUN LEE
My Favorite Things
JULIE ANDREWS

Box ♫ As Much as Possible ♫
Camel Lts.

CHANTAL ACOSTA
Lucky Star
MADONNA

Box ♫ 4 ♫ Tambourine

JANE HSEU
Vacation
THE GO-GO'S

Box ♫ 1 ♫ Hi-Chews

HEIDI EYSENBACH
Stop Dragging My Heart Around
TOM PETTY & STEVIE NICKS

Box ♫ 4 ♫ Massive head trauma

KAREN SEARGEANT
Black Magic Woman
SANTANA

Box ♫ 1 ♫ Sake

KENT LIM
True Love
FUMIYA FUJII

Box ♫ 1-2 ♫ Two Asahis

PETE LEE
I'll Be Loving You Forever
NKOTB

Box ♫ 1-2 ♫ Altoids

JENNY HSIEH
Strangers in the Night
FRANK SINATRA

Box ♫ 1 ♫
Lemon Tea with Honey

PERRY RIVERA
New Rose
THE DAMNED

Bar ♫ Not Often ♫ Alcohol

SUSAN HSIEH
My Girl
THE TEMPTATIONS

Box ♫ 3-4 ♫ None

KENNETH WONG
What A Wonderful World
LOUIS ARMSTRONG

Box ♫ 1 ♫ Moi

TWIGGIE TORRES
No More Tears (Enough is Enough)
BARBARA STREISAND *(feat. Donna Summers)*

Bar ♫ 4 ♫ Mickey's Malt Liquor

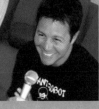

EDDIE RAYDEN
Stop Dragging My Heart Around
TOM PETTY & STEVIE NICKS

Bar ♫ 2 ♫ Margarita

PETER ZASLOV
Stay (Faraway, So Close!)
U2

Box ♫ 1 ♫ Lemon Soju

DAG YNGVESSON
Rapper's Delight
S. H. GANG

Bar ♫ 1-2 ♫ Red Wine

CHUN LEE
Sweetie
TERESA TENG

Home ♫ Once in a while ♫
Jasmine Tea

CLAUDINE KO
Take On Me
A-HA

Bar ♫ 6 ♫ Maker's

Somehow, it became this thing—a disease afflicting the suburban homes of Asian families across America, pervading block upon block like spores flying through the air. My parents got it on a trip to Taiwan back in the late '80s, when I was still in high school. Afterward, when it got bad, my sisters and I would stay locked in our rooms, refusing to go downstairs, giving each other meaningful glances when we passed on our way to the bathroom. I remember the first time my friends found out. I was being dropped off after a night out, and all I had to do was open the car door. It immediately permeated the vehicle's interior like a mysterious fog, while bouncing between the street lamps and mailboxes with an eerie echo-effect: "Tie a yellow ribbon 'round the old oak treeeeeee." **"What the hell is that?" my friends asked. "It's my parents," I answered shamefully. "They're singing karaoke."**

In 1971, Daisuke Inoue, a 30-something Japanese musician, invented the first karaoke machine. He played the electone, an electric organ, while club patrons sang along. One night, he was invited to play at a regular customer's party, but instead of going, he sent a recorded eight-track accompaniment. After that, he started Crescent, a company that specialized in renting out the tapes and echo-speakers. He did not patent his invention. Five years later, a car-audio company called Clarion first coined the machines as "karaoke" (from the music industry term meaning "empty orchestra"), and began commercially distributing their "Karaoke-8" machine. Clarion's early karaoke sales increased 60-fold after only a few months.

It's not just my parents and their friends who do it anymore. Since other Japanese electronic companies co-opted the idea, and recently deceased country singer Boxcar Willie (supposedly) brought the machines to the US in 1984, karaoke fever has become a multi-billion dollar industry, spreading through China, Taiwan, Korea, Southeast Asia, Europe, and North America. Today, "karaoke" is an official word in English dictionaries. In Japan, it's transcended the banal setting of bars or homes to include hospitals, bowling alleys, taxis, and buses. It's been the focus of panels held during academic conferences on popular music. It's even the root of violent crime. (In November 1993, a Toronto man was shot to death after insulting another singer at a Vietnamese karaoke bar.) Meanwhile, **the 59-year-old Inoue was last heard to be running a company that makes cockroach traps.**

After I left home and moved to Berkeley, I had some friends who introduced me to Korean karaoke, or noraebang. We'd go to this place at the border of Oakland and Berkeley on Telegraph Ave.

Noraebang, which is based on the railroad-car-converted karaoke rooms, or "K-boxes," first used roughly 15 years ago in the rice fields outside of the Okayama Prefecture, is less frightening than cheesy open-mic karaoke nights at bars or restaurants. Around 1985 in Japan, K-boxes were only big enough to fit a few people at most and were conducive to sketchy activity. Later, the boxes were reconstructed to fit larger groups, as to allow more families and fewer miscreants. At noraebangs and K-boxes today, you basically rent a private, mostly soundproof room which comes equipped with a TV screen, a couple of microphones, and a menu of thousands of song titles to satiate any karaoke fanatic's appetite. Usually at the end of your song, the machine's computer will "score" your singing ability on a scale of 1 to 100 by digitally comparing your voice to the guide voice tracked onto the disc. But according to a technical support guy at Pioneer, if you're really talented, say like Barbra Streisand, you might score poorly because you actually sing better than the person on the disc.

Still, karaoke isn't a regular event for me, childhood trauma and all. In fact, it was, is, and always will be an unnerving experience. As I'm sure most karaoke-shy people feel, it brings out an inferiority complex in me quicker than an over-demanding, first-generation Chinese mother.

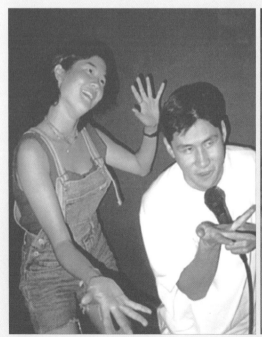
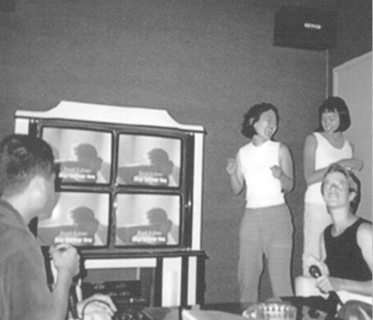

Unfortunately, I can't seem to avoid it. Every time I visit LA, my friends and I inevitably end up stopping off at this club on Sixth St. in Koreatown. We get a table, down glasses of not-so-cheap domestic beer and Korean soju until we're drunk as ice tea on a hot summer's day, fearless as gods. Then it's off to one of the nearby noraebangs for surprisingly-impressive-yet-amateurish renditions of '80s tracks by artists like Prince, Chris Isaak, and U2. I enjoy listening; my friend Wes does a killer "Purple Rain." But then there's the inevitable, "Come on, Claudine, pick a song." I'd like to politely tell them to fuck off, but I don't. As a basic rule of karaoke etiquette, it's worse to make a big deal over singing than squeaking out an off-key version of Bette Midler's "The Rose." (That's supposedly one of the easiest songs to sing.)

My parents have since graduated from the lyric-sheet addled, old-fashioned karaoke tapes to the low-grade video karaoke system: unwieldy VHS copies of songs where the words are highlighted on cue against a background of, most times, a completely unrelated video storyline. However, my mother's hot to get the latest top-of-the-line Pioneer DVD Karaoke system. More dazzling than last season's video compact discs, it's got digital echo, multi-language functions, DTS, a voice scoring system, and is fully CD-compatible: a doozy of a player. However, even with insider knowledge of Asian markets that sell karaoke machines at prices cheaper than your average American karaoke specialty store, the DVD is pretty expensive at a little over a grand. Luckily, I am pretty much no longer affected by any of this. After moving to New York, the only times I encounter karaoke is when I fly back to California to visit my parents and friends. Then I started going to Junno's.

Three a.m. on a Saturday night, I'm sitting alone at Junno's sky blue bar on Downing St. in the West Village, with my Maker's on the rocks like a sad alcoholic. The haphazardly planned karaoke session is on tonight, and Clem, the Elvis-Costello-glasses-wearing bartender, is at the mic singing Tom Petty's "Here Comes My Girl." A guy I know, Michael, comes up to chat with me and before I know it, I realize I've found one of the many hard-core karaoke lovers who hangs here. (Later, I even meet a guy who acted in a karaoke video in the late '80s!) Soon after, Michael steps up to the impromptu karaoke setup with his hands shoved in his pant pockets. As the music comes on, he clears his throat, lifts his hand, and pulls the mic closer to him. He hams it up for a sultry rendition of Glen Campbell's "Rhinestone Cowboy." Women swoon. "He wasn't this good in 1991–92," his friend Bruce observes.

A little past 4 a.m., the chairs are stacked up on the tables and I am happily buzzed; liquor and karaoke are relatively synonymous. Junno and his friends (his brother Jae, co-owner Jean, waitress Devon, and Michael) are leaving for the night when they decide to hit Village Karaoke, a K-box-style singing place on Bowery. "They have a thousand more songs than we do," he explains. I agree to go along because I have nothing better to do than wait for the next subway train to come.

As we drive across town, I am already adamant about not singing. But it begins again before we even get there. "You going to sing?" Junno asks. "No, I'm strictly observing tonight," I reply. Yet somehow, in between Jae's 86-scoring "With or Without You" and Jean's decidedly professional "Summertime," I acquiesce to Junno's threats of not letting me leave the room without a performance.

I punch in a song inspired by friends from the LA noraebang set, and mentally prepare myself for the opening line, my palms sweating, my midsection tingly. **"If I'm going to fuck this up, I'm going to fuck this shit up," I tell them as I suck it up and climb onto the vinyl-cushioned couch.** The beat starts rocking and I plunge into A-ha's "Take On Me." There are some points when I think I'm hitting the notes right, but I lend that to the late hour and the amount of alcohol still running around my innards.

When we leave and emerge into the outside world, I feel as if I've been transported to a new realm. It's light outside, and I feel vaguely high. Oh, don't get me wrong: there's no epiphany here, no moments of ecstasy as some karaoke partakers seem to feel. I still hate it and feel like an ass; it's just been a long time since I've pulled an all-nighter. 🐾

SUMIE OSAWA
Amazing Grace
ELVIS
Bar ♫ 6 ♫ Maker's

MARGARET CHO

I think I wanted *Giant Robot* to exist for my entire life. Maybe because I was constantly looking for proof of my own existence. Growing up Asian American in the '70s, you never were quite sure you were really there. I was practically raised by the TV—since my grandparents hadn't emigrated yet to provide my family with child care and my parents couldn't exactly afford a babysitter, the television was my portal to the whole world and the constant companion to my latchkey life. And in that wood-covered box, which back then our electronics were housed in wood—there were no Asians ever! Every once in a very long while, maybe one like Arnold from *Happy Days* or in the background on *M*A*S*H*, but they were the rarest of the rare. My family eventually purchased a wood-covered VCR and weekends would be spent savoring every second of a Bruce Lee film, the videocassette played so many times that the media would begin to wear down, revealing faint tracking marks on the screen, sharp little love bites in the movie, which would show where

the tape was stopped and rewound so the scene could be replayed as if to say—"Did I just see that?," "Was that real?," "Am I real?"

That was all we had. Then later in the '80s and '90s, Hong Kong cinema took hold, and a whole Asia of possibility came into view. Now you had John Woo and Chow Yun-fat, Brigitte Lin and Leslie Cheung, the sweeping historical epics and villains who made char siu bao out of their victims.

Then finally, *Giant Robot*. Here was a place we could talk about ourselves. Where we saw ourselves. Where we needed to see ourselves. Where we were frustrated by seeing ourselves. Where we wanted to see ourselves. We could wax-on-wax-off poetically about all the things we loved about who we were. We were Asians. We were in America. We were coming into view. We were. And we still are.

I thought I would never become one of those old people who would say, "Kids today just wouldn't understand..." but of course, that is what I became. But you really wouldn't understand how little we as Asian

Americans existed on the plane of media and entertainment. We just were not there at all. Nowadays, we have much more representation, but it is still very new to me. I keep thinking it will be gone and we will disappear and it will feel like we are invisible again. Asian American leading actors, love stories, superheroes, villains, comedians, clowns, good, bad, and ugly, and beautiful, and everything in between are appearing on our screens and I couldn't be more thrilled and grateful. *Giant Robot* is part of the creation of that. *Giant Robot* is the first publication that stood to appreciate what we could accomplish with the limited scope of what we had. Through *Giant Robot* we showed love for these movies, these actors, these monsters, these rock stars, these icons, these foods, these toys, these heroes. We learned how to glorify ourselves, and through that, we learned how to be here. 🦇

Margaret Cho is a jack of all trades, master of many. A seasoned writer and performer best known for her comedy, she is also an advocate, entrepreneur, and artist.

NUMBER ONE

John Woo came to America, saw an industry in need of adrenaline, and conquered its flaccid ass. How is he repaid? Now all the Hong Kong movie fans are too cool for him. Not me. His movies starring Chow Yun-fat are some of the greatest of all time. *Bullet in the Head*, too. So I was amped when I got to meet the master director, who wound up being a cool guy, too. He went off on every question, hung out way longer than the time allotted by the studio, signed autographs, and, after flipping through *Giant Robot #4*, said, "I used to do this when I was your age! I used to write poetry in the '60s. I was a hippie!" Even if he thinks *Giant Robot* is a hippie mag, it was a massive compliment to be compared to the God of Gangster Movies.

Did you see Jacky Cheung [the pop star who co-starred in Woo's* Bullet in the Head] *sing at the Shrine last month?
JOHN WOO: I was shooting *Broken Arrow* in Arizona.

Are you going to see Sally Yeh [the singer who was featured in Woo's* The Killer] *in Las Vegas next week?
No. I've got to work.

How do you stay so motivated when everyone else is copping your style?
Every new movie is a challenge. I always try to do something new or discover something about human beings. I find out something about myself as well. I never look back. When I'm done with a movie, I put it on the side. I don't watch it again and again. I don't even watch them. Sometimes, the fans or critics remember more than I do. They'll say, "In this movie there's this line..." I go, "Oh yeah?" For every movie I make, it's like I'm climbing a mountain. I never look back. If I look back, I'll fall.

Then what was it like to go back and add comments on* The Killer *and* Hard Boiled *for the deluxe Criterion laser disks?
It seemed to me like I was watching

another movie. It was very strange. After a long time, I think, "That shot's great. Who did that? That music's very touching." Even though it's my own movie, I feel like it's someone else's.

Do you enjoy making movies in the United States?
I feel great working here because people really respect the film business. Whenever we shot on location, we always could get any kind of support from the neighbors and the government. We can block several streets to shoot a scene. That is a dream in a Hong Kong film. In Hong Kong, the government only cares about the tax. They hardly gave any support for the film people. In most of the Hong Kong films, they will hardly even shoot a scene on the street. Wherever they set a camera on a street, if the police get any complaints from the neighborhood—especially from a foreigner—they will turn you away or arrest you. We were not robbing, but they made us feel ashamed. Whenever we saw a police come, we'd play cat-and-mouse, carrying everything into a quiet, dark corner to keep shooting. They don't even have a Hong Kong film library. Very disorganized. I was quite disappointed in them.

But my favorite movies are from Hong Kong!
In the meantime, I was so proud of Hong Kong film. I was so proud to be a Hong Kong filmmaker because all the time, we feel like we are orphans. We survive by ourselves. We struggle and we make all the good stuff by hand, and not with support from the government.

What's worse: working with the film industry in Hollywood, or Triads in Hong Kong?
In Hollywood, it's not that awful. There wasn't that much interference with *Broken Arrow*. Only some people

make things harder. In Hong Kong, I never got involved with Triads. Of course, some Triad companies do pretty bad things for film companies. I hate to see those kinds of unprofessional people make Hong Kong films worse. All my lifetime, I've just made my own movies, so I don't know how to feel about those situations.

Now that you live in Los Angeles, do you spend more time in Hollywood or in Chinatown?
I stay home! I'm not good at social things. I'm not interested in going to parties and meeting people. I'd rather stay home with family. I'm shy and I know myself very well: I usually look stupid in a social party. I'm not good at that. But I have so many Asian friends, we meet sometimes and go out.

Do you go out to see movies?
Actually, I don't watch that many movies. When I start from script until the movie's finished, I never go to movies. I don't want to get interference or influence from other movies. Sometimes when you see a movie that you love, you memorize it—a shot, a scene, a moment you like. Unconsciously, you use a similar shot or movement and don't even know it. I want everything to be original. Even though some of the scenes or shots are influenced by the masters, usually I do it in a tribute sort of way. I love them, so I show my admiration. When I'm at work, I don't want to see any movies or tapes.

What are some differences between Hollywood and Hong Kong movies?
Hong Kong movies are much simpler. We have more freedom. That's why our movies have so much energy. When we are shooting, there are no games. We don't have many meetings. We only have one meeting with the studio or financial company. We let them know the story, the cast, and the

🐱 **MARTIN:** I was so into Hong Kong movies that I would go see HK movie stars in concert even though

budget—it's very simple. Then we're on our own. We are fully in control of the movie. I really can do what I feel.

How do you cram Hong Kong energy into American movies?

I think the pacing of the movie and the camera movement keep the energy of a Hong Kong film. American films are usually made in a simple way; the camera is pretty static. For *Broken Arrow*, even though we had a tight schedule, I still tried in many ways to use a lot of great camera movement. That camera work really can make the whole movie feel full of energy.

For Broken Arrow, did you have the same camera crew that you used for Hard Target?

We had the same crew as in *Hard Target*. We have a lot of "family touch." We care for each other, we respect each other, and we admire each other. Most of the people are educated in film. They went to film school or have a lot of experience. While we are working, I have no worries.

Does Christian Slater really watch your movies like his character did in True Romance?

He watches my movies. John Travolta, as well. When we worked together, we felt like a big family. We all loved the characters. They all believed I could make them look good.

Did they do their own stunts, Hong Kong style?

They did over 75 percent of the stunts themselves. Christian Slater liked challenges. For every stunt, he asked, demanded, to do it himself first. If he could do it, he'd go for it, even though there was a stunt double. A lot of us were worried about him getting hurt. He didn't. John Travolta had a fistfight scene and boxed in the final scene. He did it all with no complaints. He's not a professional boxer,

but he kept practicing and training every day. He looked like a boxer.

Were you pleased by the actors' performances?

Yes. I gave Travolta and Slater a lot of freedom. Before we started, we had great communication about the characters and what they were going to do. For every scene, if they had a great idea, I'd change dialogue. If they don't feel comfortable with lines, I'd let them do whatever they wanted. That's my working style. Like Chow Yun-fat and Leslie Cheung, we know each other very well. I'll say, "Let's forget about the script. Let's forget about the scene. All I need is one line. Do you have a singular situation or thing that's happened to you in real life?" For example, in a scene about betrayal in *The Killer*, in real life, Chow helped one of his friends build a career. But this friend got successful then turned and stepped on Chow's back. Chow was hurt so much and felt a lot of pain about that. He still loved his friend and he forgave him even though he was in pain. I said, "How about you putting that feeling in the scene? You can make up a line." So they just act, bring out their experience and true feelings. Those kind of freedoms make actors very happy.

Do you have any other projects with Chow?

We're working on a script.

How involved were you in producing Chow's latest movie, Peace Hotel? Do you like Westerns?

Of course. I'm driven to Westerns: Sam Peckinpah, John Ford, Sergio Leone... I only worked on the script, though. The director was Wai Ka-fai and I truly believe he did a good job for his first movie. Before that, I produced several films in Taiwan. I give directors a lot of freedom. They have their own

minds, their own vision, their own style. I'm not like the others. I don't give orders. Some producers in Asia, they'll even write a scene and tell the director to shoot exactly what they write. It's not right.

Did you ever read Golgo 13? Some people have pointed out similarities between the Japanese gangster manga and your movies about crime.

No, but in the '60s, I watched a lot of Japanese gangster films and French films.

You're pretty famous for your cooking. Could you make a film about food, like Ang Lee's Eat Drink Man Woman or Tsui Hark's The Chinese Feast?

I love to cook, but I won't put it in a movie. They did a good job, but I'm always fascinated by chivalry, honor, loyalty, and those kids of topics. True heroes always amaze me. Cooking is my only hobby in real life. The reason I love to cook is because that's the only moment I can relax. I take three or four hours to prepare a meal. That's the only moment I forget about all the pressures, problems, and politics. When cooking, no matter if it's a big dish or small dish, I always try to make it look decent and taste good. It's the only time I can relax. After I cook a meal for my family, when I see my children enjoy it, it makes me happy. 🐱

I didn't know Cantonese! I also saw Leslie Cheung at the Shrine and Faye Wong at the MGM in Vegas.

G 115 R

ONE HONG KONG ACTOR IS DOING MORE THAN YOU THINK.

Hong Kong has the third largest film industry on the globe and that means there are tons of actors and actresses hitting the spotlight for a few years before becoming yesterday's leftovers. To last a decade is tough, and to last an entire lifetime is close to impossible. Tony Leung is one of those actors that just may last as long as he wants. He is versatile, playing in kung-fu period pieces, comedy, drama, violent gun battling action, and romance films. But the difference between Tony and the rest of the pack is his devotion to his talent and career. He's not cashing in like the big stars of the moment, he is selective and has made the transition from being a Hong Kong actor to an international star by his stellar performances in three recently released, internationally acclaimed films, Wong Kar-wai's *Chungking Express*, Tran Anh Hung's *Cyclo*, and Hou Hsiao-hsien's *A City of Sadness*. All three are distributed worldwide. But there is actually more to this man. Although acting is his love and his talent, he has his life in perspective. He is a simple human being and he knows it.

Interviewing Tony Leung was a task and something different. Usually actors mean nothing for *Giant Robot*. They are just the talent that's being bossed around by a director with a vision. But Tony is one of those actors that you take a special notice. It's in his subtle gestures, his facial expressions, the way he speaks—his acting is as real as it gets. Even though I had to spend the dough on multiple long-distance calls to set up a talk with Tony, and then an incredibly high-priced phone call to his cellular in Hong Kong, it was worth the effort. I expected short answers that would reflect him being a busy guy who had no time to talk, but he was cool. In the span of a phone call, he told me everything he could and everything he felt. He reflected that acting is just what I thought it was: a job where you get ordered around. He takes it one step beyond a lot of actors and that's why he's in here.

Tony, what are you doing right now? Are you too busy for an interview?
TONY LEUNG: I'm in a crystal exhibition of my friend's and I can do an interview right now. I'm at the museum of art. One of my friends is a very famous crystal maker in Asia. She is having an exhibition in Hong Kong, so I've been here every day. I think she represents the Asian crystal arts. It's really great.

Congratulations on winning best actor in Taiwan and Hong Kong last year!
I was very lucky.

No luck there, you kick ass.
No, no way, I still have a long way to go.

Are you excited about Chungking Express starting here in Los Angeles?
I love that film. I'm really excited. It got a good result in Korea too, and I'm glad to hear that. But I think most of the success is because of the director and not because of us actors. He's

TONY LEUNG CHIU-WAI

words | Eric Nakamura

really great and talented. He has a different style when compared to other directors in Hong Kong. He's much more modern.

Was his modern style difficult to act for?
No, actually it was easy because I love acting and I'm that kind of person who doesn't like reality. Life is too cruel, especially when you are living in a big city. What I can see from my balcony, I can see the harbor, and I used to daydream and have a lot of fantasies. So I like acting and I like to live in fantasy. For every movie, I don't feel it's difficult. You just need to love it. You just act. A lot of journalists ask me, "Do you have a method?" Yes, I did study movies and television class for a year and learned all the basic rules, but now I say fuck the rules. Just be like ordinary people, act like how you would in your ordinary life. A good actor needs to appreciate life. If he knows to appreciate life, then he knows how to appreciate movies.

Is that your style?
Actually I always say that you try to act like another character, but it's still your emotion. It still goes through your brain. Every tear and every laugh is the real thing. Even though the set and location isn't real, your emotion is real. You need a lot of study in your ordinary life. You need to appreciate the clouds, the sea, the mountains, the birds, everything, so you can improve your acting.

In Chungking Express, *did you draw from a personal experience to make yourself more comfortable?*
Yes, actually in the film I was a policeman who just had a divorce with a girlfriend. I've had a stage like this when I was 23, 24. I had this type of experience, I think everyone did.

But not with a stewardess right?
Yes. I have a really good memory. So I just think about what I did in the past and I act it out now mentally.

Is acting easy for you?
Yes. Acting is a kind of release. When I first started my career, I was just a kid. I was shy because of the divorce of my parents. I was ashamed to tell others that I don't have a father. At that time, I seldom talked to others. I didn't have any friends. I think that's the reason why I like movies so much—because that is the only way I can express my feeling. I can cry in front of others and no one knows what's going

on. Everyone thinks that it's only the character crying and not Tony himself. That's the reason why I love movies that much.

I can see that. Was it easy to work with Faye Wong since she was new to acting?
She is not a pro, but actually it's great to work with new actors or actresses. They know nothing about acting. Actually, they just do it subconsciously. I tell them to act like themselves and how they do things in real life. I can still remember I once worked with a new actress, and we had to do a love scene. The director asked her to take off my shirt. She couldn't do it. After messing up 20 takes, I said, "In real life, can you do it in a bedroom? You can do it. Just take off my shirt, that's all." It's quite easy to work with a new actor or actress if you have a good director that can lead her. I think the director is the most important part.

Did Faye Wong have problems in the beginning?
Sometimes, suddenly, if you've seen the film, you could see she would blank. Sometimes, I could feel it in her eyes. Suddenly she goes blank: nothing inside! Sometimes, it really frightens me. I think it's great. It's like when you talk to someone, sometimes they blank, too. They have problems. It may be with their family, pressure, or the weather. We change our mood. Our brain tells us how to act and sometimes we blank, but it's normal. You don't have a design for a scene or do everything on schedule. You have to follow your mood and your heart and I always say, don't trust your eyes, trust your heart. Your heart tells the truth.

Do you think a lot of Hong Kong actors use your style?
No, no I don't think so. I'm kind of sorry about that. [*Laughter*] There aren't many actors who really love movies. I can still say now that even though I'm not doing many movies, I can tell you that I love movies.

Who else do you like?
Before, my idol was Chow Yun-fat. Before, he was quite good, but I haven't seen his recent films yet. Before, I liked his kind of acting very much. But now, I can't see any newcomers.

None?
We do have a lot of talent, but their attitudes towards work doesn't show a love for movies. Especially in this big

metropolitan town, everyone is looking for fame and money. But they miss a lot. They miss how to appreciate life. That does not make a good actor. **If you can't appreciate life and people, how can you appreciate a movie? And someone always tells me that they don't like old movies, because they aren't hip. If you can't appreciate an old one, how can you make new movies now? Everything comes from that.**

Do you like working with Wong Kar-wai?

Yes, I love him very much. We're very good friends too. We used to listen to music together and sometimes, we study scripts together. Every time before we make a film, we take a few months to get together, hang around together, and get to know each other better. We don't get to see each other because we're both busy, but every time we do a movie, we arrange at least three months of time to get together and go to dinner and just go around. We don't talk about the script, we just be friends. I just want to know how is he doing now.

Do you help him with ideas?

Me? [*Laughter*] No, no. I don't have time and I'm not talented in doing that. I'm still loyal to my own job, being an actor. I love that.

Does Wong Kar-wai always wear those sunglasses?

His eyes, when he looks at light, the tears come out from his eyes. That's why he wears the glasses. That's all.

Are you ever coming to America to visit?

I hope so. They asked me to come over for a Wong Kar-wai film, but I didn't have time to come. I have three more movies this year. One is for Wong Kar-wai, one is another Hong Kong director, and one is a commercial movie by Wong Jing. I don't know why, but he wants to work with me. Hopefully, we can do something. I never make movies based on what is commercial and what's not, a good movie is a good movie and that's what I think.

How do you pick what movies you want to be in?

I read the script first and I make friends with the director first before I take the movie.

Do you have a favorite director you work with?

I think still Wong Kar-wai and Hou Hsiao-hsien, too.

How about Woo?

He's great; he does action movies. But I like the so-called "art films." I love that kind of movie they call "art films." Besides Wong Kar-wai and Hou Hsiao-hsien (the Taiwanese director), the other is Tran Anh Hung, the French director of *Cyclo*. He's young and very talented. I learned a lot from him. Not only about movies, but music, paintings, and Vietnamese literature. He's really great.

Do you read books?

Yes. For example, the last film I did, *Cyclo* was Vietnamese. I knew nothing about Vietnam. I had go there early for about a month to hang out every day with the director to walk on the streets, eat the food, study the literature, study culture, and meet people. I studied French and Vietnamese for three months, and I still can't communicate. It's really hard. You have to live there before you make the movie.

You're so serious compared to many other actors!

Because I love it. I'm proud of myself too, because I love it. I'm not rich and wealthy like other actors and actresses, but I love my job and that's all.

I thought you would have more money. Someday...

Decent life, but not as rich as them. Some actors and actresses that make eight to ten movies a year do not care about the quality. And in a short while, they can get quick money. I think that's abusing movies. I can't say if it's right or wrong, but everyone has his or her choice. But I don't do that or buy that. Yes, I do have a responsibility to the audience. You can't just treat it as a job or a habit.

How many films do you make in a year?

Two or three. Average is just two a year!

Do you like doing serious drama, comedy, old-style movies, or action best?

Depends on my mood at the time. If I'm sad or have pressure in my real life, I want to do some comedy to make a balance—like therapy. If you're happy and healthy at the time, you can do something serious. It's easy to get yourself out of character after work.

Hard Boiled and Bullet in the Head are so violent!

Yes. One time, in the explosion with Chow Yun-fat in the hospital, an explosion made glass go into my eyes, so I stopped shooting for a week and couldn't see a thing.

John Woo said you were just like him.

It's the stubbornness? I think it's the attitudes of work. We love to be serious and not playing around. No, we are serious.

You also sing? What's first—movies or music?

I also started with a lot of movies, but you can't make 10 movies a year, 365 days a year. Sometimes you need to do something else to stimulate your imagination to gain more knowledge. Not only music, I like art, paintings, and sculpture. I like everything.

Do you paint?

Yes. But I'm not very good at it. [*Laughter*] I paint for the mood. The color expresses your emotions. You can do that through painting. Sometimes you want to do some sculpture. Who cares how you do it or if it is good or bad? You try to express yourself in different ways. This helps in acting.

I draw and paint also, and I suck.

You can't judge it, but you can see the emotion in the painting. Who cares about judging?

It feels good when you do it.

Yes, you feel good. Yeah, it's a kind of enjoyment. It helps in acting. Through hearing music and songs, I can feel the weather. I can feel the color of clouds, the grass, everything.

What else do you do?

I like to water ski. I do have a speedboat so I go out on Sundays and water-ski. Sometimes, waterskiing is like life. There are a lot of waves, so don't be scared. If you see a big wave, you can't be afraid, you just go for it. After you go through it and look back, you'll say that was no big deal, and there's more waves coming up. You have to face it positively. Don't be frightened of them.

You never get scared or intimidated by a script or character?

Sometimes I do. Yes, I get scared of some characters. This year they offered eight movies. Some I got scared of... One was working with the Australian government and doing a film about a Chinese poet named Gu Cheng. He's a crazy guy, like Jack Nicholson in *The Shining*. It's a true story. He was 30-something, had two wives, and was living in an island off of New Zealand, and it's a true story. And he got fucked up in his mind, killed his wife with an axe, and hung himself in a tree!

Oh shit!

He's a famous poet in China. After reading about him and his work, he was screwed-up in his mind. It's just fucked up. I don't think I can do it. I'm not professional enough. I can't do it. I think I would go crazy. I would have to live on the island and stay there every day. I can't get out of the character.

Who's going to do it?

I don't know. I'm not going to take it. Another example is a film with Yim Ho, a director who's doing a movie with the best movie actress in Tokyo this year. He asked me to work with him, but I said no. I can't work with someone I cannot communicate with. She only speaks Japanese. How can we work together? It's tough and tiring and no fun.

Do you ever go on vacation?

I'm on one now. Actually, I just came back from Thailand, and in a few days, I will go to London for a trip with my girlfriend and mom. I used to go everywhere. I like to just look around, go to galleries, and see how people live. I love to see everything and I love life very much.

Do people recognize you when you go out?

Yes, especially the Chinese. There are Chinese everywhere. [*Laughter*]

In Hong Kong, can you go out at all and do people recognize you?

They recognize me. I don't care; I walk around every day. I have no bouncers. I don't think I need it. Outside I'm an ordinary person, just like everyone else.

So no masks or anything?

No way, I don't need to. This year is my thirty-third year of age. If you know to care about people, they will know how to care about you. They won't bother you in your leisure. They will respect you, if you respect them. At work, I'm a professional, I'm cold. After work, I'm an ordinary person. What's the difference? No big deal...

Do you go out at night or are you a home person?

I'm at home, or I go to parties at friends' homes and hang out, fool around.

What kind of music do you like?

I like classical, rock like Oasis, Radiohead, Blur, Pet Shop Boys, that kind of music.

English music?

Yes.

Do you play cover versions like Faye?

Not much. I like originals. I cannot write and cannot compose, but I tell writers what I feel in my daily life, what I feel about others, and I tell them lyrics and stuff, and they write it. I used to express my past feelings in the songs. Most are songs about my past. Now, I have different feelings now compared to the past, and I express that. I like to be positive now and I express that in movies, too.

Are you comfortable in your acting career?

Really comfortable and happy. In the first eight years, I was upset about my career since I couldn't get a breakthrough. At one time, I wanted to commit suicide because I couldn't get myself out of my character. When I went home, I went straight to my room and then went through my mother's bedroom and talked to her. Afterward, I went back and locked myself up. I was so confused, I couldn't tell if I was talking to my mother or a character. Then I think something happened. At that time, I realized I had some problems. That was for a TV serial, and I worked 18 hours a day for half a year, so you don't have a chance to be yourself. I was only a kid, 20 years old, with no strong personality. But at that time, I started to act like other characters. So that's the point. I had a lot of characters in me. You have to pretend you are others at work, then you get so confused within you. You have many characteristics inside.

Now you're balanced?

One day, I thought okay, if you can't break through, try something else. It starts with appreciating life. And suddenly after thinking this way, I didn't care who I was. Who I am is who I am. I don't think about it. It's best to be happy and be nice to people, to others. Be nice to flowers, to the animals. That would be really great and you'll feel great.

What was your breakthrough for your career?

It was that TV serial, I don't think you saw it. But I'm hoping something good will happen this year with Wong Kar-wai's next film. It's something like *Dangerous Liaisons*. It'll be a bit different. It's tough to get a big pro to do it, like Glenn Close to do it.

Is it going to be shot in America?

I don't know. He said we need to do some scenes in America. I hope so.

Do you like America?

Yes. I love New York. When I was 23 to 24, I would go regularly. I used to just go for two days for some food, some coffee, no purpose at all. I just went.

Have you toured America?

I did a long time ago. I'm preparing for my concert in April 1997 at the Hong Kong Coliseum. In 1996, before September, I have to work for movies, then after that, I can work on my singing.

Jacky Cheung came, so you should too!

I will, I sure will come. If I come, I'll let you know.

Be an actor here in America, too! If Jackie Chan can do it, so can you.

It's not easy for Chinese people to get into the field. I think there's a lot of political things in Hollywood. I would love to work with actors and actresses in the States.

They are more your type, you know?

I would love it. They are really professional. When compared to us, they are well-educated. We don't have those kind of lessons. You have to search and study by yourself from books, everything by yourself. You have to love it to be good.

Do other journalists ever mix you up with Tony Leung Ka-fai?

They always get confused…

That sucks.

Yeah. It's fine.

Do you want to direct?

Yes, it's tough… I want to do fairy tales like *E.T.*, *Splash*, like that kind of movie. I love that style and fairy tales.

Do you watch American movies?

I like American movies. I like Scorsese, Coppola, Polanski. They are my favorites. Scorsese is really nice. I met him in Venice. I was crazy, I dared not to go close to him. But I shook his hand.

Maybe he'll use you in a film.

I hope so. Yes, that would be great.

Is Chris Doyle a good cinematographer?

Yes, he used to get drunk at work, so you can see the handheld shots—it's shaky! I like him a lot, and his style is lively with emotion.

The color was nice in Chungking Express.

But every time they have to test the color and the quality of the film, the scenes, and how to do it all again later. I like to know about that, but I let the pros do it. But I want to know.

A lot of magazines write some crazy stories about you. Do they follow you?

They still do it, but you just can't help it. As long as you don't do anything wrong. You can't sue them. I don't care, that's their job. What can you say? It's their job.

You once had a nose ring? Was it a clip?

Fake. Just like when you are doing a new character, you want to have a new appearance, a new image, something new.

Did you like that?

At the time I liked it, but no more. [*Laughter*]

Who does your hair? It's always perfect. You have perfect hair.

Thanks. I just cut it and get it permed every two weeks, and then make it straight. But it's very damaged.

I want to get my hair like that.

You can! Don't cut your hair for two years and get it permed every week and then make it straight. You can do it, too!

Did you ever have long hair?

Yes. I kind of have it now for my next movie. The art director doesn't allow me to get a hair cut. It's been three months now. It's really horrible.

Many women are cutting their hair short.

It's a trend now.

ᴇʀɪᴄ: For him to mention: "At one time I wanted to commit suicide because I couldn't get myself out of my character" is an incredible commitment

Do you like that? Or do you like women with long hair?
It doesn't matter. I like a woman with a warm heart. [*Laughter*] That's the most important part!

You started as a host person on a children's show?
Yes, and the TV serial, together. The TV company arranged my part on the TV program to get used to speaking and acting in front of camera. Actually, it prepared me for the TV serial they were getting me into. It was good practice, but it was boring. The kids were naughty all around. They were hard to control, those kids.

Did you do martial arts?
I learned it when I was in my school days, and gymnastics for the artist training class and karate. It's really tough.

You are not in many martial arts movies, right?
The action is the minor parts and the emotion is the major parts of the character. I do all stunts myself. Maybe you don't notice, but before I make movies, I exercise and get fit. I take three months to get ready. It's really dangerous. My neck, knees, and shoulders all get hurt.

Chungking Express *was* easy, right?
Yes, no action. It's better.

Many make a big deal of '97. Are you worried?
No. I think there are two kinds of people. There are those who want to leave Hong Kong and escape the reality by moving to Vancouver, and there are those who want to change the government—anti-government. I'm yellow, I'm Chinese. That's my blood, that's my root here. When my country has problems, I have to face it. I don't care about the politics and government. I'll try to adapt. I can't tell myself I'm Canadian and move to Vancouver. No! I'm still yellow. I'm Chinese, and I'm proud of being Chinese. l have to face it. If your country has problems, or a disease, you can't leave the country. You have to face it together. Don't escape it.

Do you plan to live in Hong Kong?
Yes. Sure. Except, after I retire then I will bring my mother and girlfriend to see the whole world. The whole world is huge! I haven't been to Greece or the Arctic Ocean, among many other places. I want to go on many trips after I retire.

When do you want to retire?
At the age of 45. I hope so. Twelve more years to go.

Then what?
I can still act, but not regularly. I want to learn something else, life is too short. I want to make paintings, learn ballet, learn more sculpture, meet more people, make more friends in the world. I want to learn how people live in other countries I've never been to before. That's what I want to do. Meeting people and making friends is really nice.

I want to do the same things.
You'll feel fulfilled by not only considering yourself, but considering others. We are individuals.

Have anything to add?
People should be nice and care about others. That's a big deal.

So what are you doing now at this instant?
I'm still looking at the Chinese crystals at the museum.

ERIC: *Perhaps the best actor in Asia, if not the world is Tony Leung. His candidness about his work was remarkable and the time he gave was special. This one was so raw that it was moving to reread. Did Leung know he gave up over an hour of time to this relatively small zine? Was it his olive branch to an outside world of fans?*

We went on to interview Leung later during a press junket, and I mentioned this interview, and he said, "I always wondered who you were," and shook my hand for an extra couple of seconds.

MAGGIE CHEUNG
ACTRESS

After acting in 73 Hong Kong movies in a span of 13 years, Maggie Cheung is finally attracting mainstream attention in the United States for her role in *Irma Vep*.

Who would have thought that after playing a snake goddess (*Green Snake*), portraying a legendary Chinese silent film star (*Center Stage*), brandishing a sword (*New Dragon Gate Inn*), and donning a mask and cape (*The Heroic Trio*)—basically working herself from beauty contest runner-up to an internationally awarded actor—her breakthrough role would be playing Maggie Cheung? And who would have thought it would be in an independent film from France?

The irony doesn't bother Maggie. She'd rather be known for giving a sophisticated performance in an experimental film than be categorized by the American media as a damsel for Jackie Chan to rescue (It's happened five times) or a James Bond Girl (They called her for a tryout and she balked). She's reached a point professionally and philosophically where she doesn't care as much about gaining attention as she does about getting quality roles and working with good people.

Eric and I met the Hong Kong-born, England-raised, and Hong Kong-residing actor at the San Francisco International Film Festival, where she and director-pal Olivier Assayas were presenting *Irma Vep* (Maggie's latest Hong Kong offering, *Comrades: Almost a Love Story* was also showing). Refreshed from a two-year sabbatical from film, Maggie spent some time with us.

NON-STOP ACTING

What was it like to act in so many movies during the first 10 years of your career?

MAGGIE CHEUNG: I think it made it harder to grow up until I was old enough to know, to stop myself from being in just that little world of mine. I think a year before the two-year rest, it was beginning

words | Martin Wong + Eric Nakamura *pictures* | Vicki Berndt

ERIC: We flew to SF for this one, and we

to build up. I got frustrated about repeating my work, and felt that there was more to life than this.

What did you do besides act?

Not that much. I didn't have time to see my friends or family. I had no time to read or have peace in life. I was always on the set or running around. I was just busy all the time. I didn't even have time to really travel. To me, traveling is not just being in a place, but to really feel that place. That takes time and energy of mind. Like, "This is San Francisco. This is the way people live and the way people are." There's more to traveling than just seeing the Golden Gate Bridge. I think I like myself much more as a person now that I've had two years off to find who I am. I was very much influenced by people telling me who I was or what they thought of me. The people around me would say, "You're a great actor," or, "You're not a great actor." I didn't have a good judgment of myself or what I did. I was very much into listening to what other people were telling me: whether I was good enough. That's why I was very contradictory all along the way as a person. I wasn't as grounded as I am now. I didn't know what life was about. At some point, I got quite insecure with myself, thinking all actresses have short lives and careers—especially in Hong Kong—because it's very much like idolizing instead of appreciating good acting. I got insecure, thinking, "What am I going to do past 30? Is my life going to end? Etc." But no, I think life has just begun. It gets better and better. **I really don't mind getting old and I know that when I stop working I'll survive without being busy all the time.** I have enough friends and interests to keep going in life. I'm much more secure as a person now. When my career comes to an end, I'm not going to die. I'm not going to be useless. I will do other things that will keep me going.

What are some of the things that have kept you going?

I do more sports, like golf and tennis. I have an interest in photography. Just more time for me.

Did people bother you during your time off?

No. I was traveling a lot, so I wasn't in Hong Kong a lot of the time. And when you're not as high-profile, people don't pay as much attention to you and your private life. So I did manage to get some peace and quiet.

Did that make you a better actress?

I don't know. I'm still me, and I still have as much talent and creativity as I had before, but it makes me more relaxed as an actress. Instead of always trying to please or working too hard, giving more than is necessary if I had a scene when I'm supposed to be crying, I treat it as the real thing.

Is your acting more natural now?

I think so. I think I'm less conscious of the camera than I was before, less conscious especially when I'm speaking on-screen. When I used to have a whole page of lines to speak, I would get nervous and think, "Oh God, even if I remember them I couldn't express them the right way." But now I say the lines as a person would say them. Before, I would just try to get it all out and that's it. Now it's a more relaxed way, and that always comes out as more natural than when you're just speaking memorized lines.

It shows.

Thank you.

Not that the movies were bad before!

Well, there were some bad ones.

COCKNEY REJECT

Growing up in England, were you familiar with Chinese stories like Green Snake or Chinese movies like Dragon Inn that you were in remakes of?

They were all new to me when I first connected with those projects. But then they're not that hard to understand, either, because I am really Chinese. You know, I felt for them very easily. I felt a connection.

Did you grow up with other Chinese people besides your family?

<u>No, not at all. I was the only Chinese person in my school. My sister went to another school and she was the only Chinese person in that school.</u> We had a tough time growing up, being different. In England, people are narrow-minded, and we grew up in a little town, Kent, so it's not like we were in a big city. When I first went to school, I was eight. Other students had never seen an Asian person before. They would touch my hands, look at me, see my eyes... I grew up with that kind of stuff.

Is it true that the food is not good in England?

For me, I was an easy kid. Even now with food or little details in life I'm quite easygoing in that sense. I'm not picky, so I didn't have any problems. Actually, now I sometimes miss roast beef and mashed potatoes.

Were your parents very traditional?

Not really. They are traditional in some ways, but not traditional.

So you didn't watch Chinese movies or listen to Chinese music or anything?

No, except for a little bit of Teresa Teng. My mother listened to her, but not much. I recognize the songs when I go back to Hong Kong.

There were Teresa Teng references in Comrades.

Yes!

COMRADE CHEUNG

What was it like working with Leon Lai in Comrades?

Well, I've had people say, "Oh my God, why are you working with him? He's an asshole, etc." But actually when I got on to the shoot with him, he was okay. He was a person who was willing to give as an artist. He wants to do something with his career, and not just take in the money and fame and that's it. He doesn't really have that much time for movies because he's so busy

with singing. I enjoyed his company. He was very nice and gentlemanly with me. It's very unfortunate for him; I think he doesn't have that many close friends because he's always so busy and people always want to tease him in the wrong way. **He found the friendship with me was quite rare because I would tell him the truth, like, "That song sucks."**

Your character was like that in the movie.
Yes, and that carried on off-screen, too. I was quite bossy to him. Really. I'm a little older than he is—he's 30, I'm 32—and I felt like I could boss him around. But that's not the reason why I like him. It's because he's like a kid. He is very innocent in ways I was surprised to find. And surprisingly, he'd believe in what I'd tell him. He'd ask me for my opinion on his work or whatever. The character really followed off-screen. I'd shout at him sometimes. For fun, we'd do that.

And in the movie you worked in McDonald's and in real life you modeled for them, too, right?
How did you know that?

Didn't you model all sorts of stuff before entering the Miss Hong Kong pageant?
Product-wise, yes. Fast-food chains, creams, shampoos, clothes...

No more?
If they'd hire me! Actually, last month I did a commercial, but it's on a different basis now. They hire you for the name and who you are. Not like before, when I had a fresh face.

What do you think the advertiser wanted—for people to identify with you?
I don't know. I don't have a clue how the public sees me. I just know that's me. I suppose the people who like me will have different reasons. Not everyone has the same reasons. Some will like me for the way I am in films, and some people like me for the way I am, and not for films at all. There are different reasons, or I hope there are.

PICKING PROJECTS

What's your favorite type of movie to be in?
I do prefer working on stories where relationships are the main thing, things that are a little bit deeper with relationships and people, instead of just telling a story about someone getting in trouble and out of trouble and doing this and that. **It's more about moments in people's lives.**

With action, there's no real acting in it. It's another kind of skill (which I'm not very good at), but that doesn't interest me as much as expressing from my heart onto the screen to the audience, hoping that they would feel something for me, for my character on the screen. Really, who fights well? If we were in a fight, we would never survive. But to make it look nice, it's like watching a ballet. You think, "Oh, she's a really good dancer," the same way you see someone fighting. They make it look so easy and so relaxed, so fluid in what they're doing.

What do you look for in a script?
Something that I know I would look forward to going to every day. And apart from the script and the part that I play, the people I'm working with. I am quite conscious of being with people I like now. Some people can be great filmmakers, but I really hate to work with them. I don't want to spend three months of my life with somebody I hate. To have a good film on my list is great, but I have to enjoy the process of making it, to have a good time of it.

So you might not have enjoyed Heat if you got cast in it. I understand that your tryout did not go so well.
Well, not the things I heard about, which I don't know are true because they're rumors. Yeah, that's why I don't know if I would even enjoy working on a Hollywood movie. In *Comrades*, I knew Peter Chan from a few years back, and I know we at least have the same sense of humor, and we can joke and chat and share something as people and not just making a film, etc. And a lot of it has to do with the impression I get. As for a stranger like Olivier, the impression I had was that he could be an okay person to work with. A lot of it is instinct.

What if there's a real great filmmaker who's a real jerk?
Then I will judge the character I play and the script as well. If I know the person's a jerk, but then I will have a real good time playing that character, I can just not talk to the jerk. At least I have to have fun playing the part. But **if it's a bad script, a bad part, and he's a jerk, I won't work with him.** You know what I mean?

IRMA VEP

In Irma Vep, you play yourself. Did Olivier Assayas get your character right?
No. But then again, I don't blame him because it's impossible to capture somebody just from having a brief

encounter. I think I have a bit more than that, but I'm not totally different than that. Even now, he says to me, "If I had known you then when I was writing the script, it would have been a little bit different."

People who see this movie are going to come away feeling like they know you.
They're not wrong, because to some extent that is a part of me, but it's not all. It's how I'd be if I was that character.

How much of yourself do you reveal on the screen?
As much as I can in the short time I'm allowed to, but you really can't do it in 10 minutes. And however natural I try to be, I'm conscious of the camera. I might do some stupid expressions in real life that I won't do on camera, even though the way I'm thinking is the way I'd do it. The way I use my language is very close to how it is now.

Is Olivier at all like the director in the movie? He, too, saw you in Hong Kong movies and was inspired to write a screenplay around you.
No, they're not alike. The character René is much more crazy than Olivier. Olivier is a good, creative filmmaker, but he is very rounded, very earthy. He knows what works and what doesn't. He faces reality, he knows not to waste people's energy and time if a movie isn't going to work.

Do you think Irma Vep works?
Yeah. First of all, he wanted to make a comedy, which he'd never done before, and it worked in that sense. Although it won't make you fall off your chair, it will make you smile. It's humorous, like a black comedy. He wanted to talk about filmmaking and he got that in there. He also wanted to point out the differences in the world of cinema, in European films or American films or Hong Kong films, and the differences in filmmakers from all over the place and the preferences of the audience. Really, I think there are two different types of audiences who can say they love movies. They're not wrong in what they like, it's really that they have very different tastes.

After working with the same people for so long in the Hong Kong movie industry, was it easier or harder to work with new people in a French movie?
It didn't really make much difference, because it turned out very close to what I imagined. But, you know, I was not treated in the same way on the set. In Hong Kong, it's very much like people know I've been around for a long time, and

in some ways, I'm a star. And I'm quite spoiled. I'm treated as all actors are on the set, like kings and queens. But on this set, it was more like I was part of the crew, part of everybody making the film happen. There's no higher or lower.

Was it weird to perform in English for the first time?
It was much easier than I thought. It's not really my first mother language, but I'm okay with it. I can express myself well enough in English as well as Chinese. It wasn't strange or different or whatever. It just came really naturally.

Do you use English much in Hong Kong?
No, actually I don't use English that much. That's why it's not as fluent as it was. When I went back to Hong Kong from England, my Cockney accent was so strong the Hong Kong people couldn't understand my English. You know, they would find it so strange that it was not the English they're used to hearing. And because most of my friends in Hong Kong are Chinese, I use my Chinese much more than English, even when I'm traveling.

Do you hang out mostly with other actors?
All kinds of different friends. Another great thing about the film is that I made some really good friends. I've been back to Paris since the film twice, two weeks each time. It's not like before. It's a completely different kind of feeling.

Do you get to meet a lot of different types of people when you travel?
Mostly journalists and filmmakers and festival directors. The people who run festivals are very nice people, too. A lot of people work at them not for money and not as a job, but just with the interest of meeting filmmakers and the love for films. Really, there's a close connection with those people. You don't feel shy with them and they're not shy with you. You at least have one interest to connect with them.

FILMS AND FESTIVALS

Do you think filmmakers are weird?
They can be, but not all filmmakers are weird. But then, I think most people are weird anyway.

Are you weird?
I don't know. I'm just me. I might be weird once in a while, but I don't realize it. But the people who are with me would notice that!

Have you been getting lots of scripts?
I've had a few film offers. I was in New York a few days ago and I got some scripts. Usually, they're very small independent films. I'm interested in working with them, but I haven't read them yet. There are things like that happening to me now.

Do a lot of people cast you in kung fu roles and such?
No, but a lot of them have to do with Chinatowns and stuff like that.

Would you ever want to make movies?
I'm interested. I want to. But then, it's a dream that I'm putting on my list that I don't want to fulfill just yet. I don't think I'm ready to do that yet. Apart from really wanting to say something in the film I want to make, there's a lot of pressure coming out as an actress. People look at it different than as if you're a student, because I've been in the business for 13 years. There's a bit more pressure than a normal filmmaker would have.

MAGGIE THE MOD

What movies did you watch when you were growing up?
I watched things on TV. **The first film I was influenced by was *Quadrophenia* when it came out.**

Were you a mod or a rocker?
I was a mod, not a rocker.

Aren't there a lot of scooters in Hong Kong?
Not that many. Not that many cool ones.

Did you have one?
No, but I remember that time very well. That was about the second or third film I went to go and see. I remember it was an X film. I had to dress up to look 18, because I was 15. I put on high heels and makeup. That film has really stayed with me. I'm not saying it's a good film or a bad film, but it's something I grew up with, and it's how London was in that trend. The mods, the rockers, the punks...

Did you like music a lot when you were growing up?
No, I liked Sting and I remember the main singer. Leslie Ash was a famous model at the time; I liked her a lot. But I listened to what was on the Top 10. I followed the trends, but my favorite was Madness. I liked UB40. I loved The Specials. At the time, I wore a lot of black and white, the checkers. That was the trend while I was at the right age to be following trends. You're just in light of what's going on in life.

MARTIN: I actually corresponded with Maggie via email for

Mod and ska are back.
Actually, I wouldn't mind. I think mod could work again. Really. Miniskirts and stilettos, and they're very sick looking. Pale, pale lips. I remember the Fred Perry t-shirts. I love Fred Perry.

I thought you'd be so glamorous, but then walk in and see you with a punky haircut!
I cut it myself! With hand scissors!

What made you do that?
I've had it long, and I always liked in long when I was younger. Then at some point I wanted to cut it, but I couldn't. On film projects there's always continuity. I was always stuck in situations where I couldn't change hairstyles because of my role, and then it would overlap with another film that would overlap with the next. I didn't really have a period of time when I could change it until I was not working. And then I was stuck with a shampoo commercial for two years. Now, finally this year, the contract is over so I wanted to do this before I get too old, while I still have the drive to cut it all. It's good to have change. Either you don't change at all, or it's really a drastic difference. I think I'm ready to start growing it again. That's my next project. I had a longer version of this about four months ago, and after *Chinese Box*, I cut it to this length. Before I started growing it out, I thought, "Oh, I should have it real short before it's long again." Now I tried it, and it's fun, but I'm ready to look different again. Maybe next time you see me, I'm going to look completely different.

Would you ever shave your head? I think it would look alright.
Would it? Don't tempt me! But that would too limiting in my roles. But if a film asked me to, maybe I'd work on it.

You'd get cast as a monk, but you'd still look great.
That's a part of my work, too. I don't wear any makeup at all when I'm going out. Today I knew I'd be photographed and there'd be cameras.

Do you ever see yourself on web pages on the internet?
This boy, I think he's from Toronto or somewhere in Canada, he set up a home page for me and I was browsing through. I thought, "This guy, he's so sincere." We were mail friends, he would mail me things now and then. Then I kind of regretted it. I sent him a picture after he said that he'd love a picture. He put it on his page. I said, "Why did you do that? I gave that to you to look at." **I just felt uncomfortable exposing private pictures. I mean there was nothing about the picture that can't be seen, but it was just personal.**

UNKNOWN ROAD

Are you the same person you were five years ago?
Ultimately, I am the same person, but then I feel more knowledgeable. Not just in acting and culture, but knowledgeable as

a person. My mind has grown broader. I'm not as narrow-minded and I'm able to accept other things, other ways of acting, other films—stuff like *Irma Vep*. I think five years ago I would have been scared of doing it. But it came at the right time of my life, when I felt more adventurous about movies.

Are you satisfied with what you've done? Is there a lot more that you'd like to do?
At this point of my life, I'm playing it by ear. I really don't plan my life any more. I'm very much open to what comes my way. If nothing does, **I'm not ambitious enough to take that step forward to find an agent in Hollywood to try my luck there. I really want things to come to me, and then I choose from there.** But otherwise, I'm very comfortable even if I'm not involved in a project. I'm comfortable just with being here on this earth, doing my own thing. I think travel has to be a part of my life. I would not be happy staying put in one place, saying this is me and this is it. Going to different places can really inspire a person, and really fills me up with knowledge. It doesn't have to be anything intellectual, just the knowledge of people or ways of living. Even listening to a strange language is kind of fascinating to me.

Do you sleep on floors or in hotels?
I've done both. Last summer, I went backpacking through Italy, then I took the train to Sicily, and a boat to Greece. From Greece, I traveled the islands on boats. The whole trip was about boats and trains and buses and I just had this big bag of clothes with me.

Did anyone recognize you?
There were a few Hong Kong tourists, and they would recognize me. But if they recognized me, I'd deny it. We were checking into youth hostels and tiny, small hotels. They were very homey, and it was a different feeling. I went with a friend, it was a good experience. Other trips, I will stay in a nice hotel and swim by the pool, too. I'm very fortunate that I can afford to do both. Afford meaning money-wise for the nice hotels, but afford meaning youth and strength so I can not mind hard work or the cheaper ones. The fun of it is putting it all together.

Do you travel in America at all?
Mostly West Coast and East Coast. I went to the Telluride Film Festival last September. Me and these other two friends drove a car from Telluride to San Francisco, then took a plane to go to the Toronto Film Festival. That was very nice.

Where do you see yourself in 10 years?
I have no idea. I think acting will always be a part of me. If I watch a film, even if I'm not it, I'd be looking at the acting. That's the first thing I look at. I can't help it, because it's something I've done for so long. And watching films will always be a part of my life. Not necessarily making them. Maybe I'll grow into a stage of married life or something. I don't know. I really cannot predict. 🐱

a while after this interview took place and sent her mix tapes!

FALL 1997 🤖 *GIANT ROBOT #9* G 127 R

MR. WONG KAR-WAI

words + pictures | Claudine Ko

If you caught Wong Kar-wai's *Chungking Express*, you probably saw his follow-up, *Fallen Angels*. And if you weren't hooked on his films at that point, you are either dead or just weak. Since the Hong Kong director blew up in the mid-'90s, he's slowed down the pacing of his storylines and increased the amount of time it takes for him to complete a film. 1997's *Happy Together* moved away from the frenetic pop-music rhythm of his previous two works and loitered in an Argentinian wasteland of fucked-up love and waterfall melancholy. His latest film, *In the Mood for Love*, pairs up Maggie Cheung and Tony Leung in a mutual post-heartbreak haze set in '60s Hong Kong with Nat King Cole crooning Spanish lyrics in the background.

The cast reunited in a swanky downtown New York hotel, and I was there. Maggie Cheung waited at the concierge desk while Tony Leung looked like sex in a white suit nearby, smoking a cigarette and occasionally leaning over my table to use the ashtray. In a state of nervous anticipation, I sat across from Wong to figure out if he was a genius or just pretentious. Maybe both? You decide.

ERIC: This one was huge. Wong Kar-wai,

GOOD TASTE

You were born in Shanghai and when you were five years old, you and your mother were separated from the rest of your family because of the Cultural Revolution. Did you ever get to be close with your brother and sister?
WONG KAR-WAI: We have a very close relationship because all over the years we communicated through letters, and it's very comfortable.

Is that where you learned to write?
No, actually I hate writing. I think writing is something very, very difficult and should be very serious. So whenever I have to write, I have to be very serious. Same as my father—he thinks writing is a very serious thing.

What did your father do?
He worked in Hong Kong in a nightclub. He was a manager. Some of the music in *In the Mood for Love* is from the music that played in the nightclub at those times.

Where else do you get your music?
My mother. My mother has good taste in films and music, and Nat King Cole is one of her favorites.

What are your other influences?
I was born in Shanghai and I came to Hong Kong. At that time, we didn't have any relatives in Hong Kong and we didn't speak Cantonese. <u>We were living in an environment with a lot of strangers around us, so my mother and I spent almost every day in the cinema. And those days in Hong Kong, you could see American films, European films, Japanese films, local Mandarin, or local Cantonese.</u> Actually, a lot of films I've seen as a kid. So there's a lot of influences.

REFLECTIONS

How much are your movies a reflection of your own personality?
I don't think my films reflect anything from my life in a very

realistic way. It is not necessarily a reflection of my life; it's more like my hope. I think one of the reasons we make films is because there is something that we want to improve in our life. People say, Hong Kong in your films look different than real life, and I say, "Yes, because I want to improve that." I hope someday Hong Kong will become quiet, less people, and this is our projection.

Wasn't In the Mood for Love *originally called* Beijing Summer?
It's two different projects. In the beginning we wanted to make a film called *Summer in Beijing*, which is a story about two Hong Kong citizens working in Beijing. But we had problems with the Chinese government, so we had to give up that project.

When was the first time you picked up a film camera?
I spent two years in Polytechnic. I don't know why I studied graphic design, since I had no training in drawing. I think the main reason is you don't need to do any more writings, readings, or exams in graphic design. So I spent three years there, and one day there was a local TV station that wanted people to train to make television. In those days, TV was this new thing, so some students studying stage in Europe, they came back to Hong Kong and worked at these stations. And it was like a Hong Kong new wave. Most of the Hong Kong directors now came from those students. I just worked as a designer and was trained as a director.

Is there any filmmaker in particular that you like?
I like a lot, but there's no one that I say, "Okay, he's the one that influenced me." From time to time, just like *In the Mood for Love*, a lot of people say the film is like [Michelangelo] Antonioni, but to me the film is like Hitchcock. I wanted to make a film like Hitchcock. Over the years we've seen a lot of films, and there's something already left in our memories, so we just react to something, and sometimes we want to do this, and sometimes we want to do that. There's no one that I would think especially, "I want to be like him."

COOLNESS AND CLOCKS

Did you date a lot when you were younger?
No.

A lot of your storylines are about very dysfunctional relationships. Is this some kind of way to figure out your own relationship issues?
I don't have a lot of romance in my life. There's one of the reasons you make films. You can explore, you can try. You have curiosity.

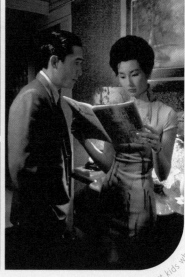

You make Asian people look cool compared to how they are portrayed in American films.
Asian people are cool.

Do you think a white actor could play one of your characters?
Yes. I would like to have made a film with Steve McQueen.

In the beginning of your career you did more action films. Now you're doing more dramatic pieces. Do you think that gun films and action films are over in Hong Kong?
No. I think it's like sometimes you do something, you get tired of it, and you move on to something else. Maybe someday you will go back to it. I don't have a special reason to make action films or films with no action. I feel like I want to make my best movie.

Why do you always fixate on time in your movies?
First of all, we are not very conscious about the clock or time references. I think a clock is like a chair or table. It's part of the space. But over the years people were trying to find a kind of motif, and sometimes they even asked, "Can we make a film without a clock in it?" We tried that, and we were always conscious about it. From then on, we tried to hide a clock somewhere as a joke.

CHEMISTRY

Out of all your films, which couple do you think has the best chemistry?
Most of them have good chemistry.

But which is the best?
I think Tony and Maggie are very good in the movie.

Better than Leslie and Tony in Happy Together?
I'm not saying that. I think most of the couples in my films work quite well.

I found it hard to see Tony with Maggie after seeing him with Leslie's character.
I think that Tony and Garfield in *Chungking Express* had very

good chemistry. He was always talking to the toy.

In the Mood for Love took 15 months to make. What do you do in between films?
Make another film.

VISION

Do you think you'd be able to make a film without cinematographer Christopher Doyle?
Yes, half of *In the Mood for Love* is without Chris.

So you're not so dependent on him.
I think we shouldn't say that because we work as a team. And I'm sure the film will be different with different

cameramen; but we don't say we can't make a film without Chris or we make a better film without Chris.

What kind of sunglasses do you wear?
Normal sunglasses.

Do you always wear the same pair?
Yes, I bought it in Kowloon City somewhere 10 years ago. It was made in Hong Kong and there were only a few left. So I bought them all.

2046

Can you tell me about the film you're working on?
We are working on a film, 2046, and the film happens in the year 2046. The reason we want to make that film is because in 1997, Hong Kong, the Chinese government, made a promise [to not overhaul the local economy for 50 years]. 2046 is actually the last year; we want to make a film about promises and see if anything has changed.

Maggie told me you were conservative. What did she mean by that?
I don't know.

How would you describe Maggie?
Conservative. More conservative than Wong Kar-wai.

A HARD TIME

All your answers are very...
Vague. [*Starts drumming fingers on the couch*]

Yes, very broad. Is there anything you have a specific answer for? Like what's your favorite food?
Chinese food. Good Chinese food.

Anyhow, you said you didn't have very much romance in your life and that you wanted to make movies about types of romances that maybe you didn't experience.
Oh, you believe that?

Oh, you're not telling the truth?
Is it that simple?

ERIC: The best part is how Claudine quotes Maggie Cheung—about Wong being "conservative"—at him, and he

I don't know. Is it?
That means because you don't have something, you want to do that something. Is that so simple?

It's not so simple, but it's an obvious rationalization.
You think it's true?

I think it is true to a certain extent, especially for artists. People who have issues they didn't resolve when they were younger often try to work it out in the present, even if they're not conscious of it.
So, from that theory, people who are poor in their childhood, they want to make films about rich people?

No, not necessarily. Maybe it'll be one aspect of a film. You're giving me a hard time now.
No, I don't think so. [*Laughs*]

BORING GUY

Tell me what your hobbies were before you entered filmmaking.
Actually, I'm a very boring guy.

I've read that before, but it can't be possible. There's something going on up there.
Not everybody is like Woody Allen, analyzing themselves and turning it into entertainment.

So you don't believe in analyzing too much.
You just react to things. And I think some people can be analytical, but in my case it's not. So actually, I don't have a lot of interesting things or colorful things that I can describe to you.

I'll give you an example: What was Chungking Express *a reaction to?*
I wanted to make a film about Hong Kong in those days, so the main characters are actually from the city.

How about for Happy Together*?*
Because I didn't want to make a film about Hong Kong. I wanted to go to Argentina. It was the farthest place

that we can reach from Hong Kong. It's the other side of the Earth. I think that's quite cool, right?

Definitely.
I think that's one of the advantages of being a filmmaker; you can travel and you can travel in time also. You can go back to 1962 or you can go to 2046. You can make ten seconds last forever or you can make ten years in one second.

PRACTICAL

That's very romantic of you. You don't consider yourself a romantic?
No. In a way I'm very practical.

How about your wife's birthday?
Buy something for her. I think there are so many things you buy for people now. You have to do something on Valentine's Day, and sometimes it becomes routine. I don't like it.

What's the craziest thing you've ever done?
Make a film.

How about before making films, because it seems like everything after a certain period in your life is all film.
To answer hundreds of questions every day. Don't you think it's crazy?

Yeah, I think it's pretty crazy. I wouldn't want to do it. I feel like I want to ask you another question. Are you bored right now?
No.

Are you agitated?
I'm fine.

You have your hand thing [*his finger drumming*]*.*
I always have this thing. 🐱

turns it around on Cheung. "More conservative" Claudine actually interviewed Cheung for *Giant Robot* as well and took great photos. It's just not published in this omnibus because our interview is not as "conservative."

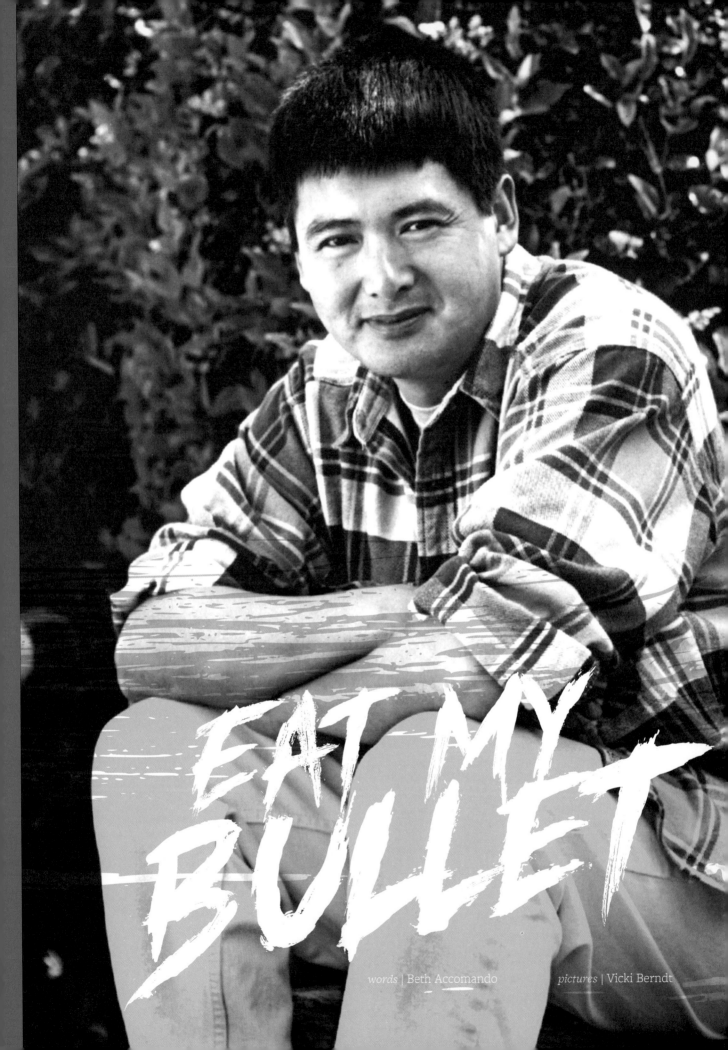

EAT MY BULLET

words | Beth Accomando *pictures* | Vicki Berndt

Give Chow Yun-fat a matchstick as a prop to nip between his teeth and suddenly the humble actor is transformed into one of his cocky characters. Chow may be one of the biggest stars in Hong Kong, but you'd never guess it from the way he presents himself in person. Arriving for his interview on foot, he walked to the Century City hotel from his LA residence down the street. Casually dressed, Chow travels without an entourage and immediately puts you at ease.

The cool and charismatic Chow has come to symbolize the irresistible, over-the-top, in-your-face Hong Kong film style. Not quite a household name in America, Chow has won a devoted following for the John Woo actioners *The Killer* and *Hard Boiled*. These tough-guy roles have earned him international fame. However, he has worked in every conceivable genre, with a quicksilver ability to move from outrageous slapstick to sensitive drama to macho action—sometimes within the same film.

When Woo was casting his breakthrough film *A Better Tomorrow* in 1986, he was looking for a modern knight, a man with real guts who would stand up for justice, someone with real personality and human qualities. "I read in the paper that Chow Yun-fat did a lot of work with orphans. This is what I was looking for. A strong man with a good heart," says Woo. The film derived its phenomenal success not only from Woo's rapturously stylized violence, but also from the empathy audiences felt with Chow's Mark character, a petty gangster who dies in the name of honor, friendship, and loyalty. This was the role that secured his place as a Hong Kong film deity.

Dubbed "the coolest actor in the world" by the *Los Angeles Times Magazine*, Chow shrugs off his star status and reveals genuine self-effacing modesty. Still, he's a bona fide superstar whose mere presence can guarantee even bad films good box office returns.

Currently, Chow is a megastar in Hong Kong, but the island's film industry faces uncertainty as 1997 approaches (even so, the Communists would love to see Chow, a national treasure, continue to make Chinese films). Hollywood also has plans for Chow. Everyone from Quentin Tarantino to Oliver Stone is supposedly courting him. As a result, Chow is now splitting his time between Hong Kong and Hollywood. Somehow, he found time in his busy schedule to spend an afternoon with *Giant Robot*.

THE REPLACEMENT KILLER

First of all, can you put an end to all the rumors and tell me what your first American project will be?
CHOW YUN-FAT: One with Columbia Pictures called *The Replacement Killers*. That seems to be my first American movie at this moment. And John Woo wants to make a movie with me next year after he finishes *Face/Off*. I appreciate that. I'm waiting to work with him again.

So The Replacement Killers would be the first one you shoot?
I hope so. Oh, by the way, there's another one attached to Universal Studios which is called *Heavy Metal* [laughs]. It's something like a future film. It's set in the year 2000 or something, and it talks about all the people in Los Angeles after an earthquake. The white people, the black people, and the Asian people each live in separate communities. I'm the guy who's picked as one of the leaders, a spiritual leader who passes through all the areas to send the men to

a place called Highland. It's a very interesting story. The topic is pretty hot because of the riots in Los Angeles. The executive producers at Universal Studios want to bring all the race problems together, and to try and use the movie to project their hope that all the people can live in harmony.

Are you trying to go for a different image from what most Americans probably have of you, which is that of the tough action hero?
Yes, it's totally different. But right now I really don't have the ability to pick out my projects. Even though people know who I am, there are only a few roles for Asian actors here. Even though some may know who I am because of my work with John Woo in so many films, the majority of the audiences in the United States is more or less thinking, "Who is Chow Yun-fat?" They don't know who I am. So the studio has to think about your commercial value. They have to think how much they can get back from the Asian market or Europe. They have to be confident to start a project for you. Otherwise, they have to answer questions from the sales department, the financial department, who'll ask, "You know this guy?" I need to have one or two projects starting now to let all the people know who I am. The studios have to base their decisions on the box office. The actor or the actress, the value of their performance—both sides have to balance.

Is there a director for The Replacement Killers yet?
No. Once they complete the deal, then we will look for the right director, the right actors. We have no idea right now because I am the new kid in town. My agents, they will arrange everything for me.

THE BIG BOSSES

Are there any directors that you would like to work with?
It's very difficult to say, because this kind of action movie will depend on who directs it. Of course they want John Woo to direct the film, but I don't think John Woo will be available, because he has a project with Paramount Pictures. I think next year he will have another project with me. My manager Terence [Chang] says that for my first American movie, it is important to work with one of the famous American directors. The studio would probably feel safer that way. Plus, if for my first American movie I work with John Woo again, people will feel that it is too much. So Terence wants me to work with a Hollywood director to get more inspiration, more experience. Then, once the movie is released he wants me, if I have time, to make an appearance in every big city doing the promotional tour. When I was here last time, I was stuck in Los Angeles all the time [*makes a face and laughs*].

Getting bored of the city?
No. I like the weather here and the people. The most important thing is that every day I've got two hours of English class. It's what I've wanted for my acting career for almost 20 years. I don't have a long period to take a rest—this is a

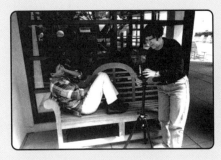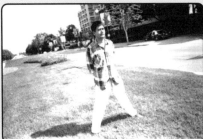

good time to take a rest. On the other hand, I have the opportunity to learn a new language. It's pretty good.

TALE OF TWO CITIES

Are you worried at all about what's going to happen to Hong Kong in 1997 when China takes over?
Not at all. Not at all.

You don't think it will change the film industry at all?
Ummm. A little bit, but it's not a big deal. Every new government has some new policy, but I don't think they will hurt Hong Kong. I don't think so.

When I interviewed directors Mabel Cheung and Wong Kar-wai, they almost seemed to welcome the change. They said it may shake things up and get the industry out of its slump, and allow for more artistic rather than commercial projects.
Yeah, because the Hong Kong government and the British government won't support the Hong Kong movie industry, because this is one of the colonies, it's not British culture [*laughs*]. It's not like Los Angeles. The government, the county itself, they give a lot of support and this is great for the film industry here. But in Hong Kong, no. Never. Even though we apply for the permit for location shooting, the police won't allow you to have the permit. So [*laughs*], we're always breaking the law, you know. Shooting on the streets without a permit. Sometimes we apply for a permit to shoot some government building or office or maybe the police stations, but they won't allow us to do it. So we set up the set by ourselves and we always have a lot of friction with the police and the government.

MONEY SHOTS

Now with very elaborate action scenes, like the opening teahouse scene in Hard Boiled, *how many days does it take to shoot?*
Not including the explosion shot, more than 10 days, just for the opening sequence. Of course, John Woo did a good job. He tries his best, and the film crew gives him a lot of support and the film company, the board, gives him a lot of support. Here, I think the studio won't allow him to extend the shooting a few more days. Actually the schedule for that scene had been seven days only, but he extended it three days more because he wanted to get more exposure, more action-packed.

And whose idea was it to have you slide down the banister with two guns? That was a great shot.
You like that?

Yes.
[*Laughs*] I don't know why the ladies like the action-packed more than the drama.

Well, I think just in terms of pure cinema, the way the camera moves, it's just exhilarating to watch a well-staged action sequence in a film.
More than what Hollywood movies are doing with more computer works?

Yeah, that gets old, but Hong Kong films just have a way of moving a camera through action that just gives it an intoxicating energy.
Not like the typical Hollywood movie that goes one shot by one shot. But that's because in Hong Kong the space is not like in Hollywood.

In the Hollywood studios, you have more room, more space, I mean for the dimension for the camera, for the screen. But in Hong Kong, our buildings, our rooms are narrow, so we must use a lot of action or movement because the depth is not enough to expand the whole images in the picture. So we must use a lot of movement. Also, we must use a lot of wide-angle lenses to enlarge the environment, the space. So every time you see actors in the movie we look wider, fatter because the lens can make the people like that [*puffs up his cheeks for emphasis*]. Usually, here we are using 50mm lenses for the close-up or 85mm lens. But in Hong Kong we use 35mm or 28mm, because the depth is not enough.

MONEY ON FIRE

What I also like about your performances are the details, the little bits of business the characters do that define them in an instant. Like lighting up the cigarette with the hundred dollar counterfeit bill in A Better Tomorrow *or flipping the butterfly switchblade in* Full Contact. *Do you come up with those bits of business? Do you work with the director in creating them?*
Usually, once they have the script, we will sit together maybe three times, four times, to go through all the dialogue. Other than that, you have to bring back the script to your home and study for a week and then we study together the details, the build-up, the character, the whole development of the character, inside and out. So, we have a lot of ideas to put in the character. If the director feels that using a bill to light up a cigarette will fit the

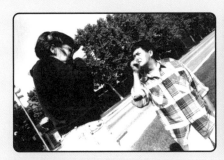
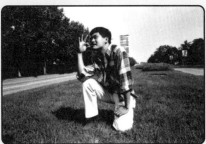
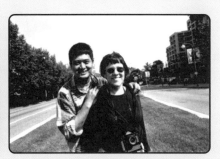

character, he will let you do it. It is very flexible. Even though on location we have, all of a sudden, a flash or a quick idea, or maybe I put a little bit of this in because I saw something in the script that made me say, "Ah, this will be fun." But other times, it happens on location suddenly. It happens, and the director thinks this situation is good for the script. I mean, if it's good for the role, he will allow you to do it. So it's very flexible, even though if you were to ask Mabel Cheung and Wong Kar-wai, [they might say], "He has a lot of crazy ideas on the locations." But they don't stick to the script either, especially Wong Kar-wai [*laughs*].

Oh yeah?
Oh yeah! He likes to get the real details from the actors and actresses. He wants to find the true spirit, the true Chow Yun-fat or the true actor from their body, from their blood, more than stick to the dialogue.

I don't remember any film you did with Wong Kar-wai. Have you worked with him?
Before, we were supposed to have a chance to work together, when he was still a scriptwriter. It didn't work out, but we know each other real well.

MEANWHILE, BACK IN HONG KONG

Are you planning to make any more films in Hong Kong at this point?
I will go back to Hong Kong to make a lot of movies if I can work with people like Zhang Yimou. But I hope I spend a lot of time to make my first American movie, this is my major purpose to stay in Los Angeles.

So you don't have anything lined up in Hong Kong?
A few months before I came here, I met Wong Kar-wai and he was supposed to have a project for me and him to work together, with Gong Li, as well. It sounds very good. I'm excited. So maybe next year, maybe after my first American movie I will work with Wong Kar-wai, maybe. It depends on the script.

INSIDE CHOW

What kind of image do you think American audiences have of you? You made the cover of the LA Times Magazine which dubbed you "the coolest actor in the world." Is that the kind of image that you want the American public to have of you? Or would you prefer that they also see your other work, your comedies, your dramas?
I appreciate that they gave the cover to me, but people will maybe misunderstand "the coolest actor in the world." <u>Maybe "the coolest guy" means you can do anything, but I prefer the audience to see that I can do a comedy, drama, action, or more, and understand me inside.</u>

Do you have a favorite role?
A lot, like *A Better Tomorrow I*, like *The Killer*, like Mabel Cheung's *An Autumn's Tale*. I made a film in 1981 with Ann Hui called *The Story of Woo Viet*, and one that's called *Hong Kong 1941*, and *City on Fire* with Ringo Lam.

Are there any films you wish you hadn't made?
A lot, a lot. <u>I made more than 70 films, and of course I made a lot of bad films. Making films is my job, okay?</u>

<u>I'm an actor and I'm not a god, you know?</u> You have to survive. Even in Hollywood, some people want to make the big movies and some artists, they want to pick up some art films. Even though they play a small role, they want the audience to know that they prefer the art performance rather than the commercial value of the movie sometimes. Of course, in Hong Kong, more than 85 percent are commercial films, but sometimes we pick up some art films like Mabel Cheung or Wong Kar-wai or some Stanley Kwan.

Which of your roles is most like you?
None of them. Because I am quite the family man. For my job, I'm on location all week—talk, talk, talk about the dialogue, associating with the people. So every time I go back home, I stay quiet.

Would you ever redo a part that you had already done before?
You mean like *A Better Tomorrow Part II* and *III*?

No, I mean more like if an American studio wanted to remake The Killer.
No. Tristar wanted me to make *The Killer* again, but I said, "No, no, not again." I mean, it's very difficult to make it better than the original. You put yourself under a lot of pressure.

TVB GUIDE

You started in TV right?
Yeah. In 1973, after I left high school. Actually, I never finished my high school. I worked at different kinds of jobs—factory worker, postman's assistant, sales assistant, office boy, you know. Then I saw one of the bigger stations called TVB—Hong Kong Television Broadcast Company, Ltd.—

they have an advertisement on TV and in the newspaper that they need new blood. So I pick up the phone, and about two weeks later they send me back an interview letter, and then they chose me for a class. I took one-year training. Then I graduate in 1974, and from 1974, I start my contract until 1986.

What kinds of TV shows were you doing?
Mostly drama, and comedy, the action type, the old Chinese stories.

Were they series?
Yes, series.

What kind of a pace were you working at in television? That must have been hectic also.
[*Hangs his head and sighs*] I am still young. I can afford it. I tell you what, you had to get up at 6:00, because 6:30 or 7:00 you have to get to the station for make-up. Usually for the males, thirty minutes for make-up, for the ladies, one hour. At 8:00 sharp you have to go to the location for shooting, okay? Then, on location shooting for several hours, then after lunch you have to go back to the studio for the recording—for the studio recording, okay?—until midnight or sometimes one or two o'clock in the morning, but usually they just stick to twelve. You can see that it's almost 18 hours, more than 18 hours per day. If you want to have the leading roles, you must work hard for the whole period. You know what I did, the longest series was 128 episodes, it took about seven months. So in this period, I think you see the actors and actresses more than you see your own father and mother, you're on the set and location more. So it's pretty hard, pretty tough. Doing a series is just like working in a factory. But on the other hand, I can say that I appreciate what I did for the TV station because it is a very good acting foundation. It's good training, because you have the opportunity to play different roles and you learn to survive in very bad conditions. **Even though you are not sleeping enough, even though you are not in very good condition, you have to concentrate to play your role. It's one kind of struggle of your spirit.**

Was TV shooting more like working on the stage? Were you allowed longer takes and allowed to work more in sequence than in film?
Shooting back at the TV studio, it's like acting machines. You know, nonstop. One day you can shoot—for my record—46 scenes; scenes, not shots.

HANGING WITH RINGO

I heard that you were in an acting class with Ringo Lam at TVB?
Yeah, we were schoolmates.

What was that like?
Every day we spent three hours, six days a week on the acting training, acting skill, make-up, modern dancing, ballet dancing, Chinese dancing, some martial arts, speech, stage play.

And how was it to be in a class with Ringo Lam?
Once we graduated, he was the first guy to play in 25 episodes of a TV series. He played the main role, supposedly the leading actor, so everybody was so jealous of him [*laughs*]. After we graduated, he was one of the biggest stars in Hong Kong in 1974 on TV. After that, he got bored and didn't like to act. He was too stiff, and he found out acting was too tough for him, so he quit to become an assistant director for one of the famous TV directors at the TV station. So after a few years, he become a TV station director.

What kind of director is he to work with? I've heard that he describes himself as a devil on the set. You have worked with him on a number of films.
We worked together on *City on Fire*, *Full Contact*, *Prison on Fire I and II*, and another one called *Wild Search*. Probably five films.

So do you like working with him?
Ahhh. [*He hangs his head then shakes it as if to avoid the question*]

You don't want to talk about it?
[*Laughs*] We are very good friends. We are close friends, but on location, he is totally another kind of alien, an alien from another planet, out of his mind [*laughs again*]. Actually, he is a very good director. What he needs is, for every scene, every moment in the picture, in the camera, he wants the real thing. So this is very difficult, very difficult to work with him to get it. But for an actor or an actress, this is very good training to work with a director who really wants your real stuff from your heart, from your soul. He also didn't like to use the stuntmen. He always wants you to do it yourself, all the time [*laughs heartily*]. So as the actor gets older and older, some physical things he cannot do, you know? It's too tough for the actor. No matter how much he uses camera tricks to help you, he must see your face in the picture. So it's a lot of fun, a lot of hard times, a lot of patience to work with Ringo Lam.

CHINESE SHAKESPEARE

You recently did a stage play?
Yeah. Actually, back in 1973, we actually did stage play training. We did a lot of the Chinese Shakespeare [*laughs*]. But after we graduate we mostly stick to TV, almost 100 percent. But 10 years later, all the schoolmates from different years we join together to make an association and our goal, the main thing, is to gather all the people together. The second thing is, we hope to do something that we learned before, but didn't have a chance to do. Now we have the opportunity to set up an association where we can do it, and **the most important thing is that we do all the shows for the charities. Nobody can get a dime, just free of charge. Everything is free of charge. It's very meaningful. It's very interesting.** And one thing I'm glad about is that a lot of the schoolmates didn't see each other for a long, long time and this allows us to work together. Actually, stage plays are our interests, our hobby, and a lot of fun, too. We did one called *Run For Your Wife*, basically it's a story from London, a very famous stage play from London by

a writer called Ray Cooley. We bought the rights, we translate it to Mandarin and Cantonese, and we play it more than a hundred times already within five years. We even performed in Los Angeles's Chinatown, in Toronto's Chinatown. In Vancouver, in New York City, in Singapore, in Malaysia.

Did you put out a CD recently?
Yes, for charity as well.

Did you enjoy doing that?
A lot of fun, yeah. In the training class we had the singing lessons, but I always got the D grade [*laughs*]. But for the past several years, I want to prove to everybody I can sing, I'm a singer [*laughs*]. But after a few records, I say forget it [*laughs*].

HIGH-RISK INSURANCE

What do you find more difficult to do, comedy or drama?
The action-packed films.

The action films are the most difficult? Why?
The action-packed, you have to face the explosions, you have to face the physical problems because you can really get hurt.

Have you ever gotten hurt?
Oh yeah, a lot. But it's not a big deal, because no insurance company in Hong Kong will allow the actor or the stuntman to buy insurance, because the action-packed films are really crazy. Even Jackie Chan, no one wants to insure him. It's terrible. Comedy is the second most difficult for me because if you want to perform it, it is very important to stick to your body language. Like Jim Carrey, he has a lot of body movement—the jaw, the eyes, the hair, everything. It has to move to make people laugh. It's very, very difficult. And it depends on the script. Some use the dialogue. The actor doesn't have much emotion, just the dialogue. So it depends on what kind of role you want to play.

DIDN'T GET SHORTY

Would you like to make a comedy here?
I think it would be difficult to do because a lot of in-jokes I don't pick up, I don't understand. I saw *Get Shorty* with a lot of Hollywood jokes. The inside jokes, I cannot get them. So if I want to make a comedy, I must stick to the script, and try to get more inspiration from the local people. Also, I have to watch more TV series because a lot of the in-jokes are from TV, from gossip—a lot of different sources go into the movies. Sometimes I cannot get it because of the local slang. Some of the American in-jokes, if you're not staying here and you don't know the culture or customs then you don't know what is going on in the movie. It's difficult. But I will try if I have the opportunity.

Some of your Hong Kong comedies are wonderful. You seem to have a real flair for comedy even in a dramatic film. You have a self-deprecating sense of humor,

you almost make fun of your own image.
Yeah right. It seems to me that in American movies they won't let the hero do both sides.

TRIADS

I was wondering if you could talk a little about the Triads and how they function in the film industry? We hear a lot of stories here about Triad infiltration into the film industry in Hong Kong.
If the Triads were a real serious problem in Hong Kong movies, I don't think we would survive for so long. I mean the Hong Kong movie industry. They just respect the industry. They stick to the rules. Everyone can invest money in the film business. I hear that the Mafia controls the film business here. It's the same. We have a funny saying that if everybody is in the gangs, if the film industry is totally controlled by the gangs, then there are no more gangs because they are all businessmen. Actually it is not a big deal.

MOONLIGHTING

Back in the '80s, there were times when you made something like a dozen films a year. How difficult was that to do? Are you just shooting constantly?
Yes, simultaneously shooting four films together.

Mabel Cheung said that she couldn't change the hairstyle on her actresses because when they left her set they were going to another one.
Yeah, right.

So do you ever forget which film you are doing?
No, you walk on the set and see the people, the different director, they show you the different costumes or put on your wig, and you are the other guy. I mean, it is one kind of way to survive in the Hong Kong film industry. We don't have very large budgets for the production, so the studio won't pay a lot of money for hiring the star. So everybody wants to work hard for more money before 1997. It's pretty tough, though. Sometimes I'm so jealous that the stars here can take two years, three years to make a movie. But in Hong Kong if you take three years, four years to make a movie, you die. You cannot survive like that. It's tough, but it is the way that we treat ourselves to be a star. Sometimes everyone is proud of themselves when they make twelve films in a year, but on the other hand there is a sadness. There is a sadness. I feel shame that we have been working like a dog like this.

You're not still working at that pace now, are you?
[*Sighs*] I cannot stand it.

A REAL JOB

What kind of a childhood did you have? Did you go to the movies a lot? Is that how you got interested in

acting? Were you a class clown and always wanting attention?

Oh no. When I saw the advertisement in the newspaper in 1973, my first impression is that this kind of job is quite funny, it's very interesting. I have the feeling that I didn't want to do a nine-to-five job. When I picked up the form, I was actually working at a job in one of the hotels, during the training class I am still working in the daytime and at nighttime I go to school. So I just take up to one year training, and I learn something that I'm wondering, is this really interesting to take a look at. I don't think that someday I can be an actor. But after the training, I feel that this is my real job. Because you don't have to stick to the office working hours of nine-to-five. This is what I wanted. The lifestyle is very fit for me. Once I become an actor I find that TV working hours are worse than the office hours. But I enjoy it, I love it. Because when I sign the contract, I feel that I got married to the acting. My job is one part of my body, I cannot live anywhere without it. It's a very interesting feeling. When I was young I saw a lot of the Canton Opera. This is very interesting because they put on a lot of make-up, everything is so dramatic, you are on the stage with the music, the live band. I was born on one small island, and every year they have this kind of festival, it is called Goddess of the Sea. This goddess protects the fishermen, so every year the fishermen have a celebration, and they invite the opera to do the show and to appreciate the goddess who has protected them the whole year. So it's a sign of respect. So in childhood, every year we have a chance to see this kind of opera, the Cantonese Opera. It is very interesting because they light up the stage, you can see very colorful costumes, the sound, the music, and all the people in the audience are chewing the peanuts, the sugar cane. It's a lot of fun, you know. I think it is one of the strong impressions. When I was 10 years old, my whole family moved to Hong Kong. My mother worked for one family as a servant,

so I was sent to a boarding school. So every two weeks I have to go back to the apartment where my mother worked, but the owner, one of the ladies, is a very decent woman, and she likes movies very much. So every two weeks she brings me to the cinema. So that was the first time I saw the cinema picture. My first impression is, "How can people act on the wall, on paper?" I saw stage plays and the actor is on the stage, but the first time I'm in the cinema, I see the man was on the paper, on the screen. "How? How can they do this? How? And they can talk. Wow. Very strange, yes." So after that, every two weeks I must have a movie gathering with the owner.

Were they local or American films?

They were American films. She liked American movies. And during the '60s a lot of the good movies like *The Longest Day*, *The Great Escape*, a lot of war films. John Wayne is one of our idols. And Montgomery Clift, yes. And Clint Eastwood. And a lot of TV series were very popular, too, in the late '60s, early '70s.

What kind of films do you watch now?

Oh, the comedies, drama, action, everything. As a member of the audience, I enjoy them. I don't mind lining up with the people in Century City. **I just want to treat myself like ordinary people going to the theater as a kind of leisure to share with the audience together. I just want to sit there with my popcorn and Coke and watch the movie and have fun.**

NO BIG DEAL

You don't seem to be very comfortable with the label of star. How do you see yourself? Do you see yourself as a big star?

I don't think "star" is very suitable for me. Because my behavior, my attitude, it's worse than a star.

I don't have a limo, I don't have a bodyguard, I don't dress well. I don't have diamonds and gold chains and a gold watch. I don't have money in my pockets. I think I am worse than ordinary people under normal conditions. I go to the market, I cook myself, I don't have any servants. No chauffeur. So I think maybe my attitudes come from being poor, I stick to the poor. Even though I have a very good lifestyle, but basically what I came from is based on the lifestyle that I had. I don't want to isolate myself from the crowd, from the audiences. Not because I want to do some research or to get some inspiration from audiences, but because it is my real life, it is what I want. This is my real life. I believe that I communicate with the people, I'm so happy I feel that I'm a man. But when I'm attached to one of the premiere gatherings and parties, I feel that I am in a dream, in a fantasy. I am lucky that I can cross in and out of two worlds. But basically what I want is the reality. It's quite amazing; I like the market. Human life is from the market. The fishermen catch the fish and put them in the market; the farmers put the vegetables in the market. Everything, all in there. You pick up the energy from the market and go back home to

If you don't eat his rice, Chow will give you his mad dog.

make the sauces, to make the food to give yourself energy. So I think the energy for me is all in the market. I like the market because I can see all different kinds of people. No matter if you are a princess or a king, you have to go to the market. **Everybody needs food, it's a very important thing, so one of my hobbies is cooking.** I like cooking. And back to what you were asking, "Do people treat me in Hong Kong as a superstar?" The people actually don't treat me like a star, they treat me like an elder brother. They get used to my living style. They know who I am. Every day I go to the market. I'm not a big deal. No big deal. I'm just like ordinary people. They won't treat me good, they won't treat me bad. They treat me just like any other customer.

Do you think audiences tend to blur the line between your roles and your off-screen personality?

They don't believe that a star like that can walk into the market every day and dressing so lousy, with slippers on or just a T-shirt on. Sometimes, I'm driving a very lousy car. Some people say, "This doesn't match your situation. You must drive a Rolls Royce or something." But no. No, not a big deal. The most important thing is that people treat you like a star more than you treat yourself like a star. That's the point. **Some actors and actresses, they treat themselves always as stars, but the audience says, "I don't think so." If I don't treat myself as a star, but I treat myself just as an actor and you treat me as a star then [*he bows*] I appreciate it. Thank you.**

So you like to cook?

Very much.

Do you have a specialty?

Some Chinese food, steamed fish. What I learn is from my mother. My mother was a very good cook. She can cook anything. She taught me how to cook. But some things, some specialties, I still cannot cook. In Hong Kong, we mix with a lot of different specialties like Chinese food, Peking food, Taiwan, even the European food, and American food. A lot, so you can mix all different kinds of ingredients together to create your own style. Because in the market every day, the fish is fresh, the chickens can run all the time, you pick it up, everything is fresh. In Hong Kong, you can even buy the snake. A lot of things that you cannot imagine we can get in Hong Kong. It's fantastic.

So, do you miss the food?

Oh yeah.

Do you feel any pressure that you have to somehow represent a whole country?

I don't think so. Not a big deal. The pressure is that I have to face my wife and my manager because they give me a lot of encouragement. The pressure is from my English teacher: "You have to do this exercise for tomorrow, this, this, this." Ahhh. It's difficult to absorb, a lot of the idioms, the pronunciation,

the vocabulary. I cannot digest it. Every time I say, "Sir, give me a break. Slow down, slow down." I mean in reality, in real life, the pressures are more than in the film life. What I want to say is that the most important thing, no matter how painful or how happy, enjoy the moment. Who knows what happens tomorrow? Of course, the main purpose that I'm staying here is to make a movie. On the other hand, it is also to enjoy my life. To meet nice people here, learning my English. 🎬

BETH: I met [Chow Yun-fat] at a hotel restaurant and remember that he had WALKED over from where he was staying. No entourage, no car with a driver dropping him off. He was so charmingly casual. Then GR wanted to do a photo shoot with him for the cover. He was very reluctant, genuinely shy. He kept saying he felt silly and didn't like doing that. But we went up to a rooftop patio and the photographer was asking him to strike an action pose and Chow just seemed awkward and again very shy. Then I remembered I had some wooden matches and remembered how his character, Mark in A Better Tomorrow, had famously flipped a matchstick between his teeth. So I handed the matchstick to Chow, he put it between his teeth, and suddenly he was Mark. He was no longer shy, he was grinning confidently, and he even agreed to go down to the street and pose on the island in the middle of the road to strike an action pose. That became the cover.

He was just effortlessly charming and gracious, and this is one of my all-time favorite interviews. We were so young and passionate back then and just wanted to share our love for these people and films, and I don't think there was money involved. Maybe Eric remembers. I got these interviews through my public radio job and was paid for that but then used the full interviews for GR. Always appreciated having them as an outlet for these interviews.

ERIC: This was an awesome day. I was there as well, uncredited, but helped out. Mr. Chow Yun-fat was an unknown commodity to most of the USA, but to me he was a larger-than-life superhero and as a person, he delivered as well. He was humble as he jaywalked from his apartment, wearing street clothes instead of a blood-stained suit. He posed for photos shot by Vicki after the interview by Beth, and I shot some as well. He's a performer, and gave us whatever we needed without a hint of needing to rush off.

I'm unsure if people would say that he succeeded in coming to America to be a star, but what did transfer is the fact that he's only a leading actor and not a sidekick buddy. Interesting how that works everywhere.

BONE-BREAKING STUNTS, A SWEET SMILE, AND SOME FISTS OF FURY FLY OUT OF THIS EX-BEAUTY QUEEN TURNED ACTION FILM STAR.

This summer, mainstream America got its first taste of Michelle Yeoh when Miramax released a dubbed and edited version of 1992's *Supercop* (the third installment of Jackie Chan's popular *Police Story* films). The Hong Kong hit has Chan sent to China, where he and Yeoh go undercover to break up a crime syndicate. Their assignment ends with a chase involving Chan leaping from a building to a rope ladder dangling from a helicopter and Yeoh jumping a motorcycle onto a moving train.

The film's director, ex-stuntman Stanley Tong, thought it would be a good idea to team up Yeoh with Chan. "Never before in a Jackie Chan movie can you see a girl who can fight," he explained. "It became competitive, and the film benefits because you're not just seeing him; you're seeing another action star who's female and they're both raising each other up one notch." She and Chan risk life and limb with such reckless abandon that it's easy to forget how truly dangerous the stunts really are.

Although Miramax tried to package Yeoh as something new, the Hong Kong film industry and its fans have been enjoying Yeoh's work for years. Yeoh first gained attention as a tough cop in *Yes, Madam!* (1985). Then, after only a few films, she married producer Dickson Poon, but they divorced. Afterward, *Supercop* marked her comeback.

In addition to playing the cop role in *Yes, Madam!*, Yeoh displayed her martial arts skills in such period films as *The Tai Chi Master* (1993), *Wing Chun* (1994), and futuristic fantasies such as *The Heroic Trio* (1993) and its dark sequel, *The Executioners* (1994). Her stuntwork in *Supercop* earned her a spin-off, *Supercop 2* (a.k.a. *Project S*, 1993), and most recently, she played a dramatic role alongside Maggie Cheung and Cherie Chung in a historic epic, *The Soong Sisters* (1995).

Giant Robot met Yeoh at Miramax's Los Angeles office when she was in town to dub *Supercop* into English. It was hard to believe that this petite, good-humored, one-time beauty queen was the same lethal lady who tears up the screen with such focus and intensity.

SUPER
MICHELLE

ERIC: It's more than obvious that the greatest export from Hong Kong cinema is Michelle Yeoh. Her career spans decades, but her footprint in North America is

Okay, So how does a Miss Malaysia beauty contest winner become the top female action star in Hong Kong?
MICHELLE YEOH: I knew it was gonna come back to me one day. I studied in England and when I graduated I was home for my holidays, and I was waiting to go back to England to finish my masters in dance. For some reason, my mom and her friends thought that it was going to be a great experience and basically good fun for me to be in a beauty contest. So they entered me without my knowledge. For a year I was Miss Malaysia and as the year came to an end, I was offered to do a commercial in Hong Kong. Somebody had Jackie Chan agree to do this commercial and he was trying to find the right girl. And my friend suggested me. So I hopped on a plane, got there, and did the commercial, and then they offered me a film contract for two years. Twelve years ago, if someone had come up to me and said one day you are going to be an actress, I would have laughed my head off. I had always wanted to be a dancer, I had always wanted to be a choreographer, I had always wanted to be a teacher, anything to do with dance. Anything to do with drama was the furthest thing from my mind. Because when I did my Bachelor of Arts degree, I minored in drama because I figured drama would help me with my expression, but the English take drama very seriously, in the sense that you are always studying Shakespeare and Ibsen, and oh my god, it just went on and on. I used to hate it with such a passion. But that's how I went from being a beauty queen to doing a commercial, and the next thing I knew I was an actress.

You had been trained as a ballet dancer...so how was it moving into martial arts work?
It was a tremendous asset. Every little girl should have the opportunity to have ballet training because it teaches you such control of your body. But for me, ever since I could walk, I mean I think I danced before I walked. At the age of four I had been going to ballet classes because I loved movement. I was very sporty when I was a kid. I was always on the athletics team, I was a swimmer, I was a diver, I was a squash player, everything to do with movement. So when they approached me to do an action movie, it felt like the next right thing to do. It was more movement and more challenges and new things to do. So I got very obsessed, in a way, with it. Which was good, because it was necessary. You had to be very dedicated, and having a dance background

helped because I was very focused mentally and physically on a certain art form, and now it was a new art form. It was similar, yet different. So having that as a background made it easier in the transition. But then of course, once I was there, I discovered that dance was very different from martial arts [*laughs*]. And it took me a long time, it took a lot of hard work. It took many hours just to get the little details. Getting the power and the force and the energy, you just have to practice very hard, punching into a bag, having someone to spar with you and holding a punch bag up for you. You're doing like a few hundred kicks this way and that way. As long as you're dedicated, it will come to you. But what I had to learn was that being a martial artist is a very specific kind of look—it's the little details, the little movements of the shoulder, of the hand, of the head, that completed the whole image. **I don't profess to be, I can't profess to be, a martial artist because I've never been formally trained. I've never gone through the belts system because I never had the time in that way. Once I started a movie, I was literally thrown in the deep end. Learning has been a lot of pain [*laughs*] but fortunately it's been fun.**

Now you do a lot of stunt work in addition to the martial arts. How is that to do?
For me it was just totally unacceptable that someone else would do my stunts. It was supposed to be me, so why should anybody else do it? It was a big barrier to break at that time for the directors and the coordinators because when I started to do action movies it was already such a new thing, a woman doing action movies? My god. My director, I swear, for a few weeks he couldn't sleep. It was going to be one of his first movies back in Hong Kong and he would be doing an action movie which he was very well-known for doing, but with women, with girls, a beauty queen, a dancer. So I could imagine all the nightmares he was having. But when we started to work on the movie, he insisted that he meet me and train with me. So I think at the time when he came to watch me train, he became more convinced that I was willing to take the blows and that I wasn't going to be like a pansy and cry every single time someone took a hit at me. So that just broke open the doors for me and for women coming in to do action movies. But the **stunt work is something that I choose to do myself because it is such a thrill to be able to do it.** I remember the very first movie I did, I used to stand there and think, "He can do it, why can't I." You know? He hasn't got an extra arm or an

YEOH

words | Beth Accomando

Michelle Yeoh on the dirt bike jumps off of a hillside ramp and onto a moving train. She actually lands in between two cars, but makes it, and then skids out, letting the motorcycle falling off of the side. The outtakes at the end show her biting the dust a

extra leg. It's physically possible. It's such a kick to be standing, like, three floors up and take a dive, you have to be a little bit crazy but when you get past that stage, it's awesome.

In a lot of your films now, there is a lot of wire work. How does that compare to doing the martial arts work, the more realistic action work?

Well, in period movies, because of the Chinese period history and background, you find that people at that time, people with martial arts, could fly. They could walk on water and now we can't do it without the help of wires. And actually, it is not fun. Because you are just strapped into a corset the whole time, and you have no control of your movements. You are trying to stay there and hoping nothing snaps around you. And in Hong Kong they have to use wires that are thin enough so that they can hide it on the screen because we can't afford to have them erased on computers. I wish we could, then we could have cables and we would be very happy hanging there for the entire day. But you are hanging there very precariously, your entire life is really on the line, on this thin little wire. And there are four or five guys on the other side of the cable who are holding on to your life. And these poor guys are running around trying to make you fly. And if one of them trips, it's quite a nasty little experience for you. And wires have been known to break. I prefer more contemporary work because it is a little bit more realistic. In a way, it is harder work, but to me it is more fulfilling.

The first action film you did was Yes, Madam! So how was that received at the time?

Well, it was so good that I've been doing action movies ever since. When we came out with it, we thought, well, the women will like it. We were confident that the women would not turn their backs on us. But the most amazing thing was that the men loved it. The men were the ones who dragged their girlfriends. *Yes, Madam!* was also very pleasing to the eye because of the kind of martial arts that we did. We didn't want it to be too hard-core, we wanted the family to be able to come in and watch it. At the same time, we wanted to be able to convince these people that we were fighting for real, we were not just messing around and having a good time out there. So we did a few big stunts, but the style of fighting was a little bit more acrobatic. We took the advantage of being women, and used that grace [that] if a guy did it they would probably go, "Ummm? That looks a little funny." But with women it worked a lot better—we didn't want to be very butch and very hard in that way. So that movie just really made it for me. It made me an action star overnight. Literally in Asia. It's been like that since.

Do you specialize in a particular style of martial arts?

I do a number of different kinds. I wouldn't dare to say that I do a particular style, it's too embarrassing. You see, every time I do a movie, if you do a contemporary movie there is no particular style, you don't have to end up doing the Tiger Claw or whatever, it is only people like Jet Li who does period movies who end up doing it in that way. Then that kind of martial arts was the thing to do. Like in the Jackie Chan's films *Supercop*, it's contemporary. If you were faced with that situation, you're not going to go [*demonstrates a stylized martial arts stance*], you don't have time for that. You just go in there and get out of that situation. When it comes to modern-day street fighting, you just go in there and kill the person, beat his head in.

One thing that impressed me about the Hong Kong films is that there are many strong female action stars. In America you can point to Aliens and Terminator 2 for female action roles, but that's about it.

But I think it's gonna change here in the states. Hopefully, *Supercop* is gonna make a difference. I also think here with action movies, with the safety standard, many things are not allowed to be done on a set. Whereas in Hong Kong, it's so much more flexible. So I think that makes a big difference here. Maybe it's because some producers think the audience here is not ready or was not ready to accept that. But when you approach a subject like this, you can't test it with a little tap. You can't have the woman come out and do two things and then think, okay, let's see if that's gonna work. You have to hit them in the face and get them going with that and take them by the hand, and let's run together and have fun, and hopefully this is what's going to happen.

Can you describe some of the stunts you did for Supercop?

Oh, my god. Actually when I was dubbing the film, I was standing there with my mouth open, going, "I can't believe I did that." Both Jackie and myself, we do some really mind-boggling stunts. The audience must remember that we don't work with and did not work with blue screens or green screens, no digital effects—the moving train, the helicopter, the bike scenes that you see are for real. It was so funny because I had someone watch this movie with me and they were going, "Wow, the blue screen effects in Hong Kong are really good." I was going, "There's none. That's a real train, that's the real background. That train is really chugging along." I'm actually amazed that I actually walked out from that movie and was still in one piece. **I do an incredible bike stunt and I think the most incredible thing is that I learned to ride the bike about two weeks before I was supposed to do the stunt.** And until

couple of times, once going over the side of the train herself.

today, I still haven't learned how to stop a bike. I just know how to get on the bike, rev it up, make it go really fast, get to where I want to go, and jump off. I could have really hurt myself really bad in that movie. I was rolling off the top of a van and onto another moving car which Jackie was driving. And I had fallen...well, you know when things are moving around, you sometimes can't find the right spot to land, and at that time I just completely missed it. I was very lucky that Jackie was there and he literally saved my neck. If not, I would have just slid off the car and gone crashing head down onto the road. And that is an outtake that you will be able to see at the end of the movie.

Now how was Jackie to work with? I had interviewed Stanley Tong and he said there was a good sense of competitiveness between the two of you.

I think competition is good, but it was very healthy competition because Jackie has always been like my big brother. He was always the gentleman, he was always trying to watch out for me. He was always going up to Stanley saying, "She's not going to do that. It's too dangerous." Then he would come up to me and say, "It's okay, Michelle, I already told Stanley that it's too dangerous for you to do. You don't have to be hanging off the side of the van for that shot." Stanley and I have also known each other for a long time, ever since Stanley was a stuntman in one of my previous movies. So we all go back a long ways. So we all know each other's character and personalities very, very well. Too well! At the beginning of the movie, it was Stanley who persuaded me to do this movie because I had taken like a three- or four-year break from the industry. And it was him who came to me with this

movie and said that it would be his first major big movie and he had Jackie Chan, the biggest male action star. He was very sweet to say that I was the biggest female action star, though retired at that time. I chose to work with them because it was good to come out in a new movie with friends that were so close. It was like family, but I had a big condition for Stanley at that time. If I came out and did this movie with Jackie, I was not going to be one of his other girls who always got bullied in the movie who never got to do any action. I wanted to be another Jackie Chan on the screen. Jackie being Jackie was like, "Okay, let's see what you can do." And so, it was great. When we got there and we started to work on the movie, it was like sparks began to hit the air. It was like you're gonna do this, then I'm gonna have to do that. **And it's tougher on Jackie because for me, as a woman, you always have that edge in the sense that people don't expect that much from you. And then when I do something, Jackie has to do three times more. Just to balance it out. And it is very unfair to him. I mean I was dying to do the helicopter scene. And then Stanley would say to me, "Michelle, wake up, if you do the helicopter scene, what is poor Jackie going to do?"** [*laughs*] That was the thing. That's the intensity that you see in *Supercop*. It was great fun because it was not unfriendly, we were just trying to outdo each other, but in the nicest possible way. And when you are working with someone that you know so well, it just makes life so much easier. You can go up to that person and say, "I'm gonna kill you," and then two seconds later everything is going to be okay.

Now how are the different action directors to work with? Does each one have a completely different style?

They are all very different because they have been brought up in different schools of training. For someone like Sammo Hung, Yuen Kuei, and Yuen Woo-ping, they have been brought up in the old style. Like Yuen Woo-ping does a lot of Jet Li's movies. And you can see that being reflected in the movies that he does, because he does the old form of the martial arts, and he is brilliant in that. Then Stanley Tong is more contemporary, and I think he prefers to do more contemporary things with the

stunt work and the action. It's very important for me who I work with, because every single time you go up and you do a stunt, you are putting your life at risk. If your stunt coordinators or your stunt boys weren't on the lookout for you, if something happens, the key thing is if something happens, they are supposed to grab you, they are supposed to save you. So it is very important for me to be so confident in these guys that even though I know that I am taking a risk, it's okay, because if I can't pull out of it, I'm gonna have my guys there, and that gives me the confidence to go ahead and do something. Because you literally put your life in their hands, and say, "Don't mess with it." It's very precious.

What kind of injuries have you sustained during your films?
Oh, god. I swear, the only time I feel pain is when I go home and I'm sitting in my bathtub and suddenly when you are trying to soap yourself you go, "Ow! Ow! OW!" And then you notice bruises and dark patches all around you. Normally after about the first three days of filming, I look like I have been thrown down a flight of stairs, I literally look that way, black and blue on my legs, my arms, my back. That is nothing, nobody winces over something like that. **I think the worst I have to live with is having a dislocated shoulder, a cracked rib, one of my neck vertebrae is slightly dislocated, I've had a ruptured artery, torn ligaments, but apart from that I'm in one piece**, and that's the most important thing. I'm still here to talk about it.

Now you've had a little change of pace with The Soong Sisters. What was that like to work on?
Oh, that was great because I worked with one of my very good friends, Maggie Cheung, who is also in *Supercop*. And Mabel Cheung, the director, is such an angel, such a darling to work with. It was good for me to work in a dramatic role. Because prior to that, every one of my movies was basically action-oriented and this was the first role that didn't have me physically going up against anybody. Just mentally, because I was the eldest Soong sister and I was manipulating a lot of the things

that were happening at that time. But the funniest thing was when people heard the cast, the first thing they said was, "*Soong Sisters* is an action movie?" I said, "Excuse me, it's the historical movie about the real Soong sisters, those Soong sisters, not an action movie." That was fun for me.

Has it been released yet?
No, it has not come out yet. They are spending a lot of time editing because it's a long movie, there are a lot of things to tell. You are talking about three of the most important women in China at that time, and to tell a story about all three of them is really difficult. And in Hong Kong they prefer not to see a three-hour movie. They want to see things that are really quick and fast and get to the point and let's get out of here, and I think it is very hard on a director who has spent such a lot of time and so much heart and soul on a movie to then have to try to find the right things to take out. It's a big project for Golden Harvest.

Do you have any concerns about 1997 when Hong Kong goes back to China?
Well, I'm Malaysian, and a lot of people are going to turn around and say, "Well, she's got a Malaysian passport. That's why she's not worried." But I've been there for the last 10, 12 years now, and Hong Kong is very much my home. And I think like everybody else, we hope that it's not gonna change and we can see that things are getting better. I mean, having two very, very different countries trying to work under one is always going to be difficult. One's a capitalist, one's a communist. It couldn't be more different than that, but you must give China the leeway and say that they are trying to work it out. They are not just blindly turning

In *Yes, Madam!*, Michelle breaks through glass while hanging on a rail guard on a second floor balcony. She then grabs two dudes and throws them through. It's a miracle she didn't get mangled. This stunt is crazy! Cynthia Rothrock also stars in this film

around and saying, "No, we're not gonna listen to you guys." They are listening and you just have to give things like this time. I believe it's gonna work out. I think a lot of people believe that is what's going to happen. **It's not going to be easy, but nothing is easy, right? So, let's just keep working at it, keep an open mind, not to be negative about it. Because it's going to happen. There are no two ways about it,** 1997. It's coming exactly a year from yesterday. It's going to be around the corner, and before you know it, it's going to be right there. I think people in Hong Kong are survivors. I mean look at Hong Kong, it's such a small place, but it's got such energy, it's got such magnetism, it's got a lot of things going for it and this is all due to the people. It's not because it's an island or it's the place. It is literally the people who have made it the way it is. And I think if they continue to work on it like that, it's all gonna come together.

Did you like watching movies when you were young?
Actually, I used to watch a lot of horror movies. I am still a big fan of horror movies. I love horror movies. Horror movies first and then action movies. Yes, I used to watch a lot of movies when I was a kid because my mom is an avid fan of the cinema and ever since I could remember, she was always taking us to the cinema.

I wanted to ask you about The Heroic Trio. That's a film that's very popular with the Hong Kong film fans here.
It's like a cult movie, right?

Yeah. But I heard that it didn't do well in Hong Kong when it originally came out.
It didn't do as well as we hoped. You know when you have such high expectations for a film, anything less is not good enough, and also I think it was hurt [because of] the fact that the movie's release was delayed. In Hong Kong, it's very different from here in Hollywood, where you would plug the movie maybe a year before it comes out. **In Hong Kong, you know that a movie is being made, you hear of it, but the promotion for it literally starts two or three weeks before it comes out, because the attention span is not too long.** And the first time that people heard about the movie coming out was at Christmas, and we had wanted a Christmas release, and that would have been ideal for it. But somehow, we got backlogged and they thought it would be better if we came out on Chinese New Year. So that movie came out like three months after the three of us had appeared at a very big press conference promoting *The Heroic Trio*. Then by the time it came out, people had

thought, "Why are they showing *Heroic Trio* again?" So it was very disappointing. Because at that time we had three of the top women actresses in Hong Kong in that movie, and everybody thought, that's it. It's really going to put women's movies back onto the map of Hong Kong, but it didn't work.

You shot the sequel to that back to back with the original?
We shot the sequel like three months later.

And you had quite a violent death in that.
I know, I couldn't believe. That's all Ching Siu-tung. I could kill him. I couldn't believe it, I said, "You're kidding, you're getting awfully violent in your old age." That was a very violent film. Actually *Heroic Trio I* and *II* were both quite violent and gory. But it was a very contemporary, moody, futuristic kind of look that we wanted.

Do you have a favorite action sequence from any of your action films?
Ohh. Oh, my god. I think in every single movie, you have one. But I think in *Supercop* there was more than one, there were quite a few that even I was impressed that I did it. That I was crazy enough to do it. But I think the one that really put me where I am today, happened in the very first action movie that I did, which was *Yes, Madam!* I remember I sit on the balcony of the first floor, and I'm fighting with these two guys who are attacking me with swords, and what happens is, that they both come at me and I duck them and swing backwards, and my legs are hanging on to the balcony, and I go through backwards in a back bend position through the pane of glass. I grab hold of these two guys and I yank them down to the ground floor. So, can you imagine the timing: I had to go through the glass, make sure everybody saw it was me, then I had to swing back out, grab these two legs, and yank them. And when we did the stunt in one take, which I was so lucky, everybody just went crazy, and then after that, all my stunt boys come up to me and said, "I don't believe you actually agreed to do it, why did you agree to do it, it's so dangerous." I was like, "Why?" They said, "If you didn't go through the glass at just the right speed, at the right angle, you would have hit the floor at the bottom. You would have missed the glass, and just fallen off. And if your legs weren't held on correctly and then if you had gone through the glass, your face is going through all these shreds and you could have been completely cut up." And I said, "It's okay, we did it, I'm okay." But that stunt, anybody who has seen that movie would never forget that stunt. I think it was that stunt that mapped my future out for me. It also gave me the respect from my peers that, okay, this person is someone we have to deal with. 🐾

from 1985. The hairstyles in this film scream '80s!

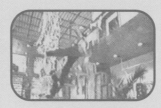

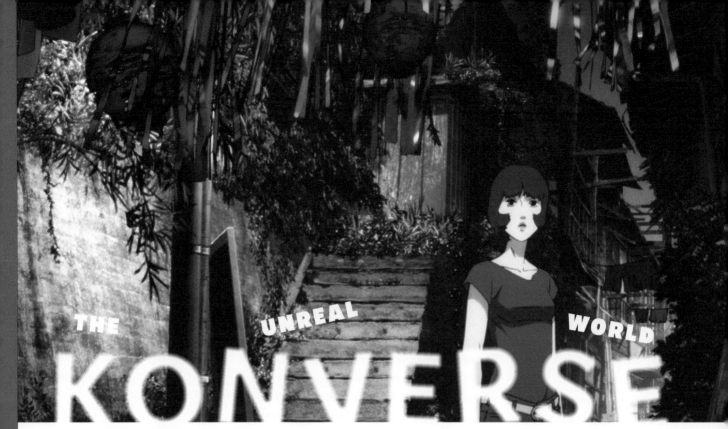

THE UNREAL WORLD

KONVERSE

words + picture | Martin Wong *film stills* | Sony Pictures Classics

Rising above cosmic soap operas, magical princesses, and gothic smut, anime legend Satoshi Kon has established himself as a visionary among hacks. Starting off by writing *World Apartment Horror* with Katsuhiro Otomo in 1991, doing design work on *Roujin* Z (1991) and *Patlabor 2* (1993), and then contributing to Otomo's *Memories* omnibus in 1995, he has made a name for himself by making a series of features with Cronenberg-like takes on reality and Hitchcockian tension. At the same time, he has earned a reputation for depicting complex, compelling female protagonists!

Kon's track record is as strong as it is varied. His first feature, *Perfect Blue* (1997), examines the seedy side of fame via a pop idol turned actress and her stalker. *Millennium Actress* (2001) is a heartfelt metamovie that examines generations of filmmaking and unrequited love. *Tokyo Godfathers* (2003) looks at the world from a homeless vantage point, but as a screwball comedy. The 13-episode *Paranoia Agent* (2004) follows the havoc wreaked by a bat-wielding juvenile delinquent. His latest movie, *Paprika*, features a device that allows people to enter the dreams of others. When it is hijacked, psychological terrorism ensues. It's a scenario that is very human yet unreal—something that could not be approached though live-action cinema.

Dreams are a big part of Paprika. Do you have a lot of weird dreams?
SATOSHI KON: I do dream a lot, and I have had some weird dreams that can't be taken literally. A lot goes on in *Paprika*, and if you overanalyze it, you'll miss out on the enjoyment. You should experience it like a good meal. Paprika as an ingredient is sweet but spicy. I hope audiences have a delicious time.

It sounds like you're really into food. Does what you eat affect the content of your dreams?
Everything I experience during the day affects my dreams. Whether there is a direct correlation remains to be seen.

Are you the sort of guy who tells friends, "I had this dream…"?
If you tell a friend about your dreams, he'll probably find it boring. So I didn't use real dreams in the sequences. If I had dreams like the ones in the movie, I wouldn't be here. I'd be in an institution. Coming up with dreams was the most difficult part of making the movie.

The history of cinema is another big theme in Paprika, as well as Millennium Actress. Are you a film buff?
I'm not deliberately trying to describe or reflect on film history, but I am influenced by everything that I have watched. It's inevitable that some of it reflects in my work.

Do you see animation as part of film history, or is it totally separate?
There's no difference between anime and live-action films. However, the process and tools are very different.

Animation is such a long process. Do you ever think, "Screw it. I'm just going to point a camera at actors"?
I have no interest in shooting live-action movies with real-life actors. I draw a lot from my painting background.

Are you into the aspect of control?
I've never made a live-action film so I don't know what that would be like, but it's not like I draw every frame. I have other people drawing, so there are differences in what I imagine versus what another person imagines.

Your movies usually feature female protagonists. Is it hard to write from a female point of view?
It's more difficult for me to write from a male perspective because I am male. Writing a story with a male perspective gets complicated because that character is closer to me. When I write from a female perspective, I can create distance between the character and me. I tend to draw strong women in all of my movies. Women are stronger than men. Japanese woman today are really strong, and most eat

their men. I also find that the main character is more attractive if there are parts that are unexplained or undeveloped.

So women are more mysterious than men, too?
Of course. Instead of making movies that are easily digested, I like to make ones that may not be easy to analyze or accept. You don't think about where you're going to eat or get a drink afterward.

A lot of the anime industry is based on selling toys. How do you feel about that?
The types of anime that have merchandising are geared toward smaller children. My movies are targeted more toward adults. I don't think any merchandising of my work would sell anyway! It's not deliberate. I just like to make movies that I like and that happen to be targeted toward adults. I don't have any interest in making movies for small children.

I like your movies because they're not just for guys in trenchcoats and backpacks.
I'm relieved that you see it that way. Those are fringe people. 🐱

Perfect Blue (1998)

In America, blockbusters feature big white ships that sink, stupid teeny-bopper dorks, co-stars who should be in porn, and stories so cheesy they'll make your lactose intolerance stain your shorts. In Japan, the highest grossing movie can be a cartoon—the latest Hayao Miyazaki film. Without the help of voice superstars like Gillian Anderson and Claire Danes (who star in the American version), it packed the houses until *Titanic* sailed in and sank it to second place. I remember friends in Japan bragging that the latest Miyazaki film just came out and me thinking, "Who cares?" I didn't know about the vastness of the man. But now with *Princess Mononoke*'s American short-run release, it has a PG rating, which will keep the toddlers away from seeing the worms coming out of arms, the animal blood, and the decapitations. It's geared towards adults.

HAYAO MIYAZAKI

words | Eric Nakamura

Finally, Miyazaki is getting a little more of an American cult following beyond the video release of *Kiki's Delivery Service* and *Totoro*. Not knowing much about the totemic Japanese figure, and him not knowing about me being a guerrilla journalist, I sat with the cheerful graying father of an old school of anime—one that isn't about cyber-technology, robots, or drugged-out youths on super-bikes, while *New York Times* maggots listened by the door, hoping to poach my questions.

Are you happy that the film has a PG rating and not a G?
HAYAO MIYAZAKI: I really can't speak to the American rating system. I actually thought for the Japanese audience, that five was plenty mature to absorb this film, although I do have a friend that took his three-year-old to see it.

Did you ever think of the audience in general when making a film?
Studio Ghibli is not the sort of place that makes a pronouncement as to the age bracket that we're targeting a movie for. If the director wants to make a movie, then we make the movie. At the beginning of making *Princess Mononoke*, I said we definitely can't show this picture to children. Then as I was making it, I felt, well, maybe it would be okay. By the end, I said, please, definitely show it to children.

Who is anime for? Or animated films in general?
Anybody who pays the admission fee. It doesn't matter. You can see it or you don't see it. You know, so many people ask me now, and tell me that in America, adults

refuse to see animated films and that it's just restricted to children, but I'm a man who understands what an ordinary prejudice is. For instance, I will never touch a golf club in my life, so I think people are allowed to have their own prejudices in a way. And, the truth is I almost never watch movies or animation myself, so we're allowed our prerogatives, right?

Cool. Where does your knowledge of Japanese history come from?
Being of a certain age and living in one country my whole life, I hope I know that much.

I was a Japanese studies major in college, and a lot of things I've never heard of was in it.
I mean, fundamentally it's a piece of fiction, but I always retained an interest from when I was quite young. **I always knew that it wasn't just samurai and farmers who made Japan**, and I was always interested in the people that I'd heard about who had wandered the mountains looking for ways to make steel. It's only been recent research that has proven much of it. But the truth is, most of it remains unknown and the rest of it I made up.

Is it more into myths or true history?
It's not like I'm generally interested in mythology or generally interested in history. I investigate what compels me, what fascinates me, so I think I have very sort of idiosyncratic pockets of wisdom.

What do you think of the neo-Tokyo robots and Akira style of anime films?
I'm friends with all those guys. I'm friends with [Katsuhiro] Otomo. I'm friends with [Hideaki] Anno. I'm friends with all of them, so we all give each other a hard time.

Or do they give you a hard time because you're kind of like, the very different one?
No, we give each other a hard time equally. Anno calls Mamoru Oshii a semi-professional, hardly professional. Then I say to Oshii, "Don't make those incomprehensible movies of yours. Just make a straightforward story about how much you love your dog, because you do love your dog." I just saw him the other day.

Why do the kodama shake their heads and make that noise?
It's kind of a little bit like a woodpecker, I think. I mean, that is, I wanted to make a wonderful sound for them to have, and I was so affected by the sound of a woodpecker in the woods. You don't have to go too far into the woods to hear wonderful, mysterious sounds. I mean, obviously my knowledge of all the sounds is quite lacking.

Do you visit forests? Or, is there a place you've been to that most resembles the landscapes in Mononoke?
Yes, I actually have a kind of mountain shack, or a mountain hut at the edge of a village on a place facing the mountains. Rather than be utterly isolated in the woods, I actually like to see paths that people have walked on, I like to be within the proximity of human activity. In terms of a basis, there's an island called Yakushima. Much of the nature has been destroyed there, but it's a bit of a basis for the nature in the movie.

Why is the deer god a deer rather than, say, a pig, monkey, or mouse?
I wonder. You know, the Japanese shi shi gambi? The shi shi comes from, you know, shi shi, which is boar, but also when you say shi shi in Japan, it refers to shiga, which is also the deer, so it refers to all of that. But I think, actually, there isn't some deep philosophical meaning. I thought the shape was right. Close to the shape I had in my mind.

I thought maybe because there's a deer in Nara, at the Todaiji Temple…
They're poor, little deer at the Todaiji. They just eat sembei from the tourists.

Did you have a hard time when you started off in anime because of your drawing style, it being kind of different than the norm?
At the time that I joined the company, I was 22. In 1963, there was only one company in Japan that was making anime.* So there was no mainstream, no minority. There was just a small amount of work being created.

I once read somewhere that you said that you didn't think your drawing style was very good, I was wondering if you still feel that way?
I actually never said that. I think that's an error. What I would say is that as a director, my job is to supervise, that all the drawings created are up to a certain standard, a certain minimum standard. So, I have to say what that involves is that I have to be involved on a daily basis with a certain number of drawings, refining them, and so in that sense the animator in me winds up being frustrated. Being an animator is the best business. Being a director is just pain.

Do you consider an anime film equivalent to say, a regular movie, like Spielberg? Or is there a special category? Or is it just filmmaking?
I would say animation is different from live action films, but we treat each film as if we are making a major film. Actually, no, we don't distinguish between live-action and animation. When we make a movie, we make a movie.

Do you ever want to make a non-anime film?
No.

What are the last books you've read?
The Structure of Nihilism is the book I'm reading right now; that I like very much.

Are you a workaholic? And if you are not working, what do you like to do for fun?
I'm not a workaholic. I don't even like working anymore. It's a burden that I have willy-nilly shouldered upon myself. I have no choice but to plod forward.

In your spare time, what do you like to do?
Go to the mountains, hunt, and walk around. That's the most.

Are you concerned about people understanding Mononoke? I know some people saw it and kind of didn't get it—it's like Akira.
There were lots of them in Japan, too. I'm sure there will be a lot of that. American movies are so simple-minded these days. Are you sure you can afford to look at the world in such a simple-minded way? There is no way to understand different

*That first project Miyazaki worked on was *Shōnen Ninja Kaze no Fujimaru*, adapted from Shirato Sanpei's manga series *Kaze no Ishimaru*.

religions and ideologies, if the world is so simple-minded as represented in most American movies.

Do you know that Totoro is probably, in America, maybe your most popular film? Do you have a reason why?
I don't even know that it is popular. I did hear that the father and the children taking a bath together would be considered sexual abuse in America, and so it couldn't be released on video. I have no daughters, but I certainly didn't portray taking a bath together as sexual abuse. Up until a certain age, daddies bathe their daughters... I mean, obviously, you stop, but you bathe your children up to a certain age.

Were you at all influenced by Tezuka, or was everybody influenced by Tezuka at that time?
Of course. Not as an animator, he didn't influence me at all. But, as a manga writer, in his '50s manga pieces, those influenced me.

A lot of the anime films, people always think of in terms of futuristic. You know—space and robots. Yours aren't in space, but is that still something that you're thinking of? Because nobody in America will know that Princess Mononoke is a historical piece. People might just see it as fantasy.
There is a lot of stuff about the near future, and you know, the near future is science fiction in Japan. That's what you mean, right, when you say futuristic?

How do you fit into that?
Certainly, when they portray the near future, it is certainly a lovely portrayal of their despair, but it's not what I'm interested in. We can live our lives fully without being dominated by the computer. And I also believe that civilization is not necessarily a bullet speeding in one definite direction. The less you know about the past, the easier the future looks. Certainly the kind of alienation and anxiety that we face right now, it's not something new in history. I mean, when a small village was isolated historically and that village came to an end, they felt the world was coming to an end. The kind of problems that we're facing now, they're on a larger scale, but they've been faced over and over again in the course of history. I think once you understand that your situation is not a first, that people have been through it before, that gives you the courage to think that maybe you'll survive it. 🐱

ERIC: *If a list of who I've interviewed got made, Hayao Miyazaki might be on the top of the list. People are mind-blown when I tell them that I've spent time with Miyazaki. I was the last inteview of the day, which is often the spot you don't want to be—last means everyone is burnt out from the same interview questions over and over. I knew this ahead of time and did what I could to wake him up—there's a few questions that no one else would ask. I recall hearing, "This is different," through the translator. That was a mark of **Giant Robot** magazine.*

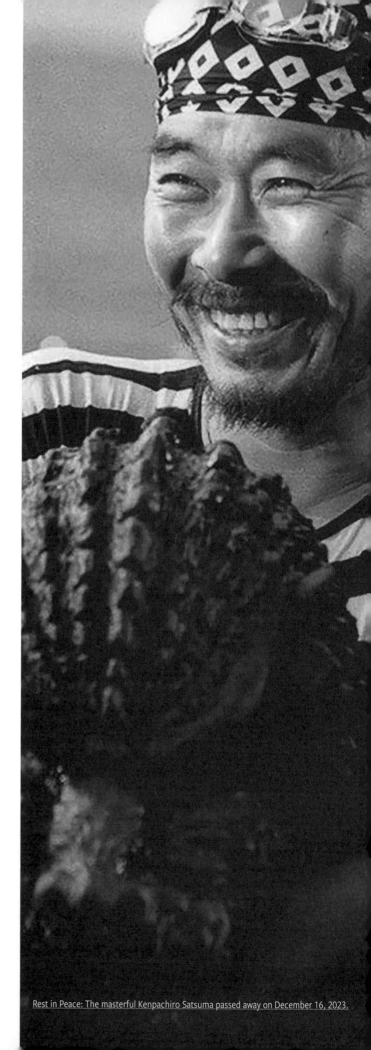

Rest in Peace: The masterful Kenpachiro Satsuma passed away on December 16, 2023.

IN GODZILLA WE TRUST

words | Eric Nakamura
pictures | Renard Garr

On a summer day in Hollywood, a young man stands up among a crowd of a couple hundred other followers to say that he "worships the King." He isn't speaking in Pentecostal tongue. He isn't referring to Elvis. He isn't even down with Run-DMC's king. He worships the jolly green monster who's been invading Tokyo since 1954.

The first three letters of Godzilla's name explain everything. Since he first emerged from the Pacific Ocean, the King of Monsters has enjoyed a rabid cult following. Each new flick from Japan draws the Weird Al look-alikes, big-waisted fanboys, and their pale-skinned friends from out of their VCR and DVD-equipped basements and into the Japanese supermarkets or comic book conventions to get the latest bootleg tape of their hero fighting rubber-suit monsters such as Ghidorah, Biollante, and Destroyer. They also attend Godzilla gatherings, like Godzilla Fest 2000 in Hollywood.

Kenpachiro Satsuma is a fixture on the Godzilla convention circuit. He knows that the cult of Godzilla is strong in the US, and Satsuma's a huge celebrity among Godzilla followers. **Unlike Santa Claus, Ronald McDonald, or even Hello Kitty, only one man dresses up like Godzilla. And he's the King.** He played Heisei (the time period in Japan) Godzilla for 10 years until the monster's 1995 death. At his autograph signings, fans walk up with their own Godzilla art, memorabilia, and even tattoos for him to see or sign. He's happy putting his name on anything with the monster's likeness on it because he is Godzilla.

After his autograph session, Satsuma still has a buzz. People walk up to him as he makes his way to the elevator. He's wearing a dark blue Japanese robe, has perfect flowing Yakuza-style hair, and is probably in his 40s or maybe 50s. He stands out. We sit in the lobby of the hotel and start talking about his life in the rubber suit. While some fans walk by and try not to stare, Satsuma tells me how he started off co-starring as monsters like Hedorah, Ghidorah, Gigan, and Megalon. Then there was a new Godzilla in 1984. "I got a call," he says, "Come to Toho! They didn't say what I was going to do." Without any warning, the job of Godzilla was bestowed on him.

That's also how Haruo Nakajima, the first Godzilla, got his job. At a film screening, the original *King of Monsters* actor told the audience that the men in dark suits just pointed at him and told him that he was it. Maybe it's like becoming a Tibetan lama. The finger gets pointed and all of a sudden you're no longer just some average Joe, but a legend in the making.

You look out of and are supposed to breathe from the tiny holes in the neck: "No air comes in," I'm told by Satsuma. He was only able to wear the 100 kg costume for three minutes at a time before he'd suffocate. **"The suit is a foot thick, and it takes five people to put it on."** Unlike a Halloween outfit, the

MEGUMI, THE PSYCHIC GIRL

Megumi Odaka started appearing in *Godzilla* films in 1989. She's had a 14-year contract with Toho studios and has been in more *Godzilla* films than any other woman. She plays the role of psychic Miki Saegusa.

"I won the Toho contest and that is how it started. I was 14 years old when my series with Godzilla took off. There's so much popularity every year, so they renewed it."

"I think it's wonderful when people come up and say they're fans. I began this career late compared to other actresses. I'm thankful of those who came before, and I'm lucky to be where I am. I still feel afraid. I can't imagine any woman would like Godzilla. First word that comes out is 'gross.'"

"I started because I wanted to be an actress. I never wanted to follow other actresses' footsteps."

"I played a girl who was blonde with psychic powers. So I got letters from real psychics. They said, 'You're one of us.' I don't have psychic powers, but I wish I had some." 🐱

Godzilla suit is custom-tailored to Satsuma's body. Every bulge, muscle ripple, and arm length is taken into consideration. It's air-tight, even making his own methane impossible to escape. He laughs and says, "It goes up to your face." I'm appalled at his answer, but he lived it and breathed it for 10 years. And although I could have botched the translation, I think he tells me that the suit cost about $100,000.

Godzilla moves the way I imagine a T-Rex used to move. With arms that are practically useless, he stomps and whips his tail, breaking anything in the way. To learn the style, Satsuma could have watched every previous *Godzilla* movie. He also could have talked to Nakajima and learned from the original master of disaster. Instead, he went to the zoo. "I didn't see the old Godzillas. I wanted to make my own Godzilla, but I wanted to keep what the director had in mind." Satsuma continues in a serious manner talking with his hands and practically acting out the monster's moves, **"I studied elephant movements at the zoo. Godzilla has the same movements with the back legs. Then I looked at the gesture of gorillas."** Satsuma then sits up like a 900-pound Silverback with his chest out. "Then the face of a tiger, the facial expression." You can guess what he does next.

During his speaking engagement at the convention, Satsuma reveals that it's conveying Godzilla's emotions that makes the job challenging. "I had to do emotions with an angry face—like the love for Junior compared to a monster that just destroys and kills."

His director during that time was Koichi Kawakita, who's now a serious front office man at Toho. And although he's probably more concerned with raising a new building than raising a new monster, he comments, "He made his own Godzilla, and I respect that."

Playing the role of Godzilla is as serious as any acting role. Satsuma is almost a method actor. He makes faces like Godzilla, even though no one will ever see his expressions, and he once had a training regimen called Godzilla shiai (exercise) or kempo (a martial art). "Godzilla can't raise his hands, so he has to keep them low. One hour before filming, I hit things, 100 repetitions of hitting things. I do the Godzilla walk before I go into shooting." He stands up and starts shadow boxing, but with open hands, low and side-arm. He's fast like Ali, punishing an invisible fool with a fast array of bitch-slaps from every angle. He has a routine like any martial artist. Spying fans around us applause as I start laughing and he lets out a Godzilla roar.

People start to gather a few feet from the table, where I sit across from Satsuma. They are eagerly waiting for me to finish asking questions so they can get something signed. But before we wrap things up, we start to talk about the current Godzillas. Any true fan hates the American butchering of the character, and Satsuma doesn't like it, either. "The US Godzilla is not Godzilla. The stance is all different." "Everything else is different, too," I mutter. Satsuma is a purist and his suit-wearing bias comes out. He knows that Godzilla should always be a live-action monster. "I think computer-made Godzilla is a mistake." And his opinion on *Godzilla 2000* is funny, citing that the movements aren't right and the person is too short!

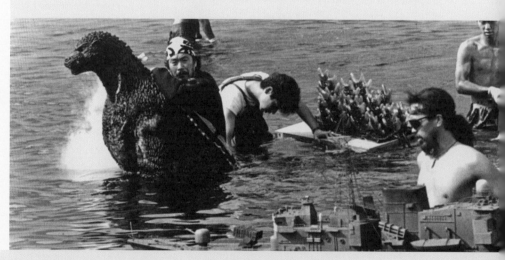

🐱 **ERIC:** Kenpachiro Satsuma is one of the great Godzilla actors before CGI took the costume away. The association and effort of this actor is part of the "fourth wall" of

Modern actors in the rubber-molded outfits aren't as dedicated as they use to be. They hop from one project to the next, being monster and acting whores to take the quick yen. Satsuma stressed more than once that he had the old-school dedication of a master like Nakajima to craft his beast. "There's not a lot of people who keep doing it, so there's not a lot of good people. I only did Godzilla and nothing else." I wonder why, then, Satsuma isn't the latest Godzilla or even scheduled to be Godzilla in the next town-wrecking film? His reasons are pure, and similar to his Kagoshima-born, samurai roots: "When Heisei Godzilla died, I died with him."

Godzilla had to die, it's been said. The reasons are simple. Kawakita explains in front of the listening fans, "He died because I was told that he should die." The office dictated it, and the monster was killed—much like they way Superman died for publicity only to be reborn. It's like *Rocky*, *Star Wars*, or even *The Bad News Bears*. **Sometimes you lose a battle, but you'll always win the war, meaning Godzilla will always be back.**

Today, Satsuma has broken out of the rubber mold. He was once a samurai actor in Toshiro Mifune productions, but now he's currently starring as a blue-faced devil with tons of make-up and sharp teeth. He will proudly show you the photo in a magazine he carries. He's also hoping to land a role in a Hollywood-produced samurai film, and he can even demonstrate how he'd hold the sword.

Meanwhile, I signal some folks to come over and get autographs. It's not crowded, and he's just as interested in a little girl as he is in a college-aged fanatic who's got a tattoo of Godzilla on his back. Satsuma laughs and slaps it.

His post-mortem Godzilla-fan cult leader status resurfaces in his evening speaking engagement, even though he's been out of the job for half a decade. When he delivers his epic Stallone-esque quote—"If Godzilla is active again, and Kawakita does it, I'll definitely do it again"—his congregated devotees applaud and cheer, hoping for some kind of reunion that will probably never happen.

After the talk, the crowd disperses to spend time and money on the latest *Godzilla* merchandise in the dealer room. I walk away with the radical humor of Satsuma's out-of-control Godzilla bitch-slap demo. The man in the suit knows how to entertain. He has a sense of humor along with honor for his work, and that's the Godzilla we should all be. 👹

BIG DADDY HARUO
THE FIRST GODZILLA

How did you get the job of wearing the suit?
<u>HARUO NAKAJIMA:</u> We had a meeting one day and everyone was present. And they said, "You're wearing the suit," and I said, "Okay."

How heavy was the suit and how hot did it get inside?
The first suit was very heavy, about 220 pounds. The suit temperature was about 140 degrees Fahrenheit. It was very hot. I would often pop my head and shoulders out in between scenes to cool down, but if another scene was about to be shot, I would wait inside the suit. On top of the heaviness of the suit, it was very hard to move around in. The suit was very stiff and there was practically no visibility either, which made shooting scenes hard for me. Sometimes I wasn't sure if I was moving in the right direction.

Was it hard to get into your part?
Well, there were two sets which all the shooting was done on—a special effects set and the set where all the actors did their scenes. I was always on the special effects stage, but a couple of times the director would have me come over to the other set and watch what the actors were doing so I could better understand how the scene was going. I never had too much trouble acting like Godzilla.

Did you realize just how big all of this was to become while you were doing the movie?
At the time, no. **I just thought it was going to be like a sci-fi film about a mutant monster and A-bomb testing. I don't think at the time anyone knew how big it was going to be.** 👹

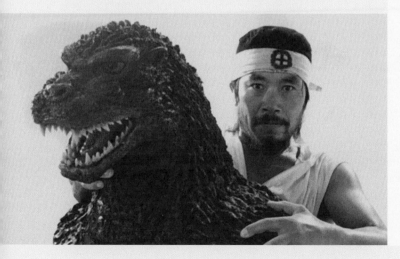

This is an example of when a single person should have had more space in print, which we would've given, but due

He was in the original *Godzilla*, before he played Godzilla in 1972 *Godzilla vs. Gigan*. He was also a bandit in Akira Kurosawa's *Seven Samurai*! and his credits are insane. He may get much less accolades, but to the hard-core fans, he's royalty. • Haruo Nakajima passed in 2017

cinema and, in this case, may be one of the greatest cultural icons from Japan.

TURA MEANS TIGER

words | Claudine Ko
pictures | courtesy of EVE Productions

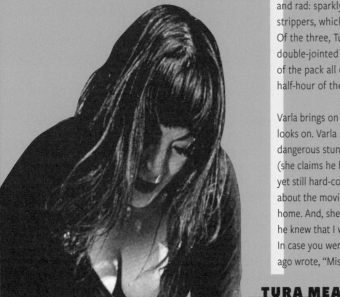

The opening scene of Russ Meyer's *Faster, Pussycat! Kill! Kill!* is all gratuitous, jiggly, and rad: sparkly, bouncing boobs, creamy thighs, and childbearing hips. It's a trio of hot strippers, which a male narrator sternly introduces as a "rapacious new breed of female." Of the three, Tura Satana's the woman in the middle that looks kinda Asian and has double-jointed flexibility. She plays supernova-sex-explosion Varla, the nasty leader of the pack all decked out in stretch-black and 12-inch cleavage. Within the first half-hour of the film, they race cars, smoke cigarettes, and show off their panty lines.

Varla brings on the conflict by killing a man with her bare hands while his bikini-clad girly looks on. Varla is one tough kitty. Thirty-four years later, the woman who said her most dangerous stunt in the action-packed cult-movie was making out with actor Paul Trinka (she claims he had "dragon breath"), is married with children, somewhat domesticated, yet still hard-core. She says her current husband, a retired cop, doesn't like her talking about the movie, so she corresponds with journalists by email or phone when he's not home. And, she can cook: "Wayne Newton used to come clear across the country when he knew that I was cooking a pork roast. Do you think that means that I am a good cook?" In case you were wondering, gossip columnist Michael Musto who met her three years ago wrote, "Missy looks exactly the same as in her ultravixen days, just plumper."

TURA MEANS TIGER IN JAPANESE

Tura was born in Chicago, Illinois, 60 years ago in the Year of the Tiger. Half-Japanese and half-Cheyenne Indian, Filipino, and Scottish-Irish, she was raised by her father who worked in silent films and her mom who performed in a circus. Before she hit puberty, she was already working it in karate and aikido. "My father started to teach us (martial arts) when we were around seven or eight years old," she says. "But he really started to teach me after I was raped at ten years of age by five men. After that, he said that I was never to be ravished again without someone paying for it." She claims it took 12 years to get even with her attackers, but in the end, one was a vegetable and another she "hung up by his balls and they fell off." You don't want to imagine what happened to the other three.

At birth, Tura was pledged for marriage to the son of one of her father's good friends. Thirteen years later, she married John Ellinger Jr., who was 17 at the time, in Hernando, Mississippi—the only state that would marry minors at the time. "We were really too young to get married, because neither of us had finished growing up," she says. "I was fully developed from the age of nine. I know that I looked a lot older than I was. Everyone thought I was 18 years old when I was 10 years old."

"I never thought that my arranged marriage was strange because I was told from the time that I was old enough to understand that I would be married to this boy. Also, it was my father who told me and my father's word was law." Tura amicably divorced Ellinger not long after and tried to go back to her old life—junior high.

"DON'T JUST TALK IT. JUST DO IT!"

When she got to high school, the senior girls ganged up on Tura because they were jealous that their boyfriends were always checking her out. She didn't put up with it—instead she broke a bunch of their arms and ribs and got kicked out. After her stint in reform school, she quit (she later returned and finished in one year) and started dancing at the Tropicana Club on the Sunset Strip. She was 15. "I learned to dance from my mother," she says. "I have always taken pride in my

dancing and in my ability to entertain people with dancing. It also helped to pay the bills after I became most proficient at spinning my tassels. I eventually became a topless dancer who twirled tassels, so I was never really topless."

Tassel-spinning is a dying art. Tura was famous for her ability to spin while lying on her back. She could twirl one at a time, make it stop, and then make it go in the opposite direction. She could even rotate directions mid-spin. "I used mostly my pectoral musculature," she explains. **"It also helped that I was not too tiny in the breast. The mass alone helps spin the tassels. They were glued on with spirit gum and occasionally they did fly off."** She's a 38FFF.

Tura had two children and took them on the road with her. She danced until she was eight months pregnant with her first daughter when she was 19. "When I worked and took my kids along, I worked mostly in theaters on the burlesque circuit," she says. "Unfortunately, that is no longer available to strippers. Backstage, there was always someone to keep an eye on the kids and help out with them when I was onstage." Being a single, working mom wasn't her only hardship, she also faced some issues being one of the few "oriental" dancers. "Some people were still fighting the war back then, even though it was a war that was over with," she recalls. "I wasn't the only oriental dancer or stripper. There were a couple of others: a Ming Lee and a China Lee. These ladies were built very well also, and they made good livings as dancers during the time, but they were Chinese, not Japanese." But she says once people saw her show, she gained a pretty good following. "There were many times when Asian men came to check me out, but mostly it was the Caucasian men who would fall over themselves to get next to me," she says, adding, "I have many Asian men who are friends, but never any that were lovers."

"I DON'T BEAT CLOCKS, JUST PEOPLE."

"I have been in several real altercations during my lifetime," Tura says. "I may not have the anger in me anymore, but Varla and I are a lot alike in some ways. I am a take-charge type of person. I don't like to leave things undone. I think that I am softer than Varla, but that helps to counteract the temper."

Once, while she was tasseling at the Silver Slipper Club in Las Vegas, a spiteful woman in the audience with her mesmerized boyfriend hucked a lead-crystal ashtray at Tura's head. The ashtray smashed onto the stage and Tura flew at her in a lightning rage. She hoisted the woman up by her neck, threatening to rip it off if she ever tried anything like that again. The couple was removed and banned from the club. But not all Tura's fights ended like that. She says her most memorable one was when she was working in New Orleans: "It was with a gal named Katy and I wound up breaking her arm and about four ribs. Afterwards, we became the best of friends, but I had to show that I could handle myself. Just like in the juvenile detention center."

TURA AND ELVIS

Tura met Elvis Presley while she was dancing in New Orleans. He was impressed by her moves, so she taught him some of her skills. "Elvis used to love the way I could throw my hips around and that I could twirl tassels while I was lying down on the floor," she says. "He was always soft-spoken to me. I can't say what he was like with other women, but he was always tender with me. Even when we would work out, he was gentle." She says his karate was okay. They dated for six or seven months, then both had to go on the road so they split up. She adds: "I only regret that I couldn't help Elvis better than I did when I knew him."

"DRIVE AND DON'T MISS... NAIL THE OLD CRUD RIGHT WHERE HE SITS."

"My father always told me to be nice to everyone on the way up, because you will surely meet them on the way down," says Tura, whose favorite authors are Hemingway and Stephen King. "I always treat everyone as I would have them

treat me. I will try never to pre-judge anyone. I can't say that I am perfect, but I try to live by the Buddhist philosophy." But Tura wouldn't think twice about ripping a deserving guy's nuts off.

Still, she knows the real score. "Women will never be equal to men in the physical sense, but mentally we are far superior," she says. **"Most men have to handle one thing at a time, while women have always handled many things at the same time.** I hope that I helped in some way to make them realize that they were just as good, if not as strong."

TOMMIE: WHAT'S YOUR POINT?

VARLA: IT'S OF NO RETURN AND YOU'VE REACHED IT!

Though director Billy Wilder discovered Tura at a strip club and cast her as prostitute Suzette Wong in 1963's *Irma La Douce*, it was her audition for B-movie director Meyer two years later that made her into a legend. Minus a few plot lines, Tura is Varla. After eight years of therapy, she continues to lead the action life as a personal bodyguard in Reno, Nevada, where she now resides. "The only thing that I would have changed was where I grew up and the things that happened to me there," Tura says. "But then if I changed that, I wouldn't be the person that I am today." 🐱

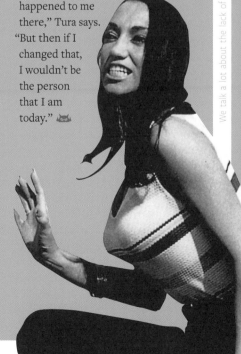

In 1984, John Hughes's *Sixteen Candles* launched the careers of Molly Ringwald, Anthony Michael Hall, and John Cusack. But everyone knows the movie was all about the Donger. Played by Gedde Watanabe with a fake Oriental accent, Long Duk Dong was a hard-core caricature who instantly joined the cult film character pantheon. Eighteen years later, 46-year-old Gedde is still stuck with supporting roles like Chan the Waiter (*Booty Call*) and Male Asian Tourist (*Armageddon*), and there are still a lot of Asian dudes who were scarred for life by his out-of-control performance. *Optic Nerve* artist Adrian Tomine was one of those guys who wanted to kick Watanabe's ass, but instead of resorting to violence or paying a therapist, he chose to interview the actor along with *GR* writer Claudine Ko.

words | Claudine Ko + Adrian Tomine

COME AND GEDDE iT

comic | Adrian Tomine

What was high school like in Utah?
GEDDE WATANABE: Miserable. I really wasn't a good student, and it was probably because I was Asian and I was expected to be one. There were like three of us and the other two were really smart. It really pissed me off. I think there was a part of me that really expected to be a part of that. I actually went to drama class—that was my hideaway from everything.

Well, that sounds like the typical artist's story. I can certainly relate to bad high school experiences that motivate you to develop a talent.
Mom and Dad were screaming, you didn't want to be home, so what better place to be than the theater? I think also the only integrated department that I remember where everybody shared a lot was the drama department.

Did the kids make fun of you just for being Asian?
I think our race just sort of disappeared there. You know, it was sort of like we were smart, so we were okay. Except not me. But I was sort of a goofball, so I guess I was okay.

So you went to the American Conservatory Theater in San Francisco—how did that change your life?
When I graduated, I just got on a plane and left. I showed up at ACT and I went right up the staircase. I said, "Hi, I wrote a letter to you and I don't think you ever really answered me, but I'd like to go to school here for your summer program." And she said, "Oh yeah, I remember your letter," because it was kind of an obtrusive letter. **It was like, "Please get me out of Utah. I don't belong here."** And she says, "Well, we just sent you a rejection letter." So she went into this little conference room and came back out and said, "Okay, you're in the summer program." I think they were impressed that I had the gall to just leave everything.

So how did you make a living?
I learned how to play guitar and went out on the streets and sang. I used to sing in Chinatown all the time. And in the summertime it was great, because we made lots of money. I used to sing Bob Dylan and folk songs. Actually, I really had a great voice.

What made you decide to move to New York?
Well, when I was street singing, somebody told me to come and audition for a Broadway play called *Pacific Overture*. So I talked to the casting person and thought, "Well, I'll go to New York."

Then how did you get into film?
Well, that was by accident. I was working this Shakespeare festival. Then somebody said I should audition for this film that happened to be *Sixteen Candles*. I went in as the character and told the casting director that I really was from...I think I chose Korea. It was funny, because they thought that I really was from Korea. I had tons of Korean friends back then. So you know, **you just learned every culture you could because somehow you knew your career was going to include one or the other.** I think I was just in the right place at the right time.

You didn't know any other real competitors for that role or anything?
I try not to really know. Auditioning is a bitch anyway. It's painful, so why do we have to create more pain for ourselves? It's like going back to school again to prove yourself. I hate that.

Did you go to the prom when you were in high school?
I avoided it. And to show you how inept I was, I didn't know—and I just learned this like two years ago—that guys were supposed to ask girls.

Well, you kinda got to have your prom date in Sixteen Candles after all...
Debbie Pollack [who played Donger's lady friend] has three kids and works at the American Cancer Society now. We had lunch about a month ago and it was so funny. We were at a restaurant and people started coming up to us. After all these 20 years, I guess people just thought we were a couple.

So are you friends with other people from the cast?
No. **Everybody was 16 or 17 around that time and I was 28.** So it was really like a culture shock for me. I remember Molly taking me to a park and listening to some music. You know,

This article was originally published as **In Gedde We Trust**—too similar to Satsuma's article (p. 151)—so we've opted to update the pun.

this poor, pathetic 28-year-old who was doing Shakespeare in the Park and I was asking her [about the bands].

When was the last time you actually watched Sixteen Candles?
Once at the beginning and once later because I happened to see it on television. And then I did something for the E! Channel. So I saw it three times because I thought, "I better look at this movie again," because there were a lot of things I didn't remember.

How did it hold up for you after all these years?
You know, it was funny. I could see what the deal was this time, because I really got to see the story, without it all being clouded, of Samantha [played by Molly Ringwald] at that awkward age. And that happens to me with movies— I don't really see what it's about until much later.

What did you think of it when it first came out?
Yeah, I thought, "This is really going to work or it's going to be [*weird gagging noise*]." I was still living in New York working on Shakespeare, so I think at that time I kind of had that attitude where I was above it all. I didn't think it was really going to do anything.

The movie is almost a purely nostalgic experience. It's this strange time capsule—seeing these actors when they were so young and hearing all the bad '80s music.
Exactly. It is a nostalgic experience and that's actually a very good comment, because that's exactly where my mind was thinking it was going.

I'm sure the reactions were very mixed, from audiences being amused by it to the Asian backlash. Do you have any thoughts about that?
Well, that kind of educated me, too. I remember both sides. I think there just weren't—and still aren't—enough images of Asian American life on television. On the other side, **I remember an irate Asian woman coming up to me and [asking], "How could you do such a movie?" I said, "Can I ask you a question? Do you support any other theater?" You know, put your money where your mouth is.** Don't point the finger unless you get involved somehow.

Was that the most extreme face-to-face reaction you've ever had?
No, I've had a few. I think there were a few [actors] who didn't want to confront me, but I think the Asian actors understood it. We're trying to make the money, we're trying to put our first foothold into something. So I've been trying to create a company. It's called A Thousand Cranes and we've done a few scripts, really specifically on Asian Americans. I don't think anyone specifically does Asian American stories, and I think that's the point.

Have you had any confrontations with Asian American males who had more of a personal reaction to it?
This is my criticism of the media right now: I think a lot of the Asian males have almost completely disappeared in the media. You know, it's just a hard dilemma amongst our race. It's still a question that I still can't get around: What to do? I think it's very different from the wonderful foreign movies that come in. Those are great and they open up a whole new door. And I think we're kind of lost. **I always said, "God, I wish there was an Asian American leading man."**

What do you think is the audience's misperception of you from the roles you have had?
I don't think they know I can sing, that I love doing musicals and things like that. I would like to do more drama. I've done it in theater a lot, but I think everyone expected me to do comedy. And I always go back to theater, because in the theater I can always find those types of roles—more diverse roles. Thank god for those.

You have a pretty long and impressive résumé. What do you attribute your success and staying power to?
I've just been really lucky. I think that I worry as I get older that I have no idea what's going to happen in the future. I still look a little bit young, so I think that helps.

Although many Asian Americans were mortified by Gedde Watanabe's performance as Long Duk Dong, the number of males from Asia studying in America has risen steadily since *Sixteen Candles* was released in 1984.

ERIC: This article is an attempt to understand why this all happened and to push back at the actor just a little bit. I like how the interview starts sort of charming.

1988

MY FAVORITE MOVIE? OH... PROBABLY "SIXTEEN CANDLES."

OH YEAH... I *LOVE* THAT MOVIE!

the DONGER and ME

© 2001 ADRIAN TOMINE

THAT NIGHT

WHASSA HAPPENING, HOT STUFF?

THAT WEEKEND

COMEDY

YOU STUPID FUCKING ASSHOLE!

ART CLASS

C'MON...JUST SAY "WHASSA HAPPENING, HOT STUFF?"

YEAH...SAY "NO MORE YANKEE MY WANKEE!"

LUNCH

THE DONGER NEED FOOD!

HEY DONGER!

MATH CLASS

B·O·NNNG! *

HA HA HA HA HA

*INFAMOUS GONG SOUND EFFECT

2001

YOU CAN'T GO INTO THIS INTERVIEW IN "ATTACK" MODE. IT'S UNPROFESSIONAL, AND HE'LL JUST HANG UP.

CLAUDINE

BUT THAT'S THE WHOLE POINT! I WANT TO FIND OUT IF HE'S EMBARRASSED, OR IF HE'S EVEN *AWARE* OF THE PAIN HE'S CAUSED FOR GUYS LIKE ME!

WELL, JUST DON'T GET ALL *PERSONAL*... IT'S PATHETIC!

YOU MEAN I CAN'T TELL HIM ABOUT MY TEENAGE FANTASY OF GOING BACK IN TIME AND KILLING HIM BEFORE HE COULD MAKE "SIXTEEN CANDLES"?

THE BIG INTERVIEW

...I HEARD THIS CRASH, AND THIS... *LEG* CAME THROUGH THE ROOF!

GEDDE

HA HA HA HA HA

AFTERWARDS

WELL... DO YOU STILL HATE HIS GUTS?

HOW COULD I? HE WON ME OVER.

I...I LIKED HIM.

THE NEXT DAY

MY IMPRESSION IS THAT HE'S A FUNNY, HONEST GUY WHOSE DESIRE TO BE A PROFESSIONAL ACTOR SUPERSEDES ANY SENSE OF "POLITICAL CORRECTNESS."

AND WHEN YOU CONSIDER HOW HARD IT IS FOR ASIAN AMERICAN ACTORS TO GET WORK IN HOLLYWOOD, HE'S GOT A PRETTY IMPRESSIVE RÉSUMÉ. I THINK HIS DEDICATION IS ACTUALLY KIND OF ADMIRABLE.

A WEEK LATER

HEY, LOOK WHAT'S ON..."BOOTY CALL." THERE'S GEDDE!

TWO MINUTES LATER

YOU STUPID FUCKING ASSHOLE!

ERIC: What an honor to have published this in *GR*. I was able to include the original in the *SuperAwesome: Giant Robot* exhibition.

Do directors typecast you now as an Asian gay character?
Ha! Well, that's probably the interpretation now. <u>I know it sounds very weird, but I think there's an indirect form of castration going on.</u>

Who do you think is doing the castrating?
I think it's possibly just the industry itself. <u>I talk to some of my Asian American actor friends, and I say, "What have you been going out for?" I think the biggest response has been doctors, judges, and a lot of accented roles.</u> And every once in a while I'm lucky because I get a role that has nothing to do with anything but whatever that person is. And then my Asian female friends get the sexy vamp type of thing. I think, creatively, I'm totally in a rut. The only way to get out of it is to create [roles for] myself.

Have you ever been to the point where it seemed the roles you were being offered were just too discouraging to carry on?
Oh yeah, I went through that after the

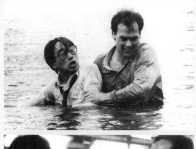

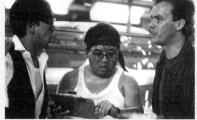

Unlike Vincent Chin, Gedde Watanabe enjoyed his brush with the auto industry. He considers acting in *Gung Ho* under the direction of Ron Howard to be a highlight of his career.

'80s—the late '80s and mid-'90s. An acting teacher told me not to give up. I have a bigger goal now, which is to try to get this company together and make a film. So I need to make a living for the greater good of the cause. I've been encouraged to write novels and short stories, so I'd like to start doing that.

In preparing for this interview I found a few interviews with you. I found one that I wanted to run by you, because I'm not sure of its veracity.
Oh, good. Tell me.

Well, you take credit for creating the Long Duk Dong character. There was no such character until you went in and auditioned and invented it...
Oh no, are you serious? Oh, that's too funny. I have no idea what this interview is.

Well, and then it kind of crescendos and according to the interview you say, "I'm not on trial here. Here's a couple final thoughts on Sixteen Candles: The gong was my idea and, by the way, I fucked Molly."
Wow...I shocked Molly, I didn't fuck her. It's so funny. I love it that somebody actually did that because usually they do it to much more important actors.

I think there are two schools of people who have viewed Sixteen Candles: one is straightforward comedy and the other is angry and politicized. Do you get a lot of the latter?
I did when it first happened, but that movie is sort of softened in people's minds. I know that there was an article about me...I finished a movie called *Booty Call* where I played a gay waiter. I was very reluctant to take it. I kept saying, "Oh, I really shouldn't take this. I'm gonna piss off every group out here if I take this role." I did the big mistake by coming back and asking for a lot of money, and they came back and gave it to me.

Gedde wonders why there aren't more Asian doctors and nurses on *ER*.

What role has been your most disappointing, and what has been the one you're most proud of?
Actually, I just loved working with Ron Howard. I loved *Gung Ho*. I was always really happy with that. I think it could have gotten a lot further, but I think at that time it went about as far as it could go. I think every movie could dig a little deeper.

What role were you most disappointed by? I was thinking it would be Booty Call...
Well, I never really did like the role in *Booty Call*. Anyway, I think it was funny.

Well, how often do you get yelled at from the street as, you know, Donger?
Well, you know it goes in seasons. Because some days it's like nothing and... Well, I shouldn't say that. My friends tell me every day somebody recognizes me. People come up and go "Donger!" and I kind of look at them and say, "You know, my real name is Gedde."

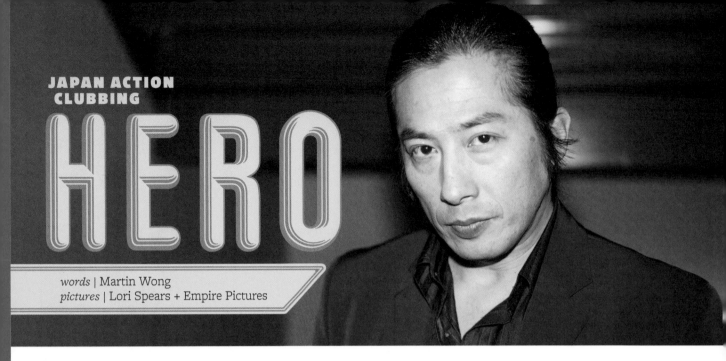

HERO

words | Martin Wong
pictures | Lori Spears + Empire Pictures

As a member of the Japan Action Club in the late '70s through the mid-'80s, Hiroyuki Sanada appeared alongside Sonny Chiba and Sho Kosugi as a badass samurai and high-flying ninja in films like *The Shogun Assassins*, *Renegade Ninjas*, and *Shogun's Ninja*. He also starred in Hong Kong movies before walking away from action to concentrate on more refined aspects of acting. He became a respected dramatic actor, and even appeared in a Royal Shakespeare Company production of *King Lear* as well as the musical *Little Shop of Horrors*.

Sanada was introduced to a new generation of moviegoers when he appeared in 1998's *Ringu* and *Ringu 2*, the phenomenon that triggered a horror movie renaissance in Japan. In 2003, he returned as a swordsman in *The Twilight Samurai*. The film resuscitated and redefined the genre, earning 12 Japanese Academy Awards.

STILL BELIEVE

The Twilight Samurai *won many film awards in Japan. Can you explain its appeal?*
HIROYUKI SANADA: *Twilight Samurai* is special because it changed the history of samurai films. For a long time, Japanese samurai films were so stylized that they were not real. This time, we tried to show more authentic human drama in the samurai period. My Seibei character is poor and dirty, but he is never ashamed. He is a new type of hero. He is a samurai and a strong swordsman, but he doesn't want to kill. He wants to be a farmer and spend time with his daughters. He loves the peaceful life. The film doesn't have big-scale battle scenes. It's more like a family drama. That's why modern people can understand it.

Your character, who has job-related problems, and Rie Miyazawa's character, who left her abusive husband, seem very modern.
My character knows that the samurai period is nearly over and that another world is coming. No more fighting, no more wars—just enjoy the peaceful life. It was very fresh to the Japanese audience.

Do you think people in modern Japan can relate to that shift in history? Today, for example, there's the fall of big corporations...
Maybe.

The film's tone is very serious and stoic. Was the director also like that on the set? He's known for directing comedies.
Yamada Yoji is a very funny guy. He loves Japanese stand-up comedy, and he created a funny, peaceful mood on the set. He could be sweet, but sometimes serious. I think that's a good balance.

Did the shooting of **Twilight Samurai** *differ from your experiences with samurai and ninja films in the '70s and '80s?*
When I was young I did a lot of martial arts films, but people went to see them only for the action. I hated that. I stopped doing action in films when I was 25. Of course, I kept training, but I stopped being in action films.

Because you got injured too often?
No, I wanted to be an actor. If I continued doing action, my image as an action star would have continued. It was not good for me, and it was not my intention. So I stopped action and chose dramas. Then after I turned 30 or 35, I wanted to do action again. Action and drama mixed together can be a good balance. That strategy has succeeded, I think.

EXPECT TO CHANGE

You have a degree in film science. What did you study?
I was a child actor. When I was five, I started acting and went to acting school. When I was 13, I started training in martial arts, stunts, horse riding, and dance because I wanted to do everything. I didn't want to use doubles. Every skill has helped me. For each role, I create a different balance of skills.

Mix different skills together—shake, shake, shake—taste it, and add a little more of this kind of skill. It's almost my hobby.

What exactly was the Japan Action Club that you belonged to?
It was a club and a company—a school of acting and action. There were a lot of classes. Every day there was a defense class. One day we'd learn traditional Japanese sword fighting. Other days we'd learn jazz dance, pantomime, and a lot of other things.

Have you kept in touch with Sonny Chiba, Sho Kosugi, and the other Japan Action Club members?
No, but all of my students came to New Zealand to do *The Last Samurai* with me.

Do you ever watch old movies like Shogun's Samurai and think, "What was I doing?"
Sometimes people show me. Two weeks ago, I saw a lot of my old films when I received a special award for filmmakers. A director edited scenes from my whole career. I was like, "Oh my god. I was so young." I was so embarrassed, but it was interesting.

How have you grown since then? Are you a different person?
Basically I can't change, but every movie teaches me a lot.

What did you learn starring in films like Samurai Reincarnation or Ninja in the Dragon's Den?
Just work hard.

Did you ever want to do anything besides act?
When I was a child, I decided I wanted to be an actor in Asian films. Other things, I couldn't imagine.

NEW WIND

What was it like when you starred in a musical production of Little Shop of Horrors? Was it scary performing for a live audience?
I love singing, and I love acting. It was a good chance to play another character, and the audience was surprised. Here I was, an action star, singing and dancing in a comedy. I enjoyed that.

You also wrote a soundtrack for Rimeinzu: Utsukushiki yuusha-tachi?
I was the music director, and I composed the theme. It was such an interesting experience. I played music on guitar, recorded it, and gave it to an arranger. Then I wrote the words and chose the musicians.

Contributing from behind the scenes must be different than acting.
Yes, but I have always thought of music when creating a character. I enjoy creating, not only as an actor.

You also acted as The Fool in the Royal Shakespeare Company's production of King Lear. What was that like?
It was so hard, and I was so nervous. Opening day, I suddenly heard one or two people in the audience laughing at my line. Then I was surprised. "Oh my god, I'm on stage, and they're laughing at my dialogue." Finally, at curtain call, I got a standing ovation, and I wondered if it was a dream. I had a good experience every day, and they never knew who I was. "Some strange Asian actor? Who's that?" In Japan, theatergoers clap just because they know me. In England, I was like a boxer who had to think, "Fight! Kill him! Win! Dead or alive!" Every day was so exciting, and it was a good thing for me. After acting in films for so long, it was fresh.

When you were cast in Ringu, did you have a feeling it was going to be a hit?
No, I didn't know. Horror films were not big in Japan at the time, but I enjoyed the script, and I believed in the director. It succeeded, then there was *Ringu 2* and the American remake. It was so amazing.

It seems like the Ringu films introduced you to a new generation of filmgoers.
Yes, I think so. Children don't know my action films, so when I meet them on the street, they point at me and say, "You're in *Ringu*!" It's interesting. **Each generation has a different image of me.**

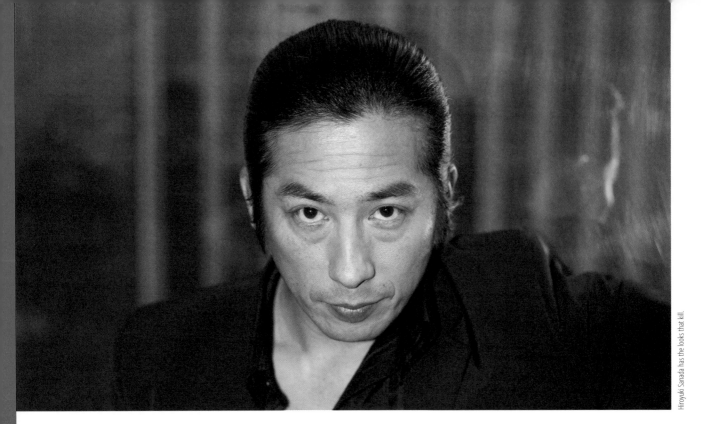

SOME SORT OF BALANCE

What was it like working on the Hollywood movie The Last Samurai? *Did you have any concerns going into it?*
Whether I could create an authentic Japanese character in Hollywood—that was the biggest concern for me. But I learned a lot from the Royal Shakespeare Company about sharing experiences and mixing cultures to make something new. It's very hard, but if you create something new it's a wonderful thing. So when I read *The Last Samurai*, I thought, "I should do that and create a new style."

Was it awkward to tell a big star like Tom Cruise how to hold a sword? To say, "You're not doing it right."
I gave him pointers every day. He listened to my advice. He's a big star, but he's unpretentious, a hard worker, and he respected our culture and my career in samurai films. We spent a lot of time rehearsing and shooting every day. He improved so quickly. If I said one thing, he would learn 10 things. We had a good relationship on the set.

Was The Last Samurai *received well in Japan?*
The Last Samurai made a lot of money in Japan, more than domestic films. It's about our culture, and there's a big market for that now, so we should make good films and not worry about the future. I think this is a good chance.

You've been in about 60 films. Are there any roles left that you want to play?
Yes. About 40 or 50 percent of my movies are samurai or ninja films. Each time I create a character I can see the next goal. **I want to climb higher mountains. That keeps me fresh.**

You took the role of a baseball player in Hero Interview. **Are you a sports fan?**
When I was a child, I always played catcher. Every boy was afraid of catching, so I said, "Okay, I'll do it." I love that kind of position. When I play music, I play double bass. The double bass is kind of like being the catcher. I also like that position in the theater or on the set; I'm always watching everybody.

Do you follow the Japanese players in America?
Yeah. I know [Hideki] Matsui on the Yankees. He came to my musical to see me, and he invited me to a baseball game in New York. I'm always following him on TV. I'm very proud of him. He's one of the samurai in modern times. 👹

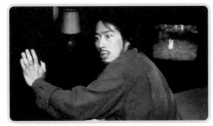
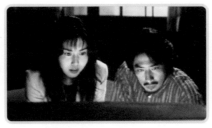

Sanada's career was not cursed by *Ringu*.

MR. VENGEANCE

words | Martin Wong *portrait* | Eric Nakamura *pictures* | Tartan Films + CJ Entertainment

The eye-pleasing yet stomach-wrenching movies by Korean director Park Chan-wook will address an opinion that most people take for granted—say, that North Korea is evil or that kidnapping is wrong—and make you reconsider it. As a result, he is both idolized by film dorks and given prizes by arthouse snobs. His latest film, *Oldboy*, won the Grand Prix award at Cannes, gaining all sorts of support from Quentin Tarantino and *Cabin Fever*'s Eli Roth, and will be remade by *Better Luck Tomorrow* director Justin Lin.*

The morning after introducing *Sympathy for Mr. Vengeance* at Hollywood's historic Egyptian Theatre, where the first annual Los Angeles Korean International Film Festival was taking place, Park made some time to talk about his movies, politics, and music.

Although your movies are very dark, it seems like you have a lot of fun making them. There's so much dark humor. Maybe you're not as pessimistic as your films would suggest?
PARK CHAN-WOOK: Generally I am pessimistic, but it's hard to live with that outlook so I try to find humor. I try to show some brightness because it's too hard to only struggle with the dark side. And sometimes when you look at a sad or dark moment, it can be funny. Things that are very, very sad make people laugh.

It seems like you enjoy taking common perspectives on what's right or wrong and turning them upside down. For example, there's North vs. South Korea in JSA and kidnapping in Sympathy for Mr. Vengeance.
Actually, in the modern age no one says things are right or wrong. To distinguish things as right or wrong is old-fashioned. Doing good and doing bad can be distinguished, but whether a person is good or bad cannot. No one is consistently good or bad all the time. Maybe whether you're a good guy or bad guy can be determined by how many hours you spend doing good or bad things.

You graduated with a degree in philosophy. Has that background affected your approach to life? Do you approach filmmaking less like a business than someone who just attended film school?
I was influenced by philosophy, especially metaphysics, but there is not one specific philosopher who influenced me. My background makes me a little different than someone who graduated in film studies. But some film school graduates are very good. David Lynch graduated from AFI but is dedicated to his art and is not just making movies for money.

*This film wound up in development hell, and real ones know that Spike Lee would eventually step up to the plate to direct the Hollywood version starring Josh Brolin.

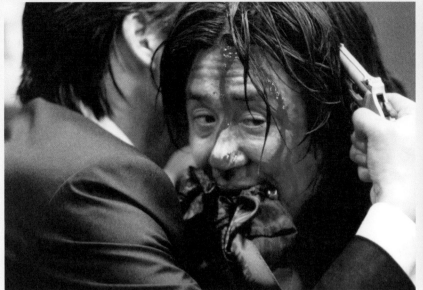

LEFT: Gags, guns, and gashes are plentiful in *Oldboy*. RIGHT: Mr. Vengeance meets the Fly Girls from *In Living Color*.

I understand kidnapping, the subject of **Sympathy for Mr. Vengeance,** *was pretty common in Korea at one time. How did that affect you as a child when you were young? Does it affect you as a parent now?*

Actually, kidnapping is not very common in Korea, but it was easy for me to depict the parent because I have a little girl. There's a scene where the kidnapper returns to his apartment and plays with the little girl, who leans on him. That type of scene couldn't be made if I weren't a father.

Sympathy for Mr. Vengeance *touches on themes of class struggle. How would you describe your politics? Do you consider your work to be revolutionary in any way?*

The female character that leads the revolutionary anarchist association is kind of ridiculous and unrealistic. But since the '80s, there have been radical groups in South Korea. I don't think their ideals are realistic. However, I don't want to laugh at them. I respect them and admire their passion. I tried to present the character and her group members in a way that's sympathetic. I presented their human side. They're not professional assassins. They're nervous when they kill.

Oldboy *had excellent actors, great production value, and scenes of incredible violence. It seems like you had it all. Was there anything you wanted to do but couldn't?*

There were things I couldn't do because of budget, but sometimes limitations of resources can result in something great or beautiful. For example, a lot of great Asian and European filmmakers who go to Hollywood do not make good work. People think it's the Hollywood system that oppresses them, but on top of that, having a lot of money can disrupt creativity and artistry. Having budget limitations doesn't really bother me.

In **Sympathy for Mr. Vengeance** *and* **Oldboy,** *characters are compared to ants. Is that something you think about?*

Actually, those were jokes that don't really mean anything. They're not based on facts. I don't know how non-Koreans view ants, but in Korea they are seen as trifling.

Has making movies about revenge made you a less vengeful person?

When I make films, I think about how they relate to my real life. In *Sympathy for Mr. Vengeance* and *Oldboy*, revenge and violence brings about more revenge and violence, and I don't want to see that in real life. After *Lady Vengeance*, I'm going to move on to new topics.

I heard that you are into bands like Nick Cave and The Clash. Do your musical tastes affect your filmmaking?

Of course I get impressions and ideas. I like Tom Waits. I want to use "Black Wings" in my next movie, *Thirst*, which is about vampires.

I liked the batting cage scenes in **Sympathy for Mr. Vengeance.** *Do you follow the Korean baseball players?*

I don't like sports. 🤖

RENTER'S DELIGHT

JSA (2000): This North vs. South Korea thriller filters the male bonding of enemy soldiers through the perspective of an international officer who comes off like a combination of Scully from *The X-Files*, Jodie Foster in *The Silence of the Lambs*, and *Encyclopedia Brown*. The message of Korean brotherhood made the film a big hit and set up fans for massive shock when Park's next project was a nihilistic art movie.

SYMPATHY FOR MR. VENGEANCE (2002): The first film in Park's "Vengeance Trilogy" tells the story of kidnapping for the right reason gone horribly wrong. No one wins and most main characters suffer and die, but there's just enough black humor to make it an amoral masterpiece and not a total bummer. Other topics include the illegal organ donation trade, underground anarchist groups, and class struggle.

OLDBOY (2003): Based on Japanese manga, this would have won top accolades at Cannes if the French didn't love Michael Moore and hate America so much. A man is kidnapped for 15 years, and finds himself freed in an expensive suit. Why was he kidnapped? Sadistic cruelty, high school grudges, and incest enter the picture as the mystery is unraveled. A Hollywood version by *Better Luck Tomorrow*'s Justin Lin is in the works.

THREE...EXTREMES (2004): This trio of horror shorts includes contributions by Japan's Takashi Miike (*Audition, Ichi the Killer*) and Hong Kong's Fruit Chan (*Made in Hong Kong*). Park's segment, entitled "Cut," shows a movie director forced to choose between the life of a kidnapped child and the fingers of his wife, a concert pianist. The horrific thriller is a perfect segue to Park's next project, a vampire flick called *Thirst*.

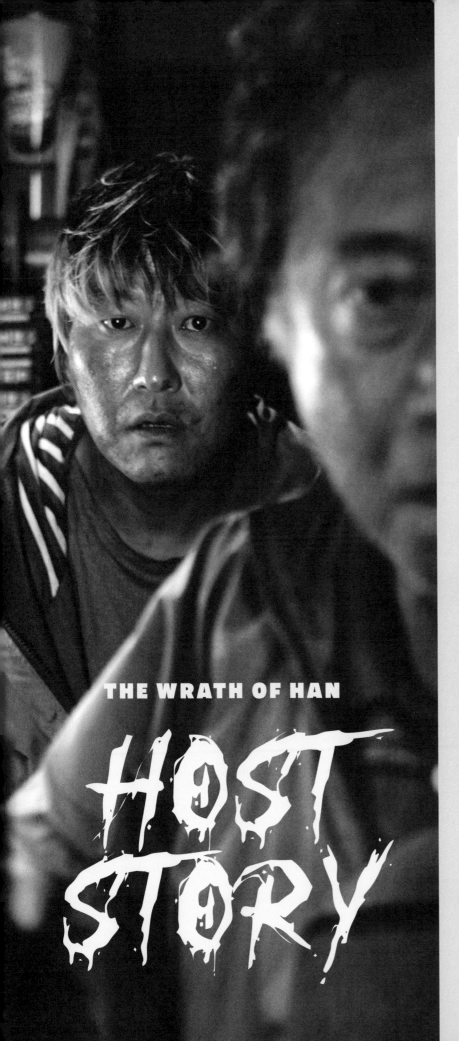

THE WRATH OF HAN

HOST STORY

words | Martin Wong
pictures | Magnolia Pictures + Kevin Rafferty

Just when Asian horror movies had become a stagnant morass of long-haired ghosts stepping over puddles and schoolgirls with black tongues, along came *The Host*. Resurrecting the monster movie, South Korean director Bong Joon-ho created a scaly, truck-sized creature with the razor-sharp mandibles of Alien, appetite of Wolfen, and swinging moves of Spider-Man. Not only is the villain sinister and spectacular, but the protagonists are intriguing, the storytelling is tight, and the production value is excellent. In short, it's more than a movie with a cool monster; it's a well-made feature that pleases critics in addition to wowing audiences.

Do you get satisfaction from winning awards and breaking box office records with a monster movie, and beating out "serious" dramas?
BONG JOON-HO: I am glad that the film did well at the box office and in sales, but I am most delighted by the fact that it has received good reviews in many countries. *The Host* was selected as one of the best films in 2006 by France's *Cahiers du Cinéma*, Japan's *Kinema Junpo*, and the US's *Film Comment*. I am very much honored.

Were you into monster movies when you were a child? How about real-life monsters like Yeti, Sasquatch, or Nessie? **What kind of boy doesn't like monster movies?** I was always interested in Yeti, Sasquatch, Mothman, and other regulars in books about the world's mysterious beings and great mysteries. I was especially fascinated by Nessie. It gave me the direct inspiration in creating *The Host*. The initial image I presented to the producer was a synthesized picture of my own photos of the Han River and Nessie.

Movies with monsters usually attract dateless dudes, but yours attracted everyone. Were you ever concerned about **The Host** *becoming a movie for guys only?* I don't consider the audience's sex or age when making films. **My first audience is myself. I am a cinephile before a film director, so I have a very simple view: I want to make a film I want to watch—a film that excites me.**

How did you determine the monster's look? Did it change throughout the movie-making?
Based on my own concepts—including the size of the monster and the flow of the Han River—I worked with creature designer Jang Hee-chul from the very beginning. For about a year and half, we worked on the look of the monster along with the scenario. The final model was used in the film, but there are a lot of models that weren't chosen—magnificent designs that might work in other movies.

Usually, monsters are shown to be sympathetic in movies. For example, they may protect their young or represent nature. Yours attacked children and spit out skulls. Did you worry about that lack of sympathy?
I thought the audience's sympathy or emotions should work for the helpless main characters. That is why I intentionally eliminated all sympathy for the creature. Sympathy might be felt in the last scene where the creature suffers under Agent Yellow or Song Kang-ho [as Gang-du] gives it the final blow, but the creature of *The Host* is not a monster that people feel sad for when it dies like King Kong.

Man-eating monsters, murder, and dognapping can be dark subjects, but you instill them with humor in your movies. Are you the type of guy who's laughing and smiling in disastrous situations?
I like it when seemingly inharmonious feelings are mixed together. Human emotions are as subtle and complicated like that in real life, and film is the best medium to catch those moments. Therefore, I like that kind of dark sense of humor.

So far, you've written each of the movies that you've directed. Is that something you do because you enjoy the process or is it something you need to do?
I really hate to write scripts. It is such a painful, lonely, and torturing job. I want to die when it doesn't go well. I sometimes think about working with other writers, but at the end of the day, I know I have a very unique taste and style of dialogue. I really want to find a writer with whom I can passionately work, though. If there are interested scriptwriters out there, please contact me!

Your movies can be interpreted as having working-class leanings. Do you consider yourself a political filmmaker? Can film make a difference in society?
Beyond the political rhetoric of "class," I am just drawn to powerless and weak characters—the losers. I think genuine drama shines through those characters. A film can't make a significant difference in society, but it can comfort those who are exhausted from struggling to make the world a better place.

MAKIN' IT
Along with the group of digital artists at The Orphanage, visual effects supervisor Kevin Rafferty blended CG and high-tech puppetry to make *The Host* a world-class, state-of-the-art monster movie.

Have you always been a fan of monster movies?
KEVIN RAFFERTY: I've always loved monster movies. As a child growing up in the San Francisco Bay Area in the '60s, I watched *Creature Features* with Bob Wilkins. He would show all the classics: *Frankenstein*, *Dracula*, *The Wolf Man*, *The Creature from the Black Lagoon*, *The Blob*, *Godzilla*, *Mothra*, to name a few. It was through his program that I saw *Night of the Living Dead* for the first time in the '70s. My true love for the creature film blossomed when I had the chance to actually work on the films, contribute ideas, and help bring these creatures to life.

You've worked on huge Hollywood movies, like Star Wars: Episode I. What attracted you to a Korean production?
While I was working on a BMW commercial at The Orphanage, I had the chance to read *The Host* script before I was introduced to Director Bong. We met for quite some time, and went over the story arc to get his personal vision. More importantly, we talked about the creature. What was she like? What were her habits? How strong was she? How heavy? By the end of the meeting, I knew I had to work on the film.

Other than getting used to cell phones that are half as big and twice as cool, how was the filming experience different than your other projects?
I wish I had brought one back! When all is said and done, the post-production protocol was not very different than the Hollywood films I've worked on. What sets South Korean filming apart from American filming is how principal photography is handled. In Korea, the crew seemed to have a genuine passion for and love of filmmaking. I felt this from the cast as well. Even if the actors weren't working on a shoot, they would still come to the set to see how things were going. Also, the boundaries between departments didn't seem as rigid as they do in American filmmaking. When a need was seen on set, it was taken care of by the person who saw the need and was closest to it, regardless of department. In America, each department has clearly defined roles, duties, and responsibilities. Both styles have their benefits.

Were you able to adapt the monster's look as you animated particular scenes, or was its look final by the time you got to it?
Director Bong and the creature designer, Jang Hee-chul, had the look of the creature finalized by the time I came on board. My challenge, as always, was to bring their creature to life: give her weight, strength, habits, and personality. At The Orphanage, our animation team's understanding of the creature got better and better as time went on. You might say her personality evolved throughout the post-production process.

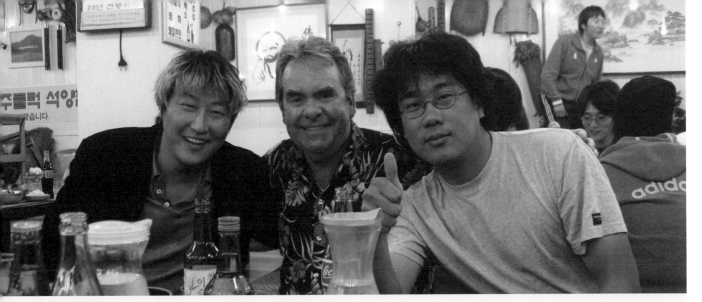

Lead actor Song Kang-ho, visual effects director Kevin Rafferty, and director Bong Joon-ho eat, drink, and make a monster movie.

Many of the shots utilized a puppet instead of CG. How does one control a 46-foot-long puppet?

Well, the puppet was a full-scale model of the creature's head—not the entire creature. Early on in pre-production, I had discussed about 10 key shots in the film where a full-scale puppet would give us more impact for close-ups, and have something for the actors to interact with. The head was about eight-to-ten feet tall, six-to-eight feet wide, and fifteen feet long, excluding the puppetry rig. We hired John Cox's Creature Workshop in Australia to create the puppet. Hee-chul and I would visit the shop periodically to check on the construction. They did a fabulous job matching the design and the CG version of the creature, and John sent a very talented team of puppeteers along with the puppet once she was ready to be on set and "act" with our principal characters.

What sort of concessions to safety did you make for scenes in which people were eaten? Was it comfortable for the actors or stunt people to be slimed and swallowed?

Our practical effects team was fabulous. First, we discussed the nature of a particular effect. Then the practical effects supervisor would design a rig that would not only achieve the desired results, but also be safe for the actors. If the gag became too physical or potentially too dangerous, we would use stunt doubles. I must say our actors were real troopers. We would wait for their last scenes of the day before dousing them with slime. That way, once Director Bong got a take that he liked, the actors would be wrapped, could shower off all the slime, and be done for the day. [Child actress] Ko Ah-sung was particularly strong. She did all of her own stunts. There was one particular shot where she was being dragged through the water held by the creature's tail. We had a rig that wrapped around her waist and attached to a crane that was floating on a barge. We did many takes of her being dragged through the Han River. I was worried that the rig may be too strenuous for her, or that she might swallow some of the water, but after we got the shot, she was smiling and ready to do more!

How did you handle the increase in meat and alcohol consumption? Did you ever get the urge to pluck your eyebrows or tint your hair?

I never got the urge to dye my hair or pluck my eyebrows. As far as food is concerned, I actually consulted my doctor before traveling to Seoul. He told me that Korean food would most likely be better for me than the food I eat here in the US! He was right. I absolutely love Korean food. Kimchi, kalbi, bulgogi, haemul pajeon, three-stripe pork—I'm getting hungry just thinking about it! As for alcohol consumption...Well, I'm Irish. I have a pretty strong constitution. Though I had never tasted soju before, it quickly became a favorite of mine. I also love the ceremony surrounding drinking in general in Korea. I love the fact that you should never pour your own drink.

Monster movies aren't usually considered for best picture awards. Is the critical acclaim something you're proud of?

To me, critical acclaim has always been a bonus—not a goal. More than anything, the sense of artistic achievement and accomplishment is what I seek and am proud of. When everything just seems to click, it's a wonderful thing.

There are plenty of monster movies with amazing special effects that are ultimately terrible. Do you think there's such thing as a "good bad movie" or are movies just plain good or bad?

Good question. I feel we can learn from the bad films, as well as the good. I will sit through what I think is a bad film to analyze what made it a bad one. What could have been changed to make it better? Same with the good films. I like to watch them twice. First, just as a moviegoer, I want to get lost in the film and become part of it. If I am entertained or affected, I will see it again, this time with an analytical mind. What made the movie good? Story, directing, acting, cinematography, art direction, visual effects, editing, or sound? It's usually a masterful blend of all of the above. However, I do believe that any good film needs to begin with a good story.

BAE (DOONA) WATCH:

The actress has been on a huge roll, not only starring in huge and cool movies like *The Host*, *JSA*, *Sympathy for Mr. Vengeance*, and *Ring Virus*, but also crossing over to play an exchange student who sings for a high school girl band in the Japanese drama, *Linda Linda Linda*.*

Bae Doona likes Citizen Fish and GBH (great big hugs).

You won the Grand Bell Award after only your second film. Was there any pressure that came with that?
Not really. The most important thing for me is whether I made a film that excites me. Winning awards or breaking box office records are just results.

Have you always wanted to be a filmmaker? Was there a specific movie that inspired you or got you hooked on cinema?
I seriously decided to become a film director when I was a middle school student. <u>I loved watching movies and I was really into comic books and drawing. I guess drawing comics has subconsciously trained me to express stories visually.</u> I watched numerous movies on TV when I was a kid. *The Wages Of Fear* by Henri-Georges Clouzot, *Bicycle Thieves* by Vittorio De Sica, and the films by Sam Peckinpah still remain as vivid shocks in my head.

Are you the sort of person who watches a lot of movies and has a huge library or DVDs from all over the country?
I fanatically collected VHS tapes in the past, and now I collect DVDs. Whenever I go abroad for a PR tour or festivals, the first thing on my to-do list is to find the local DVD shops. It's great when I can put beautifully wrapped films in my bookshelf.

What is the most enjoyable part of making movies for you?
Every part is painful and difficult, but yes, there are some thrilling moments. When I discover a location

that I really love, when I watch great performances by great actors, and when beautiful music is put on a nearly completed film—those moments keep me going on.

Does your sociology degree ever come in handy when storytelling? Working with the crew?
Not at all. I spent more time in my club than in the classroom. I don't know about sociology, but I am interested in society itself. I can recall serious discussions with friends about social issues.

Earlier in your career, you worked on Motel Cactus with Park Ki-yong and Christopher Doyle. Was that experience different than making a film on a typical Korean set?
I worked as an assistant director and also participated in the scriptwriting. Rather than learning about Chungmuro (Korean Hollywood) style, I experienced a unique situation where a Korean director and a foreign director of photography worked together. The film was novel and challenging in every aspect, and I learned a lot from the film even though it didn't get a big public reception.

The Host has won tons of awards and accolades at film festivals around the world. Are you worried about losing your edge?
The awards mean that people admit that my edginess has worked in a monster genre film. That is what encourages and cheers me on and that is the true significance of the awards.

SULU SPEAKS
GEORGE TAKEI

words | Eric Nakamura
pictures | Ben Clark

Going where no (Asian American) man has gone before, George Takei played Hikaru Sulu in *Star Trek*, perhaps the most influential science fiction show of all time. But 40 years after the first episode aired, the sound of his voice is more engaging than ever. He can make any word sound amazing, and his tone and enunciation of words is as distinct as James Earl Jones's.

Takei's acting career spans many decades, and he can somehow juggle it with community work and politics. Recently, he has come out as a gay man to speak out for same-sex marriage, lent his voice to Howard Stern's new radio show after years of being the butt of the shock jock's every joke, and served on the board of the Japanese American National Museum (JANM) in Los Angeles. In fact, it was after he presented an award to *Giant Robot* at a JANM banquet that we asked him for an interview! As gracious as he is eloquent, he was generous with opinions and verbiage.

When did you know that Star Trek was going to make your career?
GEORGE TAKEI: At the time we were working on it, that was the farthest thing from our imaginations. Our ratings were rock bottom all three seasons. In the third season, NBC put us on at 10 o'clock on a Friday night, which is traditionally known as the morgue hour. So our ratings plummeted even further, and they had the numbers to justify cancellation. So I thought, "Well, we did good work. We're proud of what we did, now we're going to move on in our careers." When *Star Trek* went into syndication, that's when our audience found us and the ratings soared. But by that time, it was too late: the show was canceled and the cast and crew had scattered to the four winds. We were glad the show was enjoying some popularity after the fact and that our good work was being validated. Then 10 years later, we came back for one film that was based on the popularity of the syndicated reruns. That exploded at the box office, and then the sequel exploded at the box office. Then we did the second sequel, and it became a movie series. This year is the 40th anniversary, so there are slews of Star Trek conventions, the biggest of which in the US is in Las Vegas. The other big one is in Frankfurt, Germany.

Are those easy to be part of?
We've been doing them for 40 years! I try to bring something more than *Star Trek* trivia to those conventions. As a matter of fact, at a couple Star Trek conventions in the '70s, I advocated the impeachment of Richard Nixon. I put it in the *Star Trek* context: I said that the United States of America is like a starship. It's got to have a good captain, and when the captain is corrupt, the entire starship is endangered. I got cheers.

It sounds like you embrace the role and make it work for you, and you're able to help people through it. That's not how it is for some of the other cast members.
They have complained. When you're that closely identified with a show, a character, and a genre, there are some unimaginative producers who can't see you as an actor. You might lose a part. Jimmy Doohan complained that they all wanted him to do a Scottish accent. But there are also the positives. My first love is the stage. I've been able to do theater all over Britain. I've done plays in Edinburgh, Reading, London, and Brighton. I'm certainly mindful that there are fine British Asian actors in London. Why do they

fly me from Los Angeles? My name has box office currency via *Star Trek*. I am reminded of that every time I come out of a stage door after a performance, because there they are, lined up with Star Trek books, rings, and action figures.

This is a collegiate type of question: Why didn't your character ever have a relationship on Star Trek?
Believe me, I lobbied for it. **The thing is that on that show we had seven regulars. Everybody was pushing for their time in the sun.** I was peppering the writing staff, the directors, and Gene Roddenberry with ideas and suggestions. What about Sulu's family? His parents, his wife, his brothers, his sisters, and children? Everyone else is doing that. And then you had two competing stars who were trying to get as much for themselves. It was a very intensely competitive situation. However, we eventually found out that Sulu had a daughter in the library of Star Trek novels. There's one titled *The Captain's Daughter*, which goes into the whole back history of how Sulu's daughter came about. But the main thing I was campaigning for was captaincy for Sulu, as were the other non-captains on the show. I was the only one who succeeded in getting that.

You are the only member to wear all three colors of the Federation uniform.
That's right. In the parallel universe, I wore red. You are a trivia expert.

Was there ever a time that you wanted to shed your association with Sulu?
I certainly made an effort because I'm an actor. I want to play roles beyond and other than Sulu. Theater opportunities are that. I've also done an Australian film, which I'm very proud of, *Prisoners of the Sun*. They cast all the other actors out of Tokyo, but for the upper-most, highest-class Japanese in the cast, a baron, they cast a Japanese American. Between shots, I was sitting and chatting with the producer and asked, "Why didn't you cast the whole thing out of Tokyo?" He said, "Well, there's no one in Japan who could speak English as you could, which the role required, and have the name to sell tickets, certainly in Australia but also Asia, North America, and Europe." That's because of *Star Trek*. **Some of my colleagues have seen their association with *Star Trek* as a big weight that they have to carry. If you make it that, it becomes that.** I see it as something I can use to enhance and expand my career.

🐱 **ERIC:** This is a great story of an iconic person. When zooming into George Takei, you realize he's not just a

Were you always pleased with your non-Star Trek roles?

Yes, and I've had many non-Sulu roles. I did *Year of the Dragon*—not that Cimino movie, but a play written by Frank Chin—which we taped for Theater in America. It was shown on public television. That was TV exposure that I enjoyed very much. I just did *Equus* at the East West Players, which was an enormously fulfilling experience.

It seems like there are many young, disgruntled Asian American actors who complain about the kinds of roles they get, like delivery boy, etc.

Good for them. The important thing is they need to speak up at the interviews. Also, they need to turn down roles. Someone else will do it eventually, but at least you've made your statement.

Have you ever had to do that?

Early in my career, I was plucked out of a student production at UCLA and cast in *Ice Palace*, a feature film starring Richard Burton. My father said, "Well, that gave you an entry into movies, but it's not a good image for you to perpetuate." Shortly after that, I went to New York to audition for a Broadway show. They wanted me to read a side onstage. Then I saw that it was for the role of a comic buffoon servant. My father's advice came to mind, and I handed the side back and walked out. When you're a struggling young actor, you make money in any way you can. My roommate in the Bronx had an aunt who catered these posh parties. So on the same day that I walked out on the role as a servant, I had on my white jacket and bow tie and was passing out canapés. But that was all right, because it wasn't my real thing. My real thing was acting, and I turned down an acting role as a servant! The irony of that still amuses me.

Your acting goes back to high school, right?

All the way back to grammar school.

How did you decide to act? Wasn't your father a farmer?
No, my grandfather was a farmer. My father was in real estate.

It seems like acting was not a good job for an Asian American at the time.
It was not. I see you have not read my autobiography, *To The Stars*.

I just got the book a few days ago.
Well, do read that. I talk about my acting training. As I said, I did my first plays in grammar school, and all the way through junior high school and high school. I began my college career as an architecture student in Berkeley. My father wanted me to design some of the buildings that he was going to develop. But after two years, I thought, "Down the road 10 years from now, I'll be working as an architect. Am I really going to be happy doing that?" So I came back to Los Angeles that summer and said, "I want to go to New York and study acting at the Actor's Studio." That's the place that was producing people like Marlon Brando, Montgomery Clift, and James Dean—all my heroes at the time. I girded my loins for a real knock-down, drag-out discussion with my father. He threw me off guard. He said, "I knew this conversation would eventually come up, and I have a deal to offer you. You want to go to New York and study at the Actor's Studio. That's a fine and respected acting school. But after you finish there, they won't give you that documentation, that diploma that says you're an educated person. Your mother and I would like you to have that. If you insist on going to New York, then you ought to be mindful of the fact that it is a very intensely competitive place, it's a very expensive place, and you're a Southern California kid. Those winters are fierce! You've got to be prepared to battle with the costs, the congestion, and the cold all on your own. But UCLA has a fine Theater Arts department, and when you finish there, they will give you that piece of parchment. You decide: New York on your own—that expensive, cold, competitive city—or UCLA with a subsidy from us." I discovered that I was a very practical kid. I went with the subsidy.

When you speak there's powerful projection. It's so distinct. Is that how you speak at home, or is there a mellower George?
Is there a different me? Oh yeah. I'm an actor. I can talk softly. I can be excited and agitated. I just give different colors.

You're paid to use your voice quite a lot. Is your voice something you've worked on? Is it your natural voice?
Well, I have my natural tools, but as a theater student, you take projection classes and elocution classes. My graduation present from my parents was a summer session at the Shakespeare Institute at Stratford-upon-Avon, Shakespeare's birthplace, where I audited classes with the Royal Shakespeare Company. My voice is a combination of the tools that my parents gave me plus all of the training and experience.

How have you adapted to the changes in directorial styles about how acting is supposed to be done?
Change is the most constant thing. When you look at the history of acting, there have been many different styles. When I was young it was the Stanislavski system, also called method, where you dredge up a memory of some experience that you've had. Now it's up to the actor to pick and choose from the various acting techniques that have been handed down to us. For example, when I did Dysart in *Equus*, he's a British Asian. I had to decide on what kind of English accent I would use. It takes place in Hampshire, on the south coast of England, but he was educated at Oxford, so he would have that upperclass, educated accent. The author, Peter Shaffer, comes from Lancashire, so I gave him a Lancashire background. You do that kind of research. You use some of the Stanislavski method, but you also have to take the givens, incorporate that, and personalize it.

Are you still learning?
What do you mean *still*? Being alive is a learning process. I think you stop existing when you stop learning. I know people in their 80s who went back to school. That's a wonderful thing. They don't consider themselves old, and they don't want to vegetate. I know an 80-year-old guy who does 10K runs, and that's the way I think life has to be lived.

It seems like you were the butt of Stern's jokes for so long, and now you're the voice of the show. How did that happen?
The first time I did *The Howard Stern Show*, I was doing a play in New York. When you're doing a play, the publicist gives the cast members assignments to promote the show. This one particular morning, I had a list of radio shows to do, and one of them was on Madison Avenue. So I went there and was waiting in the green room, flipping through magazines with the other people there, and they had this radio show on. It was the crudest, most vulgar conversation. I said to the guy sitting next to me, "Why don't they put some nice music on? This is really disgusting." He said, "That's the show we're going to be on." I thought, "Oh my lord." Then they came to get me, I was introduced, and this wild-haired guy tells me, "I didn't know you had such a deep voice. Anyone with a voice that deep has to have a big dong." I said, "Are we on the air?" That was my introduction to him. I had no idea he had such a huge and passionate following on the radio. He took some of the things I said and played with it. But then a few years later, my book was coming out. This was 1994, and I was in New York doing some promotional work for it. The publicist gave me a list of things to do, I saw Howard Stern, and I crossed him out. This very well-spoken, professional-looking woman in an elegantly tailored suit literally got on her knees and said, "George, please, please, please do the show. It means a lot to us." I said, "I don't think his listenership buys books. I doubt if they can even read." She said, "We're going to sell tens of thousands of copies if you go on that show."

ERIC: Takei has always had my back. He once introduced a JANM Biennale and mesmerized the visitors with his deep voice and how he

RENTER'S DELIGHT

Finally, I said, "Get up. I don't want to see you kneeling down," and I did the show. Then he took more sound bites from me. I had done the audiocassette version of my autobiography and they had a field day with that because they had four or five hours of me talking. That "I love black wang" phrase—I played a character named Wang in that Richard Burton movie—so he got the "wang" from that. And I was in a civil rights musical early in my career called *Fly Blackbird*, so I must have said "black" in that portrait. **They take pieces of what they catch you saying, and they had me saying things that I never even imagined, much less actually said.** One morning I picked up the phone and it was Ricardo Montalbán. I've worked with him a couple times. So we chitchat for a while, and after four or five minutes the accent starts changing, and I say, "I don't think you're Ricardo." The guy guffaws, and I think, "It's a prankster," so I hang up. The next morning, that conversation is on *The Howard Stern Show*. He sent an imitator to call me, and he put it on the air. I've had a lot of involuntary exposure.

Was that an honor in a way?
It was not an honor; just a lot of nonsense. Yes, Howard's language is crude and vulgar, and he's obsessed with body functions. That's not my cup of tea, but his right to speak as people speak normally—we hear those words around us all the time, "fucking this" and "fucking that"—that's part of the reality of life. Beyond that, his personal sense of what is really, was truly obscene, like these pork-barrel expenditures of hundreds of millions of dollars to build bridges to nowhere when our soldiers are dying in Iraq because they're not equipped with body armor. Those are the true obscenities of our society. I defend his right to truly speak out on the issues of our time. The other thing I admire about him is that he boldly goes where people haven't gone before, just like on *Star Trek*. His moving from the very safe and secure yet nevertheless constraining arena of terrestrial radio to the high-risk, high-wire act of satellite radio—he did it. He's been enormously successful, and he's been well-rewarded for that bold move. That's what makes American society move forward. He's a risk-taker, and I support that. On the second day of this year, when my phone rang and this guy

introduced himself as Gary Dell'Abate, the producer of *The Howard Stern Show*, I just burst out laughing. I thought it was another prank. He said, "No, no, no. This isn't a prank, and our conversation isn't being recorded." I said, "Why are you calling me?" He said, "I'd like to know if you'd be interested in being our announcer." I laughed again because I thought it was another prank, and he said, "We really are serious. We'd like to make the offer to you." I said, "Well, why don't you talk to my agent?" He said, "We intend to do that, but we want to get some indication to see if it's worthwhile to call your agent." I said, "It sounds intriguing, but you may not be able to afford me." I gave him my agent's number, he called, they discussed it. I didn't want to move to New York, so I said, "Let's do a week." I flew there for a week, and it was a bizarre but interesting experience. Then I recorded a lot of one-liners, and that's what they're running right now. People think I'm still on the show, but no.

You came out last year, although people probably already knew anyway.
All my friends and family knew.

Was that a risk in any way?
It was a very conscious decision. I'm involved in civic work and political arenas, so I've never publicly talked to the press about my homosexuality. But I've been together with Brad for the last 19 years now. We've been out in that sense. Last year was the first time I talked to the press about it, and the reason for that was that **I was offended and aghast when Arnold Schwarzenegger vetoed the same-sex marriage bill. I thought the bill being passed by the California legislature was a historic event.** Massachusetts had legalized same-sex marriage, and I thought California and Massachusetts were going to bookend the United States. I thought we were going to make history because when Arnold ran for governor in that recall election, he made those very moderate statements: he works in the motion picture industry, he knows a lot of gays and lesbians, he's friends with many, and he's very comfortable. I thought, surely, having campaigned on that moderate stance, Arnold would sign the bill. That's all that was needed for it to become the law of the state. Instead,

he played to the narrowest, most reactionary Republican segment of his base and vetoed it. I was outraged. It was just like Southern politicians who make moderate statements to curry votes with the African American community, and when it comes time to vote, they vote for segregation.

So coming out wasn't just a personal thing?
No, it was to make a political statement. In order to make that statement, my voice had to be authentic, so I discussed my homosexuality.

Were you comfortable doing that? Was that something you wanted to do anyway at some time?
Well, we were comfortable living the way we were. As you well know, **the press is an ungovernable creature.** It's not as comfortable after you talk to the press because everybody wants you to talk to them. Right after I made my first commentary, there was that initial tidal wave of requests. Then when it started to peter, then Howard called and wanted me to talk about it. I was very candid with him, and apparently, that went over very big with his listenership, and that's what prompted Gary Dell'Abate's call.

I thought it was heroic. It was great for you and a lot of people—even straight people who understand.
The first day that I was on *Howard*, Arnold Schwarzeneggar called in. Howard said, "George, do you want to talk to him?" I engaged in a conversation on the veto issue. When Arnold doesn't want to talk about an issue, he'll crack a joke and try to laugh it off and move onto something else. I said to him, "Mr. Governor, you are elected to an office that has serious responsibilities. What you do, what you say, and how you behave publicly as well as in your political decisions makes a profound impact on many Californians' lives. I would expect you to at least address this issue seriously." He engaged me in conversation, and as abbreviated as it was, he said, "All right. The next time the bill is passed, I commit to you that I will sign it." I turned to Howard and said, "Howard, you may be called the King of Media, but you have enormous clout beyond the media. You have just made history in California and perhaps in the United States." It turns out "Arnold" was an imitator. He was very good, he was very believable, and his political soft-shoe dance trying to avoid issues was very, very Arnold. It wasn't just the accent. He really had Arnold's persona. So I challenged Howard. I said, "You have a lot of clout. I challenge you to deliver the real governor of California." A few days later, Arnold called in and I had the same conversation that resulted in the same promise. Afterward, Howard said it was the same imitator! But my computer exploded with emails. As a matter of fact, visitations of my website went up not double, not triple, but 10,000 percent. **Amongst them, I got hundreds of people who identified themselves as white, male, suburban, conservative, and straight who said that they would support same-sex marriage because of the conversations I had with the fake Arnold on *The Howard Stern Show*.** These were people writing from places like Oklahoma, Tennessee, and Nebraska. So there were a lot positives that came out of that. I told Howard, you did make a contribution.

You got him back in a way.
He didn't know I would use it that way.

You once ran for councilman. What compelled you to get involved in politics?
My political involvement goes way back. It's the influence of my father. As you know, our family, like all Japanese American families, went through internment.* Despite the fact that my father went through that dark chapter of American history, he felt that the American system was the best in the world. **He said that both the strength and weakness of American democracy was in the fact that it's a true people's democracy; it could be as great as the people could be, but it could be as fallible as the people. He felt that it was very important for the good people to be active participants in the process.**
Even before I was a registered voter, my father volunteered me to work for the Adlai Stevenson II campaign. I was an active campaign headquarters worker during all of his unsuccessful campaigns. So I've had that kind of interest inculcated in me by my father. But, also, my theatrical instincts jibe well with it. An election campaign has all the elements of theater. There's excitement, suspense, and tension. Are we going to win or lose? And then there are various debates that candidates engage in, and there's drama there. There's either glorious triumph or black defeat, and the world goes down into the pits. I also was involved in the George Brown senatorial campaign and Tom Bradley's city council campaign. My father had a fundraiser for Tom Bradley in our living room. I was a delegate to the Democratic Convention in 1972, which was a fantastic experience. Then I was involved in Tom Bradley's mayoral campaign after he became our city councilman in the 10th district. When he was elected mayor the second time around, there was a vacancy. I had a lot of political friends by that time who said, "This is going to be a one-shot election. There's not going to be a primary and a general because it's to fill the unexpired term of the councilman who became mayor." They urged me to run. They said, "You have name ID from your acting career, so you have a great leg up." At the last minute, I was persuaded. But after I threw my hat into the ring, I went to Tom Bradley to get his endorsement. He said, "George, if I had known you were going to do it, I would have endorsed you, but I've committed to Dave Cunningham." But we had a good race, it was good fun, and I enjoyed the excitement of the electoral process on that level. I lost by a heartbreaking three percent. 🎭

*Takei would later pen a *New York Times* bestselling graphic memoir about the experience, entitled *They Called Us Enemy.*

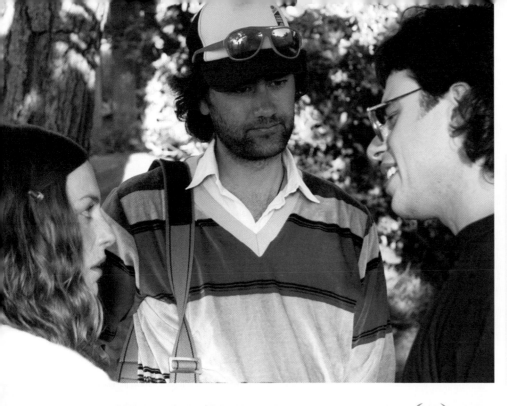

words | Martin Wong
pictures | Miramax

The title of *Eagle vs. Shark* sounds like a National Geographic Special, but instead of depicting animals attacking each other, New Zealand-based comedian, actor, and painter **Taika Waititi makes his full-length directorial debut by examining nerd culture.** Video games, theme parties, candle making, and unironic mullets— nerd life among Kiwis isn't that different from other parts of the world. What's unique is his funny, smart, and human treatment.

ANIMAL EYES WAITITI TIME

Why is the movie titled Eagle vs. Shark *instead of* "Eagle meets Shark" *or* "Eagle and Shark"?
TAIKA WAITITI: Because *Eagle meets Shark* sounds boring, and guys wouldn't go see it. **The eagle is a creature of the sky and the shark lives in the sea. Two different elements: both lonely, but both seeking.** Two different creatures who are both strong in their own way, yet outcasts through their reclusiveness. Both untouchable to the other. I liked the idea that these two animals that would never meet in real life could conceivably form a relationship in this weird story. The characters who represent these animals find love and acceptance through conflict.

Between the dress-as-your-favorite-animal party, old-school video games, pseudo martial arts, and other details, was any of it taken from your childhood?
Little bits materialized through the characters. There were moments that were taken directly from experience, like the computer porn moment and, obviously, the sex scene. But mostly, it was taken from adolescence, and even later when I was in relationships.

Usually, the relationship in a movie builds up to sex. It's the other way around in Eagle vs. Shark. Was this by design?
I wanted the characters to break up after only being together a short time, and their real relationship coming from getting to know each other and, at the same time, themselves. It's also interesting to see how Jarrod's character develops.

He starts out as such an idiot and is quite horrible, but as the story develops, you can really see the reasons why he is so unhinged.

The long-term effect of bullying was a major theme in the movie. Were you ever bullied when you were young?
A little. I was beaten up by a girl on my first day at primary school. (Is that elementary school in America? Whatever school you attend when you turn five.) After that, I tried to make friends with everyone. I hardly had any enemies.

There was some nice art on the walls, like pet portraiture and poker-playing dogs. Whose collection are they from? (Aren't you a painter?)
A lot of those elements were found on location. The dogs and horses all came from the same house. All the beautiful murals we used as backdrops were found around my hometown. We love murals in New Zealand. Yes, I also paint. I also know how to cook scrambled eggs. I can do lots of stuff.

Was it difficult for you, a comedian and an actor who is used to being the center of attention, to be on the other side of the camera?
It is hard sometimes, like when you think you could do something better or funnier than the actors you're using. But you have to get over it, because **you can't do everything by yourself.** Also, it was

MARTIN: Not sure what's more surprising, that Taika Waititi would direct Marvel movies or that Tony Leung would star in one so many years after these articles ran. Yes, they are still cool to me even though everyone knows who they are now.

important to me that in my first film I concentrated on the job of making a movie without the worry of acting.

Tell me about your relationships with the two lead actors, Loren Horsley and Jemaine Clement. Was it hard to boss them around on the set since you're friends? Did they have to be reined in, since they have theatrical and comedy backgrounds?

We three have actually known each other about 12 years. We all used to live together, and have all worked together in the past. As far as the relationship that Jemaine and Loren had to have in the story, we were all pretty comfortable. Loren was wearing a wig and had created such a believable character that it didn't feel like I was watching my girlfriend at all. It just seemed like I was watching Jemaine kissing this weird, awkward girl who I wasn't attracted to. It was easier to boss them around because they were friends. I didn't have to worry about being polite, I could say, "Just fucking kiss her!"

Were you worried about Loren looking too pretty or not geeky enough?

Loren is a stunner, there's no doubt. So, yes, I was a little worried. But she knew the character so well and could alter her body language and facial expression so that she really felt like a completely different person. But normally, I don't worry about Loren looking too pretty.

It must have been nice to have people act out your vision, rather than acting out someone else's vision. What are some things that you wanted to accomplish as a director?

That was an important thing for me: to stop realizing other people's dreams and start working on my own projects. I am much happier now that I am more creatively in control. I am interested in supporting New Zealand's film industry; I want to see it grow and develop into something quite awesome. At the moment, we only make a small number of films a year, and only a small percentage of those are good. I'd like that to change. A small part of me really wants to sell out, work in America, become a millionaire, and lose all my artistic drive, but for now I'll try and keep it real.

Are there some New Zealand-related jokes in the movie that I might have missed?
I dunno. I tried to take out some of the really NZ-specific jokes because I thought that international audiences would have enough trouble adjusting to the accent. I think the humor is pretty universal. If anything, I think Americans respond more to physical comedy like slapstick and pies in the face. New Zealand humor comes from a darker place; we laugh at emotional tragedy and the pain of family dysfunction. Basically, if something is sad for an American, we usually laugh, and probably the other way around. However, we love fart jokes.

This movie was a product of the Sundance Directors and Screenwriters Lab. What was that like? Was it like boot camp? Summer camp?
I've never experienced either of those camps. I think it was more like a holiday on a mountain with lots of brainy people all there to help you make a movie idea. Without the lab, this film would have been shit. Period.

People will compare the movie to Napoleon Dynamite, but I think it's more like Gregory's Girl. Are you familiar with that movie?
I haven't seen that. I also think this film is more like *Buffalo 66* or *Love Serenade*. I guess the Nappy D. comparison is only because there is a geeky character in it. I think the main difference is that this film is darker, deals with more human emotions, and isn't supposed to be funny all the time. It's a strange mix, I prefer to think of this film as a dark, arthouse romantic comedy...from New Zealand.

Godzilla vs. Megalon, Holy Virgin vs. The Evil Dead, Kramer vs. Kramer. Where does your film fit into this lineage?
I have no idea. I don't understand what you're talking about, American. 🐈

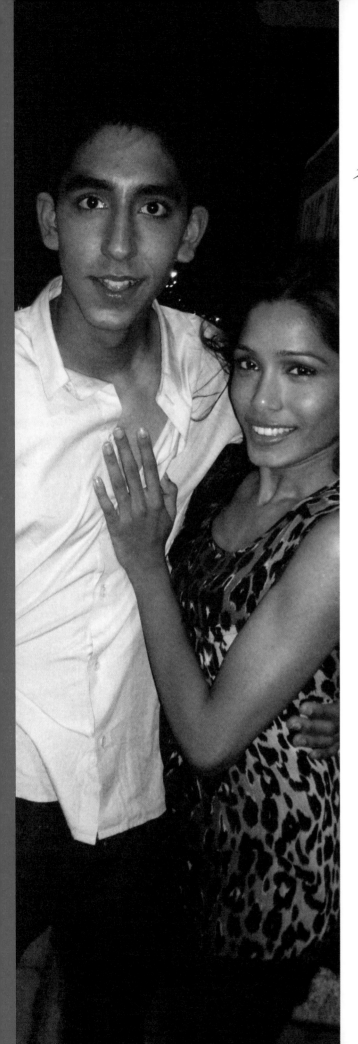

words + portraits | Martin Wong *stills* | Ishika Mohan

SLUMDOG STARS

British director Danny Boyle is known for tackling genres that include junkies (*Trainspotting*), zombies (*28 Days Later*), and sci-fi (*Sunshine*). Tying together his disparate body of work is an energetic style, vivid use of color, smart dialogue, cool music, and a requisite poo scene. His latest work, *Slumdog Millionaire*, is a dark and violent but hopeful romance about Jamal, a young, uneducated man who gets on the Indian version of *Who Wants To Be a Millionaire?* His ability to answer the questions all the way up to the final question prompts an accusation of cheating, followed by violent interrogation by the police and a retelling of his experiences in the slums, criminal world, and call centers of Mumbai.

Playing the protagonist with innocence and excellence is Dev Patel, a first-time film actor from the cast of the British TV series *Skins*. His love interest is played by Freida Pinto, a model and TV show host who dazzles in her big-screen debut. I met the actors at a fancy lemonade stand in Beverly Hills prior to the film's US premiere.

What was more daunting, filming in India or working with a supermodel?
DEV PATEL: Everything. Being out in the middle of Mumbai with Danny Boyle was daunting enough. So was doing scenes with Anil Kapoor and Irrfan Khan, some of them in a packed studio with a big audience, and then dancing with Freida.

Could the locals sense you weren't from around there?
PATEL: I asked Danny if I could come out a week early, and would walk the street for hours. No matter what clothes I wore, when I walked down the street I gave off that aura. I found it's the pace of things, really. Mumbai moves fast, but everyone takes their time and relaxes.

Freida, did you have to give him any tips?
FREIDA PINTO: Maybe when he spit his gum on the street; that was not allowed. He also got conned when he went shopping. He spent 250 bucks for a scarf that cost 80 rupees. But within a week or two, he pretty much got it.

How did you handle being the only actor who wasn't local?
PATEL: Jamal was calmness within the storm, and only became angry during certain parts. He was soft spoken, and I knew I could bring that to him.

Because he was so calm, his accent could be different.
PATEL: My accent was bad!
PINTO: I don't think it was bad. In Mumbai people speak different accents anyway. Plus, he had the call center training.

Did you really train at a call center?
PATEL: I went to a few in Pune. They're almost like universities. I hung out there for a long time, and they showed me how everything worked. They have different rooms where they learn to polish their accents to speak like they're from England and places like that. **The thing is, no matter how much I changed my accent, in the end we went to a studio in London and rerecorded everything to make it clear.** As the guide to the film for the audience, I had to be understandable.

Both of you made a transition from TV to a feature film. How was that?
PINTO: The TV that I did was just me being me. I was a presenter for a travel show for nine months. I traveled all over Southeast Asia: Fiji, Singapore, Thailand, Malaysia...

Nice! And I'm sure they didn't have you eat crummy food.
PINTO: Actually, I had to try everything for everyone because I was the only one who was not a proper vegetarian. It was fun. When I came to the end, I thought, "That's it. My life's over because I have nothing else to do." And then six months later, I auditioned for *Slumdog.*

After being yourself in front of the camera for so long, it must have been interesting to play someone else.
PINTO: I think it's fun being someone else because when you're yourself, you risk exposing too much. I did all these goofy things that were shown at the end of the show as bloopers.

What did you know about the movie going into it?
PINTO: I read the script, knew the story, and watched a bunch of Danny Boyle films. But he's very unpredictable.

Boyle had never been to India, right?
PATEL: It was good in a way, because he was really open to it and could see things that you'd turn a blind eye to if you lived there every day.

Dev, was it tough for you to go from being a supporting character on a TV series to the star of a movie?
PATEL: There was so much pressure. My dates didn't work out, so they shot nearly all the little kid stuff before I got on the set. When I did get in, I was shooting from early in the morning to late night.

You weren't there to tell the kids, "This is how I'd do it"?
PINTO: I think it was more like the other way around. But there were certain traits and a general aura that the casters picked up on, especially me and the youngest actor. We were really energetic, would muck around, and were really similar.

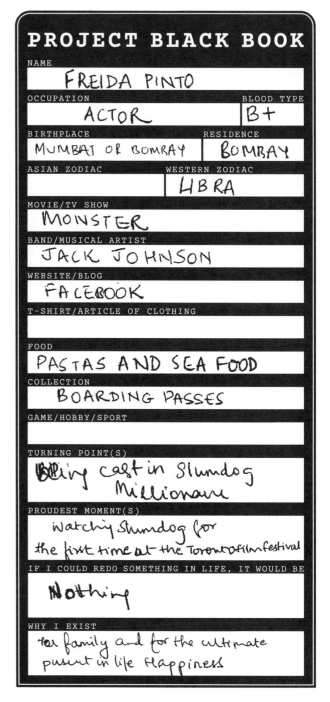

PROJECT BLACK BOOK

NAME
FREIDA PINTO

OCCUPATION
ACTOR

BLOOD TYPE
B+

BIRTHPLACE
MUMBAI OR BOMBAY

RESIDENCE
BOMBAY

ASIAN ZODIAC

WESTERN ZODIAC
LIBRA

MOVIE/TV SHOW
MONSTER

BAND/MUSICAL ARTIST
JACK JOHNSON

WEBSITE/BLOG
FACEBOOK

T-SHIRT/ARTICLE OF CLOTHING

FOOD
PASTAS AND SEA FOOD

COLLECTION
BOARDING PASSES

GAME/HOBBY/SPORT

TURNING POINT(S)
Being cast in Slumdog Millionaire

PROUDEST MOMENT(S)
watching Slumdog for the first time at the Toronto film festival

IF I COULD REDO SOMETHING IN LIFE, IT WOULD BE
Nothing

WHY I EXIST
for family and for the ultimate pursuit in life Happiness

Freida Pinto washes her own dishes.

Director Danny Boyle gives Freida Pinto on-the-job training in *Slumdog Millionaire*.

What was it like getting beat up? You got thrashed.
PATEL: I did. I got slapped in the interrogation scene as well, and Saurabh [Shukla] is a big, burly guy. The script said the constable would give me one or two slaps before I gave my name. I remember doing that in two takes. We kept the camera rolling so I got four slaps that came like torpedoes. **The hardest thing is not to flinch. You have to act like it's not coming even though you'd get one and your ear would be ringing. You just have to let it happen to you.** We only used a small snippet, but it hurt and I was literally crying. I had a slight bruise on my cheek after that day because I got slapped so much.

Did your tae kwon do experience help you out in those scenes?
PATEL: You get taught not to get beat up, but I had to let it happen.

Freida, you didn't get beat up so hard. You just got dragged around.
PINTO: Yeah, I got my hair pulled around and my arms literally crushed by these boys. But it was fine. I had Danny always looking after me. He'd come up to me and say, "Are you okay? Any bruises?"

Dev, did you receive the same treatment?
PATEL: It was different for me, I think. I got tough love from Danny.

Was the torture scene more difficult than the dancing scene?
PATEL: Oh, geez. I knew dancing scenes were going to come but we had a choreographer. The torture was the hardest because you try to make it realistic. **I remember sitting in my hotel room for hours pretending to be electrocuted.** I sat down, started shaking and stuff, and it looked funny stupid. But once I got in there with the other actors, it just sort of

happened. We had to tone it down for the rating, actually. It was much more than what you see, which is literally just my feet.

Both of your characters show a lot of emotion but don't have a lot of lines. Was it a challenge to be pretty new to acting and have to express yourselves without a lot of words?
PINTO: Definitely. The one thing Danny Boyle said throughout the filming of the kitchen scene was, "You're saying no, but you mean yes. The yes is in your eyes." That was tough.

A lot of guys think girls can do that, but it's not that way!
PINTO: It comes with practice. I think six months of auditioning trained me. From the first day to the last day, the scenes changed but that "no but yes" remained constant and Danny Boyle was my acting coach.

Dev, did anyone guide your acting? Maybe you didn't need it since you were on a TV show.
PATEL: I can't act. I've never been taught to do it.* I don't know how to switch it on or off, and that was the hardest thing—getting that fire in your eyes.

How did you get the Skins gig if you weren't trained?
PATEL: I sort of stumbled into it. My mum dragged me down to an open audition because she saw an advert in the newspaper when she was traveling to work on the train. It was like "new teen drama needs actors 16 to 18, no acting experience necessary." I was 16 and in school. I always wanted to be an actor, but didn't know how to get into it. She took me down, I got a name tag and a number, and I sat down with a girl from the opposite queue. I read the lines, and they said, "Tone it down. Don't act." I read them and everyone started smiling. I went to one other audition, got there, and it wasn't really an audition. I was reading for another guy, but I think they needed an Asian guy. They needed to have a brown guy and I was there. In *Skins*, there really wasn't much to the character. He's

literally a sex-obsessed teenager who wants to lose his virginity, so I made him me. I think all the good actors say that you have a serial killer and a star-crossed lover inside you. You just have to dig deep enough to find it, and it's bloody draining, man.

Everyone else in the movie was a professional actor, right?
PINTO: Almost all of them.
PATEL: I really struggled with the technical side of acting. It was great that Anthony Dod Mantle, the cinematographer, and Danny really took their time to show us how it is done. I only started getting into reading books and stuff after Danny got me into them. I didn't even read books in school.

So while your colleagues were thinking through their roles from a number of techniques and angles, you two were just winging it!
PINTO: I don't think the kids were thinking it through. They were natural and didn't overanalyze like we did. We have to try to put ourselves in a situation, but they're naturally there.

But sometimes kids being kids are really shitty actors. The kids in Slumdog were really good, though.
PINTO: I was particularly impressed with Tanvi, who played Middle Latika. She's a dancer, and she did a brilliant job.

People love the movie at festivals and I think it will find an audience in the US, but do you think it will get play in India? Do these types of movies get much play there?
PINTO: Coming from India, I completely loved it, its portrayal of Bombay, and the characters. It has a foreign perspective that is very true to the city and the story that it's dealing with.

The colors were amazing.
PINTO: That's exactly what people like in Indian films. The colors, the exaggeration...

The soundtrack with M.I.A.!
PINTO: M.I.A. hasn't caught on in India, but A. R. Rahman...

Your chemistry on and off screen is great, too. Do you remember meeting?
PATEL: We met on the set.
PINTO: I met him on my last audition. I said, "I'll show you around," but he was so jet-lagged and disheveled.

It's a good thing you weren't jerks.
PINTO: Imagine that. Most of our interviews are done together. It's easier that way.
PATEL: I give her my hard questions.

Has someone ever asked one of you questions and forgotten the other one?
PATEL: Mainly to her. They forget about me.
PINTO: No, they forget about me!
PATEL: Obviously, they are drawn to her. Remember that guy in India?

After having people lean toward you with microphones, you'll have to go home and sit in traffic, wait in lines, and pay for your own lunch.
PATEL: I don't mind that. I don't like the schmoozing thing. I hate selling myself.
PINTO: I hate the makeup. In Bombay, you see models and actresses going shopping with loads of make-up on their face. That's annoying. I just want to be an ordinary girl and wouldn't trade it for anything.

But after this movie, aren't you two "real" actors?
PINTO: I don't know. I keep telling Dev that the next one will tell.
PATEL: Hopefully. I'm twiddling my thumbs and pretty much jobless at the moment.

COMICS & MANGA

PORNSAK PICHETSHOTE

I just didn't feel cool enough to read *Giant Robot*, I guess.

As a part-time comic book store clerk in the mid-1990s, I'd seen that first issue countless times, with its cover of the face of a sleeping sumo wrestler. The store was good at keeping zines in stock, and I had rung up countless copies at the register. And god knows, I was definitely familiar with their merch—their Decepticon and DJ Bruce Lee T-shirts that we could not keep in stock.

But there was something about the magazine that felt too cool for me.

Maybe it was its connections to punk rock and skateboarding. I was just a comics geek after all, and while those worlds overlapped quite a bit during the '90s, I always felt on the periphery of that culture.

So it was only after I retired from the life of part-time comic book clerk-dom that I realized they covered comics too...and in the process, realized it would mean so much more to me than just "coverage."

Because yes, it was great to read people with distinctive opinions covering the Asian American cartoonists I already loved like Adrian Tomine of *Optic Nerve* or manga legends like the co-creator of *Lone Wolf and Cub*, Kazuo Koike (p. 192). It was awesome to be introduced to Hong Kong action movies I didn't know starring Chow Yun-fat (p. 132) and Stephen Chow and other artists I was completely oblivious to. But what I will always remember the magazine for is how I—someone generally considered the alpha comics geek in my crew—learned that some of my favorite comics had in fact been produced by Asians and Asian Americans.

For some dumb reason, I thought Alfredo Alcala (p. 184)—Rick Veitch's inker on the back half of Alan Moore's iconic *Swamp Thing* run from DC Comics—was Argentinian. Because it was so much easier to believe a South American artist would be working in American comics in the '80s than an Asian one. I had no idea Alcala was Filipino until I read it in *Giant Robot*.

Lynda Barry (p. 205) authored one of my favorite coming-of-age graphic novels in *My Perfect Life*, leading me to seek out every book with her name on it, and yet, it was only years later in the pages of *Giant Robot* that I discovered she was part Asian.

Because as cool as the magazine was for introducing me to new Asian artists and genres I'd never heard of, what it did most powerfully for me was shine a spotlight on how the things I already loved—things entrenched in my cultural DNA—had already been created by Asians and Asian Americans. And as I read future issues and sought out back ones, I discovered how well the magazine did that across media: introducing audiences in general, but Asian Americans like me in particular, to something new—whether it was Hong Kong cinema through Daniel Wu's (p. 254) singular perspective—or reminding us how indelibly we've been here all along—like in their infamous *Skate Manzanar* issue.

It's hard to find words to describe how powerful a discovery like that can be. The best I can come up with is "gift." Because, in so many ways, that's what discovering *Giant Robot* was: a gift.

And I couldn't be more grateful that I was finally cool enough to accept it. 🐱

Pornsak Pichetshote is an Eisner and Harvey Award-winning writer for comics and TV. He is best known for having penned critically acclaimed comics *The Good Asian* and *Infidel*.

ALFREDO ALCALA

words + pictures | Eric Nakamura

Magic comes rolling out of the pen, brush, quill, pencil, charcoal, fingers, and even through his voice. The "his" in this case is Alfredo Alcala. Those of you in the comic scene may have heard of this man. He was an inker on projects such as *Conan, The Swamp Thing*, and numerous other projects all the way up to today. At 70, you would think this man would be hanging out in Tahiti or Easter Island or something, but with a tool in hand, the art is still coming. "Art" is the important word. Comics aside, Alcala is a master painter and can handle watercolors as well as charcoal. Name the subject and you won't be turned away. He can paint portraits as well as anyone, change ideas, and can go straight to the looniest of comics.

I learned about this man from the publishers of his book, *Secret Teachings of a Comic Book Master* and I am proud to say that *Giant Robot* is the only publication that has reviewed this book. Some say racism has kept Alcala from gaining more notoriety and work these days. Some may say that his style isn't suited for today's comics. But somehow he gets by and still pursues his work. He gets jobs, but not in the same caliber that he once enjoyed.

The book, I must mention, isn't what I expected. You'd figure that the title was some way of saying that this was going to be a biography of a comic book master. But after digging in, it was more of Alcala's guide to being an artist. There are some highlighted points to follow as well as chapters that tell about Alcala's painting, American comics, and his Filipino Comics. Although it's not selling well, it's still something to look at. After all, it wouldn't be in *Giant Robot* if it wasn't!

Back to my story. After entering into his small dark "artist's" apartment, it would be easy to say that I thought I was in a workshop or even a thrift store of mighty proportions. Maybe it was the thickness of the books, papers, videos, and the tons of odds and ends, or maybe it was the small wooden table and hanging light that was set up for our conversation. Alcala sat in a shadow with a cigarette kind of reminiscent of Kurtz, but no horrors to tell about, instead it was stories about anything and everything. Critiques of things that never had critiques. A questioning of most everything.

How do you like your book?
ALFREDO ALCALA: It's okay, it's fine. The publisher is planning on making a second version of the same book, but with more drawings.

The book has a long story about your trip to Seattle with Phil Yeh.
Phil Yeh did a newspaper called *Uncle Jam* at that time. There are a lot of drawings from that trip. [*Proceeds to show me the drawings from the trip that are in the book*]

How long did it take you to draw some of these pictures?
One to two hours only. I remember telling Phil to bring a jacket because it's cold in Seattle. I wasn't that cold, but to make it more funny, I made myself look cold too. Phil was complaining a lot. So you can see what we looked like when we got there. You can see the Mt. Rainier. It looks like Mt. Fuji [*shows me a drawing of the two together shivering*].

How did Phil write about the Secret Teachings that are in the book? Did you tell them to him?
He knows my whole life, because we have been friends since 1976. We are always together. Especially when he had the gallery in Long Beach. I used to work there for four days and closed up this apartment. So he was always asking me, "How did you learn?," "How did you grow up?" So I told him my life. When I was a kid I used to shine boots. I used to sell Chiclets.

What city was that?
Manila. So Phil inserted the Secret Teachings himself.

You painted the image on the back?
Yes, it was 4×4 feet.

Do you like painting or drawings better?
I like to paint but because I don't have regular customers for paintings, I would starve here, because I don't know where to sell it. Doing comics or commercial art—it's all for orders.

Did you go to school?
No, if you read the story of my life, I was thrown out when I was young. I had to shine boots. That's the way I earned money. Two weeks in grade 7, my teacher was mad at me. She said, "Find your own teacher, find your own school." Every time she opened my homework notebook, she didn't find homework, she found drawings. So when I was thrown out, that was the end of my school days. That was before the Second World War. But because I liked to draw, I kept up with my drawings through magazines, books, and newspapers. That was my life when I was young. I learned drawings on my own, so nobody could tell me how to draw and what's wrong with my drawings. I didn't worry about it. I just kept drawing and drawing and drawing.

G 184 R

Was it better that way?

Yes, you never stop, never surrender. Once you stop, that's it. That's the end. Even fraction by fraction, a little bit, you will grow. The more you polish your memory. What you see, you can memorize. If you don't practice drawing what you see, you forget. So you can see in the book, the drawings are done by memory. I don't have a photograph. I have a photographic memory. Most of the time, I don't copy. But I do pick up the good lines or good shades from something I like. But I do need references. Let's say I am depicting a Second World War story, you cannot just draw an airplane. If you are mentioning a certain kind of plane, you cannot just draw a plane. People would say, "What kind of plane is this?" You have to use references for shapes and details. Everything is important because you are depicting history. In fiction, you are inventing things that you like. In a drawing you can put castles in with a spiral road in the mountain. As you fictionalize, you can make interesting things. That's what's good about fiction.

Do you like fiction better?

Oh yes. In fiction, I am free. I can do whatever I want. I can think whatever I like. I can make a pointed mountain, a jagged mountain, a tree can be twisting and I can put in a dragon. Nobody has seen a dragon. A dragon of the Chinese is not the same as the dragon of the Japanese. The dragon of Europe is another kind of dragon. You are more free. If you are the writer, you can control everything.

Your characters are always from the past.

No one can tell me that I was wrong. I didn't witness it. You didn't witness it. We don't know it. Same as the Bible. If you tell me to draw Jesus Christ. **Don't tell me you know Jesus Christ. I can make him big and round—a fat man. Are you sure he had a beard? I could add a moustache. I could make him a girl. Someone started to depict him and everyone followed.** In *The Last Supper* he was in the center like a king. It was so symmetrical.

Everyone sat only on one side of the table.

Yes, the perspective is wrong. He is in the center. Are you sure he was in a chair or sitting on the floor like the Japanese? Who knows, maybe he was standing. Maybe this whole thing wasn't true. Maybe it was just an invention of the story.

Do you believe in Jesus Christ?

No! Who would believe in it? When I was young, I believed in Hell and Heaven and devils and Christ. Let's say someone older than me or smarter than me said, "If you read the Bible carefully, then that's the history of the world." What do you mean the history of the world? The Bible begins with God created the world...What is the start of the humans? Adam and Eve? And so on and so on up until now. Where are the dinosaurs? The stupid writer doesn't know! During those years, there were no discoveries of dinosaurs. The writer just wrote what was around him. He saw the people, oh, Syria, camels, donkeys, and then chariots. What you see is what you write. In a world map, the Bible is in the Middle East area, Sinai, Egypt, how would the writer write about Japan and South America? The stupid writer was trapped in the Middle East.

So who do you think wrote it?

People like us. If I had a time machine and went back into time, what would you write about? If you carried yourself back to time before Abraham, you would know about TVs and VCRs even though they didn't have one. Can you tell if Hell is hot? If you were in Hell, it would be hot. But how do you know that Hell wouldn't be cool because of air conditioning? Because I am using the time of today. I am correct for my time and they are correct for their time. But people believe that the Bible is true. That is one way of cheating people. A preacher will say, "I talked to Christ." In what dialect? The preachers Swaggart and Graham, do they speak Christ's language? They speak only English! When you are young, you learn about angels that have wings. Isn't it funny that angels that are depicted by artists have wings? How would angels wear a shirt since they have wings? How would they lie down to sleep? The artist is just an innocent person.

LET *KAN'S* END BEGIN. FOLLOW ME.

Voltar was a stud. He was buff and looked like Dolph Lundgren. The helmet? Well I guess it was cool in 1963.

Do you like that kind of art?

Yeah it's just fancy art. What is a devil? A human, pointed eyes, ears pointed, wings, horn on their head, claws are sharp, and a tail. If you relay the idea to me, I can draw it. It's just a bunch of animals into a human. I like to draw that! If the Bible is true, if I am a devil trying to capture your soul, would I appear like an animal or would I appear handsome as a handsome guy? The Devil would be handsome, so these depictions are wrong. The devil is a dragon. Only a dragon. Do you believe in dragons? There's a Komodo dragon in Indonesia. Does it look like a dragon or a lizard? It looks like a lizard. I think it's more horrible to look at a crocodile. If you hear, "Komodo dragon," you think, "Wow!" So if people haven't seen it yet, they would be scared. Because you make

Not bad for an elementary school dropout. He would've been in his late teens at the time, given he was born in 1925. Not bad for an elementary school dropout.

If it seems like Alcala is harping on about this, it should be noted that during WWII, he drew Japanese bunkers and miscellaneous military equipment as references to aid Filipino guerrillas in the resistance.

people frightened by the name. Now the final thing about the Bible is it's a plain good novel. There's a good guy Christ and the bad guy Judas. If there is a god of good, then there is a devil of the bad. Black and white only. The daytime is Christ and the nighttime is the Devil. God is the pool of light and the Devil is the pool of darkness. You cannot make a good story where everyone is good. Let's say this, if everyone is good then there's no policemen. Who are you going to arrest? The police would have no place, there's no jail, no court, no judge, because everyone is good. I think the story was refined after it was written and re-written. What about Robin Hood and King Arthur? People believe in it. Let's say he's true. Robin Hood was a sharp shooter. If you are being chased by 20 people in the forest, you shoot and never miss. Later on when you are at the castle, where do you get your other arrows? He has to go back and pull the arrows out of the dead people! In a sword fight, it's steel vs. steel, the metal doesn't chip off? So they would have to sit down and sharpen their sword. I've never seen it. What if your sword isn't stainless. If you fall in the river or the sea, you get wet, you wouldn't be able to get your sword out because it's rusty already!

So when you write, do you think of these kind of details?
I am very meticulous. Let's say John Wayne. These movies cost a lot of money to make. Let's say he is surrounded by Indians. He shoots them, *bang, bang, bang*, he shot them already. Did he replace the bullets? Maybe, but after the gunfight, he still has the bullets on his waist. Where did these bullets come from? This is an error. Let's say there is a town, bad guys arrive and are shooting. The people in the town panic and run, all are grown ups, I never see any children.

Do you include children in your comics?
I will not forget those. I will put chickens too. Another example is when there is a saloon, there is a hitch post to where you tie your horse. In a whole day the riders of the horse go into the saloon and are playing cards or drinking or whatever, [*draws picture*] the horses may be there for more than six hours. Don't you always see that the ground is clean? They didn't throw any shit on the ground. They never piss on the ground.

When you drew Voltar, you were in control. In Conan did you find mistakes in it? Did you change it?
Sometimes, when John Buscema was drawing, he would draw Conan holding the sword in his right hand. The sheath was also on the right side, so you cannot pull a sword out of a sheath on the right side if you are right-handed. A sword should cross your body. Many times I noticed this. I don't really look, I can sense it.

Did you write Conan also?
No, I just drew. They won't allow it even if you have a good idea. If you tell it to them, they won't like it, but then they will use your idea. That happens everywhere. Everyone does

it, people are always limited. There are many moments you cannot create. So you listen to other people. There are many legends everywhere. You just change the people in it. Let's say there was a story about a snake in China, just change it into a lion. Just invent it. An idea is limited. You can make the world square, rectangular, triangular, round, so what? If I make Earth like a die, they say it's not true, so what if I like it flat because you are standing on Earth now, it's flat. They say that in the Bible the Earth is flat. Below your feet is Hell. Don't you know that you are standing here in the US and under your feet is China? You think only Chinese are inverted? If you go to China, everyone there is standing up so all the Americans are upside down. They never think of it in the Bible. The writer of many thousand years ago are good writers but idiots.

Do you buy new comics?
No, because they are all done by artists who do not understand anatomy, light and shade. They just draw a massive three-biceped man.

So no X-Men?
There is so much distortion. It is a little realistic and a little fiction. Why don't they use a little more natural figures. **So the youngsters of today, they learn to draw from these artists. They will never learn how to draw the real thing because they admire error.** It's okay to idolize them as an artist. But look at the drawing and at a person, is it similar?

Do you know any of the new artists like Jae Lee personally?
Oh yeah, they are lucky they got famous, but if you ask Jae Lee to draw a horse or any animal, he cannot draw it. So they are fake artists. They are lucky they landed in the comics.

Now their work is hot.
But in the long run where are they going to go? Once upon a time people were hot? Where are they? Hitler, Napoleon...? Nothing. In this world, the good and the bad are never forgotten. If you know Lincoln, then you know who shot him. If you know Kennedy, then you know Oswald. The good and the bad are always there. It's like the daytime and nighttime are 12 hours each. But in the day people say it's always bright and in the nighttime it's always dark, but you can use a lamp. In the day, you can go into a dark room. In a movie, it's dark. You can make the day dark and the dark bright.

Are you still drawing comics today? Like Ultraman?
That stopped already, and *seaQuest*. At present I just mailed drawings of *Flintstones* and *Scooby-Doo* for Harvey Comics. I do the inking.

Do you do this every month?
Yes, but *Flintstones* jumps. There was a nine-month span where I didn't do any *Flintstones*. But *Scooby-Doo* is regular.

ERIC: Alfredo Alcala's answer about artists getting more refined as they age is something that has stayed with me since he said these words. It's

Do you like that?

Yes, it's fun because I can do different things. When I say I am an artist, most people will think of me as doing *Conan* or *Voltar*. Long ago when I talked to Dick Giordano of DC, he asked me if I thought I could ink *Batman*. I thought, "What kind of question is that?" Who does he think he is? He thinks I would work on *Batman* like I would on *Conan*? He doesn't know that I can paint, watercolor, charcoal, letter, stylize, decorate; simple lines, tones. In my book, there are many different things. The camel is not the same as a *Conan*. I do cartooning also [*shows me some examples of Filipino comics*]. Cartooning with shade. Nobody does this. Shades look good in cartooning. If you look at this, it looks realistic. But it's cartoony.

Do you like the Simpsons?

No, I can draw that easily, I don't like it. I wouldn't feel happy about it.

What was Ultraman for?

Harvey also. For a few issues we did this then they suddenly stopped it.

Do you find a lot of work these days?

No, not much, the editors get changed. They are young. They hire artist who are young. They think we are old. **Artists don't get old like athletes. When they grow old they cannot play anymore. But not an artist. The older they are, the more refined they are.** But these idiot publications are using young blood. What's this? Especially DC. When we were doing *Swamp Thing* it was almost the number one circulation in the whole comic business. This was in 1986. I inked some of those issues. Public response was good. But they hired a young artist and editor and they collapsed. They cannot sell the book anymore. It became one of the worst circulated comics in DC. If I am doing good then there's twenty around me pulling things down, what can I do? The editors cannot see quality.

That's why I do my own magazine.

That's the good thing that you do, you can do what you want. If people say, you're attacking religion, so what? You're attacking politics, so what? Why should you give favor to someone you don't like. Let's say I like a woman and you don't like that woman. What am I supposed to do, make you marry the woman? If you don't like pork and I like pork, why would I push you to eat pork? Horses eat grass and buffaloes eat grass, why are they are stronger than us? So why don't we eat grass so that we can run faster and be strong as a buffalo? But we cannot follow what they want. You can print any picture and print any article you want.

Let's say someone said, "We would like you to make your own comic book." Do you have any ideas that you want to make?

I want to make a naval battle from the WWII. Historical comics. Because what you read in *The Battle of Midway* has

The *Swamp Thing* comics were perhaps a high point for Alcala while he was at DC Comics. In 1985, *Swamp Thing* won four Eagle Awards which in the comic industry means something. *Swamp Thing* was voted as people's favorite comic book, and Swamp Thing was number three behind Batman and Wolverine as favorite character!

In the back of most comics are letters from fans, and many of these are letters that praise Alcala for his fine work. In issue #57, Gary Kimber writes, "Art by Veitch and Alcala is superb. I've long been a booster of Alcala's wood-engraving inking style. With all of the work he's done in the past dozen years, people tend to forget what a great job he did on some of those classic early issues of *Savage Sword of Conan* with Roy Thomas."

Charles Brown writes, "...Moore, Veitch, and Alcala have made Lex Luthor seem more menacing than the last ten years of Superman-line stories have."

Alcala's name appeared on the cover of the *Swamp Thing* comics for a few years during its heyday, and went missing somewhere in 1988. That is when the comic began to go downhill.

little pictures. In a comic I can make as many panels as I like and complete to the story. I can depict both sides and write about what they were planning. I can show the Japanese side and American side without a bias.

Do you have ideas for fiction stories?

Yes, many ideas, adventure, fantasy, sword and sorcery, the only thing I am not interested in is drama.

What about futuristic?

I have done a few. But not my own stories. I feel guilty because today it may be correct but next year it might be a laughingstock. Let's say *Star Wars*. It's entertaining, no question. But there are gun fights in the ship and there are robots like the little one, and they are high tech, but why are they using bullets. That is an old design. Then after the fight, there are no scratches on any of the buildings.

Kamandi: The Last Boy on Earth! This story evidently is about a boy who survived the Great Disaster and is trying to survive among a world of animals. Kind of like *Planet of the Apes*. Some of the issues tell the reader that the comic is, "Now More Savage Than Ever." This comic ran from October to November 1972 (#59), September to October 1978. Number 59's story continues in *Brave and the Bold* #157. The issues Alcala worked on were from around 1976 to 1977, plus or minus one year.

An early fan writes in the back of issue #51 (pictured above), "As for the inking, the credits said: 'd-USOK,' but much of it was done by Alfredo Alcala. Since I understand Alfredo has recently moved to this country from his native Philippines, I suppose this was his way of saying that the US is okay. So's your inking, Alfredo. Stick around for a while, okay?" If you want to check out the Alcala issues, they aren't hard to find. Just check back issues at a comic shop. They're reasonable.

It's like the light sabers that are like swords.
Yeah, they use them like the Samurai style, with two hands. So you can see that there is old fashion in the new styles. And look at them swinging like Tarzan!

How about superheroes?
I call that childish. I don't like *Superman*. If I was Clark Kent and I take off my glasses, then I'm Superman. You never recognize me. Even his bullshit girlfriend. It's like the writer from *Batman*. He comes out at night, so maybe he stays at home in the daytime and sleeps. Why doesn't he sleep upside down like a bat? But bats urinate on themselves to make themselves cool. They do it by nature. They hang upside down and urine cools them. So Batman should piss on himself! [*Laughter by all*] If you want to project reality in a bat, he is supposed to have hearing sensibilities of 1000 cycles, but why does he get hit in the back? Superman is man of steel. Let's say you get hungry, do you eat railroad track, or a bridge, or a truck? What do you drink? Oil to lubricate yourself? You're the man

of steel. So I don't want to make things like this. I don't want to create error. But this is for children. I can make a superhero more mysterious that this. I would cover all the loopholes.

Do you have any future plans of what you want to do?
Nothing. If there is a financier, I would like to do the battle. The comic could last on the shelves. History is always fresh. Not like a superhero. Today it is famous, but later, it's not. Can you change history? Lincoln, Washington, Hitler? Same as a song. Famous on Monday but not on Friday. Classical music lasts on and on. Who sings like Elvis now? But who plays Beethoven or Mozart? Symphonies play it now. Historical comics last. But can you go out now and be like Elvis with the hairdo and everything? They will think you're nuts. Once, I was asked to review a film before it came out. They said that the film was realistic. but when I watched it, it wasn't right. Why is it that when the guy was sad, he had symphony music accompanying it? I never had a symphony follow me. The film crew should have focused on the symphony. When the ratings came out, there were many nice quotes from many people in the papers. So I asked why wasn't my name there? It wasn't published because I attacked it. So I asked why did you invite me? I was being honest. So I got mad and later they took out another review form that was already written favorably. They asked me to sign it for $250, so I took it.

Does Voltar get married?
No, then it would end. Voltar would live happily ever after. He may have kids. And who knows, they may be gay. I don't know.

Did you ever get married and all that?
Yes in the Philippines. So that's how that was. Tarzan stays the same age, but the actors who play him get older.

Do you like Manuel Ocampo?
No I don't like it. I can draw Swastikas and put them in, but I don't like them. I appreciate artists working hard. I like some American illustrators and some British muralists.

You finish your work when you feel you are done.
I don't want to feel guilty that I cheated a customer. Many artists try to cover up what they cannot do like fingers or something like that. I used to draw cars, and I had a difficulty with the tires, so I used to cover them with garbage cans or fire hydrants in front of them. Even though I cheated, I put something in that was realistic and interesting. I still do it. But Frazetta had a difficulty in doing feet. So he used to try to cover them. The feet were in water.

What artists do you like?
Today I like Will Eisner. He's one that I respect. He's good at balancing blacks.

Is okay if I took some photos of you?
Do I need makeup? 🦇

BOYS BOYS BOYS

Two pretty boy cops fight crime in New York City and end up in bed—with each other. A male teacher can't resist the advances of his taller, more aggressive male student and is seduced in the classroom. A freelance photographer accidentally takes the wrong photos and is forced to pay by participating in an S&M session with a powerful crime lord. Japanese boys' love manga has hit America, and it's changing the face of women's erotic literature. Like typical romances, there are rose petals, pink covers, and yeah, these tales still tug at the heart strings. But these stories feature explicit illustrations. And they star guys. Whoa! Since when are women reading and writing hot romance about sexy gay men?

Although not one of the first boys' love titles, Kazuma Kodaka's multi-volume series *Kizuna: Bonds of Love* was one of the earlier yaoi titles officially published in the US that included fairly explicit sex scenes. The series chronicles the love affair of introverted Kei Enjouji and Ranmaru Samejima, or Ran, a kendo star whose injuries in an auto accident prevent him from competing. Turns out the hit-and-run accident was meant to kill Kei, not Ran, because of Kei's yakuza family ties.

words | Cathy Camper

Could you give us an overview of your artistic work?
__KAZUMA KODAKA:__ It's really hard for me to describe my other works in just a few words. It's been over 16 years since I started my career as a manga artist, and I am happy to say that I've worked with a wide variety of different types of stories and situations. My very first book was actually a shōnen manga, not yaoi. It was a comedy centered around a schoolboy's life. My other titles are all relationship-based yaoi stories. Of course, the situation and setting is different for each: one is a tale of samurai in Edo-period Japan, while another is set in a futuristic

sci-fi world. There's also a story about a manga artist's life, a mysterious love story which takes place over a 100-year time span, a cop story, and a love story between businessmen. Oh, there's also another long series like *Kizuna*, which starts out with a case of mistaken identity and gradually traces the growth of a young man's love for his teacher. That one went up to 10 volumes, and I've actually finished it, unlike *Kizuna*, which is ongoing.

What led you to writing yaoi manga?
It all started when I drew a parody of my shōnen manga character. I didn't take it very seriously, and I even drew

the character in a yaoi style for the fun of it. Then a publisher suggested that I serialize the story for their magazine.

Is it a genre you enjoy reading?
Yes, it is. But I can't enjoy any manga appearing in the same magazine with my own because in that case I tend to read all manga in the magazine with a reviewer's critical eyes. Otherwise, I'm an enthusiastic yaoi reader, and I enjoy reading my favorite writers' manga.

Do you usually come up with a plot or characters first?
First, the characters come to my mind. It all starts when I realize I want to

draw a specific person or couple. Then, I give full scope to my imagination, like what conversations these characters will have or what scenes they'll play. That develops into a plot. If I started with a plot—which is largely the way to write a novel, I think—I wouldn't be able to fully develop my characters' personas, because the plot puts many constraints on them. Readers are very sensitive. The characters created this way would not attract them. Characters must be vivid enough that readers fall in love with them. The appeal of the characters is the most important factor for yaoi.

Do characters surprise you by taking on a life of their own?
I hadn't focused much on the characters that would eventually be used in *Kizuna* when I was first asked to serialize the parody. I had to look into each character and give him a unique personality and background. While making up the back story, I was hit by a lot of imaginative ideas, like "This guy lived such-and-such life before and will live such-and-such life in the future"—all of the various life scenes, if you will. I stored those ideas either by writing a note or just keeping it in mind. Later on, I pulled out these ideas little by little to make the *Kizuna* story. For instance, Ranmaru and Enjouji have no specific models, but Masa and Kei do. You know Arnold Schwarzenegger and Edward Furlong in *Terminator 2*? I used them as a starting point because I liked the contrast of the two guys' different statures. I also liked Eddie's hairstyle, and I wanted to draw a character that resembled him. I was also a big Schwarzenegger fan, especially in the *Conan* movies, but I liked *Terminator 2* most of all. His Terminator character guarded the boy by any means necessary. This act of protecting somebody at the risk of your own life reminds me of the term "chūgi" in Japanese, which means loyalty. I wanted to portray that relationship, and the result was Masa and Kei.

How much connection do your stories have to gay culture?
My manga is yaoi, not homosexual, and there's a subtle difference between the two. I could draw real homosexual comics, "slash," if you will, but female readers wouldn't accept it in the same way. To tell you the truth, I want to draw more realistically—realistic love scenes, for example. But I have to be careful to make it soft and mild. It's an essential point. The psychological aspect plays an important role, too. It's about how the characters feel and how they struggle to obtain love until it's finally achieved. The story is usually about the characters' feelings of pain and longing for each other, which is a more feminine sensibility.

Do you see differences between American and Asian readers of yaoi manga?
I'd say there are no significant differences between Japanese fans and American fans. Their responses were surprisingly similar. Maybe the age group for yaoi fans is a little different in the US. In Japan, it's not unusual for people who seem much older than me—middle-aged women, even—to attend my autograph sessions. In Japan, there used to be extremely enthusiastic fans; some of them were almost stalkers! But not so much anymore. That behavior has calmed down. I've been drawing yaoi manga for many years, and many of my readers who were in college when I started doing yaoi have become housewives. They got married, had children, and have matured to the point where they are mild and calm. On the other hand, new yaoi fans are emerging in the US. I feel the heated atmosphere of the fans here. Again, maybe that's due to the fact that the Japanese yaoi fans tend to be older.

Could you talk about the commercial limitations of writing manga? Do editors or publishers dictate where your story can go and how erotic it should be?
My editors and publishers hardly give me any direction or requests. It is completely left up to me. **With yaoi manga in general, editors and publishers tend to give artists free reign because they know too many directions or requests would kill the artists' creativity.** They only give

some advice, like "How about going another way?" when the manga is not well-received by readers. **Because I am given a free hand, it is entirely my responsibility if my manga is not well-received.** So, I pay close attention to readers' responses and also carefully keep watch on the manga popularity rankings appearing in magazines.

What advice do you have for American artists and writers who want to break into the yaoi genre?
I advise them to read all the Japanese yaoi manga they can, one after another. You must study the trends of yaoi manga and investigate what type of manga readers are waiting for. You cannot survive in the yaoi market if you only write what you like. I actually know many manga writers who have great talent but do not become professional writers. They like writing their favorite kind of manga freely rather than responding to readers' demands. The quality of the art has risen significantly in the last 10 years. In this fiercely contested genre, drawing a beautiful illustration is taken for granted. I myself struggle to catch up with the improvement of drawing techniques because my drawing is a relatively old-fashioned type. In any case, I advise them to enhance their skills by drawing as many manga as possible.

In Western culture, erotica is mostly made for men by men. How do you think female writers like yourself are changing what's considered erotic?
I think that women authors are just **naturally more able to understand and create what women readers really want.** The president of Biblos (the Japanese publisher for *Kizuna*) is not a woman, but the chief editor and sub-chief editor are both women. The president made the right decision in leaving everything to the women, I think, because the "You like to read this and so do I" approach really works in yaoi. You never fail in this way.

Are there any yaoi trends that are hot in Japan but have yet to hit the US?
Yaoi games are attracting attention. They are growing faster than yaoi manga. These are video games in which you choose one guy out of various types of male characters available and try to win his heart. Even a woman can experience yaoi because she plays a man in the games! That may be the reason why yaoi games catch on. Yaoi readers tend to like stories in which many different types of characters appear, such as students, businessmen, doctors, and so on. So, yaoi manga that is chock-full of handsome male characters is always a favorite. Stories in foreign countries are popular, too. 🐱

CATHY CAMPER: Around that time, I also wrote a longer, more scholarly piece for the** Women's Review of Books**, "Yaoi 101: Girls love 'Boys' Love'" (which now is of course dated). Since I already had a lot of information and contacts for yaoi creators, and I loved** Giant Robot**, I reached out to them to see if they'd also be interested in an article on yaoi. They asked if part of the article could include an interview with a yaoi creator. I remember it was hard to get a response from publishers, due to language barriers, but Kazuma Kodaka's publisher agreed to do it. I sent them questions in English, which they translated for her, then they translated her answers back to English for me. At the time, there wasn't much written about yaoi in scholarly journals. I wasn't a yaoi expert, I just wrote about it as a cultural phenomenon that intrigued me. But some time later, I remember discovering online people were quoting my articles, agreeing and disagreeing with them, and including them in yaoi discussions that could now happen via the internet. It made me happy that fans had continued the discussion forward. A few yaoi fans even contacted me, and one I'm still in touch with today.

COMICS ON FIRE

Boys' love manga go by many names. The smuttiest stuff is yaoi—an acronym for "yama nashi, ochi nashi, imi nashi," or "no climax, no point, no meaning" (although an insider joke claims that yaoi is really an acronym for "yamete kudasai, oshiri ga itai yo," or, "Stop it, my butt hurts!"). Comics emphasizing romance and relationships over sex are generally classified as shōnen-ai or shounen-ai, which translates as "boy love." Another term used is bishōnen or bishounen, which means "beautiful boy." All these terms have changed meaning over time, so the more generic term "boys' love" is now often used by the manga industry to refer to the entire genre. Boys' love manga has a large fan base, and fan fiction, called doujinshi, abounds. Often, it's similar to Western slash fiction—fan fiction starring pop heroes, like Kirk/Spock, "slashed" together in sexy gay abandon.

Boys' love manga has its own style. The men tend to be willowy, strongly defined as "tops" or "bottoms," and when they're not boinking, spend an inordinate amount of time pining and yearning. They don't act like gay men and often avoid gay culture, sometimes even denying they're gay.

Despite all that, some boys' love titles have already become big hits with female fans in the US. Most well known are probably the multivolume series often carried by public libraries. These titles are less explicit and tend to emphasize nurturing and caring, elements women have traditionally found appealing in romance.

LONE WOLF

words | Andrew Lam *comics* | courtesy of Dark Horse

Kazuo Koike is one of Japan's most famous manga writers. He is best known for the epic *Lone Wolf and Cub* series, which follows former executioner Ogami Ito walking the road between heaven and hell, pushing his infant child Daigoro around in a baby cart. Penned between 1970 and 1976, it is one of the most admired and revered manga of all time. In Japan, *Lone Wolf and Cub* paperbacks have sold an estimated 5 million copies and were adapted as a long-running TV show and a six-film series. The first issue of the US edition sold 120,000 copies, making it the best-selling manga in the country at the time.

How is Lone Wolf and Cub *doing after all these years?*
<u>KAZUO KOIKE:</u> It was the first manga to do well in the US market 15 years ago. I'm very happy about it being reissued. *Lone Wolf and Cub* was made into a movie 17 years ago here in Japan and it was a big hit. Then it was translated into many languages: French, Arabic, English, Chinese, and so on. Other works of mine have also been translated all over the world. Japanese cultural exports are growing in influence.

Why do you think Japanese manga and anime are becoming popular in the West after so many years of obscurity?
It is a mature subject. Japanese manga depicts family relations and love and there's always spiritual drama underneath. Manga and anime deal with complex characters. You don't find many US comics that have this depth. Characters in American comics are all strong. Superman, Green Lantern—they are too overwhelming, like the US military forces with its high-tech weapons. They can never be beaten, but by the same token, their comics are not that interesting to adults. <u>Manga heroes are not always so strong. They may have powers, but they are vulnerable. They might be beaten by somebody, and people who read Japanese manga sympathize deeply with the characters. Japanese manga characters have a kind of vulnerability that American comic book characters lack.</u> *Lone Wolf and Cub* is a spiritual drama as much as it is a samurai saga, so it is suited for both young and old. Japanese manga in general can deal with modern demands—work, love, affection, romance—and it describes and depicts situations that many can identify with. Good ones are on the same level as a contemporary novel.

Is there a market for adult comic books in mainstream America?
I believe so. When you read manga, images are already formed for you. That's why they are popular all over the world when there isn't time for a novel. But with adult comics, it's not about superpower strength but daily life. If Superman and Spider-Man had wives and kids and real domestic dramas,

RENTER'S DELIGHT: *LONE WOLF AND CUB* EDITION

THE SWORD OF VENGEANCE (1972): This origin film has the fun, pulpy filmmaking style and crazy swordsman action that made lead actor Wakayama Tomisaburō a huge star. After he was Ogami, he was the Japanese coach in *Bad News Bears Go to Japan*! You also see monkeys, hot springs, a ho, and ogre people.

BABY CART IN PERIL (1972): This film is a little ridiculous, but it's still fun with ninjas hiding in Buddha statues, a tattooed swordswoman, and a nemesis from Ogami's past. Daigoro plays a larger role in this episode, getting lost and also getting his own theme song. Meanwhile, the worried Tomisaburo gains a little weight.

BABY CART AT THE RIVER STYX (1972): Blood sprays everywhere and body parts roll around like it's a mannequin factory when female ninjas turn a dude into a lifeless torso. There's swordplay to the max, and little Daigoro gets to see some action, too, utilizing some of the baby cart's hidden weaponry.

 ERIC: Legendary mangaka Kazuo Koike died in 2019. His work is probably still underappreciated but his story is

DAIGORO! YOU MUST CHOOSE A ROAD FOR YOURSELF!

CHOOSE THE BALL, AND YOU JOIN YOUR MOTHER WHO AWAITS YOU IN YOMI, THE LAND OF THE SPIRITS. CHOOSE THE SWORD,...AND YOU JOIN ME IN HELL!!

they would have adult readers. Children's superheroes don't have families or deal with family life very much. When readers grow up, they outgrow this kind of story line.

What do readers find most fascinating about Lone Wolf and Cub?

People who read *Lone Wolf and Cub* are very interested in the fate of Daigoro, the samurai's little son. He is three and his father has to fight the best fighters and an army. What will happen to him if his father is killed? I am coming out with a sequel to *Lone Wolf and Cub* called *Lone Wolf*. It's what happens when Daigoro grows up. It should come out sometime next year.

You have such a large international following. Do you create stories with, say, the West in mind because of growing demands?

No, not at all. My stories are written for Japanese readers. I've never had any intention of introducing Japanese culture to an American mindset. It just happened. If I had non-Japanese in mind, I would not have any Japanese readers. I write first and foremost for my Japanese audience. Yet, because my work is so particularly Japanese, non-Japanese are fascinated with it.

Who are your favorite American authors?

I have many, but the one who first comes to mind is Stephen King. His ideas are excellent. In *The Green Mile*, for instance, the relationship between the warden and rodents in prison is just marvelous. When I was young, I used to love Alistair MacLean, whose stories about war are excellent.

How old were you when WWII ended? Can you tell me something about that time?

When I was 11, we were bombed by US planes. I remember B-29s. I could certainly sympathize with Iraqi children when the United States started the war in Iraq. I know how it feels to live like that, under bombs. I was born into a samurai family. My father was in the military during WWII and my grandfather, too. But that ended when the United States dropped nuclear bombs in Nagasaki and Osaka. I remember when US soldiers confiscated all the samurai swords in my house.

Are you optimistic about the future of Japan?

No. **Nothing of the samurai past will be born into the future. What is lost cannot be retrieved.** I would say you will be hard-pressed to find someone who takes responsibility for his actions in Japan today. The young generation doesn't have the ability. Bushidō, the samurai spirit, is gone. Japan is a 50-something state.

What does that mean?

I mean that it's becoming a part of the United States. It has become the yes man to America. That is why I want to write a continuation to *Lone Wolf and Cub*. I might be the last person to write about bushidō, the way of the samurai and the morals and ethics of a period in Japan that is over. In the days of the samurai, the most important thing was to take responsibility for your words and actions. They'd give up their lives with seppuku, the ritual suicide (p. 357). But politicians and leaders don't have this spirit. No one wants to take responsibility. **I sometimes feel as if I might be the last person in Japan who writes about samurai morals and ethics.**

It's been observed that the United States has become a warring nation. Do you see the warrior's spirit in America?

None. It's all military might with heavy technology. There is no warrior spirit in what America does. 🦇

ANDREW LAM: *That trip was quite memorable since I also got to interview two iron chefs besides regular reporting on Japan and issues related to immigration. Koike-san was welcoming and was surprised to find a Vietnamese American back then so interested in mangas but it has since exploded around the world and of course in my homeland itself. In any case, I still kept two of his* Lone Wolf and Cub *mangas personally autographed with a brush, paint, and with his trademark woodblock signature.*

BABY CART IN THE LAND OF DEMONS (1973): It seems the army of Ogami's enemies gets larger with each episode. This time, Daigoro shows his strength as he gets beat down and threatened with swords without flinching. What I want to know is where are the Japanese deserts and sand dunes that keep showing up?

BABY CART TO HADES (1972): Women's breasts are as common as sprayed blood in the third installment of the series. The film goes by fast and Ogami jumps like David Lee Roth, although I can't say it's one of the strongest of the series. One portion is shot from the point of view of a severed head rolling down the hill.

WHITE HEAVEN IN HELL (1974): Instead of soldiers, Ogami and Daigoro fight supernatural opponents and dirty mole people. After getting thrashed, the villain plants his "seed" into his sister, so they could have a future leader. You know he'll be punished for that. At the end, the heroes cruise on with the cart on skis.

epic and important. The samurai spirit is strong in his story about a traveling father and son, which gets honored as part of the plot in *The Mandalorian*. You might have skipped the manga series and went straight into the *Baby Cart* films, which are cool, campy, and worth watching. This interview isn't long but ends in a massive crescendo of doom.

PUSHER

RETURN OF GEKIGA

words | Eric Nakamura
translation | Yuji Oniki

In contrast to the great comic book artists who focus on spandex-clad crusaders, there are indie comics creators who depict the daily life of people like you and me. You may be familiar with Daniel Clowes, Harvey Pekar, and R. Crumb. Generally, such artists have been generally ignored by the mainstream media and outlets, which favor the formulaic but safe world of superheroes.

It's not too different in Japan, except that the comics scene is dominated by manga. But beneath the ocean of cute, cartoony characters, Yoshihiro Tatsumi has been drawing what he calls "gekiga" (dramatic pictures) since 1957. His stories are short and subversive, and the protagonist might be a murderer, a shit-worker, or some kind of pervert. The plots usually end in bewilderment, incarceration, or death. To this day, Tatsumi is known as the Grandfather of Gekiga.

Little of Tatsumi's work has been translated into English, but that's about to change. *The Push Man and Other Stories* is the first in a series that collects Tatsumi's works. Edited by American indie cartoonist and illustrator Adrian Tomine, it will introduce the master storyteller to a new generation of readers.

MAN

SUNDOWN IN THE CITY ALWAYS MAKES ME UNEASY.

Gekiga is a great genre. Why do so many people read manga instead?
YOSHIHIRO TATSUMI: I think it's a question of readership. The majority of graphic novel readers read manga, which is drawn for kids. The audience for gekiga is for young adults and adults.

You chose to do something completely different from what other Japanese cartoonists do. What kind of mindset did you have when you started?
In high school, classical writers like Shakespeare inspired me to express psychology through drama. I ended up doing this through comics because I had access to it. **If I had talent as a poet, then I might have expressed the same thing through poetry.**

Who were some influences on your drawing style?
Osamu Tezuka, Noboru Oshiro, and Yoshiharu Tsuge.

Was there support for your work in the beginning?
No one supported me. The publisher didn't care all that much for my work.

Your women characters seem to be either victims or tough characters. Why is that?
Extreme characters are more amenable to the short story format. There will be a different woman character in my full-length work, though.

Has your storytelling style changed much over time?
Of course. Both my narrative approach and drawing style have changed. My work evolved as a result of the changes in my thinking (in terms of the way I live) and my environment. Great novels and films that speak to me have also been influential to my work.

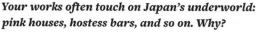
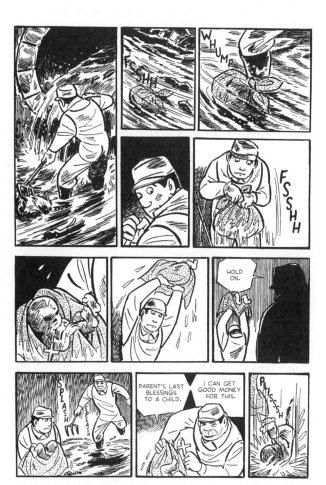

***Your works often touch on Japan's underworld:
pink houses, hostess bars, and so on. Why?***
When Japanese society was getting carried away during
the high economic growth period, I became interested in
depicting the humanity of people who were marginalized.
That's really not where my passion is anymore, though.
I'm an old man left behind by the IT era. [*Laughs*]

***Even though your stories don't necessarily reflect your
personality, surely there's something from yourself in
the protagonists, isn't there?***
That's right. The stories do reflect the way an author
lives and thinks. But I believe I've changed a lot
since I wrote those stories.

***Do you think modern Japanese society is as interesting
as it was in the late '60s?***
There are shocking events broadcast on the news every day.
I couldn't possibly keep up with them. As far as story topics
go, I might be interested in working on a historical biogra-
phy of the leading figures of the Japanese Enlightenment.

***How many pages can you draw these days while
you're running your shop?***
I closed the shop. Right now I'm publishing a quarterly
catalogue of collectors' comics. I deliver the comics by mail.
I draw about 10 pages a month.

What plans do you have for future works?
I'm planning on a mysterious and epic tale about
a protagonist who is reincarnated over and
over, no matter how many times he dies.

***Do you feel that interest in gekiga and independent
graphic novels is growing in Japan?***
There are no publishers (for example, magazines)
[that put out this kind of work]. Right now it's
hard to develop an artist.

What modern comics do you like?
I'm fond of artists who approach their work the way I do.
I don't mean to sound biased, but I have hopes for Adrian.

Any advice for younger artists?
I have no special advice, but I would say that **you should
focus on creating a unique vision in your art.** 🦇

The Grandfather of Gekiga meets Adrian Tomine.

INNER

Canadian-born and Brooklyn-based Jillian Tamaki is a hardworking illustrator who also makes indie comics, such as the award-winning *Skim*. The Alberta College of Art and Design graduate and School of Visual Arts instructor's newest book, *Indoor Voice*, is a collection of her comics, sketches, and blog work. I interviewed Tamaki for a panel organized by her publisher, Drawn & Quarterly, at the San Diego Comic Con, where she told her story, shared images from her award-winning portfolio, and fielded questions from fans. Afterward, we ran around the convention center shooting portraits of her with costumed guests—an hour immortalized in a comic that she posted on her blog.

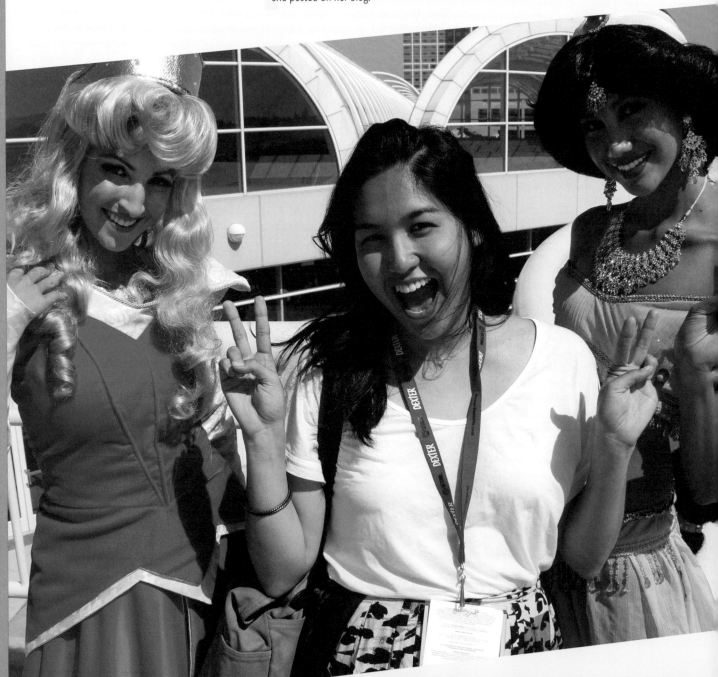

VOICES

words + pictures | Eric Nakamura

I know you work with art directors for your illustration work and you have editors for comic books, but on Skim you also worked with your cousin Mariko Tamaki. Can you talk about what it was like collaborating with her?

JILLIAN TAMAKI: I actually didn't know her that well. I grew up in Calgary and she grew up in Toronto. I didn't see her that often, and we weren't best friends or anything like that. I just knew that she was a writer, a girl about town, a performer, a comedian—someone who did everything and was just so fabulous. But she came upon this opportunity to do a small comic and she was like, "I think my cousin's an illustrator." So we didn't even know each other, but it was a fantastic experience. I saw her more often than my parents since we started doing *Skim*. What made everything work was that she wasn't precious with it. She'd say, "I'm done with my part of this process," and would give me a script, similar to a play. It wasn't like, "In the first panel, Skim is looking sad." She gave me dialogue and said, "This is yours. Do what you want." There is so much of my life in it, too—my crazy friends and their little ticks—and I was free to insert wordless passages and emphasize this or de-emphasize that. I think that's key to being a collaborator: respecting each other's roles and expecting that things will change and not necessarily be what you exactly imagined.

So in the future, would you prefer to work with a writer or do you ever plan to write your own comics?

I would love to write comics. I feel that I'm weaker as a writer than as an artist at this point, though, and at the same time I actually love collaborating with people. I love being an interpreter. It's taking something and remixing it, and that's kind of what illustration is. Billie Holiday was an interpreter. She wasn't writing her own songs, and I think it's kind of akin to that—not saying that I'm the Billie Holiday of comics or anything.

What was your reaction when you first heard that Mariko was nominated for the Governor General's Award in Canada and then later discovered that they wouldn't even consider that Skim was made by two people?

I was shocked, actually. For people who don't know, the Governor General's Award is probably the biggest literary award in Canada, and *Skim* was nominated for Children's Literature. They have a text and an illustration category, Mariko was nominated for the text category, and I was nominated for neither. So there was this big hullabaloo. Chester Brown, Seth, Bryan Lee

O'Malley, and Chris Oliveros wrote a letter and all of the national newspapers and the Canadian Broadcasting Corporation were talking about the nature of comics and pictures and words, and this totally niche conversation blew up on a national scale. We didn't win the $25,000 prize and I was really sad about it, but ultimately it was a good experience because people talked about graphic novels and people rallied to my aid.

Wasn't having some of the greatest talents in comics go to bat for you a victory on its own?

Yeah, and that's ultimately why I feel like it was a great experience.

Did you have any mentors or good teachers in the comics industry?

When I first started, I didn't really know anything about the craft of comics; I just took it upon myself to read a lot. Will Eisner's handbooks on sequential art—you know, stuff like that. But the first comic that really blew my head off was *Ghost World*. It just invoked this reaction, "I can do this!" and was my entry point. Other than that, I was reading a lot of Drawn & Quarterly: Chester Brown, Seth… I learned a lot about cartooning just from reading them.

In terms of personal satisfaction, what's the difference between your work in illustration and work in comics?

Many cartoonists take illustration work because it pays better but don't really like doing it. The way I see it, they're completely different beasts. Illustration is commercial and collaborative and, for the most part, involves interpreting content provided by others. Comics are much more personal, isolating, and labor-intensive. I bristle at being called an "illustrator" in the context of comics, because it's just not accurate. Making comics is, like, illustration in 4-D. To actually answer your question, I suppose I feel more personally satisfied by comics at the moment but I also don't feel I've explored all the possibilities of illustration: self-authorship and the like. Maira Kalman and Christoph Niemann are inspirations.

I'm sure that comics don't pay as much as illustration.

Unfortunately, but comics and the comics community offer something that illustration doesn't. Comics can be really rewarding because you put yourself out there for fans of your work. It's your stories and your content, and it's more than just two weeks of something and adding another name to your client list. That's the barometer of your success with illustration: "Who have you worked for? How much did you get paid? What annuals did you get into?"

So what is it like working with art directors at some of the biggest magazines in the world?

It depends. At some huge magazines, the art directors and art direction are really under the thumb of editors, and they're almost the middlemen between the editor's crazy suggestions or, you know, "The focus group came back and said this and that," "You need to take out that hat because the editor's wife doesn't like it," or whatever. And some art directors who have a lot of control are fans of illustration, and are fans of what you do. There's nothing worse than being hired for something that you don't do. You get that sinking feeling halfway through, like, "I'm not meant for this. You could have hired someone else." But you have to be professional, regardless.

It seems like you get a lot of jobs. How do you get out there?

I know a lot of comic artists don't like illustration because it's not your stuff and it can be mind-numbing. But I like it. I was an illustrator first and I was really lucky. I didn't have to bust my ass for five years, as I know some people do, sending out promos every three months. But that might be what it takes. I also happen to have a somewhat friendly, not scary, colorful, happy style. And I think you really have to send your work out and see what comes back, and if none of it comes

back, then maybe you need to work a bit more on your portfolio. It's not like you're getting on a blacklist. If people don't like your promo, they'll just throw it in the garbage. They aren't crossing your name off a list somewhere and saying, "We'll never hire this person. Ever."

Do you have other suggestions for new illustrators?

My advice to students: Get paid to improve. There are a lot of small weeklies all over the country that don't have a lot of money but want illustrations. They're willing to take a chance on a young illustrator or somebody new. You cannot sit on your hands. People will not come to you. You really have to go knock on doors. A lot of New York magazines and newspapers will take drop-offs and see you if you want to do a portfolio review, and I think that a lot of people get really surprised by that. But it's totally true, and it can be maddening when a really talented person expects the world to come to him or her.

Can you talk about how you got started in illustration? Did you do free jobs in the beginning?

A teacher thought I was doing interesting work, was a responsible person, and wouldn't embarrass him, so he recommended me to a designer friend. I worked with him on local things for several months. Other than that, I sent out some postcards that had a degree of professional polish, got some jobs, and entered *Communication Arts* Annual and stuff like that. Freelance life goes up and down, but it's been pretty good so far.

Once I flipped through ESPN The Magazine at an airport and saw your illustration of Michael Phelps. Was that just a quick job or what?

That was cool because I don't know anything about sports. Also, it shows that when you do a job that clients really like and wins some awards, they will hire you for that type of job again.

What do you think of illustration in print or online?

When I first wanted to be an illustrator, the dream was to see my work in print. That's still nice, but there is no print versus online debate. We just have to hope that illustration can find a home online and on electronic devices, and that it is paid for at a fair rate and respected as copyrighted work. Print will live on, but in a boutique-y way.

Can you talk about Indoor Voice? It has work from your blog, right?

Not all, but some of it. I originally made the blog to archive my sketchbook, because I sketch all the time and it has taken on a life of its own. I try to be a creative person—and not just a factory of illustration, where I'm drawing all the time but nothing is actually creative. I try to retain a sense of play. It sounds cheesy, but I started the blog to document my experiments and people have really connected with it. I get "You should do that stuff you do on your blog for your paying work" a lot, and it's easier said than done.

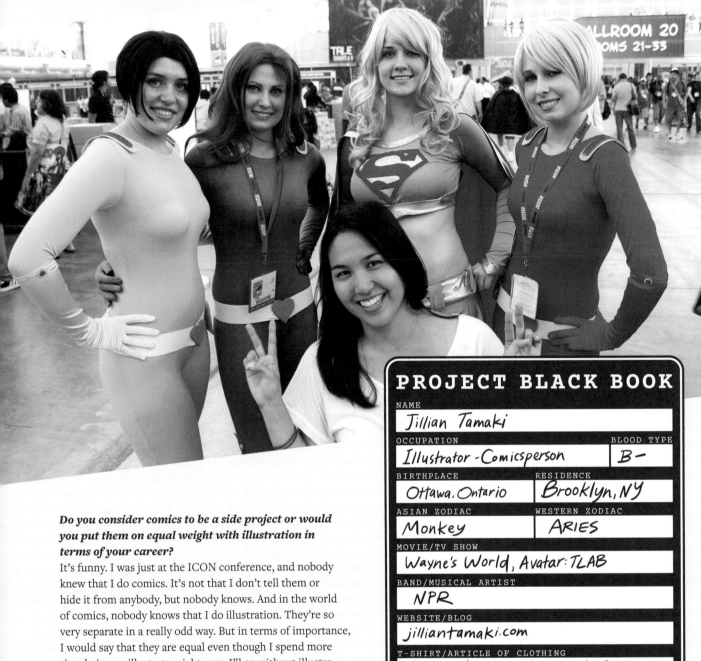

Do you consider comics to be a side project or would you put them on equal weight with illustration in terms of your career?
It's funny. I was just at the ICON conference, and nobody knew that I do comics. It's not that I don't tell them or hide it from anybody, but nobody knows. And in the world of comics, nobody knows that I do illustration. They're so very separate in a really odd way. But in terms of importance, I would say that they are equal even though I spend more time being an illustrator right now. I'll go without illustration—or relatively little illustration—for a few months to do comics because they're so incredibly time consuming. Hopefully, one day comics will be of more importance.

Is it tough being a woman in the comics industry? Did you ever encounter a gender bias?
I'd say that it's not too much of a problem—nothing that I could complain or tell you a story about. A lot of times, it's more like the ethnicity thing. I get a lot of jobs about China, Japan, and Asian things.

Because you draw Asians better than non-Asians?
I think they love having the Asian name at the bottom of a thing about Asia. I get that impression sometimes.

Do you have dream assignment?
Illustrating Charles Dickens. 🦇

PROJECT BLACK BOOK

NAME
Jillian Tamaki

OCCUPATION
Illustrator - Comicsperson

BLOOD TYPE
B-

BIRTHPLACE
Ottawa, Ontario

RESIDENCE
Brooklyn, NY

ASIAN ZODIAC
Monkey

WESTERN ZODIAC
ARIES

MOVIE/TV SHOW
Wayne's World, Avatar: TLAB

BAND/MUSICAL ARTIST
NPR

WEBSITE/BLOG
jilliantamaki.com

T-SHIRT/ARTICLE OF CLOTHING
homemade Calvin Klein tee-shirt

FOOD
fat + salt

COLLECTION
Souvenir Badges

GAME/HOBBY/SPORT
Reading, cooking

TURNING POINT(S)
Moving to New York.

PROUDEST MOMENT(S)
TK

IF I COULD REDO SOMETHING IN LIFE, IT WOULD BE
You can't live life that way, you know.

WHY I EXIST
Fortuitous chemical reaction.

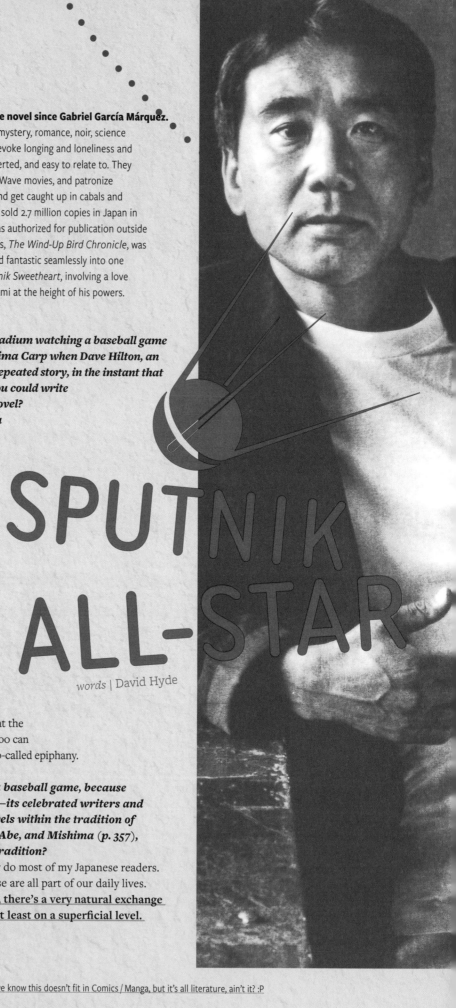

Haruki Murakami is the best thing to happen to the novel since Gabriel García Márquez. Iconoclastic and experimental, Murakami can combine mystery, romance, noir, science fiction, fantasy, and realism all in one story. His stories evoke longing and loneliness and compassion. His characters are misfits—aimless, introverted, and easy to relate to. They lose their jobs, like to eat spaghetti, watch French New Wave movies, and patronize jazz bars. They also fall in love with enigmatic women and get caught up in cabals and conspiracies. Murakami's 1987 novel, *Norwegian Wood*, sold 2.7 million copies in Japan in one year, and its translation—the first that Murakami has authorized for publication outside of Japan—was released in the US last year. His 1998 opus, *The Wind-Up Bird Chronicle*, was a testimony to his ability to weave encounters weird and fantastic seamlessly into one man's otherwise ordinary life. But his latest novel, *Sputnik Sweetheart*, involving a love triangle and a mysterious disappearance, shows Murakami at the height of his powers.

In 1978, you were in the bleachers of Jingu Stadium watching a baseball game between the Yakult Swallows and the Hiroshima Carp when Dave Hilton, an American, came to bat. According to an oft-repeated story, in the instant that he hit a double, you suddenly realized that you could write a novel. Had you always wanted to write a novel? When you were growing up in Japan, did you dream of being a writer?

HARUKI MURAKAMI: I like to read, and ever since I became a sentient being, I've been reading a lot. So then one would expect that I would want to become a writer, but in fact I never seriously thought that I wanted to become a novelist. Rather, I was more interested in making movies, and in college I majored in cinema and theater arts at Waseda University.

The reason I did not think of becoming a writer is very simple. I felt that I possessed neither the talent nor the qualifications to be a good novelist. So I never felt like penning a novel. Rather than writing an inconsequential novel, I would much rather be on the side of reading good novels. But that April afternoon, as I was watching the game at the stadium, I had the sudden notion that perhaps I too can write a novel. I don't know why. I think it was a so-called epiphany.

It's ironic that this epiphany happened at a baseball game, because your work is infused with Western culture—its celebrated writers and pop music. As a writer, do you see your novels within the tradition of the great Japanese writers like Kawabata, Abe, and Mishima (p. 357), or as part of a new international literary tradition?

I don't think I am particularly Westernized, nor do most of my Japanese readers. Led Zeppelin, California Merlot, and Tom Cruise are all part of our daily lives. As a matter of fact, one could say that, today, there's a very natural exchange of information between the East and West, at least on a superficial level.

SPUTNIK ALL-STAR

words | David Hyde

Yeah, yeah, we know this doesn't fit in Comics / Manga, but it's all literature, ain't it? :P

We are variously stimulated by these differing points of view.

I am not part of the immediate tradition of Japanese literature, but I do think a new tradition, which will include myself, is going to be created. That is, needless to say, a wonderful thing.

What has changed since **Norwegian Wood's** *publication in 1987 and the publication of the English translation this fall?*

Until *Norwegian Wood* was published, I was an avant-garde "cult" author popular among young readers. Most of my books sold 100,000 copies but no more. But *Norwegian Wood* was picked up by readers across generations, sold over 2 million copies, and became a phenomenal bestseller.

I'm not really interested in writing novels about realism, but *Norwegian Wood* is a novel of 100 percent pure realism. I wanted to experiment. I thought it was time to try another genre. And the result was that it sold. I started writing it on a whim and I didn't expect it to become a bestseller, so I was surprised.

I personally love this work, but looking at it objectively, I think it is an anomaly among my works. After *Norwegian Wood*, I have not written any purely realistic novels and have no intention of writing any more at this time.

Your new novel, **Sputnik Sweetheart,** *seems anchored in everyday life, yet the narrator gradually discovers a world of divided souls and mysterious disappearances. What inspired this story?*

What inspired me to write this kind of novel? I don't know. This sort of story comes naturally to me. Rather than stories of abnormal things happening to abnormal people or stories of normal things happening to normal people, I like stories of abnormal things happening to normal people.

In **Sputnik Sweetheart,** *Sumire notes in her journal: "Don't write dreams." So much of your own writing has an otherworldly, dreamlike quality. If you aren't inspired by your dreams, where do you get your inspiration?* <u>Writing a story is like playing out your dreams while you are awake. It's not about being inspired by your dreams, but about consciously manipulating the unconscious and creating your own dream.</u> I think I am graced with the ability to do that.

With **Sputnik Sweetheart,** *you return to a number of recurring motifs and images from your earlier novels. There are women with complicated interior lives, who exist on the edge of insanity, and there is a central character whose cool, detached outlook on life makes him attractive to these women. What is it about this dichotomy that intrigues you?*

I may have the ability to discern a sort of insanity within women. Why? I don't know. Aside from that, women serve as mediums (shamans) in my stories. They guide us to dreamlike things, or to the otherworld. Perhaps this corresponds to something within my own psyche.

You recently wrote your first work of nonfiction, **Underground,** *about the sarin gas attack. What drew you to this story?*

Everyone asks me that question, but I can't answer it very well. My most honest answer is that I felt that I should do it.

I wanted to listen to as many stories in as much detail as possible from the people who were riding the subway that morning. I was certain that therein lay something worth knowing. Now that I have finished writing the book, that certainty has remained unchanged. Interviewing 65 of the victims at length over the course of a year remains an irreplaceable experience for me.

Did you feel limited or liberated by your role as a journalist? How is nonfiction different from writing novels?

Simply put, as a storyteller, I brought out live accounts from the people's experiences. Rather than what is true, I emphasized what they felt to be true. That's where the story begins. In that sense, although this is, in form, a nonfiction work, it is much more a novelist's work, without a doubt.

How did the Japanese public receive the book?

Via letters and email, I received a lot of information from those who were also victims of the attack. But most had suffered light injuries. I wanted to listen to more accounts, but most of my interview requests to the bereaved were turned down. I was sorry about this. In Japanese society, it is thought that those who suffer unfortunate deaths should be left in peace. If a similar thing had occurred in the United States, I imagine a lot more information would have been made public.

There was a great response from the general readers. Many had been fed up with the monotonous reports made by the television and newspapers, so they were very shocked by this information, which had a completely different angle. That is exactly what I'd been hoping for.

One of the themes I wanted to write about in this book was "What is Japanese?" By writing a detailed account of the people who happened to be riding the subway the morning of March 20, 1995, I wanted to get to that question. This question intrigues me because I've found that in this gigantic capitalist society, it is difficult to be an individual.

MŒBIUS TRIP

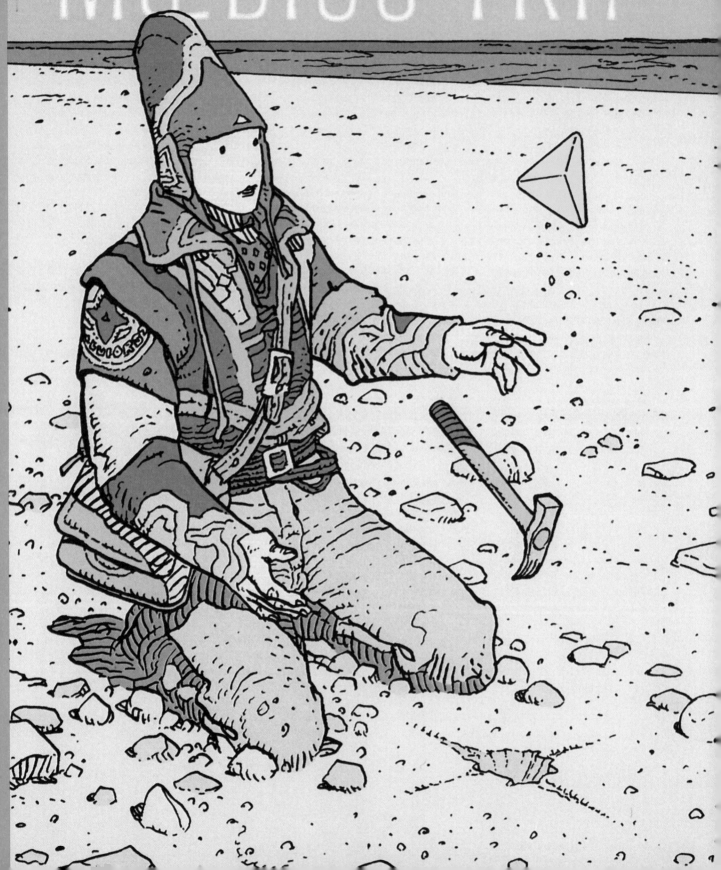

Jean Giraud single-handedly represents a classic style of animation and comic book art from the land of escargot. Better known as "Mœbius," his flat drawing technique, subdued color palette, and high fashion costuming are internationally famous and his hardcover monographs can be found in any good comics store around the world. Although he contributed conceptual designs and art direction to movies like *Alien, The Empire Strikes Back, Tron, Blade Runner, The Fifth Element,* and *Masters of the Universe,* he is still largely unknown in the United States. The French pop art figurehead met us in a Thai restaurant near his temporary production studio in Southern California, where he was producing an animated epic, *Through the Moebius Strip.*

When did you first start using the name Mœbius?
MŒBIUS: It was in '62. I was working in Paris for a satiric magazine called *Hara-Kiri.* I was trying to do something a little bit in the style of *Mad Magazine*—my favorite at the time. I did a few stories, and afterward I started to do my series *Blueberry* for another magazine in a very classic Western style. In order to do something different, I chose that nickname, Mœbius. I was 21. I thought it was a great idea, and I thought I would use it for a few weeks.

Are there any specific art movements or periods in history that have had a strong influence on you?
Surrealism—Dalí and all the poets. At the end it was French. I was following many comic styles and strange little stuff. I was directed to the underground and the vanguard and all aspects of movies, literature, and dance. I was fascinated by the radical movements—the crazy guys and their strange political attitudes. I was never in any group, but I was reading magazines. I was young and I did not know what the real stuff was, but I followed what I knew and who I met.

What were French comics like at the time?
The classical comics had a strong influence on French comics, especially through Belgium. The first was Hergé, who did *Tintin,* and he was such a genius. After a while, there were a lot of artists who were very good. The next generation wanted to be better and take their place. But in France, it was a little bit different. The comics culture was trapped in two things. One was the communist magazine called *Valiant.* The other one was a Catholic comic.

They were religious?
The comics were not really religious, but they were sold though churches or around churches so they had a big audience. And *Valiant* was sold by the people from the Communist Party. They were the only people in France who were teaching the youth. The rest didn't really care.

Did you want to be part of a movement?
I didn't want to be involved in anything. When I started in 1964, I wanted to do comics. But *Hara-Kiri* was also political.

"Arzach," originally published in *Métal hurlant (Heavy Metal)* in 1974–75. LEFT: *Capture d'un triangle d'or,* 1984.

La Déesse, 1990

They were anarchists. They were against everybody. And in a way, I was more on that side, but they were angry at everybody all the time—not my thing, so I left them. And I tried to work in communism, but I didn't like their spirit either. Then a new magazine called *Pilote* was coming from France with the American spirit. It was not political, had no involvement with anything. It was only adventure, fun, pleasure, and goodwill. So I showed my work to them and they said, "Oh yes, we are interested." I did *Blueberry* for them for 15 years.

How did you make the transition into science fiction?
When I started to do *Blueberry*, I had many friends involved in science fiction. I discovered science fiction when I was 15, and after I came back from the army, I was really into that.

What are your favorite animated films?
Everything Miyazaki (p. 148), maybe one French movie by [Paul] Grimault in the '40s, some Russians from that same period, *Akira*, and the Disney productions are special because they are a little bit odd. There are many beautiful things, but not in the commercial system. I don't remember the titles, but beautiful stuff from Canada, from Eastern Europe...Italy has a great school of animation.

Are you influenced by Miyazaki?
I don't know who influenced the other. I don't care about that. I love what he does totally. I met him once and we had nice contact. My daughter's name is Nausicaä [after the title of a Miyazaki film].

What does science fiction mean to you?
I think science fiction is an attitude. It is an attitude that says our hero is not that guy; our hero is the Earth. So through a character, you don't feel somebody's story. You feel man's story—not just one country or society, but all humanity.

Did science fiction come from America?
It's true that it's an American tradition, and all the stories talk about American guys in space all the time—Smith or Roger or something. If they try to say, "Our hero is Dupoine on the planet Mars," it's so strange. It is very difficult to do foreign science fiction, but *Akira* is science fiction, too.

How do you define the work of an artist?
When an artist creates, at first he is creating for his friends, family, and other artists; then for the core of people who are really into his work; and then for people who are interested in the arts who like not just drawing, but also music and film and so forth. Then, when they make a buzz about it, that is when it reaches the broadest audience: people who watch or buy things simply because they feel they are supposed to, because everyone is talking about it. So there is a difference between the artist who is creating for himself and his small circle, and the commercial artist who is creating for the broadest audience and wanting to jump everything in between.

What's your new film about?
There is a family traveling in a spaceship like a sphere with a line in the middle. It's a biosphere with a sun, a lake, and farms. That is where they are growing produce, and they travel from planet to planet selling organic Earth vegetables to places that don't have these things.

It's called Through the Moebius Strip?
Well, it started out as *Moebius Ring*, but now it's *Moebius Strip*. The director wanted me to have my name in it. The idea is that you are able to go through the Möbius strip, like a portal, and are able to travel through space.

On a side note, what have you been doing in LA? Do you get out?
Oh no, I'm too busy. But my family is here. I'd like to go see movies, but my wife doesn't like to see movies. You see written here, "Love and Sex"? That's the kind of movie I like to see. And here, this one, "Guns and Action"? Now that's what I like.

ERIC: Some interviews happen and you're thinking this will be ongoing. I'll interview them every so often and it'll be a regular add-in and

Comeek Relief

MIXED BARRY

words | Martin Wong comics | Lynda Barry

Before Jeffrey Brown, Adrian Tomine, and Dan Clowes—even before Los Bros Hernandez—there was the "punk art" or "new wave comics" scene of the late '70s and early '80s. Picking up where the hippie underground comix makers left off, this scene had its own stars like Charles Burns and Gary Panter, who both contributed to Art Spiegelman's *RAW*, as well as up-and-comers like Lynda Barry who contributed to free weeklies. Not only is Barry cranking out strips online and in weeklies to this day, but the Wisconsin-based rabble-rouser is also making longer stories and works, including *What It Is*—an epic, sprawling, inspiring, mixed-media tome promising nothing less than the secrets of creativity.

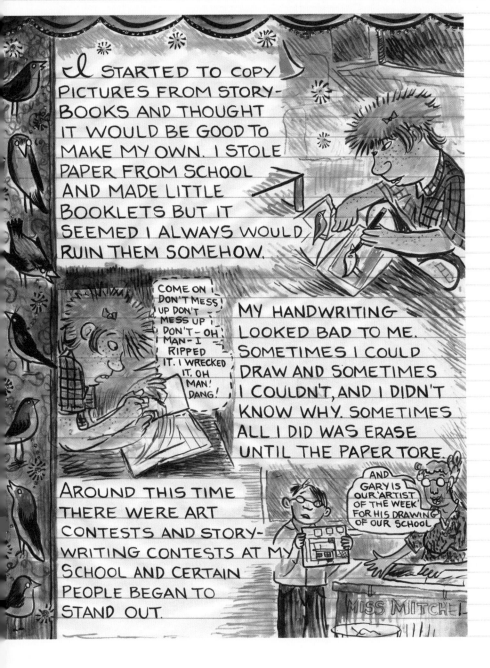

I read **What It Is** *in its entirety, as if it were a comic book, and it came across like a crazy psychedelic monologue with collages of flashbacks, discoveries, and quests. Clearly, it is not* **How To Draw Comics The Marvel Way**...

LYNDA BARRY: It never occurred to me that someone would try to read it like a regular book! That must have been like chewing on five bouillon cubes. I was thinking of it more like a writing workbook or textbook. It's based on the writing class I teach called, "Writing the Unthinkable." I wanted the book version of my class to have as much visual action as it had writing action, because pictures work faster than words and I wanted to affect the back of the mind or the half-dreaming part of the brain. I was also hoping to make a book that would make people start itching to want to use their hands and make something. I don't think it is such a good book to use if you are looking for a job as a writer or cartoonist, though.

Can you explain its format and organization?

Whenever I work, I always have two pads of paper going. There is the project I'm working on and then there is the pad of paper I go to when that project stops rolling. **I have found that if I just keep my hand moving, the project I was originally working on will start up again. I just move my hand from one pad to the other, kind of like how ice skaters keep themselves**

in motion after they fall. They don't stop moving and stare at the ice and their skates; they stay in motion. The pages I was making on the side pads of paper would often have thoughts about writing or drawing. Pretty soon, I had a lot of collages and writings about writing. Then I decided I wanted a story that could be followed through the middle of the collages. I tried to come up with a way to do that part that wasn't autobiographical because I thought it would be a drag for the reader to have to read yet another story about my childhood after all of the stories in *One! Hundred! Demons!* But I couldn't figure out any other way to tell that particular story—which is the story of how most of us can make things spontaneously without freaking out when we are little and can't make anything spontaneously without freaking out as we get older.

There's this notion that indie, alternative, or underground comic artists are insecure, awkward, or unhinged. To make a textbook suggests not only confidence and craft but perhaps even mastery and worth. At what point did it occur to you that you were doing something worthy of teaching or sharing?
The class I teach is based on what I learned from Marilyn Frasca at Evergreen State College in the late '70s. It's a writing technique I've been using ever since, and it's pretty easy to teach. I figured out that if I could teach it I could probably make a book about it, too. As far as teaching comics-making, I've never done that. I'd say when it comes to my own drawing and writing that's where I fall into the "insecure, awkward, or unhinged" stereotype.

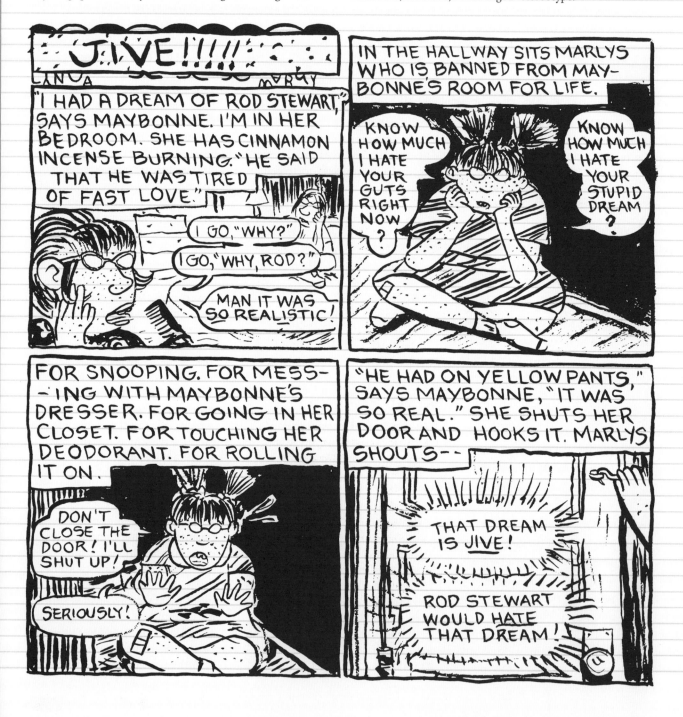

Actually, I think those three words are perfect for my kind of drawing.

How did you find yourself in the indie comics scene?
I tried for a while to do the fine art gallery thing, and, although it was okay, comics were more interesting. People were calling it "punk art" and "new wave comics," which would have been at the very end of the '70s and early '80s. I was living in Seattle and didn't know about the Kitchen Sink stuff at all. All I knew about was R. Crumb, and also the Hairy Who out of Chicago. Jim Nutt was a big influence for me, even if I only knew his work secondhand.

Is it ever a challenge to be one of the few women in comics? If not due to gender politics or a mostly male readership, then just because dorky comic guys might get sweaty when a female is nearby?
It was heaven for me because I love dudes. Ever since I was little, I always was friends with boys. I was always very comfortable around a lot of guys except when they wanted to get next to the super girlish girls. In that situation, I was a liability. There were times I was ditched, but it was never because of artwork. It was because of girls. I understood why my dude friends leaned toward their beautiful flowers until they fell. I got it! But none of them drew comics, and that was confusing to me when I was in my early twenties and thought artists wanted to be with other artists. I was a very stupid snob about that idea, and really wrong. When one of my guy friends dated a girl I thought was too straight, I would be a total ass about it.

Tell me about your illustration style. Your brushwork appears to be so spontaneous and effortless. Is that something you really have to struggle with or are you a natural?
Unless I absolutely have to, I never do roughs. I never pencil anything in and I never plan out what I'm going to do. Maybe I'll have a word in my head or limits like four panels, six pages, or two hour-long work periods, but the actual writing and line work is spontaneous work of a very slow kind. After I wrote *Cruddy* with a paintbrush, I got pretty interested in the brush and its history, and ended up reading a lot about Chinese and Japanese calligraphy and ink painting. A lot of what I read was helpful for writing stories and comic strips.

Do you think of yourself to be Filipino even though you're only a quarter Pinoy? The casual reader of your weekly strips sees only black-and-white, but I think "comeek" sounds like something a Filipino person would say. And then you'll throw a topic like aswangs in a story.
How do you know about Pilipino? Do you know some Pinoy? Do you eat adobo? Actually, my Filipino part is normal to me because that's how I grew up. My mom is half white and she married a white guy, so my brothers and I look very white—like kind of insanely white. But after my dad split early on, we lived with the extended family, Filipino style, with Tagalog as the main language and big octopus legs in the icebox. The adults smoked their asses off.

What do you think of "graphic novels"? It seems like they are reviewed and treated like art, versus strips in weeklies that are read and thrown away.
Personally, I like weekly and daily comics on newsprint in newspapers where I read them one at a time. I'm more likely to stare at them and read them over. You read them while you are killing time in weird places. You can cut them out and save them, if you like. A whole book of weekly and daily comics by the same person is something different because—at least for me—there is a temptation to try to gulp them down one after the other, and they sort of cancel each other out. There is something about adding time between stories that makes comics more alive. **I love how there are so many kinds of comics just like there are so many kinds of fish.** From guppies to swordfish, plus all the weird-ass sea creatures—comics are varied like that. There are hardly any comics I don't like in the way there aren't really any fish I don't like. One time, I was dating this French guy and I was amazed at how picky he was about the whole world around him. We were walking in the countryside and we saw a turkey. The French guy said, "I do not like this bird." I said, "Why not?" He said, "His head is not very exciting." To me, every comic strip has a head that is exciting. As for comics and their relationship to art and literature and that kind of thing—man, I don't know. No head is that exciting when it's mounted on a wall. 🐱

Are you a nostalgic person? I know your stories aren't completely autobiographical, but there's an honesty and appreciation of the past that really comes through in them.
There is no part of me that wishes I were still a kid or a teenager or a young adult. I don't ever miss the city I grew up in or any of that.

I really think I just like writing about kids and teenagers, and I'm happy that these stories seem real to people. But the time in the comic strip doesn't feel like the past to me. It feels like it is going on right now, the same way a song that was written in 1948 can be played in 2008 and be listened to right this minute.

MUSIC

NAOMI YANG

I first found *Giant Robot* in the late '90s while poking around the huge magazine section at Tower Records in Cambridge, MA. The name of the magazine and the boldly colored cover would have certainly caught my eye, but it was the way they defined themselves as devoted to "Asian Pop Culture and Beyond" that compelled me to pick it up. I had never seen a magazine devoted to anything Asian—Pop or otherwise—and I also felt an instant kinship with that "Beyond" category. It seemed like everything about me fell under the category of "Beyond," or "Other." As half-Chinese and half-Jewish, I never felt like I entirely belonged to either ethnicity. And I was a musician at a time when men far outnumbered women in indie rock bands, so in that part of my life too, I felt like I occupied a space of "other." Not to mention that my music had always been somewhere "beyond" mainstream.

The corporate, major label music business had a field day early in the

'90s scooping up all the tiniest bands, hoping to find their next big hit, and for a while that decimated both the infrastructure and the morale of the underground. But in *Giant Robot*, the original punk spirit was alive and thriving. In those pages, I found both a community of people who "had an appetite for doing cool meaningful things" (as Martin describes Lance Hahn in his tribute to him), and a world of Asian American culture that was exotic to me on the East Coast. *Giant Robot* was the lovechild of a very Californian ironic appreciation of pop culture, and these first or second or third generation kids from tightly knit Asian émigré communities. It was a magazine of and by people who were curious about art, music, film, food, and fun—both inside and outside of their cultural heritage. I never knew many of my Chinese relatives, and I felt like in *Giant Robot* I had found a long-lost family.

This attitude was an extension of Eric and Martin's approaches to life.

Their curiosity, good nature, deadpan humor, and encyclopedic cultural knowledge permeate the interviews. Interwoven with typical fanzine questions like, "Did the studio get pretty messy since it was used all the time?" or "How did you set up the show in LA?", are these other questions—questions about being biracial, or growing up Asian American. Only *GR* was asking: "Are you part Asian? Is that part of your family okay with your vocation in rock?"; "Was your family traditional when it came to respecting elders, valuing education, and all that Chinese stuff?"; "Can you tell me about your Chinese Jamaican heritage?" And then there were the answers—many of which I recognized from my own feelings, like Money Mark says in an interview: "I don't know what flag to fly." To which Eric gave the perfect response: "Fly your own."

I knew a lot of the bands *Giant Robot* interviewed and reviewed, but there were always some I hadn't heard of or maybe hadn't even imagined could

exist, like Chinese Jamaican reggae producers. And it was through *GR* that I learned much more than I'd known about the Japanese internments, something that was not part of the fabric of our heritage on the East Coast but was so clearly a part of local history, or family history, for many West Coast kids. Like in this interview with Dan "The Automator" Nakamura:

When Octagon *came out, did the color of your skin make any difference?*

I'm not a ghetto guy, and I didn't sell drugs or anything, but our parents were locked up by the government. If you are a minority, you are on this side of the fence rather than the other side of the fence. You have nothing to prove. But I don't want to make this a racial issue. I don't want to be the best Japanese guy. I want to be the best, period!"

I did some writing myself for *Giant Robot*: food-centric diaries from tour stops in Istanbul (published in *GR #53*) and Taiwan (published in *GR #33*). *Giant Robot* published a portfolio of self-portraits that I took on tour—a project from pre-cell phone days, before ubiquitous selfies ("1001 Nights" published in *GR #21*). *GR* was a space where I could ask, "Is one reason I take these self-portraits to see what others see, or don't see, when they look at me?"

Giant Robot excelled at making untypical Asian American culture visible; it busted up all the stereotypes and let individual artists speak for themselves. Like in this interview with Karen O from the Yeah Yeah Yeahs:

Do you ever feel like you're expected to be a spokesperson for girls who rock?

Well, the girls really understand where I'm coming from. Guys tend to be like, "You're so masculine onstage," comparing me to other guy rockers. Girls don't do that at all. They're like "Damn girl, you rock." When Damon & Naomi was opening for Boris on a West Coast tour, I wrote to Eric and Martin to ask if they knew anyone who wanted to travel with us and sell merch. I was thinking maybe one of their interns would be interested, but was delighted when Martin himself volunteered to come along ("Get in the Minivan," published in *GR #51*). It was a remarkable tour: both bands featured Michio Kurihara on lead guitar—first Kurihara would play a hushed opening set with us, then he'd play an explosive, ear-shattering headline set with Boris. Martin was a cheerful, steady presence on this exhilarating but exhausting tour—which made me realize: reading *Giant Robot* had always been like traveling in a tour van, exploring the world with your most fun friends.

Naomi Yang is a musician—formerly of Galaxie 500 and currently of Damon & Naomi. Also a director, photographer, graphic designer, she runs the experimental small press Exact Change with her partner Damon Krukowski.

words + pictures / Eric Nakamura

MARK RAMOS
NISHITA
TALKS
SHIT

Money Mark

I was trying to find Mark's shop on a Monday, and after walking up and down a Gardena city block a couple of times—having forgotten his number on my desk—I asked the butcher guy at the fresh fish section of the market for directions. Following a minute of pondering and screening me as an honest-looking-but-not-local kid, he pointed me in the right direction. I had been totally off. I must have walked by Mark's shop at least a few times, but the old sheet metal sign was hanging out of my view, blocked by a brand-new awning of a shoe store. I walked through the front door and approached the woodshop-looking counter that was stacked with electronic junk; there was no one in sight. But before I could hit the little metal bell, I heard a tennis ball bouncing against a wall and a bark coming from the back room.

Since he had some time off from messing with his equipment, I got to talk to him for a little while, and that little while turned into a longer while. So read on. Mark Ramos Nishita is a character who told me all about his shit.

Tell me about the show you did at Top Shelf Records.
MARK RAMOS NISHITA: I don't know, I just kind of sculpt the sound into the air. It's improvisational. I don't really look back. I try to keep going forward. I try to build on what I previously did. It's ever-changing. Every show I do is different. I have a couple of songs that I do. I'm supposed to like the setting up and the traveling, but I don't like all of the traveling very much.

How did you set up the show in LA?
I have three six-foot tables and put junk down like electronic drum machines.

Was it all organized?
Kind of. I may have only used half or 40 percent of it. I wish I could use all of it, but I don't want to plan it all out. It'll kill the spontaneity of it. That's how I perform for myself. When I'm with other musicians, things are more planned out.

Do you worry about mistakes when you play?
I worry about making mistakes in my life more than mistakes when I play. I think that's part of what I do. I just let it be. It's slightly a defiance of this world of machines that we live around. I have this dysfunctional relationship with machines; I love them and hate them at the same time. I don't mind comments from people when I hear something like, "There's a human being behind the music." It is an act of defiance.

You said technology is something we have to live with, right?
That's the first time I ever broke a keyboard in a deliberate thing. I may have gotten angry at a performance and knocked over my keyboard at a Beastie Boys show or something. That was the first time. I was going to use the keyboard for something and then I started touching the keys and it made this funky sound. I liked funky sounds, but it wasn't doing what I thought it would do and I just thought, let's try this. That's what I hate about machines—when they don't do what you tell them to. Then you have people who get caught up telling machines what to do, and when they come home from their jobs, they tell people what to do. We're not machines. I was just trying to show a little frustration.

It sounded neat when you started twisting it.
It did. I had the intention of breaking it, and then it was making these sounds. I'm not recording, so it was for whoever was in the room at the time. I might do it again. I have a bunch of little keyboards that don't function that well.

Do you go to garage sales and find them?
I do yard sales, garage sales. The innocence of it all is all gone; garage sales aren't garage sales anymore. It used to be like opening up your garage and letting people see what you have in your garage. Now it's like everything is organized and has a price.

Do you go to the Roadium?
I found some good keyboards there. When I'm on tour with the Beastie Boys and I have a free moment, I'll go out into the city and raid the pawn shops—not that I'm trying to hoard material things. I use all the keyboards that I find. That's the only thing I spend money on. I rarely buy clothes.

Were you once a carpenter?
I am a carpenter. When you learn a trade, you just kind of have it for the rest of your life.

Do you still get jobs?
That's how I met the Beastie Boys. I made a living off of it. I probably made more money doing that than I do now playing music—as a cabinet maker. I was doing other carpentry, like finishing and restoration. I learned all that here on my own.

I once worked for a cabinet person and as a set carpenter in Hollywood.

Is that bad work?
Sometimes there's a fine line between good work and bad. I don't really fit in with that business. And a lot of shit gets thrown away and I would take it home. They spend three weeks building a set and then they use it, light it, paint it, shoot it, then it's a wrap and then you throw it away.

Did you want to make a living playing music? Was it a goal?
I don't know if it was conciously. I think, in a Taoist way, water seeks its own level and that's just how I feel. You just fit in where you can. That kind of philosophy helps me anyway because then I have a perspective of things around me. Like jobs to make a show happen. I like all of the jobs. I like the lights, the sound, and even the creative management things, and I like talking to the people. I even get interested in law and stuff like that. I feel like I have to know a lot of things. For me, being a performer is no different than being a carpenter, a plumber, or any job— a magazine editor. It's what you put into it, not necessarily what money you get out of it, or credibility from other people or credibility for yourself. Just be true to yourself and things will find you. I never had to knock on anyone's door or hustle for jobs.

When you play with the Beasties, you have a lot of songwriting credits.
I split credits with the Beasties and it's mostly for the instrumental songs on any of their records.

Do you just jam together?
It's a mixture. We have all of this technology around us and it's just how you use it, like anything else. Some misuse it, some abuse it. Being the musician in the studio is different than being a musician collaborating in a studio;

it's important to know the technology around you. So some pieces we come up with are just coming out of jamming, finding good parts and assembling it on a computer. Some of it, like "Groove Holmes" is just live. We were feeling really good when we did that song. We just ate some good food. We were feeling really good—played a basketball game or something. You can go from basketball to keyboard right away in their studio. That night, it just came together. We started playing and the song ended. As long as the song is, that's how long the recording lasted.

Do you like playing solo or playing with a group?
It's different. I like collaborating. I don't really like performing the same songs night after night. Actually, sometimes I do end up liking it. But most of the time, I'd rather be using my time in a different way.

Are you a family man?
I guess, in the end, I'm basically a family-oriented person, and going on the road, there's a clash that happens there. Really it's partly the reason why I play all the instruments on the record. It takes a lot of time to collaborate—not that it's a bad thing. And there's a studio in my house. I can make salad, kick

Mark at the controls.

back in front of the fireplace and watch some TV, enjoy family, and then when I have a spare hour, there's a studio.

Were you able to buy a house through Beasties royalties or through carpentry?
I had to save some money, but mostly it was with the monetary success I had with the Beastie Boys. I just try to spend my money wisely, and a dollar can go a long way if you use it to get the right things. If you buy a salad in a restaurant, it's going to cost whatever, and if you buy a head of lettuce, it's a quarter. I see the value of things. At a thrift store I may find something and say, "Wow, this thing is really worth something. It may not be useful but it's useful for one thing." I see the beauty in the lineage of some things. Something that's a piece of junk to someone might be worth something for me. In with the new and out with the old, but maybe the old is the way to go and that's the true nature of where innovation is born. Hip-hop is born out of that innovation.

Is that what you're into? I know you have some jazz influence. True hip-hoppers are into jazz.

I've listened to the music and it doesn't sound like a hip-hop record. This sounds like nothing I've heard before.
I walked into Tower Records and my record was in a listening booth. I put on the headphones and listened to some of the songs that I recorded in my kitchen, basement, and bathroom. Innovation is born out of the necessity of things. If people said they've never heard it before, I just used techniques and rules and applied it to a different thing. So it has hip-hop elements but it's not really hip-hop. It could have elements of being innovative. If you listen to Lee [Scratch] Perry, his shit doesn't sound like anything, either, to me. Everything after that imitated that sound. He was looking deeper into something. I've been categorized in hip-hop, pop, rock,

soul, jazz, hip-hop...some say it's psychedelic. Some songs are psychedelic; I think "Hand in Your Head" is. **My favorite song is the song "Never Stop," which is just guitar, bass, and a vocal, and I don't know where that came from. It just pours out of me.** In that case it might be soul. I don't want to categorize it. I take it as a compliment if they say that they never heard that before. I get letters like that, too.

There's a lot in that album.

There's a lot of history. It's a culmination of everything I've done in my whole life up to that point. Bob Mack edited *Grand Royal #2* and him and I were going to go through every song and break it down and write a couple of paragraphs about each one.

What was "Hand in the Head" all about?

I was in my bedroom and there's stuff all around me; my son had a little stuffed animal on the shelf. So if you listen to the song, I saw that it's torn up and all the stuffing was coming out of it. **"You could be my best friend sitting on a bookend, you're looking down like a king...I got my hand in your head and pulling out your mind."**

I can see that in a movie or something.

Someone called me a couple of days ago and they go, "Hey, Mark, I was watching 90210..." and I was like, "What friend of mine watches 90210?" They just happened to be watching it and they heard "Cry" in a love scene. Every song has its story. The crickets thing, "Insects," that song essentially has two parts, organs and drums. I played

The Device in question

drums first and keyboard second. The bass is the foot pedal. The rest are chords on the left hand and the cricket sounds are on the right hand, and there's the drums.

Are you a one-man band?

That's why I was asking about that guy Arthur Nakane. I think I've seen him—in fact, I have. He's unforgettable, really.

You live in Gardena part time?

Half of the time, really. I'm going to spend more time here since I'm doing rehearsals to go on this little tour. I'm talking with Beck about getting some US slots. I'm into Beck's stuff. People have a hard time categorizing me and that same thing happens to Beck. I don't know where I really fit in. I'm a bit confused about it. People see me with the Beastie Boys, and they say, "That's the keyboardist for the Beastie Boys." I know for myself it's more than just that. I'm in this good spot; I don't have an identity. My parameters haven't been determined yet.

In fact, I hate to even know what I'm about. I don't like to look in the mirror and analyze, but I just want to keep moving forward and a few minutes before I die I can say, "Oh, that's what I've become," and then I can die or whatever.

Do people recognize you?

No, I can go anywhere.

When I see the Beasties, I can never see your face.

That's cool and I can change up.

Everyone recognizes the Beasties.

They take a lot of pictures and stuff. I'm not really into doing a lot of press with photos and shit but maybe it'll become inevitable. Maybe with the persona stuff, I think I'm more comfortable being honest and deglamorizing the whole thing. Like, fuck it, I am who I am and I don't want to be something I'm not. I don't think it'll work. For me, it's too much effort. I just want to play music and get on with it.

Do you do it every day?

I practically do it everyday. If I don't, I'm thinking about it.

What else do you do?

In my spare time, I'm working on this video thing. I'm doing this for *Mark's Keyboard Repair*. I'm in it because I play this repair guy in the keyboard repair shop. The business isn't doing that well, but occasionally people bring keyboards in. And I'm going to get Beck to bring his shit in. It's on video. In my spare time, I'm in the backroom of the shop with my chihuahua recording my *Mark's Keyboard Repair* album. It's cool if people think I have a shop. I don't care. I recorded the whole thing in my apartment. In "Cry," the vocals are quiet, subdued, and whispery in a way and that wasn't intentional. I was living in an apartment at the time and I didn't want to disturb the neighbors.

Were you always into singing?

I was, but no one really knows that. Beastie Boys, of course, they don't sing so there was no chance to sing on one of their records. I got all of my singing from my mom. She was a singer like Sly Stone and Stevie Wonder.

A question about albums. I bought the first 10", how many of those did you make?

A thousand of them.

I bought it, and then I bought the import and that had the original 10" on one side, and now the domestic comes

● This article was also published and translated into Japanese in *Quick Japan Mook* (Magazine + Book). Seeing that this happened, it gave me knowledge that we were being watched by larger publications.

out with everything again and eight new songs. Are all your albums going to overlap like that?

That was a fluke. I made the 10″ and I went on tour with the Beasties and passed out a bunch of them. Then I sold a bunch, and James Lavelle at Mo' Wax through the Rough Trade shop in London heard it. At that time I was just beginning to hear of Mo' Wax. I heard James had that 10″ and I heard he wanted to talk to me, and I didn't see it fitting into Mo' Wax but then he said let's try it; and we did a small licensing deal for the three 10″ and that's the format I wanted to release it on. It's come full circle since *Grand Royal* just released it. James does vinyl and that's what Mo' Wax is all about. And three 10″ records wouldn't fit on a 12″ disk, you can't fit it all in. It would be over 30″ a side. On one side you can only really put up to 27 minutes and have it sound good. So he decided that he would put the first two 10″ on that vinyl instead of three 10″. He did that and the CD only had the first two 10″ as well, and then he was going to put out a third 10″ as an EP. So Mo' Wax put out the two 10″ and then a third 10″ separately. The third version is sold out around here. It has a new version of "Sometimes You Gotta Make It Alone," like a sappy kind of ballady version. I don't like that version. They said they'll pay for it, you go in and make it a ballady thing. And I said, "I don't really feel like doing it," and they said, "We'll pay for it," so they paid for it and I did it, and they got the recording and I said, "I don't really want to release it," and they released it anyway.

Do you like the original version?

I like how it all happened; it just happened. I turned the drum machine and the Wurlitzer piano. If you listen really closely, there is this Korean radio station coming through. I was living at Echo Park at the time, and it was coming through on a cord or something. So I was just playing it and it was spontaneous. The lyrics happened, too. I couldn't lie to you. Like I said, **if I'm not recording, I'm illuminating on things and putting things together in my head and at some point, when the tape goes on and I push record, it somehow comes out.** I like the format 10″ on vinyl.

Doesn't that make it tougher on a DJ?

I guess I even read somewhere that the record is a gold mine of beats. I listened to it the other day after I heard the comment,

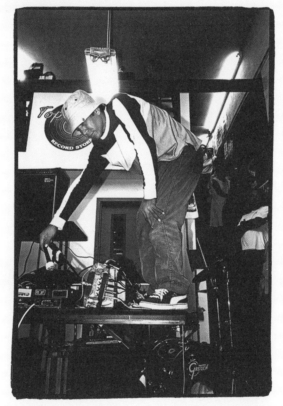

so I guess there's a lot of breaks and beats. So DJs and people are buying it. I've heard a few songs that people made up from it.

That's the first time I saw you on the record.

With the Beasties, I stay away from the photographers and press, and I slip out of the room.

I've read that you are the unofficial fourth Beastie Boy.

I get invited to press things but I never go. I don't see the point in going to that. I grew up fast and I viewed technology as crap. I grew up in LA.

Are people allowed to know how old you are?

Yes, 37.

I thought you were a kid!

I feel like a kid; I feel like I'm born up again. I take care of myself. If you don't take care of yourself, your body starts fucking up and then your attitude starts fucking up. **That's just how I live. I intend to be around for a while. These days, I'm comfortable with being who I am. I have always played music and had ideas about it, and it's just timing.** There are people out there doing what I do, they just don't have the opportunities to do it. I try to do all kinds of stuff. I think a person needs to do one thing good and then he or she can do other things. Arts cross over each other. I'm proud of myself; I feel pretty good.

You make it look easy, but...

I'm not just speaking for myself, that's what being a professional is. Like being an acrobat at a circus. It's not easy. It's being graceful at something that's difficult; that makes people feel comfortable. It's like that little handheld amplifier. That's not new, people could have done that before. The story behind that thing is that it looks like a bomb, so I don't put it in my suitcase when I travel. But I take it everywhere I go. **Sometimes when I'm on tour and I get bored, I have a little keyboard and it's battery-operated. I get to perform at the airport because when I go through a metal detector, they say, "What the hell is this thing?" And the people back off. So they tell me to turn it on and then I get to play at the airport.**

Where's the best place you've been?

We have never been to India or Africa. We were in Poland... Czechoslovakia. It's cool to play in Japan, but I can't live there.

● I'd classify him as an underdog. ● Mark's super photogenic too.

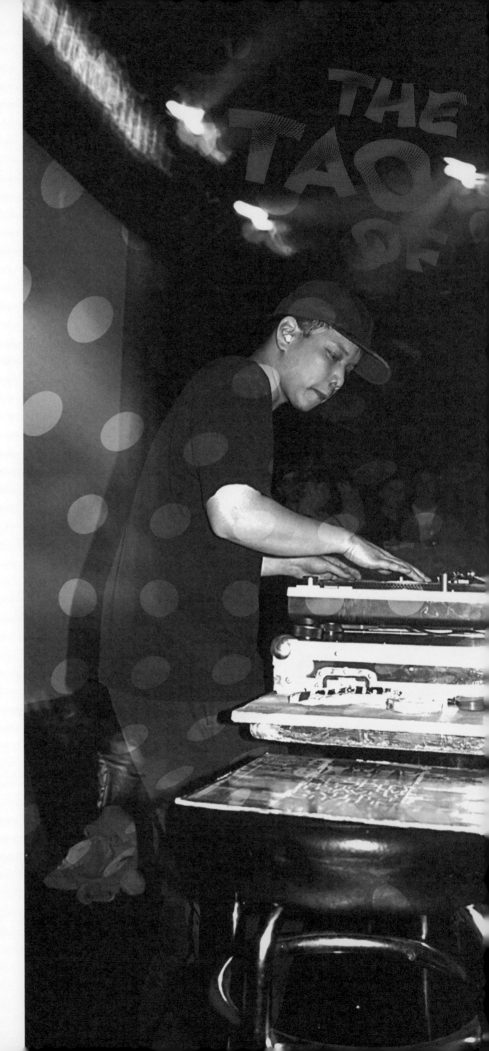

In general, the audience is a a bit more sympathetic, and listening sensibilities and the attention spans are better. The other respect was great in Poland. The tent almost fell down and there was a bomb threat. It was exciting. In either place, I wouldn't want to live there.

You are part-Asian, right?
My dad's Japanese American, my mom is from San Antonio. So I get caught up in both the Chicano thing and the Asian thing. I'm in between—I don't know what flag to fly.

Fly your own.
I'll make my own fuckin' flag. I feel close to my dog, the chihuahua, or maybe a Pinto flag. I'm interested in culture and race and I try to figure it all out since we live in this city. There's always racial tension—not that I've experienced it head-on. I used to feel it more and I see it all of the time. If I'm not allowed to stick out for one thing in particular or raise a flag, which I don't want to do, then I think everyone should raise the flag they want to raise and respect everyone else or learn shit from other people. There's an image that Asians have to the rest of the populace and I don't know what it is. **I grew up in the '70s and I wasn't that great in school; to me I was supposed to be smart with a high IQ, good grades, and going to dentistry school, and I didn't do that. I wanted to be this other person and didn't want to be categorized.** I wasn't allowed to have bad grades.

Where did you go to high school?
I went to Gardena High. I'm atypical. Just like that guy in Smashing Pumpkins and he's atypical as well. People shouldn't make a big deal about it. This country is based on immigrants, and fuck you if you don't like it—really, that's what I tell people. **I don't want to start any kind of war.** 🐱

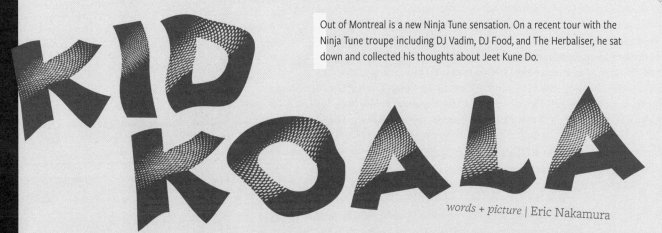

Out of Montreal is a new Ninja Tune sensation. On a recent tour with the Ninja Tune troupe including DJ Vadim, DJ Food, and The Herbaliser, he sat down and collected his thoughts about Jeet Kune Do.

words + picture | Eric Nakamura

Don't ask Kid Koala about his style, since he doesn't talk about it when he's describing his DJ work. It's not ironic that Bruce Lee did the same when he described his fighting technique. The idea instead is to learn all styles to incorporate them it into one deadly art.

At a recent stop of the Ninja Tune tour, a medium-short Chinese Canadian kid got on stage and in just a few minutes of spinning records in front of the colorful and looping videos of skateboarders, computer graphics, and Japanese words, he got people to ask each other, "Who is this guy?" Unknown to most everyone since he has no vinyl releases to date, he's Eric "Kid Koala" San, a 22-year-old straight-up Chinese Canadian who hails out of Montreal via Vancouver.

In the most recent DMC contest, he took the top prize for all of Montreal for himself, but got ousted once the contest moved to Toronto. But that's no big deal to him since he's out to keep improving his skills. Koala mentions, "Negative energy can be put into speed." While he was developing his skills, he would "tense up and mess up his routine." The speed wasn't there for him. That's when he first started reading martial arts manuals to help him out.

After talking to Koala for just a few minutes, he got me convinced that DJs and martial artists are similar. **"There's common elements like discipline, relaxation, and instrumentality. Martial arts relates to scratching."** For example, he makes mention of Lee's "economy of motion" to increase his speed in punching.

On his downtime, he's currently reading *The Tao of Jeet Kune Do*, by Bruce Lee. He tells me simply, **"Just change every time he mentions the word 'punch' into 'scratch'—a lot of DJs are aware of this."** The Technics 1200s are Koala's punching dummies, and the music is his yell reverberating into everyone's bodies.

He started the tables seven years ago when he bought the first Coldcut records and played the shit out of them. And this proved to be worthwhile, since years later he spun records at an in-store with Coldcut and did a kick-ass job freestyle scratching Ninja Tune disks without ever hearing them before.

Regarding his current affiliation with Ninja Tune, Koala keeps it simple, "I was in the right place at the right time." But it wasn't that straightforward; he did a little maneuvering. Although the entire story escapes me, he set it up so that Ninja Tune artists Porcini and DJ Food, who were visiting Montreal, were somehow going to be in a van with him, and he made sure that his mix tape would happen to be in the tape deck. He says, "Luckily, they asked who was spinning."

When he's not at the tables, he checks out Hong Kong films at the *Asian Fantasy Weekly* and is currently into the Wushu and Shaolin styles of Jet Li. And when he's running around town, he chills at home and listens to old jazz, baroque, and Ninja Tune records.

With his massive skills, one would think that he's been frequenting clubs since infancy, but he claims that he's not part of the club culture. Koala maintains that he spun records at college pubs and has a weird collection of '80s music.

Recently he graduated from the elementary education program and has helped teach kids. He possibly wants to do it full-time someday, but currently gets the leftover vinyl that are about to throw away. **"Best thing about records is even if they are scratched you can still scratch with them."**

Another side excursion of Koala's is his band called Bullfrog which is an 8-piece group. You can only guess what instrument he plays. They performed in the International Jazz Festival and he lied to some of his family and said he played sax!

Upcoming, he has a Coldcut remix and his own single, although for now he has his magical mix tape that got him hooked into one of the most popular DJ record labels today. His future is looking bright and when asked about his family's understanding with his work, he tells me, "They don't understand it. Try explaining it in Chinese!"

On a final note, he has a theory of the reasons why there are so many Asian DJs: "Asians are too short to play basketball or rugby, even though there is occasionally the odd Asian tall freak, but the rest have to do something else." He also adds, "Many Asian parents forced their kids to play music." So, Koala had a headstart in music—he played the classical piano for 10 years.

Dan "The Automator" Nakamura has carefully planned our meal. "I got the perfect spot, but we gotta leave early." After a hike to his San Francisco recording-studio house overlooking the waters of the bay, we luxuriously roll out and start driving south toward San Mateo, where one can find the best ramen in America. I've heard Dan boast about how one of his *Iron Chef* buddies devoured two bowls in a sitting. Chefs usually eat little and drink a lot, but two bowls of ramen? This small shop got the seal of approval. Parked at the end of an unassuming block, a small shop has signs telling you that once their soup runs out they close, and their stewed pork already has run out. We wait for a bit, then take our seats. The word is out, and other people wait with us.

Once the tonkotsu (white pork broth from Hakata) ramen is brought out, it doesn't take us long to down it all and then talk about what is next. It's easy to engage Dan into conversation if you know what's seemingly most important to him, and that's gastronomy. Dan has an encyclopedic knowledge of good eats in almost every city. If he's stuck, he'll open up the Sidekick 2. Stuck at an airport? He might know where the best place is to get a quick meal. Is the food in England shitty as a whole? He'll tell you that it's getting better. **Once at his New York home, he pulled out a thick collection of menus from places that deliver in the rain, and we ordered from two of them. Hanging out with chefs, Dan hears and tries what's best and probably knows about the signless secret restaurants in your city. Where one person's quest to eat ends, like at the ramen shop, we're just getting started.** Just down the block is a small spot called Happy Café where the two orders of soup dumplings turn out to be the perfect match for the ramen. We have just eaten two meals, but that's the perfect way to start a workday.

You might think Dan is all about food, but his day job is equally impressive. One of his earliest acclaimed projects is Dr. Octagon, which became an instant hip-hop classic. More recent jobs include the production of the Gorillaz's first album, Deltron 3030 featuring Del the Funky Homosapien, Cornershop, and Handsome Boy Modeling School with Prince Paul. His client list is long, his waist line stands trim, and he has remained humble over the years.

Mr. AUTOMATIC

words + pictures | Eric Nakamura

When is your album going to come out? I heard it a while ago.
DAN THE AUTOMATOR: I'm one of those guys who has the fortune and misfortune of doing major label records. There's just such a lack of stability between the downloading and things. I'm sort of outside the world of MCA, which is a very well-stocked label. So my contract fell from the Universal system and got put into the Geffen system with somebody who didn't understand what I do. It took me a year and a half to get off the label. But to make a long story short, I'm going to put out the album probably next May after I redo some of it.

Are you having a hard time finding a record label that shares your vision?
The problem is that I put out a record last year and had the absolute worst time with the label. It was just bad timing. They were about to go public with stock offerings, and things fell through the cracks. Lack of stability, different people here and there, and other stuff makes the decision to hand over your stuff a bit more complicated.

What's the difference between indie and major labels?
I like to look at it this way: **If you are on an indie label or you are putting out your own records, you probably have three or four people working 100 percent on your record. Or, you could be on a major label where you have like 20 people working at 20 percent.** A lot more can fall through the cracks, but there can be a lot more opportunities.

Musically, what is the difference?
There's no difference, except that **you won't be able to have a hit record on an indie label unless you are really lucky.** If it's a great record but it doesn't have that single all over it, maybe a major isn't the best place to be. And vice versa: if you have that cunning single but the album isn't very captivating, then maybe it's better on a major.

From the instant you finish working on a song, do you know if it's a Top 10 single or a Top 50 single?
I can't say that it is a Top 10 single, but I can say that it has potential. Right now I have a single with Jamie Cullum. It's pretty big—more of an adult single than a kid single. An album-oriented rocker or whatever you call it. Alternative college radio plays it, but it's the kind of thing that could use a push, you know?

Your title is mostly producer, but it seems like you can do everything.
I'm a producer by trade, but I can play instruments and I like to do a lot of different things. I don't consider myself a great artist or Elton John.

You haven't worked with Madonna or anyone like that yet.

 ERIC: Time capsule photo. Dan the Automator is wearing a Silas shirt! It was streetwear brand that bloomed in Japan.

No, but I've done stuff with people who are considered commercially viable in formats like alternative and rap. I've worked with Busta Rhymes, you know? I've done stuff with Primal Scream. You couldn't give away their record in America, but it's all over the radio in Europe. Let me put it this way, **if I could make Britney Spears records, I'd be making them. I'm not morally opposed to it. It's just not what comes out of me. I don't make country records. I don't make modern R&B records. I don't make modern jazz records so much. There's someone out there who's feeling it, who's going to be doing Christina Aguilera and Madonna records better than me. And more power to them, you know?** I'll probably see them drive by in their Rolls-Royces. Way back, like a year before I started making records people noticed, I kinda knew that I was making my own thing and that I wasn't equipped to copy what was going on right then.

Was this around Octagon?

Right before that. I realized either I'd be okay, or no one would ever hear me, but at least I'd be true to what I do.

What can you bring to a punk rock band that has no hip-hop element at all?

It's less about hip-hop in rock records; it's more about hip-hop in youth culture. Hip-hop has become the number one influence on culture. **Even if you are a rock kid, you might have grown up listening to NWA records. A lot of the rock kids I work with don't have any motivation to rhyme, but they grew up listening to rap.** My roots in

music are underground hip-hop, but I'm not really an underground hip-hop sort of guy. That just happened to be a way for me to express myself at the time. I'm actually a really big fan of music, whether it's hip-hop or rock or pop or whatever. I've probably made more rock or alternative records than hip-hop ones. This wasn't by accident, you know? After I made my first successful venture with Dr. Octagon, the very next successful record I made was Cornershop. That made me open my ears to the sound of Indian music. I got to tour with Radiohead. I got to do all these things that rap guys don't do. It was like seasoning.

When Octagon came out, did the color of your skin make any difference?

I'm not a ghetto guy, and I didn't sell drugs or anything, but our parents were locked up by the government. If you are a minority, you are on this side of the fence rather than the other side of the fence. You have nothing to prove. But I don't want to make this a racial issue. **I don't want to be the best Japanese guy. I want to be the best, period!**

I watched that Metallica documentary, and it was pretty cool. They did this weird rap thing where they gave a song to some guy and I think Busta Rhymes rapped on it. Is a project like that interesting to you?

Kinda. Metallica makes great records. I see them at Safeway once in a while and we'll chill. I'm interested in self-expression.

I think I read in an interview that you might take sounds from previous records but tweak them so much that it's impossible to know where they came from. Are people able to figure them out nowadays?

I actually don't sample stuff much anymore because it's so expensive. It isn't worth the clearance. It's almost like, why don't you just get them played or whatever? I'll still have two or three or four samples on a record, but I won't have a lot because it's too expensive. I miss sampling. **I miss being able to create audio collages. It's just not financially feasible.** I think it's an art, and the public will never be able to hear all the great stuff that guys like Shadow could've done. It's a shame, because I think it's a very important part of 20th century music. It's a big part of modern electronic

music and modern music, but we are at a point where people just can't afford to make records like that. I'm telling you, Josh (DJ Shadow) can do amazing things with it, but he just can't afford to. I'm sorry that I'll never get to hear that stuff taken to its fullest.

What does a sample consist of these days? I know Vanilla Ice was popular because he stole the Queen riff, but something like that is a little too obvious.

Well, if you pay for it, you pay for it. It's not a question of how much you take or what you take. And it's not uncreative to do that. The Beastie Boys take other people's three notes and make their own thing out of it. The thing is that you get to a point where you can't do anything because it gets too expensive. It takes away the fun. Like I said, I actually miss it because I am actually a big fan of the whole thing. The Bomb Squad is one of my favorite hip-hop production teams ever.

Hank Shocklee and Public Enemy, right? Those guys were insane. I even bought Son of Bazerk just because I heard that they produced it. It would have been cool to hear an instrumental version.

I love the vocal version, too. See, I'll never hear records like that again, and I miss it.

Do those guys still work?

Yeah, I saw Hank a couple weeks ago.

Is there like a producers community?

Somewhat. I'm not saying like we get together every day.

But Pharrell knows who you are?

Yeah, we are friends. We chat occasionally.

But he's like a billionaire nowadays. As a producer, is he just doing more commercially viable work?

More than me! [*Laughs*] I mean, he's good. He does Justin Timberlake records. He did all the hits on the Justin Timberlake record except for one of them. He's incredible, and he knows his shit.

It seems like he became a real mainstream artist all of a sudden. He was on one of those 60 Minutes-type shows on television. Now he's appealing to 60-year-old white men.

He's really an interesting character—not your typical pop-beat poppy dude. I actually find him to be really influential. I'm a fan of what he's done recently.

I bring him up because he was a hip-hop producer once. Now he's doing white music for white people. As white as can be! It's some kind of a weird crossover-type of thing, you know?

He's really good at it. Take, for example, Dr. Dre. That man has made more money than God. He's made hit record, after hit record, after hit record. I love all of his records, but they are mostly all rap records. The amazing thing about Pharrell is that he can do that in different genres. I'm like him in the sense that I'm also interested in different genres. <u>I'm sure Dre is interested in different genres, but he just happens to put out rap music.</u>

He probably doesn't even have time to mess with them.

<u>The thing about Dre is that he doesn't put out as many records as say, Pharrell, but everything he makes is a hit.</u> I've been following him forever. He's definitely my favorite rap producer on the LA side. He's taken chances and failed, plus he's taken chances and succeeded.

What did he fail on?

That's the thing. You don't know the failures because the records don't sell.

How about you?

I would love to be that guy who makes all the Justin Timberlake records, makes all this money, and lives in a hovercraft. But that's not really who I am. At the same time, I'm not like "Oh, let me speak to my indie roots because it's cool." I find people I like, and I do stuff with them. I know some records are only going to sell a few copies, but it doesn't really matter, does it? I mean, it's kind of about the musical output and ultimately getting to make something that you think is relatively cool.

How often do you hear something that is super fresh, like a fresh new sound or a fresh new thing? How often does that happen these days?

I think the most fruitful period for me was around when *OK Computer* came out. I think Björk had *Homogenic*, and then Portishead had a record. That was just a fruitful period. It's not like that right now, as far as I can tell.

When was the last time you have been really excited about an album?

Oh, man. Well, someone thought the Postal Service record was pretty hot. Chan, you know, Cat Power. Her new album, *The Greatest*, is really, really good. I also think that Young Jeezy is pretty amazing. I get caught in these moods where I'm working on new projects and I listen to old records that I really like to get into. Last year, I spent some serious time with The Clash, Big Audio Dynamite, and New Order. I used to listen to a lot of that stuff because I think Big Audio Dynamite and New Order have the creative energy that encapsulates what should be going on today.

So are you out buying as many new records from new artists?

I slowed it down a lot, specifically because there are so many things that I want to buy. You get to a point in your life where you're not looking for anything, but there's always music. I would always be able to go out and buy records. After a while, you realize that you are buying less and less. You still have the same desire to buy it, but there's just less records out there. A number of years ago, I started buying a lot of DVDs. But I realized that you might see a DVD of your favorite movie like 20 or 30 times, whereas you might listen to your favorite record 10,000 times. So I buy music because it can be listened to so many times. It's a lot easier to buy on iTunes, but then you don't get the pictures and it's less interesting. It makes the hobby not fun.

Does downloading hurt you? Is it noticeable from one year to the next?

Of course. Record sales in general are sliding. I don't blame people for downloading. Either you spend $12

Dan Nakamura is Eric's cousin.

on a crappy record or get the song free. I don't think it's a music thing, though. I think it's an intellectual property issue. I think that the government has to really crack down on downloading music and movies. How far away are we from downloading medical formulas? I'm serious; these guys spend half a million dollars on drug research. Don't you think that in about five years we'll have a chemistry set and be able to do that kind of thing? Or how are you going to stop somebody from downloading a PDF and then silk screening it onto a shirt? Protecting intellectual property is something that needs to be addressed on a much more stern level than it is right now. It's hurting the music industry, but that's just a small fish in the bigger picture.

Is there one album that you always go back to?
Not one that I always go back to consistently, but I listen to Serge Gainsbourg's *Histoire de Melody Nelson* a lot. Can's *Ege Bamyasi*, The Beach Boys' *Pet Sounds*, Radiohead's *OK Computer*, Björk's *Homogenic*, the Postal Service, [Boogie Down Productions]'s

Criminal Minded, Mobb Deep's *The Infamous*, the second Mantronix album.

When was the last time you put out a record of your own? Was it Handsome Boy last year?
This year, I have a new Deltron [3030] record and a new record with Josh Haden.

You produce music that fast? It seems like you do three or four projects a year, which seems like a lot.
Yeah. Now I'm working on a record with an English guitar blues-rock band.

What do you think of the mash-ups? It seems like a DJ thing right now.
We used to do things just like that 15 years ago. I like juxtaposition, but I like my mixes to be musically viable. Sometimes it's bad, sometimes it's pretty good. I've had remix records out, you know? Sometimes that stuff can be extremely crazy.

But it seems like that term came out last year or so?
When I was a kid, you'd see guys mixing "Under the Boardwalk" with

"Planet Rock." Maybe it actually helped me musically, because I didn't know anything about putting genres together.

Is there ever an issue of work being work and home life being home life?
A little bit. People think they know me through my music. For example, I don't do drugs. But after Octagon and all that stuff, I was perceived differently. You know what I mean? So when I do shows, even 10 years later, people give me drugs. To this day, I'll be DJing and people sweep things onto the mixer. You know, 99 percent of the people don't do that, but the 1 percent that does, I'd just rather leave them out of my midst. When we were doing the Octagon record, we had people showing up at our PO box. Maybe I'm a little paranoid about things, but I don't want to be part of that. It's just not worth it. There's no upside to it.

So we're never going to see an MTV Cribs at your house?
Never [*laughs*]. No, I'm not super private, but if I don't see a real upside to a situation, I don't want to get into it. It's like swinging the pendulum too far that way, you know what I mean? 🐱

Still call each other cousin. Dan the Automator to have it. Dan the Automator and I still call everywhere in the US, and we drove from San Francisco to San Mateo to have it. Dan the Automator and I Long before their arrivals en masse everywhere in the US, and we drove from San Francisco to San Mateo to have it. Dan the Automator and I Tonkatsu ramen and soup dumplings! Long before their arrivals en masse everywhere in the US, and we drove look at the food referenced. Tonkatsu ramen and soup dumplings! On the day of the interview, we ate a lot—look at the food referenced.

REBEL

words | Eric Nakamura
pictures | Bob Hsiang + Corky Lee

At 29, Tadashi "Tad" Nakamura found a way to blend new styles and techniques of filmmaking to add life to the boring genre of educational films. His previous documentary, *Pilgrimage*, which was about Japanese Americans returning to the Manzanar Concentration Camp, went to the Sundance Film Festival in 2008. There, CNN interviewed him live. Nakamura's latest short opus, *A Song For Ourselves*, is about musician and activist Chris Iijima and is currently making film festival rounds. The son of a pioneering filmmaker/UCLA department head and a screenwriter, Tad has big shoes to fill. Despite being recently denied by UCLA's film program, the bright-eyed and humble-voiced filmmaker carries a big-game swagger.

FROM MONUMENT TO MASSES.

How did you decide to make a film about Chris Iijima?
TADASHI NAKAMURA: It goes back to my parents, who were friends with him during the Asian American movement (p. 76). **I have a lot of non-related aunties and uncles that I grew up with and I never kind of realized their historical significance until I took an Asian American Studies class.** Chris was one of them. I didn't really know him that well until I went out to Hawaii to apply for school. That's when he kind of took care of me and showed me around. We started talking about the Asian American movement then and now, and he kind of became a really big role model for me. When he started getting sick, my parents and I didn't think we were going to do a film. We just wanted to interview him and get his stories down, just in case, because his condition was getting worse. So we went out there and interviewed him, and he eventually passed away.

Was going into film automatic since your dad was doing it?
Actually, I never thought I was going to do film. I was much more into campus organizing, but Asian American Studies changed my life. It even changed my perspective on school because I never really liked school. It wasn't until I became an Asian American Studies major at UCLA that I was like, "Whoa, I'm actually interested in this and can actually do well at it." That really inspired me to teach Asian American Studies like my dad, and hopefully bring it into more classrooms at a younger age because hardly anyone gets into UCLA—especially these days.

And if they do, they're probably not going into Asian American Studies.
Exactly. I was raised on the Japanese American basketball leagues, and all of a sudden, Visual Communications became something I was actually proud of, versus just being where my dad worked. That had an impact, too. It made me appreciate everyone around me a lot more. **My dad really pounded in my head that you have to have a day job that you can do your art through. But I'm kind of worried about depending on filmmaking to make a living. I don't know if I can, and I don't know if it will force me to do stuff that I don't really want to do.** I'm at that crossroads now. I need to make a living and I want to continue making films, but none of the films that I want to make will make a living, if that makes sense.

All of your films have like a '60s or '70s retro thing mixed in. What is it about that time period that interests you, and are you done with it after three movies?
Growing up, it was an aesthetic that was always very appealing, probably because

SONGS

I didn't experience it. I saw the John Lennon aesthetic and Black Panther aesthetic and was attracted to them, but never saw Asians in there. So once I discovered Yellow Brotherhood, and the fact that there were Asian Americans who totally looked just as hip, that really appealed to me. So **on all three films, what I was attracted to aesthetically was funky, long-haired Asian Americans.**

That's a continuing theme, but I think you've been tying the new and the old together. It's not just old stuff, which is cool.
It gives me more of a sense of identity. It's not that I can't relate to J-pop or the 442nd, but I can really identify with Asian Americans in LA in the late '60s. It's like, "Hey, that's Sawtelle" or "That's UCLA."

You're doing student organizing, and today's issues are completely different from the ones in the '70s. Is there a big drop-off from what it was back then? Is it more like infiltrating corporate-type stuff today?
People are trying to figure that out. The labor movement is pretty huge, and it includes a lot of Asians and Asian immigrants, but it's a totally different demographic.

It's not as hot. It's not like fist-in-the-air-type stuff.
At the same time, **community work was co-opted in the '70s to the point of almost becoming kitsch.** No one wants to do community work now, but the ones who are doing it are there for the right reasons. I actually see potential for social change becoming more entrepreneurial. That door's wide open because until now it's been very black and white: nonprofit, activist, broke, working class, or sell-out corporate America. **I think my generation and the generation younger than me are developing a gray area that's progressive but self-sustainable, so if the government cuts your organization's grant, it can still survive. I'm excited to see what comes out of that.**

So how important is film school? You made these movies without going, and now you have enrolled.
It's not important. You can totally make films without going to film school; most people do, actually. But I feel like I skipped learning basic, fundamental, and technical filmmaking skills by jumping in, grabbing the camera, and making cuts. Like I never actually worked with real film and all my stuff is shot with natural light, I haven't worked with a light kit, and I've never done narratives. What I want to get out of film school is more or less technical. Writing my own stuff, working with actors, and actually directing is totally foreign to me, and I think film school would be a good chance to experiment on that stuff without necessarily investing too much time and effort into it.

Does that mean you have interest in possibly doing a narrative? It seems like every young filmmaker's dream is to make a feature film.
I wasn't one of those kids growing up with a desire to tell a specific story, but I think there are plenty of people who are going to do that. People like Justin Lin will continue to push that and make the narratives. I can't say the same thing for documentaries. It's one of the areas where there is a huge potential that hasn't been reached. **You watch your average Asian American Studies film and the content's interesting but you're falling asleep. The entertainment value can't hang with what's on TV. My goal in filmmaking is to tell those stories and inspire people in a way that can engage a high school student.** One movie that really opened my eyes was *Dogtown and Z-Boys*. It blew me away. I was like, "Whoa." You know? I grew up skating, but never saw content like that about the Westside. At the same time, it was a documentary that was aesthetically different from anything that I'd seen.

Of course, they turned it into a feature film.
Yeah. And if you compare it to the doc, it doesn't even come close.

I'm okay with the feature film. It's just like the Muhammad Ali documentary When We Were Kings, *right? Afterward, there was the feature film with Will Smith. The documentary is so much better, but if you take it away, Smith was all right—better than Denzel Washington as Malcolm X. That was kind of weird.**

Yeah, but at the same time, more people and younger people probably saw the Will Smith movie, which was huge. That tells a lot about the audience that I'm trying to reach. I'm excited to merge those two genres. *American Splendor* really blew me away. I think Asian American films can get to that level of creativity or production value. I think that's what I wanna help do.

So you want to stay in Asian American film, and don't want to make a film about four white guys who go to some party?

Not really. The main reason I wanted to make films was to create stuff that I wish was around when I was a student. Not to say that I won't do stuff in other communities, but having a show on prime time on NBC isn't a goal of mine.

Inevitably, it becomes reality TV or something. So you get four Asians in an apartment.

Yeah, which is weird because as much as I totally pooh-pooh reality TV, I think it has represented Asian Americans more than anything else over the last couple years. At all the Asian American film festivals, the guests are always reality TV stars.

Yeah, like Yul Kwon.

Exactly, he was like the Asian American for two years. And I don't think Asian Americans want to claim Tila Tequila, but she's probably one of the most recognized Asian Americans on TV right now.**

So what kind of responses are you getting from A Song for Ourselves? Is it people who are older than you or young people that are responding?

The audience has been mostly Asian Americans, which is good because that's who I make films for. <u>Folks from the older generation say, "Hey, thanks for telling our story and documenting it" or "You really brought things back for me," but the biggest response has actually been from college students.</u> Asian American Studies classes and organizations invite me to show my films on campus, and one of the things I tried to do with the premieres for *Pilgrimage* and *A Song for Ourselves* was to make them more like concerts so they'd attract younger people who are interested in music.

You got Blue Scholars to come down from Seattle and play the opening?

Yeah, they came down. Ever since *Pilgrimage*, I've been dying to get to do a show with them. I mean, those guys have been really, really inspiring.

ERIC: **I'm way wrong here and am glad Tad didn't engage me in this to make me look more dumb. Publishing opinions are always a risk in the long run, and you won't think about them like that at the time. As Martin would say, "Even the Blue Angels crash sometimes."*

*** We have come just a little bit further since this, but if you're a younger person, these two stars are indicative of what Asian Americans were getting on television. Instead of working actors, it was reality stars who sort of broke through. It was almost unfair. Today Asian America is just getting going. There'll be some well-funded pity projects that'll fail, and we'll see some things work.*

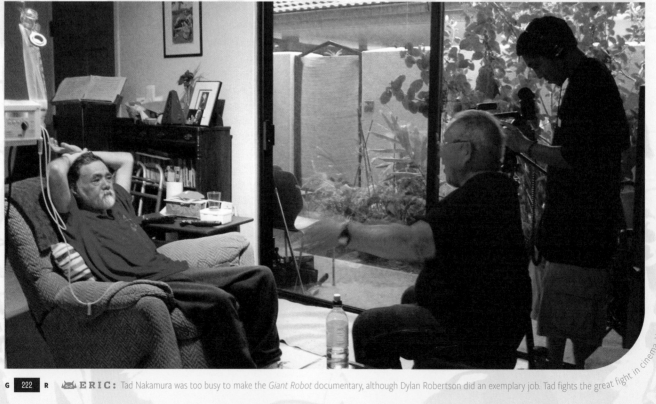

ERIC: Tad Nakamura was too busy to make the *Giant Robot* documentary, although Dylan Robertson did an exemplary job. Tad fights the great fight in cinema. You don't see a lot of folks like him satisfied with telling past stories in documentary form.

ERIC : Epic series by Martin. It's no secret that Martin loves music—aside punk, he was also into dub, rocksteady, and dancehall. This entire Chinese Jamaican series is eye opening—it intersected migratory history that you may not

TOUGH GONG CHINESE JAMAICA

When reflecting on the evolution of Jamaican music, one thinks of the raw offbeats of ska, soulful sounds of rocksteady, and bass-heavy vibrations of roots reggae, as well as the stony versions of dub and disco offspring of dancehall. Performers such as Millie Small, Toots Hibbert, and Bob Marley come to mind, as do producers like Coxsone Dodd, Lee "Scratch" Perry, and King Tubby. But what about the Chinese Jamaicans?

Chinese Jamaicans have been involved in every step of reggae's formation and evolution. As was the case in Asia, Europe, and America, the Chinese who settled in Jamaica were adept at opening businesses. Many became involved in the music industry during its formative stages. It makes sense that profit-minded immigrants drifted toward music; it has been a primary export of the island since its local artists ceased playing calypso for tourists and began infusing its folk music with soul, funk, and rock.

Even before ska emerged as Jamaica's first pop music, Ivan Chin formed a mento combo and recorded its gritty and risqué folk songs in his radio shop in the '40s and '50s. When ska arrived in the early '60s, Justin Yap recorded the up-and-coming Skatalites, and the business-minded bandleader Byron Lee introduced the joys of skanking to the world in 1962's *Dr. No* and the 1964 World's Fair in New York. The tracks that super-producer Leslie Kong record-ed of Jimmy Cliff for *The Harder They Come* soundtrack helped transform the rude boy icon into a worldwide star. (In turn, Kong was mentored by Charlie Moo, whose ice cream parlor became the influential Beverley's record shop and recording studio.)

Twenty issues ago, we featured Chinese Jamaican bassist Phil Chen and head Dragonaire Byron Lee. Now we spotlight four more producers of Chinese descent whose recordings have shaped reggae: **Clive Chin**, **Herman Chin Loy**, **Leonard Chin**, and **Jo Jo Hoo Kim**.

RANDY's ALL STAR

words | Martin Wong
pictures | Clive Chin, Randy's Archive, Pressure Sounds, Soul Jazz, Motion Records

Starting out by working for a jukebox company, Vincent Chin went on to open Randy's record store and the Studio 17 recording studio with his wife Patricia. The arc of the Chins' businesses both mirrored and pushed the evolution of Jamaican music. Selling blues, soul, and mento 45s in the '50s, then moving on to record some of the earliest ska songs, rocksteady tunes, and roots reggae and dub cuts in the '60s and '70s, Randy's was there. In the mid-'70s, the Chin family moved to New York and formed VP Records (named after Vincent and Patricia), which has become one of the biggest labels and distributors of modern reggae.

Vincent passed away in 2003, but his son Clive remains a force in the reggae scene. He took over his father's producing duties at the age of 18, and continues to keep the family tradition alive by recording bands who have been influenced by the Randy's brand of reggae, as well as DJing around the world.

SOUND SYSTEM

Has your family always been into music?
CLIVE CHIN: My father Vincent was instrumental in getting the family involved back in Jamaica. He worked for a jukebox company in the early '50s.

Was he into the music or the business end of it?
He was into the music. It started at a very tender age—probably his early teens. He loved going to dances, and he had a lot of friends who were musicians. He used to love listening to jazz and blues. This radio station was broadcast on shortwave from Nashville, Tennessee, and a record store named Randy's used to sponsor it. **That's where we got the name for our business, selling the old records that he used to collect from jukeboxes.**

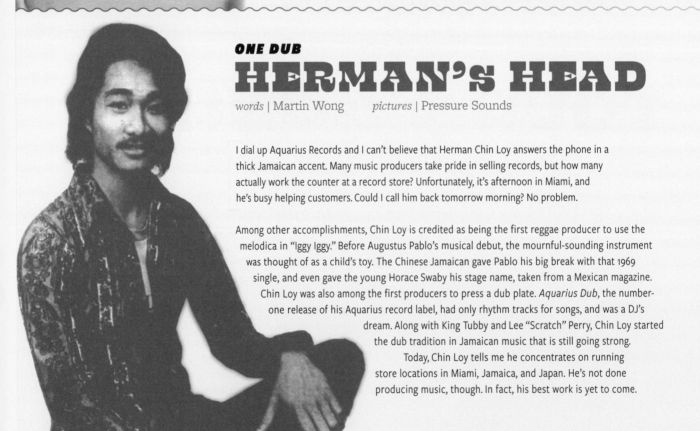

HERMAN's HEAD

words | Martin Wong pictures | Pressure Sounds

I dial up Aquarius Records and I can't believe that Herman Chin Loy answers the phone in a thick Jamaican accent. Many music producers take pride in selling records, but how many actually work the counter at a record store? Unfortunately, it's afternoon in Miami, and he's busy helping customers. Could I call him back tomorrow morning? No problem.

Among other accomplishments, Chin Loy is credited as being the first reggae producer to use the melodica in "Iggy Iggy." Before Augustus Pablo's musical debut, the mournful-sounding instrument was thought of as a child's toy. The Chinese Jamaican gave Pablo his big break with that 1969 single, and even gave the young Horace Swaby his stage name, taken from a Mexican magazine. Chin Loy was also among the first producers to press a dub plate. *Aquarius Dub*, the number-one release of his Aquarius record label, had only rhythm tracks for songs, and was a DJ's dream. Along with King Tubby and Lee "Scratch" Perry, Chin Loy started the dub tradition in Jamaican music that is still going strong.

Today, Chin Loy tells me he concentrates on running store locations in Miami, Jamaica, and Japan. He's not done producing music, though. In fact, his best work is yet to come.

What type of music was popular back then?

Jamaicans used to listen to a lot of overseas broadcasting, then they got involved in sound systems like Duke Reid "The Trojan," Tom the Great Sebastian, and Sir Coxsone's Downbeat Sound System. They would come to any area, like a town square, would take out four or five speaker boxes, and set up one turntable because, then, they didn't use two. (Machuki would be the first.) We didn't have no mixing board. Then the sound system guys who played the music decided to make records.

That's when Jamaicans started to make music and not cover American music?

American music and foreign music. They'd play calypso music before that, but mainly for tourists from America and Europe. The sound system was for the Jamaican people—the country people who couldn't afford a radio. When the man passed through, it was giant. Every week, they'd find a different place to play: Port Antonio, Saint Thomas, or Clarendon. They'd move about the place, know what I mean?

THE BIRTH OF RANDY'S

When did your father open Randy's record shop, and when did he start recording music?

In '58, my father decided to open his own shop. It started with the used records. He started recording music in '59—guys like John Holt, Alton Ellis, and Rico Rodriguez. His music spanned all the way from the late '50s right up to the early '70s when I stepped into the music business at the age of 18.

Did recording come easily to you?

Not in the beginning because I was young and didn't have much experience except for watching my father. It came gradually, and it was very exciting and nourishing.

Was there any pressure taking over the duties from your father?

No, I took it one day at a time. I didn't let anything become too strenuous because, at the time, there was a handful of recording studios. Studio One had their artists, Duke Reid had his thing going, and Federal had their own thing. There were five recording studios in the late '60s.

What was the music scene like?
The whole music industry was changing. The acoustics were changing to electronics. We were coming out of Vietnam, and even American music was more revolutionary. You had Bob Dylan and John Lennon. Marvin Gaye and Curtis Mayfield were singing about what was happening in the world. The Jamaican people needed something to listen to, and it was no more ska, calypso, or uptown music. If you listen to early reggae tunes, you can hear protest. Peter would sing "Pound Get a Blow" when the Jamaican currency, the English pound, became the dollar: "The pound get a blow, the dollar on the go." Everything had a message. As simple as the songs were, they all carried the social way of life. "Rude Boy Gone to Jail." Yes.

AQUARIUS RISING

Have you always been into music?
HERMAN CHIN LOY: Yes. Like Bob Marley said, "I started out crying at birth." I was always into the music in terms of being a country boy into radio. I'd be behind the doors dancing.

Can you tell me about your Chinese and Jamaican heritage?
My father is a Chinaman. My mother is half Chinese and half Black. I am really mixed up! My business comes out of one side, and the music comes out of the other. It's fusion.*

How did you wind up starting the Aquarius record store?
I worked in Spanish Town [on the east side of downtown Kingston] with my brother and his friend. They knew that

I loved music and encouraged me to open a store. I visited my cousins who ran Beverley's Records with Leslie Kong and Chris Blackwell. I used to work there during Christmas when I was going to school. Then I visited Randy's Records, which is now VP. We looked at this place on King Street, and Bob Marley was there on the corner. So we opened One Stop Records, where there would be music coming from a jukebox. I had a good hook-up and bought American music from KG's Records. Now I was competing with

Randy's. I was taking all their customers. I loved the music and I was giving the people what they wanted. That's business, you know? Then I closed the store, gave it to [singer] Derrick Harriott, and went uptown to Half Way Tree to work for KG. They had a discotheque in the back, so I could be more involved in playing music. I had a dual role of selling records and playing in the disco in the back. Eventually, I left there and opened my own record store, Aquarius.

SONIC PRODUCER

How did you go from playing and selling music to making music?
While at KG, I started to know guys like Hippy Boys, Family Man Barrett, Glen Adams from The Wailers Band, and Lloyd Charmers. I started to produce "African Zulu," "Shang I," and other songs.

BOB, SCRATCH, AND PABLO

How was Randy's different from Sir Coxsone's Studio One and other recording studios?
We had one of the best technical engineers around set up the studio. After a year of experimenting, we developed what became known as the Randy's Sound, which a lot of producers and artists wanted to have a part of. [Lee] Scratch Perry, for instance, used the studio every single day. I believe he developed and nurtured Bob [Marley]. I don't care what other people say: Scratch was instrumental to Bob's success—not [Chris] Blackwell. After leaving Studio One, Bob needed direction. Scratch Perry was the director.

Was Lee "Scratch" Perry as eccentric back then as he seems now? I saw him in concert a few years ago, and he was an odd guy.
What you saw is a show. Knowing Scratch and working with him is totally different. He may seem eccentric, but he is very innovative and creative. He knows what he wants and gets what he wants. He's really brilliant; there's no other word.

Was it obvious to everyone what Bob Marley would become?
Recording for the first time, there was no way anyone would have thought that he would be the ambassador of reggae. When the Wailers started, it was to get their name on a record. Everyone would line up and sing for free. That guy was singing just to have his name on the record, so he could say, "Me that. I sing that." He would so enjoy knowing that a man punched his name on a jukebox to hear him sing. Singing "Judge Not" and "One Cup of Coffee" for a record label back in '63—you cannot imagine the joy that it brought to him. It was his very first recording. No one—not Perry, Coxsone, Beverley's or anyone—knew that Bob would be at the forefront.

You also recorded Augustus Pablo early on. Weren't you and he classmates before either of you were involved in the music industry?
Horace Swaby and I go way back from before he got the name Augustus Pablo. We weren't really classmates because we were in different classes, but we were both students at Kingston College. I knew he had musical capabilities, but he was not the only musician at the time. There were guys like Tyrone Downie and Harold Butler. Plus, there were musicians before my time, like Jackie Mittoo.

Were you surprised when Pablo made his first appearance, on Herman Chin Loy's Aquarius Dub?
No. I knew he would become a musician one day because we'd cut class to play keyboards.

Was he really picked off the street for that record?
No, man. That is a lot of rubbish. Swaby lived uptown. Taking a bus from downtown, he had to make a connection, and the connection was at Half Way Tree, where Herman used to have Aquarius. He would hang around the record store rather than go straight home. The story goes that he went into Aquarius with a melodica he borrowed from a female student. Herman was known as a guy who was very adventurous. He asked Swaby

What was it like to put together your own studio?
I left the management to my older brother—which was not a good thing, but it was very exciting. I wanted to concentrate on the artistic side because that is what I do best.

Did producing come easily to you?
Naturally. The difference between me and Asian people like Byron Lee is that **they produce other people's songs. I can conjure up a bass line, put in some melodies, and then get an artist and explain it to him.** I can't read music, but I can tell someone to play "toom-toom-toom-toom, toom-toom-toom-toom," and "kuh-kuh kuh-kih, kuh-kuh kuh-kih." You know what I mean? If I say to Ernest Ranglin, "I want you to play deedly-deedly-deedly," he'll play exactly what I want.

Ernest is one of the most professional musicians I've played with. I just tell him one time, and he gets it. Another musician will play, "Badda-badda-dan, dun-dun," and he'll just get stuck. I'll tell the guy, "No, man." I've advised many young producers. And after a while, they get so big and so puffed up that they don't even know me!

You seem to have a knack for picking out young talent, guys like Augustus Pablo.
You might say so, but some of the better talents will never be recorded because they are so difficult. You have commercial artists and then you have the real artists who are not commercial but are into music, like Dizzy Gillespie and Miles Davis. You can't pay those guys to play what you want. They're going to play what they want.

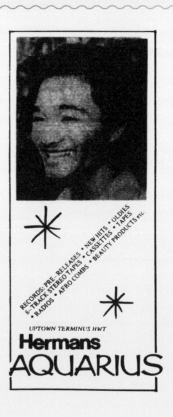

RECORDS: PRE-RELEASES • NEW HITS • OLDIES
8-TRACK STEREO TAPES • CASSETTES • TAPES
• RADIOS • AFRO COMBS • BEAUTY PRODUCTS etc.

UPTOWN TERMINUS HWT

**Hermans
AQUARIUS**

→ JUST'N TIME

Justin "Phillip" Yap ran Top Deck Records and produced many bands during the early years in ska, most notably the Skatalites. He passed away in 1999, but left behind a box set of colored 7″ singles focusing on his work from 1964–1966 and a massive career-encompassing eight-LP/CD retrospective. **Yap's friend and ex-roommate Clive Chin remembers him well.**

Where does Justin fit into the story of Jamaican music?
<u>CLIVE CHIN:</u> Justin came in '63 or '64, a time when I knew what was happening because I was out there with my father. I think his work as a producer is underrated. Justin's contribution was a very small one, but was very much a part of it all. His music will forever live.

What was it about his production that lent itself so well to the Skatalites's instrumentals?
It's hard to explain. When you put your heart and soul into something, it's chemistry—just like cooking. That's pretty much what Justin did in his music. He had a great love for music from the get-go. The musicians he worked with all said that Justin had the best of the Skatalites, including trumpeter Johnny "Dizzy" Moore.

Didn't Yap have a younger brother who played on a song called "Ska Down Jamaican Way" with Ferdie Nelson?
Yeah, man, but it wasn't a big hit like "Confucis," "Street Burial," or "Marcus Junior." Those songs were the killers. Those were the big numbers, the big guns. The Ferdie Nelson song was mediocre. Ivan was up-and-coming and had an interest in the music, but wasn't really a big artist in the '60s.

Do you remember when you first met Justin?
I met him back in '82. We came across each other in a studio in Manhattan called RCA. He was getting back into production by releasing an album called *Scattered Lights* by the Skatalites. <u>We exchanged numbers, he came by my restaurant, and we became friends. He had this label called Top Deck and he knew my parents because he used to carry his records to Randy's to sell before he went to the States in '68. Right after that, he was drafted. He served in Vietnam and spent time in the Mekong Delta.</u> After that, he started a family, had two children, and divorced. I had the opportunity to be a part of his life for over a year because he lived with me back in 1990. He moved back to Jamaica in '94 or '95 to set up a restaurant.

He was a cook?
He was very good with food. I learned a lot about Chinese food from him. Yeah, man. He was really good. I really miss his cooking. We were a team; he would do all the cooking, and I would do all the cleaning up. ♫

Cedric Brooks's **United Africa** *was full of funk and jazz, as well as reggae. Was that a challenge to produce?*
<u>I'm not going to take credit where credit is not due.</u> Most of my productions, I did myself. Then there were some where I commissioned someone to make the record. To be truthful, I was not there to have a hand in it in terms of arrangement.

REAL ART

What are some of the more artistic records you've made?
You've never heard them!

You don't consider your work with Dennis Brown or Augustus Pablo to be artistic?
They were not commercial in the sense that they were something new. I was in an experimental mood.

When you recorded "Iggy Iggy" with 15-year-old Horace Swaby (who you named Augustus Pablo), no one had ever used melodica in a reggae song before. It was also one of the first dub songs.
That was new, and it was exciting because it was the first time. But after you have done it once or twice, it's no more fun. You've conquered the frontier.

How did that innovation come about?
Dub was new for me, but I didn't create it. People kept asking for just the rhythm—the bass and drum from a song. DJs put it on a soft wax, or acetate. What I did was make it available to the common man. I sold it to guys who didn't have money. Being present in the marketplace gave me an edge, but I cannot sell something that I do not believe in.

So you were producing music you believed in, in terms of its art?
Right, and I gave the people what they wanted. There was a commercial angle. Augustus Pablo and some of those songs were really exciting at that moment in time. But in retrospect, in terms of true art, the true me is yet to come. The reality is that I need to make money to look after my family. Later on, when I've made enough, there's an album I've been trying to make with Leonard Gordon. I can't go into a studio and make it in 15 minutes. It takes more than that, know what I mean?

if he could use it. Obviously, since he had the instrument, he could do something with it. So Herman brought him down to Randy's to record a track called "Iggy Iggy": "Great ooga-ooga for my wooga! Bring back jabba senta! Ecla bom-bom, ya peyote! I bring you dis Iggy Iggy!" Herman was a toaster. Let me tell you something: we were experimenting, and it became more commercialized. The more creative you are the more attention you get. People are thirsting for change.

NONSTOP DUB

You made one of the first dub records, right?
The very first dub album that came out of Jamaica. Who do you think produced it? Me. *Java Java Dub. Blackboard Jungle* by Lee Perry or *Aquarius Dub*? The men wrong themselves, man. Errol "ET" Thompson came to work with us in 1970 after being an apprentice at Studio One. Errol and I used to strip the rhythm of the vocals, horns, and keyboards. We'd just make it drum and bass, put a delay on the drums, and tease with the rhythm.

Boop! Boop! The key to the whole thing was that we had a record store downstairs. We'd send a dub on acetate downstairs and test it on the turntable. When the people would go crazy, we'd say, "Yes. This one is done!" We'd go back upstairs and cut it on the flipside of the vocal tune. That's how we started the drum and bass dubwise—not King Tubby or Scratch Perry. Fuck them up themselves. That's not true history. Me and Errol at Randy's started that.

Were the dub records meant for dancing or kicking back, or what?
They were for dancing, for sound systems. We never made it commercial. The very first dub album never had proper label information. It was blank. It was a test, you know?

You must have done a lot of experimenting back then.
We had the capability because we had access to the studio. We never had to watch studio time, and we had the rhythm down. All of the rhythms we used for the first dub projects were already recorded by our artists: Dennis Brown, Lloyd Parks, Max Romeo, and

The Heptones. We'd strip the rhythms down and make them exciting.

The studio operated all the time, every day?
Let me tell you, man. 24/7 is a lot of time. We had to take turns. After making my first successful recording in 1971 with "Java Java," I thought, "I need

I'm totally shocked that Aquarius Dub does not reflect your true artistic vision.
Understand how I feel. At that point, that was the thing. But I did not get the time to really produce. I was in the studio, I was out of the studio, I was in the shop. When Chris Blackwell gave Bob Marley money to make a record, he had all the time to concentrate on his artistry. He could forget about all the other stuff because it had been taken care of. If I were afforded the money, I would not try to be commercial. I would have jazz overtones.

Like improvisation and minor harmonies?
More towards the direction of Cedric Brooks's *Third World* album or Bob Marley. That would be my direction in terms of reggae music—not what you're hearing right now.

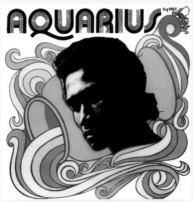

Herman Chin Loy released one of the first-ever dub albums in 1973.

Not soca or dancehall?
I would do that, too—for the money. I have six children; they have to have a place to live and they go to school. After I bring them into the world, I have to look after them. But this album I'm working on, it's like George Benson, Eric Gill, and Ernest Ranglin in one.

Where are you going to find guys that can pull that off?
It's Leonard Gordon. I have the album already made! I'm not sure about the quality after years of heat and all that, so I have to go back to the studio and recapture it.

Are you comfortable using Pro Tools and all that?
Yeah, man. No problems. You have to move on and use developments in science. I don't get caught back in the 16th century, although I know there are people who love that sort of thing.

Were you ever interested in performing in concert?
I wanted to do everything. The reason I didn't get into the concert business is the attitudes, moods, and dudes. I have to be a grown man. I have a family.

to go to school to do what?" I was doing what I loved, which is music. Errol would do the daytime sessions, I would do the nighttime sessions, and my father used to come in and do his own thing from the early '70s up until about '73 or '74 when another guy came on board. Dennis [Alcapone] went on to stage shows with Bob Marley, Steel Pulse, and other bands. Nice guy!

Those must have been really creative times.
We used to rent the studio, too. After Scratch left and opened the Ark, we had Bunny Lee, Winston "Niney" Holness, Rupie Edwards, Phil Pratt of the Sunshot label, Sonia Pottinger, Herman Chin Loy of Aquarius before he opened a studio, and Derrick Howard. Everyone used to use our studio, man. Even Joe Gibbs!

Did the studio get pretty messy since it was used all the time?
We used to eat and drink, and I won't even talk about smoking. You would not have to smoke to get high. You'd get high just inhaling when the Wailers or [Burning] Spear were using the studio. Errol used to say, "Me girlfriend tell me I smell because I smoke too much ganja." It would be in his hair; he had an afro at the time. It would be in your clothes and all over you. The whole *Marcus Garvey* album was recorded there. *Man in the Hills. Catch a Fire. Burnin'.* The Peter Tosh albums *Legalize It* and *Equal Rights.* All of them were recorded upstairs. This was every day of my life growing up as a young man. I lived the recording end of it for 20 years, and before that, I used to go to the studio with my father to record The Skatalites, The Maytals, and Lord Creator. I left Jamaica in '79.

COMING TO AMERICA

It must have been tough for your family to move to New York.
It was a rough time—not for the family, but for me. I was on the pinnacle of production. This was the time when everything was happening in Jamaica.

But you stayed with your family.
Honestly, if I had stayed, where would I be today? I'd probably be dead. It was a rough time. People, especially businesspeople, were leaving the island like crazy. The Michael Manley regime said that business owners didn't own their businesses. It was the workers. He embedded that in the minds of the poor class people. They looked at the businesspeople and said, "You don't own it anymore. We own it." If you weren't aggressive enough to fight back, you had to leave.

Randy's became VP Records, which is a huge distributor.
Well, we came with an aim and an ambition to make it that way. One thing I can tell you, the Chinese are very aggressive people. We know how to work and move forward. Byron Lee knows how to hold onto success because his family taught him. We Chinese had the advantage. A lot of our fathers owned restaurants and shops that sold everything from a pound of sugar to a pound of flour. We sold things to accommodate the poorer class of people. My grandfather had a shop like that back in the '60s.

Was your family traditional when it came to respecting elders, valuing education, and all that Chinese stuff?
Oh, yes. My grandfather, a carpenter, was from Shanghai.

THE NEXT GENERATION

How did you end up in Miami?
I didn't see Parliament addressing the problems of Jamaica. I heard all this great talk about independence and was looking forward to all these things they were promising us. Then when I reached a certain age, I thought, "This is damn foolishness." The promises are full of rhetoric. There was no truth there, and where there is no truth, there is no equity. It's all a farce.

It seems like a lot of Jamaican music from the '60s and '70s has themes of protest.
Yeah, man. The people are crying. There are a lot of spiritual overtones if you listen to songs like "Holy Mount Zion" and "Stepping Out of Babylon."

Yet modern reggae and dancehall artists don't seem as topical.
It started off more spiritual. Now you hear them talking about righteousness one minute and the next minute it's "Kiss my mum-mum." It's a paradox. That is what is going on in terms of the music being spiritual and political. It's political, meaning everybody is acting like when the Messiah was here. The

→ MENTOR

Before reggae, there was ska. Before ska, there was mento. Like the down-home version of calypso, it featured banjos, sticks, gourds, bamboo flutes, and other instruments with lyrics covering everything from social commentary to bawdy stories. In the '50s, radio repair shop owner **Ivan Chin** owned one of the most prolific mento labels and recorded one of its best known combos, both of which were named after himself.

How did you get into the radio and record businesses?
IVAN CHIN: I started selling radios about two years after I started my radio repair business. After I started selling records, I got the idea that I could start recording my own with my own label.

Can you describe the sound of Chin's Calypso Sextet?
Chin's Calypso Sextet sounded like other calypso bands of that period, using instruments that were made in Jamaica with local materials. My contribution was the quality of the sound recorded.

He came to the Caribbean with his brother, and the first port of landing was Havana, Cuba, so he spoke Spanish. The story goes that his brother was a heavy gambler, and my grandfather didn't approve, so he sent him back.

Do you ever go back to visit Jamaica?
I try to go back at least once a year. You have to try to keep some kind of ties, but Jamaica's changed so much in the past 27 years. I was there last year for Errol's funeral.

Have you gone back to the Randy's studio?
The studio's been locked down for years, but it's still there.

Do you still produce?
There was an absence. During the '80s, my ex-wife opened a restaurant. It was successful because there was a need for a Carribean restaurant in Queens at the time. I stayed in that business for about seven years. During that time I didn't do any recording. But in the '90s, I decided to head back into the studio and did some engineering and post-production with a group called the Slackers.

You're aware of all the young ska-influenced bands that came up in England and America?
Oh yeah. I kept an eye on what was happening. I would see groups back in the late '70s and early '80s like the Selecter, the Toasters, and all that early punk rock. I wasn't totally involved with them, but Rico, a friend of my father's, used to tour with The Clash.

What do the newer versions of ska, rocksteady, and reggae sound like to you?
It sounds cool. I'm happy that they find some sort of warmth in ska and rocksteady, you know? It's really the early stages of reggae. Well, you really don't call it "reggae" now because everything is dancehall. Beenie Man identifies himself as a dancehall artist, not a reggae artist. 'Nuff respect to that, but at least there are fine groups out there that respect the reggae end of it. Jeremy, who used to be in the Slackers, called me up the other day and asked me, "Come and help us out with certain things." They all know that I have it, and it really makes me feel good because they look up to me as a legendary person who can help them.

How did mento differ from the calypso that tourists would listen to? Is mento really Jamaican "country music"?
Mento is different from calypso because the melody and beat are more natural and easier to understand and dance to. Yes, it could be looked at as Jamaican country music.

What sort of steps did you take when recording directly onto wax?
Recording directly to wax was very difficult because I could not afford to make many mistakes. That would have been too costly. The result was that we had to rehearse a lot more to make sure we had it right before cutting.

What was the scene like? Did you play a lot of concerts?
I did not arrange to play at concerts.

What I had was a sound system for hire to play private parties, other functions, and stage shows at the Ward Theatre.

How did the introduction of R&B affect mento in the '50s?
It had no effect on our records. Our records were always popular at parties and functions everywhere during that period, and also at most hotels in Jamaica.

When ska and reggae artists cover your songs, do they ask for permission?
No, they do not.

When did you start burning your mento tracks onto CD? Have any of the Sextet had a chance to hear them in the new format?
I started burning CDs in 2004. Until

recently, no member of the band was discovered alive. However, I have very recently discovered that Alerth Bedasse is alive and very well. I sent four Chin's CDs to him. He had none of the records in his possession, and was looking forward to receiving them.

Now that you live in Toronto, what do you miss most about Jamaica?
I miss Jamaica for many reasons: the climate; the green mountains; the blue sea; the white beaches; the many streams and rivers; the very friendly, happy, and helpful people of Jamaica; and all the nice fruits. ♫

Do you enjoy working with modern production technology?

Oh yes. You don't walk into studio with them big reels of tapes anymore. Pro Tools and everything is computerized. The sound that you get—oh gosh, you don't hear no hissing. But **I still love my old hisses and sounds. They all spice the music.**

Some of your songs from the '70s are pretty sophisticated, and go way beyond reggae.

A lot of foreigners look at Jamaica as only reggae and calypso, but if you listen to "Stepping Up," you will come up to me and say, "Clive, damn! What was in your mind when you did that record?" You can't even figure out where our minds were when we came up with it.

Do you remember where your mind was?

No. I was too young, but we were very aggressive. We wanted to expand. 🐱

politicians were trying to crucify him because they wanted his position. It's the same way out here now: Everybody wants to get to the top. The music depicts the day-to-day and political life of our people. So in "Me no like/Them kind of Babylon," Babylon is the policeman or the status quo. And "Johnny you're too bad/Walking down the road" gives you the signs of the times.

Reggae seems to be popular with oppressed people everywhere.

Reggae music, like any other music, is emotional and spontaneous. We're very expressive people with wild imaginations. The way we walk, the way we talk—you hear it in the music. We don't mince no words. We tell you exactly what we mean and then don't feel sorry about what we tell you. The music is genuine in that respect, and it's not always good. It's not always prudent to tell the truth. We are that type of people. 🐱

ROCKER'S DELIGHT

BYRON LEE AND THE DRAGONAIRES ♫ ROCK-STEADY EXPLOSION:

Before Byron Lee turned to soca-fied party music, he served as the world's ambassador of ska and rocksteady, and helped coin the word "reggay" (which thankfully gave way to the modern spelling). Although Lee is often accused of being the slick alternative to the Trenchtown junkies who were the true originators, he did record several worthwhile albums, such as *Reggay Splash Down!* and *Reggay Fever* with funky keyboards that Money Mark would dig. My favorite record is *Rock-Steady Explosion*, with its polished treatments of Johnny Nash's "Hold Me Tight" and Desmond Dekker's "Music Like Dirt" as well as a chart that tells you "how to dance the rocksteady." [Dynamic]

AUGUSTUS PABLO ♫ THIS IS AUGUSTUS PABLO:

This 1973 debut is a bittersweet, beautiful, and mellow masterpiece. Produced by Clive Chin with his mother Pat, the all-instrumental LP starts off with an upbeat, keyboard-driven tone before cooling down into hypnotic proto-dub. At the time, Pablo's melodica playing was described as the "Far East sound," which I interpret as being far out and reminiscent of music from the Middle East. Cuts such as "Pablo In Dub" and "Lovers Mood" (Santic's versions of Horace Andy's "Children of Israel" and "Problems") are as relaxed as can be, and foreshadow Pablo's work on monumental albums like *East of the River Nile*. This re-release appears low budget, but is excellent all the way. [Heartbeat]

SANTIC + FRIENDS ♪ AN EVEN HARDER SHADE OF BLACK:

For its inaugural release, the British roots label Pressure Sounds unearthed Leonard Chin's impossible-to-find singles collection, *Harder Shade of Black*, and tacked on extra cuts from the same era of 1973–1975—perhaps the Santic label's peak in the roots era. With a stellar lineup including Family Man, Tin Leg, and Augustus Pablo, the sound is straight and deep like the Grand Canyon. Chin's production and arrangement are mind-blowing on dubs like "One Thousand Swords" (a version of Gregory Isaacs's "I'll Be Around") and "Jah Guide" (another take on Horace Andy's "Problems"), which are powered by ace engineer Errol "ET" Thompson and performances by the likes of King Tubby and Jah Woosh. [Pressure Sounds]

THE SKATALITES 🎼 SKA BOO-DA-BA: TOP SOUNDS FROM TOP DECK, VOL. 3:

The Skatalites have had more players and hits than the Yankees and Dodgers combined, and their lineup and instrumentals recorded by Justin Yap at Coxsone Dodd's Studio One are generally acknowledged to be their best. One legendary jam session lasted 18 hours! The entire *Top Sounds from Top Deck* series of Yap reissues is worth owning, but this is the best. Presenting an entire album of ace instrumentals written or co-written by Yap, and played by the original band circa 1966, it includes previously unreleased alternate takes. Don Drummond's trombone on "Confucius" is epic, and so is the rendition of "Caravan," which has been appropriately renamed "Skaravan." [Top Deck/BMG]

VARIOUS ARTISTS ♫ AQUARIUS ROCK: THE HIP REGGAE WORLD OF HERMAN CHIN LOY:

This is an amazing time capsule of the period between the nicely pressed suits of rocksteady and the Rasta dreads of dub. Recorded at Randy's, Harry J, and Dynamic Sounds, these sounds reflect Chin Loy's funky experimentation with the young reggae genre. Breakthroughs include Augustus Pablo's melodica debut and Chin Loy's crazy scat introduction on "Iggy Iggy" and the stylistic breakthrough "Aquarius Dub," as well as a killer version of The Heptones's "Why Did You Leave?" The hip, soulful, and crucial selections include many prime examples of the Far East sound, including "Middle East Skank," "East of The River Nile," and "River Nile Version." [Pressure Sounds]

VARIOUS ARTISTS ♫ DOWN SANTIC WAY: SANTIC JAMAICAN PRODUCTIONS:

Depending on who you ask, the "San-" part of Leonard Chin's record label pseudonym came from his girlfriend Sandra or his drummer Carlton "Santa" Davis. The "-tic" is from Atlantic Records. Now you know. This collection of cuts from the mid-'70s is not only a showcase for Chin's rebel-rock sound but also for Augustus Pablo, who plays melodica, organ, and clavinet on tracks like "Peace And Love Dub" (a hard version of Horace Andy's "Problems"). Those new to the concept of dub are in for a musical education when they hear Freddie McKay's righteous "I'm A Free Man" and the reworked version named after the Angela Mao martial-arts flick, "Hap Ki Do." It's so heavy, great, and still ahead of its time. [Pressure Sounds]

VARIOUS ARTISTS ♪ CHANNEL ONE: MAXFIELD AVENUE BREAKDOWN:

This collection of versions recorded by the Hoo Kim family at Channel One from 1974–1979 boasts the then up-and-coming Lowell "Sly" Dunbar holding down the rock-bottom rhythm on drums, killer keyboards by Ossie Hibbert of The Revolutionaries, and a wicked tenor sax by founding Skatalite Tommy McCook. The 7" selections on this amazing compilation, produced by Jo Jo Hoo Kim and engineered by his brother Ernest with the enigmatic Barnabas, are from a completely different dimension than the source songs. The rhythm is there, but everything else is new. Strictly intended for sound systems, these cuts redefined the art of production in Jamaica. [Pressure Sounds]

VARIOUS ARTISTS ♪ IMPACT!:

The Chin family cranked out up to 12 songs every week on the Impact! label, and it's tough to believe these monumental songs were out of circulation for so long. This collection compiles rare and unreleased cuts recorded by the father-and-son production duo of Vincent and Clive at the Randy's Recording Studio 17 from 1969–1975. It's interesting to hear the Chins combine their rocksteady foundation with the Black pride of American funk on Hortense Ellis's "Woman Of The Ghetto" and Winston "King" Cole's take on "Black Magic Woman." Tommy McCook, Jackie Mittoo, Lloyd Parks, and Augustus Pablo are only a few of the legendary performers on this CD. [Universal Sounds/Soul Jazz]

VARIOUS ARTISTS ♫ LESLIE KONG'S CONNECTION, VOL. 1:

Legend states that Kong died of a heart attack at the age of 38 after he was cursed by Bunny Wailer for pressing an unauthorized "best-of" Wailers LP. This French import focuses on songs recorded at Byron Lee's excellent Dynamic Sounds studio for his Beverley's record label during the post-rocksteady era of 1969–1971. The mood is smooth and funky, and the tracks include some of the sweetest songs by the biggest names in Jamaican music: Ken Boothe, The Melodians, The Maytals, and Bob Marley and the Wailers. What about Kong's work with Jimmy Cliff, Desmond Dekker, and Toots and the Maytals? You shouldn't need a compilation to hear them. [Jet Set]

VARIOUS ARTISTS ♫ OUT ON A FUNKY TRIP: FUNK, ROCK, & REGGAE FROM RANDY'S 1970–75:

Unlike most compilations, which feature reggae takes on American songs, this collection concentrates on straightforward funk and soul from Jamaica, which was recorded by Clive Chin at Randy's. Artists like Lyn Taitt, Tommy McCook, The Maytals, and Skin, Flesh & Bones (who were named in tribute to Earth, Wind & Fire) prove to be more than capable at non-reggae songs, and hold down the groove with vibrant horns and thumping beats. There's real heat in the crazy wah-wah pedals of Barry Waite's "Funky Sting" parts 1 and 2 and intense Afro-beat in Jablonski's "Soul Makossa." These songs represent Clive's proudest work. [Motion]

SANTIC PLANET
LOVE ROCK

words | Martin Wong
pictures | Leonard Chin, Eva Hayes Chin, Pressure Sounds

In the early '70s, Leonard "Santic" Chin produced some of the heaviest roots reggae tracks around. Records on his Santic label featured the likes of Jah Woosh, Augustus Pablo, and King Tubby on hard and proud songs like "Free Jah Jah Children," "Harder Shade of Black," and "One Heavy Duba." He left Jamaica amidst political turmoil, settled in England, and found a happier place as well as a new sound—the moody makeout music called "lovers rock." Santic helped grow that reggae offshoot before his label went under in 1983, but now he's back with a new album in the works and a renewed energy toward music.

ROOTS REGGAE

You started singing but wound up producing.
SANTIC: My first tune was "I Am Lonely." My second single, I pressed 500; I wouldn't say I sold 500. I actually felt stupid, and decided I didn't really like hearing myself. So I did a DJ version of the second one for a guy named Mojo and put out Bongo Herman on the B-side. That's how I started producing other people. It was something I wanted to do, and it felt right at the time.

HITBOUND
HOO KIM HIGH

words | Martin Wong *pictures* | I & I Sound System + Pressure Sounds

With his brothers Ernest, Kenneth, and Paulie, Jo Jo Hoo Kim invigorated the reggae scene with the unheard-of recording quality of their Channel One studio and militant double-drumming of house musician Sly Dunbar. The "Rockers" sound deepened the then-soft sound of reggae, and the state-of-the-art 16-track studio provided the audio depth required for the dub explorations of King Tubby and Scientist. The extensive and innovative production work at Channel One would culminate in the effects-heavy dancehall sound that claimed reggae in the early '80s. Following the death of Paulie in 1977, Jo Jo moved to the United States. He operates a New York branch of his Hitbound record pressing company to this day.

OPENING CHANNEL ONE

Your family started out by maintaining slot machines. How did you get into music?
JO JO HOO KIM: I operated jukeboxes. I would buy records.

When did you decide to work in music full time?
I never really decided to stop. I just gave it up. I loved music more—not really records, but sound. I liked to play something that sounded good. I used to compare my home set with other friends' sets to see which one sounded better.

This paved the way for opening the Channel One studio?
Well, I had never been into a studio. [Singer] John Holt took me into a studio control room and I thought, "This is want I want." The dream started there.

How did you pursue that dream?
I knew nothing about equipment. It wasn't like now, where you can go to an ordinary music store and buy a console. In my time, you had to order a console from somebody who built it. I didn't know which one was good or which one was bad. But we got

The labels on your Santic 7″s are cool. Did you draw the one who looks like a monster?
Yes, it was an ape. The very first ones, I drew myself. It wasn't proper art; I used a marking pen.

You recorded at many different studios. Was there a big difference between their sounds?
The studios people used at the time were Randy's, Channel One, Joe Gibbs, and Harry J. A lot of us were getting a similar sound, anyway, since we used a lot of the same people. But I was learning. When I did that first single, I think it was $20 an hour.

Was the record business booming at the time?
There were a lot of strugglers, but if it's something that your heart and soul are into, you're going to love the experience.

It seems like there were a lot of legendary producer and engineer teams back then. What exactly was the relationship between the two?
I know the song that I want and the engineer knows the board. I don't know if other producers work like this, but I write the song, do the arrangement, sit down at the studio with the engineer, and have him put it together.

SANTIC

What was it like working with producers like Errol Thompson and King Tubby?
At the time, I didn't really think nothing of it. I just go around to Tubby's to mix some tracks, you know? A lot of people ask, "Do you know Tubby?" But to me at the time, it was just Tubby. People ask, "Did you know Dennis Brown?" I say, "Yeah, I knew Dennis from when he was 14." It's amazing for certain people that I knew Tubby, Dennis, or Bob Marley before he wore dreadlocks. But it's nothing. You just know them, you know? We were all downtown at Randy's.

There must have been a lot of action then.
Oh yeah, but those days are long gone. There isn't really any creating going on any more.

You're not into dancehall or newer forms of reggae?
I was never a dancehaller. Really and truly, I'm a soulful person.

There was a lot of soul influence in rocksteady.
That's right, and people used to create. Bob Andy and all those people used to write songs and sing songs. It wasn't

this engineer from Canada who came down to Jamaica. I asked him, "What is the best one to buy?" He went around to studios in Jamaica, and said that what they had was crap. Half of the things that they had you didn't need. He suggested that I buy an API console. It was probably about four times the price of a regular console. For instance, an MCI console which was about $13,000 new. I think the API cost $38,000.

How did you choose the location?
We had other businesses there. We had an ice cream parlor and also a liquor store. We tried to do every little thing to make some money. I had an older brother who had a sound system and a motorcycle shop, which was on the same premises, too. The studio was around the back. Now I'm sorry I did it. We should have picked a different location. At the time, it wasn't scary. And then in 1974 or 1975 it got bad.

ROCKERS

Can you describe the "Rockers" sound that you developed at Channel One?
I didn't have any idea about recording before we bought the studio and the

equipment. I didn't go to a session to see how things ran since we didn't have any intention to go inside the studio. We wanted to employ people because we didn't have the time. I engineered and hired a producer. The first session we had didn't work out. It didn't sound the way I wanted it to. I came back and told the producer, "Make the studio sound tough. Make the bass sound tough."

Reggae's got to sound tough.
No, not tough. At the time, our EQ went to 60 cycles. It was more like a funk bass. So we set it down to 40 cycles, but the engineer wasn't pushing the right buttons. That was why the EQ never sounded the way it was supposed to! Me and my brother Ernest fooled around with it and came up with a fantastic sound.

So your drums had a heavier sound?
On the records that were made in Jamaica, there were no drums. There was no drummer! You didn't hear the snare and you didn't hear the high hat. We decided, "Let us hear the drum, the high hat, and the whole spectrum." We usually listened to funk, which was more bass and drum. We added more drum to reggae and everybody liked what we did.

How did you get your studio band together?
To be honest, there are some people you just cannot work with. You can't say, "Play it over, we don't like it." We were new to it, and the professional musicians wouldn't listen to us. They would leave the session.

Were they lazy or prima donnas or what?
They weren't that good. I didn't know that reggae was a trade where a man comes to play guitar and just goes "ching-ching-ching" and the piano man just goes "bam-bam." That's all they played.

So you found better musicians?
No, we didn't get better musicians. We got musicians who were willing to work. We'd say, "We don't like this one. We don't like this one. We don't like this one." We would work with musicians like Sly [Dunbar] for hours, but a more professional studio musician would play two cuts of a song and that would be it.

Was Sly really great from the beginning?
Sly didn't know what to play. If you

just banging up something. People were showing they could do it just as good as the originals. Nowadays, I don't know.

Some of your songs back then, like "Lover's Mood" and "Chalice Blaze," took one rhythm but really changed it around.
Those were hard rhythms for the time. For me, they are a bit mild.

A lot of songs are named after kung-fu movies.
Quite a few of them, like "Hap Ki Do" and "One Thousand Swords." It was a thing to do, especially for instrumentals.

Were those movies pretty big in Jamaica?
Oh yeah. In the early to mid-'70s, there was a frenzy. It was new and exciting and there was a certain energy. Just like westerns.

LOVER'S ROCK

When did you move to England?
I visited here in 1974, and stayed for three months. It was nice. Back home there were guns and I was never that kind of person. You could easily drift if you were around the wrong people.

After moving to England for good in 1975, you started producing lovers rock. What prompted that change in style?
To be honest, I used to think, "This is soft." I was working in a record shop. I knew it was reggae, but the music was moodier than back-home reggae. It was an okay sound, but I didn't really take it in because I wasn't into that vibe. Then I started listening to the lovers rock that was selling. One song was called "It's Over." I thought, "There ain't nothing to this. I could do this and make it sound better." I crossed over just like that.

What were you able to add to the genre?
I think I put more guts in it: hard licks and stuff. Carroll Thompson used something I came up with, and two days later I recorded it on an 8-track. I remember pressing 500. I came back to the record shop, and everybody put their hands up. It was a big success. After that, I went into strings. I always wanted to do strings. The second record I did was the one that really took off. It was a do-over of a Minnie Riperton song.

compare a rock drummer and a reggae drummer, the reggae drummer doesn't play at all. He doesn't move around. He uses one hand and a foot. It's too relaxing. A rock drummer makes you feel like he's playing because he moves around.

FIRSTS

Didn't you put out the first 12″ single in Jamaica?
It developed financially. When I entered the business, I made 55,000 copies for Jamaica. Every year, record sales went down to 25,000, then 15,000, then 12,000. You can't make any money. So I thought, "If I sell 3,000 or 4,000 of a disco, it makes 12,000, 15,000, or 16,000." Especially with foreign exchange. Everyone started making them after us.

Wasn't the sound better, too?
Yes, you could get a heavier sound because it spins more. You get a lot more bass.

How did the "clash" series come out? The records with different bands on each side?
What I did was put an older artist with a newer artist. I was bringing out Frankie Paul, but nobody would buy 12 tracks. So I put him with Sugar Minott: one known and one unknown.

Do you think coming from a non-musical background helped you come up with these fresh ideas?
I tell you, when we were in the studio, we didn't take any advice from the musicians. We would call someone who was not involved with music, and ask, "How does this sound?" Anyone involved in music is unacceptable.

Why?
You'd lay down a track, and they'd start dancing. We'd rather put children in the studio—maybe age 10. They'd give their honest opinion. If they ran for the door, we'd know not to take the track because it didn't sound good. That's the way we would do it.

What about your dub versions?
Before we'd put out a record, we'd play the dub first. I'd go to a record store on a Friday or a Saturday when it was busy, go to the counter, which would be full of buyers, and put on my dub plate. I wouldn't play it for more than 15 seconds. Maybe 10 seconds. If someone didn't say, "I like that one" or "Give me that one," I knew something was wrong. You know, I don't take one record home. I never have time to play records. When I'm in the studio, it takes one week. Period. And when it's released, that's the end of it. It's gone. I don't play it again.

What did you think of the dub tracks recorded by King Tubby and Scientist at Channel One? Was it really different and new?
Any engineer on my multitrack tape—I'll come back and say, "Let me hear what you did." If I didn't hear anything different on my multitrack, I'd say, "You're not working." I wanted to create something. I remember hearing the record and thinking, "You've changed up the sound, the medium." Have you ever listened to a dancehall LP?

Just a little bit.
We turned up the music with the guitar and the piano.

Did you like that style when you first started making it?
Like dub, it was the modern record. It was real unique. Let me tell you how different our studio was. You know Sting? I had a studio ready, and he came to see how it worked. He was not recording or anything like that, he just wanted to see how we were getting something so different.

No kidding.
I'm not kidding; I'm telling you. When my dad started all this, there were no delay processors on the market. When delay came on a record, we'd use four tape machines. I remember we were mixing down a song and had four tape machines going. Two were for delay, probably three.

Were there more resources for strings and stuff like that in England than Jamaica?
Yes, and I could find people who understood what I was saying. All my good keyboardists and string players were these white guys.

What did you think when punkers picked up on reggae?
The '70s were cool. There was a lot of experimenting going on. But reggae started going down when Bob died in the mid- to late '80s. Lovers rock faded, and even now there ain't no new lovers rock people doing anything.

Are you working on anything now?
My label actually went bankrupt in 1983, and I've been trying to get back. Last year, I told a few guys in record shops, "I'm going to do an album. What is it like out there?" They said, "Boy, I wouldn't advise you to spend money to do an album. Nothing's selling, you know?" I said, "I'm going to do this album. I've never done an album with an artist from beginning to end." My album was just mixed yesterday. It's called *Santic in Session*.

Was it hard to come back from such a long break?
It was '94 or '95 when I last went into a studio. There was nothing planned. I was just listening to jazz on the radio and thought, "I got tunes nicer than some of these tunes. What am I doing here decorating people's houses and so forth?" I looked in the newspaper, saw an ad for this girl who said she was a jazz singer, and went back in the studio. You know, I started this journey when I was a teenager. I've had many stops along the way. Now I've made an album that I would put in my stereo, listen from track 1 to track 10 without skipping a song, and say, "Yes, this album is mine."

What about your other records?
I feel good about them because they are my beginnings and part of my journey. If people hear my new songs and old songs, they can hear the progress. You never get to the end because you're always learning, but I'm on the road to where I want to be. I think the sound is fresh. Reggae wasn't my number-one music. I'm coming from ska and rocksteady. I've always been a lover of soul, strings, and nice guitars. I suppose this new album tells a lot about that. Like Mad Professor said to me the other day, "We all got something, and what you got is the strings and melody." 🐱

BACK TO BUSINESS

There are so many Channel One compilations and re-releases out now. Does everyone contact you and let you listen to them, or do they just get tapes and release them on their own?
I don't know! I want to talk to Pete [Holdsworth, of Pressure Sounds records]. I got two records from him that I can't recall recording! But I just realized now what happens. We have a lot of songs that weren't released. A lot of them are alternates. People have them and we don't know about it. I was talking to somebody in Miami, and he said, "You remember this song?" I said, "I know the song, but I didn't release it." I learned that you can't trust an engineer with a tape. They are all over the place, and I don't know about them!

But people want to hear them.
You know the Mighty Diamonds LP? It has been pirated so many times. What I say to comfort myself is that if it weren't good, they wouldn't pirate it. It's so good, they pirate it. It's a little comfort if you forget the money part.

You run Hitbound Records in New York now. Do you still produce records?
We are a record plant. We pressed records in Jamaica, too. When I started making records, I couldn't afford to put out six records. It would be too expensive, so we bought a factory. There was this man downtown who had a factory. I said, "Man, are you selling?" and the price was nice. But I'm thinking about starting a studio.

Would you produce new stuff like dancehall?
To me, the new stuff sounds like shit. There's nothing at all in the songs. There's no melody. It's just "boom-boom-boom," but people really like it.

Dancehall gives me a headache.
Dancehall is out of key and lacks good singers like John Holt, Barry Brown, or Don Carlos.

Do you think old technology sounds better than new technology?
No. It has to be digital. The musicians say analog sounds better, but they never worked with the system. They just don't know. When I start a new studio, everything will be digital. There won't even be one tape machine in the console.

When did you move to New York?
In 1977 when my older brother Paulie got killed, I decided to move. When he got shot, I thought, "Man, I could get knocked off, too." Let's face it, Chinese people are preyed on to this day.

Hoo Kim is a Chinese name?
My father was Chinese. [He] made up that name. His name was Hoo and he put on a "kim." To this day, there's only one Hoo Kim. There's no other Hoo Kims in the world.

Do you ever sit back and think about all the ways you changed reggae? You've got to be pretty proud of all that.
No! I tell you something. I believe in the Creator, but I don't believe He made reggae music. I don't think He wants it. He must have moved on to greater things and be concentrating on something else. 🐱

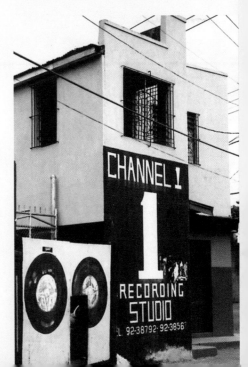

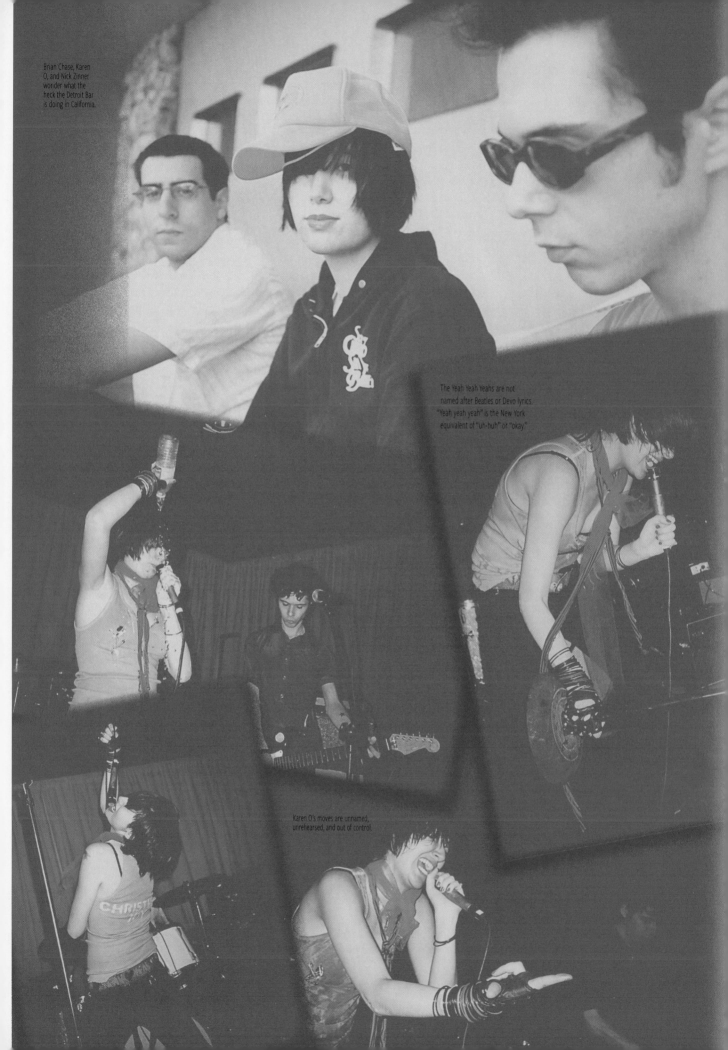

Brian Chase, Karen O, and Nick Zinner wonder what the heck the Detroit Bar is doing in California.

The Yeah Yeah Yeahs are not named after Beatles or Devo lyrics. "Yeah yeah yeah" is the New York equivalent of "uh-huh" or "okay."

Karen O's moves are unnamed, unrehearsed, and out of control.

words + pictures |
Martin Wong

The Yeah Yeah Yeahs prove that you don't need a bass guitar to make foxy music. With Karen O's saucy vocals, Nick Zinner's masterful riffs, and Brian Chase's powerful beats providing the missing link between Joan Jett and the New York Dolls, the band is making fans groove in clubs around the world. Sitting on the curb in the shadow of their very first touring bus (shared with fellow support act Liars) on the eve of a massive jaunt with the Jon Spencer Blues Explosion, the trio talked about getting famous, being deconstructed, and fixing their hair.

Some of you have been in other bands. What is it about the Yeah Yeah Yeahs that is so infectious?
NICK ZINNER: It's more for fun, and the ideas arise out of spontaneity. It's less overthought and overwrought.

Does being mentioned in **Rolling Stone** *as "one to watch" take away your band's childhood?*
BRIAN CHASE: It's weird because everyone came to us. It wasn't like a planned attack on our part. It took us by surprise.

Does the attention make it less fun? Do you find that now you have to take things a lot more seriously?
KAREN O: We're pretty good at keeping the rock flowing.
CHASE: Once it stops flowing, we're done.
O: We don't want to put up with all the other shit unless the rock is really flowing.

You mean like melodramatic, **Behind the Music** *stuff? Are you students of* **VH1** *and that show?*
O: Yeah, definitely. We have degrees.

So you have only one EP out and all this press. What's it like having the same five songs picked over to death?
ZINNER: In Germany, they scrutinize the lyrics. We don't really put that much thought into the music, so it's difficult to deal with that.
CHASE: "Our Time" gets read as a 9/11 anthem, like "New York is strong and will survive."
O: Someone from Colorado thought in "Mystery Girl" the barracuda baby was the reverse-phallic, feminist thing. I told him, "No, barracuda just sounds cool."

Do you ever feel like you're expected to be a spokesperson for girls who rock?
O: Well, the girls really understand where I'm coming from. **Guys tend to be like, "You're so masculine onstage," comparing me to other guy rockers. Girls don't do that at all. They're like, "Damn, girl, you rock."** There's all this anticipation, and then once I get onstage, it's like a release.

Karen, are you part-Asian? Is that part of your family okay with your vocation in rock?
O: My mom's Korean and she's really supportive. She's probably cooler than I am. My real problem was getting bad haircuts from people who don't know how to cut Asian hair (see p. 343). Now I'm with Seiji, who works at Enve Salon in Manhattan. I go in with a vague idea of what I want, and when I come out it's like—bam—the most incredible haircut ever and for the next six months my hair grows even more amazing.

Nick, how do you get your hair to look like that? Is that natural or do you put stuff in it?
ZINNER: It's very natural, although I need some because it's lifting.
O: The only thing you're going to find in Nick's hair is dandruff. Lots of dandruff.

What's your next record going to be like?
O: We were little babies with the first EP and now it's like we hit puberty. Things have gotten wittier and our hard songs are much angrier and angstier. And we have love ballads that are hippie and bittersweet. The scope is much larger and the level of production is much better. The songs require that. 🐱

🐱 **MARTIN:** My mind was blown when the Yeah Yeah Yeahs invited my daughter's band to play with them

(side margin text, rotated) And then The Linda Lindas opened for the Yeah Yeah Yeahs two more times in Mexico City in 2023! And then The Linda Lindas in New York in 2022. And then Forest Hills Stadium in New York in 2022. And then Japanese Breakfast at the Hollywood Bowl and then Japanese Breakfast at the Hollywood Bowl

MEET YOKO

words | Hane C. Lee

pictures | Yoko Ono, RYKO Disc + Minoru Niizuma

While your granny is hobbling into the van that takes her to senior day care, 71-year-old Yoko Ono is exhibiting her artwork around the globe, fielding licensing requests for her late husband's songbook, brawling with Paul McCartney, promoting world peace and human rights, and, lately, reinventing herself as a disco diva.

"I start around 7:00 or 8:00 a.m., then I go on until midnight. I usually have a nap in the afternoon right after lunch, maybe an hour," says the septuagenarian who will go down in history as the woman who broke up the Beatles. "Like when you want to go on a trip and you have a suitcase and you have to fill it up and you squeeze a lot of things in, sometimes you can squeeze a lot more than you thought—my day is like that."

Once despised by Beatles fans for marrying John Lennon, blamed for the band's demise, her art and music ridiculed or—worse—ignored, Yoko is now recognized as an artistic and musical pioneer. In fact, years before she became the most infamous Asian American woman in the world, Yoko had already made a name for herself among avant-garde circles as one of the founders of Fluxus, a whimsical but influential art movement that helped put SoHo on the map. The group—whose principals included George Maciunas, composer John Cage, filmmaker and producer Jonas Mekas, and Andy Warhol's Factory fixture (and Beck's grandfather) Al Hansen, among others—rebelled against traditional notions of art by rejecting distinctions between theater, music, sculpture, writing, and so on, and by stressing audience interaction as an integral component. It was at Yoko's 1966 art show at Indica Gallery in London, exhibiting such works as one in which viewers climbed a ladder and peered through a magnifying glass to read the word "yes" written on the ceiling, that she met John Lennon, who had long been an aficionado of avant-garde art.

FEELING THE SPACE

The piece that brought John and Yoko together, *Yes*, inspired the name for a major retrospective spanning Yoko's 40-plus-year art career, Yes Yoko Ono, which has been touring the world since 2000. One memorable work, *The Talking Sculpture*, consists of a telephone on a table that rings at random intervals. The caller is, of course, Yoko, who makes small talk with whoever happens to answer. At the exhibition at the San Francisco Museum of Modern Art in 2002, one visitor took the audience participation concept a bit far: He used

the piece to call his own cell phone, got the number from his caller ID, then dialed the Talking Sculpture himself.

"Well, a lot of things do happen when you put a piece out there," the affable artist says. "It's gambling, hoping it will just go through in a way you want it to go through. The nature of the piece could keep on changing because of the audience. In this particular case, I thought it was unfair not to let people communicate with me directly. That's the fun this particular sculpture provides. But I thought, 'Fine, this means I don't have to talk!'"

STARPEACE

Not only is her art aesthetically innovative, it is socially and politically challenging as well. *Cut Piece*, first performed in Japan in 1964, addresses the outspoken pacifist's stance on violence. Consisting of Yoko sitting onstage while audience members cut pieces of fabric off of her clothes with a pair of scissors, last year Yoko staged a repeat performance in Paris, nearly 40 years after its debut.

"It was very important to make a statement about world peace now," she explains. "People like to see women cut up and, you know, be exposed, physically. I think the message did go through quite well."

Violence against women is especially alarming to her. "One out of four women who go to the emergency ward these days is hurt by domestic violence," she says. "And this is in the US. Can you imagine other women in other countries? Anybody who says, 'Well, we are equal now'—they're talking about privileged women, not about women in general."

Though she herself grew up privileged, Yoko always had an acute awareness of being an outsider. Born into a wealthy banking family in Tokyo in 1933, she spent a disruptive childhood moving back and forth between Japan and the US, where her father often worked.

"I remember before the Second World War, in New York," she recalls. "I'd go to see a movie and the baddie in the film was always Oriental. When the lights went on, I would think, 'Oh dear, will they notice I am one?'"

LEFT: Yoko Ono performs *Cut Piece* (March 21, 1965 at Carnegie Recital Hall, NYC). RIGHT: Ono at four years old, wearing a Medal for Excellence (Tokyo, 1937).

"In my section [where I lived], they knew me so it was all right. But immediately two blocks away, kids would throw stones at you. I went back to Japan, and of course they felt I was a little too Westernized. Then when I was evacuated as a young child to the countryside, the farmers didn't like Tokyo people! They threw stones at me because I was a Tokyo girl."

Her experience growing up in wartime has informed her peace activism ever since. "That was the only reality I knew then. It wasn't like I was going to jump out of my skin. When you're young, you take anything pretty much in stride. But it was pretty hard, pretty frightening. Nobody wants to be maimed or lose one leg or two legs or whatever. Why do we do this?"

FLY

Most recently she's been promoting a couple of new music releases: One is a collection of club remixes of "Hell in Paradise" from her 1985 album *Starpeace*. The other is a revamped version of a song from 1980's John and Yoko's album *Double Fantasy*, rephrased for a new generation as "Every Man Has a Man Who Loves Him," which she recently performed live at a Gay Pride event in New York. (There's also a version called "Every Woman...")

"'Every Man...' is something I really want to make a statement about: Let's be nice to each other. Let's not get upset that someone wants to get married. It's outrageous. It's about human rights. [Gay people] have the right to

marry someone they want. It's to do with promoting love in the world."

Last year, the remixes compilation of her 1980 single "Walking on Thin Ice" (which John and Yoko were mixing the night before he was shot dead by a crazed fan) hit No. 1 on the *Billboard* Club Play charts, and the new releases are poised to follow.

"I really believe in dance; the importance of dance is something John and I discussed," Yoko says, sharing an anecdote about a time when the couple tried to create a new jig. "We rolled around on the floor for a while, but we couldn't find a good dance step. Well, there are a lot of good dance steps, but we couldn't find a unique and original one. We just kind of gave up after five minutes."

LIFE WITH THE LIONS

Despite her newfound popularity with the club set, Yoko's music wasn't always so well received. While she and her Plastic Ono Band (John Lennon, Ringo Starr, and Klaus Voormann) weren't exactly considered "underground" due to their ultravisibility, they were anything but mainstream. Featuring experimental collages of found sound as well as Yoko's trademark cacophonous banshee wails, the first albums she put out were almost universally blasted as unlistenable. Nowadays they are hailed as precursors to art-rock; Yoko's innovation and improvisational instincts blazed the trail for scores of bands such as Sonic Youth, the B-52s, Deerhoof, Melt-Banana, and countless others.

True to Fluxus's philosophy, Yoko's music invited audience collaboration; however, the point was lost on the public.

The first albums she put out were called *Unfinished Music No. 1: Two Virgins* (1968) and *Unfinished Music No. 2: Life with the Lions* (1969). "Of course I was influenced by Schubert's *Unfinished Symphony*," she says. "In this case [unlike Schubert] I was still alive! [Interviewers] would ask, 'Why is it called unfinished music?' They're unfinished until it goes into the minds of the people who listen to the music. **The thing was to ask people to actively participate in the music in the sense of overdubbing or putting their voice over it. This was before karaoke came out, remember. It was a pretty wild idea at the time! But then nobody did anything about it.**"

That is, nobody did quite what she had intended. Instead, a group of Japanese kids sent her a photograph of themselves in front of a garbage can whose contents included one of her albums. **"They wrote, 'Yoko's LP is in the trash can!' John was like, 'Why would they do this?' I was surprised. In my mind I thought that I was making good music."**

APPROXIMATELY INFINITE UNIVERSE

Still, Yoko continued to create sonic works of art that stretched the boundaries of pop music to its furthest limits.

"It just came from my heart and my soul," Yoko says of her inspiration.

"Something like 'Greenfield Morning' (from the 1970 album *Yoko Ono/Plastic Ono Band*)—that was a collage I made meticulously from different bits of outtakes and things like that," she says. The song is one of her best, featuring echoing vocal drone over a hypnotic beat and bass groove, fading out to the sound of birds chirping—something that could have easily fit on a PiL record 10 years later. "All of [the tracks] are doctored by me in terms of the sound and the collage. Also it was engineered in such a way that some of it was slowed down, or double time, that kind of thing. I think of them as electronic collages."

In addition to her own oeuvre of experimental films, such as *No. 4 a.k.a Bottoms* (1966), which depicts close-ups of hundreds of naked ass-cheeks for 80 minutes, Yoko stars in a little-known B-grade skin flick with the catchy title *Satan's Bed*. The plot concerns a handsome New York City drug dealer who wants out of the business in order to start over with his FOB fiancée (demurely played by Yoko in a kimono). But the local crime boss has other ideas, kidnapping the young bride and raping her (offscreen). Cinema sleazemeisters Michael and Roberta Findlay actually made *Satan's Bed* from an earlier, unreleased film called *Judas City* by someone named simply "Tamijian," adding footage of a trio of junkies dressed in black who roam the city molesting and robbing young housewives, and turned it into the exploitation curio it is today. Here's how Yoko remembers it:

It was really weird because a producer/director came to me and asked if I'd like to be in a film. **I immediately called Jonas Mekas and asked if this director was kosher or if he was one of those dirty old men. Jonas said, "He's fine." So I met him, and this guy was very, very decent**. He told me he wanted to create an image of a very pure Asian woman. He didn't want me to touch someone or even kiss someone [in the movie]. He was filming me like that, and then I just forgot about it and went on with my life.

Once I became famous as somebody with John, we came to New York City. A producer I didn't know called and said he had the film, but there wasn't enough footage, and would I mind coming in and adding some? Of course I didn't know anything about it. I didn't want to add more footage; I was busy being me and John! So I said no.

What he probably meant, I found out later, was that he wanted some risqué shots. **The original director sold it to him because he didn't have enough money to finish it, and this guy who bought it wanted to make it into *Satan's Bed*. He got these girls wearing a black wig in the shower. It was supposed to be me! But anybody can see it's not the same girl as [the one] wearing the kimono!**

John and I and (former Beatles manager) Allen Klein and his girlfriend—the four of us went to see it in Times Square. We had a great laugh. It was so funny! It was just girls running around in the hills and then going to a house and sort of taking a shower. It was amazing...Actually, it's not worth seeing from any point of view.

"When we finished [*Yoko Ono/Plastic Ono Band*], it was like dawn. **I looked at John and he looked at me: Wow! I thought, like Madame Curie and her husband discovering something incredible, like radium, but in a musical realm.** Wow, this is great! Not hearing applause in my mind, but close to that. I was applauding myself. I was surprised when it was met with incredible antagonism. Whoops! It wasn't the way we thought about it."

RISING

For all the critical and popular abuse Yoko was and often is still subjected to, she's remarkably resilient. She has diligently defended her late husband's legacy, refusing Paul McCartney's request to change some songwriting credits from "Lennon/McCartney," as they've always been attributed, to "McCartney/Lennon" when the Beatles' *Anthology* CD sets were issued in the mid-'90s. When he went ahead and reversed the credits on his live album *Back in the US* in 2002, Yoko took the high road and let it go instead of suing. Amid popular disapproval, Macca's since backpedaled, saying he has no intention of pursuing the change on any future releases.

She continues to make art, tout her son Sean, whose own second album is set to come out next year, and speak out against war. It's been an incredible transformation from Yoko as pop music pariah to icon of world peace. But instead of gloating, she seems bemused, reflecting on the incident of the kids throwing away her album.

"I would like to ask them what they think now. First they put the album in the trash can; now maybe they will retrieve it."

*HANE: It was a personal career high getting to interview Yoko Ono, one of my biggest heroes—not only because of her art but also for the fact that she just kept on doing her thing and being herself in the face of so much racist and sexist animosity (which somehow persists to this day). **Basically, she's the OG queen of giving zero fucks.***

Our interview was over the phone, so there isn't a whole lot I can describe about it, but I remember I had to get up while it was still dark out so that I would be sufficiently awake and mentally prepared. I was at my then-boyfriend's tiny apartment and was trying to be extra quiet to not wake him—though he told me later he could hear me giggling. You might not guess it, but Yoko has a great sense of humor.

Also I think I unintentionally caught her off guard when I brought up Satan's Bed, her 1965 film debut (see above), which I gathered she'd never been asked about before. But she was totally frank and open about it and made me laugh. One topic that didn't make it into the article was her health regimen, which included getting regular massages—and lest anyone dismiss it as some kind of luxury, she came up with an interesting idea about women (in particular) forming massage clubs the same way they do with book clubs. Probably won't catch on, but a cool idea nonetheless!

MARTIN: Cho is a comedian and actor writing about music here, but she's a real punk, too.

CIBO MATTO IS YUKA HONDA & MIHO HATORI

THEY ARE
SUPER RELAXED

words | Margaret Cho

Cibo Matto had their share of magazine covers, photo spreads, and media coverage last year. They were billed as the new shit from Japan even though they've been living in New York for the past few years. And now that the food-frenzied media furor is just about over, they are now talking more with their music and not with their appetites. Margaret Cho, a Cibo fan, took a break from her comedy schedule to meet with Miho Hatori and Yuka Honda after their sound check at the Troubadour Club in West Hollywood.

Margaret Cho came between Miho Hatori (left) and Yuka Honda (right).

It's amazing how evolved the sound check is. When I perform anywhere, all I do is make sure the microphone is turned on. You guys sound great. Are you playing to promote Super Relax now?
MIHO HATORI: Yes, we have to be. But recording and playing is a little different. But I think the last album EP is more like a live recording. It's a one-day studio recording.

Who is in your band?
HATORI: Sean Lennon, and Tim Ellis is the drummer.

They play on the album as well. I always think you and Yuka play everything with synthesizers and stuff.
HATORI: Cibo Matto is Yuka and Miho. And now we are on tour. We have to play gigs. We played just the two of us for a long time, but our music sense is getting changed. We have more songs that we couldn't play with just a sampler, so we have to kind of try lots of things. Now we have bass and drums. It's a new form of Cibo's gig style. Recording *Viva! La Woman* is the basic form of Cibo Matto and we want to try a lot of things. We don't want to have a wall for it and we have to continue to style it. It should be free since it's music.

When did you start music? What instruments did you start with?
HATORI: I don't have serious musical education.

My family loves music, so I learned to bite opera a little bit. Classical doesn't affect me right now. But every now and then we go for it and play around.

Your music combines many different kinds of music and you made your own genre. How did you start music? Did you start at a young age?
YUKA HONDA: I had some piano training when I was a kid. It was classical music and I was a bad student, but I was good at ear training. My ears are really good. I didn't like the music that I had to learn. I also didn't know that with piano, you can play any other kinds of music. I thought with piano you can only play classical music because that's all I heard people play at the time. Now I can appreciate classical more, but when you are a kid, it's boring. Then I didn't play for a long time. I came to New York because I wanted to live with my boyfriend and he was a really great musician. I was kind of watching him play music all the time and wanted to imitate him. So I started to play music as soon as he leaves. That's how it kind of started.

How did you two meet each other?
HONDA: Through a friend. He was starting this punk band with a mutual friend and I joined the band. It was called Leitoh Lychee. It means frozen leechee nut. We wanted music like that. It was a punk band, but it was like a leechee.

Cibo Matto, maybe one of the coolest groups ever. Their album *Viva! La Woman* is still a solid classic and I'm honored to have this in *Giant Robot*. She went on to write more for us.

When did Cibo Matto start?
HATORI: We played at an improvisation gig. It was the first time I played with Yuka. It was the first time I realized Yuka is a sample player. Before that, in the punk band, she was playing guitar, I didn't know. **It was the first time and I said, "Wow!" We talked a lot actually. It's hard to find friends with whom you can talk about music.** If I talk about a Japanese song in the '80s, Yuka knows it and it's easy to talk.
HONDA: **We never said let's start a band and record music and all that. We were asked to play one show. We hung out a lot and like Miho said, we talked a lot about music and we watched a lot of movies. We were into soundtracks, and we would play music that we like for each other.** So we had this show and we were excited about this one little show and we wanted to do something special that would be a combination of a lot of things. We liked soundtracks, hip-hop, rock, punk rock. We wanted to mix.
HATORI: Casserole music...
HONDA: That's a good name!

I really loved the theme of food. Are you going to continue in the theme of food or into different subjects? I hear Cibo Matto is done with food. I hear you are going into color or fabrics. Do you come up with a topic and then write songs?
HATORI: For *Viva! La Woman*, it was the beginning of this band and we wanted to just play gigs at small clubs. We didn't think like that. It was the method of *Viva! La Woman*. I don't know about the next album, yet.
HONDA: We never said let's write songs about food and, actually, none of the songs are about food. But Miho always wrote a song that always have some food in it. Leitoh Lychee is a food name, too. **We are really into good food, the culture and cooking, and so that's one of the things that we did. We are a little sick of people taking it as a gimmick and it takes away from the music.** We are sad about it.
HATORI: I think words and music are communication. If I say, "It's like an artichoke, isn't it?" I know Yuka can

understand what I am saying. It's language. It's Cibo Matto words. It's our music and we communicate with music. It's a creation. So, next album, we don't know yet.

Are you writing songs now?
HONDA: We don't want to say that the new album is about cars or whatever. We do want to play music. We want to have elements of fun things—maybe some cinema. There are some things that we want to get into and like, we were a little like, "Ahhh!" with people's reactions since they said this band sings about food and would ask things like, "What kind of food do you like?"

What else inspired you beside films? Who did you listen to growing up?
HONDA: I like soul music. I grew up in the '70s. I learned a lot music from the '60s. It's hard to say. I like the Pretenders, Talking Heads, early '80s music, Eno, or jazz. We still listen to a lot of music and have friends that come and say, "Have you listened to this?" And they will play the music that we haven't heard. We hear new music on CD or radio and read about it. It's constantly coming and you like it more and more.
HATORI: Everybody has nostalgic music for their life. Music was a remedy when I was in junior high school. There was nothing to do and we listened to the

radio. Whatever I heard, even a cheesy '80s song, makes me really nostalgic. But I don't know of influences to me musically. It's just music. We listen to a lot of good music. I like hip-hop a lot.

How about Michael Jackson?
HONDA: I liked the space era, with "Beat It." We've been into Michael Jackson. His pop stuff is awesome.

What do your parents think? I grew up in a family who encouraged me to play music, but it was all classical, and I thought it was boring. And when I wanted to be a comedian, they hated it. Now they are happy since I am making a living. How do your parents react to the idea of you becoming rock stars?
HATORI: **We aren't rock stars. We are drinking water, not beer, no boys waiting outside, no groupies.**

I think you would have a lot of groupies. I would think that you would have some. Everybody says Cibo Matto are so cute and so on.
HATORI: Where are they? Really?
HONDA: They are afraid of us.
HATORI: We don't bite you...

I love Yoko Ono. She is great. Can you tell me a little about your relationship with her?
HONDA: We first met because we did a remix of a song on her album. For us, she was like living on Mars even though we were living in the same city. Know what I mean? I have seen her one time walking. And when we got the job we were excited and we wanted to do a great job. She liked what we did. So she invited us to lunch and we got to meet her. Since then, it's been great. Also, we are learning about what she has done and it's inspiring to us. And also, Yoko is a great Asian woman to break [down] a lot of walls and she is courageous and she has gotten so much shit. It's unbelievable how much shit she got.
HATORI: It's different because I ask a lot of things about Yoko to American people. They just say, "I don't know." They don't answer. They totally shut it out. **For Asian people, it's a big deal**

that she exists and is kicking ass.
HONDA: I was reading some book and they asked, "Who do you think is the most famous Asian person today?" And they said, "Yoko Ono." **No one knows who the prime minister of Japan is today, really. Everybody knows Yoko Ono. I think it's really awesome that she got so much shit and she never screamed back. She was kind of graceful and did a lot of good things.** And people don't know what she has done. She has done a lot of amazing things. People only know how the English press reacted to her being with John. It's a shame. I think Yoko is happy because more Japanese girls are coming and are breaking walls.

In a way she is similar to Jackie Kennedy. But they aren't regarded in the same way. Both were strong women married to visionaries who were murdered in front of them. Jackie Kennedy is treated like an icon and people don't think about Yoko at all. I think it's unspoken racism.
HONDA: I think it's very strong racism. She talks a lot about it. She suffered from racism a lot when she was coming up—there were not many Asian people visible. She was visible. If she was a blonde, white woman married to John, people would have treated her differently. You know that to be true. Yoko is so much more punk than Jackie O. She's so much cooler.

She's great. So have you experienced racism or anything like that within the music industry? You are rare in the industry. There are very few Asian women in the music industry.
HONDA: When we started, because we were girls from Japan, they put us in the bag of Japanese like Shonen Knife and P5, just because of our sex and our race. And that pisses us off a lot. We have nothing to do with Shonen Knife. Not even a little element resembles them. First, it surprised us a lot. We were playing small clubs in New York, and that was to people who loved our music. They would come and it was a friendly, peaceful relationship.

But as soon as we got a larger level of recording music, and put out music in stores, and did national magazine interviews, we heard so many new things about ourselves, like, "I don't like Shonen Knife, so I won't like Cibo Matto," and it freaks us out a lot. We learned a lot by doing this. Hopefully, it's meaningful and more Asian bands will come up. Sometimes we play and some Asian people come up and say, "I'm so happy you are doing this."

I'm so proud of you and it's great that you are out there. And you are so wonderful.
HONDA: So are you guys.

HATORI: In New York City, I didn't feel anything. Because it's a small area where we are living—the East Village is like jackpot. Nobody cared who's from fucking somewhere. I felt totally free. But **when you get out of interviews, and hear, "Konnichiwa," it's a disappointment. Nobody knows about present Japan and what's going on and what they are thinking** (and having education). There's a misunderstanding between the US and Japan, I think. People ask us, "What is going on in Japan?" There is a lot of technology like the internet, but it's still really far from here and I hope it's going to be more free.

HONDA: Sometimes, it's hard not to have resentment of this Americanocentric mind of the people who we meet every now and then. People who have watched a lot of TV and never left their town, never left their country, but think they know everything. And they think they are sitting on the top of the world. **We traveled to so many countries and I lived in many countries, and it's so amazing how you can be living in a little box and think like, "I know everything."**
HATORI: I think mass communication has so much power. There is an Oriental style. Even in *Breakfast at Tiffany's*, the stereotype is so strong and you have to get rid of that.

How about Butter 08? The album is great. Are you going to do more with that?
HONDA: We are very busy people. The band is a combination of a many busy people. It's hard to get time.

If you saw a scary ghost in front of you, would you run from it or would you stay and try to understand it? What if you had a sword? Would you attack it?
HONDA: I don't think I would attack unless it attacked me. I think we would try to talk to it, like, "What's up?"

Which version of "Chicken" is your favorite?
HATORI: Maybe the Jan Hammer version.

I like that song you cover. Are you thinking of going more in that direction? Your voice is so perfect for that bossa nova. I want you to play my wedding if I ever get married.
HONDA: We want to think only when the moment comes. The first album was organic. The music came one after another. We just let it happen, and that's the way we will work.

When you go to sleep, pajamas or lingerie?
HATORI: Depends on the situation.
HONDA: Depends on the temperature of the room. 🐱

POPICALIA

words | Eric Nakamura
pictures | Ben Clark

Tell me about your art. I read that you used to do drawings before being in a band.

LUÍSA MATSUSHITA: Yes, I used to do T-shirt prints. That was my last job in Brazil. Not just T-shirt prints but also shirts and fabrics. I used to work on a brand. Now I do most of the T-shirts for CSS. I should do more but I am quite slow. I also do all the graphics on the covers. For the cover of *Donkey*, Luiza [Sá, her bandmate,] took the photo and I did the donkey. Sometimes, people don't realize it's a donkey, but that's a donkey on the cover.

Why is the album called Donkey? I thought that was kind of weird.

It's very silly and doesn't make too much sense, but it makes more sense for us. I have a friend who is Brazilian but has lived in LA for the last 10 years and she has very funny English. She'll take Brazilian slang and put it in English literally, and sometimes it makes so much sense. She calls everybody "donkey," and when she doesn't like something she calls it "donkey." She'll be like, "This bottle is very donkey because it makes everything hot." Also, we like animals.

While you were making designs and drawings, were you singing?

No. CSS is the one and only band that I have ever joined. I started when the band started.

Did someone say, "We need a lead singer and it should be you"?

No, no. Actually, I was going to play the guitar. But I was the last one to arrive at the first rehearsal and there were already three people playing guitar. Not that I know how to play the guitar. There was a microphone in the room and nobody was singing so Adriano [Cinta] said that I should sing.

It was just like that?

Yeah, but I was very shy so I sang very far from the mic where nobody could hear me. I couldn't hear myself and it was quite frustrating.

By the third rehearsal, I wasn't as shy and would scream through the entire thing—very high-pitched with no direction, no nothing. Just screaming. It was quite cool.

I think that your sound is different than it was on the first album?

I know. That was the first one for me, and I had no idea what I was doing. I didn't really sing and talked most of the time. For this one, I wanted to sing a bit more because it is easier when you are playing a show. If you are singing like talking, it's too low.

What do you think of the iPod commercial? Do you like it? A lot of people know your music from that but might not even know the band.

It's funny. We were not even playing that song anymore on our set, but now people react strongly to it as if it were a single. But the way that it happened was very cool. There was this guy, Nick, who studies politics in Leeds in the UK, and he made this fake advertisement

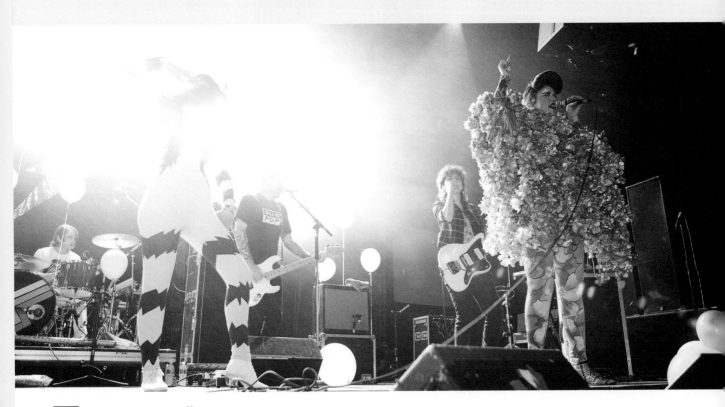

Luísa Matsushita is on a hectic pace of doing press since her band CSS is the hottest thing to come out of Brazil since Sepultura. The charismatic singer goes by the name of Lovefoxxx, wears custom outfits onstage, and is treated like a hero by indie music fans. The 24-year-old, half-Japanese Brazilian speaks in an accented English as we meet in a giant tour bus hours before the first of two LA shows. She's tired, but gains energy as we talk about T-shirts she's designing for Graniph of Japan.

and posted it on YouTube. Somebody at Apple saw it, and that's how our song ended up on the ad.

That's kind of indie.
Yeah, it's Apple but it's still indie. Not that I mind. You know, you use Apple, I use Apple, we all do. It's a great product and it makes our lives better. I wouldn't do it for something that I didn't like.

Is it easy to work with big companies? Your bus says Ray-Ban on it. Do you like Ray-Ban?
I don't mind it. *Death + Taxes* magazine in Texas and Ray-Ban are sponsoring us with this bus. I use and wear Ray-Ban stuff and the magazine is a nice magazine, so I don't mind them helping us.

From the sound of your band, I'd never guess you're from Brazil. More like England or Portland or someplace like that. Is there a scene for your band's kind of sound in Brazil? We never had a scene in Brazil. I think if we did, we would have them support us. The thing is, we are a mix of electronic and rock. The rock people in Brazil would be like, "Oh, they are too electronic," and the electronic people would be like, "Oh, they are too rock 'n' roll." So we were never accepted by any scene. We were always by ourselves, playing with any bands we could. I don't know what is going on in Brazil right now because I have not been back in a very long time. I don't really research it.

Where do you live now?
I live in London, but I know that the bands that were in São Paulo when I moved there still play. There are lots of independent and underground bands that play every week for 150 people, and nothing much happens for them because they sing in English. In Brazil, you never grow too much if you sing in English.

I think the biggest band I know from Brazil is Sepultura.
I was never a fan of Sepultura. What happened to them is like what happened to us, but they were more like a metal band so they didn't get too mainstream. I think we see ourselves as a pop band.

Tell me about your clothing. You really go for it and wear outfits.
We had a tour with Tilly and the Wall in April last year, and we got to be close. The girl who designs clothes for them is Peggy Noland. She sent a package to me through them, and we never stopped talking. It's funny because the only bands she makes clothes for are SSION, Tilly, and me. We all tour together now. She is very amazing. Sometimes we collaborate on ideas and sometimes she just sends me things straight out of her head. I don't have anything new to wear today, but it's alright. I will get a new package tomorrow.

You have great energy. Where does it come from?
I spend the whole day like this—like how you see me now—and I save

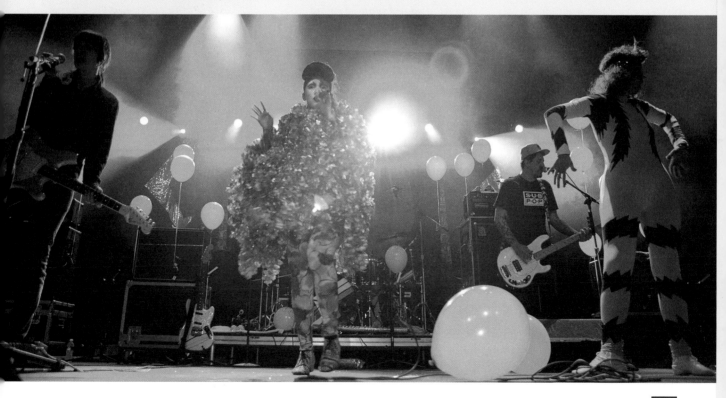

it all for the show. We have been touring almost nonstop since July '06. The longest time we stopped was to make this record, which isn't a holiday, right? I am more tired than usual, but I save all my energy for the shows. This tour has been very nice because I really like the two bands playing with us. It is great to see them before we play because I get very hyped. And, of course, I drink some tequila sometimes. Just one shot is great; it makes you very happy. And the crowds. I think if we were just by ourselves then nothing would happen, but our crowd is very down to party. That is what makes the show for us as well. And coffee.

So how tough are you? Everybody knows that Brazil is a pretty tough place. You must be extra tough because you are half Japanese. Well, <u>Rio is not entirely like *City of God*. It is very pretty.</u> There are the beaches and the city and the hills. All of the poverty lives in the hills. I used to live in São Paulo and had no idea I was on the hooker street. The rent was so cheap there and the apartment was big, so I was like, "Oh, that's great." Then my first night I found out, but I had to stay two years because of the contract. That was very tough because there are lots of young kids sniffing glue and going crazy. You have to confront them and walk very close to them because if you go away people think that you are stealing from them. I would always look them in the eye and give them sandwiches and things like that. I am glad I don't go through that anymore. It's very hard, very sad, and dangerous.

Also, people in America would assume people from Brazil like bossa nova. Is that true or is it sort of played out? I don't know that much about Brazilian music because my parents were never into it. I started enjoying music when I moved to São Paulo at 16. Then I started listening to and buying music. But I'd say that with each day that goes by I get more interested in Brazilian music. I like tropicália.

Where did you live before São Paulo? Campinas. It's a small town one hour from São Paulo. It is way smaller.

What do you do for fun in London? It's been quite a while since I have stayed there for very long, but I really like the summer. It is very pleasant. I like cooking. Lately, my boyfriend and I bought some paint-ing supplies. I don't know. I love my house so I spend a lot of time there, or I am riding my bike.

Are you going to stay in London for a while? Is that the plan? Yeah, yeah. Because most of the things we do are in Europe or America—hopefully, more in Japan. It is unbelievable that going from London to Tokyo is 12 hours and to go from Brazil to London is like 11. They look so close in the map.

How did your Japanese grand-mother end up in Brazil? When she went there, she was 10. People were saying that there was this amazing place called Brazil where people could make money and be rich.

They say that about America, too. <u>You know, they wanted to live an amazing life so they came here and it wasn't like that. They worked on plantations.</u> My grandmother worked since she was very little, and whenever I try to talk about it, she gets very emotional. So I just don't—it's too much. But apparently my grandfather had a very good life in Japan. He had a Harley Davidson and he had a peacock. I think even today, to have a peacock and Harley means you're doing good.

ERIC: CSS was a group that was fun and exciting. Since I was a kid, I knew there were more Japanese in Brazil than in the US. Being an American,

words | Martin Wong *pictures* | Martin Wong + Reed Burgoyne

LANCE HAHN

1967–2007

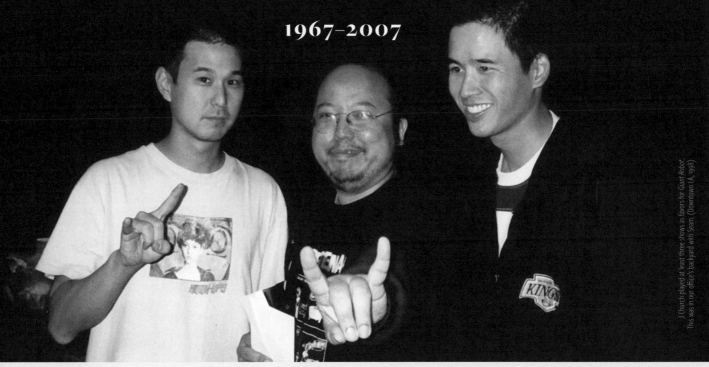

J Church played at least three shows as favors for *Giant Robot*. This was in our office's backyard with Sean. (Downtown LA, 1998)

Last year, J Church was supposed to play my wedding. If it happened, I might have realized two dreams at once. First, to have my favorite punk band play after a massive, traditional Chinese banquet with vegetarian tables. Second, I'd have an excuse to supply the "one plus one" singalong part in "My Favorite Place."

None of that happened. Lance agreed to play the show, but scheduled the tour's stop in Los Angeles one week too late.

That wasn't unexpected. My house became J Church's designated place to crash starting in 1995 or so, and I witnessed all sorts of mishaps. Once, band co-founder Gardner Fusuhara accidentally broke my fence while trying to hop it and left a long apologetic note. (The fence was falling apart anyway.) Another time, my security alarm went off when I was at work and he was staying with me. (The rent-a-cop was a *Giant Robot* reader!) More often, it was simply bad timing: booking a show in an out-of-the-way place in Orange County, opening for a band whose fans hated J Church, or playing against The Kills or any number of other groups that had the same audience. J Church was the Charlie Brown of touring bands—if anything bad could happen, it did happen to them.

Before I made Lance's friendship, I was a fan. I saw Cringer (his old band) and J Church whenever they came through town, and I was shocked when he introduced himself to me after a show with Lync at UCLA's Cooperage. He was a fan of *Giant Robot*'s second issue, citing my essay about being Hello Kitty for a mini-mall Sanrio shop.

On the next tour, he gave me a T-shirt that borrowed a graphic from the back cover of our third issue. I'm not sure if it really mattered, but that night at Jabberjaw knocked him off the pedestal for me.

It turns out that despite being a brilliant songwriter, voracious reader, and practicing political punk, Lance was not jaded at all. In fact, he was just as prone to fanning out as I was.

Lance was a connoisseur of everything from *Kamen Rider* to Kafka, Hong Kong movie stars to French situationist thinkers, vegetarian Chinese food to vegan anarchists, and Super Bomberman to Spider-Man. He could have simply griped about society in his songs, but he chose to celebrate mundane, obscure, and awesome details of life wherever he lived: Honolulu, Los Angeles, San Francisco, Austin.

The combination of punk rock roots, refined taste in Asian and popular culture, and appetite for doing cool, meaningful things made Lance not only an exceptional musician, but also a perfect contributor to *Giant Robot*—and, most of all, an engaging and ideal friend.

A band featuring my friend Adam Pfahler, one of Lance's many drummers, wound up playing my wedding instead of J Church, and perhaps that was better. The organizational craziness and family obligations were over when he arrived in Southern California, allowing me to spend time at the house party in San Pedro, drive down to the gig at a surf shack in San Juan Capistrano, and have lunch with the band in Monterey Park before they departed to Arizona.

That was the last time I got to hang out with Lance—a person who never disappointed anyone as a punk, a pal, or a human being.

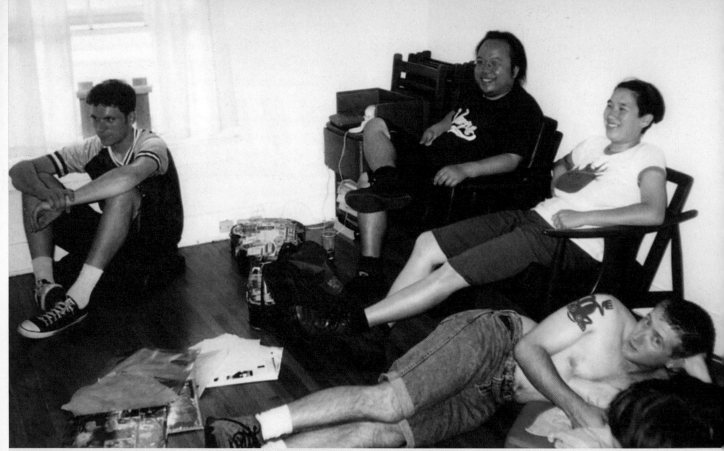

J Church crashed at squats, punk houses, and friends' homes around the world, and my place was one of them. This visit included (left to right) Reed, Kim, Gardner, and laser discs. (Silver Lake, 1997)

MIKE MILLETT
(BROKEN REKIDS)

You seem pretty selective about the bands on your label. Why J Church?
They were my friends first. I saw the band's first show and asked them if I could put out a record. Taste-wise and politically, we had a lot in common. Great music and lyrics. At one point early on, I told Lance if he ever wanted to add a second guitarist, I was available. Obviously, they did not need one!

When you think of Lance, what memory comes up first?
I shared a practice space with J Church and Jawbreaker. One night, I was playing guitar by myself and Lance came by. He got behind the drums (he was very good, by the way), and I think we played some Clash and songs from my first band. Afterwards, it was pouring rain and we were getting soaked. We stopped at a Thai restaurant to dry off and get a bit of food. The rain let up a bit when we left, but we were still getting wet. I'm tall so I could jump the puddles and rivers of water, but Lance was landing in them. He kept saying, "This fucking sucks! I have holes in my shoes!" He could barely get the words out, he was laughing so hard. Finally, we got a bus at Van Ness, got to the theater, and saw The Clash movie in soaking wet clothes. A year later at a party at his house, he mentioned to me in passing, "Remember that night we saw *Rude Boy*?" Sure. "You know, I went home and wrote 'November' that night."

ADAM PFAHLER
(J CHURCH, JAWBREAKER, THE MOONS, WHYSALL LANE)

There was a time when you were playing with both J Church and Jawbreaker. Did you ever consider making J Church your full-time band? Did Lance ever try to recruit you?
No, because I was consumed with Jawbreaker. We were writing, recording, and touring a lot in those days. And it wasn't Lance's style to poach people from other bands. I was one of many J Church drummers. But that's what was cool about that band. It was clearly Lance's (and to a point, Gardner's) thing, but the revolving door of rhythm sections wasn't a result of him being some kind of tyrant. Lance always invited everyone to the table. When he needed a drummer to record "The Sound of Mariachi Bands" for *The Mission District* 7″ box set, I did it. And I was stoked, because I think it's one of his best songs. After that, he would call on me periodically over the next 10 years.

Tell me something non-music related about Lance's interests or personality.
Lance was from Hawaii, but he couldn't swim. Lance lived for years in San Francisco, but wouldn't ride a bike. Lance lived in Los Angeles, but never learned to drive. This last one is remarkable if you consider that the man toured the world, logging hundreds of thousands of miles from Modesto to Manila and never once took the wheel. What a diva.

ERIC: Kim (pictured above) is Barry McGee's sister!

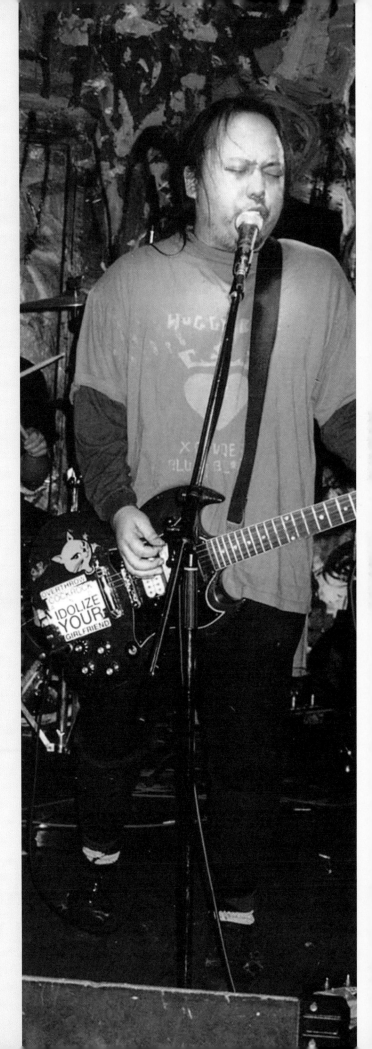

J Church filled the gaps between anarcho-crusty punk and pop punk, East Bay punk and Britpop, riot grrrl and indie rock. (Osaka, 1998)

When you think of Lance, what memory comes up first?
We were in Arizona on our way to play a skate park with The Didjits, Drive Like Jehu and Pegboy. Gardner, Lydia, and I wanted to check out the Grand Canyon. We were running late and Lance wasn't into it because he wanted to make sound check, but we bullied him into going anyway. So, of course, it took a really long time to get there. We pulled up, hopped out, and rushed to the scenic overlook à la the Griswold family in *Vacation*. We took in the majesty of the place as the sun was going down. After this moment of silence, Lance said, "It's a pretty good canyon...I don't know about grand." That said something about Lance: <u>he would rather be in a smoky room full of his friends knocking out his brand of smart, loud, punk rock than just about anywhere else in the world.</u>

MOLLY NEUMAN
(SIMPLE SOCIAL GRACES, BRATMOBILE, THE PEECHEES)

How did you meet Lance? What was your first impression of him?
Lance was one of the first people to make me feel welcome when I started hanging out in the Bay Area in 1992. He was incredibly supportive of girls in bands and, honestly, I struggle to think of anyone who had such a positive and supportive outlook in those times—especially anyone who worked at *Maximum Rocknroll*!

Tell me something non-music related about Lance's interests or personality.
I knew Lance mainly through music, so I can't speak much to anything non-music related, but he was a true punk and those are very rare.

BLAKE SCHWARZENBACH
(JETS TO BRAZIL, JAWBREAKER)

As a fellow songwriter, did you ever talk to Lance about the creative process? If so, what transpired? What can you say about his songwriting from your perspective?
We enjoyed a very close working relationship for a time—we were neighbors and played a lot of shows together, some of the first J Church shows. What I remember most was the space and separation of the three-piece and how refreshing that was. Lance had a very angular, lean approach to guitar (I think a result of his eclectic and more international taste in music). He would work these two-string chords or single-note melodies, usually on the higher three strings, and this was during the heyday of bottom-heavy, "chugga-chugga" stuff. That economy opened up a lot of possibilities for what a band could do. His songs were very short but ambitious in their composition—they could go big or elegiac in a three-minute format and still have the song register as exact.

When you think of Lance, what memory comes up?
He was very optimistic. I never saw him unexcited about music. If he didn't particularly like what was happening in one scene, he was always sustained by goings-on in Edinburgh or Chapel Hill or Winnipeg.

MEGAN LUTHER
(EX-ROOMMATE, CO-OWNER OF DOUBLEDUTCH BOUTIQUE)

Did you go to J Church or Cringer shows? Were there any differences between Lance the musician and Lance the roommate?
J Church shows. Onstage, he seemed tireless. At home, well, that was often a different story!

As a roommate, did you get insight into his writing process at all? Once he told me that he tried to write one song every day!
If Lance was in his room, he was usually writing. On the floor, surrounding his futon mattress, there were piles of inspiration: records, magazines, books, videos, and notebooks (what I assume were journals and notebooks of song lyrics). There's so much personal history and honesty in his songs. The people, places, and experiences in the songs are real. Yes, it's totally possible that he wrote a song every day.

JEFF MAHER
(J CHURCH, NOTHING COOL)

How did you wind up playing bass in J Church? Were there tryouts, an official rite of passage, or anything like that?
My friend told me that J Church did not have a bass player. At the record store where we worked, I asked Lance if he was looking, and he responded, "Yeah. Do you want to play? Do you have a passport? Can you take time off work to tour?" I answered yes to all of these questions and asked him if he wanted me to try out. He told me he had seen me play and there was no need.

Tell me about Lance's songwriting. How was his music different than what you played in Nothing Cool or other bands you played with?
His style was very different. Adam and I were given a cassette

with new songs—just rough ideas of what he was thinking—and we wrote our parts separately. This remained rough all the way to the studio. Lance was so into trying new things and letting the songs evolve on their own. This was a very fresh and fun way of going about it.

ANDEE CONNORS (J CHURCH, AQUARIUS RECORDS,
TUMULT, A MINOR FOREST, P.E.E., TICWAR)

Correct me if I'm wrong, but while you were in J Church, your diet consisted solely of meat, corn, and Pepsi. He was a vegetarian. How was this handled on the road?
Well, the thing about a shitty vegetarian diet is that it's not all that different from a shitty carnivore diet. Lance and I seemed perfectly matched as far as food. Other than the facts that I ate meat and he didn't, and that he drank and I didn't, in every other way, diet-wise, we were a perfect match. J Church tours were a steady diet of pasta, pizza, rice, bread, french fries, chips, shitty truck stop food, and soda.

When you think of Lance, what memory comes up first?
We were in the UK, in a city called Bath, playing in front of a really rough crowd. Crusties and skinheads. I think there had already been a few fights. The first thing out of Lance's mouth was, "You know what's ironic about the fact that this place is called Bath? It's that no one here seems to have ever taken one." I could barely play, I was laughing so hard, and sort of freaking out that we were gonna get our asses kicked.

JONATHAN FLOYD
(FAT WRECK CHORDS)

You're name-checked in the first line of one of J Church's most popular songs. Do you ever get sick of it?
Funny thing is, until Lance moved to Austin, I never really called him. The phone call he is singing about in that song actually was for his roommate who had my Spanish book. As for getting sick of it...Nah, it is a good song.

You're a fixture in Bay Area punk (not just being mentioned in "My Favorite Place," but also the namesake of

J CHURCH
FULL-LENGTH
DISCOGRAPHY

ALBUMS:

Quetzalcoatl | Allied | 1993
Prophylaxis | Allied/Broken Rekids | 1994
The Procession of Simulacra / The Map Precedes The Territory | Jade Tree | 1995
Arbor Vitae | Rugger Bugger/Honey Bear | 1995
The Drama of Alienation | Honest Don's | 1996
One Mississippi | Honest Don's | 2000
Society Is a Carnivorous Flower | No Idea | 2004
The Horror of Life | No Idea | 2007

⚓ **ERIC:** I interviewed Lance Hahn once and Martin said it was the best thing I wrote up to that point. But Martin's send-off to our friend is the best

The Thing That Ate Floyd *and all those Fat comps*)*, and so was Lance. Was it weird when he relocated to Austin?*
Yeah, because Lance was everywhere, and all of a sudden we didn't see him that much. Lance was really an in-the-moment type of guy, so if you didn't catch him face-to-face, there was a good chance that contact was going to be minimal.

BEN SNAKEPIT
(J CHURCH, CAPITALIST KIDS, PARTY GARBAGE, SNAKEPIT COMICS)

When you think of Lance, what memory comes up first?
Whenever we would learn a new J Church song and I would really hear the lyrics for the first time, it was always awesome. I never had any idea what the songs were about, and he'd give me this detailed history lesson about revolutionary France, the tragic death of an actress, or something. It would blow me away how his lyrics could be so smart and referential, but still remain poetic.

RAMSEY KANAAN
(AK PRESS)

You and Lance had been working on a book about anarchist punk bands. Can you tell me how the project began?
Good writing is really rare. Lance had it in astonishing amounts. Lance was already writing about anarcho-punk, publishing it in his zine and in *Maximum Rocknroll*. All I did, really, was encourage him to continue and to help reshape it into book form.

LIBERTY LIDZ
(LANCE'S LONGTIME GIRLFRIEND)

Tell me about moving from San Francisco to Austin. What was that transition like for you and Lance?
Lance was pretty pleased when I was accepted to UT Austin. He'd vowed to come with me wherever I was going to go to grad school, but Austin was by far the most musician-friendly of the places that I'd applied to. I was actually a bit surprised by how much he liked it here. When we lived in the Bay Area, he'd complain about the heat being intolerable when it hit 65 degrees, and I don't think I'd ever seen him on the street without his signature cardigan and wool scarf.

Although Lance was in and out of the hospital, I never thought passing away was an option for him. Did you two ever talk about death?
Lance had a large number of near-death experiences, so he was very conscious of the fact that he could die at any time. When he was hospitalized for congestive heart failure in 1999, the doctors thought he was about to die, and he spent the whole time in the hospital thinking that he was about to die. He told me several times that he had come to terms with death and wasn't afraid of it; what he couldn't stand was the thought of not growing old and gray together. Also, the hospitalization in summer 2006 (when he had gone back into congestive heart failure and had gone into kidney failure) was completely life-altering. **But we didn't talk about death a lot. As they say, thinking positive is good for one's health.**

Did you expect Lance to receive such a huge outpouring of tributes, thoughts, and condolences?
I had a hint of the love so many people had for Lance in all of the ways they tried to help him. In fact, when he passed away, I found a copy of the *Let's Do It for Lance!* compilation in his Discman. I've received so many messages over the last few weeks that I can't even hope to keep up. A huge number of people who may not have seen Lance in many years, but had been very close to him on tour, during high school, as a roommate, etc., have written or called to say that he had had a big impact on their lives. Lots of fans have told me how J Church and Cringer songs have changed their lives. Even though we'd been together for eight years, Lance was friends with so many people and done so many things that people have constantly been telling me stories about him that I'd never heard before, which is pretty wonderful. 🐱

MARTIN: *I've had so many recent conversations with Adam, Blake, Molly, Andee, Ben, and others who are cited in this article that have gone something like "Lance would have totally been here," or "Lance would have loved this." I miss him dearly, but his name comes up so often and his music, which I still listen to all the time, is so uniquely personal, that it feels like his spirit and presence are stronger than ever.*

SINGLES COLLECTIONS:
Camels, Spilled Corona and the Sound of Mariachi Bands | Broken Rekids/Damaged Goods | 1993
Nostalgic for Nothing | Broken Rekids | 1995
Altamont 99 | Au-Go-Go | 1998
Meaty, Beaty, Shitty Sounding | Honey Bear | 2001

SPLIT ALBUMS:
WITH DISCOUNT | Rugger Bugger | 2000
WITH CONTRA, *Fuck You, I'm Craig And It's My Birthday* | Traffic Record Violations | 2000
WITH ANNALISE, *Asphyxia By Submersion / Head Held High* | Beat Bedsit | 2001
WITH STORM THE TOWER | Broken Rekids | 2003

IMPORT COLLECTIONS, TOUR CDS, LEFTOVERS, AND OTHER STUFF:
Soul Patch and Cho Chos | Skippy | 1995
Invitation to Inevitable | Cassette | 1995
You Think You're Cool | Snuffy Smile | 1996
Whorehouse: Songs and Stories | Damaged Goods | 1996
The Ecstacy of Communication | Startracks | 1997
Cat Food | Damaged Goods | 1998
Slanted | Snuffy Smile | 1999
Palestine | Honey Bear | 2002
Seishun Zankoku Monogatari | Snuffy Smile | 2004

thing we could offer. One day there will be a documentary on Lance Hahn. Maybe it'll happen at a time when docs are less cool, because there's even one on us. His life still matters.

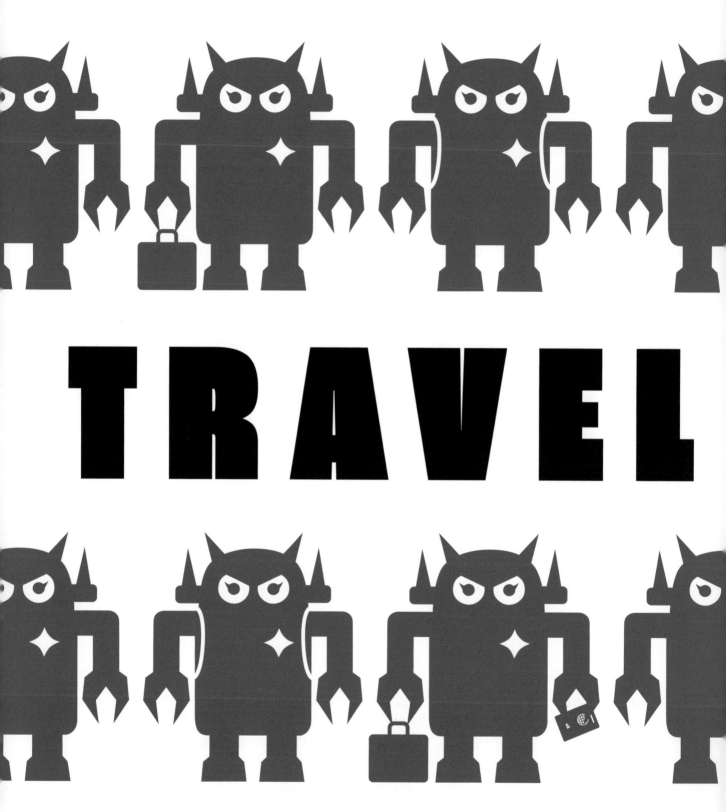

DANIEL WU

I remember the first time I laid my eyes on *Giant Robot*. It was 1994 and I was standing outside a San Francisco bookstore. The face of a slumbering sumo wrestler caught my eye through the window. It was a copy-and-paste zine just like the skate and punk ones I had read before but when I saw the title, *Giant Robot* in Helvetica font, I sensed immediately that something about this one was different, that this was specifically for me. I walked right into the store, bought it, then went straight to my car and read it cover to cover.

I grew up a skater, into punk rock, hip-hop, DIY art, graffiti, anything youth, urban, and alternative, but I also practiced Shaolin kung fu and watched Hong Kong movies rented from the Chinatown video store. Oftentimes, I felt at odds with my passions as it was difficult to synergize these seemingly disparate parts. I loved all these things but they didn't really go together. Or so I thought, until I read issue #1 of *Giant Robot*.

I couldn't believe that somewhere out there were a couple of irreverent Asian American boys that were just like me, that were into the same things I was into but with the biggest difference being that they were completely unapologetic about it. That fascinated me because I hadn't discovered how to do that yet. I didn't speak much about kung fu to my skater friends nor did I talk about the Bad Brains show I saw to my family and fellow kung fu classmates. I think I kept it all separate because I was afraid of being judged, I was afraid

of having to explain these seemingly different things to people who wouldn't understand. Eric and Martin, however, didn't give a shit. They mixed it all up and were telling the world that all these things can be together and can be cool and they did not care if you agreed or not.

I was so excited to have found kindred spirits that I wrote a letter to Martin gushing about how much I loved the zine and if there was anything I could do to help contribute. That letter eventually led to a working relationship and friendship that continues on today, almost 30 years later.

Eventually, I was allowed to write for them and I ended up contributing to almost every issue that I could from 1997 onwards. It became an important part of my life as I journaled about my experiences in the Hong Kong film industry.

Through the years, I met and became good friends with so many of the subjects and contributors of *GR*. I had finally found my people. Some made art, some made music, some made toys, some made films, some were Asian American, some were from Asia, some were not even Asian, but it didn't matter because we were all part of this misfit GR family.

So when the magazine finally came to an end, the realization set in that it was the end of an era. I was devastated. *GR* had grown and evolved into so many beautiful permutations over the years from zine, to black-and-white magazine, to glossy magazine, to having stores selling cool merch in LA, SF, and NYC, to an art gallery

supporting new and upcoming artists, and even a restaurant, gr/eats. My own personal career paralleled GR's growth with my first article written days after arriving in Hong Kong. And by the time I wrote my last article, I had starred in over 50 films. It was such a comforting constant in my life that when it ended, I felt lost. Although I stayed in contact with most of the "inner circle," not having the magazine around was not the same.

During the panel discussion of the recent *Artbound* Giant Robot documentary premiere, I was asked, "What did *Giant Robot* mean to you?" As I tried to answer, I was suddenly hit with a wave of emotion as I burst into tears and eked out, "everything." What I meant to say was that it felt very special to be part of *GR*, it felt awesome to finally feel like there was a group of people that understood my entire being and that I understood them in return. It felt awesome to contribute to something that was making a difference, influencing others, and most importantly making people feel less alone. They had slowly but surely built their own culture that was unique to *Giant Robot*. I still miss getting the latest issue of *GR*, ripping off the plastic, taking in the cover, and then reading it cover to cover in one sitting. To this day, nothing has replaced that feeling. 🦇

California born Daniel Wu is an award-winning actor, director & producer. The Hong Kong film veteran, martial artist, and race car driver was a correspondent for *Giant Robot* from 1997 to 2011.

HK FILM REALITY

words | Daniel Wu + GR

I WENT ON VACATION AND BECAME A HONG KONG MOVIE STAR

In June of '97, I graduated from the University of Oregon with a degree in Architecture, for which I busted my ass for five years. Four days later, I threw it all away and took off for Hong Kong to become a movie star.

Actually, I didn't intend to throw it all away and I never even had the slightest thought of becoming an actor. It just happened. I needed a break before starting life as an architect and thought the '97 Hong Kong Handover was a great excuse to get away for a while. **So I gave my parents a slick little story about how I thought it was important to be a part of Chinese history, packed my bags, and left with them expecting me back in a couple of months.**

My original plan was to go, check out the Handover, and then bum around Asia for a few months before heading back home. The Handover was cool; I saw Grace Jones and Boy George perform in one night at a really fucking huge rave. It was way nuts. Here I was, expecting to see some serious communist shakedown happen and it turned out to be just one really big party. After all that stuff calmed down (it lasted about 10 days), I started my travels. I got as far as Taiwan and Japan before money started to run short, so I decided to do some modeling to make some quick cash.

Being a male model sucks. Hardly any of it is the glamorous shit that girls get to do. Girls get to be sexy and are wined and dined and treated like queens. On the other hand, guys do boring jobs and eat at McDonald's. **Most of my jobs consisted of shitty clothing catalogs and cheesy credit card commercials. At least it paid cash.**

After four months of this, everything changed. One of those cheesy ads I did was spotted by a director and I was cast in his film. Two days later, I met Jackie Chan through a friend at a party, and three days later, I was signed up with his agent, Willie Chan. Before I realized it, I was officially promoted as a Hong Kong movie star, meeting great directors, working with stars that I used to watch, being nominated for awards, traveling around the world, and having one hell of a time!

As an HK movie fan in the States, I used to have certain questions about the industry. **Two years and six movies later, now I have answers.**

🐱 E R I C: This is the story a kid from Oakland becoming one of the biggest stars in Hong Kong and a household

How long does it take to make a Hong Kong movie?
DANIEL WU: I've had the pleasure of working on very low-budget films and really high-budget films. The lowest budget and worst film I've worked on is *Young and Dangerous: The Prequel*. This was shot, edited, and released in two months. Principal shooting lasted 21 days. I didn't know what the fuck was going on half the time because we had virtually no script. But this is not even that bad. A recent film, *Mr. Viagra*, starring Anthony Wong, was filmed in six days.

On the other hand, my two most recent films, *Gen-X Cops* and *Purple Storm*, worked from high budgets and took about three to four months for principal shooting and then another two to three months for post-production work. High-budget films are the shit. Director is good, script is usually good, sets are good, costumes are good, money is good...No complaints.

How heavy is the Triad influence in the HK movie industry?
It's not so bad anymore. It used to be really bad. I remember hearing about Jet Li's manager being killed because Jet didn't want to do a movie and shit like that, but since the industry is in a slump and there is no longer any big money to be made, the Triads have worked their way out to other more profitable operations such as video piracy (which is now running fucking rampant here). **Of course, some of the big bosses have been tied to organized crime and probably still are, but I can't talk about that...my family could be in danger.**

Do you need to know martial arts for the fight scenes?
No, but it helps just so you have a concept of what the hell is going on. If you understand the movements conceptually (like I'm supposed to break this guy's wrist and then shove the remaining stump of arm up his ass) and you are a semi-coordinated person, you should be okay. Of course, if you do know some martial arts, it helps a helluva lot. On the other hand, don't ever think because you know martial arts that you can do movie fighting. **My biggest lesson was to realize that after training wushu for 10 years, I still didn't know shit about movie fighting. Things that may look and feel good to you, like a** turning kick, may look like shit from the angle it's being shot at. So you have to adjust. Sometimes you may have to do a kick or punch that in real life wouldn't hurt your own mother but kicks ass on screen.

Do you practice the action choreography?
No. Usually the choreographer will tell you what's going on shot-by-shot. **There is no time to rehearse anything. If it's some kind of big stunt, he might tell you the day before. That way you will shit in your pants and not be able to sleep the night before, but be extra alert for the stunt.** Not rehearsing choreography can be good or bad. It's good in that the action looks fresh and real, unlike Keanu's shiite robotic movements in *The Matrix*. It's bad when it gets messy and people get hurt. I've punched a guy right in the face and slammed another guy's head into a concrete wall because they didn't remember the movements correctly.

What's the fake blood made of?
This is the only consistent item that I have worked with. Each director is different and each cameraman has a different technique, but the blood is always the same. So here's the secret: it's made of cough syrup and a red vegetable dye powder. The cough syrup is that sweet-tasting kind made out of longan fruit or something like that and they just mix it with the dye. It's usually really thick and gooey, but you can change the consistency by adding water. Make some and go scare your friends, but be careful because it stains the skin.

Who are the cool stars to work with?

I've worked with pretty much all the new up-and-comers like Stephen Fung, Nicholas Tse, and Sam Lee. I've also worked with Leon Lai, Shu Qi, Andy Lau, Francis Ng, and even Joan Chen. Of the new guys, Sam Lee is the coolest because he's really fucking funny and a pretty talented actor. I think the fact that he was an electrician and skateboarder before he started acting helps a lot. Francis Ng, who you probably don't know but would definitely recognize, is one of the best "old school" actors. He's kind of weird and quirky when you're talking to him, but he can get into character super fast. Plus, he's just a nice guy.

What's it like to be a celebrity in Asia?

It's really weird. I grew up in the States and I'm really unfamiliar with this kind of lifestyle. First of all, if you're young you're automatically considered a pop star. People expect you to have a dual acting/singing career. I don't know how many times I've been asked when my CD is coming out and I don't know how many times I've said, "Look, I don't fucking sing!" But having any involvement in the entertainment industry automatically means you get treated like a rock star.

On our promotional tour through Asia for *Gen-X Cops*, me and my co-stars, Nicholas Tse, Stephen Fung, and Sam Lee, were treated like a rock band, probably because Stephen and Nicholas are pop singers. We had security protecting our asses from screaming teenage girls. I actually never thought I could be scared of a 14-year-old girl but when one starts pulling on your clothes and screaming, it can get kind of hairy especially since you can't, like, hit them or anything. The shitty thing is dealing with local press who only ask stupid, dumb-ass questions, like where do you shop, how often do you go out with your girlfriend, whether you fold or crumple the t.p. when you wipe your ass. Almost every publication is gossip-oriented, so you can imagine the horror.

Do you get treated differently being an ABC?

Yes, most definitely. It's funny. When I was in the States, stupid-asses would ask me why my English was so good and shit like that (I was born and raised in California). In Hong Kong, people are surprised that I know how to use chopsticks. What the fuck? I eat chicken chow mein for dinner and apple pie for dessert. Basically, if you come from the States and your Cantonese isn't perfect, then you're considered a "gwei jai," a white boy. However, being ABC can help as well, because growing up with a different background, morals, work ethic, etc., makes you different from all the rest. Before there were very few ABC's in the biz, maybe just Michael Wong, but now you've got Christy Chung, Françoise Yip, and Theresa Lee, who've all come from the States or Canada. And then all the up-and-coming kids have either studied or lived abroad for some time, so the local audience is more used to it.

Do you get paid a lot of money to be in a movie?

No. Well, of course the more famous or popular you are the more you can get, but basically it's a lot lower than you think. For my first film *Bishonen* (or *Beauty*) I was paid around $6,000 for a lead role. I've actually made more money doing modeling stuff. But whatever. I didn't really care, plus I got to go to all these film festivals around the world for free!

What's the best thing about acting in Hong Kong?

The best thing is that everybody is busting their asses to get shit done. It provides a really intense, creative working environment. The promotional events are pretty good, too, like traveling around other parts of Asia. Our recent *Gen-X* tour took us to Singapore, Malaysia, Taiwan, Shanghai, and we'll be heading to Japan and back to the States soon. See you there!

words | J. Scott Burgeson

JAPAN'S LADIES MAN
SMOKING CHIBA

Host clubs are great. More and more women are gaining financial independence in Japan, so why shouldn't they be able to enjoy the same things Japanese men do? After all, everyone likes a little special attention now and then. If you're the type of woman who doesn't settle for second best, then you probably go to New Ai, the best host club in Tokyo.

In front of New Ai stands a glass case with photos of the top hosts who work there. Most look like typical pretty boys. Chiba-san stands out. Ranked number three on their chart, he looks smooth, tan, and worldly. He has so much style. He looks like a Japanese James Bond.

So what time did you start work tonight? At 1:00?

CHIBA: I usually come in around 1:30. But the new guys, the new faces, have to come at 11:30 and clean and set up. The club hours are from midnight to 6:00 in the morning. Actually, I usually leave around 5:30. The big spenders don't come late.

I just want to say I think you're incredibly fashionable.

Ah, yes. Arigatou gozaimasu. Thank you very much.

Who made your suit?

Well, this suit is tailor-made. I've got a lot of suits by Versace. I've also got a lot of Versace neckties. Also, Dominic. This one is by Ferré. I wear Versace the most—Gianni Versace.

You must have a fantastic wardrobe.

Oh, not really...

Is it rude if I ask you how many suits you have?

Well, let me see...about 200. Most of my suits are tailor-made, not brand names. If I buy ready-to-wear suits, I usually go for Versace or Armani...but I usually order tailor-made suits. I have my own special tailor. I tell him to use English fabrics.

How does the ranking system work exactly? Is there a lot of competition among the hosts to hold on to the top positions?

It's based on each host's monthly earnings—not by the number of customers who choose him. You may, for example, only have one customer in a month but if you earn 30 million yen, you can become number one. None of the other hosts would consider that person number one, since he's fooled around with his earnings—the customers haven't spent as much as he says they have. Insiders know what's really going on after all; word gets around. None of the hosts who're playin' fair would admit he's number one.

Where are you from and what did you want to be when you grew up?

I'm from Gunma Prefecture. Originally, I wanted to be an actor. After school, I applied to Toei [Studios] as a "new face," and got in. I was in chambara (sword fight or samurai) movies and played samurai. I acted in TV movies as well. Anyway, one time a woman, actually a geisha, suggested I apply for a job at a certain host club. I didn't even want to think about doing such a silly job. I looked down on it. I thought that this was the kind of work that was run by yakuza. Later on, I visited the club and the shacho (owner) asked me to try out being a host for just a month as a part-time job. After the first month, I was ranked number five. In the second month, I became number one. I guess I was lucky I was chosen by good members.

I contacted Chiba-san and he graciously consented to be interviewed. When I met him at the club, I was nearly blinded by his gold Rolex, gold bracelet, and diamond ring, which was bigger than Hokkaido. He even had an 18K gold Dunhill lighter, which probably costs more than I make in a year. He had a deep, dark chestnut brown complexion that glowed, and his hair was super shiny. When he smiled, his teeth were so bright it was like being struck by lightning. He even smelled clean.

How old were you when you started?

I was 23.

That was in Tokyo?

That's right.

And how long have you been working at Club Ai?

It's been 28 years. I worked in Hokkaido for about two years, in Sapporo. An acquaintance of our shacho wanted to open a new club there, so I went there under a contract for 10 million yen a year.

How many hosts work here?

Right now, there are a few less than 80, I think.

Any gaijin?

No—we don't recruit gaijin hosts. In Okinawa, for example, there are many half, but now they've got Japanese citizenship. I used to have an assistant who had a "foreign" face just like yours, but he couldn't speak any English.

How many Club Ais are there?

Well, there's Diana, Gain, and Marilyn. Gain and Diana are mini-host clubs. They're very small, mini-supper clubs,

we call them "host pubs." They don't have a band; they have karaoke instead. They're small. When the hosts become popular there, then they come to a place like this. They're kind of like lessenjo (practice or training centers). In addition, there's a club for onabe—for women who like women. The women who work there dress like men and wear ties and suits. So that's four clubs, and then the main one, which is us. We have the largest number of customers.

Can I ask the name of the owner?
His name? Aida Takeshi. The kanji for "ai" is the same as the club's name. He used to be a host himself, he was number one. After he stopped hosting, he became a club owner himself. I've been with him from the start. I worked as his assistant when I was still new.

Do you know how many host clubs there are in Tokyo?
Well, there are host clubs in Asakusa as well. If a place is small, and doesn't have a band or space for dancing, then we don't call it a host club. It's called a "host pub," just like Diana, for example. There are at least 10 host pubs just in Shinjuku. There are some in Asakusa and in Koiwa, so all together, I'd say there are about 14 or 15 places that can be called real host clubs.

What have you heard about the host scene in Osaka?
Of course, there are good host clubs in Osaka and Kyoto. There's a number one host in Osaka, and I'm number one in Tokyo. If one of my customers is traveling to Osaka, then I'll introduce her to the number one there. And if the customer of the number one in Osaka is coming to Tokyo, then he'll introduce her to me. We number ones are good friends with each other.

Hostesses evolved from the world of geishas. What about hosts?
Host clubs came out of dance clubs. That's why when we first became hosts, we were called "sensei." Originally, we did social dance, like the tango, the waltz, salsa, the jitterbug, and so on. There are customers who come waiting to dance, but the hosts don't want to invest the time and energy to learn how to dance. It's been at least 50 years since the first host clubs opened. The very first host club started near Tokyo Station. It was called "Night Tokyo." It was five times larger than this club. There was a second floor, and there was a sushi bar, too. It was a dance hall. It was huge. Nowadays, there are few hosts who can really dance.

What percentage of your customers are women for the mizu-shobai, and what percentage are just regular women or married women?
Ah, yes...Generally, about 80 percent of the customers are from mizu-shobai. They work in the fuzoku (immoral pleasure trades, i.e. hostess bars, strip clubs, etc.) such as Soapland, health clubs, and so on. Those are the women who have a daily cash income. But personally, I don't have customers like that. **My customers are the wives of company presidents, boutique owners, and owners of beauty salons—female owners, I should say. The kind of customers you get depends on the type of individual you are.** Women from the fuzoku go for guys with a Johnny's type face and bleached hair (Johnny's Office is a famous Japanese talent company responsible for producing such big-name, pretty-faced idol groups as SMAP, V6, and Kinki Kids). In my case, many of my customers are older than I am. So there are different types of customers. It depends on the individual host.

About how many women come here on a good night?

On average? Well, yesterday all the tables were filled with about 30 different groups. This club can seat 80 customers. Last night, there were no empty tables, even the counter was full. There were customers waiting in line. Generally, it's like that every day. The club usually fills up by 4 o'clock.

And what would be the average amount a single woman might spend here in one night?

On average, I'd say about ¥40–50,000. The big spenders, according to my calculations, spend about a million yen a night.

What's it like now compared to in the '80s during the bubble economy?

Yeah, well, generally, the economy's not doing so well now. So I agree that's affected business. It's not that different. This isn't the kind of place where salary earners come, you know what I mean? I hear the clubs in Ginza have been hit hard, but this kind of club isn't directly tied to the economy.

What happens when a women or group of women first enters your club?

When customers first come in, they're welcomed, "Irasshaimase," seated, and offered a quick drink. At the same time, the first group of hosts comes down the stairs. While customers are being served drinks, they're asked, "Your nomination is...?" If a customer says, "Chiba," then my assistants would take care of everything, such as bringing the ice, o-shibori (hot wet towels), and so on.

How many assistants do you have?

In general, as many as 15. Each assistant is guaranteed ¥4,000 a day, that's what I get as well. So the minimum monthly salary here is ¥120,000. After that, how much you earn depends on how much you sell. If you can sell as much as ¥100,000, for example, then you get ¥50,000 from that.

That's 50 percent right?

That's right. It goes on and on and on; the more you sell, the more you get. The more your customers spend, the more you earn. That's how we can make as much as 2 or 3 million yen a month.

And your assistants?

Each assistant gets ¥1,000 per group. If I get six groups of customers, then an assistant will get ¥1,000 for each group. So, he can get ¥6,000, in addition to his ¥4,000 base salary. And remember, I have 15 assistants. If I have no customers, they get only ¥4,000 each. If I have 10 groups, then my assistants get ¥10,000, plus the ¥4,000 guarantee. That adds up to ¥14,000.

And what happens at the table?

You know, we always tell the younger hosts to read the newspaper. But there are many who don't. That's why they don't have a lot to talk about. There are some customers who like playing golf, and others who like soccer or baseball, so reading the newspaper is absolutely necessary. I always tell them to read the paper. Anyway, nowadays, since they don't have so many things to talk about, they usually play drinking games, mainly janken (rock-paper-scissors). That way, they can increase the amount of sales.

What distinguishes a good host from a bad one?

The first thing is looks, in my opinion. Suppose you come here one night to enjoy yourself for the first time. You'll choose a face that suits your taste. Naturally, he should look smart, he should look "intelligent." In addition, he should have sex appeal. In this world, when we say, "Oh, she's nice," the underlying feeling is that we have to have sex with her. It's instinctive, right? In addition to that, being able to dance is necessary. Also, he should be able to sing. If a host can sing well, the customers will ask for him.

Do women ever fight over you?

Yeah, that's happened, women fighting between themselves. Some of my customers are quite feisty. "You've been at their table for too long!" They time it with a watch. "You've stayed there five minutes longer! We're paying the same amount of money. Why?!" Naturally, I say, "Well, they've ordered a more expensive bottle." So then the other table starts to act like rivals. "Well, then we'll take the same bottle!" They start bickering and make a scene. They get really jealous. The best thing to do is not get involved. Ehh...I escape by saying, "Next time. Don't worry next time." Or sometimes, I simply apologize.

Do hosts ever have to go on dohan (dinner dates) with the customers?

Yeah, that happens...with dohans, you have dinner together, or maybe just coffee. Whatever the case, the time is different, that's all. Your pay is still the same. So if a host normally has to start work at midnight, if he goes on a dohan, he doesn't have to come in til 2:30. As for me, if I see someone outside the club, I'm more likely to run out of things to talk about. If I meet someone on a dohan, then I tell all my funny stories before we've even gotten to the club. I'm tired by the time I get here! That's why if someone calls me up and asks, "Do you want to have shabu-shabu tonight?" or "Shall we have fugu?" I tell them, "Oh, I'm already full." After work though, sometimes I go out drinking with customers.

What's the most difficult thing about being a host?

It's difficult keeping the customers coming back. That's the most difficult thing, don't you think? In this world, if you're not popular, then you won't make any money. Besides that, drunk customers are difficult to deal with. Some people's personalities change when they drink too much—they become violent, even if they're women. That troubles me the most. It's tough.

Hostesses really hate it when the customers grope or grab them. Is there anything women customers do that you really hate?

Naturally, if someting happens with a woman who's my type, it's okay. But if a woman who's not my type kisses me or asks for a kiss in front of everybody, that's the most painful. I have to do it, even if she's not my type. Even if she's not my type!

What's the most enjoyable thing about being a host?

That would be the money, right? To be frank, it's possible to earn 4 or 5 million yen a month, no? It depends on your sales.

If someone offered you a job as the president of Sony tomorrow, would you take it or would you prefer to remain a host?

Oh, I'd definitely want to stay a host. In order to be the president of a First Section company, you need a lot of nerves and brains. I don't think I'm capable. Money-wise though, I have no problems. Anyway, I have more freedom being a host. The owner of a blue chip company has to have nerves and a sense of responsibility, since he has lots of employees to look after. In my case, it's just like I'm renting space here. All I have to do is take care of the customers who sit at my tables. I'm the owner of just those tables.

What do your parents think of your job?

Of course they hate it. Things were okay when I was involved with movies, but now...If I try to use my cell phone to make a call or something like that, then my parents say, "Don't use that, you're embarrassing us!" **When I go home in my Benz, people think I've become a yakuza.** That's because countryside people often get the wrong idea.

Are you single?

I'm divorced. I have a daughter and also a son. They're college students. My son always says, "After I graduate, I want to work with you, Dad." It doesn't look good if a father and son do work like this together. My daughter's already grown up. If she calls me "Papa" or "Dad" now, it's like we're out on an enjo kosai (compensated date between an older man and a much younger girl, see also p. 335). I'm her real father, but if she says something like, "Buy me that Chanel," then that makes people even more suspicious!

Do you like to go to hostess clubs?

Sure, sometimes I go. Many of the women who come here are hostesses, so...

So you go as a part of work?

Yes, that's right. But sometimes I go just to look for nice women who're my type. Otherwise, I go out of giri (a sense of duty or obligation). I pay one visit for every six times someone visits me.

From all your experience, what's the secret to making and keeping a woman really happy?
Of course, to let them dream. Almost certainly 90 percent, maybe 99 percent, of the women who come here, I'm struck by how sweet they are. For me, all women are like that. Apart from that, women who aren't in love always become ugly. If a woman isn't chasing after her dream, if she isn't in love, then she always gets ugly. There was one woman who was really ugly, until she met me. Well, my job is to give her a dream. She started to change her makeup, and the way she dressed changed, too. The other hosts said, "Wow she's started to become really pretty, Chiba-san. She's really becoming pretty." She changed that much! Her face changed, her fashion sense changed, everything about her was different. I think it was all because I was able to give her a dream.

What's the meaning of life?

That's a difficult question, isn't it? Well, as I said before, I want to be in love, every day. I have no way of telling what kind of customers will come in each night. All I can do is arrange my schedule, and then welcome the customers. But whenever I see a new customer, I have to admit that my heart starts to beat a little faster. Yeah, I also want to be in love every day. I'm just the same, I want to be in love with the customers.

So love is the most important thing in life?

That's right, it's love.

And after that?

I guess it would be money, wouldn't it? Money, right?

Wakarimashita.
[*Laughs*].

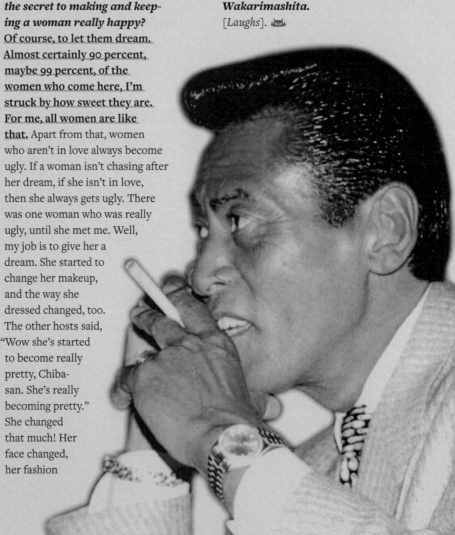

Since the era of Marco Polo, travelers have ventured to China where they marveled at the Great Wall and acquired treasures such as double-embroidered silks, carved jade, gold jewelry, and ornate cloisonné. Today, tourists still travel the eastern leg of the Silk Road to see the sights and bring back similar antique (and not-so-antique) trophies. This spring, I visited China for the first time. There, I sang karaoke, caught the latest Chow Yun-fat movie, searched for bootleg Sanrio goods, and brought home Bruce Lee and Jackie Chan stuff for my friends. That should tell you about my lack of distinction between high culture and low culture. With that disclaimer, here are some impressions of the no-longer-Sleeping Dragon, presented alphabetically.

CHINA
from A to Z

words | Martin Wong

Airports

The first thing you'll notice when arriving in China is billboards. Massive billboards are everywhere, from the runways to streets surrounding the airports. Most are cigarette ads, but some advertise computer companies like IBM or candies like White Rabbit. Getting off the plane, you descend on a movable stairway onto the asphalt. Arriving in Shanghai, I felt like one of the Beatles or some other old-time celebrity that you see departing a plane in newsreels. However, the novelty wore off with each breath of exhaust and every minute that my ears rang afterward. Even so, the vast majority of workers didn't wear masks or earplugs.

Since China's so huge, you'll probably want to fly from city to city. When you do, be prepared for funky planes and funkier food. If you notice Russian writing on the outside of the plane's unusually thin door and '60s-style wallpaper on the inside, you're in a MiG. My ride in an MiG was bumpy, cramped, and scary—when the plane finally lurched to a halt, all the empty seats fell forward. However, you can expect typical meals to include cold piggies-in-blankets, almost thawed chicken, dried fruit, damp buns filled with sweet beans, and chocolates. Stick to the sweet stuff and nuts. As for drinks, cans of local beers and juices are at your request. Pop open a cool haw

(plum) juice and enjoy the fine video entertainment, such as Jacky Cheung karaoke videos and Benny Hill clips.

Those traveling around Beijing should beware of "China's Bermuda Triangle," a poisonous cloud that has swallowed up both pedestrians and planes. Supposedly, rotting plants in the Black Bamboo Ravine (in the Sichuan province) emit a gas that suffocates people and makes them "fall into an abyss." Victims have included Nationalist soldiers in the 1950s and a group of geologists in the 1960s. People still vanish today. Details are unclear, but the missing airplanes must have been flying pretty low when they vanished in the vicinity.

Bowling

Technically, bowling in China isn't much different than bowling in the States. The lanes and equipment are standard Brunswick. However, the conditions and equipment can be difficult. The oil on the lanes is spotty, and the setting equipment jams often. (Once in a while, you'll see an arm reach from above to set up stray pins!) On the bowler's end of the lane, shoes and balls are in short supply. It's unlikely that you'll find anything in decent shape or in the proper size, but what can you do? Most travelers don't lug bowling balls with them.

At the bowling alleys I sampled, the clientele was truly international, speaking

Japanese, Spanish, French, and German. There wasn't much Mandarin, though. Bowling is too expensive for most locals— it costs a little more than it does in the States. As for the international language of bowling, you won't find much of that either. You'll see few spares, strikes, or circled splits on any neighboring score sheets. Bowling etiquette is at a low, too. People hoard balls, and some people even wear tennis shoes on the lanes. As a result, you won't find placards signifying sanctioned 300 games!

I only bowled in the People's Republic (under Beijing's World Trade Center complex and in the Garden Hotel in Xi'an). I hear conditions are much better in Hong Kong.

Cigarettes

Why does the Chinese government even worry about birth control? So many people smoke in the PRC that lung cancer and secondhand smoke will eventually take care of the population. Why do so many Chinese smoke? One reason may be all the cool brands: Double Happiness, Great Wall, Monkey, and more. Another reason may be Chow Yun-fat. Epitomizing cool, he chain-smoked his way through the awesome *Better Tomorrow* gangster trilogy, as well as the cops-and-killer classics, *The Killer* and *Hard-Boiled*.

More men than women smoke in China. This is because women who smoke are

perceived as having loose morals. Even in westernized Hong Kong, more men than women smoke. They smoke everywhere, too. On the street, in the office, in taxi cabs, and in elevators—it's hard to get away from tobacco smoke. As for other varieties of smoke, I didn't smell cloves or pipe smoke once. No weed, either. It would be very foolish to smoke pot in the People's Republic because the government has very strict policies regarding dope. Perhaps this is a result of the country's experiences with opium.

Marlboro Reds are a status symbol amongst the Chinese. Packs go for the equivalent of $5 in the PRC and $10 in Hong Kong. A lot of tourists tip locals with them. Sometimes, busboys will grab empty Marlboro boxes left by tourists, pack them with local cigarettes, and then sell them for a nice profit. **Although it can be hard finding stores or vendors that sell Marlboros, most department stores carry Marlboro-brand clothing. You can also find music compilations on compact discs that bear the Marlboro brand.**

Although coolness is probably the number one reason Chinese smoke, I think that some smoke just because they don't want to work. Why dig holes, build fences, or guide oxen through muddy rice paddies when you could take off your shoes and have a smoke? In China, you can always tell when someone is taking a break to smoke because a pair of shoes will be sitting in the doorway, window, or floor near the deserted workspace. I saw a lot of deserted shoes.

Dominoes

When you're in Tiananmen Square, watching stuff for your friends who are waiting in line to see Mao's body, don't pull out your dominoes. Soldiers will think you're gambling. In China, dominoes, especially the long skinny ones, are used mostly by gamblers. You find really nice sets of bones for reasonable prices wherever you can buy mahjong sets.

In China and Hong Kong, you can hear the shuffling and slapping of mahjong tiles anywhere, any time. A family friend once commented that m.j. is the greatest

game ever invented. Then he added that it's also responsible for stunting China's development by hundreds of years, because people spend so much time playing it. In China, mahjong is truly the new opiate of the masses.

If you decide to buy a mahjong set in China, consider size and quality. Most people like big tiles that sound solid when slapped on a table. Others like the lighter, travel-sized ones. Of the sets made in China or Hong Kong, Chinese ones cost less, but the engraving isn't as nice. Neither is the color. Some of the nicer ones made in Hong Kong are layered like fancy Jell-O, with different colors in different levels. For a little more money, disco fans can buy tiles with gold or silver lamé on the backs. Bargain and you can get a real nice set for around HK $300 (about 45 bucks). No matter what type you purchase, expect a grueling walk back to the hotel—they weigh a ton!

Elvis

While the adults of Hong Kong worked hard to elevate the British Colony into a commercial powerhouse, the kids listened to Elvis Presley. There, Hongkie teens developed alongside their American counterparts on the other side of the Pacific. Chinese guys who copied the Pelvis's look, wearing leather jackets and jeans, were called fai jai in Cantonese. Jai means boy, fai refers to the "flying" hairstyle, long and out-of-control in front, and slicked down close to the scalp in the back and on the sides. Somehow the youth movements diverged in the '60s. As Americans got into sex, drugs, and rock and roll, Hong Kong kids moved in a different direction, toward the polished and produced Canto-pop industry that rules the airwaves and video channels today.

However, Elvis lives on in China and Hong Kong. At least he does in a restaurant in Beijing where I saw his glittering likeness (Las Vegas era), framed alongside traditional Chinese landscapes. Later, in Xi'an, a friend of mine was asked to sing "Love Me Tender" by a friendly hostess in a hotel karaoke bar, too.

Karaoke (p. 108) is huge in all parts of China and Hong Kong. Even in the

most remote corners of the People's Republic, it's not uncommon to see one neon sign with "KTV" or "OK" lit up. In urban areas, it's uncommon not to see one. If you get the urge to sing, don't let language get in the way. In addition to the Canto-pop staples by Faye Wong, Anita Mui, Andy Lau, and other stars, most places offer at least a few discs in English.

Songs my group and I tried to sing include: "Music to Watch Girls By," "YMCA," "Do You Know the Way to San Jose?," and "Top of the World." **At one yuan per song, the price is right. However, if you're a drinker, it can get expensive in a hurry.**

Food

Just as there are different types of food in the United States (Southwest, California, Cajun, etc.), there are also many varieties of Chinese food. Probably the biggest difference is between northern and southern cuisine. In the north, wheat is the biggest crop. And as a result, there are more bread and noodle based dishes. Southern cities, like Shanghai, are also known for their spicy dishes. What most Americans regard as "Chinese food" is Cantonese style, from the south. As Chicagoans and New Yorkers boast that their pizza is the best, the Cantonese boast that they have the best Chinese food. Many argue that the finest Chinese food in the world is in Hong Kong, just a train ride away from Guangzhou/Canton. Not being a big meat eater, I can't truly attest to either's claims, but the dim sum I sampled in Hong Kong was way better than what I've had (and loved) in Southern California.

If you're into meatless dishes, you'll find plenty of vegetarian restaurants in China and Hong Kong. However, most cater to locals, and speak only the local dialects. Ordering may be awkward, but it's worth it. At a Shanghainese vegetarian restaurant in the Tsim Sha Tsui area of Hong Kong, the world was my oyster-flavored sauce. Every dish was spicy and flavorful, as southern-style food should be. However, the clear standout was the faux monkey brain. (Remember *Indiana Jones and the Temple of Doom?*) Each flavorful cluster of mock cortex is crispy on the outside and soft and hot on the inside.

The texture and taste are terrific. We thought we were pretty cool, until we saw another table being served a mysterious coiled dish that looked like snake.

Drinkers should definitely try the local brews. Beijing, Shanghai, and every other town seems to have its own label of beer, and each city is known for a certain type of liquor, too (p. 302). One Guilin specialty has a snake in it. Another contains the penises of various mammals and reptiles.

Guilin

Although astronauts have admired the Great Wall from space and the Terracotta Warriors inspired an excellent movie starring Zhang Yimou and Gong Li, my favorite Chinese tourist trap is Guilin. You may not know where it is on the map, but if you've ever seen Chinese landscape paintings, you know exactly what it's like. Crazy lumpy mountains with stalagmites dripping off the sides rise out of a mist in a lush, green countryside. The climate is tropical, almost like Hawaii's. As soon as you spot the landscape while descending upon the tiny Guilin airport, you know the trip will be worth it.

Generally accepted as the most beautiful area of China, Guilin attracts visitors from all over China as well as the world. If you take a cruise down the Li River, which weaves through the famous landscape, you'll be surrounded by as many Chinese tourists as foreign ones. As the boat worked its way out of the docks, my traveling companions and I broke out the dominoes. Slapping bones is usually a very stylish way to pass the time, but this time we were outclassed by a group of locals who proceeded to whip out mahjong tiles and go berserk. The whole lower deck can get noisy and crowded, but once you get on the boat's upper deck and find yourself surrounded by gorgeous wonderful scenery, you'll feel tranquil and all alone.

The town of Guilin is nice, too. It's small enough so you can walk through it all. You can even rent a bike if you feel adventurous. Check out the bookstores. Books are dirt cheap there—too bad I can't read Chinese. Now I know how it feels to be illiterate. Still, kids books are worth a look. Reading primers have big illustrations of kids learning how to plow fields and shoot guns. Chinese-translated manga are cheaper than their Japanese counterparts, too. If you poke around, you might find some English translations. For fewer pennies, I picked up an English version of the story that inspired the Gong Li vehicle, *The Story of Qiu Ju*.

Hotels

The hotels I visited were designed to provide a lifestyle of leisure. Weight rooms, saunas, tennis courts, and multiple restaurants were standard, as were gift shops with various levels of cheesiness. Too bad most of the aforementioned services were for a fee. At least bottled or boiled water is provided complimentary every day. Beware of snacks and drinks, though. They'll charge you an arm and a leg for them!

The attention paid to lodgers was massive. Most hotels stationed people by the elevators 24 hours a day, waiting to push the "up" or "down" button for you. All of them had guards at every entrance, too. I did feel pampered and safe, but I think there are ulterior motives. It seems to me that the management wants to keep Chinese people out. When distant cousins met my family for lunch at a posh hotel in Guangzhou, they stuck out like sore thumbs—the only other local people were workers. More specifically, the powers that be want to eliminate any possible romantic meetings, of economic or amorous type. Purportedly, you can get into serious trouble if you bust a move on a person of the Republic. That's why a guide strongly suggested to a traveling acquaintance of mine to go to the hotel's massage parlor and not visit an outside one.

Island,
Hong Kong

As a whole, Hong Kong Island is pretty boring. Besides Victoria Peak (and movie settings, if you're a Hong Kong movie geek), the place with a view where rich Europeans live, there's not much to see. The island is mostly for businesspeople, and the terrain reflects that. Deluxe modern high rises and expensive malls sit side-by-side everywhere. There are some cool toy stores and street bazaars, but the good-to-bad ratio is much lower than on the Peninsula side. Even the highly touted Nathan Road shops are overrated. (The Temple Street Night Market on the Kowloon side is a lot cheaper, much more interesting, and slightly less touristy.) Taking a ferry from the Kowloon Peninsula to the island is cheap and pretty, but plan on taking a return trip soon.

One interesting phenomenon that you might notice on the Island is the gathering of Filipina maids by the Star Ferry port. A lot of Filipinas work in Hong Kong, rake in the bucks, and then move back to the Philippines. Many of these maids are well-educated—it's just that the money they make in Hong Kong for basic labor is much more than what they can make at a professional job at home. Presumably, they hang out and talk about the homeland and compare notes about lame Chinese bosses.

I prefer the Kowloon Peninsula side. There's more energy, more people, and more stuff. Stores are open later, too. Even the shopping centers are more fun. (One mall had an entire wing devoted to manga and comic books.) When you walk around the peninsula, you'll notice tourists and businesspeople from Africa, Europe, the Middle East, and everywhere else, too.

I didn't see any punk rock kids or stores, but I did find the BFD skateboard shop [now closed], where I talked to some locals. Apparently, there are about two hundred skaters in the area, most of whom show up late at night in parks. There aren't any ditches and no one builds ramps, so most skaters frequent steps, planters, and benches. Surprisingly, American equipment is more popular than Japanese goods, but both are very expensive.

Like everywhere else in the world, Hong Kong skateboarders are hassled by the cops, and can get ticketed for having fun in public. The BFD skate shop crew is way into hip-hop. They sell mixed tapes made by their own DJ. They promote their own dance club, too, but it had been shut down by the cops when I was there.

Japanese toys in Hong Kong

· · · · · · · · ·

On just about every street and in most malls, there are toy stores that sell new and old toys. Prices aren't much cheaper than in the States, but the goods are quite plentiful.

In two days, I stumbled upon three decent stores from just walking around the Peninsula. One of the better ones was the Superman Model Company [now closed]. It's small, but packed with good stuff for reasonable prices.

Kids

· · · · · · · · ·

Except for hip Japanese kids, there are no riot grrrls, rockabilly cats, straight edgers, skate punks, or even preppies in China or Hong Kong—just kids in school uniforms (or trendy designer clothes). For this reason, if you're Asian and look young, don't count on getting into places for a student discount. In addition to needing a local school ID, you have to be wearing your uniform. If you're serious about saving money, you could probably lift a school uniform off a clothesline somewhere. Everyone hangs their clothes outside to dry in China.

Labels on Jackets

· · · · · · · · ·

You can tell by all the bootlegged material in night markets, street markets, and covert vendors that Chinese people love labels. Perhaps that's why people in China and Hong Kong leave the name brand on the sleeves of their jackets. It can be jarring to see someone who seems well groomed and stylishly dressed, and then notice the tag. (Tags are also on unstylish people's sleeves.) Perhaps this is related to the hip-hop style in which one leaves tags on shoes or baseball caps.

Movies

· · · · · · · · ·

I didn't see any Chinese movies in the People's Republic, because I had seen them months before in the States. However, from the outside, the theaters look cool. In addition to displaying one or two movie posters behind glass, murals are painted on the upper portions of the building. It was good to see a massive depiction of Brigitte Lin, even if it was for one of her lesser movies (*The Three Swordsmen*, costarring Andy Lau). Also, the epic *The Great Conqueror's Concubine* was showing around the mainland, although Rosamund Kwan's image was a little tweaked. Like most of the PRC, the insides of theaters looked kind of beat-up. I wouldn't count on air-conditioning.

In Hong Kong, you won't find double features or reduced prices for matinees, but it's still worth checking out. When you buy your ticket, you can choose from the lower priced general admission or the deluxe "dress circle" area. Either way, your seat is reserved, and an usher shows you to it. There aren't concession stands, and usually, the theater opens up right into a mall or the street. If it opens into the street—look for food vendors to set up camp right outside, stir-frying vegetables, preparing noodles, cutting up pastries, and whatnot. My traveling companions and I caught a matinee of *Trouble Maker*, a goofy Ng Man-tat movie, and the Friday night late showing of Chow Yun-fat's latest, *Peace Hotel*. The former was empty, the latter, packed. Everyone should see *Peace Hotel*, Chow Yun-fat is god.

Everyone says that the Hong Kong movie industry is hurting and I believe it. At seven bucks a flick, it's way too expensive. A booming laser disc and video market (legit and bootleg) provides stiff competition, as does cable television. In my hotel rooms, I was glued to the television—and I hardly ever watch it in the States.

Nose Picking

· · · · · · · · ·

In China, locals aren't afraid to dig away at boogers in public. For most, the index finger is ideal, although some also use the pinky. I think the practice is common because the air is so dusty and dirty. Coal-burning energy plants, dirt roads, cars without catalytic converters, and agriculture add up to lots of particulates in the air. As a result, after you blow your nose, the tissue is speckled like a chocolate-chip cookie. Perhaps nose picking has cleared the way for ear picking. For this job, the pinky seems most popular. Although some people use keys, too. At free markets or vendor stands, you may wonder what certain little jade or ivory scoopers do.

Those ornate tools are for cleaning your ears. Picking teeth is very common, as well. Every restaurant provides tooth-picks with the table setting or hands them out when the meal is over. Fancy places will give you cinnamon or mint flavored toothpicks. Proper etiquette dictates that you shield your mouth with one hand while picking your teeth with the other. (Pretend you're Chow Yun-fat playing the harmonica in *The Killer*.) This way, you don't shoot plaque or food bits at the same people who paid for your meal. If you feel like it, don't be afraid to let out a big belch. It's a sign of appreciation that comes naturally with picking your teeth, especially if you're in a restaurant. This practice seems to be dying out, but a few senior citizens carry the torch proudly. On the other end of the digestive system, small children pee in public all the time. More than once while watching koi fish in the reflective serenity of an ornate garden, I turned to see a parent encouraging a little boy to take a whiz in the lake. A lot of kids wear jumpsuits with a trap door in the back, exposing their buns, too. I didn't see any children laying cable, though. I didn't see any spittoons, either, but spitting is very common in China and Hong Kong. People spit indoors, outdoors, and even in crowds. It's pretty gross.

Old Men

· · · · · · · · ·

You can't avoid old men in the PRC. They use internal radar to sense you're a tourist, and then walk right up to you and stare. Usually, they'll be smoking a cigarette. Often, they'll be wearing kung fu shoes. Sometimes, they'll be wearing an old Mao jacket, cap, or pin. If one starts talking to you, check out

his hands and teeth, both yellowed and tweaked. Thanks to the system, most of these coots have done their time serving the country and get to relax full time.

If you get up early, you can see old men practicing tai chi. On sidewalks and patios, they go through the motions, sometimes with a wooden sword. Once in a while, you'll see one practicing his moves against a tree. You can tell he's been at it for a long time if the bark is stripped off where he hits it. In parks and even parking lots, it's common to see large groups of older men and women going through steps as one, inhaling and exhaling together.

Old men sometimes walk around with a fancy bird cage held up on a shoulder (like the old Panasonic Platinum ghetto-blaster commercials). This is the equivalent of taking a dog out for a walk. One reason birds are popular pets is because the upper class used to keep them in the old days. Another reason is that they don't take up much space; living quarters are small in China. Also, birds are popular pets because they're not livestock, like cats or dogs. Old men are proud of their birds and like to show them off.

You won't see mahjong action out in the open, but you will see old men playing a lot of Go and a little Chinese chess in front of food stands or within parks. Like everyone else, they get around on their bikes. Where are the old women? I didn't see as many of them. They're possibly busy doing laundry, babysitting, cooking, and cleaning. If that's the case, so much for the Great Leap Forward!

Paper, Toilet
·········

If you're looking for a restroom in China, ask for the WC. That's an abbreviation for water closet or bathroom, British style. Before entering a restroom on the mainland, tie your shoelaces. If there's running water, chances are it's running over the porcelain and onto the floor. As for toilet paper, don't get your hopes up. If there is any, it comes in little waxy squares that better serve as coasters. **It's crucial to BYOB (bring your own butt-wipe), no matter where you go,**

especially if you're a woman. Whether you're squatting over a hole in the country or squatting over porcelain in the city, you'll need it (p. 94). Even in the fanciest hotels, where a well-dressed employee opens your stall door, turns on the water faucets, and hands you a paper towel, the toilet paper sucks.

Although the toilet paper quality—and bathroom hygiene in general—is lacking, men's urinals and hand dryers can be futuristic. The urinals detect when someone is done taking a whiz, and flush automatically. (Unfortunately, usually either the aim is off or there's overflow, so someone is always on hand to mop up the wet, stinky floor.) Hand dryers have sensors, too, turning on when you place your hands under them.

It's also important to know that tap water is bad all over China and Hong Kong. Boiled or bottled water is the way to go, even for brushing your teeth. When you take a shower—and you'll take a lot of them if you visit during the hot, humid summer—you'll notice that you feel sticky after drying off, like you didn't rinse well. I don't think the water's good for your skin at all. A few days before leaving for China, I took a bad fall while skateboarding in a ditch. My open wounds remained open throughout my three weeks in China, and actually turned yellow and gooey! Once back in the States, they healed right up. For this reason, I don't recommend long hot showers or prolonged karaoke practice sessions while washing. Who knows what you'll inhale?

Qingping Market
·········

The home province of Chiang Kai-shek, the George Washington of China, and the home province of most American-Born Chinese, Guangdong is also home to one of the most lively markets around. Conveniently located near Shamian Island (where many tourists stay), the Qingping Market in Guangzhou (Canton) is a great way to mingle with locals and soak in National Geographic-caliber atmosphere. It's also free.

Various portions of the four-block marketplace are labeled in Chinese and English: vegetables, herbs, or wildlife. Every table has its own personality (and odor), but the wildlife is the reason to go. Dodge motorcycles and bicycles loaded down with produce or livestock as you work your way down the narrow, dark street. Avoid stepping in puddles composed of runoff blood, guts, and whatnot. Try to hold your breath as you walk by aromatic slabs and carcasses of rabbit, dog, duck, and fish, hanging from string or laying on planks of wood. Admire the skillful butchers brandishing their knives on squirming, flopping, and slithering creatures. (Is that a Ginsu 2000?) Shoo flies away from your face as you go on a search for more of the living.

Look down and check out the shallow but dense buckets of frogs and snakes. Try not to look like a tourist when you notice cages stocked with rats, bats, and possum. Watch a vendor puff a plump rabbit from a stack of cages and toss it into a burlap sack. (Some lucky honey is getting fresh hare tonight.) Watch old men hang out with playing cards in one hand, a cigarette in the other, and each foot on a mesh bag. In the bags, notice turtles trying to crawl away in a Sisyphean struggle. Wonder how one proud vendor coaxed a slouching ostrich into a five-foot high cage, before venturing further in (fortunately) fruitless search for sad-eyed monkeys.

Gasping for air and squinting from sunlight, emerge from the market in search of refreshment. Perhaps the river up ahead will be a nice rest stop. Leaning over the wall, watch a red cloud emanate from a sewage pipe on the market's side, further fouling the already brown water.

If you prefer a little more distance between yourself and the animals, try the Shenzhen Safari Park, conveniently located near the Hong Kong border. Every day at the popular zoo, up to a thousand animal lovers pay HK $20 (about US $2.50) to throw five chickens at lions, tigers, or bears. A sign reads: "Excitement and fun—see beasts chasing after small animals." If this is your idea of excitement and fun, visit soon—Hong Kong's Royal Society for the Prevention of Cruelty to Animals has already begun an effort to

quell the practice, citing complaints from repulsed tourists and startled children.

Roads

I would never drive in China. It's too dense and out of control. Big buses, little taxis, and bikes jockey for position like it's the starting gate of a marathon. Meanwhile, pedestrians cross the street all the time, walking right behind cars, then waiting in between lanes before walking some more. Whenever a car does anything—changes lanes, speeds up, slows down, nears a pedestrian, approaches another car, or whatever— the driver honks his or her horn. Everyone does this. As a result, there's nonstop honking from dawn to dusk.

In big cities, like Beijing or Shanghai, there are as many bikes as there are cars on the streets. In smaller cities, like Xi'an and Guilin, bikes outnumber cars. About half of the bikes have a passenger riding sidesaddle on the rack over the rear wheel. Bike parking is dense and massive. In larger cities like Beijing, you have to pay to park your bike by train stations and markets. If you park your bike in front of a large free market, finding it later can be as tough as looking for your car at a busy mall during the holidays. Once I saw two cyclists duking it out on the side of a road. Surprisingly, I didn't see many more conflicts or collisions. I wonder if there's bicycle insurance?

When it rains, people have no problems riding bikes and holding umbrellas at the same time. They wear bright slickers, too. It must get slippery riding on muddy paths, though. Because China is so dusty, cars get dirty quite easily. As soon as it stops raining, entrepreneurs come out with running hoses, offering to rinse cars driving by, even late at night.

On the side of any road in China, you'll find a lot of barbershops and beauty shops. You can spot them easily because their windows and walls are plastered with headshots of Hong Kong movie stars like Joey Wang, Aaron Kwok, Anita Yuen, and Maggie Cheung. (So why don't more people in China look like those stars?) Not only do haircutters occupy just about every other storefront, but they're also out on sidewalks or in parks. And when stores are closed and restaurants are shutting down, barbers and beauticians are clipping away, doing brisk business even on weeknights. With so much hair cutting available, it seems odd that the Alfalfa look is still very common, even amongst men in suits.

Star Shop

Forget the Warner Brothers store and forget the Universal Studios tour shops. The Star Shop is the cool place to shop [now closed]. The first thing you'll notice as you walk into this jam-packed Tsim Sha Tsui boutique is a notice, letting customers know that everything in the store is official Golden Harvest merchandise. Then when you get to the bottom, you'll see that it's signed by Raymond Chow and Jackie Chan! Look around and you'll be overwhelmed by lobby cards from too many films to mention and autographs and sketches by all of your favorite stars: Chow Yun-fat, Maggie Cheung, Anita Mui, Jet Li, and much more. There are also plenty of artifacts: a jumpsuit signed by Jackie Chan, a motorcycle helmet signed by Andy Lau, and a shrine to Bruce Lee.

What can you buy? Posters? Yes! Cards, mugs, playing cards, stationery— you name it, the Star Shop probably has it adorned with your favorite movie stars. You can even purchase rulers or key chains that contain movie frames from movies that matter like *Rumble in the Bronx*, *Center Stage*, *Rouge*, and *Fist of Fury*. No low budget movies here. There's also a full line of clothing, embroidered with all your favorite Golden Harvest stars and logos, including T-shirts, polo shirts, rugby shirts, and sweatshirts. (You may also find leftovers from Jackie Chan's ill-fated clothing line, mostly of the acid-washed denim variety.) Bring your traveler's checks, American dollars, Hong Kong dollars, or credit cards. This is where I bought most of my friends souvenirs, and this is where I expect my friends to buy souvenirs for me, too.

Tourists

Since China opened its doors, it's become a huge tourist attraction. I heard tour guides speaking in German, French, and Japanese, as well as English (the Queen's and American). On one hand, it's good that different people can check out the Forbidden City, Great Wall, and Terracotta Warriors. However, it's eerie seeing these places full of tourists and devoid of locals. The only Chinese people there are the ones selling postcards and trinkets to the tourists! Still, however touristy China becomes, foreign visitors are a huge source of income for the now thriving China. They also provide the capital needed to renovate the aforementioned landmarks.

If you want to get away from tourists in China, it's not hard. Most visitors are herded from landmark to gift shop to restaurant to hotel without many deviations into the "real world." Just go one block away and you're on your own. What you find may not be polished, translated, or even clean, but there will probably be some friendly people. Everyone I met was really cool and really curious. Many young Chinese people know a little English, too, so don't be shy. Toss out a "Nee how" and then ask questions, bargain, or whatever.

Underworld

Because land is so scarce in Hong Kong, cemeteries are packed. Everyone wants good feng shui, so waterside cemeteries are steep and dense, with rows upon rows of graves. If you want to visit a relative there, be sure to have someone to take you. Without a guide, you'll never find anything.

I happened to be cruising through Xi'an in the PRC during a Memorial Day-type holiday. Groups of people were huddled around fires, burning play money for their ancestors to use in hell. The streets were quite post-nuclear in appearance with lots of big industrial buildings, desolate dusty roads, and

no vegetation. It was straight out of *Mad Max*.

VTV

If my cable company in LA carried VTV, I'd sit in front of the tube all day and night. First, there are the videos. Where else can one see Faye Wong, Sally Yeh, and Green Day all in a row? There was even a Nirvana tribute with commentary by R.E.M. and a bunch of Hong Kong rockers. Then, there are the show hosts. My favorites were Petrina and Shadow. Both spoke Cantonese with seamless interjections of English phrases like, "Know what I mean?" and "Too cool!" and "All right!"

In the music scene, singer and actress Anita Mui (*Drunken Master II*, *Rouge*, *The Heroic Trio*...) was in the news continually during my stay. She recently gained notoriety by including blue lyrics in some of her songs, and then having the audacity to perform them live. Then a few of her concerts went over the 65 decibel limit. All this led to no shows by Mui for quite a while. Everyone was excited because she was planning a big show in Hong Kong.

When I wasn't watching VTV, I scanned the remaining seven or eight channels. There may not be as many channels as in the US, but I found the quality to be much higher. Over a mere two weeks or so, I caught stuff like the *Planet of the Apes* cartoon, Muay Thai kickboxing, *Ranma ½*, *Lum the Forever*, *Throne of Blood*, *Webster*, and the NCAA Finals. When UCLA won the championship, every slam or block was accompanied by the announcer exclaiming "Ay yuuh!" I also saw films starring the likes of Chow Yun-fat, Jackie Chan, Maggie Cheung, and Steven Chow.

Watson's Drug Stores

The difference between Watson's Drug Stores in Hong Kong and Thrifty's Drug Stores in the US is that I didn't see any pharmacies at Watson's. However, it has just about everything else a traveler could possibly want. Watson's was the place to go for bottled water, toothpaste, and more. Check out the bootleg Sanrio goods and selection of *Sailor Moon* merchandise. Look at the cool lunchboxes and impressive mix of Asian and Western candies and snack foods. Located all over the peninsula and island, it's convenient to go into Watson's all the time just to enjoy nonstop Jacky Cheung videos and air-conditioning.

X-mas

No one can accuse the Chinese of being grinches. As you cruise down the dustiest of streets, you're bound to see glitter and tinsel holiday greetings at any time of the year. I didn't see any nativity scenes, but Saint Nick's image was all over the place. Christmas carols are also easy to find in China. While at Children's Palace in Shanghai, a bunch of kids played "Jingle Bells" on lutes. A street performer in Suzhou played it, too.

Why the Christmas mania in a traditionally non-Christian country? I suspect its just an easy way to yank Westerners' plugs. What could sound better to an American or European tourist in the Orient than the familiar sounds of Christmas carols? The songs and the greetings are just ways to loosen Western pocketbooks. I can imagine some schmoe at the tourist trap asking his wife, "How many days until Christmas? Maybe we should buy something for the neighbors too."

Yeti

Here's a chance for *X-Files* fans to make like Mulder and Scully and go on an abominable snowman hunt. In April, the Shennongjia branch of the China Travel Service (CTS) Bureau announced incentives and rewards for anyone who can prove that the hairy biped exists. That's up to ¥500,000 for a live one and ¥50,000 for a dead one. For photos or videos, you can earn ¥30–40,000. If you can pick up an abominable turd, you also pick up ¥10,000 (US$100 = ¥840). If the gold and the glory aren't enough to lure you into the mountainous region of the Hubei province, the CTS will also provide cooking utensils, oil, and grain to any foreign or local Leonard Nimoy wannabes. I didn't learn about this offer in time to take advantage of it, but it's not too late for you.

If you can't make it to China, you can always try Disneyland. Have you ever wondered why there are abominable snowmen at the Matterhorn attraction if the real mountain is located in the Swiss Alps? When the *Mickey Mouse Club* added the snowmen in the late '70s, they should have given the attraction a huge face-lift. The mountain should be named after a Chinese peak. Instead of sporting those tired alpine-style shorts and suspenders, the hosts and hostesses should be wearing something more interesting, like Red Army uniforms or monks' robes. And wouldn't you rather hear Mahayana Buddhist chanting than that annoying oompa-pa music while you're in line? Next time you visit the Magic Kingdom, drop a note in a suggestion box demanding that the Yeti be returned to China, where they belong.

Zip-Guns

Nestled among the cameras, camcorders, and video games in Hong Kong electronics store windows, you'll notice guns. However, these aren't the real deal. They're just plastic replicas (like the Japanese ones described in *GR #3*). The guns come in all models from Zip-Guns to Berettas to MACs, and can easily run up to HK $1,000. You can also buy accessories, such as laser sights for HK $800 (US $10 = HK $760). Don't expect to bring the faux firearms home, though, since customs will take them away. In China, guns are popular, too. I saw a few billboards for shooting clubs and battlegrounds for those who want to play army.

CHUNGKING OBSESS

words + pictures | Bill Poon

The Chinese cabbie had no idea what Cantonese I was speaking and was driving haphazardly through the streets of Hong Kong waiting for me to enunciate clearly and correctly. Like his English was any good. I was left with no alternative but to ask, "Take me to where the hok gwei dwell." That he understood.

LEFT: Watching TV with the air-conditioning on is nice, but sending a fax from your private bath will lead to misfortune. RIGHT: Those who go to the Chungking Arcade seeking Pac-Man or pinball will be disappointed.

The Chungking Mansions were built some time in the 1960s and located in the Tsim Sha Tsui area of Kowloon. The rooms in the 17-story hostel have always been cheap, as they are rented out by your typical green-collared capitalist trying to make a few Hong Kong dollars. My first exposure to the building was from multiple viewings of Wong Kar-wai's *Chungking Express*. It's the site where Brigitte Lin, looking crafty in her blonde wig and sunglasses, suffers a deal-gone-bad with the underground.

When I initially inquired about the Chungking Mansions with my travel agent, she looked at me suspiciously and asked if I knew exactly what it was. My agent was originally from Hong Kong, so she informed me it was a whorehouse until 15 years ago. Cool! "How corrupt could it be now?" I wondered. Besides, prostitutes aren't necessarily bad people. I began reading travel books and online journals, and they agreed there was an element of danger present. One passage read: "Under no circumstances should you travel alone." Another described it as "not the kind of place you'd want to recommend to anyone uninitiated in the seedier side of travel." **My friends from Hong Kong told me they mostly avoided the structure and, in an interview, Wong Kar-wai himself said he was never allowed to go inside as a kid. A local girlfriend warned me not to visit the mansion. Consequently, I booked a room for a night.** My instructions were to go to the fifth floor and look for a guy named Mr. Lim.

As I ducked out of my tiny taxi, I saw a tall gray building, inconspicuous among other nondescript structures. On the wall, a camouflaged sign read Chungking Mansions. As I entered the dimly lit lobby, there were several South Asians milling around in polyester pants and button-up shirts. They approached me like paparazzi and bombarded me with questions: "Do you need a room?" "Do you have a place to stay?" "Where are you staying?" I declined politely, although after repeating myself several times, I had

to be curt. They eventually got the message and left me alone. Because it happened to be Chinese New Year, the building was empty with the exception of a few isolated vendors, a short security guard in blue, and hungry cats.

Trying to find my room was disconcerting. There were no help desks or information pamphlets. The two elevators stopped at every other floor and the mansion was actually divided into five blocks. Flights of steps seemed to be randomly located and some traveled only a couple of floors before ending. The narrow staircases were filled with graffiti and the acrid smell of urine. I saw what may have been blood sprayed across corners. (Or was it catsup? Kneeling over and smelling the stain didn't seem like a good idea.) Most windows were chicken-wired and boarded-up while the few that were open usually led to a trash-filled chasm. Hallways were almost like mazes, and I must have passed the same merchant several times. **My limited sense of direction was being taxed as I wandered aimlessly, approached random exits, walked through alleys, and emerged on the main street before reentering through the primary entrance.** There was no Mr. Lim to be found.

Eventually, a man speaking Cantonese asked me if I needed a room. I declined his offer but solicited his aid, showing him my reservation voucher. He said to follow him and offered me a stick of gum. Figuring he was trustworthy, I trailed him into an elevator where he pressed the 12 button. Errr, my room is located on the fifth floor, my man. But that was bad, according to him. Too many colored people there, he said. He had a room on the twelfth floor, which apparently was much safer, and it was only US $7. I was tired and wanted to sleep, and any place with a mattress was good for me. So I agreed to the room and gave him some money in exchange for a set of keys. I never did get his name.

The bedroom was clean and had its own toilet and shower facility. The television worked, and I found a few channels

LEFT: A short barrier goes up at night to keep out dogs, kids, and Bill. RIGHT: The man with the golden jacket and white pants guards the boxes of carefully packed trash.

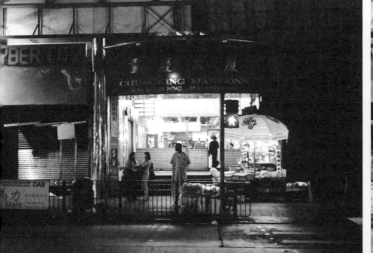
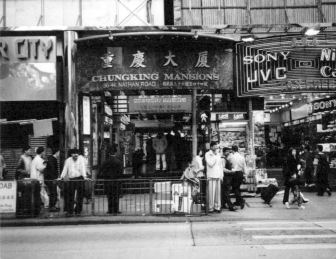

showing anime and music videos. The space was small but ample enough for me and my backpack. Traveling light was a precautionary measure in case I had to bail fast.

For some peculiar reason, the proprietor felt the need to repeatedly tell me that two beautiful young Korean girls slept together on that same mattress the night before. Did he think I was going to sniff the sheets or something? I didn't know and I didn't care. I went straight to bed and fell asleep.

Waking up after an uneventful evening, I grabbed my belongings, dropped off my keys, and made my way to the lobby. The second day offered more activity as stores were opening up, and people began littering the hallways. Breakfast seemed like a good idea, but there was no particular aroma to guide me—only the smell of dry dust and people's travel-worn clothes. Food booths consisted mostly of 10-by-10-foot spaces with a glass counter where you could see the one or two faded orange-brown curries stored in metal containers. I ordered a

cauliflower stew. It was probably once savory, but after days of sitting there it was now diluted of taste. Nonetheless, it was a good complement to the fresh Mexican tortilla-looking chapati and sweet milk tea that accompanied the meal. Savory Chinese food was very accessible in the streets outside, so I think the clerk was pleased I decided to try his cooking. Making small talk, he informed me that food here was primarily Pakistani despite the Indian menus, taking pride in the difference between the two ethnicities, which I had not noticed. Sitting at a booth consisting of a stool and a tiny elementary school table, I watched as small groups of men in business attire gathered to eat, talk, and laugh.

Finishing my meal, I revisited the retail stores on the first two floors of the mansions. Walking along halls lined with empty cardboard boxes, I was greeted by Bollywood soundtrack music playing on cheap stereos. There were several stores selling compact discs, mostly traditional Hindi music. Judging from the faded and poorly printed inserts

Air-conditioning units falling from the Chungking Mansions cause 4.7 deaths annually.

in the jewel cases, they were probably bootlegs. My closest experience to this type of music was the first 10 minutes of *Ghost World*. There were also a few shops selling textiles and suits, but they, too, had few customers. The busiest merchants were barbershops where groups of three or four Indian men congregated and conversed while one friend had his hair trimmed.

There didn't seem to be many women at the mansion. The few I saw were Japanese or European tourists walking to and from the elevator or, on occasion, older ladies dressed in saris with bindis on their foreheads. They declined my requests to be photographed, as did most of the locals. Eventually, I resorted to shooting without permission or a flash.

Navigating through the crowd, I spied a tall white guy in a dark navy uniform being helpful to the people around him. He was a Hong Kong police officer. I spoke to him in English and asked where the action was. He seemed puzzled by my inquiry, although he was a sharp detective, guessing I was from Los Angeles. He was Australian and had visited the States several times. **I asked why I had been warned about visiting the Chungking Mansions. He told me the mansion was primarily occupied by Indians, Pakistanis, and Nigerians—and, consequently, Muslims and Hindus. Considering September 11, he suggested that I not keep a high profile as an American.** "What about the warnings from my local friends?" I pondered aloud. After pausing a second, he said candidly, "The Hong Kong Chinese are extremely racist. They don't like Black people and look down on the Indians and Pakistanis. They don't understand the language and their English is poor." But he reassured me by saying, "You won't get mugged, you won't get robbed, and you won't get killed. It's perfectly safe here with the exception of a few purse snatchings." What about prostitutes? He said there were some, but that they wouldn't approach me. I thanked him for his time and took his picture with the provision that I wouldn't put it up on the internet. I agreed and left the mansions.

Thinking there might be some more activity later, I returned at 1:30 in the morning. However, a chain gate was lowered and only guests were allowed in. So I left the Chungking Mansions wondering what the big deal was. Maybe the expiration date on danger was past due or existed only in a filmmaker's imagination? As I walked away, the last words I heard were, "Do you need a room?" 🐱

The officer from Down Under promised Bill that he wouldn't be mugged or killed, then picked his wallet.

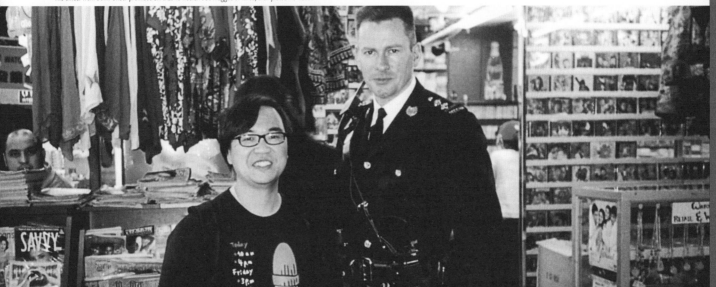

IN JAPAN

words + pictures | Eric Nakamura

The actual trip there happened over one year ago, but these events remain fresh in my mind. Japan has been in the news since the earthquake and now has reappeared thanks to the rising yen and the cult sarin gas poisoning (see p. 200). The yen is currently in the high 80s low 90s. A little more than one year ago, it was somewhere near 105. So imagine the difference today. It's 10–15 percent inflation for an American traveler. Imagine things the other way around. For the Japanese people visiting America, it is even cheaper.

1. NARITA

Landed in Narita airport after being in China for one month. The place is clean and everything is efficient. But getting a cab to my "business hotel" was a $20 ride that lasted about 10 minutes! Business hotels are dives for people on stopovers. My $50 room was showerless and was about a 10 by 10 tatami-mat room. No bed. It was little and I was dirty. I wished it was one of those capsule hotels that can house thousands of people in almost no space. I heard those are noisy since most people who stay at those are drunks who missed the last train.

2. THE NEXT DAY—RAIN!

I took the first train to get out of Tokyo to see my relatives in the Southern Island of Kyushu. Lucky for me, I left early. What I thought was rain was actually a typhoon that swept hard in Tokyo. The trains were terminated for hours, and people were stuck in the train stations waiting for the rains to stop. You can set your watches to a train in Japan. They are seriously perfect in their timing. There are vendors selling box lunches in the trains. It's best to buy your lunch at the station before you board. It's cheaper that way. Drinks, lunches, and so on are more costly on the train, but they are tasty. Bullet trains in Japan are fast. They go over 100 m.p.h. and are comfortable. The stops are broadcast over the loudspeakers in English and Japanese. If you're on a local train, then there's no Japanese.

3. KYUSHU

I stayed in the countryside where my relatives live. It's a town called Maebaru. The advantage of living out of a big city is that the homes are bigger. You may see two-storied ones that are about the same size as a home here in America. If you live in a big city, then you get a tiny apartment that's super expensive. Since Japan is little (smaller than California), the countryside is never too far from a city. It's not like you're in the Mojave Desert or something. Houses in the countryside sometimes have a man-made stream flowing next to it. There are usually frogs and crayfish around. The toilets are usually the hole in the ground type, but they don't smell at all. Air fresheners must be the key. Once a week, a truck comes and pumps out the feces and that's when there's an odor.

4. LOVE HOTELS

These are everywhere and kind of hidden. I learned about these at school and was determined to figure out where they were. But honestly I couldn't tell most of the time. Many of these places have themed rooms. Like ancient Japanese rooms, Las Vegas rooms, cowboy saloon rooms, etc...I guess these exist because families in many cases live together, and the apartments are too tiny for amorous adventures. Many of these hotels are discreet and have vending machine entries. No need to deal with a person. It's all covert. I even saw once in a documentary that there are telephones that have recorded backgrounds of train stations, restaurants, and other places so you can fool your poor spouse!

5. PACHINKO

Cool game that I got lucky with. I think I came out ahead $130. You play the game in crazy Las Vegas–style casinos that are everywhere. Inside there are rows of machines. Some rows will be crowded and some will have no one trying their luck. There are a bunch of theories on how these work. Some say that the nails in the machines are bent a certain way to help you win more. Some say it's all done computer style in a back room, so some machines pay better at a certain time of day. I learned from a cousin that if you go in the morning and pick a machine near the front door, it'll pay off. People want to see a generous pachinko parlor. His theory worked and I won. There are people patrolling often so there's no potential of cheating with magnets. The balls. You buy these in a vending machine. Pick the machine and fire away. I like the Sumo pachinko

machine the best. After you win, you collect the basket(s) of balls, dump them into a counting machine, and then get the receipt. I think if you have one basket of balls, it's usually worth about $70. Some lucky gamblers have stacks of these baskets next to them. With the receipt, you go to the counter to exchange it for goods or for the "pens" that can be exchanged for cash. This part is interesting. If you want the cash, you exchange your receipt for "pens." They are multicolored and used-looking. Since it is against the law for the pachinko machines to pay off in money, there are booths outside where you can covertly exchange the "pens" for money. You cannot see the person in the booth and maybe they cannot see you. But that's how you get the cash. It doesn't seem like any-one cares if this is legal or not. Every pachinko parlor has this booth outside and the "pens" are somehow coded. I have no idea how. Note: When I was in Kyushu, a devastating typhoon was coming close to town. And although there was some panic, the pachinko parlor was still lively and we were in it.

6. TYPHOON

Because we were playing pachinko and having fun, I assumed that the typhoon was nothing to fear. I was laughing when people were boarding up their windows, since I've never been in a tropical storm. While we played pachinko, people were dying in Okinawa and on the other side of the island in Nagasaki. Luckily, the typhoon swerved around where I was staying and demolished some of the neighboring island of Shikoku. I think I heard it was one of the worst typhoons in 50 years!

7. NAGASAKI

I was here in the morning before the typhoon swept in. Luckily, we left before it came. Nagasaki has a war memorial and a museum that has pictures of melted people and de-molished buildings. The photographs were horrible. The city was flat and grey. The films were also sickening. Besides the museum, I saw some of the sights in this town. A long time ago, there was a Dutch town, so I saw some of the settlement homes. The coolest thing is called Castella. It's a Dutch pound cake that's made in Nagasaki. It's famous and tasty.

8. BACK TO KYUSHU

Even in this southernmost island, there are young hipster kids wearing baggy clothes. They look like fashion skaters. American hipster T-shirts are priced in the $50 to $90 range. Used 501s are at least $40 and used scrawny T-shirts are $20! One of the coolest things about the Hakata area is the outdoor food vendors. They serve great food. Watch out for the ramen from this area, it's called Hakata ramen. The broth is made out of what's called tonkotsu and it smells awful, but tastes great. It is white in color since it's mostly pork. Don't get near me if you burp after eating this stuff.

9. COMICS, MANGA

People read this everywhere. On the train, in the bus, while they eat, etc. It's amazing. Every week, many different huge comics come out. These have about 10 stories in them and they are thick. No collecting with these. Everyone dumps them after they read them. A lot of Japanese kids are addicted to these. The day it comes out, they buy 'em. If they go on vacation, they have their friends save the old copies for them. I notice that a couple will go to a restaurant and sit across from each other. And instead of talking to each other while they eat, they whip out their comics and read while they eat. I guess they were jaded. But this happens in ramen shops.

10. MOVIES

Damn expensive, so most people wait for the videos. Movies are about $20. It's an event when you go see a film, and people don't do this regularly. Hong Kong movies are available in Japan on video. Chow Yun-fat is the man. I think I saw *A Better Tomorrow II* dubbed in Japanese and I actually understood a lot of it. You can also rent CDs in Japan, so they can be dubbed.

11. VENDING MACHINES

They are everywhere. You can buy cigarettes, candy, drinks, and even beer. Soft drinks are everywhere. There are too many to choose from. It's not like a lonely Coke machine at a gas station. There are three or even more soft drink machines next to each other. The liquor machines cut off sales at a certain time. Every year,

See #7. TOP: This torii gate was blown in half by the atomic blast. It is a famous landmark. ● BOTTOM: Nagasaki Peace Park. Peace statue points at the atomic bomb in Nagasaki. The other hand is supposedly pointing to the west.

a certain soft drink gets hot. A few years ago, it was a lemon honey drink. When I was there, it was a creamy tea drink that was excellent. Who knows what's hot now. Since I mentioned gas stations—gas is expensive. Although it's in liters, I think it's well over $2 a gallon. The service at a gas station is incredible. It's just like the gas stations from the 1950s here. The attendants are fast moving and energetic. No hicks or rednecks working at these stations. They wear a white uniform, a hat, and run around. When you leave, they help guide you on to the street by stopping traffic so you can get out.

12. SHINTO ALTAR

There are little stone statues on the sides of the roads. That is called Jizo. He is protector of a lot of things, including unborn babies (aborted), people who die in accidents, etc. These are everywhere. Near a relative's place, there is a shrine that has been there for ages. It's not a Jizo one, but something else. I visited this shrine and offered some money, etc. But my cousin decided that since I was there, he should venture into the unknown and show me what was up. As you get further into the shrine, there are more doors you can go into. You can see everything because the doors have big window gaps. But usually, you do things such as pray outside. So we ventured in and got all the way to the

sacred box. Although my cousin has lived in that area for his whole life, he has never opened or got near the box. So when I asked him what was inside, he had no idea, so he took a peek. He described the inside as a statue painted half-red and half-white in a strange pose. Kind of like a Madonna Vogue position. He freaked out when he saw it and went home. Once he got back, he told his parents what he did and instead of them getting mad at him, they were curious at what was inside of the box.

13. NINJA PARK

I went to a small theme park that was a ninja park. You walk through a trail and ninjas pop out to freak you out. Then there's a haunted house, but that was boring. This is what some do for amusement in a small town.

14. EARLY MORNING RISER

While I was staying at some relatives' house, I was awakened at about 4:30 in the morning. The next day when I asked what the noise was all about, I found out that one of my relatives' wife was involved in a new religion cult that has the title of Early Morning Sect. What she does every morning is leave the house at 4:30 or 5:00 to go to a meeting. What happens there, no one really knows. But they whisper about it when she's not around. New religions

have been sprouting since World War II. Many are into these for some odd reason. Lucky I didn't sniff any sarin when I was there. Fortune tellers are also hot in Japan. People line up for them.

15. KYOTO

A small town based on a Chinese city design. It was once the capital of Japan and has a lot of temples, shrines, and religious beliefs. Everything is laid out in a grid, so it's easy to find your way around. Many cities in Japan have no road signs! The area I was at was called Shijo Kawaramachi, which is the popular region of the town. But I slept at a friend's place in the mountains. A $5 ride by train to the city. The trains that go down the mountain are the same old ones that were made probably 50 years ago. The inside has the original wood panels and it makes creaking sounds. The employees of this train line have some interesting mannerisms. I wonder if they are doing the exact same things as the original train employees from back then. They still collect tickets by hand and have a style of driving the trains. They kind of command each other by yells and signals. Employees of other trains didn't do this. My friend in Kyoto is Masa, the beer bottle-opening champ of Japan. He can open bottles with anything and has been on TV to demonstrate.

16. MORE KYOTO

Lots of temples in Kyoto. Also there are make-out parks where teens go to

BOTTOM: *See #12.* Shinto shrine where my cousin decided to be nosy. ● ABOVE: *See #16.* Kyoto couples sit and wait evenly spaced until the sun goes down. That's when the action starts.

make out. I walked into one of these on accident. There is also a river that runs through the city. Along the banks, couples gather to sit and hang out. When you walk across a bridge or are just in that area, you can see them. There's a name for that river that refers to couples, but I forget what it's called. Couples sit perfectly spaced from each other along the banks. So perfect it would be safe to say that there is 15 to 20 feet of space in between each couple and there may be more than 25 couples at the same time. It's a really strange sight.

17. DRUNK AREAS

The drunk area that has a bunch of dark alleys and bars are numerous. There are "pink houses" that have pictures of the girls you can go and meet inside for a high price. And often you can see geisha women pop out of some dirty-looking door in a beautiful outfit. You are also bound to run into a drunk businessman in a three-piece suit pissing in an alley in full view of people. Pissing in public by men is something that people seem to ignore if it's at night.

18. YAKUZA

I saw an office for these dudes right across from the coolest café. The café

is called Pachamama and the dude who runs it has a lot of toys at his shop. His musical tastes are all over the place. He serves coffee and other non-alcoholic beverages. Not many of these type of shops around. Everyone gets drunk instead. Cafés have little chance. The yakuza office is small-looking from the outside, and there is always a man sitting at a table at the front reading a newspaper. Who knows what goes on inside.

19. RENT

It's cheaper in Kyoto than Osaka or Tokyo, and it's a cool place to be. You can find places for about the same as you would in LA and other cities. There are good deals since there are lots of students. I know of people who are paying $200 a month. Of course they sacrifice a shower. To take a shower, they have to go to a public bath. These are common in Japan and a lot of people use these. It's not a perverted thing or anything like that. It's for anybody who doesn't have tattoos. If you have one, you need to wrap it up or go early in the mornings. If not, you're stuck with the yakuza public bath where you might end up screwed.

20. OSAKA

Home of the Boredoms and Shonen Knife and more. This city rivals Tokyo in size and popularity. I wasn't here long but it's seems like an alright place. There is an area called America Mura (town). And here you can buy American thrift store clothes, junk, records, etc. It's like a Melrose, Soho, Telegraph,

Haight Street, but with its own flavor. All different kinds of stuff going on for high prices. I didn't hang out here long, although I had a good punker woman tour guide. Kobe is nearby. Kobe was settled by Dutch people and their old settlement may still be around after the quake. There is a port there also. But I wasn't there long.

21. HANSHIN TIGERS

Osaka's beloved team. This is the best place for spectator baseball in Japan. Yes, Osaka gets a sumo tournament, but baseball is it here. Someone beats on some huge drums in the stands. Many people have noise makers, and during the seventh inning stretch, everyone, almost everyone, blows up these big balloons and lets them go. The sounds from the built-in whistle chorus and it's loud and nutty. After the game, if the team wins, it's party time. The crowd never leaves at the seventh inning, they stay to sing the victory song at the end! If they lose, it's a quick walk with heads down to the train. I saw them win, so it was a joyous event.

22. AQUARIUM

In Osaka, there's a huge aquarium that houses a whale shark. I heard there was once two, but one died. The shark is so huge that all it does is swim in circles. They should set that fish free. But it's a menacing sight. It's like the big daddy in the aquarium. There is a posse of fish and remora that follow the thing around. Their animal fish instincts tell them that they will get the scraps from the

BOTTOM: Lady displaying her Shiba dog. More newsworthy is the Akita breed, but the Shiba is a nice dog that's small. Dogs in Japan are always tied up and are never in a house. ● ABOVE: *See #21*. Balloons at the Hanshin Tigers game.

26. YOYOGI PARK

When you get off of the train, the first thing you see are Persian men selling phone cards. The phones in Japan work only with a card that you buy at a vending machine. No change can be put in. At first it's weird and confusing, but the system works. These men doctor the card somehow and sell them cheap. They have stacks of them in hand. What are they doing there? Evidently they were let in for a while on free visas, but many are now there illegally. At the park, there were signs that said something about it being illegal to be an illegal alien. Makes sense right? The Persians in Japan are all men. I saw no females and they are just about jobless.

27. AT THE PARK

On a Sunday when I was there, there was a flea market at this park. I figure a great a chance to find cool junk, but even these can be expensive. Junk (real junk) sells for high prices. For some reason, there were a lot of Rasta-looking Japanese people selling stuff there. It was also a kind of hippie gathering. Hair wraps and the whole tie dye deal. But the rest of the park on a Sunday is amazing. There are perhaps 15 or 20 bands that play next to each other at the same time. It's funny. There's cheeseball rock bands, pop, metal,

big daddy. The remora just suck. I hope that fish is still doing alright.

23. NARA

Close by to Kyoto is this town that is dominated by a huge Buddha statue. It's one of the more famous ones called Todaiji. My friend's baby girl freaked out at the sight of the statue and started crying and wouldn't stop until she was at least a couple hundred feet away. She would look up and yell in fear. The peaceful Buddha did nothing but sport his archaic smile.

24. TRAIN TO TOKYO

Quick jump here. By the way, I've been riding the bullet train for long-distance trips. Tickets for the train are super expensive. A three week Japan Rail pass is about $600 or so! Super expensive, but you'll actually save using this. I know I did. But there are ways to travel without it. There are local trains you can take, and the trip will take much longer but you can save a lot. This works if you have the time and energy to figure out how to engineer a local train trip.

25. TOKYO

City of Ruins, Pizzicato Five, a bunch of sumo wrestlers, and more. Stayed at a friends place that I met while in Kyoto. This saves bucks. The only

night I stayed at a hotel was the very first day. I stayed very close to the Futagoyama Beya, which is where the Hanada brothers train. The 7-Eleven which was a less that one minute walk was always frequented by a sumo wrestler of some sort. Usually, it was some lowdown scrub. But they were still large. I would go in and just check them out. They seemed pretty boring. They never spoke or anything, they just stomped around wearing their robes and geta (wood slippers). But to be a part of the strongest stable in sumo is an honor and probably explains their attitudes (if they had them). I discovered mochi ice cream at 7-Eleven. Two in a pack for a buck!

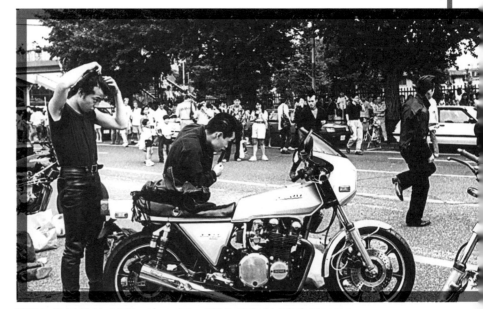

BOTTOM: *See #27.* Rockabilly dude gets his hair ready for some dancing. ● ABOVE: *See #22.* The whale shark at the Osaka aquarium.

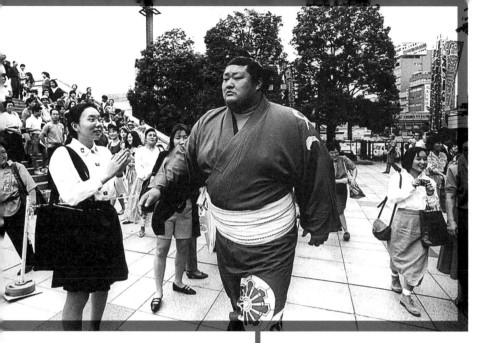

new wave, and just instrumental. Each of the groups had their own groupies. For example, some metal band will have 10 girls in the front and they would all be doing the same head bob movements to the music in unison. Imagine seeing some band and the crowd doing the exact same thing! All of the bands were bad and had to pay to play. A cool thing was that the sounds didn't drown each other out. The best thing there were the rockabilly dancers. There were at least four groups of these guys and girls who would dress a little differently as if they were in gangs from the '50s. The music would be Elvis and they would have a routine dance they would do in a circle with the leader in the center. Most of these people were probably corporate types who slick up their hair on Sundays. It was a trip and they were funny. It made me think that I was in an episode of *Happy Days* or something but in Japan.

28. SUMO STADIUM

I know I've mentioned parts of this before. But to see sumo in Japan if you don't already have tickets is no problem. There are rush tickets in the mornings of each event. You have to line up at 6:00 a.m. and you get the cheapest seats in the house. I think it was $15, but don't go in when the doors open because there are no ins and outs. Once you're in, you're stuck until 6:00 p.m. I went in and sat for

hours and hours watching the scrub wrestlers do their thing. But if you do go in early, you can sit in the expensive seats and watch closely. At about 3:00 or so, the top wrestlers walk in to the stadium from the street, and that's exciting. When they walk in, groupies start yelling, screaming, and running toward them to take their pictures. They come out from their cabs or vans. Some of them just walk from their stable which is close by. I walked by many of these and usually there is a sign with a handprint to signify that it was a stable. The best groupies know exactly which way each wrestler will walk, where they turn off, and who is coming just by the color of their robes. I joined in and took some pictures of these men walking in to the stadium. The best wrestlers enter from the basement, so you don't get to see them unless you are at a different tournament besides the Tokyo ones.

29. SKATEBOARD

I found a Christian Hosoi Hammerhead skateboard in decent shape that day of the sumo event. Someone left it in an abandoned area nearby. Too bad, it was mine and I still have it. It weighed a ton and I carried it home.

30. MUSIC

No punk rock shows I could see. Who would want to pay $60 or so

to see some bands from America? The local shows themselves are about $15 and that's high for some bands you have never heard. Vinyl records are getting tough to find. I noticed that the stores that carry them are tiny. Kind of in a secret spot or something and they are about $20 per record, used! So your old cheapo thrift store records actually have value in Japan. That goes the same with those old T-shirts.

31. SUSHI IS TOO EXPENSIVE IN JAPAN

The only way to eat sushi is to go to a revolving sushi place. They count the number of plates you have and that's how they charge you. A tip, eat the vegetable rolls. The fish rolls at these types of places are suspect. Cucumber roll, pickle roll, these are safe. Ramen and fast food are affordable in Japan. McDonald's is more expensive than here and sport just about the same menu. The funniest places are the fast food restaurants that attempt to disguise themselves as an American place. There's Mos Burger and another big chain called Lotteria. Yoshinoya beef bowls actually get customers in Japan.

32. DEPARTMENT STORES

These are everywhere and multistoried. It is a sensory overload going into one of these meccas. Everything you need is in these places. The basement usually has the food. They sell hot food and the variety is endless. Department stores in Japan are actually fun, since some of the products are crazy. Malls—there are a lot of these also. In every big town, there are malls. Kyoto has a huge mall system that is so large, you would get lost. Many of the stores look the same, so it's tough to find your way around.

33. ON THE PLANE RIDE HOME...

I met a cool dude sitting next to me, so I showed him around LA.

SUMIDA RIVER BLUES

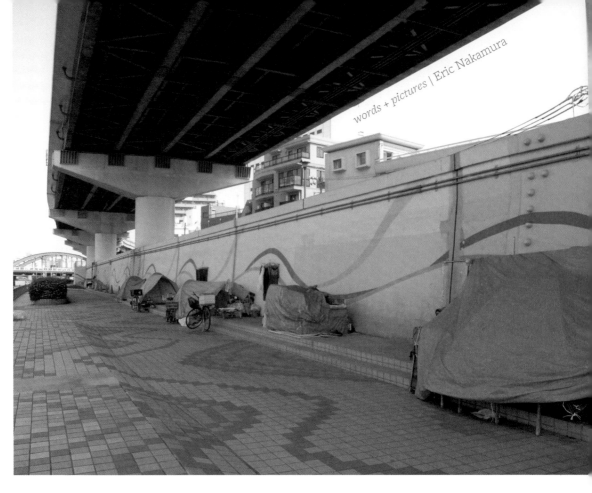

words + pictures | Eric Nakamura

I'm on a mission to make a film for a Scion project, *Easy Ten*. It works like this: you dream up an idea for a movie and they help make it happen. I chose the topic of Tokyo's homeless, many of whom are natural architects and builders that create comfortable homes out of scraps. Teaming up with LA film-maker Sheldon Candis and a local artist and clothing designer Nao Harada, our mission was to find the perfect subjects who: (1) made their own domiciles, and (2) would be willing to talk on camera. The project started out as an architectural statement about the homeless in Tokyo but became a series of personal stories about the lives of homeless friends.

The Shin-Ohashi Bridge is one of many that span Tokyo's Sumida River. All day long, people drive, stroll, and pedal across it, admiring the view of water and passing boats. The area is in no way frequented by tourists—except for fanatics tracking down locations of pieces by hall-of-fame woodblock artist Ando Hiroshige. The bridge appears in two of his more famous pieces, *Plum Garden Over Shin-Ohashi Bridge* and *Sudden Shower Over Shin-Ohashi*, both created centuries ago and immortalized in books and prints. (Today's Shin-Ohashi Bridge is a 1976 remake of a 1693 bridge, and it's certainly different with its glowing green lights at night.)

From Metropolitan Tokyo, it takes a few transfers to get to Hamacho Station, which lacks the high convenience-store-and-vending-machine-per-capita ratio compared to many others. If you mention the station to Tokyoites, most will have no idea where it is located.

It's only a few minutes' walk from the station to the riverbank, and along the way we cut through Hamacho Park where we see a destitute-looking gentleman sitting next to a huge cart filled with dozens of pieces of cardboard. We approach the bridge with its illustrious history, but we find that the structure doesn't begin to explain what's there. As is often the case, the true story is told by what's underneath.

Some of the first things you'll notice along the riverbank on the east side are two shed-like structures. One is a green box with a silver arched roof—which we discover was built to deflect careless cigarettes thrown over the bridge. The second is blue, yellow, and speckled with bird droppings. Its door is comprised of crisscrossed packing tape. Armed with cameras and rehearsed lines of introduction, we slowly descend the staircase toward the dwellings.

ERIC: Scion was a boxy car released by Toyota, and with their marketing arm, I did some of my best work with them. Aside from

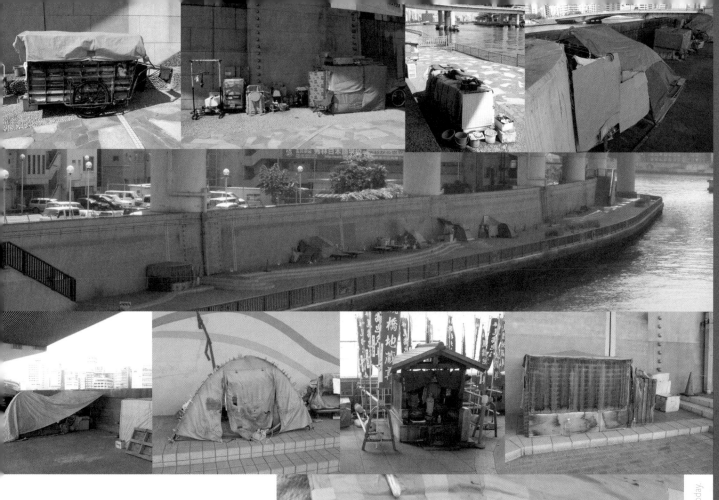

In Japan, people don't stop and talk to strangers. They won't ask for the time, directions, or if you can make change for a parking meter. Meanwhile, Americans will ask anyone anything. It became our M.O. for me to introduce myself as a Japanese American to start conversations. Then, when it came to details about what we were doing, Nao would step in and negotiate. Sheldon, an African American with a big smile and, according to many, a resemblance to MMA fighter and celebrity in Japan, Bob Sapp, worked as a curiosity factor. When I interviewed *Wings of Defeat* director Risa Morimoto, she said that **only an American could come to Japan, ask questions that a Japanese person wouldn't, and make a documentary. Now we are those people.**

The project gets underway quickly. An elderly man peers from the yellow and blue hut, and we say, "We're filming a documentary." We've woken him up, but he's happy and friendly—obviously a morning person. He steps out

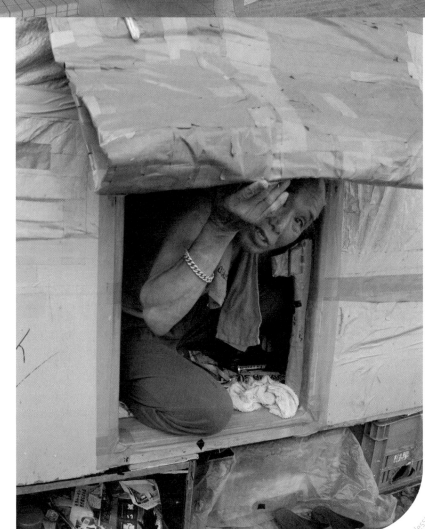

Sheldon Candis—the filmmaker—went on to make a film, *Luv,* starring Common, and is a working director today.

designing my own car, I produced a film about two unhoused men who lived along a river in Tokyo. Why not use Toyota's money to make a film that highlights homelessness in Japan?

and shakes our hands. His neighbor emerges from the green house. He says not a word, but in strong gestures, he gives us the signal that it's okay to film. With two MiniDV cameras, we have a somewhat professional look, and the friendlier of the dudes keeps asking the same question: *How much is that camera?*

We film morning routines like the making and drinking of instant coffee, getting dressed, and having a smoke by the river, but still aren't sure if these should be the subjects of our film. We see plenty of other houses along the river and decide to check them out. But before we can leave, the two warm up and begin joking around to the point of one of them hopping on our skateboard, pushing mongo style, falling, and nearly breaking his back.

The idea of documenting houses of the Japanese homeless came from a book titled *Zero Yen Houses* by Kyohei Sakaguchi. The photographic collection is divided into various locations around Japan, with images of dozens of homes. Many look similar with their blue tarped roofs—as if they were built by the same person. There's little imagery of people or information about their lives, and that's what we hoped to explore with our documentary.

One of the chapters in the book is about Miyashita Park, which is not far from the trendy area of Shibuya. While scouting, Nao discovered that the park's naming rights had been acquired by Nike, which plans to erect skate ramps and a café at the location. Over 30 homeless people were purportedly forced out. Ueno Park, which is in a more recessed and less cool area, once had one of the largest homeless populations numbering 1,000, but was also recently cleared out. Even though a study puts the number of homeless in Tokyo at 5,000—which is considered miniscule in comparison to the homeless in other countries—they still have to live somewhere.

We walk northbound up the river towards Asakusa and see small settlements on both sides of the water. A man wearing a vest and a baseball cap is packing hundreds of cans into a bag that he'll take away on his bike. As we look at the area and take photos of his setup, he asks us in a scowling voice, "What are you doing?" After we explain our case, he immediately backs down and says, "No problem. Shoot pictures." He packs up and rides away to collect a few dollars.

Like a small platoon of soldiers, we proceed past more homes that aren't what we want. We see more homes a half-mile away and come across even further along. One has a maneki neko (lucky cat) mounted on its corner. I decide to knock on the "door."

Inside, Mr. Miyashita sits in his shorts and reads a newspaper. There's not enough space to even stand but he's friendly and allows me to take photos. Most of the folks we meet won't allow us to interview them. **Some don't want their families to see them and others say they owe money to loan sharks.** One even claimed he was wanted in both Japan and the US for his involvement in the

open case of Japanese businessman Kazuyoshi Miura, who allegedly murdered his wife in Los Angeles. While Miura currently awaits extradition to California to be prosecuted, the alleged accomplice sits in front of his makeshift home next to a mosquito coil. In front of him is a mountain of used books gathered from recycling bins. He'll eventually sell them to used bookstores. He's friendly, and wishes us luck.

Eventually, we come across the final cluster in the area. We've walked for miles in blistering heat and humidity, and approach one final person who sits on the ground between two homes and although he's friendly, he too doesn't want to appear on camera because he doesn't want his family to see him. Cross-legged and hands together, he bows in a Buddha-like manner amidst his reading material.

Later on, we reconvene and concur that our first subjects were best. Perched under a bridge, the green house was the most outstanding in the area. His neighbor's home, although noticeably cheaper in quality, served as good juxtaposition. We eventually dubbed them R2-D2 (the brainier mechanic) and C-3PO (the PR man).

But when we show up early the next day, they're both gone. The homes are "locked" up. The door on the green house is open but is hidden from public view since it faces a fence. The yellow house's entrance

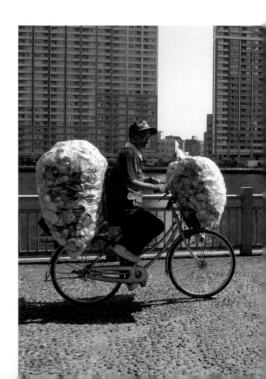

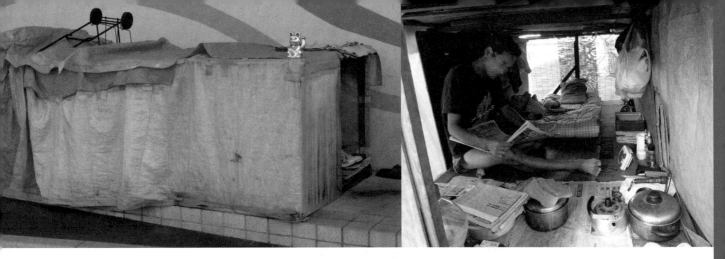

is tied down. Plans for an easy day of shooting foiled, we decide to shoot some establishing shots and interview a fellow who watches us. He's Mitsuru Imai, a casual smoker who sleeps next to his friends' homes and is an out-of-work magazine illustrator in desperate need to speak to anyone.

Our interview with "The Artist" begins with long-winded rambling about his career and what he's done. He cites magazine gigs, karaoke images that could be seen across Japan, and the fact that he did hundreds of illustrations a year. He wears a baseball cap and gray clothes, and could use a shave.

Sheldon and I are happy to roll tape on The Artist, but questions revolving around how he became homeless, who his family is, and what his dreams are yield short answers. He'd rather share work stories, so we ask him to sketch a passing boat as he talks about his family. They live in Osaka, he has their digits, and he sees them once a year. The divorcé still hopes to be reunited with his family, although the chances of that happening are grim.

Without much hope in getting back on his feet, he seems content to read on his bench. After making stops in two other homeless camps, he only recently arrived at Sumida River, and we talk for an hour. He has already written a song called "Sumida River Blues," and it doesn't sound half bad.

R2-D2 and C-3PO are in a crabby mood when they return, but it's 7 p.m. and dark. We need to shoot them or else we'll have to start over the next day. We offer ¥2,000 (about $20) and their moods brighten up immediately. From his yellow house, C-3PO says, "I can be bought. I like money."

It turns out the quieter, more mysterious resident of the green house spent the day betting on horses at an off-track betting location. He brags that he wagers ¥100 ($1) each race and comes out ahead because he's a pro. He's been gambling for 50 of his 68 years and is proud to call himself a lifetime gambler. Short on hair but energetic, he's thin and wears Hawaiian shirts inspired by his fandom of Elvis.

"Lifetime Gambler" has been on the streets for 20 years. He won't give us his real name, but he says he erected both houses. His house is made of corrugated plastic with hundreds of nails driven in neatly, one inch apart. **It's the only home of its kind in the area, and perhaps the only one made from professional, bought materials.**

When we mention that it's the best one we've seen, he squirms and smiles. Cute would actually be a fitting description. The house is raised off the ground on concrete blocks with wheels in case it needs to be dragged elsewhere. If a typhoon floods the riverbanks, he can either go upstairs or even sit inside. (His neighbor snickers, and says he never sits inside and always flees to higher ground.) A portable gas stove sits outside of his door, where we filmed him eating a dinner of cold noodles and a thick slice of

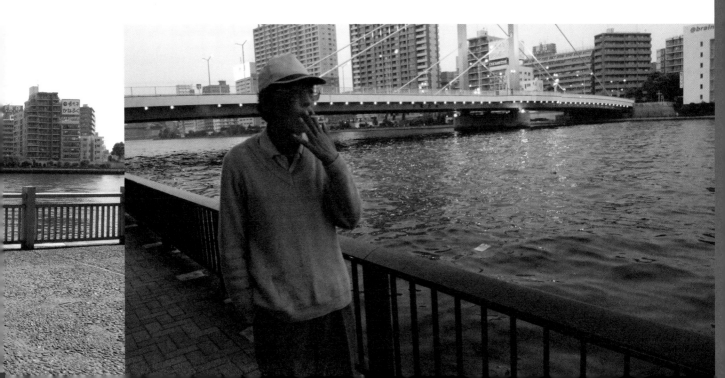

bread. He breaks off the crusts and pitches them through the fence of his door for birds to eat in the morning.

Our subject is elusive in his answers but often refers to gambling. Perhaps accidentally, his neighbor tells us that Lifetime Gambler receives money from the government every two months that goes to his bank account. We infer it's around ¥300,000 ($3,000), which isn't enough to live in a local apartment. (Whether seniors receive enough pension money is a hotly contested topic in Japan.)

Receiving a stipend and paying no rent, he points and laughs at the apartment dwellers on the other side of the river who can't go gambling every Saturday and Sunday. He won't divulge any information about his family except that he visited his father's grave 10 years ago. He frequently points to his legs, and loves kicking them to show he's got vitality and can walk everywhere. He jokes that he still fires

up wood in the morning, although he admits that females are in the past for him. Still, he doesn't get lonely and seems to miss no one. Although 20 years of street living has hardened him, his sense of humor and energy remain intact.

When I sit inside his palace, I'm surprised to find that it doesn't stink. There's a CD player, a flashlight, and manga, as well as a liquor bottle with flowers just outside of the door. We follow him while he does his laundry routine that includes taking a plastic bag, dirty clothes, and detergent to the Hamacho Park public bathroom. There, he fills the bag with water and shakes it violently until it suds. He empties the water onto the floor, and then repeats the routine a few times to rinse the contents. Without an iron, he rubs the collars flat on his shirts and hangs everything next to his home.

It's Monday, and ironically a national holiday in which grandchildren celebrate their grandparents. But the Lifetime

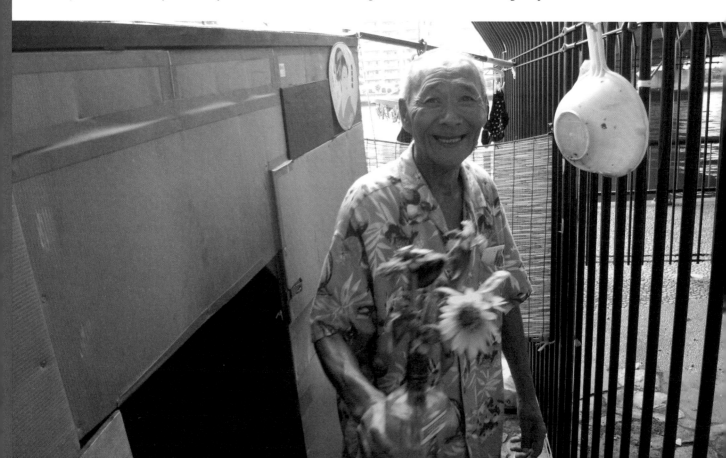

Gambler is celebrating despite being separated from his family because there's an extra day of gambling. The horses are running, so he waves and walks away.

His friend is a lot more forthcoming. We mic him up, and learn that he's homeless because the place he once stayed, a Korean Christian center, closed down. He opens his wallet and shows us a Jesus image. He also has a small cross.

The Christian homeless friend is a lot more emotional, gets lonely, and misses his family, but has a debt that created so many problems that he needed to hide out. He says his family actually lives nearby, but has no idea that he's homeless.

More of a gramps-type guy, he says "Hello" to folks who walk by, including security guards who seem to know him well enough to share a smile. We conduct our interview with him while he sits at his house. He's open and free, holds nothing back, and even shows us his camera collection. I'm not sure what he photographs and he has no images to show us, but his gear includes both film and digital equipment.

The interior of The Christian's place is also devoid of bad smells. He has pockets made of tape and paper affixed to his wall, where he stores pens and many other "household" items. He poses for photos and shows us a tattoo that he claims isn't gangster but a product of his youth—one that couldn't have predicted he'd be living on the streets at the age of 65.

As we conduct the interviews, I notice people stopping at the bridge railing and staring down at us. A policeman in his koban (police box) just above us watches us with no intervention. Families walking down the river on this holiday day peek at our production, too. It's not often cameras roll on homeless folks at Sumida River. Our final subject is proud to tell passers-by that he's part of a documentary project made by a crew from America.

The current Shin-Ohashi Bridge will stand for decades or perhaps centuries. But if you can imagine it as a Hiroshige woodblock print—crossing the river as people cross above and ships go underneath, and apartments dotting the background—along its banks you would also see folks like The Artist, Lifetime Gambler, and The Christian sitting in their zero yen houses. 🐱

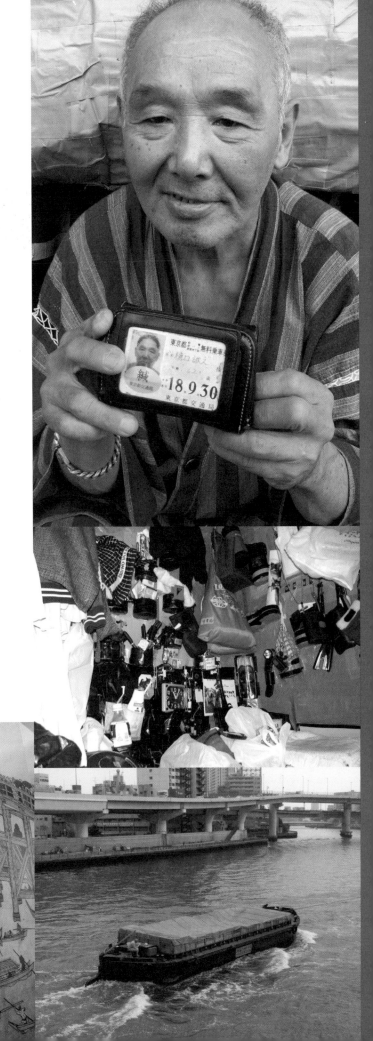

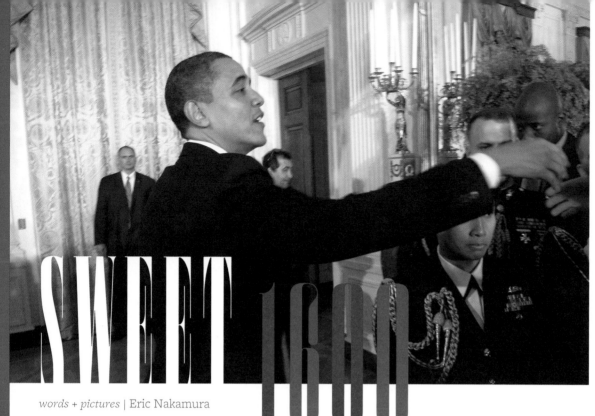

SWEET 1600

words + pictures | Eric Nakamura

THE EAST ROOM
This is where announcements and speeches are made. I've since seen more than a few speeches in this room on television and, because the room is used so often, the stage platform gets moved around so there are different backgrounds. The president's small talk is as good as anyone's, and he's definitely a cool and personable guy that can relate to anyone. It was odd how some people didn't care to meet him, and just split out after the event.

The White House is the single most symbolic and celebrated building in the history of the United States. Its significance extends far beyond being the residence of the president; it symbolizes an entire political system. The structure is adored by an unending stream of tourists who can get nowhere near the front door yet, for the same reasons, the building is maligned by haters all over the world who would rather burn or spit on its image—except when it appears on a $20 bill.

On a Friday, a one-line email arrives in my overcrowded inbox, saying in the simplest terms, "I want to invite you to the White House." The skeptic in anyone raises spam force fields and apprehension at being asked to send money to the deposed Prince of Nigeria or the CFO of Hang Seng Bank. What's one supposed to think?

But I make the appropriate call, and it's real. My security check (requiring only my name and social security number) clears and I find out that I'll be the youngest member of an entrepreneurial group that will hear President Barack Obama speak about small businesses in three days, on Monday, March 16. Carrying Hugo Boss over my shoulder, I get on a red-eye flight Sunday night to Dulles Airport outside Washington, DC. **Before we take off, I receive a text from a friend, saying, "Have a safe trip. My friends are stoked that an Asian bro meets the President. Thanks for representing."**

After landing in Washington, DC, at 7:00 a.m.—much too early for the 11:30 meeting time at the southeast entrance of the White House—I take a cab to the Mayflower Hotel, which is infamous for being the hotel of choice for politicians and their affairs. (In 2008, Eliot Spitzer, the governor of New York, hired a $1,000-an-hour prostitute who met him in Room 807.

It was also the site where Clinton was photographed with Lewinsky.) I make a straight line to a bathroom toward the rear of the hotel, and use the handicapped stall to transform myself from just another guy to White House-worthy.

The line to a white tent at the entrance begins at 11 a.m. From there, it's a fast walk past a Secret Security checkpoint with guards in black military gear. They look unbeatable. We're led into the White House through a long hallway dotted with photos on one side and picture windows on the other, framing a nice view of the Washington Monument. From there, we ascend a flight of stairs to the columned Entrance Hall and the sweeping Cross Hall that provides access to the Red Room, State Dining Room, Blue Room, and the East Hall. Dozens of us mill around and most of us don't know each other, but I recognize Pat Tenore, who owns RVCA Clothing. He looks bewildered, is short on words, and, like me, his eyes are darting everywhere. We walk by a sign that specifies no cameras, bags, etc., but it doesn't seem to be enforced; everyone's cameras and cell phones are out, clicking away, including mine. How anyone could possibly refrain is beyond me.

As the shock of being at the White House wears off, I begin a self-guided tour of rooms where past presidents entertained foreign dignitaries and First Families ate dinner. Each room has high ceilings, antique furniture in perfect condition, and a collection of oil-painted presidential portraits. Eventually, everything feels quite normal and comfortable. After all, **there are better antiques, better art, and larger buildings; the White House just has more history, baggage, and mystique. None of that prevents me from uploading a live photo to Facebook via iPhone.**

ERIC: Dr. Konrad Ng, a friend of ours, is Barack Obama's brother-in-law, and that closeness is jarring at first,

(1) The Mayflower Hotel is about a 10-minute walk from the White House. (2) Me about to use the john. (3) The view of the Washington Monument from the downstairs window. (4) The protestors' demonstration was definitely Guantanamo-related, but some were fat. Bad casting. (5) The White House piano player can get funky. (6) There were portraits all over each room. That's me with a portrait of Bill Clinton. (7) Lincoln and me. This was my favorite painting, right next to a Kennedy portrait.

Finally, it's time to enter the large multi-chandeliered East Room, where the media has already assembled behind a roped-off area. (I am later told by my mother that she saw me walking into the room on television.)

Secretary Geithner and a few small business owners give preliminary speeches while Barack Obama gives them full attention. Then the 44th president takes the podium and goes into a short talk about the importance of small businesses and the credit lines and loans that are needed to help them survive. The entire event doesn't last long, perhaps 20–30 minutes. Dozens of cameras flash at the president's every gesture and smile. Hands with cell phone cameras are up in the air. We visitors look around the room to take the event in, wondering who among us in the folding chairs are Secret Service agents posing as small business owners. Is it the Asian guy who doesn't seem to mix in with everyone else on the guest list?

After the event, Obama stays to meet the people. He's flanked by security, but smiles, makes small talk, and listens to super-abridged versions of their stories. Using skills cultivated by years of cutting to the front of concert audiences, I grab Pat and weave through the rows of chairs and people to a spot where the president will pass on the way out of the room. When we intercept the commander-in-chief, Pat calls for a shaka, which doesn't happen. I catch Obama's attention and

say, "Thanks much for inviting me to your house," to which he responds, "Thank you." His grip is medium, and you can tell from his vibe that he's quite personable.

Obama leaves the room through a side door, and it's downhill from there. There's nothing left to do but look at paintings and statues. We come to find that the coat check area is actually the White House movie theater. The person working the room tells us that it was once an oatmeal color, but Laura Bush made it antique Americana in bordello red—akin to *The Best Little Whorehouse in Texas*, she says in a quiet-yet-matter-of-fact voice. We take our time reaching the exit, finding reasons to stall here or there.

Outside an adjacent building, Yosi Sergant meets us and says exuberantly, "You were just in the White House!" Sergant used to do PR in Los Angeles, but is now in Washington, DC, pulling some strings and making a difference. The current White House administration has brought more creative people to its doorstep than ever before, so while my journey has been fun, it's also symbolic. The inclusion of *Giant Robot* is an acknowledgement of the value of a sliver of Asian America and indie entrepreneurship to the country, culture, and economy.

Walking away from the White House as onlookers gaze and take photos, Pat and I go our separate ways. Ironically, he is on his way to New York to secure some loans. I slowly make my way back to the airport for a flight home. 🐱

(8) The chandeliers in the East Room are massive and nice, but I don't think anyone looks up to see them. (9) Pat from RVCA gives the shaka and the media waits for us to turn around. (10) In the center is Yosi Sergant, a guy making a difference and helping others do the same. (11) That's how close I got to the man in charge. When I put photos online, more than a few females remarked how they think he's "hot." A hot president—that's pretty cool.

but seems less weird in retrospect. We all do something, even if it's nothing, and President is a job that someone does, much like an editor, publisher, or owner. Over time, the big "whoa" factor goes away, and what's left? We're just people here with multiple levels of despisal and likings.

NATASHA PICKOWICZ

I'm eating a bowl of fried rice right now, the dish of my childhood. Every Chinese household has their own way of preparing chǎo fàn, of scrimping and pushing together simple ingredients, bound together with old rice and a little oil. But I only know my mother's way, which later became my way.

Eating together as a family was a nightly, non-negotiable ritual, and my mother cooked traditional, simple, northern Chinese food almost every single night. In the rare instance that I was allowed to miss dinner, it was for something "worthwhile," whether extracurricular (crew team, volunteering, classical piano) or academic (calculus tutor, SAT tutor, Latin tutor). On those nights, fried rice was my on-the-go food, easily scooped into a porcelain bowl or packed into a Tupperware container. If I was lucky, my parents would allow me to attend punk and hardcore shows at the local all-ages venue, permissible

to them because it was straight-edge, vegan, and conveniently located on the UCSD campus where they both taught. My mother would thrust a bowl of fried rice into my hands, making me promise I would eat it on the way. I'd pass it around in my friends' cars, trading bites until the rice was gone.

My mother's fried rice was a coveted prize among my white friends, who mostly understood "Chinese food" through a whitewashed, Americanized restaurant experience. My mother's fried rice really didn't taste like anything from the suburban malls in our neighborhood, which sat out in chafing dishes, shiny underneath the dangling lamps. My friends were surprised to see that my mom's fried rice wasn't just dotted with a few errant, freezer-burned peas and carrots. Eating a bowl was like being inside her vegetable garden, steady with life; it was like standing at the bottom of the deep canyon our house sat on, which glowed with low light.

Even though I never realized this, what my mom was making was soul food—nourishing, simple, tender meals that provided an antidote to the commercial, office park chains that plagued southern California in the early 2000s. When I was 16, before my school's big winter dance, I hosted a dinner for my friends and our dates at our house. We were so tired of Coco's or Hard Rock Cafe, typical pre-prom choices in San Diego at the time. By popular request, my mom made only one dish: a showstopping platter of fried rice, crowned with knuckles of lobster meat and shredded short ribs from 99 Ranch, dotted with sweet peas and ribbons of scallions and snow peas. My friends and our dates lined up for photos before we left for the dance, our bellies bulging from dinner.

But my mother's approach to fried rice is not static. As her years in California began to match the years spent growing up in China, the fried rice began to transform, too. Art is

FOOD

the way that we can document and note such cultural and diasporic transformations; *Giant Robot* shows us, with humor and with grace, how our seemingly idiosyncratic and personal traditions—particularly around something as quotidian as rice—make us part of a larger, ineffable community.

When I was little, my mom still fried lap cheong, a fermented pork sausage so sweet I called it "meat candy," into crispy, greasy coins. A few more years went by, and she cut the sausage out of her fried rice repertoire completely, replacing it with wild-caught shrimp or local scallops from the Whole Foods down the hill. She relied less on the sodium from soy sauce to season the rice, and more on flavorful aromatics, like green onion and Thai basil. A scoop of brown rice replaced her standard jasmine.

Like twisting knobs on a stereo, my mother gradually increased the amount of vegetables and decreased the amount of rice, until the flecks of rice became the negative space against which the "goodies"—what she'd call vegetables like broccoli, carrots, celery, and mushrooms—would shine. She began to introduce more Western-style ingredients into her rice, like blanched broccolini and sautéed kale. No two iterations of her fried rice were the same. Like so many great home cooks, there were no recipes; nothing was written down. The food sprang from intuition, experience, and passed-down technique. It was the meal of our everyday, but also the meal of celebration, special occasions, and opulence—the same joyful spirit of sharing and improvisation that drew me to punk and DIY music scenes.

Now nearing the end of my 30s and 3,000 miles away, I've inherited my mom's love of experimentation and resourcefulness, which is really what fried rice is all about. Lately, I've been playing around with mixing and matching leftover grains. I crisp a mixture of barley, farro, rice, or quinoa in a hot pan shimmering with oil. I unearth the forgotten, wilted ends of vegetables—greens more grey than green, broccoli emitting a low-level funk, frozen peas, furry with freezer burn—and chop them into a fine rubble. The whole mess comes alive with a sputter of sesame oil, a thumb of fresh ginger, a few twists of white pepper. A hot bowl is healing and plentiful. Is it still fried rice, if I add a scoop of lentils, a handful of cooked orzo, some mint or crumbled bacon? I think my mother would say that it is. 🐱

Natasha Pickowicz is a chef, writer, and a three-time James Beard Foundation Award finalist. Her work explores the relationship between food and social justice, with her recipes woven into stories about food history and her own family.

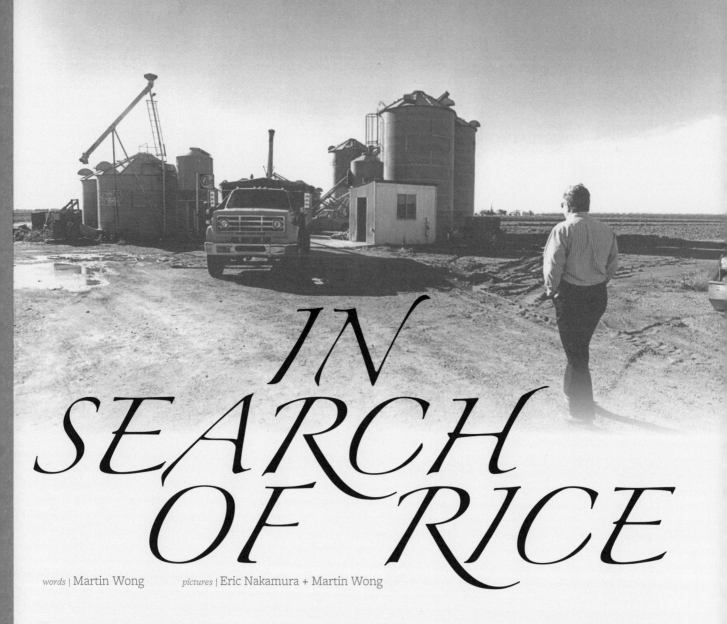

IN SEARCH OF RICE

words | Martin Wong pictures | Eric Nakamura + Martin Wong

The sun was still rising over the desert horizon as Eric and I rolled out of Los Angeles on a frigid winter morning. Some people go searching for their roots. We were looking for a grain—the ingredient that puts the mush in mochi, adds crunch to crackers, and fills bowls and burritos. We were in search of rice. **Where does it come from? How is it grown? Who grows it? Do they wear coolie hats? No one ever told us, so we had to find out for ourselves.**

The quest started at Yaohan, not Yahoo! The internet can't compete with Asian supermarkets with their neat stacks of long grain, short grain, jasmine, and other varieties of rice. After copying some names and numbers off a few sacks, we were ready to score some grass knowledge. Northern California, near the Sacramento area, is the rice capital. That's where the rice in your sushi is most likely grown.

Speeding north on the I-5, we passed Good Sam's, truckers, and fog. We spotted grape vines, cow fields, and dust bowls. Stopping at the Casa de Candy for gummy provisions and gasoline, four hours into the trip, I called George Okamoto Jr., one of the masterminds behind the Nomura & Company rice empire. The day before, he said that he would squeeze us into his schedule that afternoon, but that day he wasn't there. We pressed on and called from a pay phone across the street from their corporate office south of San Francisco, but were given the runaround once more. There was not one rice flunkie in the office who could talk to us about the main grain. Full of bitterness and hunger, we made a detour to SF to eat El Farolito burritos with Windy [Chien] from Aquarius Records and the Automator (p. 216) from Dr. Octagon. Then we put Plan B into effect: bypass the corporate bullshit and drive straight to the fields. We invited ourselves over to DJ Shadow's neighbor's house in Davis, rested for a few hours, and entered rice country early the next morning.

If you drive up the I-5, bypassing the turnoffs for Oakland and San Francisco and blowing by Sacto, you'll eventually notice that you're surrounded by absolutely nothing. That means you've arrived. During the winter after the harvest, rice fields look like rows of mud. This landscape can be found all around small towns like Arbuckle, Yuba City, and Williams.

Stopping in Williams, population 800, at lunch time, most of the stores were closed. Coming out of the "Chop Suey and Chinese American Food" joint with its $3 lunch specials and then looking in dusty and junky antique shops under the wooden

ERIC: We often worked with strangers and printed their stories. It was a time before social media when people

awning (perfect for tying up a horse), we felt like we were in a Western movie.

"It's a different lifestyle. I miss it," remembers Brian Rosser, who lived with his grandparents off-and-on in Williams. Growing up there, he caught crawdads, played with hunting dogs, and watched big rigs drive by on I-5.

Brian's grandfather had purchased a rice field after the Depression and was still running it when Brian would visit about 20 years ago. Brian never worked in the paddies: he never had to because rice is a low-maintenance crop. <u>"Once rice is harvested, you let the water evaporate, harvest it, let everything bake in the sun, burn it off, and it's fertile again for the next planting. It's super easy," he says. "There's a lot of free time, so farmers do other things.</u> Some grow other crops, but a lot of them just raise dogs."

Even the harvest is pretty mellow. Farmers lease the harvesting machines, which usually come with drivers. Unlike Zamboni drivers, they don't go back to hit the spots they miss: "Whatever's left is just plowed under and burned. They leave a lot."

Most farmers sell their raw harvest to the Calrosa company, KODA, or some other conglomerate that handles business such as milling, packaging, distribution, promotion, and distribution. In this bigger picture, Rice Researchers Inc. is responsible for advancing the quality of rice.

The RRI complex is about 20 minutes south of Chico, past streets with no signs, sad heifers, a closed-down general store, and a library that's only open one day a week. The compound is comprised of 110 acres of paddies and a small cluster of buildings. In the structure that looks like a typical clean office—except the workers who wear boots, flannel shirts, and baseball hats—RRI is shaping the future of rice.

rice stories from you

The following are rice stories from our readers via email. We thank those who sent these in.

BOTAN RICE CANDY BLUES:
This is about Botan Rice Candy. You know...the chewy stuff that comes with a sticker. When I was six, my friends and I had a whole bunch of that Botan Rice Candy. We spread it out on the floor and started eating it as fast as we could (we had already eaten a bunch of cake, candy, and ice cream before this, so we were hella hyper). I grabbed three and put 'em in my mouth and started chewing. It was pretty stale so I chewed more vigorously. Then it just got stuck like glue. I tried really hard to open my mouth, then it just popped open. I was like...Okay, cool...and I started chewing again, but something wasn't right. I noticed all my friends were looking at me. I looked around and noticed my mouth was dripping with blood. I spit out the candy and there were two molars stuck to it. Of course, seeing blood and being six, I started crying.

TIFFANY TOMKINSON, *Renton, WA*

BUGGED RICE: I recall making dinner one evening at a friend's house. She is half Taiwanese and half Hongkongnese (Is there such a term?). I screamed when I opened up her rice container because there were legions of little light brown bugs that squirmed throughout the white uncooked kernels. I suggested immediate disposal of the whole rice bucket. She then stared at me blankly and wanted to know why. Tactfully, I suggested that she see an eye doctor. Unperturbed by my statement, she told me that all we had

This list is in no way complete...Apologies to the complainers.

TYPES OF RICE

I. AROMATICS
A. Basmati, Patna (India, Pakistan, good for curry, but naan is better. It is long grain)
B. Jasmine (Thai, smells great, filling, and absorbs coconut milk)
C. American (Texmati, Lundburg Royal, Wehani, Gourmet, Della)

II. ARBORIO (Italian risotto, extra-absorbant; this isn't pasta)

III. BAHÍA (Spanish rice)

IV. GLUTINOUS/WAXY RICE
A. Japanese (short grain, round, and sometimes gourmet shit)
B. Chinese (long grain, tasty, and not as sticky as above)
C. Thai (sweet, for desserts, to cool the spice)
D. Malagkit (Filipino, processed and glutinous)

V. AMERICAN SHORT GRAIN (pudding rice from Carolinas, good in tapioca)

VI. WILD RICE (aquatic grass from North America, healthy-looking)

VII. INSTANT (the main man Uncle Ben, Rice-a-Roni, Minute Rice)

VIII. MEDIUM GRAIN (brown and white)

IX. LONG GRAIN (brown and white)

I'm unsure if it's because *Giant Robot* magazine got less less personal to everyone as we got slicker.

and it was harder to get stories from people.

to do was wash the rice and the bugs will drown. After which, we could skim the floating bug carcasses off the top and cook the rice. She also informed me that her grandmother said the rice bugs made the rice healthier. So, not only should we use the bug-infested rice but we should also encourage the growth of the colony. To this day, I've always wondered whether:

A) The grandmother was loony; B) My friend was loony to believe her grandmother; C) This must have been a weird Taiwanese thing because my Hong Kongnese grandmother used clean rice; D) My friend was a great liar; or E) The excrement of certain bugs does increase the healthiness of rice.

C. C. WONG

BIRD SHIT: Almost every morning when I was a kid my mother would make leftover rice ochazuke and ham or fish for my sister's and my breakfast. My sister would scoop the rice into her polka-dot and my Doraemon rice bowls and sprinkle the ochazuke and I would take the plastic off the pickle dishes and pour the hot water from the little ceramic tea pot. One morning, my sister only ate pickles and fish and didn't serve herself any rice. When my mother asked her why she wasn't eating her rice she would just say she didn't want it today. I slurped up mine eagerly before it got too cold. The next day, my sister did the same thing. I wasn't complaining, since there probably wasn't much rice left from the night before. My sister just smiled and ate her pickles. Well, my mother never kept rice for more than two days and when she took out the pot from the rice cooker she looked like she was going to vomit. My sister let her parakeets rest on the rim of the rice cooker while she washed dishes a couple of days before and they shit all over the rice.

CATHY THOMPSON

Vice President and General Manager of RRI, Dr. C. Lorenzo Pope describes the group's function as fourfold: (1) to develop better rice for lower prices, (2) to maintain the superior seed and make it available, (3) to farm the seeds, (4) contract rice from others. In short, they help Nomura & Company improve its prestigious Kokuho Rose brand sushi rice by breeding and testing new strains. Some of these new rices are mixed into the Kokuho Rose blend.

"Economics have forced us to look for a blend," explains Dr. Pope, sitting behind a big desk and surrounded by the diplomas, awards, and pieces of rice folk art that adorn his office. "We have found that we have to change the blend as we go through the seasons to maintain our quality. Luckily, the blend is better than anything by itself. It's kind of like making wine. Most good wines are a blend of several different types of grapes."

The different types of rice are created through radiation. "The original Kokuho Rose is tall and long-seasoned. If we irradiate that with Cobalt 60 (the same that you use to control cancer) and pull out all the ones that are shorter and ripen earlier, we might find that they're pretty good in our cooking test. These might be good only in October and November." So, the blend is changed with the seasons.

Dr. Pope continues, "A plant breeder is an architect. You have a vision of what the finished product should look like. The question is, this particular selection you're looking at, does it fall under the parameters of what you would accept as a finished product? If the answer is yes, then you advance it. It has to go a couple years. After the fourth generation, you start testing it for yield. Will it yield comparably to the other varieties we have? **Can it withstand the cold water? Will it withstand some of the diseases? Will it withstand the heat?** You screen it for all these different purposes, take and plant the best lines, and look at all of them in different environments to see how they're doing."

We walk out of the main building and enter a small structure where Dr. Shawn Hung is extracting and sorting rice seeds according to clarity, shape, and time of harvest. Schooled on rice in Taiwan and the Philippines, Dr. Hung also conducts taste tests once or twice a week to rate sweetness, stickiness, smell, springiness, appearance, and factors that you may never even think about. For example, **if you cook Kokuho Rose, save it, and re-warm it, it will stay soft. (If you take Calrose or some other generic rice, the kernels will harden.) Also, many sushi bars choose Kokuho Rose**

RICE PRODUCTS

I. RICE CAKES

A. Mochi is also used in Korean food, Chinese desserts, and probably used in many other Asian countries.
B. At your supermarket, these are in the health food section. It's like eating air.
C. Grainaissance mochi (plain, raisin & cinnamon, wheatgrass & mugwort, cashew date, pizza, sesame garlic)
D. Ohsawa organic brown rice mochi (regular or with millet)

II. RICE CEREALS

A. Cocoa Pebbles, Fruity Pebbles
B. Rice Krispies (also Rice Krispies Treats)
C. Rice Chex
D. Puffed Rice
E. Kashi
F. Total
G. Ener-G pure rice bran
H. American Prairie organic creamy Rye and Rice hot cereal
I. Grainfield's whole grain crispy Brown Rice Cereal
J. Nature's Path Millet Rice bran flakes

III. RICE CRACKERS

A. Glutinous rice (arare-small, okaki-large shapes)
B. Non-glutinous rice (Soka Senbei type, Niigata Senbei type)
C. Hot-Grain Brown Rice Crackers
D. San-J (Tamari Brown Sesame brown rice crackers)

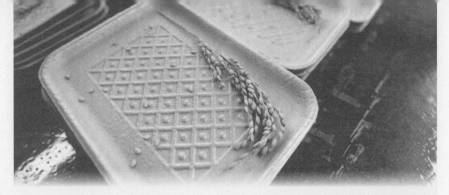

because they can cook it in the morning and it stays soft and tender for a prolonged period of time.

Back in RRI's headquarters, the taste-testing room looks like a Home Economics classroom with long tables, plastic chairs, and counters with fixtures. The cabinets are filled with small rice cookers. Dr. Pope points out that RRI's taste testers reflect Nomura's target market: "Generally, they're Asian. They eat premium rice. Most of them are Japanese or Korean. Generally they're over the age of 35. We screen them, asking, 'Which is better, A or B?'" The elimination process is not unlike the NCAA basketball tournament, except there are more than 64 competitors in the running.

Every year, RRI develops about 30,000 different types of rice. They sort it, keep the best, and send the rejects to mills for generic use. RRI keeps six or seven thousand a year and plants them the next year with new ones. Although Nomura & Company may not always choose to use the new strains of grain, the development is ongoing. Over a five year period, you might be able to tell the difference between sacks of Kokuho Rose.

It's this constant research that makes Kokuho Rose the "Cadillac variety" of rice brands. Dr. Pope says, "Kokuho Rose has been out the longest and has set the standard. It continues to set the standard. We have Nishiki from Japan and some of the others that come from other mills. To me, they're an inferior product. On our taste panels, their scores are lower."

Stuffed with rice knowledge, we headed back to the I-5 and decided to visit Rop at the Lookout! Records store in Berkeley. We knew that the PeeChees guitar player and ex-singer for hardcore punk band Rice had been hospitalized and we wanted to say hi. Rop told us about the operation on his infected liver that looked like spaghetti, and how he has a long list of things not to consume such as adobo, red meat, liquor, cigarettes, and soy sauce. Now he survives on plain rice and feels great.

Driving back to LA in dense fog that had claimed four lives earlier in the day, Eric and I tried to make sense out of everything we learned about rice—the evolutionary science and the selection process. We also got a free bag of rice from Dr. Pope who handed us a five-pound complimentary bag of Kokuho Rose, confident that we would never shop for rice the same way again. But the biggest result of this rice trip was our learning how to judge the quality of rice by appearance, taste, and feel. Now a simple bowl of rice is not so simple, and the innocence we once had about rice is lost forever. 🦇

RICE BALL: You know onigiri, those triangular Japanese rice snacks with some goodie in the middle and nori wrapped around the outside? Well, when I was attending college in Japan as an exchange student, the Japanese students at my university had a phrase, "onigiri byo" (byoin no byo), that means "rice-ball disease." That's how they described the fact that the white Americans would all hang out in a clique instead of mingling more with the Japanese students. So, a gaijin clique looked like a rice ball! The much funnier stories involve things like squat toilets (p. 94), and the Japanese perception that white Americans eat nothing but steak, three meals a day.

MELISSA REEVE, *Hawaii*

RICE GLUE, PART 1: When I was growing up, my mom always tried to get me to make my own paste out of rice instead of using Elmer's. Rice paste would not be cool in kindergarten.

CARYN AONO

RICE GLUE, PART 2: In third grade, I had to paste some stuff together. I was in a real rush before going to school and I had to get it done but we were all out of Elmer's, so my mom scooped some rice up and we smeared some on the paper. It worked good except the paper was sorta lumpy.

NA-YOUNG "YONG-WOONG SHIN"

THE HOMEMADE: Not necessarily hilarious, but amusing in an issei kind of way. When I was in college in NYC, my grandmother (in SF, CA) used to make these homemade senbei type things by wadding up rice and frying it, or baking it or something. Then she'd season it, pack it up in plastic nori bottles, wrap the whole thing

E. Westbrae Natural Brown Rice Wafers (Five-Spice, Sesame, Onion/Garlic, Unsalted)
F. Edward & Sons Brown Rice Snaps (Unsalted Sesame, Tamari Seaweed, Onion)
Garlic, Buckwheat Tamari)
G. Health Valley Rice Bran Crackers

IV. RICE NOODLES
A. Chow fun (Chinese fat and flat noodles)
B. Cheung fan (dim sum roll)
C. Laksa (Malaysian)
D. Mai fun (thin, dried, and puffed Thai)
E. Mi Krop (Thai sweet and sour)
F. Bánh Pho (Vietnamese rice noodles, like chow fun)
G. Gỏi cuốn (Vietnamese spring rolls)
H. Bun (Vietnamese rice vermicelli noodles)
I. Bánh hỏi (Vietnamese rice vermicelli noodles)
J. Rice pasta (sold in health food stores for wheat/gluten-free diets); Ener-G makes tagliatelle pasta (cross between linguine and fettuccine and lasagna pasta; Pastariso makes brown rice spaghetti and fettuccine; DeBoles makes spaghetti and fettuccine; Soken makes brown rice ramen with miso soup; Annie Chun's All Natural Rice Noodles
K. Dumpling dough (not quite a noodle, but it's made with rice)

V. RICE FLOUR (mochi ice-cream skin is one use, also thickening)

VI. RICE PAPER
A. Bánh trang, Vietnamese (used to wrap spring rolls)

in bubble wrap, take it to the post office, and buy INSURANCE on it for up to, like, $1000 or something, and mail it to me. It was cool.

KARL OCHI, *Oakland, CA*

RICE BAG SLING: Do you remember those big ol' bags of rice where the bags were made of brightly colored floral prints? Some of the Chinese moms in the neighborhood would make baby slings out of them (the bags, not the rice).

JO, *San Pedro, CA*

SMOKE OUT THE WHITE:

In college, a roommate of mine tried smoking rice once (uncooked). I wasn't there when it happened, but the next day I found the notes he had taken (yes, he's the kind of guy who would take notes on something like that), which read something like, "12:45 a.m. Trying rice. Nothing...then yaahhh—RICE." Apparently it was just like coating your mouth, throat, and lungs with a thin film of rice. I haven't tried it, nor will I ever, and I don't recommend it for anyone. The guy who tried it is in med school now, so apparently the effects aren't lasting.

STEVE REBER, *Washington, DC*

RICE PARTY—WE WEREN'T

INVITED: I had a rice party about two months ago. All sorts of rice dishes: numerous types of fried rice, plain white rice, Rice-a-Roni, rice pudding, horchata, rice snacks, etc...Even had this thing called "ca." Have you run across it? It's a Japanese rice cracker that tastes like nothing, but is strangely fascinating. It reminds me of Communion.

MARY

CHOKE ON THE GRAIN: When I was in college, I was at a friend of mine's apartment and he had whipped up some fried rice with egg and peas and that

random rice jottings from Japan and beyond

words | Matt Kaufman

Mayonnaise, bacon, and cheese rice ball *(Family Mart)* ¥120
I used to pour soy sauce on plain rice. I was told again and again pouring soy sauce on rice is something that is just not done in Japan. Okay, I can live with that because it is very important to be respectful. I like the taste of plain rice anyway. You can imagine my surprise when I came across a bacon, cheese, and mayonnaise rice ball at a Japanese convenience store called Family Mart. This rice ball wasn't round, it was a triangle shape that comes wrapped in seaweed and is usually filled with salmon, fish eggs, or kelp. I've eaten a mayonnaise and tuna fish rice ball that was pretty good, but bacon and cheese seemed a little too ridiculous. The thought was absolutely revolting. The cheese was fermented way past the legal limit. It reminded me of the time I ate fondue for the first and last time.

Anpanman furikake *(Nagatanien Corp.)* ¥250 for a package of 20.
The box lunch at work is usually delivered about two hours before lunchtime. The rice gets soggy and cold and loses its flavor. Then I discovered furikake, which my dictionary defines as "a tastily seasoned dried food for sprinkling on rice." (I wouldn't go as far as to call furikake a food: it's more like a seasoning.) You can buy furikake in jars or in packets. I prefer the packets because you can choose from some really cool cartoon characters. My local department store carries Sailor Moon, Pocket Monsters, and Anpanman. I don't

care for Sailor Moon and I wasn't about to take any chances with the Pokémon since watching the cartoon gave over 500 kids seizures a while back. The choice was obvious—Anpanman. The package of 20 came with four different flavors: okaka (shaved bonito flakes), sake (salmon), tamago (egg), tarako (fish eggs). The package says that one packet contains the same amount of calcium as 50 milliliters of milk (about a ½ a cup). The front of each packet is adorned with Anpanman characters like Shokupanman, Karepanman, and Melonpanna-chan—and there's a simple quiz or puzzle on the back. My package of furikake came with a nice sticker of Anpanman on a skateboard. This is one product that will turn even the blandest-tasting rice into a feast.

Komebitsu *(Yodoko Inc.)* ¥8500
I used to spill rice whenever I had to measure it for the rice cooker. Sometimes I would even drop the bag or knock it over. I could never figure out a good way to store rice. All that changed when I bought a komebitsu (a rice storing cabinet) last year. All you do is pour the whole bag of rice down a chute on the top. Whenever you need to make some rice just press one of the levers on the bottom and the rice comes out into a pullout tray. It's easy to measure, the left lever is one cup and the right one makes two cups. Need six cups? No problem, just press the right lever three times. My komebitsu has an extra cabinet with a door for storing dishes and stuff and space on top to keep a rice

cooker and a built in outlet to plug it in. Find someplace that sells a kome-bitsu in the USA. You'll be glad you did.

Rice vending machine (*Akita Prefecture Economic Group*) *¥940 for a 2 kg bag.* Akita is nowhere near Osaka, but I found this beat up old rice vending machine in my neighborhood. Akita is famous for quality rice so I guess there are machines like this all over Japan. I stuck a ¥1,000 note in and pressed the button. A hefty bag of rice came out. It was a trip buying a bag of rice from a machine at midnight. I hope the rice tastes good. 🐱

more random rice jots
words | GR

Rice washing
Japanese American families have different ways of washing rice. Some like to randomly agitate the rice while others use a certain pattern of swishing the rice around. This may be due to family tradition or provincial differences in Japan. Don't talk shit cause everyone thinks their way is the best.

Paddy pattern
In traditional Japan, each village designated a small rice paddy to produce rice for Shinto ceremonies. The sacred rice paddy looked different from normal ones because seedlings were planted from the center out; in concentric circles instead of straight rows.

Mochi
Traditionally after the harvest, villages in Japan had mochitsuki. During this time, everybody got together and pounded rice to make mochi. Japanese American families used to do this, too, but now temples are replacing this function since families are spread across the US. Or they just buy mochi instead. During Oshōgatsu (New Year's), Japanese people eat o-zōni, which is a soup containing a piece of mochi. It is said that the longer you can stretch the mochi before it breaks, the longer your life will be. Also you're supposed to chop the pieces with your front teeth before totally chewing it, symbolizing that you're cutting away the old year, and starting with a blank slate for the coming year.

Rice and po
In the old days, only nobles could afford white rice. Everybody else had to eat the cheaper brown (un-hulled) rice. Paradoxically, peasants might have had a more balanced diet since brown rice is more nutritious. They probably lived longer.

Fry the leftovers
To most Asians, "fried rice" equals yesterday's leftovers. It's funny when people order it in a restaurant.

Soak the old
New rice doesn't need to be soaked long before cooking it. Old rice is drier and needs to sit longer.

Indian style
It's not supposed to be cool to put a bunch of rice on the plate and to then pour curry over it. Rice goes on the side in small quantities.

Chinese sausage. So at one point I'm standing there eating and talking, saying something I thought was hella important at the time, and all of a sudden I took a breath and somehow ended up with a lungful of rice grains. Well, of course I immediately collapsed to the ground, hacking and spraying rice everywhere on the kitchen floor. They thought I was joking, that it was another one of my weird performance art things. But I was really choking. I tried making all those so-called "international symbol for choking to death" gestures, but they just started laughing their natural asses off. My complexion was a little brown, so I guess I wasn't turning purple enough to convince them, but I was about to pass out. My sides hurt, and my muscles were straining so badly to expel the rice from my bronchioles that I started cramping everywhere. After literally about thirty minutes of this, I lay exhausted on the gray college-apartment linoleum, its cheap oily smell filling my head, with the side of my face in a puddle of starchy, salty goo. I was unable to move, or even think about standing for several minutes. One of the guys that lived there stepped into the kitchen to get something. On the way out, he looks back at me and says, "Dude, you're gonna clean that up." Damn you, rice; damn you all to hell!

LEMEL, *San Francisco, CA*

ANOTHER ONE RICE THE DUST:
Over the summer, I was eating lunch with my friend and co-worker. He was eating a plate of rice, meat, and potatoes when suddenly his face turned red and he attempted to gulp down some water. When I asked him what was wrong, he merely pointed to the back of his neck. I didn't know what he was talking about, blew it off, and went back to my peanut butter and jelly. He started pounding on the table

and pointing to the back of his neck again and then I realized he was choking. I ran over to the other side of the table to give him the Heimlich, but by then he had already dislodged the tiny piece of rice that stuck itself so rudely in his windpipe and regurgitated it along with the water he tried to swallow. Then he went back to his lunch. He told me later that he was only trying to save face by continuing to eat his lunch after the incident. How disgusting. Anyway, I always thought the worldwide sign for choking was putting both hands up to one's throat, but I guess I was wrong...

MICHAEL KAI LOUIE

RICE WEIGHTS: My father is affiliated with Victory Music Club. They sing and put on Chinese Operas. Gong! True to their Asian instinct, they use small bags of rice (uncooked) to weigh down the curtains so they don't flap around. After the show, my father brought the bags home, we cooked some, and distributed the rest to family.

YVONNE NG, Los Angeles, CA

ROCK 'N' RICE: When I was traveling in China, I took a train from Beijing to Dalian where I met two Thai women and a Japanese woman. We started talking about our experiences in China and I told them that Chinese people always ask me if I had gotten used to the food yet. During dinner, I put a big gob of rice in my mouth and when I bit down, my molars came down on a rock. Everyone always puts rocks in their rice there. I've been told the farmers husk the rice by putting it on the road and letting passing trucks run over it. Anyway, I winced with pain and put my hand over my mouth. After I got through spitting out all the rice, one of the Thai women asked me if I had gotten used to the food yet.

MIKE

Grain will tell
If you leave grains of rice in your bowl, you'll end up marrying someone with skin resembling the leftovers in the bowl. Eat all of your rice.

No stabs
In Japanese culture, stabbing both chopsticks upright into a bowl of rice is part of a funeral rite. It's taboo to do this because it symbolizes the last meal for the dead person.

Period party
In Japan, after a girl has her first period, it is good luck for her to eat sekihan (red bean) rice. Eating the pink rice is a symbolic rite of passage.

Origin of rice
According to a Chinese myth, the rice plant existed from the beginning, but its ears were not filled. Kuanyin, the goddess of mercy, saw that men lived in hardship and near starvation. Kuanyin was so saddened by the situation that she secretly went into the rice fields and squeezed her breasts until her milk flowed into the ears of the rice plants. And that's how rice came to be.

88 rice
In Japan, your eighty-eighth birthday is called beiju. Bei, the first character, means rice! This is because the character for rice looks like its composed of two eights and a 10 or 88. Also there is a saying that it takes 88 people to produce one grain of rice (in planting, harvesting, threshing, and so on).

Orange rice
Mexican-style. This is really good. This is a secret recipe from the Muzquiz family.
✿ 1 cup Mahatma long grain rice

✿ 1 Medium tomato chopped
✿ 2 cups Water
✿ 2–3 Garlic cloves chopped
✿ ½ Onion chopped
✿ 1 tbsp or less of oil (I prefer less so it ends up less oily.)
✿ Dash of salt
Instructions: Place the rice and oil in a pan and fry it up in high heat. Add garlic, and onions, and keep stirring the rice and let it cook until it starts turning a little brown. After rice is browned, add water, tomato, and salt, and cook until the water level reaches that of the rice. Then cover it, and lower the heat to simmer. It should be ready and tasty in minutes. This can make a great addition to any meal.

Horchata (for 6 servings)
Ground rice drink. Don't buy it, make it.
✿ 1 cup Long grain rice
✿ 4 cups Milk
✿ ½ cup Sugar
✿ 1 tsp Vanilla
✿ ½ tsp Cinnamon
Instructions: Place the rice in a bowl with enough hot water to cover. Let the rice sit overnight. Next day, remove the water. Place ½ cup of water, and 2 cups milk in a blender. Blend until rice is all ground up. Mix in ¼ cup sugar, ½ tsp vanilla, ¼ tsp cinnamon. Do the same with the other half of the ingredients. Strain through cheesecloth (or whatever). Serve over ice. Makes 6 glasses.

Sweet rice drink (Sikhye)
✿ 3 cups Glutinous rice
✿ 3 cups Malt powder
✿ 3 tbsps Pine nuts
✿ 3 cups Sugar
✿ 40 cups Water
Instructions:
1) Pour 40 cups of water over the powdered malt and let it stand for one

ERIC: The orange rice recipe is quite great. Take a pic of this now and you'll thank me later. I've directed people to this recipe multiple times.

night. Stir and press the malt powder so that the malt flavor seeps into the liquid. Strain the malt water through a fine sieve and allow the malt-water to settle leaving a clear liquid. Soak the glutinous rice in water and drain.

2) Steam it in a steamer sprinkling some more water over the top when steaming-hot to produce more steam and sticky rice.

3) Place the steamed rice in a large bowl to cool. Add the clear malt water to the bowl and stir it well. Then leave it at 100°F, until it ferments.

4) When four or five grains of rice float to the top, take the liquid out of the container. As it cools, all grains of rice will float to the top. At this time, separate the grains from the liquid.

5) Wash the grains of rice in water and drain.

6) Simmer the fermented rice liquid and add the sugar to taste. Let it cool and store it in glass bottles.

7) Place the sweet rice drink in individual serving bowls and top it with some grains of the fermented rice.

Flying Botan

Perhaps the most bizarre thing to do with Botan Rice Candy (the enigmatic snack featuring a thin rice paper coating that melts in your mouth) is to make a kite out of it. I recently found a posting on the Web (circa 1994) that mentions making edible kites with Botan Rice Candy as the main ingredient. Imagine going on a picnic, flying a kite, and then eating it! I doubt that's what these posts were really about and I think making kites that were edible was just part of a strange contest, but the things you'll need to make this flying treat include cinnamon sticks for the frame, dental floss for the string, honey as an adhesive, and Botan Rice Candy for the kite. The kite is probably a tiny one, perhaps less than one foot long, and will most likely fly no more than a couple of feet high. I have no idea what these people were thinking. A response to this post was to use nori (dry seaweed) instead of the candy. I could only fantasize about making this kite and correspondence with the inventor of this idea led to no hints. He went underground after I started asking too many questions. Most likely, the object is to remove as much rice paper a possible with a knife and then adhere it to the cinnamon stick frame. I think your best bet is to bypass this scheme entirely and just eat this Japanese import that has made people scratch their heads for years, but if you make a kite, send a photo, and we'll run it for sure. 🐱

RICE IN JAPAN:

1) In Catholic School when I was a kid, they had a charity drive every year before Christmas and everybody and their families had to contribute. It was called Operation Ricebowl. And I felt queasy about it cuz it stigmatized rice for me at that tender age and I ate rice three times a day.

2) If I ran out of Elmer's Glue while doing a homework project, my mom would insist or even force me to use sticky-ass leftover rice to adhere the stupid shit to looseleaf. No one was ever more embarrassed than me the following day, cuz my homework, originally intended to look two-dimensional and neat, was all puffy and fucked, looking like a mountain range diorama.

3) For whatever stupid socialist reasons, the rice market over here is super controlled so the dumbass farmers who won't sell their land for 1 billion dollars won't starve. A 5 kg bag of rice costs at least 3,000 yen, or about 28 bucks! All the rice grinders don't care cuz of racism, nationalism, or whatever. They believe that there is nothing better than Japanese rice. Whatever. So all the unsold imported rice from Thailand, Philippines, and Cali is fed to the pigs or dumped in the landfill and burned cuz it's so gross.

ERIC AND BETH, Japan

STEALING RICE: When I was in Japan, we'd pay for all the groceries and bag them, but keep the rice on the bottom of the shopping cart and wheel it out. We discovered it by accident halfway through the process and kept doing it until they started following us around the store. Then we switched stores.

AKIKO CARVER, Oakland, CA

XXII. RICE CHEESE A. Rice Slices/Rice Chunks (made from organic brown rice... comes in Mozzarella and American flavors)

XXIII. RICE IN BABY FOOD

XXIV. DOG FOOD A. Natural Life Pet Products (Lamb & rice, veggie) B. Petguard Premium (comes dried, canned, and uses chicken, lamb, brown rice, and vegetables)

XXV. RICE PROTEIN POWDER A. Futurebiotics Brown Rice protein concentrate

XXVI. RICE PIZZA A. Frozen pizza (sold in health food stores in the freezer section with soy cheese and a rice crust)

XXVII. RICE KITE A. Some fools on the net posted a message saying that they make kites out of organic materials. One dude said he uses Botan Rice Candy outsides and makes the kite with it!

XXVIII. RICE HUSK ASHES A. Used for incense burning. Good for ancestral worship!

...from Christine, who was Eric's girlfriend at the time.

Name	Rice Cooker	# Times a Week	How You Measure	Favorite Recipe	Where'd You Get It
BETTY MUZQUIZ	Pot	7 times a week	1 cup rice : 2 cups water	Rice and beans	Puerto Rico
MERF SCHULTZ	Hitachi Chime-O-Matic RD-4053	3 times a week	2 cups of water with 1 cup of rice	Any vegetables with curry	Hand-me-down
ERIC DE QUIROZ	Salton RA-1	At least 7 times a week	Ginger method	Chicken Adobo	Gift from parents
VINCE TRAN	National "Rice'O-Mat" SR 10-E	2–3 times a week	Knuckle technique	Gai lan and chicken	Got it in the last riot
AKIKO CARVER	Hitachi Chime-O-Matic RD-481A	11 times a week	Small bag, one knuckle, Large bag, (20+ lbs.), lines inside the bowl	Mochi	Laney flea market
ROP VASQUEZ	Hitachi Chime-O-Matic RD-4053	Almost every day of the week except on weekends when I have it twice	"The thumb one"	Adobo	Got it from Gramma
BOB NAKAMURA	National SR-35EH	7 times a week	Finger	Fish	Mutual Trading Co.
CHUN LEE	National SR-2183FK	Every day	Palm in water	Chinese preserved salted fish	Bought at the Hong Kong supermarket
KIM NGO	Zojirusho NEH-1800	At least five times a week	Finger method	Petha, fried anchovies	Hawaii Supermarket
TOM HAYASHI	Hitachi RD-405P	14 times a week	Cup	Anything	Bought it a long time ago
FUSAYE YAMANAKA	Zojirushi NAZC-15	Every day	Lines in cooker	Sukiyaki, must have tsukemono every night	Bought at Marukai
C. LORENZO POPE	National SR-6E	Twice a week	Uses marks	With stroganoff	Took it from work
WAYNE KHOE	Zojirushi NHS-10	3 times a week	Uses marks	Spam and egg fried rice	Mum bought it for me before I went to school
ANTHONY LEW	Aroma ARC607	4 times a week	Number of cups of rice + 1	With stir-fry	Free gift from Chinese bank
CHRIS KOMAI	Zojirushi NRC-18	5 times a week	Cup	Sausage and eggs	Gift
ORIS YAMASHITA	Zojirushi NRC-10	7 times a week	Cup	Anything	Bought it
KENNETH WONG	Pot	7 times a week	Instinct	Fried rice	Hardware store
YOKO MIYAGAWA	Zojirushi NFR-1003	7 times a week	Eyeballing it-about ½ inch of water	Ochazuke	Bought it at Yaohan
JOHNNY MORI	Zojirushi NSBC-E18	8–9 times a week	Eyeballing-Finger	Rice and tsukemono	Gift
MATT "QP" HOLLE	Toshiba RC-380B	5–6 times a week	Cup	Any meat dish	Bought it, can't remember where
CHRISTINE MUZQUIZ	Pot	7 times a week	1 cup rice : 2 cups water	Rice and beans	Puerto Rico
HAPPY TSUGAWA	Hitachi Chime-O-Matic	Once a week	Uses marks	Plain	Handed down
CLIFF SON	Panasonic Rice-O-Mat	3 times a week	To top of flat hand	Plain	Handed down
BRIAN ROSSER	Sanyo EC5	4 times a week	One knuckle technique (in 3 places)	With citrus soy and tofu	Gift bought at Yaohan
ANN ROSE VAN	National SR-SA 18N	7 times a week	Knuckle	Sauteed garlic	Bought it
ELSIE LAU	Sanyo Jar-type Steam Cooker ECJ-PF18	9 times a week	Finger technique/lines in pot	Tomato and egg	Bought it
WILL WONG	National SR-FS10N	14 times a week	Finger	Anything	Bought it
ANGELYN WONG	National Rice-O-Mat SR-6E	5 times a week	First knuckle technique	Wet rice	Handed down
SING WONG	Toshiba RC-10B	5 times a week	First knuckle technique	Plain	Handed down
EMILY RYAN	Illumina Pot (Made in Indonesia)	3 times a week	Cup (2:1 don't wash the rice! Too lazy)	Watermelon + egg fried rice	Got it from Dad
ELAINE WONG	Rice-O-Mat	7 times a week	Uses marks	Plain	Borrowed
KELLY O'SULLIVAN	National SR-6E	10 times a week	First knuckle technique	Mochi	Borrowed
LISA YU	National Rice-O-Mat	3 times a week	To top of flat hand	Plain	Handed down
MATT KAUFMAN	Mistubishi Maicom NJB10M	10 times a week	¼ inch of water over rice	Bibimbap	From Japanese brain surgeon in a bar
ANDREA KESSLER	Hitachi Chime-O-Matic RD-4053	4 times a week	Eyeballs it + adds salt to water	Hawaiian chicken	Xmas gift from brother
CAROLE KO	National SR-15EGH	8 times a week	Old Korean Cup	Whatever	Has been in the family forever
VICKI BERNDT	Aroma ARC-717	1-2 times a week	Lines in pot/cup	Hot green tea/butter	Gift
PETER LEE	National SR-6E	Every day	Finger method	KFC Original recipe	Hand me down from parents
CHERYLIN SADSAD	Zojirushi B-7	10 times a week	Uses notches	With brown gravy	Wedding gift
MIWA OKUMURA	Aroma ARC-407	Once a week-once a month	1:1 water and rice	Curry veg.	Bought it at Yaohan
SHAWN SITES	Black & Decker Happy Steamer HS80 Type	4 time a week	1.5–3 cups, 50 min.	Big bowl of rice & sake, soy or sesame seeds	Xmas gift
MIKE TANG	Sanyo EC-23	7 times a week	Finger	Just plain rice	Mom bought it, in Chinatown (LA)
QUEENA SOOK KIM	Zojirushi NMDC-R10	3 times a week	Palm method	Bean sprouts and raw eggs	Handed down
LAI YIM-FONG	Pot	12 times a week	Finger method	Ted's seafood hot pot	Borrowed from son
MARGIE NAKAMURA	Zojirushi NY 1000	9 times a week	Finger	Umeboshi	Mutual Trading Co.
TRANG LAI	Faberware Nutra-Stream	Twice a week	Uses finger	Baba (Vietnamese dish with tofu, eggplant, and tomatoes)	Got it from Mom
SCOTT McMULLIN	Aroma ARC-717	Every day as much as possible	No technique, throw water into it	Teriyaki sauce, ketchup	Got it from Mom
CHOI SOON HI	National SR-102P	7 times a week	Palm method	Brown rice and red beans	Bought at Korean store
GREG WONG	National SR-6E	6 times a week	Knuckle technique	Curry	Handed down

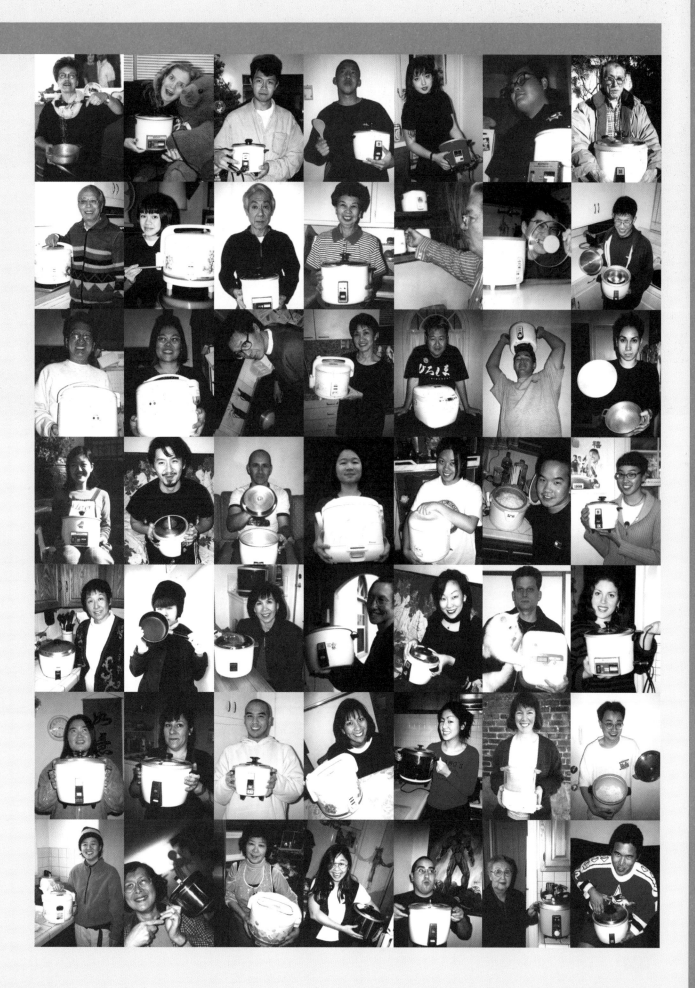

words + pictures | Martin Wong

Decades before children's toys made in China were discovered to be adorned with lead-based paint or White Rabbit Candy was found to include melamine, there was monosodium glutamate. The fear it inspired was big enough to not only inspire a disease ("Chinese Food Syndrome") but also start an industry ("No MSG" neon signage for restaurants).

But if the crystalline form of MSG was patented by Professor Kikunae Ikeda and marketed by Ajinomoto in Japan in 1908, why is it associated with Chinese food? And **why do Cheetos, Doritos, and KFC get a pass on containing the ingredient but not Kung Pao chicken?** And aren't the symptoms somewhat random and unproven anyway?

It's obvious to me that the demonization of MSG is nothing more than thinly veiled China-bashing, sadly carried on by celebrity chefs from Martin Yan to Mr. Chow to Philippe Chow, who turn out to be nothing but charlies in the kitchen.

I recall my grandmother, who moved from China to the United States in the 1930s, adding Ac'cent (an American brand of MSG) to just about everything she made, and she was healthy into her eighties.

Americans glorify the eating of bacon, doughnut, lard, and a host of other much unhealthier foods for the sake of being rebellious, comforted, or hedonistic, and I think the same should be done with MSG but in the name of Yellow Power.

The challenge is to eat MSG with as much purpose as pride. Because it comes in a crystallized powder form, it isn't visible like mayonnaise (the White Pride condiment). Sprinkling it into your food as it's being prepared isn't as dramatic as deep-frying (which has been claimed not just by the South but also by the carnie sub-culture).

So how can you fly the flag?

Boycotting restaurants that advertise "No MSG" is an obvious step, but a more active route is carrying a box with you everywhere you go. MSG is rather cheap and usually available in the Oriental Foods aisle at supermarkets that cater to lower tax brackets. It might be most effective to add MSG to your food while cooking it, but that is just selfish and benefits nothing except your palate. A more subversive strategy is to bring out a box of the substance in public places—a restaurant, your break room, a picnic—and simply sprinkle a spoonful over whatever it is that you're eating.

The first few times I put the box on a table in public weren't easy and, to be honest, I still haven't done it while dining out with my young daughter. Heads turn, eyes glare, and mouths clench tight. But I know that **behind the haters' pursed lips, salivary glands are gushing at the very thought of the forbidden "fifth flavor."**

Supposedly, MSG unlocks a food's hidden flavor that stands apart from the traditional four: sweet, salty, bitter, sour. It was first described by the Japanese inventor as "umami," or savoriness, and is a riff off of the glutamates found naturally in dried seaweed, mushrooms, tomatoes, and parmesan cheese.

Most often, I add the flavorful crystals to my lunch—typically leftover Chinese food made by my in-laws. Again, I dust it onto my food only after leaving the kitchen and entering the office so others can see. I've even been adding it by the spoonful to non-Chinese food, such as Mexican leftovers and delivered pizza. But that doesn't make it fusion cuisine and it isn't even that weird; MSG is found in just about all store-bought tortilla chips as well as most pizzas from chain restaurants.

Chinese patriots aren't alone in the fight to rescue MSG's reputation. There are also foodies who have joined the cult of umami, flocking to themed restaurants not only in Los Angeles and San Francisco but Boston, Miami, and Westchester. They may see a difference between "their" hip glutamates and MSG, but we know the truth.

And what about the snobs who will eat nicely packaged Japanese crackers, seaweed snacks, or bricks of ramen that are loaded with MSG, but scoff at the suggestion of eating Cantonese diner food? Korean, Vietnamese, and other Asian cuisines use MSG, as well, but also manage to avoid the stigma suffered by Chinese food and injustice directed at Chinese people.

Fighting a war by oneself can become lonely, so I've been offering my box of MSG to others in the office—namely, volunteers and interns. Most politely decline, but one was quick to add it to a slice of pizza when I ordered pies during deadline. In the evening, she claimed the powder made her parched during her drive home, but I think that's just because I was too cheap to order drinks.

Headaches, heart palpitations, numbness, diarrhea, swelling, and chills—the list of alleged symptoms goes on for pages and everyone's reactions are different. I'm not saying that no one suffers them, but isn't fear the real cause? Fear of a communist cuisine served on a round table, family style? Fear of laundry owners that know your stains and secrets? Fear of economic domination by a nation of billions?

But these days Chinese culture is also cool culture, as evidenced in fields such as modern architecture, contemporary art, and new cinema. This is the time to eat MSG with pride. This is the time to promote monosodium glutamate as the real MSG, while Madison Square Garden is home to losing basketball and hockey, and the Michael Schenker Group's legion of headbangers are losing their hair and hearing.

So pile on the MSG and share it generously—but in moderation. I don't want to see your eyes bleed. 🐱

DK'S DONUTS & BAKERY

CAMBODIAN DOUGHNUT CARTEL

HOW DID THEY RISE TO THE TOP OF THE DOUGHNUT SHOPS?

words | Eric Nakamura

When you think doughnuts, you think Winchell's. It's just like the relationship of photocopies and Xerox, Cola and Coca-Cola, or gun movies and Chow Yun-fat. It's the ultimate last statement about doughnuts—Winchell's. When I was young, I couldn't wait until I got into one of those big yellow triangle signed shops. If I was a good kid that day, I got the fancies. Bear claws, fritters, cream filled, my tastes weren't yet refined and I was trying everything. My favorites went from cherry jelly, eclairs, old-fashioned glazed, devil's food, and now sugar raised. Everyone has a doughnut eating experience of some sort.

These days, Winchell's uses Homer Simpson in hopes of rejuvenating their dying doughnut shops. But according to the statistics, it's not helping. Perhaps it's because the doughnuts are the corporate version of anything—just formulaic and average. No lift to the raised, oily tasting cake and bad formula lemonade to wash everything down. I hope not to offend any of you hard-core doughnut fans who only have a Winchell's in your town, but there's a lot more to the world of doughnuts than Winchell's. When Verne Winchell figured that he was going to be the Karl Karcher of doughnuts, he never thought that a Cambodian-born person named Ted Ngoy would step up and suck out the cream from his eclair. Enter the Cambodian Doughnut Cartel.

Today in California, most doughnut shops are owned by a Cambodian person. When you walk into one of their shops, you'll see some hard work and definitely the best doughnuts. What's going down is a non-hostile takeover of the dough-nut business. No buyoffs, drive-by's, or executions. It's just an explosion of doughnut shops that began in the late '70s. Amongst friends of mine, we've always said that Cambodians

make the best doughnuts. What started off as a joke is actually true. For some reasons Cambodians learned how to make this round bagel-looking pastry better than anyone else.

By the facts given below, it is easy to understand that Winchell's is going down and Cambodians are getting stronger. It's basically a bar graph going straight up in the Cambodians' favor. Cambodians started coming into the United States about 15 years ago after the Khmer Rouge took power and killed between 1 and 3 million people. Refugees came to the United States and some of them found shelter by working at Winchell's. After learning the tricks of the trade and then fig-uring that they could do better, they decided to open up their own shops and so the ball went flying. Whenever a comrade comes into town, boom! They either get a job at or get set up with their own doughnut shop. This is how Ted Ngoy began his illustrious career in the doughnut trade. In 1977, according to an *LA Times* article, Ted was the first Cambodian to own a doughnut shop in California. That set up the future for Cam-bodian immigrants. But the story continues with his nephew Bun Tao, who was a partial owner of B&H Distributors. (B&H supplied everything from equipment to the ingredients for doughnut shops.) Teaming up with his childhood friend Robert Chau, they ran B&H Northern and Southern. Together, they helped supply 2,000 or so shops in California. Today, B&H is run by Ning Yen, who was yet another one of Ngoy's protégés. When and how the transfer of the ownership transpired is confusing, since Bun Tao was shot after the 1993 *LA Times* in-terview. Although he recovered, he sold his part of the business. What remains is that B&H posted $8 million in sales last year.

According to the 1993 article, B&H and doughnuts in general were in for some hard times. Due to the health conscious public, less people were apt to venture into one of these shops to digest a ring of fat. In addition, the LA riots helped down about 40 shops. Yet with $8 million in earnings, the new doughnut king Ning Yen looks to be in decent shape. By the way, Ted Ngoy is out of doughnuts and is pursuing politics in Cambodia.

How do so many Cambodians get the money to open their doors? B&H can't supply everything. Well, **like in many Asian/Asian American circles, they get the capital by use of a money pool. There are different names for these in each language but basically it's a group of people who put in a certain amount a month, let's say $500 per person each month. If there's 20 people, then the pot grows to $10,000. And there you have the capital for a small doughnut shop.** Who gets the money? Sometimes it goes by need or by bidding, and someone gets to leave with all the cash. Of course, that person then needs to come back with money for the amount of time to repay this loan. The greatest aspect about this is that **you don't have to have collateral or deal with paperwork from the banks. But you do need to have everyone's trust, since people have split with the dough.**

Locally, there are two doughnut shops nearby. One is called Donut King and the other is called DK's Doughnuts. Both are Cambodian-owned. Their doughnuts are usually fresh. The only good part about Winchell's is that since it is corporate-owned, they have codes. Old doughnuts need to be thrown away after a specific amount of time, and the employees have regulated chores. Even though the doughnuts are subpar, the system is secure and clean. In an independent shop, there is no big boss to scrutinize the doughnuts. Things can get punk rock messy. If times are tough like they currently are, old stock may not get thrown out. On the average, the doughnuts at a Cambodian owned shop are better. Why? Perhaps it's just an updated secret formula that they have all worked on together. Like many Asians, Cambodians have a lower sweet threshold and a higher chili threshold. When I asked Mr. Lee of DK if he eats doughnuts, he replied, "No, they are too sweet." If they don't eat them, how do they know what's best? It may remain a mystery.

Along with these credit pools and help from B&H, the Cambodians are in control for the moment. One DK's Doughnut store employee said, "We will put Winchell's out of business. Someday there will be no more Winchell's." And when I asked another employee if he's ever been to Winchell's, his reply was a sincere, "What's that?" Perhaps he didn't under-stand what I was saying or maybe he was being honest.

The future of Cambodians in the doughnut business may be grim. After the second generation of Cambodians come of post-education age, they will most likely be seeking other upwardly mobile jobs. This is what seems to happen in most immigrant niche fields. For example, the third generation Japanese Americans are not looking for jobs like chicken sexing or gardening. It's a search of the lazy big bucks. But for now, the doughnut business is in Cambodian hands.

Because of the limitations of a doughnut, some doughnut shops even have Chinese food during the day time. But taking things a step further, Mr. Lee of DK's just opened up a separate Chinese fast food restaurant two doors down. Even though de-tractors like Susan Powter speak against eating foods like doughnuts, the Cambodians still persevere. A friend named Paul who is an avid doughnut eater once said, "The flavor of a Winchell's doughnut comes from the glaze, but the flavor from a Cambodian doughnut comes from within."

They were often Cambodian or

NOTES

1 The Khmer Rouge period began in 1975 and ended in 1979. Although there is no exact number, well over a million were killed and since 1975, refugees have been admitted into the US. Many Cambodians settled in the Long Beach area. There is a neighborhood in that region of Southern California called Little Phnom Penh. The 1970s history is undoubtedly much more complex, since mass killings and starvation continued on until the 1980s.

2 In a book called *Voices From Southeast Asia: The Refugee Experience in the United States* by John Tenhula, there are a few pages about a woman named Sirathra Som "The Donut Queen" who opened up a Winchell's franchise in 1976. Her Berkeley shop predates Ted Ngoy's doughnut shop making her possibly the first in California of Cambodian ancestry.

3 At the local shop called DK's, when asked where he learned to make doughnuts, he an-swered Winchell's. He also verified that many who come from Asia start at Winchell's and then go independent. Doughnuts are a quick way to get established and to earn money.

4 Gen Lee, a graduate student at UCLA, helped with some information for this article. She is currently working on a thesis involving Cambodians and doughnuts.

Cambodian Chinese and they have a story about how they got started. This is that story. It has since become a documentary.

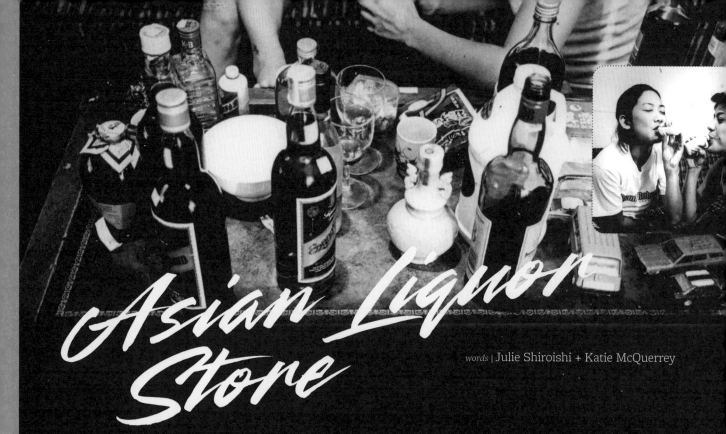

Asian Liquor Store

words | Julie Shiroishi + Katie McQuerrey

I've parked my ass on enough barstools to fill a stadium, and spent a few years believing that shots of Wild Turkey were the only way for a respectable girl to end an evening out. So, I was undaunted by the prospect of a liquor taste test. After all, martinis and Manhattans had become too trendy, and since Katie, my barfly roommate, and I were partial to hot and cold sake and had seen *Red Sorghum*, the idea of finding new ways to get drunk appealed to our jaded taste buds. Fuck Mr. Jenkins and Mel, too. We were jonesing for some Eastern spirits.

But it turned out to be harder than we expected to track down Asian liquors. With the exception of rice wines and beer, most Asian grocery stores do not stock native liquors. And at many Chinese and Japanese markets, expensive Scotches and cognacs are prominently displayed, while the smaller selection of homeland brews gets dumped on lower shelves. When we hit the motherlode of Chinese booze at a corner liquor store/porn shop in Chinatown, the labels were worn and faded, the bottles dusty and the liquid contents, in some cases, were evaporated an inch or two from age, but at that point in our drinking mission, we just didn't care.

And, to show just how little we were paying attention to the warning signs, neither of the native Chinese clerks had ever tasted our purchases, and they actually laughed at us when we asked them if they did. Only after it was too late did I read in the *New Encyclopedia of Wines & Spirits* that "Chinese history has it that wine-making started as early as 2500 BC. According to legends and written history...the product did not find imperial favor, and a prohibition of alcoholic drink seems to have followed."

So, totally oblivious to the bizarre sensory experience we were about to undergo, Katie and I sat down to a table packed with proof and a fresh pot of rice to cleanse our palates and stabilize our stomachs. But we quickly learned that we'd swigged more than we could swallow. After the first six liquors, age and wisdom dictated that we call it quits and reschedule for a later tasting. As with most gut-heaving experiences, it was the mixture rather than the quantity that led to trouble.

After having smelled, sipped, and gargled twenty kinds of booze—some of which would've made Bukowski think twice—we decided that the best brews were made from rice or sweet potatoes. Mainland China is no Napa, and the nastiest drinks of all were the Chinese wines. The sorghum took some getting used to, but the buzz came in spades and temporarily cleared our allergies. And, while we'd probably drink any of them if we were hard-up enough, we hoped our friends would enact some 12-step intervention before we got back to the plastic econo-jug of Korean table wine.

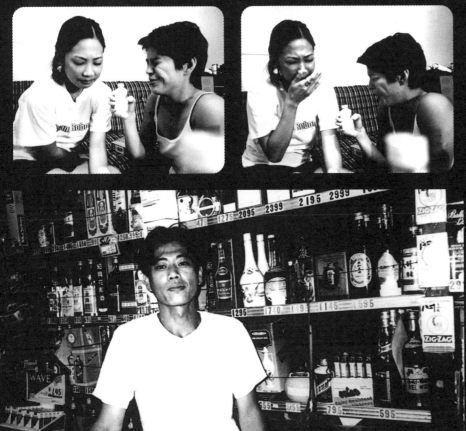

Toasting to the Moutai like Nixon and Mao, Julie and Katie made a discovery: Moutai sucks.

In Los Angeles's Chinatown, there's a cool store on a street corner that has just about all of the Asian liquor discussed in this article. The dude in the picture is the one who hasn't tasted any of the liquors in the Chinese section of his shop. We blew some big bucks in this shop and his straight face in the photo blew up into laughter.

MOUTAI CHINESE 🍷 104 PROOF

Made famous as the drink that Nixon and Mao Zedong toasted over, although the photos are nowhere to be found.

Katie: Poison in a bottle; it's like drinking gasoline. The fumes are unbearably potent, and it evaporates before it slides down your throat. You've got to be a real junkie or a politician to want to drink this stuff. But I give it a ten for the packaging. It's small, easy to conceal, and probably has been used as a grenade in war time.

Julie: This is the roadkill of liquors. I'm repelled, but fascinated. It's definitely emitting vapors not unlike bus exhaust. This taste just can't be intentional. They must be keeping the good stuff for the comrades.

Mao, the dude who never washed his hands, wipes his mitts on Tricky Dick.

The Nixon-Mao meeting happened in a time of turmoil for China. At a time when Mao was losing his power, Nixon showed up in 1972 to lift the trade embargos and to open the doors of China to travelers. This bummed out a lot of Chinese government officials. Nixon was once referred to as the "God of Plague and War" since he opposed China's entrance into the UN. But while he was there, he was doing all kinds of fun stuff. He stayed in China for more than a week. To this day, Nixon is a hero, and yes, he supposedly drank the Guizhou Moutai and lived to tell about it. The people of Guizhou province are proud of this fact, and will gladly tell you about it.

KORYO GINSENG JOO KOREAN 🍶 40 PROOF

Julie: Judging by the snot-like white sediment floating at the bottom, I think this bottle's been sitting on the shelf awhile. It has a pleasant, pungent smell like a ginseng root just pulled out of the dirt. Tangier than I expected from the proof, the taste really captures that thin, sharp, root vegetable flavor. Not exactly anything you could get hooked on, it's probably good for colds or fertility.

SANLIANGYE CHINESE 🍶 106.8 PROOF

Julie: The way this is packaged, I thought we might have accidentally schlepped home someone's doggie urine. It comes in a very attractive tiny, mint green ceramic bottle with dragon-like squiggle-handles on either side. But what initially tastes sweet and lemon-lime citrusy immediately degenerates into the same rancid meat flavor as the Taibaiju—making me wonder if my first impressions of the bottle were true...Hopefully it was just a bad year for sorghum.

KURACHI SHU SHOCHU JAPANESE 🍶 74 PROOF

Julie: Clearly the Japanese, sweet potato equivalent of vodka, this stuff has a pleasant kick to it. Thicker than I expected, it coated my throat going down and really warmed my tummy. I'm a sucker for packaging and was charmed by the gourd-shaped bottle and cork stopper. It's clear with a sweet afterburn that shot right up my nose. This must be a product of the coldest, northernmost reaches of Japan 'cause I'm no red-faced drunk, but this had my ears lit up like a Christmas tree.

JINRO SOJU KOREAN 🍶 48 PROOF

Julie: The Manischewitz of Asian liquors...a milder, Korean version of shōchū, it's much sweeter and its potency is cumulative. A good drink to have straight up if you like White Zinfandel and fruity cocktails with umbrellas in them. It hits you pretty friendly, but once the sugar/alcohol combo wears off, you're going to come down hard and will probably need a tongue scraper to de-fuzz your tongue the next morning.

HWATO: SZE CHUAN DAH POO CHIEW CHINESE 🍶 50 PROOF

Julie: Even before I had any, I was really into this one because the bottle comes with its own shotglass. Then, I remembered that Nyquil does, too. It's definitely not for happy hour, but for a summer cold, I'd replace my usual hot toddy with this sweet and spicy, almost creamy liquor. It's got strong hints of something like cinnamon or maybe star anise that'll cut through the most illness-deadened taste buds.

THAI WHISKEY THAI 🍶 UNKNOWN PROOF, WE COULDN'T READ THE LABEL

Katie: It smells like rubbing alcohol. I think I'm allergic to it. But it's actually quite tasty for a bourbon. I could see hitting the skids with a bottle of this in my hand.

Julie: This is pure liquor pleasure. I don't even need ice. If the bottle weren't already flask-shaped, I'd be proud to fill mine with this. As good as the best cheap bourbon. I'm keeping it.

CONFUCIUS FAMILY LIQUOR CHINESE 🍶 78 PROOF

Julie: Sweet and searingly strong, it smells and tastes like Cherry 7UP that'll fuck you up. There's a weird, underlying odor of canned peas that might put you off at first, but after the first slug, you probably won't be capable of smell anyway. You might be able to improve it by serving it chilled with a twist. Give some to a kid and he or she will spend the rest of his or her life sober.

SANG SOM ROYAL THAI RUM THAI 🍶 80 PROOF

Julie: This is either mislabelled whiskey or I've been converted to actually liking rum. It was really smooth without that excessive sugary taste that rums usually have. I'd have it on the rocks or poured into some strong black coffee for a late-night pick-me-up.

Hard Lickers

words | Martin Wong

With personal trainers in between matches and Met-RX logos on the entourage's T-shirts, the Ultimate Fighting Challenge is becoming less like an anything-goes video game and more like a corporate sporting event. That's why I'm waiting for some stinky, stubbly guy to stumble into the octagon, appear like a drunken fool, and proceed to jack his Olympic-level jock opponent with a crazy, inebriated uppercut. It can happen.

Drunken fist boxing is an actual Wushu technique that dates back to the 1840s. An offshoot of the Monkey style, drunken fist boxing was developed over a course of ten years by the imprisoned martial artist Kau See. To pass the time and to keep fit, Kau See emulated a troop of monkeys that lived outside his cell. Focusing on the leader, Kau See rolled, squatted, and fell like the monkey. Then he would twist and unleash a well-aimed and potent jab or kick. One day, Kau See saw one of the monkeys find and drink a half-filled jug of wine. This drunken monkey must have been annoying, because the others attacked him. To Kau See's surprise, the plastered primate defended himself despite its inebriated state. This monkey's unpredictable, staggering style inspired the drunken fist boxing style.

Today, most Americans know about drunken fist boxing from Jackie Chan's *Drunken Master* movies in which he plays Wong Fei-hung: *Snake in the Eagle's Shadow* (1978), *Drunken Master* (1978), *Drunken Master II* (1994). In them, not only does Jackie pretend to be drunk to deceive his enemies, he actually becomes drunk to increase his power. Because he cannot feel the pain when he is drunk, he can fight longer. However, therein lies the danger—he can hurt himself and not feel it until it is too late.

Want to learn Drunken Boxing? Good luck. It seems that even the world of ass-kicking is not exempt from political correctness. Not one studio in Los Angeles that I called offers the potent, potable discipline. Still, you can always purchase a season pass to the zoo where you can watch the monkeys. It's probably cheaper, anyway.

In *Drunken Master*, Jackie is a wino grasping the sorghum jug that's too big to fit in a brown bag.

MARTIN: "Hard Lickers" is the article that Daniel Wu responded to, saying that he could teach me drunken fist boxing! We became friends and pen pals,

TAIBAIJIU CHINESE 110 PROOF

Katie: No! Noooo!! [*covering face*] Noooo! Don't let the innocent-looking man staring at the moon on the bottle fool you, this noxiously clear liquor is dangerous. Probably used as smelling salts for the dead.

Julie: Do not drink this in a poorly ventilated room. This reeks like an NYC sewer in August. The label lists that it's made from sorghum, barley, and peas, but there's a definite protein content—maybe an animal crawled into the still to die. It has less of a taste than a sensation. It made my pupils dilate.

KUMBOKJU (DILUTED VODKA) KOREAN 50 PROOF

Katie: This Korean vodka is the perfect kimchi accompaniment if you're on a date—it would kill that chili garlic smell. Easy to slam, it's true to my heart. A very utilitarian, let's-get-fucked-up drink.

Julie: Diluted vodka...what a great idea. It's the perfect mixer for friends who can't handle their liquor. Out of the freezer with a twist or in a Bloody Mary, you could enjoy all the rituals of drinking alcohol with less risk of exposing your drunken alter ego. Like the patch for nicotine addicts who try to quit smoking, reduced-alcohol vodka could be a stepping stone to AA.

LYCHEE WINE CHINESE 🍶 28 PROOF

Katie: Another good dessert wine. It smells like woods and flowers. I'd drink it with a Napolean or maybe a Twinkie. Is lychee an aphrodisiac? With the two sexy lychee balls on the bottle, this drink is quite suggestive.

Julie: It smells really yummy like a freshly opened can of lychee nuts, but the taste is way too sweet for me. It looks like whiskey, but pours like maple syrup. I could imagine a group of mahjong-playing grandmothers really cutting loose with this.

ANGGUR MERAH INDONESIAN 🍶 32 PROOF

Katie: It tastes like melted blow pops. Probably a favorite among winos in Jakarta because it sells for $1/bottle. Assured hangover after drinking this one.

Julie: This syrupy wine could only be tasty on a snow cone, but have some fun by pouring it into a decanter, serving it with a moldy cheese and trying to pass it off as a rare, vintage port.

YAKJOO (TABLE WINE) KOREAN 🍶 UNKNOWN PROOF

Julie: The generic white plastic jug and "Shake well before opening" label should have been enough warning to skip this one. There was an actual fizzing noise after I shook it, and the yellowish liquid has flecks of what looks like soap scum in it. The label says it's made of rice, but it tastes like no rice wine I've ever had. It smells like our sink did when the garbage disposal was broken for three weeks. It's not as strong as a liquor—just plain nasty—like what I imagine sulfur water tastes like. This stuff must be a DIY abortion kit.

Games for Chinese Drunks

words | Martin Wong

Drinking games can be incredibly stupid. Why are dart boards so popular at pubs? Sharp projectiles are the last thing I want some inebriated slob to be flinging if I'm in the room. And what about quarters? That coin could be put to much better use in a pinball machine. A much more sensible game for drunks is chiu-ch'uan, or guess-fingers.

The rules of the game are simple. Two drinkers show a hand with zero to five fingers out, while guessing the correct total number of fingers that are out. Whoever guesses the actual sum wins. The loser drinks. Sound simple? It is. But like all drinking games, it's more interesting to those who are sloshed.

If that's too pedestrian for your potable playtime, try one of the many variations. Everyone knows the Japanese style (rock, papers, scissors), but how many can play the Three Kingdoms version? That game requires its players to be familiar with the Chinese literary classic, *Romance of the Three Kingdoms*.

Numerous other variations of guess-fingers exist, but I don't ever see anyone playing these simple versions. The fact that I don't hang out at bars could be a factor, but that shouldn't stop you from being a trendsetter. Purportedly, the game is huge in Taiwan, so the potential is there. With your help, guess-fingers could be the next Six Degrees of Kevin Bacon game. 🐱

SAKE IN A BOX JAPANESE 🍶 UNKNOWN PROOF

Julie: Leave it to the Japanese to package alcohol in single-serving, Hi-C-like paper containers. Although the sake can be drinken either hot or cold, its cloying flavor will taste a little off whichever way you have it. But then quality is hardly the point when the drink is portable and so damn cute that you could fearlessly stroll past a police station taking sips out of the three-inch straw that comes attached to the box. The main drawback is that the containers are not microwaveable.

ANGGUR PUTIH INDONESIAN 🍶 32 PROOF

Katie: It smells like Robitussin and makes my nose hairs tingle. But it smells worse than it tastes. It would make a good dessert wine or cough suppressant. For a white wine, this drink is strong and sweet.

Julie: If banana Italian soda syrup were fermented it would taste like this...except I don't think there are any bananas in it. You could probably get drunk on this, but you might need to throw up first. Does Thunderbird come in red and white varieties? If so, these two are the Indonesian equivalent.

NIKKA WHISKY

JAPANESE 🍶 **86 PROOF**

> **Martin:** Maybe being a small, northern island country, Japan feels an affinity with the UK—whatever it is, the Japanese have adopted whisky-drinking as a national pasttime and even set up distilleries to make Japanese Scotch(!). While this stuff won't make any converts out of single malt devotees, it's smooth and woody enough to do in a pinch, and enough of a curiosity to suspend brand loyalty for at least one long, soggy night.

LAMBANÓG

FILIPINO 🍶 **UNKNOWN PROOF, BOUGHT OFF A BOOTLEGGER WHO REFILLED AN EMPTY J&B SCOTCH BOTTLE**

> **Katie:** The piss color is enhanced by the kidney-stone looking grapes that come in it. The grapes are potent, and would probably knock you out if you could handle dingleberry-looking items in your drink.
>
> **Julie:** Disappointingly, there was no coconut flavor at all. Actually, there was almost no flavor. It's a multi-purpose liquid: You could either drink it or use it to disinfect wounds.

GINSENG JUICE WINE

CHINESE 🍶 **UNKNOWN PROOF**

> **Julie:** The cap was crusted to the bottle with a funky-smelling brown goo, and the pale, humanoid-looking root floating in the wine looked unwashed. The smell of this dark-brown wine alone gave me a headache. It has a honey-sweet taste at first, but immediately turns so bitter it dried up all the saliva in my mouth. I'll be scanning myself for increased body hair growth in the next few days.

MIDORI MELON LIQUEUR

JAPANESE 🍶 **46 PROOF**

> **Julie:** While, for certain pride-related reasons, I wouldn't be caught dead ordering this frou-frou drink in any bar except Benihana's, Midori accurately captures that candy melon flavor (and color!) that's so popular in Japan. Way too sweet on its own, it's the ultimate girly-girl drink mixer.

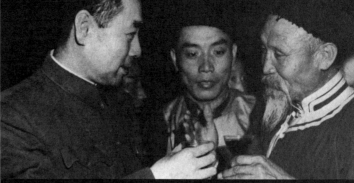

Zhou Enlai meets with a Mongol dignitary and a flunkie in the middle. They must be toasting some strong sorghum.

LEGEND OF SORGHUM

Maybe it was my fault. I shouldn't have suggested that we taste two sorghum liquors in a row. Whatever the case, Katie just hasn't been the same person since. Soon after she mentioned something about experiencing hallucinations from the Taibaijiu, I returned home from work one day to find out she had gone to Mexico "where they make liquor out of normal, decent stuff like cactus and worms," her note said. Recently, a friend told me that Katie's somewhere in Baltimore downing scotch and sodas, and refusing to return home until I clear out all the sorghum bottles.

I'll admit it's pretty nasty stuff and, yeah, Chinese peasants did use it to make Molotov cocktails in *Red Sorghum*. But Gong Li didn't wrinkle her delicate nose at it. And until Japanese invaders swooped down on the sorghum farm, distillery workers celebrated and sang that catchy, off-key wine song even before they broke the seals on those gallon-sized jars or had a chance to catch a buzz off of their burgundy brew.

I was curious to know exactly what sorghum was, so I made a trek to the library. The very first book I opened said it all: "The importance and qualities of sorghum for human food are not well-recognized in the West." **Suddenly, it all made sense. The truth was, I'd been weaned on beer and Bushmills and no amount of sake was going to drown my Western taste buds.**

Humbled, I went on with my reading. Known in China as Kaoliang, sorghum started out as a weed in Ethiopia. After it was domesticated, the generic-looking grain spread throughout East Africa, worked its way through Egypt, Arabia, and India, and finally hitched a ride along the Opium Trail to East Asia. It gained popularity in the northwest regions of China and Manchuria where it was too cold to grow rice. It used to be enjoyed as mush, as well as liquor, but since long-distance food distribution has improved over the last hundred or so years, its seeds are now primarily used for feeding livestock or for making wine. The stalks are used for fuel and roof construction. Admittedly, it was something of a relief to know that the liquor that had stunned Katie and me was made from a grain now used primarily for pig feed and roof thatching. It also explained why the Chinese liquor store clerks laughed at us. But the human lust for inebriation runs deep. During Prohibition, people risked going blind to drink bathtub gin, and I've heard that prisoners will make booze out of whatever rotting fruit or vegetable matter they can hide in their cells. So, in a pinch, who knows? But, Katie, if you're reading this, I swear the Moutai is gone and there's a bottle of Dewar's in the cupboard. You can come home.

PINOY PRISON RECIPES

words + pictures | Teena Apeles

The basic turkey stew, mashed potatoes, and gravy meals at Los Angeles County Men's Central Jail don't exactly cater to the Asian palate. And when you consider that the last bland meal is served around 4:30 p.m., it's no surprise that Filipino inmates known as the Parés—who usually number 6 to 13 guys per cell and reside in an Asian section of the jail called "Baker Row"—have developed special after-hours dishes. The jail's store ain't no supermarket, so the Parés have to be creative when conjuring up their community dishes for the evening. Also, time to prepare each dish is approximate since, as the source notes, "You don't really keep track of time when you're there." Use the following recipes to try your hand at these nighttime meals with some friends. We've taken them out of jail so that you, the Asian food connoisseur, don't have to be convicted to try them.

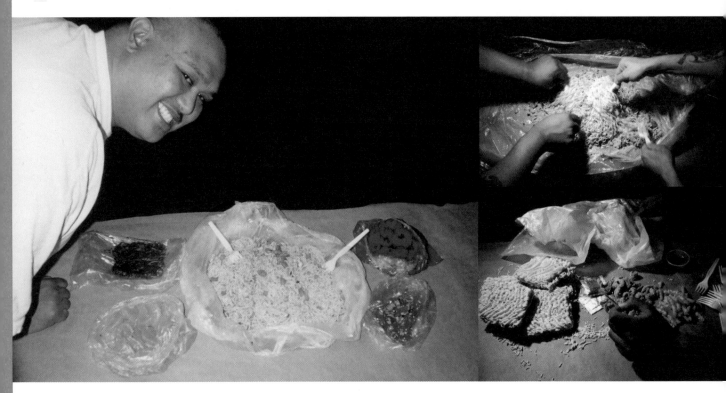

THE SPREAD

This flavorful main course feeds up to 10 prisoners and takes 5-10 minutes to prepare.

6 cups of hot water (from cell sink, which means it's not boiling)

6 packets Top Ramen noodles (bought from store)

3 packets of mayonnaise (saved from lunch)

1 bag of pork cracklings (what Filipinos call chicharrón, bought from store)

½ bag of crushed Cheetos (bought from store)

1 packet of red chili sauce (saved from dinner)

3 packets of Top Ramen chicken or beef seasoning

1 garbage bag (Trustee can provide. A trustee is an inmate who has a long jail sentence and does the rounds. His cell is always open and he provides his row's inmates with a variety of needs.)

1. Fill garbage bag with 6 cups of the hottest water you can get from the cell/bathroom/kitchen/laundry sink and add the Top Ramen noodles. Tie up bag so noodles can soak.

2. Fill sink with hot water and place garbage bag full of noodles in the sink. Let bag sit for 5-10 minutes or until mixture gets moist.

3. Open up bag and add mayonnaise, pork cracklings, chili sauce, crushed Cheetos, and Top Ramen seasoning packets. Stir contents.

4. Gather cell's residents in a circle and serve immediately. Cut open bag to create a makeshift plastic bowl by having each guy hold up a side of the bag. Dig in.

JAILHOUSE-STYLE TOCINO

Traditionally, this fuchsia-colored Filipino side dish is made of pork, pineapple juice, sugar, salt, and salitre. This version feeds up to five prisoners and takes "a long time" to prepare.

3 bags of pork cracklings (bought from store)

5 tablespoons of fruit punch powder (saved from previous meals)

2 cups of water

1 packet of red chili sauce

1 plastic bag (trustee provides)

1 Put pork cracklings in bag and add water.

2 Add fruit punch powder (for color and sweetening) and red chili sauce to cracklings.

3 Close bag and let sit for "a long time."

4 Open bag and serve when hungry.

DIY KIMCHI

This single-serving side dish requires 3–5 hours of preparation.

1 serving of cabbage and lettuce (saved from lunch)

¼ packet of red chili sauce

1 plastic sandwich bag (saved from lunch)

1 Place cabbage and lettuce in sandwich bag and mix in red chili sauce (add more if you want it spicier).

2 Seal bag airtight and let sit for 3–5 hours. (Inmates usually prepare right after dinnertime around 5:00 p.m. and wait until 10:00 p.m. to eat.)

3 Open bag and serve.

REESE'S PIECES BROWNIES

This simple dessert feeds up to six unselfish prisoners. Preparation time depends on the weather.

6 servings of chocolate pudding (saved from dinner)

6 peanut butter packets (saved from lunch served on Thursdays and Sundays—bologna sandwiches served all other days)

2 plastic bags

1 Put pudding and peanut butter into plastic bag and stir until it thickens.

2 Cut other plastic bag into a wannabe rectangular cookie sheet and lay on floor or shelf.

3 Pour contents of first bag onto plastic sheet and spread evenly onto surface.

4 Let brownie mixture sit until it hardens—or until it begins to resemble brownies instead of (fill in the blank).

5 Share.

SEASONED ORANGES

This refreshing dessert feeds up to six prisoners and only takes a minute to prepare.

6 whole oranges (saved from meals)

2 packets of Top Ramen beef/chicken seasoning (leftover seasoning packets saved from Top Ramen used in "The Spread")

1 plastic bag

1 Peel oranges and place slices in bag.

2 Add Top Ramen seasoning.

3 Close bag and shake well.

4 Take out seasoned oranges and serve.

On tabletops in most Asian restaurants, stores, and homes, is the bottle with the green top. The plant is in Southern California and the man behind it, David Tran, gave me a personal tour.

THE FAMOUS HOT SAUCE FACTORY TOUR

You've seen the bottle and you've probably burned your ass with the contents. I've heard people refer to the clear chili bottle with the rooster logo and green top as "Red Cock Hot Sauce," but most of us know it as Tương Ớt Sriracha (Sriracha is the name of a coastal Thailand town). People across the country probably have loads of names for this bottle of crimson fury, and I'm sure it's aided in the creation of some of the best mixtures of Thai noodles, dipping sauces, and spicy tuna rolls—along with multiple cases of stomach pangs of red chili rejection.

Tương Ớt Sriracha may be (next to soy sauce) the most common form of flavoring. It's absolutely everywhere. When something is lacking that massive twang, a squirt of the red rooster brightens the day in a hurry. But where does it come from? **I had always assumed the sauce was an import item straight off a Bangkok freighter until I read the bottle (printed in five languages!) which said it was made in Rosemead (just out of LA).** So after dialing up the phone number on the bottle and getting a hold of a woman named Donna, I got hooked in to meet the chief assassin of chili, the sultan of spice, the ringleader of the ring of fire—David Tran.

I expected a man wearing a suit and smoking a cigar (looking like Chow Yun-fat), but instead Tran was a humble man wearing a golf shirt (looking more like John Woo). The man was soft-spoken as we sat in a small waiting room filled with sample bottles of sauce, wall-mounted newspaper articles, and a wooden model rooster.

Perhaps the most popular part of the sauce isn't the flavor, it's the packaging. The rooster, proud of its prowess, practically crows. "Why a rooster?" Tran answers simply that he was born in the Year of the Rooster. A Vietnamese refugee, Tran named the sauce Tương Ớt, after the boat that took him

to Hong Kong in 1978. The trademark green top represents the freshness of the chili used. Says Tran, **"We use the best red chili. The vegetable is red and the stem is green. If the stem is purple or black it means the chili is not fresh. The cap is like the stem."**

"In Vietnam, I planted chili. I was a farmer," remarks Tran. Although he left everything behind him in Vietnam, he didn't forget about his sauce concoction. In America, he started his business in 1980, making sauce for the Vietnamese community. "We liked to eat spicy food. We could get sauce, but then we thought we could make it better. Before I started, I did not research the market. I just tried to make $1,000 a month—enough for my family." Now Tran can't fill the demand and although he pawns off 7 million bottles and makes $10 million a year, he needs to make more.

During the chili season, September through October, the plant receives shipments of tons of chili from an 18-wheeler. The chili is ground right away and placed into vats for months of aging and further processing. The plant can grind down 100–200 tons of

chili in one day, and Tran upgrades his machinery annually.

When shopping at stores for just about any sauce, you'll notice that most bottles are almost always made of glass with pretty labels stuck on them. Instead of paying more for freight and a shiny, colorful, affixed label, Tran gets plastic bottles screened in one color— white. Since the bottles are unbreakable and unuseable as weapons, there's at least one jail buying his sauces for inmates. The economy of the bottle is a reflection of the streamlined company which only employs a total of 17 or 18 people, many of whom are relatives.

For some reason, Sriracha sauce has attained a powerful cult status. The word is spreading slowly, and more and more non-Asians are beginning to know about it. Attributing his success partially to Americans' changing tastes and the growing popularity of Asian restaurants since the '70s, Tran is sure that his sauce is the best in terms of flavor, heat, color, texture, and most of all, price. For example, if you price shop Tabasco versus his Sriracha sauce, they are roughly the same price—if you buy the tiny Tabasco bottle and his 17-oz. mid-sized bottle. Each one is about $1.50. But if you want the ultimate deal, then show up at his shop and buy a case of twelve 30-oz. bottles for a mere $18. He made me lift a case to prove his point about the value. Yes, the box was heavy.

After our quick talk in the meeting room, I got the tour of a lifetime. You wouldn't think much of a pepper plant, but after stepping into the rooster-logo'd golf cart, we cruised his spicy fragrance-filled plant. It looked more like a laboratory—perfectly clean with glass windows for observation. From the mixing area (where a worker or two mixes the raw chili with vinegar) to the next room (where it gets bottled), there is not one single drop of sauce

ERIC: A factory tour where food is made is now commonplace, but not at the time. Knowing where your food comes

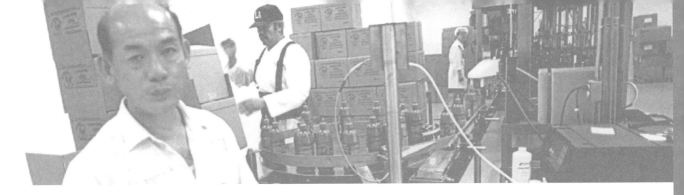

anywhere. This makes Tran proud. He relays a story about the Health Department, who actually enjoy coming to his factory since they have to do little or no paperwork. They are able to relax, and occasionally they bring a new inspector to show how clean a plant can be.

In the bottling machine's area, not only was the floor spotless, the machines were shiny and dispensing the exact amount of sauce per bottle. Tran mentions that he went to another sauce plant that uses the exact same equipment and 10 people, including one to hand-wipe each bottle due to the sauce spillage. At Tran's plant, only two operate the same machine. Also Tran mentions a horrifying article: "I once saw a chili plant in a magazine, and oh my god! Terrible! In Louisiana."

The sauce machines are all prefabricated, but no machine is exactly tailor-made for the creation of the sauce. When there is a discrepancy about efficiency, Tran takes to his tools and makes modifications in his own on-site machine shop. There, he fabricates parts, welds them, and customizes his equipment unless he subs the job out.

I asked about his work schedule and how he manages to maintain such a clean and highly productive factory. Tran claims that he only works 8-hour days, 40 hours a week, with his daily activities being machine work and efficiency figuring. But when there is an emergency, he's there 24 hours doing the fixing.

Even though the chili sauce gets made in rapid speed, there's simply not enough produced to fill the demand. Year after year, the orders grow and the company expands. Just recently, Tran purchased the old Wham-O building two doors down. It is a huge ten acre complex that has a 170,000 square foot warehouse and office. It could house a number of jets, but instead it's used for storing sauce. We cruised it in the golf cart with Tran using his remote controls to open every roll-up door and turn on almost every light. The ride was long and the office space will most likely never be used since he'll never hire the 1,600 people who once worked for Wham-O. Instead it's all going to be for storage for when the sauces someday make the American supermarkets.

After 17 years of operation, not one cent has been spent on advertising, professional research, or promotion. Although there are a few other flavors of Tran's sauces that haven't caught on nearly as well as his Sriracha sauce, he claims that they are all good and will just need some more time to catch on. He claims to have his sauces with every meal. The word on the Red Cock Hot Sauce is still spreading like wildfire through word-of-mouth. Tran envisions his future as a slow growth, keeping his prices as low as possible, penetrating new markets little by little, and still with no plan to waste a cent. That's one of his secrets of success—to not let any competitor even get close. 🐱

TUONG OT SRIRACHA (USA)

FLAVOR: 4.5
HOT: 1

Angelyn Wong: Good flavor. The Pace Picante sauce of Asian sauces, this stuff's definitely not made in New York City. I'd put this on anything that needs a kick. Do they sell this in jugs at the Price Club?

Jayson Sae-Saue: This is the market standard plain-but-good Asian ketchup.

SAMBAL-BADJAK (USA)

FLAVOR: 5
HOT: 2

Chantal Acosta: The garlic smell would send Dracula reeling, but the fresh, ripe onions give this sauce a delightful flavoring. I wouldn't mind eating this stuff just off a spoon. Yummy!

Jayson: There's a bit of an aftertaste, but I think it's the Hsin Tung Yang seeds lingering on my molars. Put this on your toast, in your salad, or just toss it down straight.

TUONG OT VIETNAM (USA)

FLAVOR: 3.5
HOT: 2.5

Chantal: Pretty standard hot sauce. I think it would taste good on rice.

Martin Wong: Hot, garlicky, and grainy, the label says you can add this to American, Italian, and Chinese food. This potent sauce can boost any flavor with a blast of pure sink.

SAMBAL OELEK (USA)

FLAVOR: 3.5
HOT: 2.5

Jayson: Taco Bell hot sauce with seeds! Make a run for the Great Wall...

Angelyn: This one's making me sweat. Instead of going to the sauna, take a swig of this. The description says it "heats up" any dish. Microwave companies, watch out!

CHILI SAUCE (TAIWAN)

Jayson: My head hurts. I should have taken the steam that singed my nose hairs when I opened the bottle as a warning. Someone must be holding a gun to the man giving the thumbs up on the label. The Chinese characters probably say "Do Not Eat."

Martin: The hot and sticky sensation of this concoction gagging down my throat will no doubt be repeated in my sphincter tomorrow morning. This comes from the Har Har Pickle Food Factory in Taiwan, and the joke's on me. This sauce sucks.

FLAVOR: -2.5
HOT: 2

CHILI SAUCE CAP JEMPOL (INDONESIA)

Chantal: This reminds me of pineapples! I really like its sweetness, which adds a new, unexpected, and flavorful dimension to your food.

Jayson: I was somewhat skeptical about this one after seeing the thumbs up on the case since my previous experience with a thumb logo was so bad. Actually, it's just sweet and bland. If these labels thumb-wrestled, the Har Har brand chili sauce would kick this Indonesian sauce's ass.

FLAVOR: 5
HOT: 1.5

RADISH PEPPER PASTE (JAPAN)

FLAVOR: 1
HOT: 0

Angelyn: You know how the smell of puke causes gagging reflexes? This stuff did that to me. The mystery is, how could something smell so putrid and taste so bland? This is really just stinky baby food.

Martin: Smells like vomit but tastes like puréed carrots. There's no flavor, so I don't know what the point is.

KIMLAN HOT BEAN SAUCE (TAIWAN)

FLAVOR: 4
HOT: 3.5

Angelyn: Mix up some soy sauce and chili oil and you get this hot, but somehow sweet and salty goop. I made the mistake of licking my lips and now they won't stop burning!

Martin: This one's almost sweet in a plum-sauce fashion, but mostly it's just creamed fire. The beans add a smoothness that the others lack. You can dip fried wonton skins in here to make Chinese nachos.

SWEET CHILI SAUCE (SINGAPORE)

FLAVOR: 4
HOT: 0

Jayson: How hot can it be when the major ingredient is sugar? Yeo might have been influenced by Mexican tamarind action.

Angelyn: This tastes like a Mexican tamarind lollipop and could be an ice cream topping compared to the rest of these sauces. Little kids would probably sneak into the kitchen cupboard for this sweet treat.

SAMBAL EXTRA PEDAS (INDONESIA)

FLAVOR: 5
HOT: 1.5

Chantal: Hey, wait a minute. I just tried this. Same ingredients as Cap Jempol in a slightly different order. Tastes just as scrumptdidliumptious!

Jayson: Either my taste buds are numb and dead or this tastes like nothing. Extra hot, my ass.

MOMIJI OROSHI (JAPAN)

FLAVOR: 1
HOT: 1

Chantal: It reminds me of spicy tomato soup. I wouldn't bother putting it on my food since it would probably just give a reddish coloring but not much flavor.

Angelyn: This one's a waste of sauce. No flavor. No heat. A rip-off.

LINGHAM'S HOT SAUCE (MALAYSIA)

FLAVOR: 2.5
HOT: 0.5

Chantal: I was thrilled to read that sugar is the main ingredient of this sauce. Then when I tried it, I thought they overdid the sugar. My stomach is cramping up a little from this marmalade-like sauce.

Angelyn: This is the Grey Poupon of hot sauces with the fanciest packaging. It tastes like relish with a little heat mixed in.

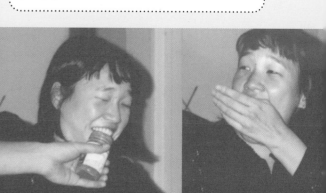

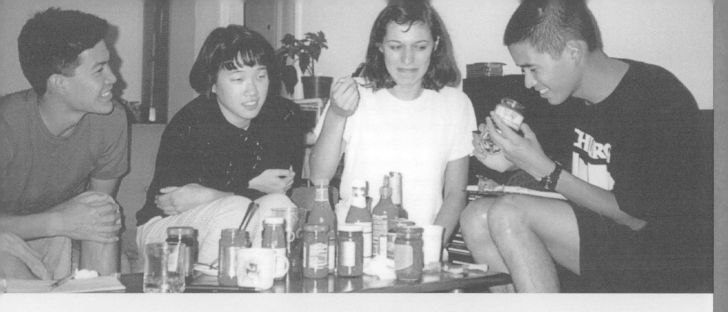

CHILI PASTE WITH HOLY BASIL LEAVES (THAILAND)

FLAVOR: 3
HOT: 2.5

Chantal: Not really hot, just nasty, especially the texture. It's way too oily. Just smelling it makes me want to puke. I wonder how long it's going to take me to digest those chunks of basil leaves.

Martin: This looks like the Swamp Thing's snot, with lots of green leaves, seeds, and oil. At first it just tastes salty and oily (like you're licking a potato chip bag), but when you bite a seed, out comes some funky heat.

HSIN TUNG YANG CHILI SAUCE (TAIWAN)

FLAVOR: 3
HOT: 2.5

Jayson: Looks like GWAR regurgitated this back into the bottle, and tastes like it, too. The seeds stuck in my teeth like corn.

Martin: You can't get away from the seeds in this thick, salsa-textured jar of glop. With nothing but chili, salt, and sesame oil, this is probably the cleanest-burning flavor fuel of the batch.

TIA CHIEU SATE (USA)

FLAVOR: 4
HOT: 2.5

Chantal: Recreate the Stinking Rose experience in your own home with just a little Tia Chieu Sate on your noodles or meat. If you have a weak spot for sauteed garlic sauce, this sauce will sa-tis-fy you.

Martin: Super-garlicky and smooth, this one will be affecting my scent for years. Even if you don't believe in vampires, it's still worth eating, because the flavor is excellent.

SAMBAL KEMIRI CANDLE-NUT (USA)

FLAVOR: 0.5
HOT: 5

Angelyn: Lots of crunch like super-chunky peanut butter, but half the taste. This one goes from mild to fire-engine hot in 10 seconds. The flavor sucks.

Martin: "Candle nut" sounds very testicular, so this must have some sort of potency-boosting or aphrodisiac qualities. Why else would anyone consume this shitty-tasting sauce? Earthquakes, riots, and fires—add this stuff to the list of LA disasters.

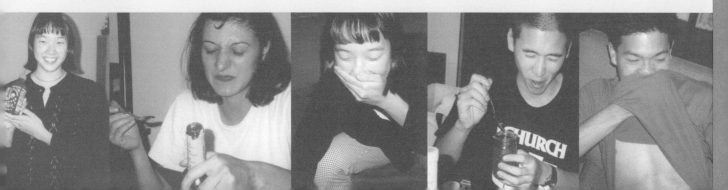

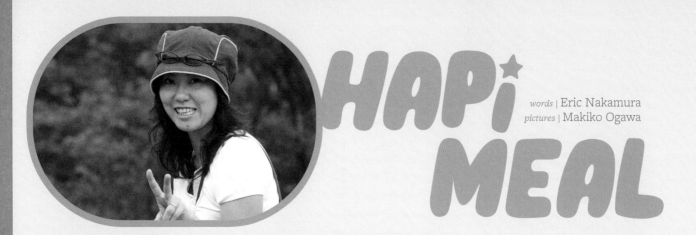

words | Eric Nakamura
pictures | Makiko Ogawa

HAPi MEAL

Bento is a centuries-old culture in Japan. It's simply defined as a boxed lunch that's often homemade, but also sold by 7-Eleven. Makiko Ogawa takes bento a step further by making cute, edible art pieces for her two elementary school-aged kids. She uploads photos of her masterpieces to her blog and Flickr sites, where they have received jubilant remarks and inspired charaben (character bento) efforts from the US and other countries. While a few companies have taken note—and even hired her to create character-shaped foods—she's still committed to the careful task of creating the best lunches possible for her children.

Why did you start making cute bento?
MAKIKO OGAWA: I made the bento for my 8-year-old son when he was in kindergarten. He hated to go to kindergarten. He cried and cried. It was not easy to take him to kindergarten, and I hoped that my bento would make him happy.

Do you feel bad about eating the cute bento?
No, there are many things that are shaped like animals or smiley faces in the world, such as gingerbread men. **I've never been reluctant to eat my bento. Bento is bento.**

How long does it take to make it?
About 30 minutes. If the making of bento takes too long, I'd hate making it.

Do you refer to bento books?
There are many bento recipe books in Japan. I looked at many books that give recipes for side dishes, but there were no charaben books. At that time, there was only a website

of charaben/kyaraben. I've made my bento by watching others or by myself.

Do you make particular themes?
Basically, I just make bento that my children would want. If I had to describe themes for my bento, it would be "cute," "enjoy making them," and "to please children."

Did you come up with the bento concepts yourself? Where do you get your inspiration?
I keep a lot of illustrations for bento in my notebook. Some are from TV animation, old postage stamps, antiques, picture books for children, or the drawing sketches of my boys. There are various materials that give me a lot of inspiration.

If you make bento for an adult, are those cute, too? Or just plain?
Twice a week or so, I take my bento to go. They are not all charaben; they're just ordinary, traditional Japanese bento.

At what age will you stop making charaben for your kids? What will you do after that?
My kids are seven and eight now. They still love the charaben that I make. However, when they don't want it, I'll stop. After that, I'll make charaben for me.

Do you make chara dinner, too?
No. Never. It sounds too troublesome.

What do you think about traditional bento? When you make it, do you add any style to it?
I believe that Japanese food culture

is something that we can be proud of, and bento is a piece of culture from the old times. But I only make bento that I want to make. There is no fixed style in particular.

Can you tell me a little more about bento culture?
Japanese bento culture is very old; it's from the 16th century. At department stores, many gorgeous and elaborate bento (not character bento) are sold. As well as its flavor, it's important that its appearance is beautiful. The Japanese used to say, "Enjoy food with your eyes." Charaben may have come from enjoying with your eyes.

What is the most elaborate bento you have made so far?
Three piggies bento. It was a lot of stuff—a side dish. Because the gourd type of bento box is larger than the others, I had to stuff a lot of side dishes. At the same time, I had to think about the balance of colors.

Can you tell me about the food you designed for companies? How did that happen?
I have a bento blog written in Japanese. Companies give me bento work through the blog. It's not easy, but it's really interesting.

Tell me more about your bento work for companies. Is that kind of work great? Do you want more?
All bento work is great for me. There is a feeling of strain, but I believe that feeling of strain gives me a lot of inspiration. I want more bento work but at suitable intervals. All of my bento work is charaben for children.

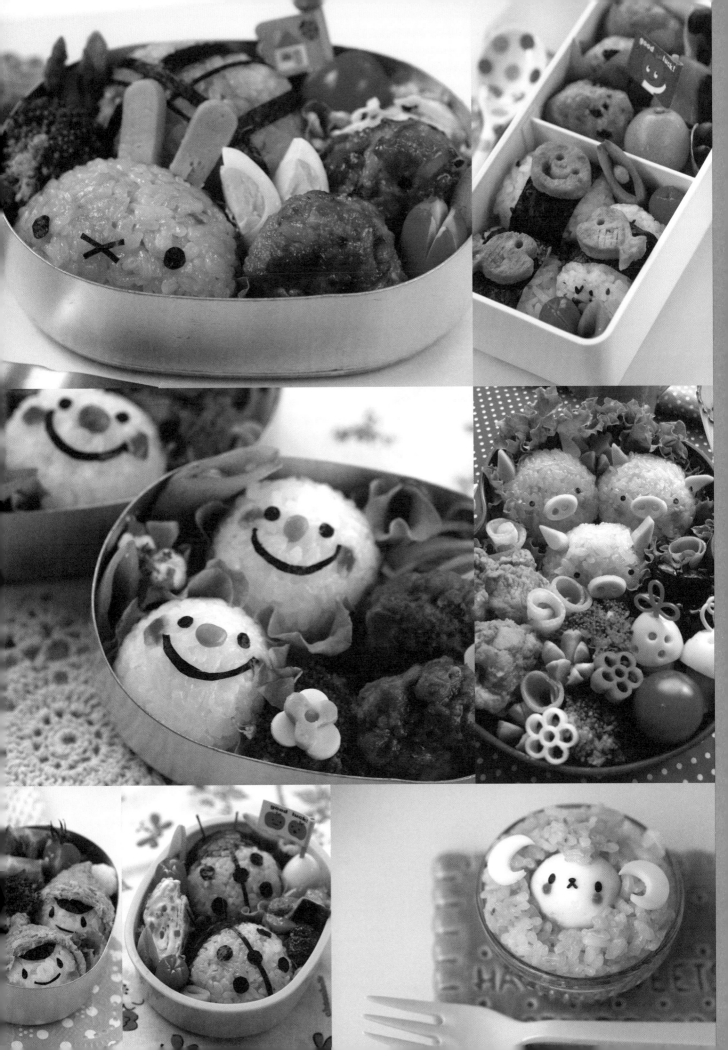

ASIAN AMERICAN LUNCHBOX

words | GR

In the '70s, long before metal detectors were installed in elementary schools, the Golden Age of Saturday Morning Cartoons was also the Golden Age of Lunchboxes. Packing tin meant you were a cool kid. Not only were you spared from eating the cafeteria's Shit on a Shingle (diced turkey in grey liquid), you could also participate in lunchbox bowling while you flew the flag of your favorite TV show. But that was just on the outside of the box. What you carried inside dictated whether you were a hero or a zero. If you pulled out a Coke can or a Snickers bar, you were studly. If you packed PBJ on Wonder, you were "normal." To be Asian American often meant packing a seaweed-wrapped rice ball filled with a pickled plum, chicken chow mein in beat-up Tupperware, or a cold pork chop wrapped in foil. That meant being a freak and a geek egg-rolled into one. It might have seemed like punishment at the time, but in retrospect, the embarrassing Asian-influenced lunches were far superior to the coveted all-American lunches. Kalbi, kimbap, and egg rolls or Oscar Mayer and Ding Dongs? The Asian American lunches were better, even if you had to take shit from bullies (who probably eat at Benihana and Panda Express now).

CHINESE AMERICAN LUNCHBOX

This lunchbox might have zongzi ("Chinese tamales," according to Mom) and various soups as main portions. The less saucy, more oily dishes taste good cold.

Shumai: Back in the '70s, dim sum was only for locals. If you brought some of these shriveled leftovers for lunch, kids would say, "There's pork in that cocoon?" The closest thing might be kreplach, but how many kids know what that is?

Haw Flakes (under the napkin): Like Chinese yo-yos or snaps, Haw Flakes are something that every kid brings back from Chinatown—probably because the disks of dried-up plum and sugar are dirt cheap.

Har Gow: Because the skin of this dumpling is translucent and the shrimp inside is pink, this could be mistaken for just about any organ.

Chow Mein: For some reason, it's okay to mix up leftovers when you have Chinese food. This is probably because almost anything can go with chow mein. Fried chicken, tofu, and vegetables fit right in, and the noodles work cold, too.

Fruit: The only meeting place between lunchboxes of all people. It's almost like the universal languages of sports and old TV sitcoms.

Zongzi: While everyone else pulls PBJs out of high-tech Ziploc bags, we unwrap sticky rice out of a gigantic bamboo leaf, which only calls more attention to the gnarly core of chestnuts, shriveled mushrooms, lap cheong (Chinese sausage), and salty egg yolks. "Do you eat the outside, too?"

Various Soups: Hot and sour, egg drop, or winter melon soup sometimes gets packed in the Thermos! Unlike what most non-Asian kids got—alphabet or chicken-noodle—Chinese soups never come from cans.

Hong Kong Phooey

After the rise of Bruce Lee and the wave of martial arts movies that followed, Hanna-Barbera could have followed up the *Chan Clan* with the ultimate Asian American hero. Instead, they chose a talking mutt. *Hong Kong Phooey* ran for 16 episodes from 1974 through 1976. Working undercover as a janitor in a police station, Penry would hear about a problem, jump into a filing cabinet, and emerge as a masked hero who would take off in his Phooeymobile. Voiced by jazzman Scatman Crothers, the canine would bring out his Hong Kong Phooey chop that he learned from a kung fu book that he somehow carries in his gi. Although there are too many unanswered questions for the show to make sense, the cartoon was one of the many reasons why everyone thought Asian kids could know martial arts and be buffoons at the same time. There have been talks to make a movie that could only end up as a CG disaster like Ang Lee's *Hulk*.

LUNCHTIME STORIES

Ming Tran: I remember the first time my dad packed me a Vietnamese pork chop. It was so embarrassing, I cried. They never packed me a pork chop again. But I recall having spring rolls with peanut sauce, cold egg rolls, Vietnamese sandwiches, soy bean milk, coconut juice, and Bánh chưng (glutinous rice, pork meat, and green bean paste wrapped in a square of bamboo leaves).

Cate Park: Futomaki and that roll with spinach and whatever...Sometimes sushi. The other kids were really jealous. Who wants friggin' peanut butter and jelly for lunch?

John Pham: I had stinky rice dishes that my classmates were weirded out by.

Wei-En Chang: I went to elementary school in the Midwest and my mom would give me rice and leftover Chinese dishes from dinner, like pork chops and onions, beef stew flavored with star anise, scrambled eggs with tomato, stir-fried bean sprouts, shredded chicken and snow peas—stuff like that. I would kill to have lunches like that now, but at the time I was a little kid who wanted to fit into white American society, and my lunches embarrassed me. The other kids at school would ask me questions about my food, and I got so self-conscious that I begged my mom to just buy me bologna sandwiches and chips so they wouldn't bug me and make me feel different.

JAPANESE AMERICAN LUNCHBOX

This lunchbox is a direct descendent of the bento box. Neatly packed with a balance of the four food groups, the meal is based around rice balls.

Fishcake: The trick to opening one of these without a knife is chewing through the plastic—or using the tab. The contents look like a fleshy pink wiener, but it's made out of fish! Inevitably, it inspires wee-wee jokes.

Croquette: "Koroke" is basically a McDonald's hash brown, except it's mashed, breaded, and deep fried. These rule and pretty much get a "pass" from the other kids.

Dried Seaweed: These seasoned seaweed sheets are more like snacks, and always elicit comments like, "Eww, seaweed!"

Green Leaf Thing: For some reason, Japanese moms like this decorative plastic. You don't eat it, and you don't take it back home. You just throw it away. I still don't get it.

Takuan: The bright yellow pickled daikon is deceptively stinky and more sweet than sour.

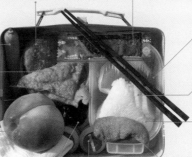

Wonton Triangles: Even though it's sort of Chinese, triangle wontons are a Japanese American favorite—especially at carnivals or parties. Too bad the word "wonton" can never sound cool.

Rice Balls: Handmade rice balls could be plain or filled with pickled plum, fish, or other leftovers. Who would have thought they'd ever become trendy?

White Peach: Straight out of the Asian market, this delicate fruit is superior to the more common red delicious apples.

Fruit: Grapes are tasty. This might be the only thing in common with the other kids' lunches.

Yogurt Drink: You can easily down a five-pack of these sweet drinks. They look like bukkake, but luckily no one knows what that is in the lower grades.

Inari: If you call these rice balls wrapped in fried tofu sheets "footballs," it's cool. If you call them inari, you are screwed.

The Amazing Chan and the Chan Clan

Basing *The Amazing Chan and the Chan Clan* on the "Oriental detective" pulps and movies from the '20s through the '40s, this Hanna-Barbera cartoon series oddly did the right thing during the "who cares about Asian Americans" era, and booked a mostly Asian American cast to play Chinese American characters. Instead of depicting him as a dickless wonder, H-B dressed the widowed detective like a pimp and portrayed him as the studly father of 10 kids, which perhaps earned him the nickname "Amazing." From 1972 to 1974, there were 16 episodes in which the sleuths basically did the same thing as Scooby Doo's crew: found lost gemstones, got into trouble, and then solved a mystery by the show's end. Also, five of the kids formed a band called the Chan Clan, which rocked '70s bubblegum pop. I wish Asian Americans really did that.

Stacy Wu: One day, my mom packed these fried dumplings in my brown bag, and they stunk up the entire cafeteria. The teacher came over and embarrassed me in front of the whole school. Yikes. Trauma.

Sharon Young: When my brother and I went to an international school in the Philippines, my mom would pack our lunchboxes with rice balls filled with fish, pork, or dry shredded beef and egg. Other lunches included Spam and egg fried rice, porridge with pickled cucumbers, and egg sandwiches. For drinks, we'd get a Capri Sun or Yakult, and snacks consisted of Granny Goose corn chips or Haw flakes. I had a lot of American and European classmates, and I was into trading for a PBJ and an apple. Did I take those meals for granted, or what?

Mitch Mitchell: On field trip days, my mom would make a box lunch for me consisting of omusubi, fried chicken strips coated with panko, strips cut from omelettes made with soy sauce, and dill pickles cut into thin pieces. The thing I remember most is how my mom would try to make it look special. Although she used American Tupperware, she'd organize the food in little compartments in a traditional way—very much like a Japanese bento box. I don't know where she got it, but she'd cut green paper (plastic?) sheets in ways to make it look like blades of grass and place it carefully to give it a nice aesthetic touch. In classic "Bamboo Kid" style (refer to "Go Straight to Hell" by The Clash), I'd drink a Coca-Cola with the meal. For dessert, if I was lucky, I'd have a box of Botan Ame (rice candy), with the little plastic cars. This was before they went cheap

HAWAIIAN LUNCHBOX

This lunchbox is a mixture of many Asian foods and a calorie counter's nightmare. It will fill the stomach of tomorrow's sumo wrestler or any big local guy you see walking around.

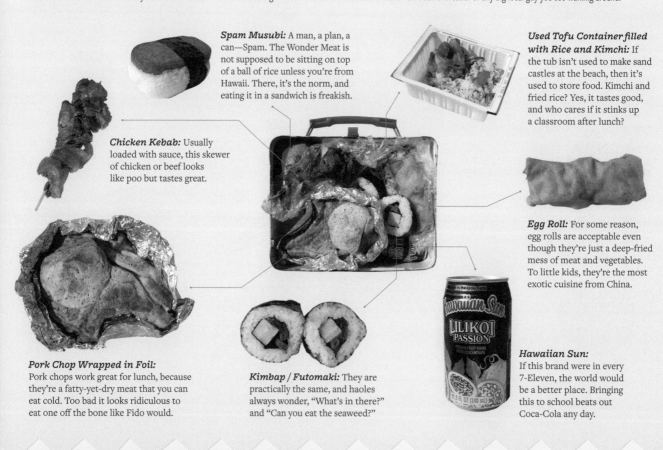

Spam Musubi: A man, a plan, a can—Spam. The Wonder Meat is not supposed to be sitting on top of a ball of rice unless you're from Hawaii. There, it's the norm, and eating it in a sandwich is freakish.

Used Tofu Container filled with Rice and Kimchi: If the tub isn't used to make sand castles at the beach, then it's used to store food. Kimchi and fried rice? Yes, it tastes good, and who cares if it stinks up a classroom after lunch?

Chicken Kebab: Usually loaded with sauce, this skewer of chicken or beef looks like poo but tastes great.

Egg Roll: For some reason, egg rolls are acceptable even though they're just a deep-fried mess of meat and vegetables. To little kids, they're the most exotic cuisine from China.

Pork Chop Wrapped in Foil: Pork chops work great for lunch, because they're a fatty-yet-dry meat that you can eat cold. Too bad it looks ridiculous to eat one off the bone like Fido would.

Kimbap / Futomaki: They are practically the same, and haoles always wonder, "What's in there?" and "Can you eat the seaweed?"

Hawaiian Sun: If this brand were in every 7-Eleven, the world would be a better place. Bringing this to school beats out Coca-Cola any day.

Kung Fu

From 1972 to 1975, David Carradine starred in this TV series, whose concept was stolen from Bruce Lee. In the tradition of Mickey Rooney in *Breakfast at Tiffany's*, the white man plays an Asian character. Abandoned as a child, trained at the Shaolin temple, and wanted for murder in China for killing the Emperor's nephew while defending his master, Kwai Chang Caine flees to America, where he deals with hicks and spreads his selfless message of pointless roaming and not having sex. Looking back, this show would have changed the lives of every Asian American if Bruce Lee were the star. Aside from having high-quality martial arts and real philosophy, Bruce would be in TV reruns, as well as co-star in the 1986 TV special with his son Brandon and make a cameo in the 1992 remake. Even if the show failed miserably, Bruce would still be signing autographs at comic book conventions at the very least.

and went to stickers. Come to think of it, some American kid probably choked on the thing, and they got sued…

Anne Ishii: When I was at Japanese school, everyone brought "ethnic" lunches: little rice balls wrapped in zigzag nori, pieces of carrot cut in the shape of Sakura flowers, perfectly char-grilled pieces of mackerel or salmon. Everyone but me. My mom would send me off with a spicy chicken sandwich from Jack in the Box and a Slim Jim, sometimes. For this, I was ostracized by the rest of the school. At American elementary school, I didn't take ethnic lunches, but one time, I made the mistake of taking dried squid and smelling up my desk area. The coolest thing at my elementary school was when this Indian girl came with tandoori chicken. We were all like, "Oh my god! Red chicken!" She became everyone's best friend after that.

Ryan Castro: I used to rock an old *Transformers* lunchbox (plastic, not metal). Every now and then, my mom would pack me rice with, well, just about anything. Sometimes corned beef, sometimes lumpia—rice just made it that much better. My aunt was an ESL teacher at my elementary school, so sometimes I'd end up having lunch with her and the other teachers. That was pretty cool. This was in Jersey City, which was already pretty ethnically diverse. The Indian, Korean, and Chinese teachers would bust out food and share it with us. I never remembered the names; I just remember it was good. Did my food gross out anyone? Not really, it wasn't like I was eating balut, and also anything was better than the crap they served in the cafeteria.

Bryan Ness Tamayao: I remember opening my lunchbox on my first day of school and finding my favorite lunch: chicken adobo, pancit, and rice. At that point, I was the shit. Every person always asked me if they could have some portion of my lunch, whether it was the adobo, one of the pan de sals, the pancit/pancit canton, apritada, and even the rice (which surprised me). I always washed the food down with freshly squeezed (by my lola, god bless her) calamansi juice, barley tea, or soya milk (my favorite). The thing that I (and other people who mooched off my well-prepared lunch) really loved was the dessert—whether it was flan, turon, mung bean hopia, baboy (as in the root, not pork), or my personal favorite, halo-halo. The best part about bringing ethnic lunches is that I got to trade with my other Asian friends. I got to taste pho before it was popular, and discovered the wonders of mochi and sushi at an early age.

Christina Kim: Living in Nashville sucked balls when I was growing up. Once, I took rice wrapped with seaweed, and everyone said I was eating leeches! I took bulgogi, and they said I was eating poop. Kids can be so cruel. I conformed and gave in to purchasing school lunches—pizza and fries every day—which made me gain a whole lotta weight. Thanks, Nashville, for making me a husky kid.

Mylani Demas: Growing up on Kauai, we could either bring lunch or buy a bento/box lunch for field trips. Bentos were

ordered from a local plate-lunch place, and cost about $5. Of course, they came with a can of a Hawaiian Sun passion orange juice or guava nectar. Usually, the options were teriyaki beef, chicken katsu, or sometimes fried mahi mahi. The lunches were presented on a disposable plastic tray with little compartments for all the accoutrements: sticky white rice upon which the meat lay, pickled cabbage salad (namasu) or macaroni salad, daikon, fish cake (kamaboko), fried Spam or a fried corn-beef hash patty (my personal favorite), and that weird jagged faux grass stuff for decoration. I don't think we were ever offered forks; it was chopsticks, a napkin, and a packet of "shoyu" held to the box with a rubber band. I always looked forward to this lunch, as I'm sure most of the kids did. It was fun having our own little sampler platters of salty goodness. Looking back, that was a lot of food for a fifth grader but, man, was it delicious!

Heather Yurko: As a kid, I took all kinds of crazy shit to school in my lunch. I was obsessed with Asian culture, and would take chopsticks on the days that I got to eat the school food so I could eat things like Jell-O and fish sticks with them. Maybe this doesn't seem so odd, but I'm a white girl who grew up in very white rural Pennsylvania. Thankfully, my parents let me get away with it. Besides the chopsticks, I would take other weird foods to school: haluski and kapusta (noodles and cabbage); pierogi (potato dumplings filled with mashed potatoes and cheese); halupki (cabbage rolls stuffed with ground meat and rice, and covered in tomatoes and sauerkraut); bagel halves with butter and pepperoni slices; lettuce, cheese, and mustard sandwiches; peanut butter and honey sandwiches; and these crazy popcorn balls that my mom would make (she would dye them with food coloring, so it looked like I was chowing on some kind of nuclear snowball). I think they even tried to put kishka (blood sausage) in my lunch once, but that's where I drew the line. Yeah, my ability to eat anything (except what other kids ate) pretty much grossed out everyone around me. Matter of fact, some of the other kinds had a rhyme for me: "Heather Feather tells the weather and eats leather, that's Heather…" I guess that pretty much sums it up. Thanks for making me relive my painful childhood. I'm gonna go suck down a sea cucumber now and follow it up with a durian.

Kristina Santiago: I'm not Asian, so I didn't have cool things like rice noodles. But for some odd reason, my mom packed a random Asian lunch for me. That bitter green stuff with shrimp didn't gross out my friends, but it grossed me out. She'd give me that, crackers, and an '80s version of Yan Yan.

Valter Guevarra: I still remember when I started my job in the hospital, the "dinosaurs" (the ones who have been at work for some 20 or 50 odd years, and feel that they own the hospital) were heckling me about my lunch. They would ask me what kind of meat I was eating, and one of them even suggested it must be roadkill—what he drove over on the way to work. Just to gross them out, I would either meow or bark. 🐱

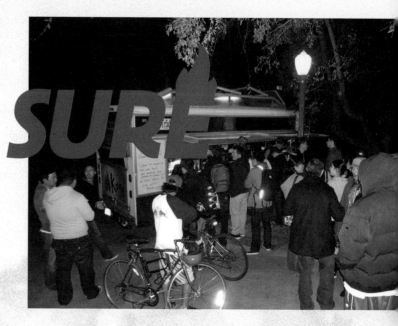

words + pictures | Eric Nakamura

KALBI SURF

In only two months, the Kogi BBQ truck has created more buzz in Los Angeles than any ex-Matsuhisa chef's sushi joint, Jonathan Gold article, or episode of *Top Chef*. Informed by Twitter and the truck's website, crowds begin gathering long before the vehicle rolls up in anticipation of a hot, tasty meal. Chef Roy Choi and his crew work inside the truck until late in the night, crafting each $2 taco as if it were their last. Chef Roy's partners in crime are idea-maker Mark Manguera and Caroline Shin-Manguera, the numbers person.

Why a truck?
__ROY CHOI:__ It was Mark's idea. He and his sister-in-law went out one night, and they came home drunk with the thought, "What about Korean BBQ in a taco?" He always has ideas and 90 percent is fluff, but this one stuck. The next morning, he called me. (We had worked together at the Beverly Hilton.) I thought about it: I've always been searching for a way to translate Korean food as a chef, but I couldn't do it. I love street food and street culture, so a truck was the perfect vehicle for it. A friend of ours owned all the taco trucks in LA. All of that lined up.

Did you start with any budget?
We didn't have much money, and it started off as a hobby. I had opened and just left RockSugar restaurant, and I was going to take any job that was offered to me. In the meantime, this was a way to express myself as an artist. **It was kind of like spending three hours a night, cooking what I wanted to cook—no guests, no politics, no one telling me anything. It's like spray-painting on a wall. No one could tell me what to do.**

Can you just pull up anywhere?
We brainstormed cool ideas. The truck comes with all of the permits, licensing, and insurance. You can park anywhere as long as it's 200 feet from open food establishments. You can park in front if it's closed. The first spot we chose was West Hollywood. In 30 minutes, we sold some tacos and got kicked out. We kept driving around, and got a call from the Ivar Theater, who asked us to park in front. Then we got kicked out of the Ivar. In between, we started driving on Hollywood Blvd. We had to beg people to eat our food. We had days with zero dollars in sales. It's almost like selling a mix tape out of your trunk. We were peddling it to people. No one would bite.

How did it become so hot?
Once people took the first bite, the whole dam broke. They'd put it on Facebook and word got out from there. We had a smart strategy to use Twitter and social networks.

The main thing is we were grassroots and guerrilla. We went all over LA. For the first two weeks, we were giving it away.

What is your biggest problem?
I'll say a couple problems. Perception. I'm going through a little bit of a psychological, emotional, spiritual journey. I started this "graffiti"—a chance to express myself after growing up in LA for 37 years. And then, all of a sudden, as it became popular, people tried to put it into a box: "You weren't here at this time," "Why don't you have this?," "I want two tacos without this or that," "I want to sub this." They created their own conception of what it is: "It's a roach coach," "It's just Korean BBQ in a tortilla," "It's the greatest thing in the world." People made it into a trend, but it was my expression of what I see. It's like a tagger having people telling him, "There should be more green in your letter there," or "Have black fade out there." All of a sudden, I'm confused. What the fuck is going on here? And that's been a journey. The beauty of Kogi and the success is that it's so unsecured and nonconformist. **It's a nervous, uncontrollable thing. Now I'm trying to keep my head, do everything that made Kogi popular, and keep an edge by not conforming to what the public wants. If I buy into what the public wants, I might please them, but it might take away from what it is.**

What else?
The structural element of the truck. If you look at other trucks, there are no more than 5 or 6 people in line when they are busy. We have 800 in line and a finite amount of physical space to work with. Part of me wants to say, "When we're out, we're out." I want to turn the key and drive away. I still hold true to giving the best of what I got. I'm not going to pre-wrap burritos or streamline things by putting the meat in the tacos first and adding toppings as we go. Every order is still fresh. We don't buy shredded lettuce or cabbage. The challenge is, how do we go from serving 50 to serving 800 a night out of same truck after a month and a half and not run out, find storage, and be creative and move the line as fast as we can.

ERIC: Roy Choi didn't write anything new for this book because he has a contract that prevents him from

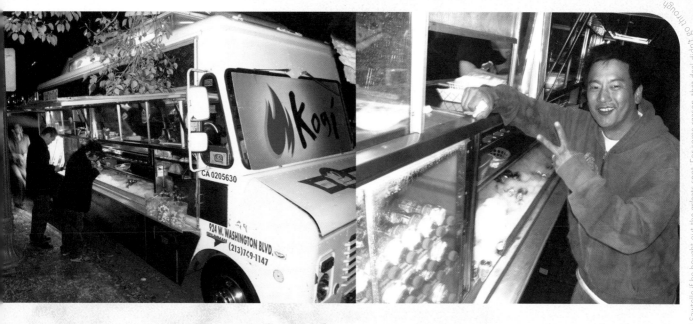

What's your restaurant experience? I taste culinary-school cooking—especially in the salsa and toppings.
I went to the CIA in New York, I cooked in New York for two years, and then I went to five-star hotels from coast to coast. I paid my dues. I did what I had to do to prepare, and walked the silent path. I was the guy rowing the ship, toiling behind other great chefs. It's almost like martial arts. I took a lot of shit in my life. I failed many times. I succeeded sometimes. I searched out the best chefs in America and worked under them. **I feel like I have it in me to express this food, and I'm not worried about titles, promotions, or whether or not people look at me as a chef.** I don't need accolades; I've gone through that and am going to the core of cooking again. What you get comes from years and years of training. Every detail is looked at—the cut, the sauce, the way we clean the kitchen, the way we train the staff, the way we buy the food—and put it together for $2. It's for the people. That's what it's about. I can take away the waiters, the energy costs, the insurance, the dishwasher, and all these things; bring it to the core; and give the people the pure product.

Is there a reason to drive around and do this outdoors?
I have a lot of pride in LA and I want to bring a culture we haven't had, which is hanging out in the street, knowing your neighbors, talking, enjoying the architecture, and absorbing your own city. You see it in Boston, Chicago, and New York, but not in LA.

What are lines like now?
There are times when I get scared. In the San Gabriel Valley, we rolled up and there were 800 people in line. The line went for four straight hours, a one-and-a-half hour wait. It was the most incredible thing I've seen in my life. We did everything we could to give them the best experience possible, but the truck can only handle so much. That's been the toughest issue.

Why Korean food? They don't teach that at CIA, I'm sure.
When I started, I didn't want to be a Korean chef. I wanted to define myself, and formally trained in French cuisine. But

I grew up around Korean flavors. As a Korean American, **I've been running away from Korean food my whole life.** I grew up in a Korean restaurant. My mom is a chef; I grew up as a kid in third grade doing homework on kitchen tables. I grew up with old ladies making kimchi. Kogi is not Korean food, but it's coming from a Korean American person. It has Korean ingredients, but I cook it in the way I know how. When you eat the food it is familiar, but it tastes nothing like what you've had in a Korean restaurant. I don't know how to cook traditional Korean food, but I know how it should taste and I base the flavors around that.

Is this the next level for Korean food?
I'll be honest: Korean culture is a hermit culture. We're not as pop as Chinese, Thai, and Japanese. Koreans are hot blooded, closed, and we have certain stereotypes as immigrants. Whether they are true or false, I can't comment. We are like the "angry shop owners." Our immigration is not as early as Japanese or Chinese, and their third-generation kids are still trying to find their identities. Maybe this is a chance to explore and reach out to the American public with a new side of Korean culture—a side that's American but from a Korean sensibility—to have them see what we are and that there are other textures and layers to Korean people.

FASHION

JIAN DeLEON

The story of Asian Americans in fashion is a story about renegades and misfits. While San Francisco may not be regarded as a global fashion capital in the same breath as, say, Paris or New York, it's birthed some of the unlikeliest stores, labels, and personalities that help make the modern fashion landscape what it is. There's Kyle Ng from Brain Dead—a young fan of punk, zines, Barry McGee, and comic books—that now runs one of today's most exciting independent labels. The premise of the art-collective-turned-lifestyle-brand is simple: If clothing can be a vehicle for co-signing niche interests, it can also become the kind of uniform that brings communities together.

Before him, there were people like Alyasha Owerka-Moore, whose prescient label Alphanumeric melded different facets of street culture together in a way that fused technical outdoor garments, hard-wearing militaria, skateboarding, and street art together, in a way embracing all these elements without marrying itself to one. Along the way, it happened to net a sought-after Nike Dunk collaboration that set the stage for the sportswear brand's proper foray into skateboarding. Over on the East Coast, jeffstaple turned the pigeon from a symbol of New York City's grit and grime into a proud logo

kids wanted to wear on their chests and on their ankles—giving the city its first legitimate sneaker riot of the 2000s.

But there were many pots brewing at the time, and before the internet made it easier to find your people, those who had the luxury of traveling and meeting like minds were setting the stage for today's culture of convergence. Hiroshi Fujiwara (p. 338), a student of Malcolm McLaren and Shawn Stüssy alike, lit a flame under the Japanese creative scene, birthing an entire consumer culture of hype and predating a day when brands like UNDERCOVER, visvim, and A BATHING APE became synonymous with luxury goods from Louis Vuitton and Prada. Now, Japanese labels are regarded as some of the crème-de-la-crème collaborations and covetable brands on global shelves.

And on the retail front, Kiya Babzani's Self Edge began as a humble San Francisco boutique where he'd curate some of the world's best selection of artisanal Japanese denim. Dovetailing with a trend in the early 2000s that fully embraced American heritage labels, what gave it staying power was an appreciation of craftsmanship without being so prescriptive about the costume. Now boasting a fleet of five stores in the US and Mexico, Self Edge's early embrace of internet culture and roots in

underground style have made it both irreverent and innovative, the kind of place today's TikTokers wax poetic about $5,000 Rick Owens jackets made from Shinki Japanese leather, $360 chunky flannels from Iron Heart, and $100 white loopwheel cotton T-shirts from Whitesville that have become a cult item thanks to TV shows like *The Bear*.

From its early days, *Giant Robot* covered this gamut of a burgeoning global streetwear scene and the rise of street style as a new form of aspiration. What mainstream magazines and media showed you about style wasn't anywhere near as cool as the things you'd find on Bobby Hundreds's (p. 346) old blog, or the Goth Lolita movements heralded by quirky boutiques like Baby, The Stars Shine Bright (p. 349) (further highlighted in the underrated 2004 film *Kamikaze Girls*). It approached fashion from an inclusive lens long before a paradigm shift made it an imperative. And because of that, ushered in a new age of thinking about clothing, grooming, and the way we present ourselves as a valid form of self-expression.

Jian DeLeon is the editorial director of *Highsnobiety* where he reports on the intersection of streetwear, sneakers, and luxury fashion. As a writer and editor, his work has also appeared in *Complex* and *GQ*.

JENNY SHIMIZU

STRAP-ON

words | Eric Nakamura + N8 Shimizu
pictures | Eric Nakamura + Pryor Praczukowski

I always figured that talking to a supermodel would be a drag. I figured Jenny Shimizu would be the same after seeing her strut on a runway modeling fashion on the E! Channel a couple of years ago, and standing silently in black and white for Calvin Klein's advertising campaign. Everyone knows that she's supposed to be a tough mechanic with the short, cropped hair and the tattoos, but I figured it was clever posturing by The Man who's creating an image. But on the morning of our afternoon hookup, she left me a message, "Hey, Eric. Anyways, I was working on a friend's GTI all morning, and it's 1:30 and I'm sitting here wondering if I should Bondo my car." So I broke in and started asking her if she uses Husky brand tools, to which she barfed and cussed me out and started professing, "I use Snap On, bitch." She didn't Bondo her car, but she did pull a dent from her 1972 Scout and then she finally agreed to get out of her tiny garage and into our office. Along with her came her ass-whipping lady, Florice, to back her up since Jenny was scared. But it was no big thing. N8 was watching my back, so the battle was even. The first thing I had Jenny do was check out our gas line and stove since it wasn't hooked up. She said it would be an easy 30-minute job. These days Jenny isn't working in front of the camera, she's using her brain and hands to earn her tool money.

Am I allowed to ask anything I want?
JENNY SHIMIZU: Go ahead, feel free. Just ask.
I'm just sober samurai. That's all I have to say.

How much money did you make for a photoshoot?
I made a lot of money during those times. The last thing
I did that was a lot of money was the Pirelli calendar.

PIRELLI TIRES THE PINNACLE

Tires?
Yeah, Pirelli. In modeling, if you get the calendar it's one of
the top jobs in the world. I know it sounds weird out here.
It's for Italy, but it goes all over the world. If you do the
Pirelli calendar, it's the twelve most beautiful women in the
world. Every year they do it. They vote, and it's not mechanics
and stuff voting, it's actually photographers and everybody
like that. That was the last job I did in New York City.

The Pirelli calendar?
Yeah, and it's actually in the Pirelli museum now. My
aunt wrote to me and told me it was on *Entertainment
Tonight*. I don't even watch that. I didn't even know
about the Pirelli calendar until I got it. It was one of
those things that I was like, "Oh, another happy, lucky
thing happening to me." Like I said, I wasn't striving
to be a model. I wasn't trying to be most popular.

Who else was in it, Pamela Anderson?
No. Kate Moss, Christy Turlington, Naomi Campbell,
Claudia Schiffer. They do it almost every year.

Was that the first time you ever did that?
Yeah, it was the highest level of modeling you can go. That's
when I moved back to LA because I really didn't want to be
a model. You know, if I aspired to be a model for my whole
life, then I'd be staying in New York and all that. But I didn't.
I had my fun. Now I want to use my brain a little bit more.

Who votes for this Pirelli thing? Herb Ritts?
Well, Herb Ritts is not so much a fashion photographer. He's
more of an LA doo-dah. In LA, he's postcards. In New York
City, fashion photography is so different. There are gods and
stuff, like Bruce Weber. There's people like [Richard] Avedon.
I worked with him. That's who I did the Pirelli calendar with.

Avedon?
He's insane, and it was great because I'm kind of insane
myself. So we ended up just going crazy the whole day
and then I had to get hired the next day because we
didn't do any of the work we were supposed to do.
We were playing like we were gorillas for the entire
day. I got paid another day which was a lot of money.

What was going on?
He was like a little animal and so was I. We had fun. He was
nuts, so I was like, "Alright, I'm going to go nuts, too." He
was fun. They actually got me a chaperone for three days
to wake me up, come get me, and to take me to the place.

THE BUCKS TO THE NOSE

How much money did you make?
Oh, god.

Could you buy a car with that money?
I could have bought a lot of cars with that money. I made a
lot. I made a little bit over a million dollars in three years.

No way.
I swear. The Avedon job, for Pirelli, I was paid $20,000 a day.
It's a lot of money, and then a lot of money is taken from you
by your agency. Especially when they are thieves. They still
owe me. Don't let your daughters grow up to be models!

Did you make more than the photographer?
No, because I was working with people like Bruce Weber.

They make more than $20,000 a day?
They make 50 grand a day at the least. Richard Avedon's
fees are $100,000 a day and all he does is run around
and act like a gorilla. Just genius. Mismatched
shoes, just the mad scientist. I love that.

**Did you like the photos they took of you? Did you
look at it and go, "Hey, that looked good"?**
I'm like, "Oooh, who's that hot motherfucker?" Actually,
I really don't see myself. I look at those photos and I go,
"Wow, that person is photogenic." But I had a problem
because I wouldn't associate it with being me. The photos
I always like of myself were just the ones without makeup.

I was always a mechanic. It's so different because I guess I never pictured myself as being someone who was going to be physically...Physically photogenic?...to so many people, and people would pay me all this money to take my picture when I think of it as a joke. That's the thing that's kept me sane, I think. Especially for me, if I start thinking like, "Oh, my god, I'm dirty. Oh, my god, am I going to have zits?" Because I do right now. It's not good. It's a lot of money, but it's not worth the shit that happens in your head. I don't want to be like all those 14, 15, 16-year-old models that are so twisted now. It was very painful to see the changes in these young girls who weren't finishing high school because they were making all this money. But you could see that if they don't marry a rich guy...because they're not going to save that money...it comes as fast as it goes in New York. You don't keep track of it when you're 16. A half a million dollars is so much money. You just blow it. You don't realize there's taxes, there's drug dealers, there's your parents you have to pay off and all that. No, I'm kidding. Not that, but it's so true.

What would you do with all your money? Would you go shopping and spend like crazy?
I wouldn't do that. I'd go shopping...

Did you buy yourself a Prada bag?
That's the funniest thing. I never bought myself a Prada bag, but I bought some other people Prada bags. I bought a lot of things for other people. It was dirty money to me. It wasn't like now. I'm doing art department and stuff for films, and I work hard. I feel like I earn my money. I feel a lot better about it. I don't mind having a lot of money, but there are different, varying degrees of integrity.

Can you still get those jobs?
It's harder now that I moved from New York, because in LA, there's not really modeling here. It's more commercials, TV, and all that. I can't sell butter or something normal out here. I have stopped. I have an agency. I don't call them anymore. I don't know what it is but I think I'm taking a break. I've gotten some acting things. I'm gonna actually do that thing with Margaret Cho coming up. And I feel like, you know...I don't know. I feel kind of weird about sitting around all day and getting made up. For certain things it would be wonderful, yes, but in LA it's kind of...Not a lot of good photographers come out here. It's more cheeseball. I don't want to do a Hush Puppies commercial or something like that. Maybe I would do it if they offered me one. I moved out here to do a different thing, to do something different.

Do you know what it is yet?
Well, to do something that feels more human. You know, like contributing, not being so selfish.

Where did you live?
I lived in a huge, beautiful, gigantic loft. When I first moved there I lived near, right across about two streets down from...What is the big building there?

The Empire State Building.
Yeah, the Empire State Building. I lived there in a huge loft with a fireplace, and it was sick. I was like, "What in the hell?" Because I moved from Koreatown in LA. I packed my bags for three weeks. I was going to go shoot with Bruce Weber. I ended up staying in New York City for three years with one bag. I got this loft from another model that was one solid floor, the seventh floor. I had 20 huge French windows. It was my place alone. We used to skateboard in my loft. We had huge parties. I lived there by myself and I was lonely, but I was living.

Damn.
It was all luxurious. I moved to a two-story loft, an even bigger place. It's famous. It's on Greenwich Street and I can't remember the name of the building. It's an old, huge building that's right on the Hudson River. The Archive Building. Yeah, it's this famous loft building in New York City. Very posh, let's nosh. No, I did a limerick. I threw these extravagant parties and I played basketball because it was two stories so I attached a hoop. And, yet again I was lonely, too. It was so extravagant. And I never lived that way before and it was so boring to me.

Did you save your money, all of it, or some of it, or whatever?
I didn't save practically any of my money. Also, a lot of legal things happened to me that I wasn't expecting.

I WANT MORE

When you were modeling, how did you lose weight?
A special diet. It's called being very unhappy and doing very unhappy things to yourself. You don't eat a lot when you're snorting. There was definitely a lot of partying.

How extreme does it get? Did you do X?
No, I hate ecstasy. Why, do you got some? I need some Quaaludes. Can you hook me up? No, I'm just kidding. I'm just sober samurai. How extreme can it get? It can get very extreme. There's a whole dark side to New York. In New York City if you're modeling, you get free drugs. I would get free drugs every time I went to visit people that were supposedly taking care of me, like my agency. Am I going to get sued for this? It's the damn truth. When you're doing well like I was, because I was kind of hot and new, they would be handing me off. Doing handoffs to me of drugs. I'm sure everyone relates modeling to cocaine. A lot of cocaine, a lot of heroin. It was a mixture. There are so many different girls, so when you went to a party you never knew. Like "Oh, she needs an upper, bring coke," or "She's a downer, bring..." It got really out of control. The death of Mario's brother...

Who's Mario?
You know Mario! Mario Sorrenti. He used to go out with Kate Moss. Mario is the guy who did the first Calvin Klein ads with Kate on an island in black-and-white and she's on the beach. He was her boyfriend at the time. He's an older

🐛 E R I C : This interview is one of the epic stories that I pulled off. Jenny is a superstar, a supermodel, and a

model. He's a cool guy. He comes from a family of fashion photographers. He started the whole CK look, for Calvin Klein to reinvent Calvin Klein. I was kind of caught up in that whole crowd, Kate and everybody. I moved away and about a year later, his brother overdosed on heroin. It struck a big chord in everybody, because it was the group. I couldn't take it anymore, so I moved back to LA.

How did they give it to you? Did they shake your hand and it was there?
It's not even like that. It's so fucking obvious. We'd go to a party and the drug dealer would come that served the agency, and they would just put it on your tab and bill the modeling agency. That's how easy it was. Rumor has it you could call your agent and say, "I need..." and they would deliver it to your room.

Instant flow.
Yeah. There's a lot of people jeopardizing their lives and they're getting fed things like drugs and glamor. I felt like I didn't have any real friends out there. <u>I'm kind of a skeptic. I feel sorry for a lot of people that are caught up in that world. They're so serious about it. But the reality of it is like Mario's brother's death...What was the purpose? Just another model party for what reason? They weren't doing anything to benefit anybody else</u> except selfishness and grossness. Everyone mourns, but does it stop? Shallow life.

How is it that models that have been around for a long time, like Cindy Crawford—
She's a smarty smart.

She still looks fresh. Did she get plastic surgery? It must take a toll.
Cindy doesn't do drugs. Cindy doesn't drink either. Cindy's a muff diver. I'm kidding, I shouldn't say that. I can get sued by her. She's a big powerful woman. She's smart.

THE RUNWAY

What was it like modeling when you did your first big show? Backstage? Was it like mad naked chicks?
That's how it was. I was nuts. I was looking at everybody. <u>I've seen Claudia Schiffer's ass. I've seen everybody naked and I felt like I had died and gone to heaven.</u> All my male friends in New York had decided that if they died they wanted to come back as me. It was so amazing. The first show, it was a Versace show. That was so scary. It was the first time I had ever seen Claudia Schiffer, Christy Turlington, Kate, everybody I had just met that night and I was in Italy freaking. I was having a nervous breakdown. Gianni Versace was so nice to me. He was really sweet to me.

Is he the guy that died?
Yeah. He is. What do you say? God rest his soul or something? <u>He made me feel really good. He hired you for you. So, I just went out there in butch glory.</u> My head was thinking naked bodies of women. I don't even know. My eyes were glazed over. I was in such shock. Do you want to know? To be quite honest, the woman who has the best body out of all the girls...

That was my next question.
The hottest body. Naomi Campbell has the rockin'est body. If anybody could sculpt and create the most perfect female body, Naomi, I swear to god. You would not believe the cellulite that happens. No one sees that side. I was shocked. But Naomi Campbell, her body's like metal sculpture. Perfect in every way.

Who teaches you to walk? There's a technique right? Naomi's got a strange style of walking, right? She doesn't walk like anybody else.
Yeah, she works it.

I saw a show and I saw you walk out and you did it differently than everybody else.

There's really no technique. The funniest thing is, when I was in Italy that same week, this guy came up to me, and I was so nervous before my shows. He said, "Jenny, just pretend you have a quarter in your ass and you're trying to keep it in there while you're walking." The way I walk is like that of a truck driver. I'm walking down the runway, quarter in my ass, I'm doing a truck driver thing. I'm totally confused. I think I fell off the runway.

How old are you, Jenny?

I'm not telling...I'm older than you. I'm 30 years old.

I like the backstage stories.

Oh, god. I have really good ones.

Are the models all drunk sometimes?

That would be me again. No. Everybody gets real drunk, but the cocaine takes the edge off. Serious. This is for all you hemp bunnies out there. I never ever smoke a joint and go onstage because I end up looking down at myself and having one of those paranoia, self-esteem slashings. Once, I looked at my outfit and I was like, "Why am I a bumble bee and out on this runway?" Never again did I smoke pot. It traumatized me. Another backstage...This is a good one. Speaking of drunk, backstage antics, I have a really sad family story to tell you. My mother is cousin to one of the first Asian models that made it big. That would be Joan Chen. No, I'm just kidding.

Tina Chow?

No. Not Tina Chow. No. It's...She did the movie...I can't even remember her name right now. She did the movie with Mickey Rourke. I know I know her name and I blank out on it because she hates me.

How old is she now, about 40?

Yeah, she's about 40-something, but I am related to her in this second cousin kind of...I can't remember her name and it's probably better that I don't. When I was growing up I'd be like, "Wow, I'm related to her." I thought that was really cool. I ended up going to New York and doing a show she was in, and Isabella Rossellini was in it. So, of course I get really drunk. Me and this other model, Michele Quan, who is really funny.

What is she known for? Is she famous for a certain ad? Is she an ice skater?

No, it's not the ice skater. She's actually an older model. She's French Canadian and Chinese. I was hanging out with my homegirls. So, anyway, I go to this show and I see this woman whose name I can't remember, but it will come to me. She's half Japanese. Anyways, I got so excited. Her grandmother and her brother called me when I got to New York City and were all like, "We want to welcome you to New York City. Please come have dinner with us." And they're far away relatives, and I was like, "That's cool." So I ended up working with this girl. I finally bump into her at a show, and I'm like, "Oh, my god. It's my relative. Should I go and say hello?" She just shines me on. Just so rude. I'm running around thinking, "What did I do?" So I got really drunk with this other girl, Michele Quan, and we started chasing each other around like two mature women would backstage. I, of course, trip Michele who has a glass of red wine, and she spills it all over that lady and the wardrobe she is going to wear. Michele Quan is laying underneath me because we've fallen, and we're really drunk. And that is how I treat all my family. I'm always a little sloppy and I don't mean to. We ruined her whole thing, and she just hates me ever since. More than she hates that movie, *Enter the Dragon*, or something she did.

Since everybody's all fucked-up backstage, do models get wasted falling over on the runway and shit? Because they're wearing outfits with these crazy-ass shoes?

No. What I used to do a lot was bump into the girls. I'd always bump into their shoulders because you're supposed to do this sneak when you pass by each other. I wouldn't sneak, and then I'd start cracking up. I'd look at them, but

of course they're professionals and looking straight ahead, not a smile or anything. I'd be drooling and cracking up. Anyway, there's a lot of fiasco. But it is amazing how girls can turn it on for that five-minute appearance they're doing, and come back when the show's over and be just...Like I said, the cocaine takes the edge off.

B-BALLING

You went to college?
I went to college for two years exactly.

Where?
I went to Cal State Northridge, home of the Matadors. I played basketball. I red-shirted my first season, and then my second season I was too drunk to even proceed and that's why I quit. We used to drink vodka. What was that? Smirnoff, blue label.

Where did you play basketball before that?
I played for Ernest Righetti High School. I was a varsity player as a freshman.

You were a guard?
Yeah. I was point guard.

I played basketball, too, but not at my high school.
Really? You played Nerf Hoop at home and got your grandma to play.

Did you play in those Asian leagues, too?
Are you kidding me, man? I would rip. I was the center for the Asian league. Thank you. And I played on the Olympic Basketball Development Program when I was in high school. I was a genius basketball player. I used to play Sunday at the YMCA in the men's league. I would get into some crazy-ass brawls with the old dudes. The old guys always wanted to mess with me. I remember one Sunday I played with Robert Townsend—

Yeah, yeah, yeah. He was that guy that was in that movie...He wore a cape. He did a Bruce Lee imitation.
Yeah. I played with that man before. Yeah, I can hold my own on the court.

Right on.
Thank you. I've heard Shaquille O'Neal rap into somebody's answering machine. I've had pizza with Magic Johnson and we discussed his old-school, knee-high socks. No one wore their socks like he wears his socks. There's only one more guy in the NBA that wore them like that, and we discussed that. I'm down with basketball trivia. Magic is like, god. We were having pizza, and he was handing me my pizza in his kitchen, and I swear to god his hip bone was right at my head. I was like, "Jesus Christ, man! What's up with the AIDS, dude? You rock!" He's a big guy. He's a good guy.

BACK TO MODELING

So when you modeled...back to that again.
Goddamn. Will you get off the modeling thing already? I'm a scratcher. I'm a welder.

We'll get to the welding. But, what would you say? You did a job about every two weeks? Is that about it?
When I was a model, the first year, I was home maybe two weeks in New York. I worked almost every other day.

You were at castings, right?
No, I was working. I sincerely worked—

Oh, you got hooked up.
Yeah. I was flying. I would fly on overnight flights to Italy, to Paris. I was crazy flying. It was a whirlwind. It was so quick, and before then I had only gone to Mexico. I was like, "I'm not going out of the country. I am so USA." I didn't want to know nothing about no foreigner. I was like, "Love it or leave it." And then all of a sudden I had a passport and I was in Russia. No, not Russia, god forbid. I was in Germany. Then I was in crazy places, in Greece, everywhere.

You did a lot of European stuff, then the Calvin Klein stuff—
I was doing everything.

I've only seen you in Calvin Klein shit.
I wore a lot of his men's T-shirts. He did give me a suit for the CFDA awards, which I gave to my maid. It's like the Super Bowl of modeling. Everyone dresses in black tie, and we pay tribute to all of the editors and fashion designers of today. It's a big hoity-toity. I sat next to David Bowie and Iman. I was so totally stargazing. I was

like, "Oh, my god. Can I go steal a spoon or something they sucked on? I was freaky, I ended up chucking pumpkins down the stairway and getting chased by security guards.

Calvin Klein. Was that like a contract or something?
Yeah. Calvin Klein. I'm still in contract with him, by the way.

You're not wearing Calvin Klein now, right?
I'm wearing some Calvin Klein underwear.

You don't have to wear that shit?
I don't have to wear it, no. I don't have to do anything really. I just have to sit here and talk to you.

When does it expire?
I don't know. You know, that's the whole thing. You sign a contract with Calvin Klein, for god, for...hell if I know. All I know is that it is aired in all these other countries which make it hard for me to get contracts there. But I don't care. You know, whatever.

You're done with that.
I am. I feel like I am done with that. So, can you please lay off the modeling questions?

It's exciting.
Is it?

Yeah.
It was very exciting.

I wish I could have been a little janitor working backstage at one of those things. You know?
I was the little janitor, Jesus. That's what I was doing. I wasn't modeling. I was janitorizing.

MOVIE FOX

What was up with that movie? With Clint Eastwood? Called Foxfire, Firefox—
Foxfire. Goldie gets laid and then snuffed. No, I'm just kidding. That's my character, Goldie. Goldie is tarnished. Florice, my girlfriend, has

the best saying in the world. "You can't polish a turd." I love that.

Tell me about that train movie set you were building. What was that all about?
Yeah, the art department. My personality is very high-strung. I'm hyper and I like to rush around. That's kind of like art department. You need to build things fast and make them look good. Hollywood magic, basically. We did the interiors of an old, abandoned train. We made it look very futuristic and art deco. Imagine the Royalton Hotel on Amtrak. It was beautiful. We did it all for under 37 cents, thank you. Low budget. It was amazing because I've never been really hired to make things. I've always made things at home, halfway. I'll halfway finish a project and leave it there. Then I finish it about four months later.

Like what?
I made a flame fence. We got a little puppy. So, I made this fence that is flames...

Out of metal?
No, out of wood.

So, what happened with your phone number? Did you have a weird stalker?
Yes. Just some weirdos. There's weirdos everywhere. I receive a lot of crank phone calls. But this person was calling me early in the morning hours and not saying anything. At least say something. Call me a fucker or something. When you get phone calls at five o'clock, you worry for your family. It was giving me trauma. So I changed it. This five o'clock stalker needs to go somewhere else.

Let's talk about acting. Where did those skills come from?
No skills, because I have none in acting.

They said, "She'd be great for this role?"
They were just like, "Hey. Who's that OG Japanese girl? Get her. She's got something."

Is this the only one you've ever been in?
Yeah. That's the big one. The other ones are just, like the one coming up with Margaret, a chance meeting. She just called me and we met. She is more genius then I ever...I thought she was great when I first saw her. She's such a great person.

Is that what you are doing next? Is that the plan?
Yeah. That's the only plan. I'm gonna sell my Triumph. Does anyone want to buy a '71 Triumph?

I saw this thing on TV where all these fresh, young models had to all live together in like a dorm thing. Is that real?
That's for poor models. No, that's for girls that aren't really doing that well. It's so rude. I met a couple of girls in New York that had to live in those model apartments and it's just gross. First of all, they're paying extremely high rent because the agencies own the apartments. They have one phone. So they're all fighting over it. It's really gross. It's not right to have so much self-obsession in one apartment. Five models and one mirror. Can you imagine? Cat fights.

Is it better to act than model?
Yeah, for me, because I get to use part of my brain. Modeling is fun and all, but how many times can you talk about who's cute and how much cocaine you did that night? Basically all you need to say is, "Johnny Depp, three grams. Johnny Depp, three grams. Johnny Depp, three grams," for the rest of your life if you were modeling. Is it okay to say his name? I hope he doesn't read this magazine because he'll never purchase it again, and I wouldn't want to do that to you.

I never saw Firefox. Who else is in it?
Angelina Jolie. She's a new up-and-coming actress. She's beautiful, beautiful, beautiful.

Was Alyssa Milano in this, too?
If she was, I'd be with her and not with my girlfriend because she's hot. I want her.

What was it about?
Wayward children who fight against a molester. It's an *ABC Afterschool Special* gone R.

Were you supposed to be 18 in that?
Yeah. I was I guess. It was really odd. The book is so amazing. It's set in the '50s. A girl gang in the '50s is what it's supposed to be about. It was a really good book and then they turned it into '90s Seattle bullshit.

Who plays your dad?
Chris Mulkey. He always plays evil guys.

You had a white dad?
Yeah. I have a white dad because I play a Vietnamese mixed—

[Laughs.]
Shut the hell up! I hate you. You know what? I'll do anything for money. I'll be a Vietnamese vet if I have to. I'll eat kimchi.

MORE BASKETBALL

Did you go to any Knicks games?
You know what? For two years I got courtside seats for the playoffs, Knicks/Bulls game. Thank you, Madonna. She would take me. I sat next to Bill Cosby and we also discussed the high-tubed sock wearers in the NBA. Not only that, but Bill Cosby was kind of irritating me. I was like, "Can you leave me alone? I want to watch the game." I met his son, too.

Did you know his son's girlfriend?
He was actually on a date with Naomi Campbell.

So what were you doing the whole time?
I was like, "Everybody leave me alone. Scottie Pippen is playing and he sweat on me." You're sitting courtside, and it's the playoffs, and all the noise, and they put us up on the big screen because it was Madonna, me, Bill Cosby...

RICE AND HOME

Do you have a rice cooker?
I've had about three or four. Whenever

my mother comes to visit me and I've moved, she brings a rice cooker. And what do I do? I never use it, and when I leave, I leave it in the closet. But now I realize what an idiot I was. They're easy to use. They're fast, and I love rice. Do you know how much I love rice? I mean, do you love rice because you're Japanese? Every day. That's all I want, is white rice and umeboshi.

What are you guys doing on New Year's Eve?
I don't know.

Party at your house.
Yeah. Everyone has to eat mochi. Have you seen the mochi ice cream that Dreyer's makes now? My god. That's so scary to me. I will not eat that. It's blasphemy. My grandmother used to make us mochi all the time, and it just makes me sick 'cause soon there will be a mochi McDonald's or something.

Where's Santa Maria?
Three hours north of here.

My dad's from Arroyo Grande.
Really? It's 15 minutes away from Arroyo Grande. I partied with the Arroyo Grande High School cheerleaders when I was younger. Broke up a fight actually. I was damn funny. Yeah, Arroyo Grande is just a pit. It's beautiful because it's right by the beach and if you're surfing, it's really cool. But I think growing up there is kind of rough on the kids because all there is is Budweiser and 4×4s.

Is Santa Maria better?
No. Santa Maria is worse. Because there is only Budweiser, 4×4s, and school. I would chew tobacco when I was younger. We could actually chew tobacco in class. I wouldn't do it in class. I would do it on the weekends. All the girls would complain about their boyfriends tasting like that. They would sit there with their Styrofoam cups in class, spitting in it. It's a hick town. A lot of great muscle cars, though.

That's where you can get the car you want.
Exactly.

What is it, a '72...?
No, it's a '69 Roadrunner. The Roadrunner is what I want forever. A '69 Roadrunner. If anyone has one in their backyard and they don't care about it and they want to give it to me for free...Ask Eric, and he'll contact me.

No. I'll put your email address in here.
You know what, Eric? To be quite honest, when I came here...I have an Apple laptop, printer, and everything and I have all these things and I don't know how to use them.

Bring it over.
I know. I was thinking I would hook up with you and we could do internet sex stuff. Just naked pictures of you and N8. 🐱

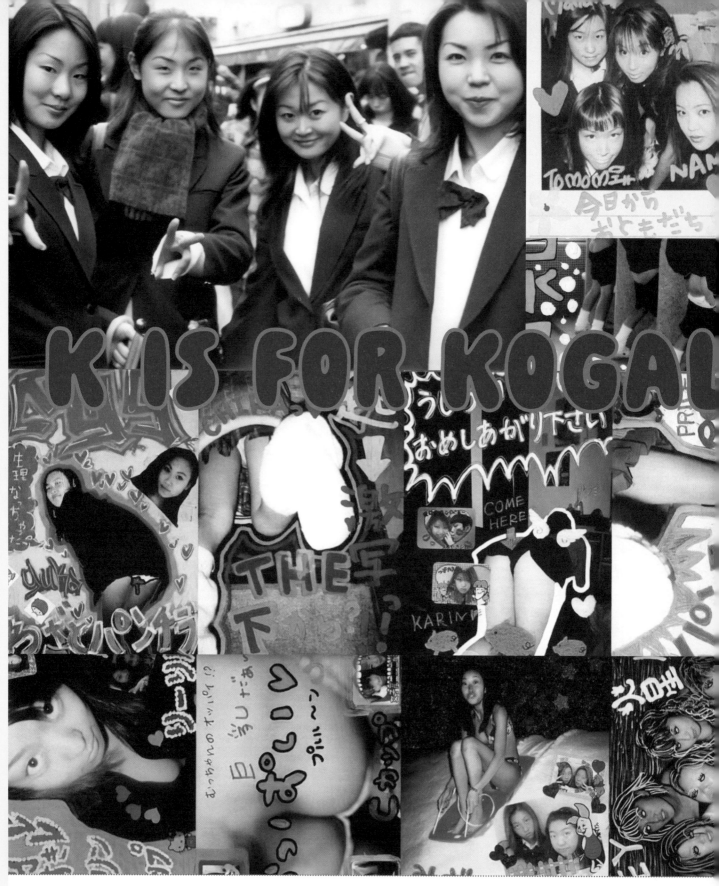

ERIC PLANET DE JESUS: ALL POWER TO THE KOGALS! Kogals say "kogaru" in Japanese cuz they can't exactly pronounce the letter L. Kogaru means high school girls who want to look like glamorous women. Kogaru are awesome. Kogaru are stupid. Kogaru are the smartest teenagers in the world. Kogaru are the richest teenagers in the world. Kogaru set the trends. They wear the creepiest weird '70s retro fashions. They look a lot like Iris in *Taxi Driver*. They wanna look like elegant hookers in blaxploitation flicks, but end up looking like pimps. They look like an *Eleganza* catalog, circa 1973. They look like the bitches in *The Killing of a Chinese Bookie*. And their Lon Ge boyfriends look like Scott Baio if he had been Japanese during the Bicentennial, with wide, dark disco lapels and feathered chapatsu. They hide their high school uniforms in Shibuya station lockers after school to get into clubs after dark. They wear awesome boots with gigantic high heels

👾 **E R I C :** A time capsule. Kogal was a trendy movement that came and went. If it still exists—I'm sure it does in

words | Sky Whitehead + Eric de Planet Jesus
pictures | Elizabeth Duby-san + Brad Bennett
extra help | N8 + Matt Kaufman + Lisa Ling

Walking up from the subway towards Hachiko Square in Shibuya, the suit-and-tied man is treated to candy thigh glimpses at each flight of stairs. At ground level, the world-famous courtyard is a meeting place for waves of pedestrians flowing to their respective trains. Center-Gai is an expanse of shops ranging from karaoke, fast food, apparel, music, street vendors, drinking establishments, and both love hotels and sex-for-pay outfits. Here, the post-pubescent girls catch his eye: their waists, the cliché plaid skirts, white button-up shirts, Polo sweaters, and loose socks (wrinkled and bunched at the ankles) giving the leg a straight, trunk-like appearance.

OPPOSITE PAGE: Four kogals give the universal "K" sign and samples from a kogal photo album. LEFT: This woman was seen putting her schoolgirl outfit into a coin locker, and now she sports a furry jacket and a brand new Louis Vuitton bag (photo by Elizabeth Duby-san). BELOW: A kogal ad, beyond Sailor Moon style.

The glimpse of panties up a juvenile's skirt barely makes the trip bearable for the commuter. After transferring to another packed subway, he spots some nubile nymphets and firmly presses his old body upon them. Finally, he begins his walk to work. Beginning the trek towards Dogenzaka, the man's gaze rests on the gaggle of uni-formed schoolgirls in Matsumoto KiYoshi, their discount drugstore and shoplifting hangout. Directly above his head, one of two Diamond Vision screens advertises the latest music video by one of countless superstar idols.

Making his way through the thinning crowds and up the hill, he makes his way beyond telephone posts plastered with advertisements showing breasty and ready animated high school girls. These are ads for local "Health" and "Image Play" sex establishments. "Crystal," a chain of these service stations, has a hawker on the street advertising the morning special, which is ¥1,000 off of their "Grand Opening" bargain price of ¥3,980. "Good morning," the OLs (office ladies) greet him, welcoming him to work. Welcome to the mind of some middle-aged Japanese salaryman.

Countless cyclical waves of what are called "boom" have washed over Japan. Until very recently, one could not avoid the boom surrounding Japan's high school girls, who are also dubbed kogal (kou-gyaru). The word is believed to have its roots in kou, meaning "high," as in high school, and gyaru, for "gal." It was first used among students, and then the press

because they want to be taller. Their eyebrows are sculpted into sharp-ass points like Asian glamor kittens from the spy-kid days of Manila in the '30s. Their coats go down to their calves, and they are long and slinky with soft fur collars and cuffs to caress. They're shiny, dark, and smooth at night. Their skin is fluid like caramel and deeply tanned, while the squares buy tons of high-tech cosmetics to make their skin pale. Tanned like a million school days skipped on the beaches of Waikiki or Phuket, blowing money they earned in secret. Their hair flows straight over thin shoulders like waterfalls down Shinto mountains. It's dyed brown because brown's the shit, especially when your whole country is one indistinguishable mass of black hair waiting for the light to change, following the rules. They consume and consume and consume without thinking, like total suckers at a carrot. Their fickle tastes lead the masses of office ladies and housewives up

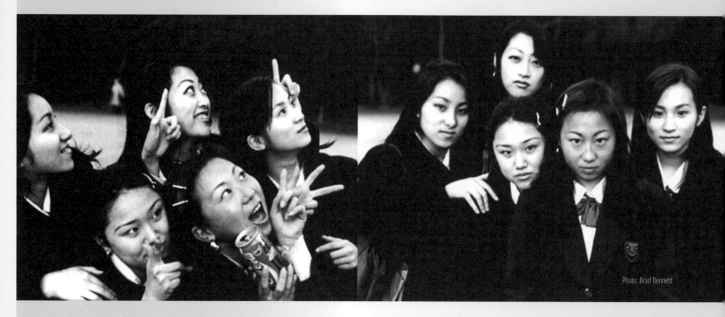

Photo: Brad Bennett

blitzed on their shocking practices. The term "kogal" conjured images of their sailor girl uniforms, and later, the most cosmopolitan, fashion-conscious of the high school female set who sport brown-dyed hair, skirts rolled up high, thick white loose socks, expensive bags, and cell phones.

Those portrayed in the press are often involved in prostitution, doing and dealing drugs, skipping school, and using their profits for ultra-consumerist items such as visits to tanning salons, expensive Italian-made handbags, Gucci earrings, and sky-high cellular phone bills. Is the media responsible for the shocking images of kogal? Or was there truly a kogal movement: a new emergence of curious, consumer-minded girls who were waiting to be discovered and raised as a national issue?

The Japanese media has been less than self-critical regarding their exploitation of the kogal. In percentages, the ratio of girls active in the promiscuity and drug use associated with the kogal is believed to be low. Television provided exposure only to the most hard-core of these girls, and mass media went so far as to attach a celebratory mood to their exploits, giving the reward of attention to those extreme enough for prime time. A nationwide stereotype soon developed; wherein the modern schoolgirls' uniform, embellished with loose socks and a cellular phone, has come to be perceived as the dress code for promiscuity, easiness, greed, and stupidity. That these girls cannot escape the pigeonholing they suffer for being in-style within the boundaries of their uniforms has become more and more of a source of anger for them. "At least every week I am propositioned sex for money," says a 17-year-old student in Ikebukuro.

Along with Shibuya, Ikebukuro is considered one of Tokyo's meccas for kogal. Many kogal congregate there because of its many cheap karaoke boxes, fast food restaurants, department stores, and close proximity to Waseda University. However, this student who travels through Ikebukuro during her daily commute to and from school simply finds it a convenient place to stop and study. "I ride the Saikyō line, which is one of the most crowded, into Tokyo every day. Very often I run into chikan (train perverts), who press their bodies against me, often palming my body and becoming noticeably excited in their pants." X-ko, who is still a virgin, feels strongly that it's her appearance that attracts this attention. She, as well as her three friends who accompanied her when we met, have the same appearance as the most stereotypical kogal, including brown-dyed hair, expensive (parent-bought) leather handbags, and cellular phones. The three expressed strong affirmation at the opinion of their friend. "I wish that

I have beautiful daughters. They mean a lot to me. I'm responsible for them, as an adult and a father.

Accept adult responsibility / Give youth a future

Telephone Clubs, Date Clubs and "Enjo Kosai" (paying for dates), what they all lead to is prostitution. Buying and selling sex should never be allowed. Adults must protect youth from being sexually exploited.

♦ TOKYO METROPOLITAN GOVERNMENT

A public service ad placed by the government tells parents not to let their kids grow up to be kogals.

and down shopping streets and depātos all over Tokyo like dominatrixes with paying suckers on leashes; they create the feedback that pushes a product over the top and into a craze. They inspire hatred in almost everyone over 20. They inspire love in almost everyone over 20. They are loud on crowded trains. They are the sassiest teenagers. They are everything that's wrong with Japan. They are the only other thing (along with the 13-year-old boys with the butterfly shivs) that's right on with Japan. They're so easy to understand because they are just like every other stupid ghost of youth culture past. They are so difficult to understand because they are the most modern, wealthy, secret, and unique youth cult there has ever been. They are riot grrrls who roll their high school uniforms up and up into vicious miniskirts on escalators. They aren't pretentious enough to know about riot grrrls. They are the ones with blue eyeshadow, the glitter makeup, and sparkling

I were in high school at a different time. Now, with kogal being such an issue in Japan, nobody can see me for me. They only see me as kogal, like the ones they see on TV."

Despite the many innocent girls hit by the media, kogal as portrayed on TV exist. And these days, with the kogal boom and media blitzkrieg over, it isn't so much mainstream media but kogal-oriented publications that keep the fires alive. While certain kogal magazines, such as *Cawaii!*, focus on style and perpetuate the unified image of the kogal tribe, other magazines go a step further. The most popular of these is *Egg*, which, besides providing hints on clothes, hair, and new products (especially brand-name leather bags, clothes, and cellular phones), also serves as a sort of kogal forum. Readers are invited to send in pictures and letters for several different open forums in the magazine. Letters tend to center around what would seem to be the true pillars of the true kogal's existence: sex, money, shopping, and men. Yet the letters printed tend to involve the most extreme portrayal of the kogal, and a peculiar sort of one-upsmanship escalates from issue to issue.

What the media really latched onto as the manifestation of the corruption of the kogal's morals was enjo kōsai (see also p. 257), a euphemism for their money-for-sex trade. As the number of girls who looked up to the lifestyle of sex, drinking, karaoke, and good times increased, they were greeted with waiting legions of older men willing to pay them for sex. This was facilitated by the Telephone Clubs. These are establishments where men pay to be connected to girls who call for free (or are in fact paid to talk to the men and keep them on the line), and after being connected, any negotiations between the two might be possible. There are many "chat areas" from which one can choose the type of partner they are looking for, and Telephone Clubs invariably have an area whose name connotes the fact that it is an area designated for one to meet young girls.

As a booming private sex trade industry took off, men were willing to pay similar prices for inexperienced high school girls at Soapland and other brothel-type venues. For a time, to be paid for sex was good for the girls, who might earn on average between ¥30,000 and ¥50,000 per outing. As the market heated up, the tables turned. A huge increase in the numbers of high school girls involved in the trade was followed by even more poser girls pretending to be kogal. Girls engaged in the traditional sex industry found that they could make more money independently. Even some office girls moonlighted as kogal to make ends meet.

This sudden influx of willing participants created an oversupply in the market, and prices plummeted as the customer base became better informed. The position of the girls became more vulnerable, and yarinige, a term

→ KOGAL DICTIONARY

All of these words are considered rad and are in use as of **April 2, 1998**, but no doubt some of them will only be used by squares and their mothers in like a week or so.

CHAPATSU: Brown or dyed hair.

CHO: Means supernatural or severely. They throw this in front of almost any word to be all dramatic and shit.

CHO-MABU: Super heavily sexy.

CHO-MUKATSUKU: Super ugly. See CHO-MUKA.

CHO-BLUE: As in *"I'm cho blue today. I got kicked out of my house."*

CHO-MUKA: Very fucking angry.

CHO-BA: Very bad.

CHO-UZAI: Uzai is 'an asshole,' i.e. *"You're cho-uzai korosuyo!"*

ENJO KŌSAI: Literally means 'compensated dating.' Lately means 'paying teenage girls for sex,' as in *"Daughter, please tell me you are not involved in enjo kōsai."*

ENKO: Short for enjo kōsai, as in *"She's totally enko."*

FUE KO: From "Kogaru Face," meaning the leading, best-dressed, most influential scenester. Every school has one or two.

GOMU NUKI: The more recent loose socks without any elastic, and that totally require sock glue to keep on. And sock glue is very toxic.

HI SO: The newly hip, dark, tight, high and blue Polo socks the FUE KO wear.

JIJEE: Ugly old man, as in *"That jijee freaks me out. He's cho-mukatsuku."*

KANARI: Recently has been taking the place of CHO since even college women use that word now. It's old.

KARESHI: Means boy friend, but the Kogaru stress the *re* and the *shi* thus making 'friend' imply 'more than a friend,' as in sexual partner or even slave.

KICHIGAI: A creepy man over 25 or so. A lech.

KOROSUYO: Used to only be the reserve of yakuza wiseguys, now the favored threat of the Kogaru. Means 'I'm gonna kill you!'

LON GE: Means simply 'long-haired boy,' and they're usually the kogaru's partners-in-crime.

ME SHU: The slutty-looking blonde or gold or brown streaks in the SHA GI hair of Kogaru.

MENCHI KIRU: A very mean, dirty look. *"She just gave me menchi kiru!"*

OYAJI GARI: Literally means 'uncle hunting' as in 'teamu go oyaji gari (uncle hunting)' with their kogaru girlfriends as bait.

PAPA: Short for patron, as in *"A Papa gave me this Gucci bag."*

PANCHIRA: To flash underwear.

PICCHI: Short for PHS, which is short for Personal Hand Phone System which links all the boys and all the girls like a giant walkie talkie game from Radio Shack after school.

SHA GI: Shaggy, uneven, thinned-out hair.

SHA GI SHI: Weird scissors that are used to cut the SHA GI haircut.

TEAMU: From the word 'team,' as in gang.

UZEIN DAYO: "What the fuck do you want?!" Always good for the staring freaks (KICHIGAI) on the trains.

ABOVE: Two women shop for discs. The socks on the left woman is wearing the new trend—Polo socks. The one on the right wears the loose baggies, which are going out of style. Kogals glue GOMU NUKI to their legs!

sea blue lipstick like they're drunk on the Pacific Ocean. They ride trains to the ocean en masse, like mods to Brighton, to bodyboard and smoke out the Filipino boo. Their nails are little sharpened blue velvet paintings for scratching out the eyes of kichigai chikan on crowded subway trains. They hate men. They sell their teenage bodies to men for fucking Gucci and Prada shit, and they don't share your European-import morality. They drink too much beer even though they aren't old enough to drink. They smoke cigarettes even though smoking can kill you. They know the Big One's going to level Tokyo at any moment. They rip off beer, sake, and cigarette machines with 500 won coins from Korea. They join Phone Clubs. They all have PHS cell phones so their shy pussy johns don't get their parents when they call to make dates. They created the entire cell phone market of today doing this. They hitchhike around Japan trading sex in neon love hotels for rides and gifts.

LEFT TO RIGHT: Photo submissions often have tons of funny writing on them. The ones above were taken from *Cawaii!* magazine, which is upscale and fashion conscious. For the trashy kogal action, get a copy of *Egg* magazine. They feature kogals much like on the following page. They try to be extreme. Two girls walk up the steps and got their photo taken. The sack is full of expensive gear.

describing when a customer flees the scene of intercourse without paying for services rendered, was coined and used not uncommonly. Even as fringe participants in the market dropped out, average payment got lower and lower until prices as low as ¥5,000 were recorded just over six months ago. Many kogal, used to large incomes, were in debt. The cell phone and drink bills started to pile up.

The desperation of the situation could be heard on one message I heard at a Telephone Club. "17-year-old high school student is seeking 'daddy.' One time: ¥5,000. As I'm pregnant and saving money for an abortion, condoms are not required. Please leave a message at box number X."

The withdrawal of kogal from the private sex trade has not been accompanied by a similar withdrawal of the patrons they have attracted: the Japanese salarymen. **A quiet rivalry has developed between the high schoolers, contemptuous of corporate sellouts and authority, and the soulless-drone salarymen oyaji who have provided the financial backing and demand leading to the situation today.** One product of this rivalry is oyaji-gari (meaning "oyaji hunting"), where a kogal, propositioned by an older man, leads him down a side street where her friends, male and female, jack him for his money with some swift kicks of revenge. Another is in the recent decrease in the difference in age between high school girls and their partners. Whereas before relationships with older men were often sought as a source of financial support, more high schoolers are turning to their own for partners. With high schoolers dating high schoolers, segregated from society both by its attitude towards them and vice versa, they have built a sort of tribalism, a line between themselves and general society.

To hear Japan's high school girls talk about the oyaji, and vice versa, it is surprising that they are describing the same relationship. The word which most often describes the kogal's impression of Japan's working men and their fathers, is nasakenai (pitiful). **Many, when asked about their fathers, see them as slaves to their work who sacrificed their relationships with their families and daughters. Most of their fathers drink nearly every night, whether it's after work at a bar or at home late at night, served by the wife.**

Most likely unsatisfied sexually at home, he is suspected of occasional cheating vis-à-vis sex-for-hire. Kudaranai, meaning mundane, is a word which also comes up with regards to the life the kogal's fathers lead. Three kogyaru I talked to were surprisingly open about their sexual relations with older men for money. An interesting turn took place when one began saying that, "It really isn't for the money." It's a large breach of my understanding to comprehend why such beautiful young girls would choose to bed old men, besides for money. "It's also that I feel sorry for them," she continued. She was surprised to answer, "Yes," when asked if her older patrons somehow reminded her of her father. She had never thought of it before. Not only did they remind her of her father, but by being with them, she felt that she was giving something to them that she saw as a need for her father.

Four middle-aged men in their 40s and 50s were getting drunk at the table next to me at a local izakaya. Weather, politics, and business covered, it did not take long for their talk to turn to the subject of women, and, subsequently, kogal. Three of the men had daughters in high school at the time. None would admit to paying for enjo kōsai, although the question

They team up with their boyfriends for oyaji-gari and jump stupid men who can't believe their luck and can't see the Lon Ge with the club in the bushes. They are totally willingly exploited like stupid girls. They are totally feminist because they don't give a fuck about anything except their own pleasure and want-lists. They are setting the cause of women in Japan back 50 years. They are so far beyond the old school '70s women's lib movement that they simply *are* women's liberation. They are Cho-Mabu, ne? They have their own impenetrable secret language. They don't speak real Japanese. Their little fashion particulars change almost weekly. So does their language. So does their taste in boys. They hate boys. They prefer men. Men are old and stupid, and like dogs, they can be used. Like cows. Like pigs. They love to listen to sugar-coated pop idol pop songs. They prefer '70s German porno soundtrack jazz. Their pop idols sing veiled references to enjo kōsai and

was met with silence. One man did mention, however, that he had paid for sex at an "Image Club," and requested that his partner be dressed up in a girl's uniform. "Tamaranai," they echoed, when asked what they thought of the kogal. (Tamaranai describes an uncontrollable attraction one feels.) No matter how they were asked, any description that they could offer of the kogal was completely physical. The conversation moved from their phones, to their skirts to their socks, and then thighs. All of these were "tamaranai." All of these men felt unable to quell their inexplicable attraction for young women.

Walking across from Hachiko Square and up Dogenzaka towards Mela, the kogal I see are a diverse group. Some innocent girls lick ice cream. Some hard-core kogal negotiate on their cell phones. Others sit in the window of Dunkin' Donuts, studying. More are taking Print Clubs at the game center. A couple are being accosted by a good-looking surfer-type on the street, for possible recruitment to work at either a bar or brothel. More often than not, they are in groups of their own, mixed with other high schoolers.

It seems that a line has been drawn. What remains of the kogal phenomenon is difficult to grasp and define in easy terms. While the media was more than willing to exploit the boom for increased viewership, as usual, the follow-up has been lacking. The media consumer is still left with sensationalized images. High-schoolers continue to marginalize themselves from society, while defying definition in nearly every other sense. Surveys of kogal reveal a declining trend in participation in enjo kōsai, although statistics regarding lack of respect for authority and loss of virginity seem to be holding steady. Drug use seems to be on an even line.

But despite efforts to catalog, track, or understand them, kogal aren't that simple. Said one 16-year-old girl in Shibuya, **"I just want to be as I want to be, as an individual. I want to escape the stereotypes people have of me from my uniform, and from how they see it on TV. I think everyone should do what they want, and allow others to do the same. I don't want to be a kogal, I want to be me."**

These kogals have a special technique.

shabu. They listen to SPEED's "Go! Go! Heaven" because that means 55 heaven—as in 55-year-old salaryman sugar daddy who gives up the loot and the gifts. They want to stay in school and learn some English slang so they can pepper their conversations with cool-sounding katakana. They want to drop out of school and split to LA or the Gold Coast and hang out with foreign guys. They are under 20 and they are all different except for their loose socks held up like garter belts to their knees with glue. Some of them are exactly like this. Most of them are like this a little. All of them just wanna fuck around forever and have hella fun, unlike every preceeding post-war generation in Japan that sold out their youth for the fucked-up ideal of global economic power. They introduce a new world with a shrug.

URA-HARAJUKU GODFATHER *words + pictures* | Eric Nakamura

STREET BEAT

You're always described as a man who sets trends. How do you feel about that?

HIROSHI FUJIWARA: I don't feel nothing. You can't really control what people think anyway. When I was really young—like 23, 25, or something like that—I was really trying to fight it with my public image, but it didn't really work. Now, I don't really care. I guess people know what I'm doing. You know, in the '80s or '90s, many DJs would say, "Hiroshi came from fashion, and is not really a professional DJ." They wouldn't really listen to me, or what I played. Then on the other side, fashion designers said, "Hiroshi is doing a clothing line just for fun." They didn't really recognize what I was doing. But now I think people understand that people can do a lot of things.

Is that a Japanese belief, that a person can or should only do one thing? I've asked some people who do framing or printing for artists if they made their own art, and they always say, "No. That's taboo for me." Is that how things are?

It used to be people should only do one thing. Like The Rolling Stones just keep on rocking. But some people like rock, soul, and hip-hop together. I still respect people who do one thing for life. I like having dinner with specialists—like artists—and it's always good to talk to them and get deep information about one thing. But I can't do that. I love everything. I move around a lot.

Which came first: fashion, being a DJ, or something completely different?

Both, but the first influence for me was punk rock in the '70s. And that was the music and fashion anyway.

When Hiroshi Fujiwara mentions he likes something—it could be anything, from a rock band to a clothing brand—it becomes tomorrow's hit. For example, I saw him purchase a piece from an "overlooked someone" at the GEISAI art festival. By the show's end, the artist had a field day.

Today's global street fashion—where underground music, new art, and action sports meet limited-edition clothing and high-concept, lowbrow style—was incubated in Japan, and much of it can be attributed to the hands and mind of Hiroshi (no last name needed). He's often referred to as the father, grandfather, or just plain god of street culture. His design and branding ideas have been tapped by companies around the world, and if he ever typed a resumé, it would be pages long and include everything from luxury goods by the most exclusive companies to everyday items like sneakers. Hiroshi is flown around in private jets, his blog is read by minions all over the world, and he even made a cameo appearance sitting next to Scarlett Johansson in *Lost in Translation*. Even so, he humbly describes himself as a DJ. When Hiroshi arrived to meet me in a Tokyo café, my crappy seat was instantly upgraded to a secluded, private location.

Was that Japanese punk rock?
No, it was the Sex Pistols. I was about 12 years old and living in Japan, and **punk had something to do with fashion and music. It was 50-50. It's kind of sad; now music is music and fashion is fashion.** There's nothing new.

You don't see anything in music now that is inspiring to fashion or moving with fashion out there in music?
No.

What was the last thing then?
I think that was punk. Maybe hip-hop, but that was not as strong as punk.

What kind of music are you into these days?
I'm not really into music so much: some metal, rock, and acoustic rock. I listen to a lot of John Mayer.

Do you play acoustic instruments, too?
I play piano or guitar. Actually, I play guitar almost every night. When I travel, I always have a guitar with me at the hotel. If I don't, I just call John Mayer or whoever and ask for a guitar, and he can bring it to my room.

What kind of music do you play at that time?
Nothing, really. It's just really good to have an acoustic guitar.

Back to the trend thing. Was it weird to know that if you said a camera was good, a huge segment of the population would go out and buy it?
Not really, I try to be honest.

It sounds like you're pretty true to what you're into, but has it always been like that? Have you ever felt like you were following anyone else?
Well, I do follow a lot. I copy a lot. I just go for it.

Jeffrey Ng, a.k.a. jeffstaple, is the founder of Staple Design and Staple Clothing. He has opened retail locations in New York City and Tokyo, both named Reed Space.

When did you first hear of Fujiwara?
JEFFREY NG: I first met Hiroshi in 1999. I was art directing a magazine called *The Fader*, and I was also contributing some stories. Back then, the notion of "limited edition sneakers" was still in its infancy. But I wanted to give the story some coverage here in the States. That required me to go to Nike Japan and interview some of the key players. After interviewing Nike Japan's Marcus Tayui, who was the head of making limited edition shoes and went to start up Nike SB, he said, "If you want to get the real story on this culture, you need to speak with this dude named HF." Prior to that though, I had no bloody idea who the hell he was. As I was looking for a photographer and interpreter to help me with the interview, people were like, "What? You want me to help you interview God?" or, "No way! I am not qualified for this." I was really shocked. Who was this dude? It even got me shook, because I had no idea what to expect.

I was picturing someone looking like Thor wielding a hammer or something. Well, we did the interview, had a nice conversation, and really connected. Basically, the interview turned into dinner and chillin' back at his crib, and we have been friends ever since.

Do you have a favorite project that Fujiwara worked on?
No, I don't. In fact, we rarely talk about work now. Sure, he does a ton of things and I do, too. I think we both know this, and the last thing we wanna do when we hang out is talk about leather colorways or collaborations. But if I had to answer, I am a big fan of Head Porter and its bag collection.

How has Fujiwara inspired or influenced your work?
The best thing I've learned from him is modesty. In so many people's eyes, he is this great god—a grandfather of street culture as we know it. But I can still walk into a Lawson (kind of like 7-Eleven in Japan)

and grab some ice cream with the dude. He almost doesn't understand why all this has happened. All he ever did was talk about and do things that he was really into. And for me, things really became more positive for Staple and for myself personally when I started to have the same philosophy.

What do you think is Fujiwara's greatest contribution to "street culture"?
Maybe the tab label you see on T-shirt sleeves. You see it on BAPE. You see it on 10.Deep. You see it on a lot of companies. I think he was the first to ever do that. He should have bought a patent on it.

Is there something you can share with us about hanging out with him?
What surprises a lot of people about Hiroshi is that he is such a funny dude. He loves cracking jokes on people—especially me. You should also check out his magic abilities! He could start a second career as David Blaine. I've seen him levitate right in my office.

do anything that he doesn't want to do. Also, Hiroshi is a connector of people and he does it enthusiastically without any concern for return. **His contribution comes from his willingness to share.**

Is there something you can share with us about hanging out with him?
He would take me to Pride fights in Tokyo. In the middle of a match, I happened to mention that I liked the Stüssy skateboards that had the Louis Vuitton inspired logos (I believe they were pulled off the shelves soon after for legal reasons). He immediately got on his keitai and made a call. They were sitting on my desk when I got into the office the next morning. That is the kind of guy he is.

What do you think is Fujiwara's greatest contribution to "street culture"?
First, his personal point of view. He doesn't

Inside had a special W+K Tokyo label. Only 50 were made.

How has Fujiwara inspired or influenced your work?
I think Hiroshi's openess to new things, his hunger for fresh ideas that can be inspiring to people, is how I relate to him. **He is a cultural sponge and understands how to use information to bring out ideas.** I am very guilty of being late on a collaboration on a book project with him. I was waiting to open my new creative space in Portland, Studio J, to start the project. It's been open for six months but has yet to start. I have made it my 2007 resolution to finally design it.

John C. Jay is the executive creative director and partner in Wieden+Kennedy, which has offices in Portland, Tokyo, and Shanghai. He is a key player in Nike Japan.

When did you first hear of Fujiwara?
JOHN C. JAY: I first heard of Hiroshi in 1996 through Japanese magazines. I found out more about him when I moved to Tokyo in 1998. I remember seeing an article that mapped out his extended influence. I think I met him that year.

Do you have a favorite project that Fujiwara worked on?
Yes, the Wieden+Kennedy Air Force 1 shoes that we designed exclusively for the staff of W+K Tokyo only. They were white pony skin with Tokyo written in kanji on the back.

I saw you at GEISAI. Have you always been into new, street-level art?
Not always. I can't say I've always been into young artists—in fact, that was the first time I visited GEISAI— but I always look at art. I thought it was amazing. There were no borders. I couldn't say, "This is European or Japanese." There shouldn't be any borders anyway.

Are you still an analog type of dude? Has the internet changed what you do?
Both. I'm trying to not lose analog—but I can't ignore digital. I don't think I can live without the computer anymore.

Did you go to a fashion school?
I only went for two to three months, but that was my reason to leave my hometown and come to Tokyo.

Was it easy for you to leave home?
Yes. When I was 18 years old, my parents paid for school.

It seems you're pretty good at a lot of things. What would you say that you're not good at?
I'm not good at being in a big group. Sometimes I go to parties, but I'll only be there for 10–15 minutes and then leave. I don't like crowds. I really like to have dinner in a small group.

Have you always been that way or did you go to parties when you were younger?
I went to parties when I was younger, but I was always independent. I'm otaku. I want to be in my house.

Why do you think streetwear is so strong in Tokyo? Japan was very poor in the '40s and '50s, but you helped streetwear take root in the '90s.
When street culture came out in the end of the '80s or '90s, we had so much money in Japan. We could buy things like designer fashion. I really liked Stüssy. It was one of the best—real street or surf culture meeting something else. Then we thought, "Maybe we can start something."

Do you think it's strange that you could influence street culture and fashion around the world?
It is true that Japanese fashion has influenced everyone, but it's not me.

Japan is such a small country and the United States is huge.
But basically in America, there was no fashion anyway. There was street culture, but not fashion. Europe had fashion and no street culture. Maybe they met in Japan. Japanese people were really good at picking that—we were there and were always looking for new information from Europe and America.

ERIC: Hiroshi Fujiwara is much lesser known publicly than his protégés like

There was a time when everyone in Japan wanted to buy vintage American Levi's. It seems like that's less popular now.
Americans make good jeans, but they don't understand how good they are. The same goes with military vintage or whatever. Japanese people know. And then it kind of came back. I remember I would go to secondhand clothing stores in New York or LA in the early '80s, and I would always buy $15 Levi's jeans and jackets.

Do you think there's too much focus on limited-edition things now? Whether it's a toy or a shoe?
Yeah, I really think it's too much. But I think it's shrinking—especially the toy business. Maybe it's a good thing, so only the people who really like it will buy it.

Are you a major consumer of goods? Do you have a collection of limited edition toys?
Not because it's limited, but it's because I like it.

How have you seen things change in the last 10 years? It seems like there are a lot of successful young designers making fashion brands and shoes. Do you think they show respect toward the culture?
It's hard to say, but I think Nigo, BATHING APE, and that stuff is too strong. <u>Now everyone is trying to be a DJ and make toys.</u>

I read that Nigo was a protégé of yours. Do you like the direction of his career and business?
I haven't spoken to him in two years, but I think he's very successful. He's going in a completely different direction than me.

Do you think your direction came with more age and wisdom?
Yeah, I think I'm doing good in that way, trying to be in the middle.

Is that the real you?
Yeah, I think so. I like to go to buy a bento box all the time. But on the other hand, I kind of drive nice cars. I like to ride my bicycle every day. Nigo is really into boats. I respect what he does: make a lot of money and make Japanese culture popular.

You've made some money, too. Do you feel like it is easy?
No. I don't think so. I was just lucky.

Do you think it's easier to make money than to make something you really care about?
Yeah, I think so. I never really cared about making money, because I have a really good partner who I trust 100 percent. He does everything, and I don't even have to worry about money. I am lucky to have a good team.

Do you always produce things that you are entirely happy with? Or do you ever regret projects?
Of course, sometimes that happens. But I'm okay, because I don't work that much. Many people ask me to do things, and I say no if I can't do it. Because of my situation, I don't have to worry about money. I'm lucky.

Were there any memorable things you've done that were disappointing to you?
I think there's a lot, but I don't remember. I try to forget about it.

What stresses you out?
I wish I had more time. That stresses me out maybe. If I don't have control, suddenly my dinner schedule is packed!

Are you interested in helping young artists and designers? Do you feel a responsibility towards street culture?
I always try and help young artists or designers, but not too much. I try to give them chances by introducing them to people or a magazine. That's all I can do.

You've done a lot of product design. Did that come from fashion?
I didn't really learn anything. But I can say that the computer changed the whole thing. I'll think, "I'm into bicycles, so I need to make a messenger bag." Or I'll buy a camera and need a bag for it. It's really simple; I make what I want.

What kinds of things are you doing now? Are you starting new brands?
Not really, no. I'm doing the same things. I don't have plans to start something new.

but like the pull quote says, they don't know who he is. People know who he is, but like the pull quote says, they don't Fujiwara is a proven commodity and still talked about with an air of mystery. People know who he is, but like the pull quote says, they don't being true trends that transcend and inject themselves over time into the big box stores. Fujiwara is a proven commodity and still talked about with an air of mystery. to the other side being true trends that transcend and inject themselves over time into the big box stores.

KAWS is a Brooklyn artist who operates the OriginalFake store in Tokyo in conjunction with MEDICOM TOY.

When did you first hear of Fujiwara?
KAWS: When I was working on painting a mural in the Hectic store below his office in 1998.

Do you have a favorite project that Fujiwara worked on?
The Woven Concept Folding Chair manufactured by IDEE in 2002.

How has Fujiwara inspired or influenced your work?
I like the way he keeps involved in many projects at the same time so you don't really know what his specialty is because he does a bit of everything.

What do you think is Fujiwara's greatest contribution to "street culture"?
In Tokyo, "street culture" is his contribution.

Is there something you can share with us about hanging out with him?
No, he is a private guy. 🐱

Is there a limit to your scope in terms of what you want to do and what you just definitely don't want to touch?
No, I don't have a limit, but I'm trying to see my potential. There's a side of me that says I'm doing too much and taking too much time.

Is there a point where you just want to stop and go fishing?
I want to retire all the time, but that never really works. I've tried to stop many things, but when I stop something, it keeps me busy and busier. I don't know why. But I retired from DJing, so maybe I'll have more time.

Besides playing guitar, do you have any other hobbies?
At the moment I like riding bicycles. I go to the park at night and ride my track bike with friends. It's fun to go downhill; it's like snowboarding in the street.

Are you a competitive person?
I don't think so. I'm more passive and protective. Many people know me, but not many know what I do. I don't really want people to know what I'm doing. I want to be mysterious. People say, "You must be really busy." "No, I'm riding my bike every day." I don't like to say what I do.

Was there a time when you were really busy?
Yeah, I'd be designing bags and being in meetings during the day and then DJing at midnight.

Is sleep important for you?
I don't like to sleep. I wish I didn't have to sleep at all, because time is really limited. Sleeping is wasting time. I don't drink, either. People spend time drinking and sleeping a lot, which I don't really do. I want to use time for something else. Even if I'm not producing something, there are so many things to do. Even at home, I want to read a magazine, watch a DVD, or play the guitar. I don't have time for sleep. Also, it's weird but I don't dream. Maybe I don't remember, but I think that means I sleep pretty deep.

Perhaps you don't need to dream because you do everything you want to do?
Maybe. I have no idea.

Do you feel like you're getting better? Is your eye for design getting better?
Yeah. I get more information. I started going to college last year. I'm learning psychology. It's fun. I think I'm going to take art history. 🐱

HAIR CLUB FOR MEN

words + pictures | Michael Kai Louie

History never fails to repeat itself. And perhaps there is no recurring trend more embarrassing than hair—even on men. Fashion now, yes. But tomorrow? Burning cheeks of shame.

Remember the shaggy mop on Bruce Lee in the '70s? That was a great cut and he was a handsome devil at that. Unfortunately, it takes more than hair to be like Bruce. Just ask Bruce Li. Then in the '80s, you had the convenience of the perm. It was easy: wake up, rub your head a little to shake it out, and then it's off to chemistry class. Only you didn't look like Kevin Arnold— you looked like an Asian Joe Piscopo. Shirley at Koi Hair Design in West Los Angeles remembers a period of golden ignorance when the men's perm was embraced like Men's Pocky: "It looked good at the time, but now you're like, 'No!'" It's not always a complete lack of taste that plagues Asian males. Noriko, another hairdresser in West Los Angeles, believes that **Asians in America are often at the mercy of unskilled barbers.** "If you are Asian, you must have had bad haircuts from Americans," she says. Part of the problem may lie in weak barbers, but Shirley thinks it's also the challenge of Asian hair. "Asian hair is probably the hardest to cut," she says. "You have to cut it perfect because you see errors better since the hair is so straight." With all these factors intimidating the bowl-cut honorable grandson, haircuts are becoming increasingly homogenized—thus the rise of the fade. Like lowered Hondas, the fade is everywhere. Featured best on guys over 5'8", the fade is easy to spot and comes in colors like peanut butter. The fade consists of bald sides with the top one to four inches sticking straight up. It's easy to manage, too, so if you told me you

only spent "one second" on your hair, I'd probably believe you. This clean, versatile cut fits in at the office and also stays in place as you figure out how to hide your boner while dancing. It is highly fashionable and mandatory for all new members of Lambda Phi Epsilon. "About 80 percent of the Asian guys who come into Koi get the fade," Shirley says. Like the recent presidential election, popularity wins no contests, and the fade is embarrassingly common. And all you really notice is that Chia-pie on the wearer. That's appealing if you like *Dragon Ball*. Also, the fade offers no sense of mystery. Everything is exposed from bad complexion to hairy moles to black eyes. And then there's the "Japanese" haircut. From the mecca of light-speed trends comes a stringy, sloppy style not unlike Thurston Moore's shaggy, straw-like, washed-with-hand-soap mop-cut from the '80s. What it lacks in clean style, it wins in mysterioso points. If you're not up for conversation, it fills the same role as a sombrero during siesta, clearly stating, "Leave me the fuck alone." "There's a big difference between having an Asian American haircut and a Japanese haircut," Shirley explains. "Asian Americans have a more conservative, clean-cut sort of thing. Guys in Japan don't go for just highlights; they'll color the whole thing." And there are other cuts. There's the shaved monk, the FOB bedhead, Vietnamese gang bangs, the toilet brush, and the "Sulu." Every day new ones sprout like naughty ideas in a church girl's mind. Like Britney Spears, I'm not that innocent—of a bad haircut. In October I gave myself a bad cut, bad as in "of poor quality." The front looked fashionably rough, but I gauged how much to cut in the back by how much hair fell on the floor. I met my friend later, eager to mention how I'd never go to

Supercuts again. I was stoked until she said through thinly concealed laughter, "It looks like someone took a bite out of your head." I guess the back was about as patchy as a hobo's blazer. One thing to say about a bad haircut is: "Don't cry. It'll grow back." But you'll always be haunted by the stain of memory.

MICHAEL KAI LOUIE: *I wrote this soon after I moved to LA from Delaware—the naïveté and novelty of the piece is very clear to me now. I didn't grow up around much Asian culture outside my family, and other Asian kids I met at school didn't interact much. I think this shows in this article, ha! Moving to the GR house in the Sawtelle area was a big shift for me. And the fact that schools had all-Asian fraternities was fascinating, though these were clearly long established and commonplace. I remember I went to UCLA with a bunch of Giant Robot magazines. I was pretty sure none of these guys had ever heard of us. I had long considered fraternities my archenemy throughout college, so I think partially I saw this as a chance to make fun of them. We came up with the haircut names collectively in the GR garage—I recognize the ones I came up with: the Skulnick, the Rapscallion...but it was Martin who came up with "The Duranimal"—which is the clear winner. The great irony of this article is that my own haircut was the worst one out of all of these—"self-inflicted" is how I'd later describe it. After the article, I shaved myself a New Wave mohawk the day before I got my new California drivers license, thinking it would make a funny story. I guess it did for a while.*

which means it, porcupines out when at a certain length, and then falls when at a longer length. Eras of bad cuts and trends come and go, but the "bowl cut" remains a constant for generations. Did you have one?

ERIC: This was ridiculous although true. Asian hair isn't all the same, and it's nothing like white people's hair. It's often coarse and straight, which

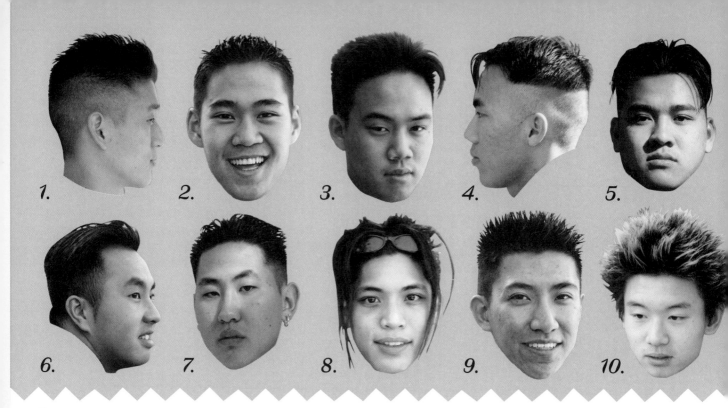

Afros, braids, and mullets—these are some of the indigenous hairdos worn by male African Americans, Native Americans, and white people. But Asian guys have hairstyles, too. Look into any pool hall, noodle joint, or lowered Honda, and you'll see thick, straight Asian hair in variations of the fade, the Dragon Ball, the toilet brush, and more. Here's a small survey of what's creeping up on college campuses today. There's good, there's bad, there's ugly, and there's more to come.

1. FADE [Will]
Who cuts it? I cut my own hair.
How much? It's free.
Why this cut? I don't know.
What goes in? Hair gel, sometimes hairspray.
How much time (to get ready)? 5 minutes.
Your worst cut? Since I cut my own hair, I would screw up a lot. I would try to get the fade, but end up shaving off all the hair.
The worst trend in Asian cuts? Sideburns.

2. BON-BON [Huy]
Who cuts it? My barber in San Jose.
How much? 10 bucks.
Why this cut? I just told him to cut it straight up, so he shaved it and that's how I comb it.
What goes in? Gel or mousse.
How much time? About a minute.
Your worst cut? Back in the day when it was all long and shaved underneath.
Why isn't your hair black? Nothing wrong with it; it just looks so normal.
The worst Asian cut? I don't like Japanese guys with the big-ass afro with color.

3. PACO [Shin]
Who cuts it? I cut it myself.
How much? It's free.
Why this cut? I'm growing it out, so I'm leaving it.
What goes in? Gel, occasionally.

How much time? A few minutes.
Your worst cut? The bowl haircut I had in seventh grade.
Your opinion on colored hair for Asian dudes? It works on some people; on other people it doesn't look right. It depends on the face I guess.
The worst Asian cut? All the Asians have dirty haircuts. Maybe just really long hair.

4. TOP-SHELF [James]
Who cuts it? My mom.
How much? It's free.
Why this cut? She always cuts my hair like this.
What goes in? KMS Gel.
How much time? 5 minutes.
Your worst cut? When my girlfriend shaved my head for the first time, she ended up shaving it up really high. Then I had to shave my whole head bald.
The worst trend in Asian cuts? The really long, colored hair—the HK superstar syndrome.

5. FRENCH CUFF [Quay]
Who cuts it? I get it cut at home.
How much? It's free.
Why this cut? Just because.
What goes in? Gel.
How much time? 2 minutes.

Your worst cut? Just a sorry fade two years ago.

6. REPUBLICAN [Johnny]
Who cuts it? A barbershop in Westminster.
How much? 10 bucks.
Why this cut? I gotta keep it semi-professional, clean, and short.
What goes in? Mega-mega-hold gel.
How much time? Like 5 minutes.
Your worst cut? Super-long on the top and then shaved all the way around so it looked like a mohawk—in middle school.
The worst Asian cut? The mullet.
What about colored hair for guys? Colored hair is cool.

7. FADE-A-BILLY [Newman]
Who cuts it? My friend cuts it.
How much? It's free.
Why this cut? It's the only cut he knows.
What goes in? Orange Dep Gel.
How much time? 2 seconds or 2 minutes.
Your worst cut? The bowl cut when I was a kid.

8. DEVIL LOCK [Yanson]
Who cuts it? I cut it myself.
How much? It's free.
Why this cut? I used to have really long hair and I wanted to cut it short, but didn't want

to miss my long hair. So I left one strand.
What goes in? Nothing.
How much time? 5 minutes.
Your worst cut? When I shaved my whole head and just left the strand there and it looked like a stalk coming out of my head.
The worst Asian cut? The guys who shave the sides of their head so it's bald.

9. CRAB GRASS [Vu]
Who cuts it? My roommate.
How much? It's free.
Why this cut? I like it like this.
What goes in? Gel.
How much time? 5 seconds; it's really easy.
Your worst cut? In high school, it was just really long and grungy looking—not greasy, just long.
The worst Asian cut? Those dreadlock things.

10. HEDGEHOG [Wilson]
Who cuts it? I was bald for a while and then I started growing it out half a year ago.
How much? Nothing.
Why this cut? I just started styling it like this two days ago. Before, I slicked it all back.
What goes in? Hairspray and just 'fro it.
How much time? 5 minutes.
Your worst cut? Back in grade school, my mom made me get a really big perm.
The worst Asian cut? The fade.

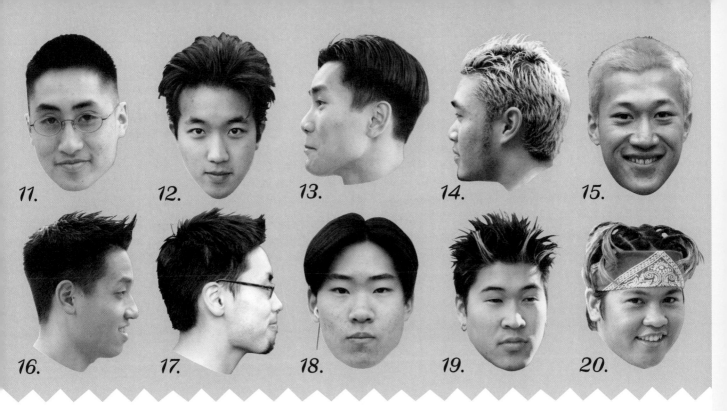

11. EASY RIDER [Nguyen]

Who cut it? I cut it; it took 10 minutes.

How much? It's free.

Why this cut? Low maintenance.

What goes in? Gel once in a while.

How much time? 10 seconds.

Your worst cut? My friend did a pyramid on my hair. He cut it up and kind of, like, in, so I looked like a conehead for a while.

12. DURANIMAL [Albert]

Who cuts it? My mom

How much? She used to charge me 10 bucks.

Why this cut? I kinda want to get off the fade thing. I just style it like this because if I don't, it'll look like his [Wilson's].

What goes in? Hairspray the top, gel the sides, and then hairspray.

How much time? 5 or 7 minutes.

Your worst cut? I actually had a perm. It looked like a curly rice bowl cut.

The worst Asian cut? Guys with bald heads.

What's wrong with black hair? I like black hair but after a while it kind of gets mundane.

13. SKULNICK [Billy]

Who cuts it? I actually cut my own hair. It's actually very hard. There's a lot of blending.

How much? It's free.

Why this cut? I just like this because it's short and easy to handle.

What goes in? Usually I put gel and then an overcoat of hairspray over it.

How much time? 10 minutes.

Your worst cut? I was trying to get an undercut, but I cut it too high and it looked sort of like a mohawk, I had to shave it all off...

The worst Asian cut? The same hair that everyone has, you know short on the sides and then spike it up.

14. PYRITE [Marc]

Who cuts it? My friend does it.

How much? It's free.

Why this cut? It's natural expression.

What goes in? Gel, mousse.

How much time? 3 minutes.

Your worst cut? When I shaved it all off once. It's just weird without hair.

15. RAPSCALLION [Leo]

Who cuts it? I cut it in my room.

How much? It's free.

Why this cut? It's easy to cut and I don't have to take care of it.

What goes in? Nothing.

How much time? A minute.

Your worst cut? The bowl cut when I was 10. It was down to my nose and I just parted it in the middle.

16. TIN-TIN [Johnathan]

Who cut it? My mom cut it for me.

How much? It's free.

Why this cut? I've had this haircut since my sophomore year. It just kind of came with that long part in the front.

What goes in? Gel.

How much time? 5 minutes.

Your worst cut? Probably a crew cut when I was back in elementary school.

The worst Asian hair trend? The bear cut—when it's cut short all around and then it grows out all fuzzy.

17. OG [Barry]

Who cuts it? Supercuts in San Francisco.

How much? 12 bucks.

Why this cut? It's an all-Hamaguchi original.

What goes in? Aquage Hair Paste from Japan.

How much time? Less than 30 seconds.

Your worst cut? In high school, I had it really long in the front and short everywhere else. I pushed it forward and it looked like a mask. Like a reverse mullet—a mullet right on the front of my face.

18. BUTT CUT [Will]

Who cut it? Koreatown, Jenny's Beauty Salon.

How much? $15.

Why this cut? I just like the bangs long, and I can part it or whatever.

What goes in? Gel and hairspray.

How much time? 5 or 10 minutes.

Your worst cut? Having no hair just looked like shit.

19. GHIDRA [Chris]

Who cut it? I cut it myself.

How much? It's free.

Why this cut? I have very fine hair. I grow it out so it looks thicker. My hair grows out messed up, like the right side goes back, the left goes forward, the back 'fros out...

What goes in? Hairspray.

How much time? Couple minutes.

Your worst cut? Elementary school, when I didn't cut it at all; I just let it go wild. That shit was everywhere. Like I had flies around my head.

20. PRIVATE DANCER [Dennis]

Who cut it? I got it at Segal's.

How much? $10.

Why this cut? I braided it like this because I have an audition today.

What goes in? Gel and hairspray, no mousse.

How much time? About 30-45 minutes to braid it.

Your worst cut? When it was really short and it looked really ugly because I couldn't style it. It looked like crap; I just could move it at a certain angle.

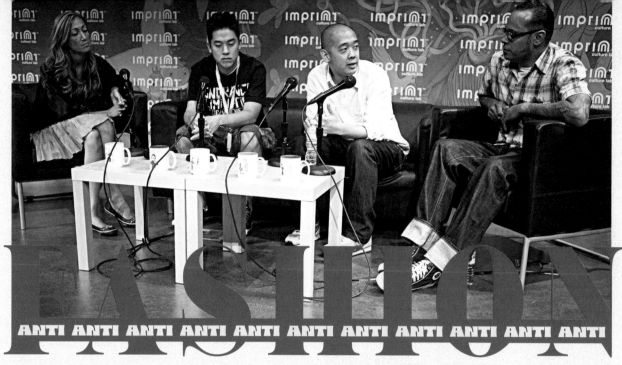

FASHION
ANTI ANTI ANTI ANTI ANTI ANTI ANTI ANTI ANTI ANTI ANTI ANTI ANTI

words | Eric Nakamura *pictures* | Ben Clark **STREETWEAR PEOPLE**

Streetwear is an intriguing topic. It may look simple from the outside, but from the inside it can be really complicated. Really early on, there was a company called Freshjive that did a shirt that looked like Tide but said Jive. It basically took something that was corporate or Fortune 500 and turned it into a T-shirt design. A lot of companies in the late '80s and early '90s did that, and it was an early form of what streetwear is today.

The participants of the following conversation were invited to talk about the past, present, and future of streetwear. **Alyasha Owerka-Moore** has done just about everything in the fashion world, from Phat Farm to Fiberops. Next is **Jeffrey Ng** (a.k.a. **jeffstaple**), who owns Staple Design and Reed Space. His shops in Tokyo and New York are two of the few stores where I'll actually buy something. Then there's **Bobby Hundreds**, who is doing his own thing with The Hundreds. And finally there's **Jennifer Yu** from New Era. Caps are the new sneaker, and a really important segment of what streetwear is today.

First, tell me a little bit about what you guys do?
ALYASHA OWERKA-MOORE: At the present, I do Fiberops, a brand that I started with my really close friend, Tabo, a Japanese guy who grew up in Hong Kong. Tabo passed away last December. The brand is only sold in Japan and a few shops in Europe and Hong Kong.

JEFFREY NG: I started the Staple clothing line in '97, silk screen T-shirts at the lab at Parsons. They only let you silk-screen paper, so a friend and I would have to break into school at night with a pillowcase of blank T-shirts to print stuff for ourselves. We'd give them to friends and really had no intention of starting a business or anything like that. We saw cotton shirts as a kind of medium that our generation could relate to more than canvas or framed prints.

I wore a T-shirt on my birthday, March 7, in '97 in a store called Triple 5 Soul. Today, the brand is a large urban brand, but back then it was just a boutique that carried a lot of cool stuff. The owner of the store said, "I really like your shirt. If you want to try to sell it here, we'll buy 12." That was how the business started, and it grew from T-shirts into a full collection.

But, to this day, I don't consider myself to be a fashion designer. That's because we have this other business where we do consulting and design work for other companies. One of our biggest clients is Nike. Another one is Burton snowboards.

In 2002, we opened up our first retail store called Reed Space. I named it after my high school art teacher Michael

Reed, who changed the course of my life. I just saw a need in the industry. I wasn't really happy with retail stores in the sense that they weren't representing brands like ours properly. Our store is an entire lifestyle shop, with clothing, books, magazines, jewelry, CDs, import music, and hard-to-find stuff. **If a martian landed and wanted to learn everything about street culture and the underground art world, it could just walk into our store and learn it from A to Z.**

BOBBY HUNDREDS: My name is Bobby. I run a company called The Hundreds. I have a real simple story: I grew up in Southern California and was always really into Aly and Jeff. I tried to learn more about them, and somehow I ended up doing it myself with my business partner who I met in law school. **When we started The Hundreds four years ago, it was half blog and half T-shirts. Anything that was on my mind, like political views or whatever, would end up in our designs.** We make everything now: T-shirts, wovens, and denim. We opened our first store in LA in February this year and another one is opening at the end of this year (not in LA).

We like to educate the community about artists and people around us who we admire. First and foremost, my business partner Dan and I are fans. We don't see ourselves as being in the industry at all, and we're no different than the consumers. And there's no ethnic group, age, or socioeconomic status that defines our customers. The only thing they have in common is that they enjoy what we do.

JENNIFER YU: Unlike the panelists who have their own brands, I actually work for a big, corporate company. My role as Entertainment Marketing Manager is specifically based on celebrity collaborations, product placement, and some celebrity custom product as well. We get a lot of cover shots on urban and hip-hop magazines: Russell Simmons, Nigo, Travis Barker, and Stevie Williams. Travis is a partner of ours as well; we do his line, Famous. We just opened a flagship store in Atlanta. We also have stores in New York City and Buffalo. We also recently opened in London and Toronto, and have plans to open in LA. We have a lot of partners who we make products for, so we have to be careful where we open our stores. We work with Bobby and Jeff as well.

NG: I don't think Alyasha did a proper job of introducing himself. He's pretty much the grandfather of Bobby and me. Alyasha, maybe you can properly describe your lineage?

OWERKA-MOORE: I grew up skateboarding in New York. A group of friends and I met on my roof and created a company called SHUT Skates. We cut our first 100 boards by hand in 1986. A guy named Bruno Musso, who is the team manager for Burton now, and Rodney Smith, who started Zoo York, were both 18 and I was 16. I did a bunch of designs for skateboard companies and moved to Southern California when I was 18 to work in the graphics department at *Transworld Skateboarding* for a year. Then I moved back to New York to work for my mom, a textile conservator who restores ancient textiles for The Met, National History Museum, and private collectors and dealers. That's how I paid the rent. Then I got into music and started making beats. I lived on the same block as John Forté, so he and I had a group. Mos Def lived across the street and down the block, so I made a lot of his early demo tapes. Then I got a big break when a friend of mine asked me if I wanted to do some stuff with the Jungle Brothers. I produced three beats for an album that went through three years of production. I ended up doing stuff for The Beatnuts and a guy named Minnesota. My tracks never made it onto the Jungle Brothers album, and neither did The Beatnuts's tracks.

By happenstance, a good friend of mine in the music industry ran into Russell Simmons. Russell wanted to start a company and call it Phat. **My friend said, "You know a little bit about design." That was all graphic stuff, but I had really been into collecting clothes. I had a huge Paul Smith collection, as well as a lot of Polo stuff (as did most kids in New York at the time). So Russell, Paul Mittleman (the creative director for Stüssy), and I sat down and drew a range plan. I was thinking about the name Phat, and thought that you might as well call it fresh, dope, funky, or cool. It was just a colloquialism that pertained to a certain period of time. Polo Country was the big thing in New York at the time, so I thought, let's call it Phat Farm so people will at least think it's half-assed witty. We presented the name and the line to Russell, and I became the first designer for Phat Farm.**

That was 1992. I was 22, and I was making more money than I had ever seen. I gave up on music and internalized the brand too much. Russell and I bumped heads, and that was the beginning, end, and beginning of my design career.

After that, I bumped into some old skateboarding friends. Chris Pastras, who had started Metropolitan Wheels and Stereo Skateboards, asked me if I wanted to do a board company again. I started a company called American Dream. The whole thing about it was that we had a completely minority team. Contrary to what Pharrell says, we had the first all-black skateboard team. We did that for two-and-a-half years, and we started outselling the major shareholders in the company and got shut down.

Immediately after that, a friend of mine, Phil Pabon, who was the original marketing director of Mecca USA, asked me if I needed a job. I knew him because he managed the Jungle Brothers. I had worked there for about a year when I was hired by DC Shoes. At the time, they were doing Dub brand outerwear and a denim brand, DROORS. I was the creative director for Dub and DROORS, so I moved to San Diego in 1996. I was doing hands-on designing, traveling for manufacturing, and doing product placement. I knew a lot of people in the music industry in New York, so on The Beatnuts album *Stone Crazy* and a bunch of Wu-Tang videos, they're wearing Dub stuff.

When I left New York, Mike Alesko, who owned International News which owned Mecca USA, thought I was moving to California to live in my friends' garage with little skateboard kids. But he was an awesome guy who taught me a lot, and he said, "Promise me we'll work together again." I didn't take the comment seriously, but he called me up and asked if I wanted to do anything. So three other guys from New York and I started Alphanumeric in 1998.

The ultimate goal for Alphanumeric was to respond to everyone on 7th Avenue in the garment industry who wanted to put kids in boxes: "That's the hip-hop kid, that's the punk rock kid, and that's the skater kid." Personally, I grew up in the New York hardcore scene but I've probably seen more hip-hop shows than anyone here. I saw EPMD's first show in the city outside of Long Island. I saw Stetsasonic, Run-D.M.C., and the list goes on. **I'd see a matinee at CB's and Cash Money at night, and skate in between. There were a lot of kids like that, so the idea was to create a general youth lifestyle brand that was streetwear.**

Meanwhile, I did the first Triple 5 Soul logo and helped reintroduce the Dunk as a skate shoe. After the Wu-Tang Dunk, Alphanumeric made the first Dunk collaboration. I met with Vince Salazar and Drew Greer and basically coerced them to make it. Four years into it, my partner Tabo and I decided to start our own brand, and that was Fiberops.

And how do you describe streetwear today?
OWERKA-MOORE: At this point in time, streetwear means cottage industry. It is clothing that speaks to you in some way. It's twisting a corporate conglomerate's thing, like a Tide box, on its head and making light of it. It's also Jeff screening his own shirts and us making our own skateboards. It's like, "Hey, we can do it, too."

There are heavy, socio-political overtones and messages, or just really cool graphics. Not all of us want to wear the Coca-Cola logo or any large, branded logo. Streetwear speaks to us a lot more. There's a really funny phrase: "streetwear is the new urban." Once corporate America catches on, they think, "We can do that, too." So it's gone full circle. Now, except for a few companies like Bobby's and Jeff's, streetwear is the antithesis of what it was.

NG: I agree with the cottage industry thing, where you make it yourself or at least start that way. I had dinner with Damon Way, the founder of DC Shoes, and he said, "Streetwear started out as the push against everything. It was the anti to whatever was normal." Nowadays, that feeling is gone. It's become very playful, colorful, and frivolous, if you will. There's no anti going on, and that's where it thrives.

HUNDREDS: For me, the cliques that hung out in high school were separate: the punks, the hip-hop kids, and the skaters. But four other guys and I skated, and we also listened to hip-hop. We were heshers and we went to punk shows. We did everything. When the clothing company started, we wanted to do something that reflected all that—not just urban or skate. **At trade shows, the buyers were completely confused by us. "Are you hip-hop?" Yeah, I like hip-hop. "But you're wearing skate shoes." I like to skateboard. I was like, "I make clothes for everyone, what's the big deal?"** The buyers said, "You're going to have to choose." I wasn't even familiar with the word "streetwear" at the time. Can you be rural or from the country and still wear my clothes?

I think the term is like when "grunge music" started and none of the bands wanted to be called grunge. They were just punk bands. Same thing with streetwear. Everyone uses the term in the industry, but no one wants to be known as a streetwear brand. It's a media term. But I think being independent, doing things your own way, and keeping the corporate out of the way is the heart of it.

YU: I agree. It's an umbrella term now. At New Era, we have these boxes to put our consumers or partners in. Now we're finally realizing there is no specific urban, suburban, or women's market.

NG: Do you know how New Era got into the business? New Era made caps for Major League Baseball. Now its street industry is as big as that. It all started with Spike Lee. He would always sit courtside at New York Knicks games with a Yankees cap, and he said, "I want a red Yankees cap." So he called New Era and asked them to make a red cap with a Yankees logo. There are a lot of rules when you make things for Major League Baseball, so they said, "We can't sell it, but we'll just make one." Then he was seen in *Sports Illustrated* with his red Yankees cap, and New Era was flooded with phone calls to get a red Yankees cap. That's what spawned their street industry, and that is streetwear. It was making something that you couldn't make. It was the anti. **A rule was broken, it was made, and everyone loved it. That's the spirit of streetwear.** 🐱

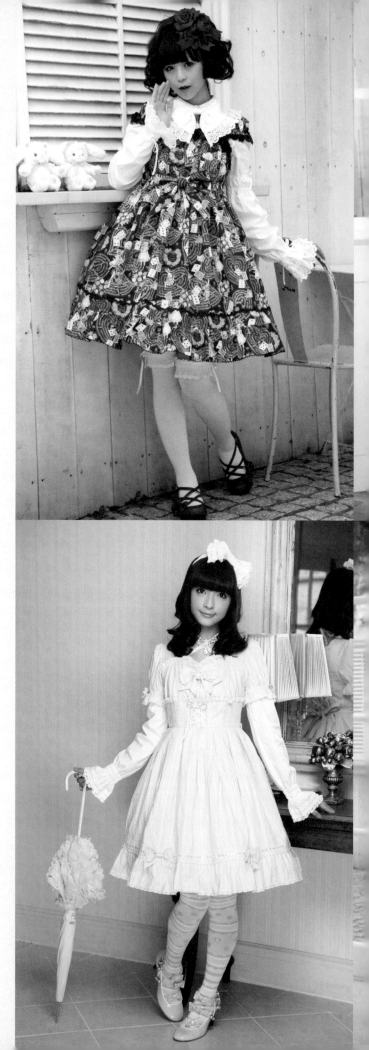

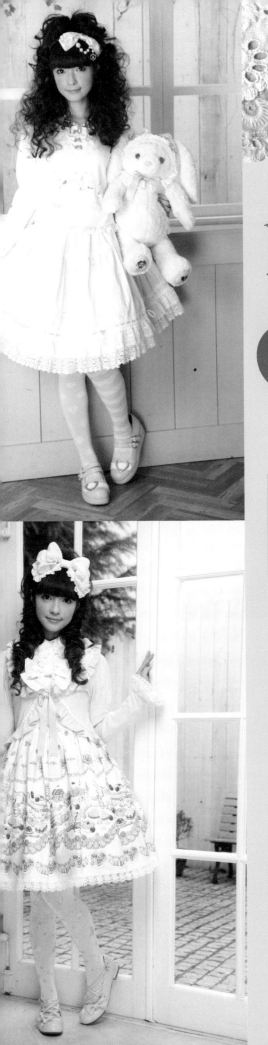

Victorian Secret

words | Martin Wong
pictures | Baby, The Stars Shine Bright

Founded in 1988 by the husband-and-wife team of Akinori and Fumiyo Isobe, Baby, The Stars hine Bright was one of the first brands to service Japan's Gothic & Lolita scenes. Not only does it clothe a loyal army of doily-wearing girls in Harajuku—as seen in the 2004 movie *Kamikaze Girls*—it has opened shops in Paris and now San Francisco. Fumiyo Isobe and chief designer Kimiko Uehara answered some questions on the eve of opening their first shop in North America, which is in Viz Pictures' brand-new J-Pop complex called New People.

Have you always been into clothing? Did you always dress up (*not necessarily Gothic or Lolita*) when you were young?
KIMIKO UEHARA: Yes, I became interested in clothing when I was in elementary school. Whenever I went out, I always wore my favorite clothes. I wanted to become a fashion designer so I studied textiles in high school and college.

When did you get into the Lolita culture? Was it through comics, music, or just the look?
UEHARA: I was introduced to the world of Lolita during high school by my friend and have been addicted to, and making Lolita clothing ever since. Right now there are tons of cute materials to work with, but when I was in high school, there were hardly any, and they were very difficult to find.

Are you a scholar of the Victorian period, like of the politics, cuisine, or music of that time?
UEHARA: I'm not really interested in anything else from that era, just the clothing.

How did you go about opening a store with your husband? Did either of you have a business background going into it?
FUMIYO ISOBE: We founded our business 20 years ago. Of course, at the beginning we didn't have enough resources to run our own shop. We made products little by little, and had shops that handled various brands sell them for us in Tokyo and other cities. But with that method, we could barely earn what was needed to make

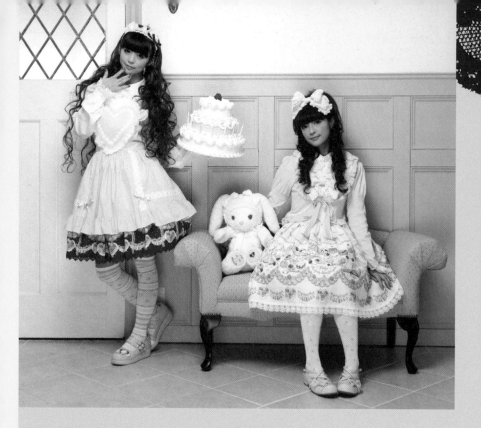

a living. We had always imagined owning our own shop one day. Suddenly, around 1997, this sort of fashion with cute taste became very popular, and with the earnings from our designs, we opened our first shop in Daikanyama.

Were there like-minded brands or designers that you looked up to?
UEHARA: No one in particular. I'm just into doing things my way!
ISOBE: I got to know Baby when I was studying fashion design in college and Baby instantly became the center of my life.

How did the brand gain a following in the very knowledgeable but rather fickle Japanese fashion scene?
ISOBE: We gained our following primarily through our customers and fans. The fashion scene in the '80s was about brands sending out messages, holding fashion shows, and advertising in print media to sell clothes. That was the strategy then, but I think it's different now. I want to keep a very close relationship with our customers and try our best to create products that people never tire of. That is why we keep close relationships with magazines like *Kera* and *Fruits* that mainly focus on fashion snapshots on the streets.

Can you talk about your customers? Since you sell directly through your shop and mail order, do you forge personal relationships with them? Do fans approach your brand as the protagonist does in the Kamikaze Girls movie?
ISOBE: We hold small tea parties called ochakai. They're like small get-togethers that have been around for a while within the Lolita fashion brand community. Our shop's staff are mainly the ones who host them, and our fans join us at these parties. They approach our brand very passionately.

When you go out for a simple task or chore, do you feel pressured to dress up to represent your brand's image?
UEHARA: Yes, I dress up in my own way.

Do you think customers wear your clothes every day, or are your designs strictly for special occasions?
ISOBE: I think there are both types. It's really up to the customers.

It seems to me that your brand is more of a lifestyle than a look. For example, it takes extra time to put on all the layers of clothing, and it's not like you wear it without doing your hair or makeup. There are a lot of personal sacrifices that go along with the clothes. Can you describe this dedication?
ISOBE: There are definitely people who devote everything to their Lolita look. But I feel that is only a fraction of our customers. Our staff or designers wear Baby clothing daily, but do so without using too much time for hair and makeup. They simply wear Baby clothing beautifully every day. Our staff's lifestyle revolves around everything kawaii, but it's not too difficult and doesn't require complete dedication through sacrifice.

Tell me about opening a shop in France. Was there a sense of accomplishment, providing clothing in the country where the Rococo look had originated?
ISOBE: I feel that Lolita fashion and Rococo are two different things, so in that sense, I did not feel a sense of accomplishment. But as for those fashion scenes that still do not recognize this style as a fashion, being able to open a shop in Paris, the heart of the fashion world, did give me a small sense of accomplishment.

What about the new US store? Do you have to change sizes, colors, or any other aspects of your line to fit American customers better?
ISOBE: I have a different kind of hope for the US compared to Paris. There are many more people in the US, so I would like as many people as possible to see Baby clothing and wear it. In order for that to happen, we need to overcome the issue of size. I am also thinking about things like designs that are easier to wear and made from different materials.

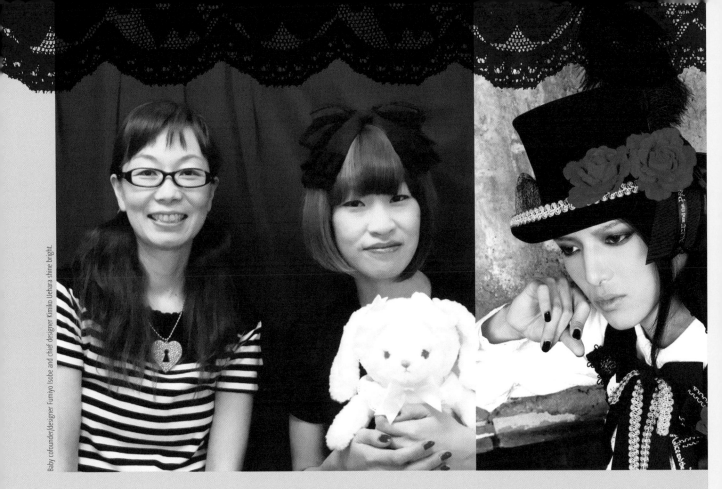

One of the most interesting things to me about the Gothic or Lolita style is that the European look is contrasted with the Asian facial features, skin, build, and so on. Do you think anything is lost when a Caucasian person wears it?
ISOBE: I think design-wise, it looks better on Caucasians. If I had to point something out, the only thing would be that it looks too perfect and you miss the human qualities.

Has it been difficult to find the perfect people to work at the shop in San Francisco? Will this staff be very different from your Japanese staffers in terms of what they wear, their mannerisms, etc.?
ISOBE: We have already found our manager for the shop. Together, we will continue to communicate and discuss the different aspects of the US store as we grow.

In a way, do you think that American fans of the Gothic and Lolita styles are more hard-core than Japanese ones, since they're so out of context in the local culture?
ISOBE: I don't think that's necessarily true, because web-based communities exist. Even in Japan, there are many girls who live in small towns that are far away from Tokyo, and they get started and proudly wear their Lolita fashions. I believe the same thing is happening all over the world.

Are you selling the sub-brands at the new store? Will there be new sub-brands for the US?
ISOBE: Yes, we will carry Alice and the Pirates. I think that the brand concept of "the vague line between masculinity and femininity" matches the culture of San Francisco very well. I have an image for a new sub-brand, but for right now we have our hands full with the two brands, Baby and Alice, so it will have to come further down the line.

The Everything but the Girl song "Baby, the Stars Shine Bright" is really different from the visual kei stuff that's popular now. What are some other ways that you've witnessed the scene growing or changing since your brand began?
ISOBE: I chose the name Baby, The Stars Shine Bright for my brand because I liked the words, so the reasoning behind it had nothing to do with whether the clothes reflected or went with the song. But I do like the song by Everything but the Girl. Tracey Thorn's voice has a sad and lonely tone, yet has a very feminine feel, don't you think?

Do you ever wish you lived back in the Rococo time? Or maybe in a group where everyone dressed like that, you'd be dressing modern!
UEHARA: I admire Rococo dresses, of course, but Lolita fashion isn't just about the dress. It is only part of it. So **I do want to try on a dress from the Rococo time, but I don't particularly wish to live during that time.** Besides, isn't Lolita considered "fashion" because it is in the present day?

SPORTS

PEGGY OKI

First, I wish to acknowledge the variety of nationalities and cultures in this world. None are necessarily "better" than others. It is through raising awareness of cultures, their unique qualities, as well as common threads in music, visual arts, that can bring about appreciation, and hopefully, greater unity. Having been born and raised a Nisei, I at least was able to grow up with some Japanese culture while being American. What an opportunity to directly experience both worlds of the East while living in the West. Knowing a bit of history on Asians in America, including internment, it is hard to understand anti-racial attitude, including anti-Asian sentiment and laws. Sometimes I wonder, were they based on misconceptions, envy, or fear?

Even to this day with hate crimes, there is a need for understanding, acceptance, and pride. But above all, a need for unification of all peoples across the world. I see unification happening through skateboarding, which doesn't seem to be about color or religion, but rather a culture based on dedication and personal development to the art in itself. A skateboard does not know race or gender.

In other interviews, people asked if I felt any issues with being the only female on the Zephyr team. As shared in the *Giant Robot* article, from my early youth I would get into rock fights, girls' vs. boys' teams. I was used to being active in things boys did, such as riding my Schwinn Sting-Ray out on the big vacant dirt lots of my neighborhood. So, I didn't see myself as being different from the boys at all. Jay Adams was probably my favorite teammate to hang out with. While out skating, I also enjoyed brief conversations with Shogo Kubo. We related to each other on our Japanese roots.

Whenever you opened *Giant Robot*, there were so many other interesting articles, including a piece about Michelle Yeoh (p. 140). I hadn't known about her until seeing her in *Crouching Tiger, Hidden Dragon*, one of my favorite martial arts films. Such art and a magnificent story. I loved how she and the other actress Zhang Ziyi kicked butt as martial artists. Before then, I didn't know that Asian women practiced martial arts. I felt honored to have the article about me in the same magazine.

I thought then—and still feel—that the article now included in this book was the best article about me I'd ever read. But in saying that, I realized it was great because the article wasn't just about me. I was part of a team, and our presence influenced a lot of skaters at that time, including Steve Caballero, Ian Mackaye, Ray Barbee. Though I didn't know "The Cab" or Ian during the "Z-boys" era, it was wonderful to rediscover, through Martin's questions, their insights about how our team inspired them.

Steve said, "Once a skater, always a skater. It's in our blood and there's no denying it!" I fully resonate with those words which are true to this day. Martin included our fellow skateboarders, bound together in a way by that common thread of skateboarding. In a way, that may also be true about being Asian. And being human.

We weren't trying to necessarily say, "Hey, look at us." But as Asians, we were certainly part of a melting pot brought together through skateboarding.

Peggy Oki is a pioneering pro-skateboarder and an original member of the Z-Boys, inducted into Skateboarding Hall of Fame in 2012. Today, she is a public speaker and environmental artist and activist with a strong focus on the protection of whales and dolphins.

words | Martin Wong
pictures | Glen E. Friedman + Scott Gibson

DOGTOWN GIRL

Peggy prepares to meet fans and stalkers at the *Dogtown: The Legend of the Z-Boys* book signing at Hennessy + Ingalls in Santa Monica.

Tonight the hips, rails, half-pipes, and street obstacles at the Vans Skatepark in Orange, California, have been marked off with yellow tape. Tables have been set up with bowls of snack food. On a temporary stage, roadies are tuning up instruments for Suicidal Tendencies, but the real action is at the kidney-shaped bowl where skateboarding legends like Tony Alva, Steve Alba, and Omar Hassan are ripping up the coping in honor of the *Dogtown and Z-Boys* documentary premiere.

"Skateboarding is so popular now and it definitely has a culture around it," Peggy Oki tells me as we enter the huge indoor facility, which is packed with pro skaters, industry people, and fans from the past and present. Alluding to the movie, the only female Z-Boy explains, **"These are the roots. Skateboarding didn't begin with us, but the radical style and attitude did."**

Peggy, who always seems to be smiling, grabs a handful of M&M's and tells me that she was approached by members of the Zephyr Surf Shop's skateboarding team to become a Z-Boy in 1974 when they spotted her skating on Bicknell Hill in Santa Monica. "I had no thought of being on a team, but I went over to the Zephyr shop and checked it out," she remembers. "They asked me and I said, 'Okay.'"

THE Z-BOYS

Although the Santa Barbara-based artist and surfer makes it seem like becoming a Z-Boy was no big deal, it's not like just anybody could join. It required high quantities of toughness and style. *SkateBoarder* magazine described the West Los Angeles crew (Dogtown is the area where Venice, Santa Monica, and Mar Vista meet) as "more like a street gang than a skate team."

"There weren't any other girls on the team," she says, "but I have been a tomboy all my life. Even when I was 9 or 10, I used to get into rock fights. So I didn't get intimidated. I felt like one of the guys. They were doing all these things and so was I. As far as falling, getting scraped up, or bruised—that sort of thing never bothered me. So they probably saw that I wasn't some little foo-foo girl. That brought me the respect to be a part of their group."

Back then, Peggy would meet the other Z-Boys (which included the likes of Alva, Jay Adams, Shogo Kubo, and *Dogtown* filmmaker Stacy Peralta) a few days a week at Jeff Ho's Zephyr Surf Shop. Skip Engblom, who handled store business while Jeff was shaping boards, would send them off to Kenter Elementary or Revere Middle School to ride the banked edges of the playground, pushing each other in terms of speed, style, and power.

"I feel really nostalgic about having been on the team with all these guys and all the fun and adventures we had skating together, going to these places, jumping the fences at Kenter, and hanging out at Berendo," says Peggy. "It was so much fun."

Expressing that she feels weird about knowing only the "old people" at the *Dogtown* party, Peggy walks around the skate park's rails and ramps, seeking, meeting, and hugging other members of the Z-Boys who have been gathering in Los Angeles to celebrate the release of Peralta's award-winning film, as well as the coffee-table book of vintage photos by Glen E. Friedman and articles by C. R. Stecyk III. By the soda machines, she introduces me to Cris Dawson, who was a skateboarder and a graphic designer for Zephyr. After the original Z-Boys dissolved, Dawson followed Peralta to G&S Skateboards and, eventually, Powell-Peralta Skateboards, helping to create the street design style that became mainstream. At the base of a gigantic rail, we find Shogo Kubo, who is raising a family in Hawaii and who also has a new limited-edition skateboard deck that bears his name.

Peggy says she was closest to Jay Adams, whose stepfather would drive them to contests. **Adams was the youngest Z-Boy, and she was the oldest—a positive and stabilizing force for the free-spirited 14-year-old skating protégé.**

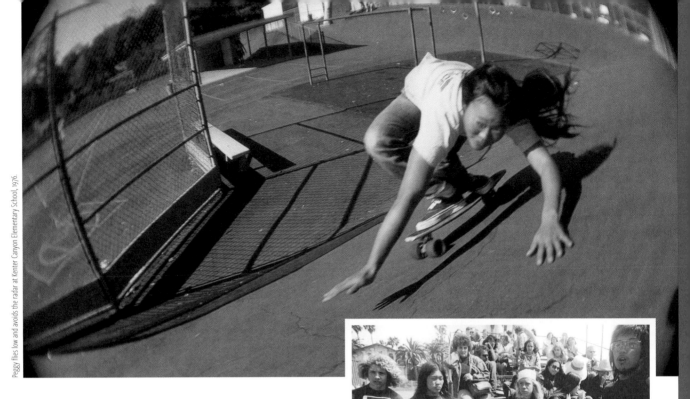

Busted for drug-related charges in Hawaii, Adams isn't allowed to attend the premiere festivities for parole reasons, but Peggy says seeing his stepfather for the first time in decades at the movie premiere was a tearful surprise.

As Peggy introduces me to other Dogtown skaters, I feel like I'm at a class reunion with the students who ditched school to surf and skate. But while the valedictorians probably went on to take mundane jobs and wear suits, the Z-Boys changed the face of skateboarding, music, fashion, and culture.

DEL MAR, 1974

In the documentary, Peralta presents the 1974 Del Mar skateboard contest, held only months after the Z-Boys came together, as the team's defining moment. Old footage shows the other skate teams doing pirouettes, handstands, daffies, and other elegant (but goofy) freestyle tricks from the '60s. Then the skaters from Dogtown are shown revolutionizing the sport with their all-out, high-speed, slashing style inspired by progressive surfers like Larry Bertlemann, who stayed low, made radical cutbacks, and touched the waves with his hands.

"This was the first big event and it was the first time we were seen," remembers Peggy, who started skating when her brother cut her a board in woodshop at school. "**Other girls were wearing short skirts and cute shorts. Some were barefoot. I skated differently—just like the guys skated differently than the other guys. We were pretty rowdy and radical. Who'd think that would carry over into current skate culture?**"

The contest marked a turning point for the sport and the team. The new outlaw style gave a burst of energy to the skateboarding world, which was benefiting from the introduction of polyurethane wheels. And as the sport's exposure and business grew exponentially, the team started going to more contests.

"We did contests because that's what we were supposed to do when we were sponsored," says Peggy, who competed in Santa

Z-Boys with their toys, circa 1974. (left to right) Tony Alva, Shogo Kubo, Jay Adams, Peggy Oki, Wentzle Ruml IV, and Jeff Ho.

Barbara and at the Los Angeles Sports Arena and appeared in the movie *Go for It* with Jay Adams before hanging up her Vans. Skateboarding was becoming more popular and more commercial. It was also becoming less fun. Sitting around and waiting for a turn and then dealing with clueless, corrupt, or political judges was not what skateboarding was all about for Peggy.

The free spirit of skateboarding is present at the Vans Skatepark pool, where pros from the '70s and '80s push each other to skate harder, go faster, and fly higher with the only measurements and rewards being style and fun. Steve Caballero, Duane Peters, Dave Reul, and Eric Britton stamp their boards in approval by the pool's lip as Brian Patch pulls off huge rocket airs. In addition to the professional and amateur skaters who directly followed in the Z-Boys spirit, there are others in attendance, such as Ian Mackaye, who fed off the energy and applied it to other forms, like music.

THE DEEP END

Peggy had already stopped skating when the original Zephyr skate team started to break up in pursuit of individual sponsorships. "By then, I was tired of contests and wasn't skating as much," she explains. "I was older than the other Z-Boys, and I went to school to study biology at Santa Barbara. I didn't hear talk about this person getting an offer for this much money or that person getting an offer for that much money."

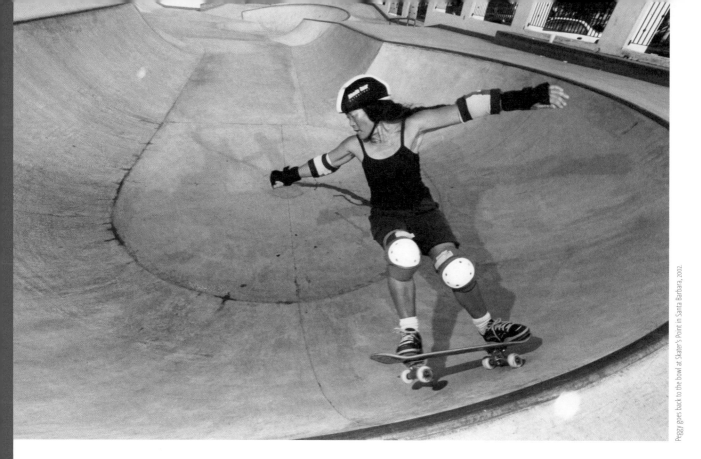

Stacy Peralta and Paul Constantineau joined G&S Skateboards, Bob Biniak and Jay Adams rode for Logan Earth Skis, and Wentzle Ruml IV became the poster boy for Rector. Fed up with making money for other people, Tony Alva started his own skateboard company.

Peggy missed out on the rivalries that developed from the split up of the Z-Boys, as well as the fame and other trappings that came with the commercialization of skateboarding. Tony Alva gained rock star status and partied with groupies at the Riot House, where Led Zeppelin and Black Sabbath hung out. In a recent interview with *Juice* magazine, Jay Adams expresses remorse over his experiences with a murder rap, substance abuse, and drug trafficking. Peggy doesn't remember drugs as part of her Z-Boys experience, perhaps because the team was younger and less wealthy in its formative years.

Although the Z-Boys were heading in different directions, they still skateboarded together—especially in pools. Some of the most intense sessions took place at the Dog Bowl, in the Brentwood backyard of a kid with a terminal disease whose parents let him invite skaters into their pool. But like their ill patron, it couldn't last forever.

Peggy stopped skating well before skateboarding's popularity peaked in the late '70s, but she says that her days in Dogtown have made a lasting impression on her—just as they have on the other Z-Boys: **"When I see the guys now, we still have the same personalities. We're still pretty rowdy. I'm adamant about what's happening to the environment. Maybe instead of jumping over fences, I'm speaking out for the environment at protests."** Currently, Peggy is a hard-core surfer who paints nature-related postcards, and is an organizer and activist for whales, dolphins, and other environmental causes.

As skaters grab handfuls of food, Suicidal Tendencies packs up its gear, and guests are shuttled toward the skate park's entrance, we intercept Ray Flores, who shot and contributed a lot of the documentary's vintage skate footage. He currently runs a modern furniture and skate shop in Venice and says, "Every time I get an email from Peggy, it's like getting a message from an angel."

BACK TO THE BOWL

A few days after the party at the Vans Skatepark, Peggy tells me that she's been pool riding every day at Skater's Point in Santa Barbara. She's been hooked up with shoes from Vans (which produced the movie) and a board from Rookie (a skateboard company run by female skaters). Skating at a park is new to Peggy—when she was a Z-Boy, it was so early in the rebirth of the sport that there weren't any skate parks—but she's having a blast. After two weeks of morning sessions, she's reaching the coping.

Later on, I tell skateboard legend Steve Caballero how thrilled Peggy was to have met him at the *Dogtown* party. "I'm stoked that she's back into skating," he says. "Once a skater, always a skater. It's in our blood and there's no denying it!"

More or less. One week later, Peggy lets me know that she broke her wrist while skating. Although the doctor says the injury is a "seven out of ten," she stays positive and can't wait to skate again. Peggy relaxes and says, "Whenever I'd see someone skating—now it's stuff we weren't doing then because skateboarding has progressed so much, getting into ramps and skate parks and street skating—I think, 'Man, I skated way back then, and isn't it funny that I was on the Zephyr team and nobody would know it?'"

A CHILD WEAKLING WHO GOT BUFF AND THEN KILLED HIMSELF
YUKIO MISHIMA
THE BODYBUILDER

words | Robert Ito
pictures | Tamotsu Yatō + Eikoh Hosoe

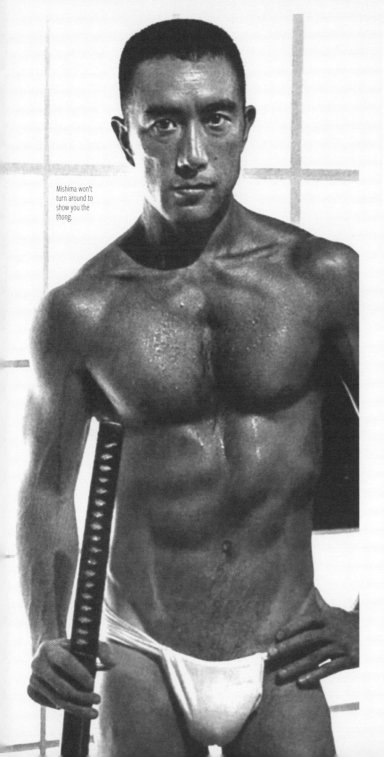

Mishima won't turn around to show you the thong.

On November 25, 1970, Yukio Mishima entered a military base in the heart of Tokyo. Mishima, one of Japan's most celebrated novelists, had just finished the final installment of his four-novel masterwork, *The Sea of Fertility,* and had alerted the press that something big was going to happen that day. Arriving at the base with four of his student followers, Mishima was soon led into the commanding general's office. After a brief conversation, Mishima ordered his students to bind and gag the base commander, then delivered a rambling, pro-Emperor speech to the mustered troops outside. Mishima then returned inside the office, stripped off most of his clothing, shouted three spirited banzais, then sliced open his own belly.

Although the news of his death shocked the nation and the world, Mishima's suicide should have come as little surprise to his millions of readers. For much of his adult life, the novelist had been obsessed with the idea of seppuku, or Japanese ritual suicide. According to biographer Henry Scott-Stokes, Mishima had been "endlessly rehearsing his own death" for years, indulging his mutilation and suicide fantasies as a film actor and model, as well as in several short stories and novels.

While these cinematic and literary exercises played a role as mental "rehearsals" for Mishima's final act, the physical preparation was of far greater importance. For Mishima, a beautiful suicide required a beautiful body. Thirty years old and disgusted by his own aging, pasty white frame, Mishima worried that he would never possess the muscular physique necessary for what he termed a "romantically noble death." The solution to his problem: bodybuilding.

By the time the author had spilled his intestines out on the army general's floor on that autumn afternoon, he had transformed his previously spindly, sickly frame into a tanned, superbly conditioned slab of Grade-A Japanese beef.

Readers and critics continue to offer up explanations for Mishima's suicide: he was insane; he was making a political statement; he viewed seppuku as the ultimate sexual act; it was a shinju, a double suicide, committed with his male lover, Masakatsu Morita; and so on. But **equally intriguing is the question of what drove Mishima to bodybuilding, what drove this self-admitted non-athlete to embrace an athletic lifestyle with such a vengeance.**

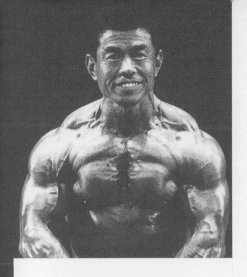

WIMPY BOY

Mishima was a weak, sickly child. His grandmother, a mean-spirited lady weakened by gout and plagued by a case of syphilis contracted from Mishima's grandfather, forced the young boy to spend much of his childhood in the old woman's sickroom. Coddled by his overprotective grandmother and a doting nursemaid, Mishima suffered from a variety of physical problems, including anemia and "autointoxication," a disease which almost killed the young boy.

Predictably, Mishima grew up fascinated by healthy, physically fit young men. His early writings reflect this fascination, and are full of vivid descriptions of young athletes, soldiers, and physical laborers: the tight-fitting trousers of a "night soil man;" the "intoxicating" aroma of perspiration wafting off of the sweaty bodies of marching soldiers; and paintings of warriors and martyrs, particularly young ones dying violent, bloody deaths. **Mishima's favorite Christian martyr was St. Sebastian. Guido Reni's painting of the martyred saint had a great impact on the young Mishima, who first eyed the painting in one of his father's many art books.** In the painting, the saint is bound to a tree, naked except for a piece of white cloth around his privates, with his arms upraised and two arrows sticking out of his body. Mishima described how the arrows had "eaten into the tense, fragrant, youthful flesh, and are about to consume his body from within with flames of supreme agony and ecstasy." The painting prompted Mishima's first masturbatory experience, and became a model of physical perfection for the young man, an image that would haunt the author for years to come.

For Mishima, there were two constants related to male physical beauty. The first was its link to pain and gruesome death, as noted in his fascination with St. Sebastian. In various works, Mishima described his idea of "murder theater," a fantasy in which beautiful Grecian soldiers, "white slaves of Arabia," hotel elevator boys, and military men would be tortured and killed using a variety of specially created devices. Mishima would kiss the lips of the tortured men writhing in pain, and in one particularly gruesome fantasy, even dreamed of slicing open and eating the flesh and organs of a bound, naked boy.

The other constant in Mishima's male aesthetic was his acceptance of his own exclusion from the world of beautiful men. While he appreciated and even idolized young, fit men, he accepted early on that he would never be one of them.

EARLY TRAINING

At the age of 30, Mishima had an epiphany. Glancing through a magazine, Mishima came across the Japanese equivalent of a Charles Atlas ad, promising that "anyone at all could develop a similar physique." He quickly contacted the man who had taken out the ad, a university coach who impressed Mishima by rippling his chest muscles so that "their activity was apparent even beneath his shirt." Mishima had found his first personal trainer, and began training at home with barbells, dumbbells, and home exercise equipment.

While home training led to significant size and strength gains for Mishima, it was the community gym that sparked his imagination. Here was Mishima's fantasy theater made real: the young, sweating men; the grunts and hollers; the leather and steel; the "torture devices." But most of all, the pain.

Pain is often seen as an unpleasant but necessary aspect of weight training. **For Mishima, a self-avowed masochist, pain was not the price of a good workout, but its reward.** Beyond Mishima's aesthetic and erotic interests in pain and physical suffering, he saw his own pain as a means toward "hearing" that other language, what he termed "the language of the flesh." According to Mishima, pain "might well prove to be the sole proof of the persistence of consciousness within the flesh, the sole physical expression of consciousness." An incredibly prolific writer, Mishima was beginning to feel uncomfortable with what he perceived to be the limitations of the written word. **Here, he had found a new, more vibrantly honest language— the language of the fit, human body.**

MISHIMA'S BODYBUILDING PRINCIPLES

Mishima attacked bodybuilding with the same discipline and enthusiasm that he applied to his writing career. One key to his success was consistency. He followed a rigid workout schedule, with bodybuilding workouts on Wednesdays, Thursdays, and Saturdays, and kendo training on Mondays and Fridays. Mishima's workouts were almost always scheduled in the afternoon, and he insisted that his other engagements and obligations not conflict with his physical training time.

Mishima also maintained his motivation and focus by keeping accurate records of his progress. One way for beginning bodybuilders to chart their progress is by taking photos of themselves at regular intervals, so that they can get good "before and after" assessments of their muscular gains. But while simple Polaroids will generally do the trick, Mishima's fame allowed him to attract professional photographers and even filmmakers to record his physical progress for posterity. In addition to standard gym photos, Mishima also indulged in more artistic shots: the novelist completely naked, chewing on a garden hose, or sprawled out in front of paintings of various Catholic saints.

Similarly, Mishima's unique writing style led to an understandably nontraditional "workout journal." **More than just a list of sets, reps, and weights, Mishima's "journals" recorded his actual sensual, tactile memories of his workouts and workout facilities.** In a *Sports Illustrated* article published two months after his death, Mishima spoke lovingly of a training camp for boxers that he attended, remembering the gym's "barbaric elegance," torn punching bags, and even the "odor of the toilet encroaching upon the shower room." Mishima loved everything about working out, in the truest tradition of the archetypal gym rat.

He also rewarded himself after a good workout. "Gym rat" is an apt title, since humans react in much the same way to rewards as their rodent counterparts. If you give yourself a little treat after each workout—fresh fruit, or even half of a candy bar—your brain will associate those happy feelings with the workouts themselves, and you will be more apt to maintain a consistent workout schedule.

One of Mishima's favorite postworkout rewards was a hot shower. He described showering with a young boxer, who smiled at the novelist and exclaimed, "The ones going crazy over the mambo, they'll never know what it's like to stand under a shower like this." Mishima shared the young man's feelings: "The feel of a hot shower after vigorous exercise—surely this must be one of the elements essential to a man's happiness. No matter how much power a man may amass, no matter how much he outdoes himself in dissipation, if he never experiences the feel of such a shower, how far is he from knowing the real joy of being alive?"

THE DREAM

Hot showers, intense free weight workouts, even the toilet odors; Mishima loved everything about the gym, and wanted everyone to enjoy the rewards of physical fitness. In 1970, he wrote about his dream for low-cost fitness centers that would be open to all, with caring instructors and flexible hours. The writer who had been a high school loser, fitness-wise, dreamed about a place "where everyone would get his place in the sun no matter how awkward and inexperienced he was."

The world of athletics opened up a whole new world to Mishima as the weak, sickly child became the tanned and muscular man. Although skeptics may argue that Mishima was just preparing a beautiful corpse for his final glorious act of ritual suicide, he dearly loved bodybuilding for its own sake, and loved the feel of his fit, rejuvenated body. As Mishima became older and more disillusioned with his writing, athletics remained one of his strongest pleasures, a pleasure he extolled in the article for *Sports Illustrated*: "Athletics exert a man's strength to the utmost. To run and leap, to dart about with sweat pouring from your body, to expend your last ounce of energy and afterward to stand beneath a hot shower—how few things in life can give such enjoyment!" 🐾

In 1966, Mishima posed for a photo shoot as the martyred saint, complete with arrows, loincloth, and a wistful, upturned face.

ROBERT ITO: At that point in my career, I had written a few academic pieces as a doctoral student at UCLA, and a few small pieces as a cub reporter at Los Angeles Magazine, *so I had a more traditional outlook on heds, deks, and captions. For instance, a typical hed and dek for my Mishima piece in a typical magazine might be something like "Body of Work: The Revealing Obsession of One of Japan's Greatest Novelists." So I was a bit taken aback by the hed created by Eric, or maybe Martin, which I thought was a bit on the nose ("Yukio Mishima the Bodybuilder"), and by the irreverence of the dek ("A child weakling who got buff and then killed himself"). An archival photo of Mishima shot by the acclaimed photographer and filmmaker Eikoh Hosoe was captioned "Mishima won't turn around to show you the thong." But what did I know? Not much, particularly about zines and their readers. Zine readers didn't need a bunch of flowery crap in their heds, deks, or captions. They just wanted to know what the piece is about.*

In 1980, Magic Johnson and Larry Bird changed the NBA game forever. The old game of underhand free throws and ass-sticking-out set shots got pushed out by a new game. The two revolutionized roundball at a time when the oversized 'fros of Artis Gilmore and the Doctor turned into more aerodynamic easy pickin' pincushions. The world of sports was shifting to 2000 with each triple-double, 30-foot buzzer-beater, and championship ring.

SUMO

Words | Eric Nakamura

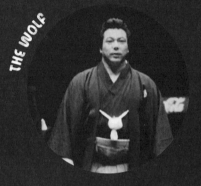

THE WOLF

But this transition wasn't only going on in hoops. It was going on in Japan, with every sumo throw down and push out orchestrated by The Wolf. Unlike a lot of the other big boys, The Wolf, or Chiyonofuji, was trim. He was all muscle, speed, and technique, like one of the NBA's elite Top 50. But instead of slamming an orange basketball in high-cut hot pants, The Wolf ruled the dirt dohyo ring, throwing down larger opponents like sacks of short grain in what some people call a G-string. And not only did he achieve the top rank of Yokozuna, he was busy looking good with his hair oiled and formed into the shape of a chrysanthemum 'fro (like samurai).

Around 1980, the Yokozuna and a company of brothers came to America to promote the goodwill of sumo. I, as an 11-year-old, attended the spectacle at UCLA's Pauley Pavilion. I can hardly remember the event except that vendors sold boiled water chestnuts instead of peanuts, bento box lunches instead of hot dogs, and that I met The Wolf. I remember running up to the lone legend who sat in a folding chair awaiting his match among a crowd of perhaps 10,000 onlookers. I got a program signed and felt the tight grip of his hand. Soon after, he was purifying the ring by throwing salt. He was young, perhaps 25 at the time, and didn't know his own strength. He crushed the spine of my program before he crushed his opponent. A week later, the autograph

got thrown away with the newspaper. I, too, got crushed by The Wolf, but it was just a delayed reaction.

DIG THE NEW BREED

Although The Wolf still lingers in some people's memory as being one of the best ever, today there's another legend in the making, a new kid on the rise: Yokozuna Takanohana. With a boyish face and huge cheeks, he's the winner of 18 titles and is the heartthrob of Japan amidst scandals and paparazzi. He stands 6′1″, weighs about 350 pounds, and has great technique. **Most who step in the ring know they are in trouble from the get-go. They might try to run and sidestep, but once he grabs your belt, it's all over. He either uses his strength and does a two-handed wedgie to lift you out of the ring, or else he uses one of the technical knockout throws to put you down.** He doesn't lose when his hands get in his opponent's pants. Unlike other athletes who have ferocious game faces, Takanohana has a "ho-hum"

face that reads like, "Okay, it's time to kick your ass," with a yawn. Even in pre-match stare-downs, he looks like a little kid about to blow a Double Bubble.

This year, Takanohana and the sumo squadron of the top division, Maegashira, came to show their skills to the Canucks in Vancouver, Canada. It has been years since they last came to North America, and I went again, this time as Press. The dubbed "once in a lifetime event" now has happened twice for me. With camera in hand along with some carte blanche in the form of a media pass, I got to see what these big motherfuckers look like close-up. Martin did, too.

LOW RIDER

Having a press credential is cool. You get a few perks, like seeing the big men up close and getting to go to press conferences. But on this particular trip, the best moments came when the wrestlers chilled on couches, wearing colorful robes while waiting for their star-studded entry. For some reason, sitting alone 15 feet away was the black-clad Takanohana with his attendant at guard. I wondered if he was alone because of his rumored hepatitis. In a previous tournament, he had a red rash on his face and finished with a bunk record which basically screamed, "I'm illin'." I disrupted the quiet moment and with my Japanese language skills, I started to mumble some sentences, and Takanohana disrupted me back with a

TAKANOHANA IS THE MAN. WE HEAR THAT HE AND HIS BRO ARE FEUDING.

grin and broken English, "How are you doing?" I asked him the same question back and he said, "I'm healthy." Being a public figure and a large man, he's probably not hitting the video game arcades or putting greens. He made the hand motions of a steering wheel and said he likes, "do-ri-bin-gu," or driving. Yes, I was glad to get a one-word answer, but then what kind of car? Does he like the speed? He answered, "Lincoln." And with a relaxed hand thrust forward, he said, "Slow." If he were American, he wouldn't read the *Toy Machine Racing* magazine, he'd go straight to *Low Rider*.

NOTHING TO SAY

Inside a room in the luxurious Pan Pacific Hotel, a battle royale of media came to roll tape. Akebono, the first non-Japanese Yokozuna, was the focus of everyone's attention. At 6'8" and 500-plus pounds from Hawaii, he's a dark mound of rebound with kinky hair and a hand thrust that can push any man down. His style is to use his jackhammer hands to push in your face in until you have to fall backwards on your ass. He thwarted most questions with one-word answers—as all sumo wrestlers do. Any answer longer than a word is usually a safeguarded quote. However, there was some joke time when someone asked why he chose sumo instead of football. Akebono replied, "I didn't like contact sports," raising a bunch of laughs. And when the question of salary arose, Akebono told the crowd he gets paid "a little more than a camerawoman."

Sumo wrestlers aren't great quote books. Since the sport has a 1,500-year-old history, each wrestler

is closely watched by the system. **A few years ago, another Hawaiian, Konishiki, accused the sumo association of racism when he didn't get promoted to Yokozuna. After what may have been tons of pressure from the sumo officials, he recanted his accusation. On this trip, he was a live commentator and ambassador for the sport, throwing out shakas to fans. He's still 6 feet, 600 pounds, and wears one of the largest suits ever made.**

Sitting next to Akebono was Takanohana, who fielded a question or two about his health. Next to him was Wakanohana, Takanohana's older brother and newest Yokozuna. Although smaller at 5'11" and 295 pounds, his legs are thick and chiseled like frog legs. With a heart of a lion, he's a crowd favorite because of his technique and hard effort to win. The next two to know about are Musashimaru, who's a thick Hawaiian, and Takanonami, a large and tall Japanese man at 6'5". Both are at the Ozeki level (one below the top). The press conference focused on Akebono since he speaks English. The rest of the wrestlers basically blurted one word each, although I did get to talk to Takanonami, who was getting no attention. A big dude, he's a funny guy, as you can see from the photo. When I told him I thought he was cool, he said, "No, I'm not cool."

REVOLUTION JOURNALIST STYLE NOW

Most of the 250 press passes went to Canadian journalists who didn't know shit about sumo. The Japanese journalists got their own special treatment.

TAKANONAMI IS NOT COOL.

They had a higher security level and a separate section where they could lounge. I thought it was funny that on a goodwill tour, the press would be segregated. There were signs printed only in Japanese. From security level A which is all access, we were put at the lowest, K! That basically set us up with nothing but our instincts. On top of that, the itinerary of the wrestlers was poorly planned. Imagine each press event being located hours away from Vancouver, some on islands! Unable to pay the ferry or helicopter fee to get to the scheduled press events, we passed and played pinball instead. What would we get, but more one-word answers?

One event we did hit was the Virgin Megastore autograph signing, which took place down the street. Among a crowd of hundreds who lined up and eventually weren't allowed in, the sumo wrestlers took their seats and started signing. Akebono rocked to the beat of some ragga-trash. Each person who walked up took his or her time to get a handshake, an autograph, and a photo. Some even had the wrestlers hold their babies, which is supposed to be good luck, although most of the babies seemed scared. Takanonami facilitated some crying by growling and scaring some kids off. We figured that we would get a few questions answered here, but again, we were met with one word answers. Akebono's favorite music? "Anything."

BHATTMAN

Bhatt, an older Indian gent who supposedly set up the entire event, is a fame whore at heart. *Sumo World* magazine did a long spread on the man.

Who gives a shit, right? That's what I said. He took the mic at the Virgin Megastore signing. After getting in between the wrestlers to get in photos, he made an attempt to raise the roof by yelling on the mic, "Make some noise!" The crowd of hundreds just stared. He did it a few times and nothing happened. It's funny how old people try to be promoters and fall flat. He might have raised five million dollars to get the event going, but he couldn't get five people to make a sound. After an hour and tons of sweat coming off the wrestlers just from sitting and signing, it was over. But before the wrestlers left, they made good fun of the fans by whining and crying back at them, like babies complete with hand gestures.

Some sumo wrestlers move into the "stable" that they call home before they hit puberty. Their minds and bodies get cultivated by rules, slaps of a stick for when they suck, and meals of chanko nabe stew. So instead of a "normal" childhood, they are thrust into a world of being a servant and getting shat upon. But in their personal time, they are jokers and goofy kids. Even with some of their childhood taken away by training, the serene and soon-to-be-legendary Takanohana had a goofy streak in him when I talked to him for a couple of minutes. You had to be there.

RUMBLE IN THE MUDDLE

With scalpers in plain view of security, a lot of Canadians were set up to see sumo for the first time. But one thing the press credential gave, whether you were an A or a K, was a front row floor seat ahead of the most expensive ticket holders. These people spent hundreds. From our seats, it was easy to see the effort that goes into each aspect of the match. From the full-force crash of heads at the beginning to the end when one tumbles out or gets thrown down, there is no fronting. You can't see it on television, but these dudes get pissed when they lose, even for just a moment. It's the shit talk that goes on in sports that cameras just can't catch.

INSANE CRANIUM!

Before the wrestlers strode into the ring for their turns, they took a seat right in front of us. With a large expanse of skin—their backs blocking our point of view—you have no choice but to focus on the sheer size of each man. Some are hairy and have a few zits on their backs, but most are clean and smooth like a coffee table. **And unlike a beer-belly gut—which has the texture of pock-marked tofu—the guts on these big boys are solid like meat.** The flab mixed with pounding and muscle appears to be a hard sheath of protection, kind of like whale blubber. I once saw a documentary of sumo wrestlers messing around in San Jose on their last trip. Takanonami visited the San Francisco 49ers practice session and had problems putting on a helmet. **He said, "Sumo wrestlers have big head," which explains it all. Even the smaller men, who are 250 pounds, have heads as big as pumpkins.** In case you're wondering, they didn't smell.

Prior to the wrestling, there were a few exhibitions of techniques. The one that put people in awe was their flexibility. Each wrestler can do the splits and then lay down forward! But the best time came when the little kids got up to wrestle the pros. At times, kids went into the ring to try and push one of the gargantuas out. With all their might they pushed, but nothing happened. They ended up getting squashed. One wrestler even spun a couple of kids by their belts. Musashimaru gave a yell and one of the kids practically pissed in his belt.

The real wrestling followed in a sped-up mode. Compared to the real events in Japan (which move at a snail's pace

with each ring entry, salt purifying toss, and—perhaps the best part—the staredown), the Canadian version moved faster for the shorter attention spans. However, the staredown in person is a spectacle almost highlighting each match. Unlike the crowds in Japan who look at the staredown as ho-hum with a few cheers, in Canada the Rocky Balboa complex comes out and people go nuts. The biggest crowd-pleaser was the Mongolian Kyokushuzan, who has tricks from Mongolian wrestling that he has introduced to sumo. A Mongolian woman told me (with nationalistic pride) how before Kyokushuzan showed up, sumo was boring since wrestlers only pushed, and how great it is with his contributions. With a more animated style than most, he had the day's most exciting matches. Two of them were so close they had to have a judges' meeting to decide on the winner. One of the men in black was The Wolf, who along with having his own stable is now a judge. He still looks like a million bucks.

POST-BATTLE CRY

The crowd of 12,500 went wild for action each day, cheering at different times and even stomping their feet. The first day's winner was Akebono, who said in the post-tournament victory press conference, "There was also a difference in the way people would cheer very loudly, then be quiet, then get excited again." In Japan, it's a steadier stream of noise; although right before the wrestling begins, the noise turns into a roar. Perhaps the funniest question was when a reporter asked, "Can you say more than just, 'I'll do my best' when talking about your chances of winning tomorrow?" Akebono answered with, "I'll do my best." After a 22-second final match (which is a fair length sumo match), some reporters thought that it was too quick! After walking away from the podium, Akebono muttered under his breath with a smile, "See you here tomorrow."

But the following day, Takanohana swept through the day, putting at rest any notions of illness. He even beat his brother for the first time as Yokozuna and then beat Akebono with ease to secure the two-day title. The event ended with the wrestlers saying good-bye, waving light sticks. It was funny to see them wave. One had to start it. Then some waved with both hands and got the crowd pumped for more. In the press conference, Takanohana did the usual politically safe interview, although he did compliment Canada for its clean air. Perhaps the most telling answer was regarding his health. To get healthy, he said, "I'm eating well."

As the wrestlers left the arena on the final day, people were hustling autographs and pictures in the exit tunnel. Even the folks wearing the yellow security jackets were getting in on the frenzy, trying to get to anyone who wore a colorful robe with the sumo 'fro hairstyle. I spent a few minutes looking for The Wolf, but he was hidden in the judges room. His popularity has died off since his retirement. The kids have no clue that he's one of the reasons why there are stars like Takanohana and Akebono. Near the end of his career, The Wolf lost to the young, up-and-coming Takanohana. He knew that his time had passed and it was time for sumo to move to the next level.

While I waited around for autographs, **The Wolf popped out of a room and left the arena. Some people were staring as he walked out, probably wondering who he was. People who knew dared not approach. Other people just assumed he was a bookie. His face looked mean. I caught up to him like I did when I was 11. This time his hair was trim and he sported a pinstripe suit like a yakuza. He didn't crush my book this time, instead he signed it with ease.** When I told him that I got his autograph years ago in LA and lost it, he grunted an "um." His mind was probably on the next plane out of Vancouver, and in goodwill sumo unison, so was mine. That's where the similarities between a sumo wrestler and me end.

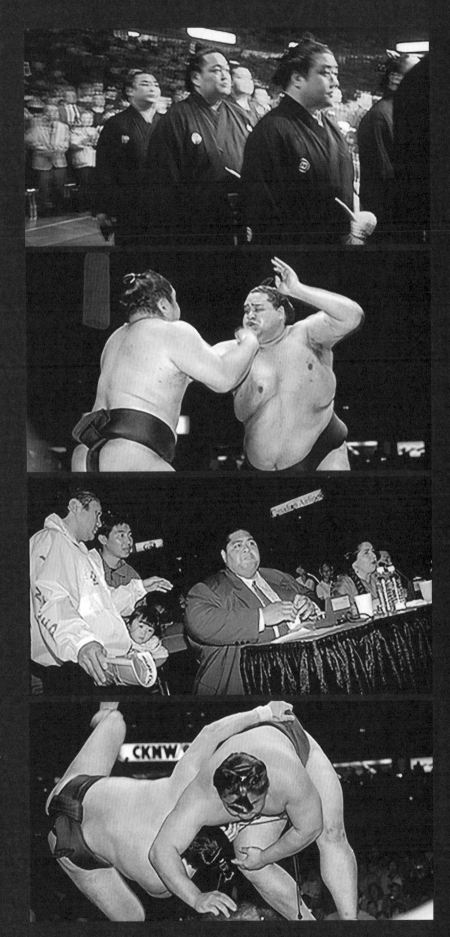

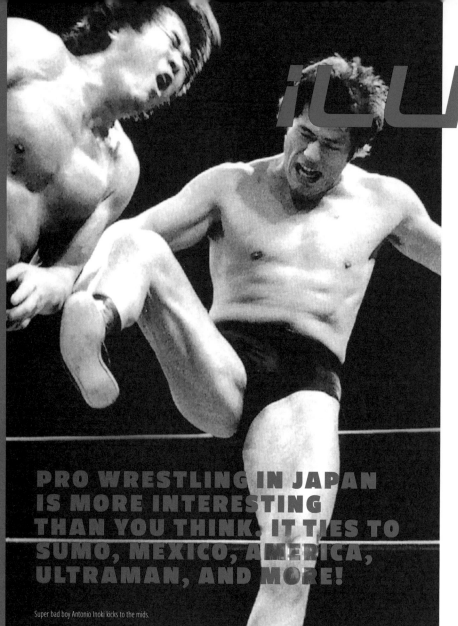

words | Eric Nakamura

iLUCHA

PRO WRESTLING IN JAPAN IS MORE INTERESTING THAN YOU THINK. IT TIES TO SUMO, MEXICO, AMERICA, ULTRAMAN, AND MORE!

Super bad boy Antonio Inoki kicks to the mids.

The origins of wrestling can be traced back to the Greco-Roman era and beyond, but modern professional wrestling began in the late nineteenth century both in Japan and in America. In the West, perhaps the first world champion was William Muldoon who wrestled in the 1870s through his retirement in 1891. In the East, perhaps the founding father was a former sumotori turned professional wrestler named Shokichi Hamada (Sangokuyama), who in 1883 toured America. In June of 1887, Hamada brought back 20 American wrestlers to duel out some submissions to a packed opening day crowd only to find out that the following days would bring pain and empty seats. **Sumo has been the national sport representing wrestling in Japan predating recorded history, so people weren't fast to accept a new type of one-on-one fighting.** After some mediocre productions, wrestling was just about nonexistent in Japan, while in the US, it was slowly building. Failed promotions continued and nothing could bring the public's interest to pro wrestling, not even the early women's matches. Perhaps it was due to the violence during this time—the bouts were supposedly real fights.

In 1950, a sumo wrestler named Rikidozan retires and in 1951, pro wrestling of the modern age was born when he became a pro wrestler. Once again sumo brought the public's attention back into the sport of pro wrestling after over a half century of failure. After a few years of bouts in Japan and America, Rikidozan became a drawing figure. People actually came out to see him battle it out with American wrestlers as well as other Japanese wrestlers. Following his lead were other sumo wrestlers, but Rikidozan remained the most popular during the '50s and early '60s. He even formed the Japanese Pro Wrestling Alliance in order to legitimize Japanese wrestling to the smaller world audience. Americans came to challenge only to lose to Rikidozan on many occasions,

The white-hot spotlight flares through the smoke machine fog to a dark corner section of an overfilled and yelling audience. In moments, from the locker room and onto the red carpet walkway to the ring, is a strutting and usually tanned, half in-shape, half out-of-shape monster of a human. Once in a while, this gladiator will be masked or costumed in some bright and shiny outfit or in spiked leather vests and shorts, but many wear nothing but a spandex Speedo. It's not the Ultimate Fighting Championship (UFC); this event is a bigger show. After a wrestler steps into the ring, it's time for some serious aerial slamming. High flying daredevil leaps, grappling, eye gouging, punching, and kicking. If things get out of hand, then the battle happens outside of the ring and on to the floor next to the fans. Blood begins to pour out like a ripe watermelon. This makes the front seat worth every bit of the hundred bucks. Instead of just the traditional human vs. human battle, chairs, clipboards, tables, and bottles are there for the breaking. No one is safe and no one knows who and how someone's going to win, except for the wrestlers and those in charge.

Even though wrestling is completely a set up show, thousands fill arenas around the world to watch an event that's as tame as the Ice Capades. It's a true phenomenon that actually spans the entire globe. In Japan, the pro wrestling industry is as big as it is in America. There are many similarities in terms of the character wrestlers, the good guy (face), bad guy (heel) concept, and so on. But what makes wrestling in Japan different is its strong ties with sumo wrestling, anime, live-action shows, real fighting, Mexican wrestling, and American wrestling.

ERIC: This article was spawned because of Antonio Inoki's co-promotion of an event in LA. One thing

NIHON!

and soon, he became an international champion. His transition from sumotori to wrestler continued successfully until 1963 when he was stabbed to death by a yakuza member. The wrestling community was shocked and turned off until new blood developed.

In his shadow, Rikidozan left many wrestlers who were once his servants. They were much like the sekitori (pro sumo wrestlers) with their tsukebito (attendants). One of these prospects was Antonio Inoki who was brought into pro wrestling in 1960 after being scouted in Brazil! Inoki with his dominant chin, decent looks, large size, and well-developed body became the Japan's pro wrestling poster boy. In the West, he's known as the Japanese wrestler who fought Muhammad Ali in an exhibition in 1976. Instead of the event being a hoax, as most current day wrestling, Ali suffered kicks to the legs which led to some minor injuries. Inoki, on the other hand, avoided getting hit by outmuscling Ali. The bout was a disappointment for the fans, yet it brought Inoki into the mass international public. He became the wrestler that was associated with the all-popular Ali. Today, they remain friends and do charity work together. Yet another place you might have seen Inoki is in the film *The Bad News Bears Go to Japan*. Remember the wrestling scene? Yes, that was Inoki acting pissed off as ever getting beat up by a bunch of little leaguers and a coach! Today Inoki is the president of New Japan Pro-Wrestling, which is the biggest in Japan today. Although his skills are no longer the same since he's now in his early fifties, Inoki is still regarded as the current Don King of Wrestling.

The second biggest company behind Inoki is All Japan Pro Wrestling with Giant Baba (Baba Shohei) as the president. Standing at about seven feet, Giant Baba, with his elongated and boyish face, is a crowd favorite. His body shape is something of a spectacle. Imagine a tall man with lanky arms and a body like a flat sheet of plywood. In the '50s, Baba Shohei was an unsuccessful pitcher for the Tokyo Giants so he turned to wrestling in 1960. Although he's now as immobile as a camel, his size and funny personality make up for his lack of smooth moves—people love him. He is a regular on current Japanese game shows and still wrestles in tag team matches. Don't look for him to always win, he loses a lot. His promotions are large, but can't compare to Inoki's New Japan which is branching out internationally.

In more recent times, other sumotori have retired from sumo and then continued their career in professional wrestling. Some make it and some don't; it depends on their showmanship skills. They can't hide under some kind of flashy mask, since they are already typecast as a sumo wrestler. They rely on their past experience as sumotori to pave their way, yet many can't translate their pushing and balancing skills to a pure showboat arena. A perfect example of this is Kitao Koji. Even though Kitao isn't a famous household name like Hulk Hogan or Inoki, he has the distinction of once being a sumo yokozuna under the name of Futahaguro (and what is more strange is that he became a yokozuna without winning one title). Few make it to the pinnacle of sumo like Kitao, but instead of living the rest of his career as a sumo legend, he got into a fight with his stable master's wife and was forced to retire. After shaming the sumo world, this bad boy turned to wrestling with limited success. Now, Kitao runs his own karate dojo and his own wrestling league. His popularity is still at a minimum, but look for him someday in the Ultimate Fighting Championship. Presently, Kitao wants to fight bare knuckled and full contact. Many other pro wrestlers attempt to legitimize their wrestling skills as being "street ready," by challenging real competitors to all-out fights. On the other hand, some fake bouts end up turning real when

Justin Liger, the New Japan superstar gets some air.

both sides don't "cooperate"—the match turns into a shoot (a real fight). Kitao has been involved in a shoot.

Another circuit of wrestling is called Pancrase hybrid wrestling. This is the most real of all professional Japanese wrestling. The participants can't strike to the face, but beyond that, the rest is like a free-for-all fight, except wrestling and submission techniques are used to win. Most ardent fans won't back down on their opinion that Pancrase is real. But the champions seem to rotate every tournament! **Some feel that Pancrase is rigged entirely, since the wrestling and submission moves look too pretty, as if they are rehearsed. Yet officials with Pancrase will contend that the superior skills of their fighters make the matches looks rehearsed.** Ken Shamrock, a UFC superstar is one of the on-again, off-again Pancrase

In the Tiger Mask cartoon, Baba was the Great Zebra! A seven feet monster mosher.

champions. On the flip side, many of the American UFC participants are now getting in on the Pancrase action, including UFC 6 winner Oleg Taktarov!

Perhaps the martial arts background of Japan leads to the public enjoyment of real fight events like K-1 (a stand-up fighting tournament for all styles and disciplines), Vale Tudo (a UFC-type of event), and Pancrase. Only in Japan are there as many fighting promotions, real or fake. Dave Meltzger's (*Wrestling Observer Newsletter*) theory may explain everything. He suggests that America's main contact fighting sport, boxing, forces most people to believe that all fighting is like watching Mike Tyson mow down a slug opponent. If you've been exposed to real street fights, then you know that fights inevitably go to the ground. Yet when matches at the UFC go down to the ground, most dismiss it as being boring while in Japan, people seem to understand that fighting includes grappling. The Japanese public won't boo a ground battle. Many skilled martial artists from around the world make lucrative careers in Japan while having no fanfare in their own country. Who knows, one of your neighbors next door may be a big star in Japan fighting everyone in his path for big bucks.

Many wrestlers in Japan wear masks much like the Lucha Libre (Pro Mexican wrestling) system. In Mexico, many wrestlers wear masks to hide their identity to recall the days of the masked Aztec warriors. There are many other theories on exactly why the masks have gotten so popular, but the Aztec theory is what many believe. Yet another theory provided by August Ragone, promoter and co-founder of *Incredibly Strange Wrestling*, mentions that like many comic book characters, the masks hide an identity which brings about a mystery to the wrestlers while also serving as a gimmick. **Wrestling would be a bore if everyone looked the same. Perhaps this theory also applies to the many surf music and garage bands like Los Straitjackets, The Go-Nuts, The Finks, and so on. They wear wrestling masks while they play a set of music!** It's also worthy to note that many surf music bands' record jackets have photographs of Mexican wrestlers.

The subject or iconography of the masks is something to note since many are of manga, anime, and sentai characters. Shows like *Tiger Mask*, *Ultraman*, *Jushin Liger*, *Kyōryū Sentai Zyuranger*, and others have been transformed into characters. Perhaps the most famous cartoon character turned wrestler is Tiger Mask. The original cartoon appeared in the late '60s and was a story about a professional wrestler who was friends with Rikidozan, Antonio Inoki, and Giant Baba! It was a cartoon that depicted real wrestlers during that time and was quite popular. Tiger Mask would wrestle against the villains of the wrestling scene and beat them with joint manipulations and artistic moves only a superhero can perform. But in 1981, cartoon turned into reality when Tiger Mask, played in-the-flesh by pro wrestler Satoru Sayama, appeared at the wrestling scene for the New Japan company. Copying the entire cartoony Tiger Mask look, Sayama performed acrobatic moves with ease, bringing a huge interest into the light heavyweight division. In these lighter weights, athletic ability is a must. Sayama being incredibly athletic and obviously proficient in some sort of martial art fit the mask perfectly. A few years later, Sayama retired, got married, and wrote a book that explained the ups and down of pro wrestling. He soon returned, quit, and then returned again as himself to promote new leagues. He most recently fought a real battle in an exhibition fight during the Vale Tudo and won. But the popular comic character has too much history to just end, so other Tiger Masks have come and gone. Presently, the fourth reincarnation of Tiger Mask is wrestling in the small Michinoku league.

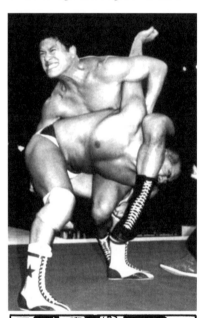
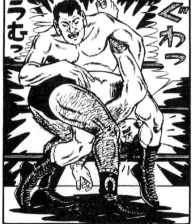

Inoki in real life and in the comic used the same moves for submissions.

With audience turnout in the 400 range, most of these promotions are in small auditoriums and gymnasiums, but the action is wild and athletic. This league is similar to the Lucha Libre system since there are many masked wrestlers, many of whom are from Mexico! Since Tiger Mask is still a reality, a few of his comic book villains are beginning to show up in promotions. They include The Convict—who is actually Mexican, but assuming the role of a Japanese character in Japan—and the Giant Zebra—who was originally Giant Baba in the comic in disguise. The Great Zebra is played by a 6′7″, 280-pound Japanese wrestler named TK.

Meanwhile, on the other side of the globe in Mexico where Japanese hero shows have been televised since the '60s, it's easy to guess that some of these characters are now wrestling in Mexico. Tsuburaya Productions showed episodes of *Ultraman* liberally, so today there's an Ultraman and an Ultraman 2000 fighting it out south of the border. When asked about possible legal problems with an Ultraman running rampant in Mexico beating on opponents for more than the three minutes that Ultraman can survive on Earth, Kate McMains of Ultracom, the Tsuburaya company in America, replies that Ultracom knows about the Ultramen in Mexico, but chooses to let them be. She chuckles that they are afraid of them! And most recently, Jushin Liger, a live-action TV character from at least five years ago, is now sweeping the fans into his corner in Japan. He's a light heavyweight in the New Japan league who dons a devilish looking red mask and outfit—he's destined to be a huge star everywhere. Other transformations in Mexico include the Power Raiders (Power Rangers) and the American Ninja Turtles! Japanese comic characters are well-used in the world of wrestling in both Japan and Mexico, while the Mexican home-spun characters do well in Japan.

Japanese wrestling and Mexican wrestling have a strong bond since they are the top two places for professional wrestling according to Dave Meltzger of the *Wrestling Observer Newsletter*. When asked how he would rate the world's wrestling, he immediately says that Japanese wrestling is the best, Mexican second, and American third. The Japanese wrestling in comparison to the American uses superior wrestling maneuvers and real martial arts skills compared to the weak, slapping style of the World Wrestling Federation (WWF). It seems that size and flamboyancy are most important while talent isn't, which explains why Japanese wrestling is more highly respected. Many Americans and Mexicans move to Japan and become quite successful. In some of the smaller local promotions in Los Angeles, the opposite exists! There are some wrestlers who pose as Asians although they are actually Mexican. One is The Unholy who claims that his character is from Hong Kong! Another claims he's Asian and does a gi-wearing

kung fu act. He not only plays an Asian role, he actually can pass as one! But the other extremes also exists in Japan. For example, one wrestler, El Samurai, wears a mask and obviously uses a Mexican type of name, yet he is Japanese. Almost every possible variation of characters and race mix-ups between Japanese and Mexican wrestling exists today.

Many American wrestlers now find their residences in Japan. Remember Abdullah the Butcher or Stan Hansen? You don't see them on WWF anymore because they're now stars in Japan. Many sign contracts and split the American scene. But now the opposite is happening. Within the last year, Japanese promotions are now reaching America via word of mouth and TV exposure. Now transplants of Japanese wrestlers into America are taking place. The World Championship Wrestling (WCW) has recently signed on a deal with New Japan, and now Japanese are fighting Americans in wrestling on your TV set. So if you dare tune in, you'll see more Asian faces in the wrestling world in America. Currently there are two prominent Japanese wrestlers in the American system. They are Kurosawa of the WCW and Hakushi of the WWF. Both are relatively new to the wrestling scene and have limited experience although they show a lot of talent. Fans are taking note of both since they are beginning to make top ten hated lists in the magazines. They have thus far successfully crossed over and played powerful villains who speak broken English. So don't expect them to talk your ears off in one of those post-wrestling interviews, these guys let their action speak the wrestling language.

With promotions beginning to tie in to each other, more Japanese wrestlers will inevitably come to America to gain stardom. Yet many will stay where they are going to be most appreciated—at home. The levels of wrestling in Japan and America aren't lopsided as in baseball. Japanese wrestling is actually better according to many, so there is no need for a wrestler to prove anything overseas. Where else can a comic book or TV superhero materialize to fight in a ring besides in Mexico? Wrestling in Japan has many gradations, from the wacky masked wrestlers to the "real" Pancrase matches. And by peeking into the many high quality Japanese wrestling magazines, crazier promotions which involve wrestlers and pyrotechnics, barbed-wire rings, and a bed of tacks in the middle of the ring are completely over the top. In America, the fights and promotions are oftentimes just too fake with a limited amount of high-flying action. In Japan, the promotions are not as stupid while the wrestlers perform at a more believable level—the wrestlers are handled like boxers. Perhaps aside from the antics and acting jobs, the actual history and the cultural tie-ins of Japanese wrestling make it something one can appreciate without any love for pro wrestling.

KOSTON FOUND

words | Martin Wong *pictures* | Lance Mountain

Thrasher dubbed him "Skater of the Year" for 1996. His moves will blow you away in the famous *Mouse* video by Girl Skateboards. He's in Fourstar Clothing advertisements. You might even be wearing a pair of his signature skateboard shoes for éS. At 22, the Girl wonder is an institution in skateboarding.

It took two weeks of leaving pages and trading phone messages before skate video ace Wing Ko and I actually roll up to his place. He's always out skating. Walking up to the porch we can see a bunch of pro skaters (Mike Carroll, Scott Johnston, and Aaron Meza) watching the Lakers clobber the Nuggets on a big screen.

The Lakers win, the guests split, and the tape recorder starts rolling in front of the elusive Eric Koston. Pause. Mike York, another pro skater, shows up at the door, hungry. Eric travels too much to stock up his kitchen, so we walk two blocks to talk over Indian food on Melrose Avenue. He warns me, "Watch out for the spice."

As we dig into the front booth, the soft-spoken skater tells his story. Born in Bangkok to an American Air Force man and a Thai mom, his family moved to California when he was nine months old. He settled in San Bernardino when his parents divorced. He was four or five.

Koston began skateboarding at 11 when his older brother handed him an old Mark Gonzales board with mismatched trucks. He picked up on skateboarding just like that and began sessioning on the driveway. His first trick: "Put the wheels in the crack of the sidewalk and ollie straight up." His second trick: "Ollie to the side." Did skating come easy? "I don't know. Maybe it took a couple days."

He doesn't think too much about the tricks that he masters, refines, and combines with other tricks these days, either. Stabbing a vegetable samosa, he says, **"It could easily be years since I've learned a trick. You always want to learn new tricks, but it's almost like everything's been done."**

Koston's either a mediocre skater who fools people with stunt doubles and Photoshop or he's just modest. I call him out on the latter and he admits, "There's more to be done. You look at things way differently than the average person would. All skaters do. If it's possible to skate it, you look at it differently."

Conversation stops as the entrees are served. We pass around the rice and raita and everyone digs the hip-hop tabla music.

Koston continues his story. He was a purely recreational skater until Eddie Elguera (Skater of the Year, 1980) hooked him up with free boards from H-Street. "I met him from living so close and skating around," explains Koston. "Then right after the tenth grade, I went to this summer skate camp

in Wisconsin where Eddie was director." Getting a staff position at the skate camp was a turning point for Koston, who then realized he could make a living by skateboarding.

Dropping out of school, he relocated to a five-bedroom house in San Diego where H-Street skaters lived. He left H-Street to skate for 101 before moving on to become a charter member of Girl Skateboards in Los Angeles. "Rick Howard brought it up one day," he remembers. "A bunch of skaters wanted to quit their teams and start their own company. Rick and Mike Carroll already came up with the name, Girl, and I was into it."

Eric feels better off as part of a company comprised of skaters and friends. With H-Street or 101, he says, "You rode for them, and that was that." With Girl, he is more knowledgeable about what's going on and more involved with the business—including the Fourstar Clothing division. Pointing to the Fourstar shirt he's wearing, Koston says, "It's for skaters, but it's also a little bit better. Make the colors you like to match the shoes you've got."

He also has a signature shoe model. "It's fun and they're doing good. I see them on a lot of people's feet. éS just asked me. I get input on everything: color, fabrics..."

At any given time, there are three variations of the Koston shoe on the racks. Back at his house, Eric busts out a big box of shoes that were sent as color and fabric samples. One of the rejects is white leather with turquoise trim. One of the new prototypes is reflective like space tape! He explains that he sells way more shoes than decks because "people need shoes more than they need decks."

But what would Koston do without skateboarding? "I have no idea. I started so young—from toys to skateboarding." As for his part in the skateboarding business, **"There's no major plan, no major takeover. Just do it and keep doing it. That's it."**

Eric Koston might seem like someone who has a knack for being at the right place with the right people at the right time. But the pieces of his life fall into place gracefully for the same reasons that he can pull off landings of impossible skateboard maneuvers. The result is fully natural, seemingly unconscious, and made possible by putting out large amounts of sweat and trust. 🐱

Koston does the Fandangle as seen
on T-shirts, catalogs, and ads.

words | Greg Wong
pictures | LeRoy Grannis + Greg Wong

LONGBOARD LEGEND

WATER WORLD

As a kid in Oahu, Donald Takayama began surfing on any piece of scrap wood he could find. Soon, he graduated to boards that he crafted himself from redwood railroad ties. When Donald's school attendance began to drop, his mother hid his trunks in a vain effort to cure her son's case of Spicoli-itis. Unwittingly, she helped launch his career when a photographer captured him hanging eleven.

Takayama moved to the mainland in the early '50s to compete in contests, make boards, and cash in on the nascent surfing industry. At first, competitions were rigged toward haoles, and he could not place higher than second or third. Eventually, he was recognized as the world's best surfer, winning the US Surfing Championship five times. He began honing his shaping skills in Hermosa Beach, and opened a shop in 1969.

On a Tuesday morning, I make my pilgrimage to Takayama's store in Oceanside, California. At the Hawaiian Pro Designs retail shop, I can survey both the evolution of the ancient sport and a career that spans half a century. Vintage posters and memorabilia of the longboard rider and shaper line the wall. There are black-and-white photos of Takayama with shoulder-length hair, dropping into an overhead wave in Waikiki, and smiling on a center podium. Rows of his boards reach toward the ceiling like colorful tikis.

Inside a courtyard there is an office trailer with a "Surfboards by Donald Takayama" decal on the door and plastic patio furniture. A lucky black cat rushes though the open fence and into the cathouse. "There's a lot of pussy around here," Takayama says. Despite the passing of time and the growth of the sport into a multimillion dollar industry, he has the same joie de vivre as the kid who used to surf naked.

Ernie, a visitor from Molokai, gives me a five-minute, one-hallway tour of the factory while Donald makes some calls behind a reasonably clean desk. Surfboards line the corridor, six feet boards closer to the entrance and twelve feet boards

at its end. Grinding noises originate from the opposite doorway on the left, where a man wearing a respirator mask shapes a blank with a drill and sanding attachment in a cloud of white dust. Through the next door on the right is the artist's room. Messy paint cans line the shelves and the walls are airbrushed like rainbow sherbet. In another room, 30 years of excess spray from fin-attaching resin has formed multicolored stalactites in bunches along the walls like gigantic inverted Magic Rocks.

In the finishing room lies a balsa board with a personal inscription from Donald to young longboarder phenom Noah Shimabukuro. Lifting it half an inch, I realize the Duke became an Olympic-caliber athlete by lugging such a telephone pole in and out of the water. Speeding down the curl of a wave on a balsa board must be like riding a torpedo.

Most of the boards on the floor were crafted with technology developed in the '50s, when the first polyurethane foam blanks were shaved and coated with fiberglass. **It was at the dawn of the modern longboard that Takayama began his craft under the personal tutelage of shaper gods such as Dale Velzy, Bing Copeland, and Hap Jacobs.** Now, with 50 years of experience, every board is a coveted masterwork.

Donald Takayama's experiments have not been limited to boards; he has also tinkered with fins, wax formulas, and barbecue sauce. After sending a few jars of marinade home with friends after luaus, requests for refills started piling up and he established Surfer's Choice brand Teriyaki Sauce and Pineapple Marinade. Donald recalled meeting Dodgers Manager and Hall-of-Famer Tommy Lasorda, who became a Surfer's Choice fan at a Fancy Food Show in San Francisco years ago. Unfortunately, high demand for surfboards has pushed the sauces to the back burner.

As Lasorda is to baseball, Takayama is to the ancient sport of kings. He has toured France, Japan, and Australia to promote the style, which fell out of favor in the '70s but

is now just as popular as shortboarding. In the '90s, Takayama mentored the young Joel Tudor, who has also played a part in resurrecting the cult of longboarding.

Donald currently sponsors numerous riders in San Diego, Florida, South Africa, Japan, and Hawaii, including Shimabukuro from Maui who is staying with Donald (and borrowing his van) between contests in Oceanside and Huntington Beach. Considering the sport's worldwide popularity, Donald hopes Noah will someday surf in the Olympics—but first someone will have to perfect a wave machine to make it a fair competition.

To get through his orders, Donald began work at 2:30 in the morning. It's now 10:00, and he has to supplement the delicious chocolate chip cookies sent by Noah's mom. So he invites Ernie, Noah, and me to have breakfast with him at the restaurant with the best cinnamon rolls in town.

We slowly drive along Coast Highway and check out the surf. When we stop to admire a shoulder-high left on the south side of the Oceanside Pier, it becomes apparent that everyone in the car is goofy-foot. The Harbor House Café is just a block or two north from the pier. After a false alarm, the waitress confirms there are plenty of rolls left so Donald orders two as an appetizer. Just then, legendary Oceanside surfer L.J. Richards and a friend from Park City walk through the door, just back from San Onofre.

As we push two tables together, L.J. gives the Trestles surf report. Ernie and Noah reminisce about plate lunch and Donald recommends the new Hawaiian restaurant nearby. L.J. and Ernie tease Noah about not having a girlfriend, while Donald offers to set him up with a blonde surfer from the women's circuit. Ernie invites everyone to his new place in Molokai and tells us about the island's annual fires. Everyone also provides family updates. Donald's daughters Alana and Leilani, both former US Ski Team members and models, moved to Colorado and Minnesota, respectively.

Donald compares his new home in Tallows, Australia, to Hawaii 35 or 40 years ago. A forest path connects it to the beach, which is warm, clean, and stocked with clams and yellowfin tuna. When the topic of sharks arises, Donald cites a study indicating that more shark attacks occur on the East Coast than in Oz.

From Australia, Donald and his wife Diane will be able to travel to new parts of the world.

Maybe they will visit the city where his Japanese grandparents came from, near Mt. Fuji. He also notes that China has untapped potential for the surfing industry, not just cellular phones, jeans, and computers. He hopes his friends will visit him. It's hard to imagine that Donald will really leave California. He's a regular sponsor of the annual UCSD Cancer Center Luau and Longboard Invitational and Surfrider Foundation fundraisers. He's also a member of the California Surf Museum's Advisory Board. Yet he's ready to get away from the crowded beaches and streets of California. Donald will not miss America's pastime or San Diego's taco shops. He doesn't like any sports other than surfing and full-contact fighting. He will make his own burritos. **When his New Zealander friend kids him about the "ugly American image," Donald says, "I was born in Hawaii before it joined the Union, you Kiwi!"**

To satisfy his customers, the Surftech Company will manufacture epoxy copies of Takayama's boards at plants around the world. Purists argue that these machine-made products are bogus, but no one can deny their durability. More importantly, more people can experience the ride of a Takayama board now and in the future. "No one lives forever," Donald points out.

In weeks or months, Donald and Diane will get away from the ever-increasing demands of the industry and relax. Finishing a smoke, he says that his doctor told him he has the lungs of a 30-year-old, about half his age. There is no better exercise than surfing.

Now Donald is looking for someone who will go to Pala with him—he's a gold card member. The Native American casino is not only his second source of income, it's also the perfect escape from phones to answer, paperwork to sort, and the paradoxical invitation/question combo that has haunted him for ages: "Let's go surfing—is my board ready?"

TOP TO BOTTOM: Donald Takayama in Oceanside on July 8, 2003. • Ernie enjoys the paint room's atmosphere. • Free massage day in the shaping room.

TOYS

Toys. Nearly all of us enjoyed playing with toys as children. Action figures, Barbie, Hot Wheels, LEGO, woodblocks, and more helped define "fun," sparked imaginations, introduced us to our first shiny objects, and initiated us into a culture of play and the market around it. Whether playing with a doll or using building blocks to create something new, toys encourage children to think creatively, to explore their world and the possibilities ahead. As detailed in several of the collected articles in this chapter, toys offer a lifelong experience for many collectors that extends well past early childhood.

Adults' passion for toys is not limited to those of their youth. As founder and editor of *Vinyl Pulse*, I've spent the last 18 years writing about toys created by independent designers and artists, rather than the larger toy industry. Initially known as designer toys and then later art toys, these figures are primarily created for adults rather than children. In a way, designer toys complete the circle of creativity that starts with children exploring their imaginations. Instead of just playing with toys created by others, artists are now able to turn their characters into toys for others to enjoy, display, and be inspired by. With this movement, toys are not just catalysts for creativity but an exciting, dynamic outlet for that creativity.

What sets these toys apart from their more "mainstream" counterparts is how and by whom they are created. Starting in the late '90s and early 2000s, pioneering artists in Asia such as Michael Lau (Hong Kong), Eric So (Hong Kong), and Hikaru Iwanaga of Bounty Hunter (Japan) began to create toys on their own terms without the need to rely on and being beholden to conventional toy companies. The medium of choice for these pioneers was rotocast vinyl, chosen for its relative low cost and ability to support making, say, a thousand or less of a figure versus the much larger production runs of mainstream toys.

As detailed by Martin Wong's interview with Lau (p. 390), the "Godfather of Vinyl" based his coveted designs on the urban culture he was immersed in. Friends in the hip-hop and skate scenes became the subject of Lau's quirky, personable toy designs. With stylized features, unusual proportions, and an emphasis on city life, these first designer toys had a sense of "life" far removed from designed-by-committee toys. Collectors were drawn to these toys that immediately stood out as something starkly different, exciting, and perhaps subversive.

Almost overnight, Hong Kong became the center of this upstart toy movement. Alongside the vibrant "urban vinyl" scene in Hong Kong, Japanese artists and indie companies including Gargamel (p. 380) unleashed a tsunami of sofubi toys ("soft vinyl" in Japanese) inspired by the kaiju (monster) toys that had risen to popularity decades before. That this movement began as an Asian-led movement is not necessarily seen as extraordinary within the scene but taken as a matter of undisputed history.

While Asians struggle for representation in many industries, Asian artists are central to the origins and continuation of art toys. This refreshing reality has resulted in a back-and-forth flow of inspiration between what collectors refer to as Western and Eastern vinyl. While times have changed, Asia's role in this toy movement and form is now still as central as it once was. In the two decades since the emergence of designer toys, the focus shifted from Asia where it all began to the West and back again. In the past few years, China has seen a tremendous growth in designer toys, where a new generation of artists has captivated collectors with super cute designs for the resurgent "blind box" concept—where the identity of the figure inside the box is a surprise, revealed only after opening.

As the designer toy movement spread from Asia to the West it began to morph and take on a new character. Starting around the mid-2000s, Western artists, many in California, began to make toys based on their artwork. To name a few, Gary Baseman, Tim Biskup, Tristan Eaton, Camille Rose Garcia, David Horvath, Sun-Min Kim, Frank Kozik, Junko Mizuno, Jermaine Rogers, and Amanda Visell, among

JACK MURAMATSU

many others, began to popularize designer toys in the United States and beyond. Painters such as Biskup, Baseman, and Garcia introduced the characters in their original paintings to new audiences by transforming them into toys. Collectors and fans were now able to add relatively affordable sculptures drawn from paintings—that they perhaps had admired from afar—to their shelves. Others took a more emergent path. The story of the rise of the Uglydolls designer plush sensation starts with Sun-Min Kim hand-making plush toys based on David Horvath's characters that he included in his love letters to her. What began as private gifts to bridge their physical distance became a popular product with their informal, grassroots introduction at Giant Robot in Los Angeles.

While designer toys have always unquestionably been "art," a notable shift occurred early on as artists incorporated toys into their existing practice. Toys became an extension of artists' portfolios, a new medium to explore rather than the primary creative focus. Along the way, MD Young of MINDstyle and others started to popularize the term "art toys" as a recognition of toys as a new medium for art explored by painters, street artists, and more. An apt description, the term "art toy" meshes with the perspective that art toys are sculptures, often made of plastic, but sculptural works nonetheless. Sculptures transcend

the boundaries of the two-dimensional surface by allowing characters to enter our three-dimensional world. This distinction, while perhaps sounding trite, is rather profound. While my focus on art toys colors my perception of this, a character—whether a cute rabbit or cool skateboarder—gains a tangible presence in the transition from painting or drawing to sculpture. They are no longer just part of a scene on a wall, but rather, in sitting on a desk or shelf, they emerge from their worlds as one could only imagine previously. This physical presence encourages, perhaps, a deeper level of reflection and consideration of the character in its own right.

Change is constant, and as time has passed since the beginnings of designer toys, trends have come, gone, and evolved. For most of my time collecting and writing about these toys, they have been an unquestionably affordable entry into art sculpture. While this remains partially the case, recent years have seen an elevation in the status of art toys and along with it, an altered pricing rationale. The once common pricing logic driven by a toy's physical size and, to a lesser extent, its edition size, has increasingly been replaced by perceptions of demand for the artist's work as a whole. In-demand artists ask for and command higher prices for their art toys. These art toys are being priced not as toys per se, but rather editioned art, much as the market for prints.

As a parting observation rather than a definitive conclusion, the increasing separation between the perceived value and the cost of manufacturing of these toys seems to have occurred alongside an increased focus on sculpture within the larger art scene of which they are part. Consider the work of internationally recognized artist KAWS (p. 342). Initially known for his street art, including striking bus stop posters, KAWS became a sought-after gallery artist focusing on character-driven paintings, often of his Companion, his stylized appropriation of the world's most famous mouse. While a prolific creator of art toys in his own right, KAWS has recently transitioned his focus from paintings to towering sculptures of the Companion, be it in galleries, museums, or public spaces. While his toys once flowed out of his paintings, now his fine art sculptures serve as the inspiration for the toys.

Art toys are a vibrant, exciting, and changing art form. Born in Asia and spread worldwide, these toys offer individual artists and designers a creative outlet, removed from the rules of the larger, conventional toy industry. While the future is unpredictable, it seems likely that the lines between art sculpture editions and art toys will continue to blur. 🐱

Jack Muramatsu is the founder of *Vinyl Pulse*, which has covered the art toy scene for nearly two decades.

words | Lynn Padilla

Beyond the Valley of the Dolls

Every day, tourists buy star maps and drive around Beverly Hills looking for celebrities who might be taking out the trash or watering the lawn. Little do they know that they may be driving by the home of Corazon Ugalde Yellen. Who's that? She may be the world's biggest Barbie fan. However, her collection has much more than Barbies. In her doll room, her collection of 4,500 includes 1,000 Barbies, rarities, antiques, and limited editions from decades ago. She even has a *Bewitched* doll and a Sean Connery James Bond doll! If you step outside her doll room, you'll see her other collections of antiques and art. Model, actress, and author of *Total Beauty and Life*, there's much more to Corazon than meets the eye.

You've lived in the Philippines, Norway, and now Beverly Hills. Did you have any Barbies back in the Philippines and Norway?
CORAZON UGALDE YELLEN: No. Actually it wasn't available in the Philippines in the '60s. Maybe in the late '60s, early '70s. l don't think they had distribution then. Before, I played with dolls, baby dolls, or children's dolls—things like that.

Barbie has gone from American icon to international. How has she evolved?
It started in 1959 when she was based on a German doll called Lilli. Of course, she was made in Japan. Some people thought the very first Barbies' make-up had an Oriental look. Then in 1967, because of the mod era, the Beatles, and Twiggy, it had more of like a flower-power look—not sophisticated. 1959 dolls were more classic and sophisticated. They changed the facial painting of Barbies to a sweeter, younger, teenager look with bigger eyes and lashes. And now she was smiling with teeth. In the '70s, '80s, and '90s, they changed it again—they had the Black Barbies and an Oriental Barbie friend, Kira, and others. Now they have international Barbies, which are from anywhere: European, South American, and even Filipina Barbie.

Is Filipina Barbie sold here?
Actually, it's sold in the Philippines, but it's sold here in the secondary market. People can buy it at Barbie shows and doll shows, but it's not sold in stores here.

What is the Filipina Barbie wearing?
They issued the first ones and she's wearing five different outfits, which were like María Clara in long formal gowns. Think Imelda Marcos. They made the second set more ethnic, like in Mindanao with the Muslims and in the northern part, Igorot (Aborigines) type. More tribal. There's like ten different outfits. Different issues. l have some international Barbies.

Does Filipina Barbie look Filipina?
Yeah, she has darker skin, she has brown eyes and black hair. She looks Filipina and she's smiling. It's the Barbie face mold, but she looks more Filipina.

I saw Chinese and Japanese Barbie—they look just like Barbie with different clothes on.
Right—the painting is slightly different.

Is she (Barbie) as popular in Asia and Europe as she is in America?
I would think she's more popular here in America, definitely. But I understand that in Europe she's becoming really popular. I don't think she is as popular in the Philippines. People buy other dolls, too.

Plus, they have their own dolls there.
Right, so it would be definitely America, then parts of Europe like England and France. I believe they are very popular there.

In your opinion, is Barbie's physique based on the statuesque physiques of models, or are models' physiques based on Barbie's proportions?
According to Ruth Handler, founder of Barbie and Mattel, when they started Barbie, they bought this doll called Lilli from Germany. She was a cartoon character. She's exaggerated like Jessica Rabbit. Maybe because she got popular, the models kind of see that as kind of a model figure.

There are women on talk shows that have really molded themselves to look like Barbie.
I heard of one woman who did that to look like Barbie. She had a nose job and whatever.

And breast job.
And everything. I think that's extreme. I think there's always an extreme population that does extreme things. I think that's very extreme. It's just a toy for me.

A lot of people criticize Barbie and what they believe she stands for. She is just a doll, but do you see as her as a positive influence on culture and society? Is she a role model?
You mean if she is positive?

Yeah, for young girls...
I think the positive thing about Barbie is that she has come out with many different careers. She has been a teacher, astronaut, dancer, ice skater, pilot, and stewardess. If you have a child and you buy something like that, it's positive because Barbie is a woman and she can also do all these things. It's not just the men that are career-oriented. It doesn't mean she can achieve everything, but I think it's positive because they can look at her, imagine themselves as school teachers. As I said, there is always someone who is negative, but if you look at it in a positive way, the positive thing is that she has a lot of careers. She has some kind of identity.

Beyond just being with a man.
Right. And when it comes to materialism, it's not just Barbie. If you look at fashion magazines, Gap and Guess, the fashion, the clothing—we're in a world of materialism. It's not fair to say the doll is doing this. A lot of other things influence teenagers and women: TV ads, TV shows, and movies. We're in a world of materialism. So I think that just reflects Barbie. I don't think it's something negative, it's just the way it is—the lifestyle.

Yeah, I notice the ads for accessories and her cars are always whatever car is hot now.
Right, she had a Thunderbird, let's say, or a Porsche. It just shows her lifestyle. It's really what you see in movies and TV, too. Barbie is the way of life for a lot of Americans.

In an article from Barbie Bazaar, you said you purchased an antique doll when you were pregnant with your daughter. Was there somehow a connection between purchasing a precious doll and the fact that you were soon to have your own living doll?
As a child, I always loved dolls. I played with them. You know some girls played with teddy bears or other things? I always played with dolls. So I just thought, I'm gonna have a child. Of course, it could have been a boy. **It was something that reminded me of childhood. This doll was something for me that was reminiscent of childhood. And since I'm having children, it would be nice to have a collection of dolls.** A doll is a children's toy, so it's like a nostalgic thing for me.

I read that you made outfits for Barbie. It's funny because when I was young, my mom would sew, and she would make outfits for my Barbies out of the leftovers of my clothes.
Yeah, I did the same thing. If I have some outfits that I like, that I did for a fashion show or a TV show, and I have excess material or similar material, then I make that into an outfit. I like to sew anyway. I made some dolls, too. I made porcelain doll heads, about 60 of them, and I made the clothes. So I like to do some with Barbies. It's like my hobby.

You design many outfits for Barbie, some based on other designers' works that you have modeled. What other influences do you have for the outfits?
Sometimes I did some from magazines that I like, that I think are fun to make. The same with other dolls I make. If I see some fashion I like, it's fun creating them. It's fun to see them in three dimensions.

I read in your bio that some of your Barbies have been shown at the Smithsonian in Washington, DC. Are there any current museum displays or future shows planned for any of your collection?
Not currently. This was last October '95. They were international Barbies,

suits, walking runways, and appearing on the cover of magazines. Her longevity is impressive.

because it was called "Urban Folk Fashions." So I had the Filipina Barbie, Japanese Barbie, Peruvian...It was more of an international motif. They had urban folk fashions like scarves and kimonos, then they had the dolls wearing the international motif.

As a collector, where would you recommend other collectors go if they wanted to collect dolls?

I go to doll shows and auctions. Sometimes we have doll auctions here in California. Sometimes Sotheby's in New York has doll auctions. **If you read newspapers or collectible magazines, they will usually list the local doll shows and conventions. I go to doll conventions. Sometimes flea markets. If you're lucky, sometimes garage sales, I don't really go to garage sales.** The most would be at doll shows and conventions.

When did you found the Beverly Hills Barbie Club, and what inspired you to do so?

December '94. I started it because I had a group of friends, maybe about seven of us, and we'd meet from time to time and go to Barbie shows. We figured we'd form our own club. We hold it here in the house. After that, we go to different shows and people hear about it. We were featured in *Barbie Bazaar* magazine, and from then on, a lot of people from all over the country call me and fax me, saying they want to be involved and be a member. Now we have about 80 members. And I have members from Europe, Australia, and Japan. We correspond. Different people are pen-pals. It's a very good way to network and connect with Barbie collectors.

How large is the National Barbie Convention, and what are the attendees like? Are they mostly women?

Mostly women. There are some men, husbands or boyfriends. Not too many men collect Barbies. They are predominantly women.

Are any of them models like you were?

I think very few. I think mostly they are all different careers. I know some collectors who are stewardesses, teachers, graphic computer artists, and other different types. Same with my club. Some are decorators, some are housewives. All different ages. I know some collectors who are teenagers, from 14-year-old girls to senior citizens. Mostly thirties to fifties, maybe. Most are married or have a career. Not many singles.

Is it usually at a convention hall?

There's only one National Convention. They do it yearly. It's the biggest. It's four days and they have fashion shows, exhibits, sales rooms, and presentations from Mattel. It's very interesting.

So you've modeled at these?

Right, at the conventions. I was in Germany last year and I modeled there, too, at the convention.

At the International Barbie Convention (Germany), you were a guest speaker. What did you discuss?

I discussed my collection and the Beverly Hills Barbie Club and our purpose.

What designers have you modeled for?

I started in the Philippines when I was thirteen. I did some ads for Pepsi-Cola and modeled for couturier there. In New York, I did a lot of showroom modeling. In Beverly Hills, I modeled

for the Excelsior. Before that, I modeled for a restaurant that had designer clothes like Yves Saint Laurent and Gianni Versace. I used to model for them.

You also modeled in Norway. How long did you live there?

Yes, I lived there for four years. I modeled for commercials, department stores, and fashion shows.

How does your family feel about your passion for Barbie and doll collecting?

Yeah, they support my hobby. But mainly I collect. Because they know I'm interested, if there's anything Barbie-related, they let me know about it.

Any last words for the readers, fans and critics of Barbie?

I believe collecting is a way of expressing yourself. I have some antiques and art, too. It's a hobby and there are some rewarding things. In the process of collecting, you make a lot of friends because you have something in common. I think it's nice sometimes to relax and enjoy yourself. I think collecting is a way of relaxing and mingling with your friends.

I think Barbie would agree. 🐱

LYNN: I have fond memories of Corazon Ugalde Yellen. She was so welcoming and it was a fun interview. We even had a social lunch near my job in West Hollywood after the interview. I wasn't sure what to expect, as she had quite the Barbie room and it was like nothing I had ever seen before, since I didn't grow up with collectors at that level. With a twenty-first century gaze, it's interesting to see how back then she thought few men collected Barbies, but now we see there are plenty of men who collect them: even in The Simpsons, *Waylon Smithers is a huge Malibu Stacy (stand-in for Barbie on the show) collector; and on Barbie Dreamhouse Challenge, some of the superfans were men.*

POCKFIGHTING

words | Gabe Soria *illustration* | David Choe

The early '90s: the *Pokémon* cartoon premieres in Japan and becomes a national sensation, as it teaches valuable lessons about loyalty, bravery, teamwork, collecting cute crypto-zoological animals, and epilepsy. The nation is stunned and amazed, and soon, Pokémon becomes a worldwide sensation with total sales on Poké-merchandise projected in the billions of dollars. Billions. According to official sales figures, Pokémon games accounted for five of the top ten selling games of 1999. Pokémon is so popular that schools across the United States have banned Pokémon cards and video games for the disruptive effect they have on the learning environment.

But I love the little beasties. Why? Cockfighting. Pikachu is nothing but a prize rooster in electric-yellow drag. The underground sport can most likely expect an influx of new adherents in a few years: kids tired of the Pokémon fad who need bigger and gorier thrills, but who still want to experience the paternal thrill of raising a cute champion to fight their battles. The biggest video game and marketing phenomenon in the world seems to be nothing but a thinly veiled advertisement and recruiting campaign for the ancient blood sport. Coincidence? If so, it's a perfect one.

Fantasy cockfighting. A brilliant idea. **All the fun of pitting two psychotic roosters against each other in a mortal battle with no muss, no fuss. You can do it anywhere, and Snorlax is much cuter than a bird that shits everywhere. And he doesn't need corn to live; he only wants four fresh batteries, the latest Gameboy cart, and a fresh booster pack of trading cards.**

Reports have it that even the ancient Romans took a break from throwing Christians to the lions to enjoy a good cock-on-cock bout. It's still practiced and loved across the world. Is it any wonder that some genius got the (subliminal) brainwave to repackage one of the world's oldest, most fascinating, and reviled sports into an undeniably cute merchandising juggernaut, to make it palatable to the kiddie market? No longer do you have to travel to the rear yard of a mechanic's shop in East Los Angeles or an out-of-the-way bar in Southern Louisiana to get your kicks. Cockfighting has finally been semi-sanitized for your protection. Kids struggle to become the King Pokémon Stud of the Schoolyard. They experience all the pathos of a good cockfighting career, but with a lot less bleeding.

Well, not always. In October 1999, in Montreal, a 14-year-old boy was stabbed by a 12-year-old who was trying to get away with a stash of stolen cards. While knife fights amongst humans at cockfighting matches are a common sideshow, these passionate fits are usually born from a combination of frustration, an excess of alcohol, and a severe loss of cash. But when you replace "an excess of alcohol" in the above phrase with "an excess of sugary sodas and candy bars," you can kind of see the line between the two worlds blur in a hilarious way. Hilarious to me, at least.

What's next for Pokémon? A trip into the ultra-violent world of its cockfighting origins? It might be just what Nintendo needs to breathe new life into the franchise. Imagine it: Spearow pecking at Pikachu's spilled guts, triumphant as the ever-so-cute mouse sighs its rattling last breath, or Charmander prancing around a dazed and bloody Jigglypuff, dashing in to slash him with the mini-spurs tied to his legs. With the release of the *Pokémon Stadium* game for Nintendo 64 (in which you can fight Pokémon in an honest-to-goodness arena), it seems like there's hope for us sadists.

Now if only a savvy game company would have the stones to actually develop a true cockfighting video game. I can see it now: a full page magazine ad that reads, "Coming Soon to Your Gameboy Advance: Los Pollos Locos! Hatch and raise a fightin' gamecock! Travel around Mexico, fighting your guy on the amateur circuit! Take him all the way to the Championship! Trade your Crazy Chicken with friends!"

I can dream, can't I? 🐱

ERIC: I never thought Pokémon would last, and yet they continue to appeal. GR2 Gallery is a Pokémon Gym in the mobile game *Pokémon GO*. At the height of its popularity, there would be multiple groups in front many times

Walking into the astroturf-covered backyard of a non-descript house and stepping into a field of robots standing at attention is like walking into an army of Terracotta Warriors. Most casual toy collectors think there are six Jumbo Machinders, but Tom Franck's collection, one of the world's largest, weighs in at about 70 pieces.

Jumbo Machinder is the copyrighted brand name of a series of robots made in the early '70s by Bandai's offshoot company, Popy. Made out of polyethylene, the same plastic used to make shampoo bottles, these colorful specimen stand two feet tall and fire missiles. **Franck will tell you that Popy was "stupid" to make these toys since they were too big and expensive. But because of their huge size, they were the first toys to get tossed out of the tightly cramped apartments of Japan, and now they are some of the most collectable toys in the world.**

Mattel opened up the American market with the same exact toys repackaged in new American boxes in 1977. The first three were Raideen, Dragun, and Great Mazinger. They followed up with Godzilla, Gaiking, and Daimos. This set of six were part of the Shogun Warriors line, and a lot of American toy collectors think that Jumbo Machinders end there. But Franck is sure that Popy made 50. However, no one knows the exact quantity of large robots made by other companies. Licensed and unlicensed Jumbo Machinder toys were also made in Italy and Hong Kong. Although some purists don't consider non-Popy toys to be real Jumbo Machinders, Franck is the authority, and he can make his own rules. Since the off-brand robots have the same properties of the Popy Jumbos, he considers them to be Jumbo Machinders as well. He also knows about the Robot Factory jumbos that were "build 'em yourself" kits. These came with plastic screws and were packaged in smaller boxes for easier storage and transit. Franck also keeps tabs on bootlegs.

When Franck buys an Italian Robot Factory bootleg robot, he can tell that the body parts are cast from both licensed and un-licensed Japanese robots. He shows me one of his Italian bootlegs called Space Valour, and immediately points

JUMBO

words + pictures
Eric Nakamura

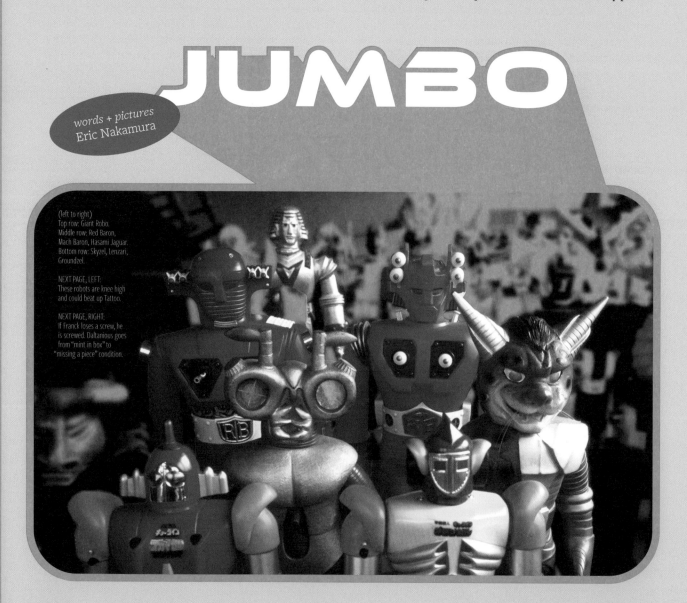

(left to right)
Top row: Giant Robo.
Middle row: Red Baron,
Mach Baron, Hasami Jaguar.
Bottom row: Skyzel, Lenzari,
Groundzel.

NEXT PAGE, LEFT:
These robots are knee high
and could beat up Tattoo.

NEXT PAGE, RIGHT:
If Franck loses a screw, he
is screwed. Daltanious goes
from "mint in box" to
"missing a piece" condition.

ERIC: For your information, Giant Robo is the actual robot that Giant Robot is name after. He had a Sphynx-

out that the legs are from one robot and the chest from another—but the head is of a toy that supposedly doesn't exist! So now he has his eyes out for this unknown robot. With a firm conviction, Franck says, "It's a lot like archeology."

The legend of Franck's Jumbo Machinder army has reached Yu Tak Ming, a big-time robot collector from Hong Kong. "I think Tom is the only person that I know of having such a huge collection. I have two friends in Hong Kong, they have only 40 pieces and I think Tom has almost 60 pieces," he says.

Franck's method of collecting is simple: "First you buy the American ones. Then you go to the lower pedigree (Japanese "common" Jumbo Machinders). And then, if you're serious, you have to go to Japan to buy them." A common Japanese Jumbo Machinder in the box isn't easy on the wallet. They command between $1,500 and $2,000, while the mid-range is between $2,000 and $3,000 and the high range goes from $4,000 to $6,000. Franck admits, **"I once had to buy a $4,500 toy to trade for something.**

Money isn't good enough for some people." But for the novice collector, Jumbos can be acquired at a cheaper price. American-released Shogun Warriors in the box are worth between $100 and $300. Raideen is the easiest to find, and Great Mazinger is the most difficult.

Now with about 70 Jumbo Machinders, Franck only knows about nine that he is missing. "I'll be depressed when I get all nine. So much is the thrill of the hunt. If Bill Gates wanted to collect Jumbos, he couldn't. It's not a question of money."

Although Franck has searched the US and Japan for these prized toys, he's seen many one-of-a-kind robots—and those are in his possession. If he misses a chance, then he has to hunt the robot down and ask dealers who bought it and for how much. Then he has to play a psychology game to see what it's going to take to make the collector let go of the toy. Franck has been on five missions to Japan to find these toys.

For our photo shoot, Franck puts together a Robot Factory robot called Daltanious, inspects it, and mutters, "Beautiful…" Smiling, he adds, "I want them to be buried with me."

MACHINES

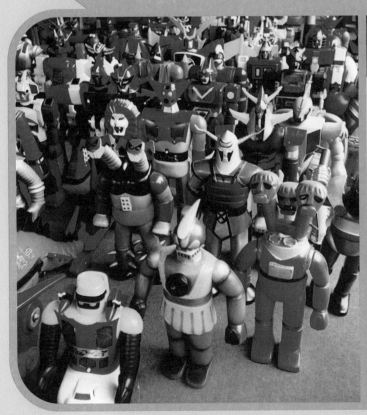

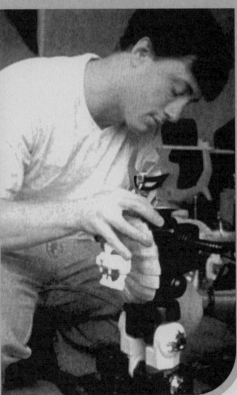

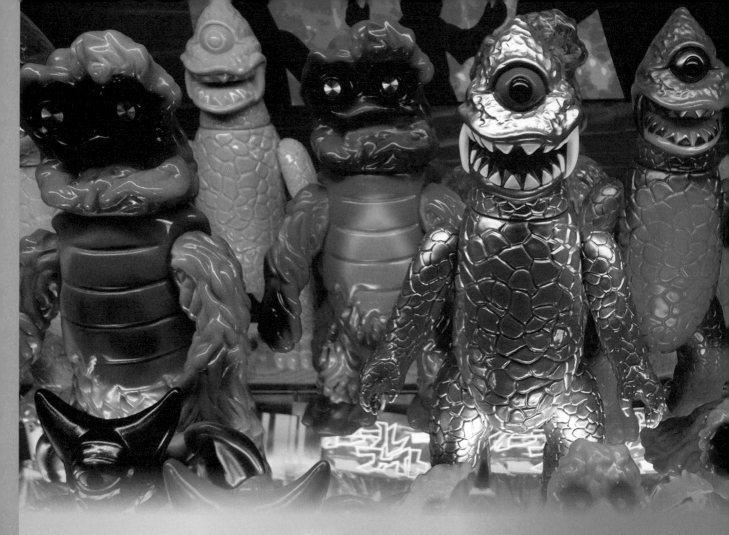

ORIGINAL BOOTLEGS

words + pictures | Eric Nakamura

Decades before LEGO-like figures, stylish plushes, and urban hip-hop figures crammed the shelves of toy fiends, kaiju fans had their Godzilla dolls. In recent years, masked-hero and rubber-monster toys have made a comeback in the form of reissues. New versions of rare pieces valued at $1,000 can now be purchased for $40. But since being a fan of caped heroes never really jibed with things like music, art, or having a girlfriend, the aesthetic remained dormant, separated from the hipster toy market. As a result, endless shelves of toys have been manufactured to look exactly like fuzzy images seen in fanboys' bootleg VHS collections.

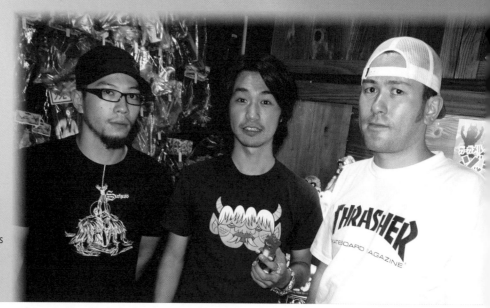

ERIC: If the classic Bullmark vinyl kaiju toys were first generation—like the Sex Pistols were to punk—then Gargamel is like Black Flag. I visited Gargamel at their

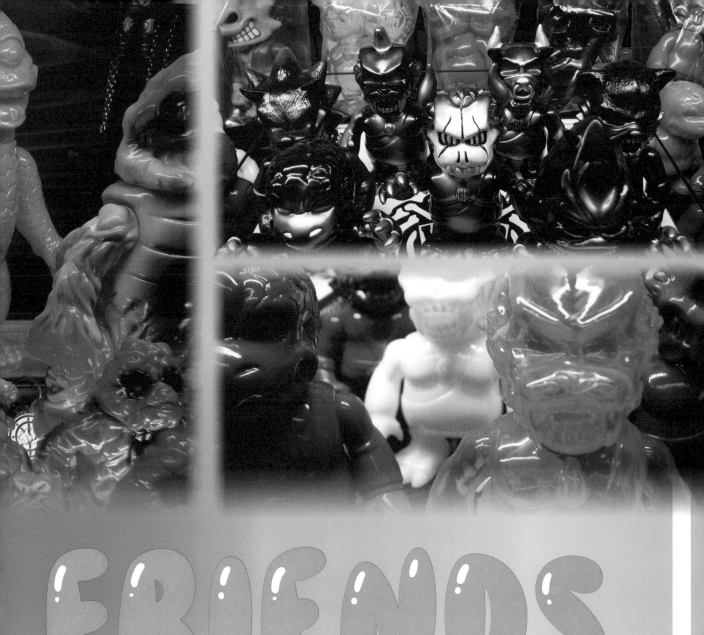

FRIENDS

Messing with the program is Kiyoka Ikeda, who helms a lesser-known, up-and-coming toy company called Gargamel. The company's flagship store, Thrash Out, is not far from the Kōenji train station. Walking past vintage shops that sell American clothes and up some stairs, you'll see fighting tournament posters and hear thrash metal. Dark and furnished with brightly-lit cases filled with multicolored, vinyl monster toys, the shop has a boutique feel. It wasn't busy when I arrived, and a girl actually came into shop—a rarity in the kaiju toy world.

For a maverick toy company to be named after Papa Smurf's nemesis seems odd at first, but it makes sense when Ikeda reveals that as a young toy collector, he always preferred villains to heroes like Ultraman and Kamen Rider.

Ikeda was a 22-year-old salaryman when he decided to make toys. He quit his programming job and got a position in the toy factory. The longish-haired, thin toymaker remembers, **"The professional sculptors don't teach anything. You had to watch and learn. Then you studied and learned to make originals."**
With a laugh, Ikeda says he was fired, and mentions that he was employed by Medicom for a short stint before he joined a boutique toy company. After that job, which remains a topic of discontent, he started Gargamel.
Gargamel figures have a unique smooth, rounded, and nearly melted style, which lends itself to making the *Ultraman* villain, Hedorah, as many toy companies have done. But Ikeda has moved on to develop a different style (sculpting with wax instead of sandpaper) and

top dollar for their sculpting, figures, and custom painting

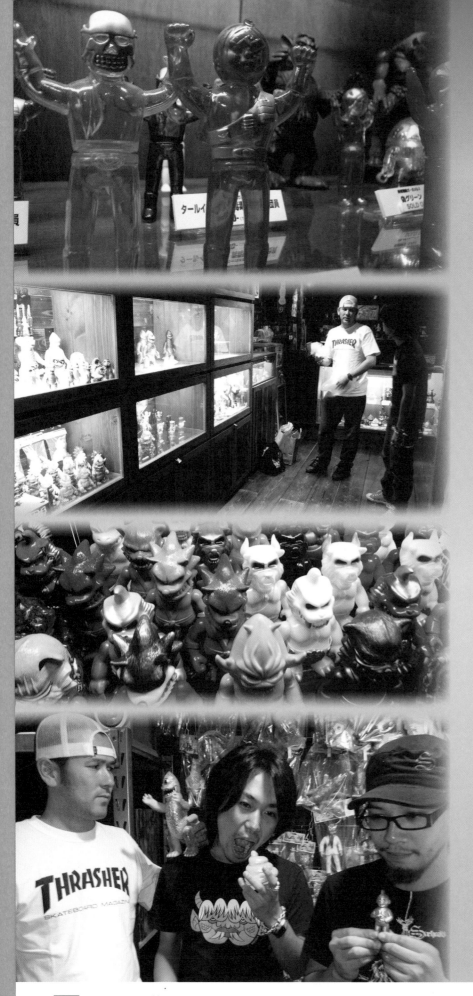

make completely original pieces, often shaped without a plan. The eyes on some of his characters are metal; he was the first to chrome plate his vinyl dolls; and toy fans are noticing such details. Even with small production runs, no budget for marketing, and its home page as the company's sole form of advertising, some of the figures make it overseas. When Gargamel made its first appearance at the San Diego Comic-Con, the old-school figures with the new-school angle were a hit.

Ikeda suggests that his tweaked versions of classics are a result of being raised in a family with three brothers and a limited income. As a result, Ikeda played with bootleg versions of toys. Gargamel pieces often have old-style header cards that echo the vintage pieces. "I liked those," he says. "I am a bootleg collector, so that's how it became like this."

Whether a toy is legit or bootleg, quality of design and concept are what matter to Ikeda: "The fakes have a great concept, and I'm updating them for this generation. If you call that a concept, then it's a concept."

Large commercial companies are starting to take notice as well. Gargamel made a display figure for Coca-Cola that was distributed to stores and bars. Ikeda quips, "If Coke asks to make something with our small company, then it's like we won."

Behind the shop's front counter, "manager" Koji Harmon adds that Gargamel is working with outside artists, too. The company has made a co-branded toy with Napalm Death (Gargadeath), is sculpting a doll stylized by artist Martin Ontiveros (Oni Rojo), and has projects in the works with artists Bwana Spoons and Tim Biskup.

The kaiju scene seems to be hitting a growth spurt, and with the addition of non-otaku elements, it may even cross over to other toy fans.

Gargamel's risks and ventures are paying off—not in piles of money, but excitement. While sales are dipping in the designer toy market, the pieces made by Ikeda and his small staff are both anticipated and coveted. The path to toy notoriety has been winding, but Ikeda has finally arrived.

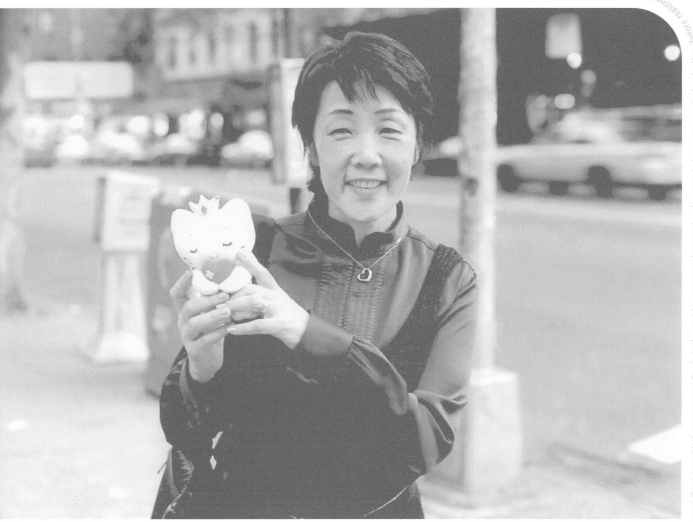

words + picture | Claudine Ko
illustration | David Choe

HELLO KREATOR
CAT SKETCH FEVER

Sitting between her translator, the artist Stephen "ESPO" Powers, in New York City's Cooper Union building, the 57-year-old could have been mistaken for any little Japanese lady hunting for produce specials at her local Mitsuwa. She says, "Hello, my name is Yuko Shimizu. I cannot speak English." Shimizu, who had been invited to speak at *Tokion Magazine*'s Creativity Now Conference, is the creator of one of the world's most recognizable icons: **Hello Kitty.**

After studying oil painting at Musashino Art University, Shimizu was hired as an in-house designer for Sanrio. She created Kitty in 1974 after numerous failed attempts with other cute animal characters including a bear, a rabbit, and a goose. "I realized simplicity was important," she says. "I couldn't express the mouth in a cute way, so I decided not to use it. Some characters don't get names. But if you design them and they sell, they get a name. Some of them get dropped before going public." Because Kitty did so well at the Sanrio test store, they decided to develop her.

The year before Kitty, Sanrio's profits were $1.05 million. After Kitty products were introduced—the first was a clear vinyl coin purse with her face stamped on each side—the Japanese company doubled its sales. At that point Shimizu quit her job of six-and-a-half years, got married, and started a family. In 1977, Sanrio profited $46.7 million without her. Today more than 20,000 Kitty products pull in about half of Sanrio's $1 billion annual sales.

Even so, Kitty's creator is virtually unknown. When asked who originally designed Hello Kitty, a Sanrio spokesperson at US headquarters in San Francisco answered: "Yuko Shimizu."

Although she seemed more interested in talking about her own cats than the business of them, Shimizu gave straightforward answers about the ubiquitous Sanrio mascot to the hipster audience that attended *Tokion*'s conference. Then she promoted her new creation, Angel Cat Sugar, produced by Tact Communications, a company headed by another former Sanrio employee. The new feline was born in the land of angels and has the power to heal broken hearts.

ERIC: A shoutout to both "ESPO"—a NY graffiti legend—and *Tokion Magazine*. Its art director, Deanne Cheuk, designed the GR2 logo we still use today.

Are you famous in Japan?
YUKO SHIMIZU: I know Kitty is very famous, but I don't think people know who I am.

How do you feel when you see Hello Kitty?
The first time I saw Hello Kitty in public, she was on a paper bag. I was extremely happy.

Was it unusual to be a female artist in the '70s?
I wasn't really an artist. I was a designer, and there were plenty of female designers because Sanrio products are geared toward females.

Did you have a personality in mind when you created her?
In the beginning, we just designed a mascot's appearance. If it was a hit, then we gave it a personality as well as siblings, a mother, a father, and an environment. In the very beginning, we had no idea about a character's personality.

Do you feel Hello Kitty has been exploited?
At times they have overdone it. Sometimes they have a product and they put a crab or squid head on a Hello Kitty body. If it's an apple, mandarin orange, or strawberry, that's kind of cute so it's okay. But when they put grotesque things on it, I get a little sad. I have no connections to Sanrio now, so I haven't really told them anything.

Do you own cats?
Yes, I have five cats. I love cats. I've had cats since I was three.

Any inspiration from your cats?
No.

Do you have children?
Yes, one. Yochan.

What's her favorite character?
Kitty came out and then three years later my daughter was born. So it was like she was raised with Kitty. Now she doesn't really like Sanrio that much.

Do ever buy Hello Kitty products?
Yes, I buy things at the Sanrio store for my friends' kids. Sometimes I get gifts from my friends who work at Sanrio.

You mentioned that Angel Cat Sugar was developed partly because you've seen a lot of pain in the world. Can you describe this pain?
That's not necessarily what it is. She's a character who heals all the pain in the world and tenderly nurtures all the sufferers of the world.

Was it easier to create this character?
No. It was about the same.

Did you sign a contract?
Of course. It's a different era. After I started doing the campaign for Sugar, I've been making a lot of appearances. I didn't before that. I made appearances for the Sanrio internal newspaper, but not in public.

Do you think Sanrio appreciates what you did for them?
I haven't heard anything from them, so I don't think so. If you write that, Sanrio might say something to me—or maybe they won't. 🐱

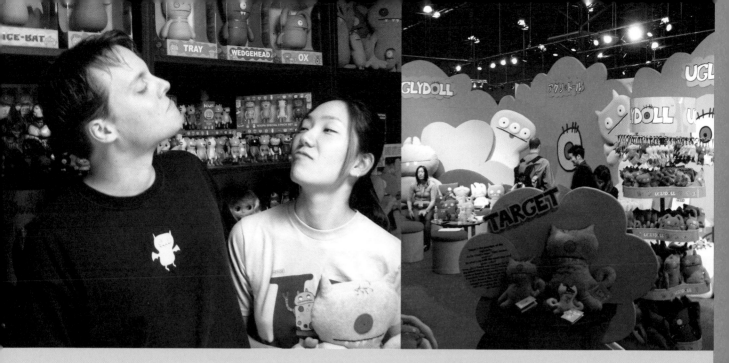

THE UGLY TRUTH

PLUSH POWER

words | Eric Nakamura
pictures | David Horvath +
Sun-Min Kim

Not long after the first Giant Robot store opened in Los Angeles in 2001, David Horvath walked in with a modest smile and plush doll in hand. It was the first Uglydoll ever made. Upon seeing it, the first thing I did was to ask for more so we could sell them. David called his girlfriend Sun-Min Kim, she got to work, and the rest is history.

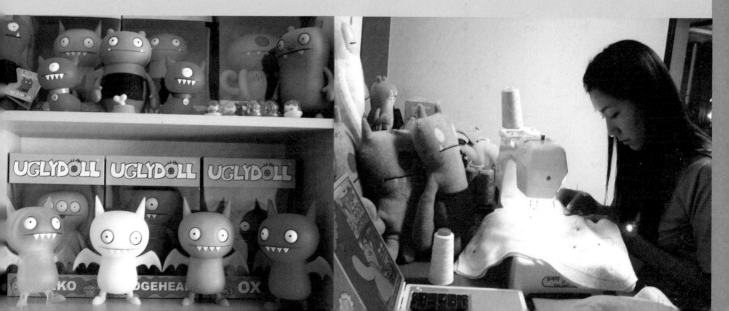

The handmade Uglydolls started as a two-person business and, with overseas factory production, multiplied like a tribble. The press caught on, and David and Sun-Min's story showed up in local papers, made multiple appearances on the *Today* show, and became a 10-minute spot on CNN.

To this day, David and Sun-Min have maintained their original strategy of selling Uglydolls mostly to small shops and keeping them out of big toy chains, and they have become the platinum standard of indie plush dolls. What started off as a modest project has spun off in many directions, including a TV show, books, stationery sets, vinyl toys, and even art shows. If you're in Paris this summer, you'll see Uglydolls displayed in an exhibition of the history of toy design at the Musée des Arts Décoratifs in the north wing of the Louvre.

Let's go way back. Where did you meet?
SUN-MIN KIM: We met at Parsons in a drawing class in 1997.

What were you doing there?
KIM: I always wanted to be an artist, like a painter. When I realized I liked characters and not abstract stuff, I decided on illustration.
DAVID HORVATH: I think we were drawing fruit or a nude model. Instead, I made some kind of creature, and Sun-Min came up and laughed at me. I combined nudes and what I really wanted to draw.

Technique-wise, did you take anything from school?
HORVATH: I think my favorite art class was math, which was like in elementary school. That's where I developed my style. I would fill in answers with the same drawings you see now. Before Parsons, I went to ArtCenter for advertising. I think I took more from that, realizing that there's so much on the business side. That came from child-hood and the influences from my parents. My mom designed toys at Mattel. My dad was in advertising.

I've heard people say that you have had more success because your mom works at Mattel.
KIM: That's totally opposite...
HORVATH: I was influenced by my mother—not by what she did there but what Mattel wouldn't let her do. She would make incredible prototypes. The model-making that went into it blew my mind. Then the final product would come out and it would be washed out, just corporate looking. She wasn't so devastated, since it was part of her job. I would be stomping around angry, like, "What in the world happened?" I got a job at Toys International from 1989 to 1994. It really pissed off my father that I left ArtCenter. I became the man-ager and would sit down with distributors and ask questions. So I learned the ins-and-outs of how the whole business works on that side, while asking my mother questions and getting help from the other side. My mother was worried and said, "You have to go to this one company. I'm going to send you on an interview." So I went with an early draw-ing of the Uglydolls, and they said, "You can't really make

toys like this. It's just not how it works." I learned if you want to get your own ideas across, it's not the way to go.

Was that devastating?
HORVATH: It was like hearing from the top dogs that there's no room for what you want to do. That was really tough. **The ironic thing was that a couple of years ago, the same company came to us and offered us a lot of money for the same idea they could have had for free if they gave me a job there.** The same lady was in the meeting.

I think you two pushed the industry in that direction.
HORVATH: It got me off my ass when Sun-Min had to go back home. That's when I realized if I don't do what I'm supposed to be doing, I wouldn't ever see her again. Then it was just a lot of weird coincidences that led to it.

What year was this?
HORVATH: Sun-Min went back to Korea in October 2001. Right away, we started working on another toy idea that got rejected by Hasbro. I had no idea that Sun-Min knew how to sew or make a doll, and she didn't, but she sent back the first Uglydoll as a present based on drawings I drew in my sad letters to her. I used to mail her the "I miss you" things, and I would put the little guy at the bottom with the apron. It was kind of like me working hard to find a way for us to get back together. When I saw the first Uglydoll, I brought it over to show you. When you said that you were going to sell some, that was it. When the newspaper article came out, we started getting emails asking, "Where can we find these things?" The typical response was, "Wow, that store is right next to where I live, and I didn't know it was there." The mom-and-pop shop owners and boutiques were happy that Uglydolls were bringing new people to them.

How did you learn to make the first doll?
KIM: I just tried. When I was young, I liked to watch my mom cook and sew stuff, and sometimes I sewed buttons on. After the first toy we pitched didn't work out, I felt bad. So for a Christmas gift, I tried to do something special. I was really happy that you liked it. I made them right away. In the beginning, it was by hand. I had back and finger pains. Then I learned about the sewing machine.

I read you made 1,000 of them by hand.
HORVATH: That's when we stopped. We were either going to stop completely or start to get them made. In a previous *Giant Robot* article, you had us saying we weren't going to have them produced, but it wasn't fair anymore. We'd send them to you guys, and then they'd be all gone.
KIM: I can't believe I made so many. Now I only make samples.

I thought they were a good deal. Were they too cheap?
HORVATH: I thought Sun-Min might get upset when I told

her how much I was selling them for, but she was okay with it right away. I think it was Sun-Min who said, "Because I work hard, we could make it $100. But that's not accessible and that's not fun for whoever comes in contact with it. I think being able to afford it would be nice." When you put a high price on something like that, you're making a statement. **We were just trying to make things for people to have. It wasn't for decoration; it was supposed to be a real, functional plaything.**

Was that part of a calculated, longer-term plan?
HORVATH: There was no plan. I thought we were making 10, selling them for $30, and that was it. But seeing it in your shop blew my mind. I figured it could start the wheels turning.

It seems selfless, but it worked out to be beneficial.
HORVATH: It's funny when companies focus on how to make money. Their thinking is different. It seems like you make less when you set out to make money. If you set out to do something you love, it pays off with satisfaction, and then it pays off with money.
KIM: We didn't know what was going to happen. We just tried hard. I was so happy that someone liked and bought them.

Was it hard to find a manufacturer that could actually make Uglydolls in Sun-Min's exact style?
HORVATH: Luckily, it was a Korean company, so Sun-Min and her mother could go over to the factory. It was really tough to get it right. It took like eight months and dozens and dozens of samples.
KIM: The beginning was so funny. Even though I gave them a pattern, Babo's eyes were way too big and the shape was wrong. I couldn't understand. It was such a simple doll. Why can't they make it?

HORVATH: There was no good safety testing in China or Korea, but we wanted to pass Japan's tests. They put it in a machine where a real strong robot arm pulls on it.

I think you two helped to create a plush movement. What do you think?
HORVATH: We collect a lot of the plush stuff out there, and I really like some of it. The thing that's different about Uglydolls is that we've always focused on the characters. People feel and touch them, but it's the story that closes the deal. I think that's what people respond to.

The route you took and the hard work you put in are part of it, too. A lot of people try to get in the fast way.
HORVATH: I think people see what we tried from afar. They don't realize the trail of blood. We get letters from people who want advice. We tell them to make what they love, whether it's a plush doll or a hammer.

I've heard people say, "Why are Uglydolls so popular? They're so simple." How do you respond to that?
KIM: The doll's face is simple, but whether it's smiling or frowning depends on a person's imagination.
HORVATH: We get tons and tons of photos of Uglydolls strapped in cars with a seatbelt. It's not just kids doing this; it's adults. It's like Mad Libs. They let people fill in things with their own imaginations. That's what toys are supposed to do.

Is there a big line between Uglydolls and the other stuff you make?
HORVATH: There was a big line. There were a few projects that we did because Uglydolls were doing so well and all the attention was there. It was like, "Here's Uglydoll. Let's fail with these other ideas." For a while, we were doing Noupa toys. We had wanted to do these before, but there was no way to get them out. We've slowed down on the other projects; I would say 100 percent of our time is on Uglydolls now.

I heard about some TV projects.
HORVATH: We're working on a pilot for Uglydolls. If it comes out right, then everybody will see it. If not, no one will know. We get to hold onto the rights and control everything. If it starts looking like they'll be wearing dope, phat gold chains and fresh sneakers, then no.

Why did you name them Uglydolls?
KIM: I think people are too focused on how they look. They always want to have pretty things. It was sort of breaking stereotypes.
HORVATH: Some say beauty is in the eye of the beholder. That means ugliness, as well. The Uglydolls have weird bumps: funny twists and one turned eye, three eyes and one leg, hair here and there, and ears in weird shapes. I have weird shapes and hair coming out of odd places, too. These things should be celebrated. They make us who we are. For me, ugly means beautiful.

What's the weirdest story you have about Uglydolls?
HORVATH: We get letters that report on how the Uglydolls are doing. They say "hi" and how they miss Mommy and Daddy. There's one family that brings Babo everywhere. He's in Rome and everywhere.

Any sad stories?
HORVATH: There are many touching stories. We get letters from folks who are dying. Also, family members who give them to their children, grandparents, or family members who are dying. There was a lady undergoing a really painful treatment. Someone in her family gave her Jeero, and the person got animated again for the first time in a long time. We get thank you letters, and it really blows us away to think that Uglydolls bring comfort to anybody.
KIM: There was another story about a kid with a learning disability who was so shy, he didn't speak at all in class. But he brought in an Uglydoll and started telling the doll what he learned from the teacher. That was touching.

Are the Uglydoll characters supposed to be Asian?
HORVATH: I think it's because Sun-Min is Korean. When I was two or three, I had Mazinger and Ultraman. I was kind of a *Final Fantasy* freak, and I learned a little bit of Japanese. *Star Wars* wrecked me for a little while, but when *Akira* came out in the '80s, that woke me up.
KIM: There wasn't much character stuff in Korea when I was young. We didn't have many animated characters, but we had one tape that had *Dynaman* and *Power Rangers*. I watched it at least 100 times, over and over. That was first time

I saw something from Japan. After that, my aunt lived in Japan. She brought me Hello Kitty stuff, and when I brought it to school, all the girls would be jealous.

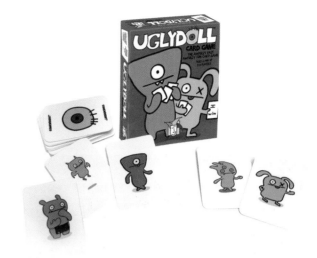

What do Uglydolls stand for?
HORVATH: If you think, "There's no way for you to get it done," "This profession doesn't exist," or "There's no outlet for me to do this," it really is possible to do something on your own.

Were your parents supportive from the get-go?
HORVATH: My mother was worried that I wasn't going to get a job at a toy company, but after she saw the *Daily Breeze* article, she started getting comments from people and thought there might be something there. There were some rough days, realizing how expensive everything was going to be and turning away big offers from big retailers, animation companies, and toy companies. It was tough to turn them down. It was like a test.

How about your parents?
KIM: I interviewed with a design company in Korea, and everyone there said, "I love your work, but your style is way off." I decided to get freelance jobs. My parents supported me, and they were happy to see me making dolls. They believed in us, somehow. When I told them Uglydolls were selling well and people liked them, they were happy.

What do you think about the rip-offs?
HORVATH: We found actual knockoffs in Chinatown. They look terrible and the tags are photocopied, but they are the characters. That's when you know you've made it, and it

doesn't bother me. But then there are big companies that say, "We want to order some." We say, "We love your store, but we can't sell to you," and they say, "You have to, or we'll knock you off." We've heard that so many times. It's probably something they say to shake up the boutique-sized businesses.

Tell me about this Toy of the Year award.
HORVATH: We won at the Toy of the Year awards. There's Hasbro, Mattel, and Fisher-Price, and we won the specialty category. We were sitting one row from the owner of Hasbro. We got them good, but we didn't beat the Cranium board game because that's another category. So Gary Baseman still won. He wins every year.

He didn't invent that game. Is its success due to its look or game play?
HORVATH: I think it's the game play. Sorry, Gary! 🐱

The legend of Michael Lau is well-known among urban vinyl collectors, streetwear historians, and Hong Kong subculture connoisseurs. Straying from his roots as a fine-art painter, he began contributing a street-culture comic strip to *East Touch* magazine and then fashioned 3-D figures to adorn a CD by his friends in the metal band Anodize. From these projects, the 12″ Gardeners were born—a convergence of skate style, hip-hop, and action figures that made toy collecting cool, and not just for nerds. That was enough to carve out Lau's place in toy history, but the very next year, 1999, he introduced the Crazy Children line, which mixed street culture with vaguely modernist sculpture, and officially signaled the beginning of the "urban vinyl" movement.

MARTIN: I first interviewed Michael for *Giant Robot* when I visited Hong Kong in 2000. This time, it was when he was in LA for his first big solo show.

Since then, Lau has gone on to become a celebrated artist and crossover star: doing high-profile works for friends like the Hong Kong rap group, LMF, and Lamdog, and gigs for brands such as Nike, Colette, and Maharishi, as well as having shows around Asia and Europe, and finally making it to Los Angeles in time to celebrate the 10th anniversary of his Gardener figures. The last time I interviewed him was in 2000 at his old flat where he was surrounded by vinyl pieces and tools. This time, it was at a Melrose boutique shortly before the opening reception for his exhibition.

GARDENER

words | Martin Wong
portraits | Max Wanger
pictures | courtesy of MINDstyle

Is it weird looking back at your 10 years of making Gardener figures? Because when you start something, you never think it's going to last that long or envision the body of work becoming so big.
MICHAEL LAU: When I first made the Gardeners, it was out of my own passion. I was making it for myself, for fun. But then people liked it, and things started to take off. I didn't really plan what would happen in the 10 years to come. Luckily, opportunities came up, and the Gardeners traveled to Europe, to different places in Asia, and finally to the United States. I'm just glad folks still like my stuff and that I'm still around.

I remember seeing some of your earlier works, the painted stuff. It looked like pictures of you swimming.
The *Water Garden* collection was after I had already graduated, but there were some paintings from when I was a student.

Those works were very painterly and traditional. If you pursued that two-dimensional work, where do you think you would be today?
I think if I hadn't started to do 3-D forms of art and just did 2-D painting, I probably wouldn't still be making art. It's hard to survive in Hong Kong just by painting. I think there are a lot of artists that do painting and I think they are very good, but I think I'm better doing 3-D forms of art. My strength lies more in making characters and 3-D art forms. Even now when I do my paintings, I emphasize character more than technique or whatnot.

It seemed like the Water Garden pieces were about you, while the Gardeners are about your friends.
When I made the *Water Garden* paintings, I was trying to express the state that I was in at the time. When people looked at me outside of the water, it was kind of twisted—not like the Michael Lau that I think I am. Underwater, I feel very free and I like it. When you're floating in the water, you're wondering, "What's next? What's the direction? Where am I going?" That was my mental state at the time, and I was trying to express lack of direction in the water.

ERIC: This is probably the last of all of the Michael Lau coverage in *Giant Robot*. I think I coined him as the "godfather of designer vinyl toys" in his

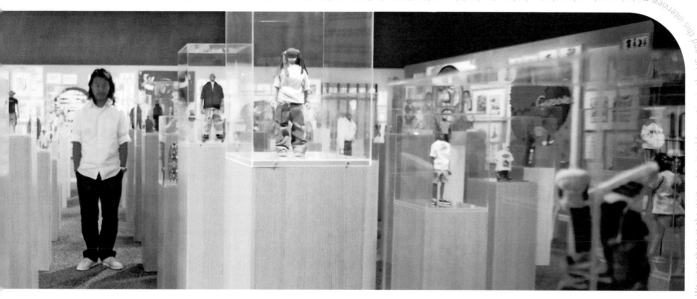

I feel like the Gardener characters have that same flowing feeling. Like there's energy flowing around the stylized curves.

A lot of people who look at the Gardeners work see a dream. They feel my dream is in realizing the Gardener. For other people, looking at the Gardeners is like looking at the history of street culture. Some people don't realize they were created back in the day, but after they do, they say, "We're still wearing the same stuff nowadays."

It's interesting to see older brands like Alphanumeric (p. 346), which went away and came back. Brands that were hot back then.

Or DC.

It's like a time capsule not only of brands, but of your friends and who you hung out with back then.

A lot of them have disappeared somehow.

It must be like looking at an old yearbook or old class photos.

Every time before an exhibition, I'm like, "Oh my god. I don't want to take the 100-plus figures out of the boxes and do all the work," but when I actually do it, it still feels fresh to me.

Do you ever have to redo parts?

Even if some of the parts may be broken, I don't want to repair them. I want to keep them in their original shape, so they become part of history, kind of vintage.

How do you store them?

I put them individually into boxes with tissue paper. I'm lucky Gardener exhibitions happen every few years, so at least they are out of the boxes at least that much.

So they don't get too crusty.

Yeah, the weather in Hong Kong is very humid.

Oh yeah, it's terrible for archival purposes. What about the Crazy Children pieces? They were so different when they first came out, but so many people have tried to copy the forms. Somehow you keep envisioning new shapes, adding grids, or exploring themes. Can you talk about that process?

Every time I create a new collection, I try to illuminate the style that I did before. I want to do something new. I wanted to do something non-Michael Lau, meaning

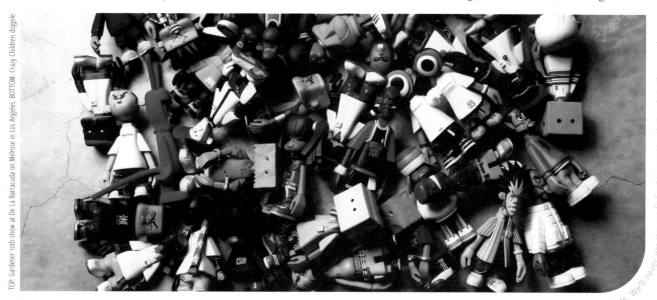

TOP: Gardener 10th show at De La Barracuda on Melrose in Los Angeles. BOTTOM: Crazy Children dogpile.

first appearance. I'm sure that's been used since, and thanks to Martin and Daniel Wu, we were the first to import his figures to the US, pre-Giant Robot Store.

Gardener strip for East Touch.

if I've done something before, I don't want to repeat it. I always want to do something new.

I liked the sci-fi collection.
I personally like that collection a lot. For some reason, commercially it was more welcomed by people in the Western world than in Asia.

What I liked about it was that while your other series are very much about trends, brands, and what's cool; science fiction is the domain of nerds.
The audience in the West appreciated the concept more than audiences in Asia, who probably just look at the trends, like you said. Or whether it was associated with a brand, or if there's a crossover, or whatnot.

I know a lot of the earlier pieces were made for friends who were in bands, whether it was Anodize or LMF. I know it probably didn't seem like anything special at the time, but was that a special era of Hong Kong culture?
Again, it's not something I planned. It just happened that I knew Anodize because of Prodip [Leung]. Prodip is lazy, so he just handed me the work and I did it. To me, the most important thing is to have fun and have no boundaries.

But music, skateboarding, toys, and street art were all happening, and you were right in the middle of it, bringing it all together.
I feel lucky that I can be multi-dimensional and touch on different worlds. Because I am a creative person, whatever I do or whatever I am asked to do, I can merge myself into that world and think of myself as a part of that arena.

Yet you're just a regular dude and you don't look like a hipster.
I don't really spend a lot of time thinking about my outfits or brands or anything. I would rather spend the time creating something for my collection—and also playing soccer.

The last time I saw you, you were telling me about buying furniture in Thailand and how that's where the great design was. So it seems like even then you were interested in the designer stuff as well as street stuff.
I still like street culture; I just feel like the boom was in the late '90s. It will always be here, but it has passed its heyday. And because I am getting older, my interests have changed to furniture, lighting, or whatnot.

And the new Gardeners aren't wearing skinny jeans. You haven't moved on to things teenagers wear, I guess.
I tried to wear skinny jeans. I couldn't. I'm too fat.

I mean that when you started making Gardeners, they wore what was hot, like fat pants and sideways caps, but the new ones aren't wearing skinny jeans.
I felt when I created the original collection in 1999, I used up

all the inspiration from the street culture. So when I made the new Gardeners for the new exhibits, like in Hong Kong in 2006 or now in 2009, I wanted to create them based on the location. This time I was coming to the States, so the characters look American. I want them to revolve around the location and the place.

What's it like making versions of people like Federer and Kobe? That's pretty different from making your friends in bands or skate teams.

I created the Nike project because I liked Ronaldinho at the time. The creation process is pretty much the same; the only difference is that when I'm creating figures for my friends, I would never show them and ask for their approval. When you're creating something for Federer, you have to get approval and make sure he likes it. Luckily, the approval was pretty quick and he liked them.

Is it harder to get into their heads and try to understand them before making the forms? If it's one of your friends or peers it's easy, but if it's someone like that...

Creating those athletes is more based on the facial features. If I'm creating Prodip, I know him and I know how he behaves, so I can highlight the things I know about him. Creating athletes is more based on their facial features, but I still try to highlight the key things on their faces.

MICHAEL LAU

Maybe you're like the Federer of figure-makers.

It's lucky I'm not the Ronaldinho of the toy industry, or I'd be...

...Peaked out? Is it hard to struggle to keep up? I mean, you never know how long the industry will last and there are so many people trying to do the same thing. Is it stressful or is it still fun?

It's really stressful. That's why I play soccer! People call me the Godfather of Vinyl now, but I never really think about it. I just want to keep doing what I love and trying to get better each time.

Now that you're married, is it hard to keep striving to be the best at what you do but not be a crappy husband? Do you find yourself struggling with that?

Luckily, my wife understands what I do. It was one of the criteria I used to screen her before I made a decision! If I want to do something, of course I want my wife to understand, but at the end I am an individual. If I really, really want to do something, I can still do it.

It seems like you take on a lot of branded projects, whether it's for MINDstyle or Nike, where other people have something in mind and you execute it in your style. Is that easy for you to do because someone else has the

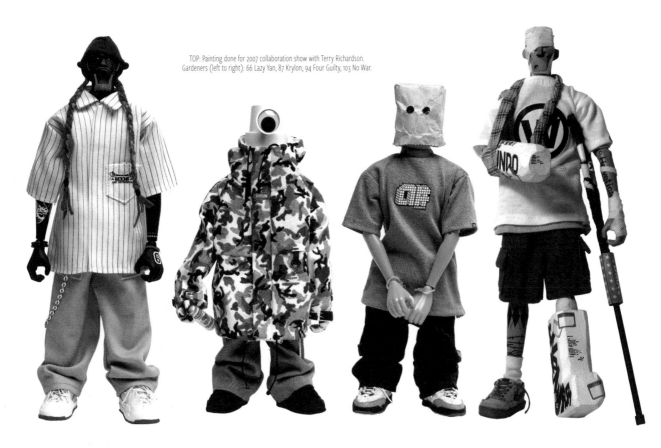

TOP: Painting done for 2007 collaboration show with Terry Richardson.
Gardeners (left to right): 66 Lazy Yan, 87 Krylon, 94 Four Guilty, 103 No War.

inspiration and you just have to follow it? Or is it harder because maybe it's not necessarily your thing?

My theory is if you come to me and ask me to do something, you should have to trust me. <u>The partners that I have worked with so far are people that trust me, or I trust them. A lot of times they never see anything until the very end, so there's no chance for them to change or reject something. To me, the most important thing when working with different partners is to understand each other's needs.</u> Otherwise, if a partner is requesting a lot of creative input or trying to interfere with my creation, I would not accept the project.

In light of all these jobs, do you have a requirement where, for example, every month you have to make at least two or three things for yourself to keep evolving your personal art?

I tried, but it didn't happen. It's never as I planned. Even this year, I thought I could spend more time working on my own thing because of the economic downturn, but there are still a lot of different projects being offered to me. I've ended up spending a lot of time on other people's projects rather than my own.

Can you tell me about your paintings? They seem to be purely yours, and not commercial at all.

The paintings mainly revolve around the Gardener characters, and in some of them you might see details that I picked up from the characters. For example, the Prodip one with the tooth and the stars. And for Krylon, you see the clown behind the bars because they were caught doing graffiti. So they still revolve mainly around the Gardener's character.

It's purely instinctive. Whenever I sit down, I draw. And sometimes when an idea comes up, and I think it's a good idea, I execute it. And I have a lot of sketches at home that have never been executed. Probably more than what you saw.

Do the sketches resemble what you exhibit? Or are they very different?

Very different. Some are technical drawings of the figures. Some are new ideas that I have not executed.

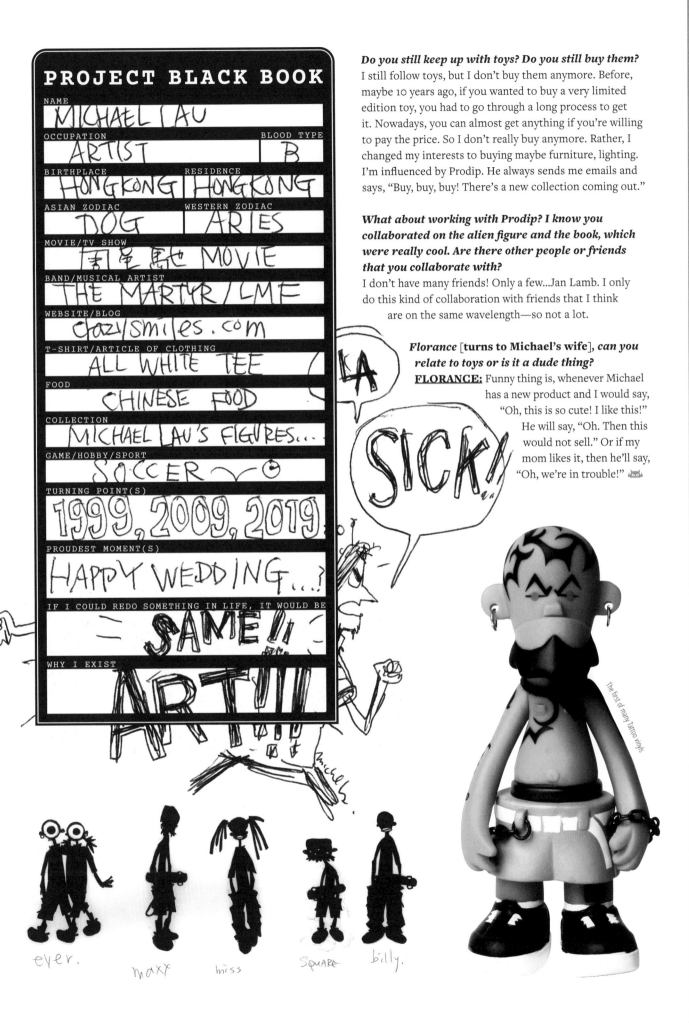

PROJECT BLACK BOOK

NAME
MICHAEL LAU

OCCUPATION
ARTIST

BLOOD TYPE
B

BIRTHPLACE
HONGKONG

RESIDENCE
HONGKONG

ASIAN ZODIAC
DOG

WESTERN ZODIAC
ARIES

MOVIE/TV SHOW
周星馳 MOVIE

BAND/MUSICAL ARTIST
THE MARTYR / LMF

WEBSITE/BLOG
crazysmiles.com

T-SHIRT/ARTICLE OF CLOTHING
ALL WHITE TEE

FOOD
CHINESE FOOD

COLLECTION
MICHAEL LAU'S FIGURES...

GAME/HOBBY/SPORT
SOCCER

TURNING POINT(S)
1999, 2009, 2019

PROUDEST MOMENT(S)
HAPPY WEDDING...?

IF I COULD REDO SOMETHING IN LIFE, IT WOULD BE
SAME!!

WHY I EXIST
ART!!!

Do you still keep up with toys? Do you still buy them?
I still follow toys, but I don't buy them anymore. Before, maybe 10 years ago, if you wanted to buy a very limited edition toy, you had to go through a long process to get it. Nowadays, you can almost get anything if you're willing to pay the price. So I don't really buy anymore. Rather, I changed my interests to buying maybe furniture, lighting. I'm influenced by Prodip. He always sends me emails and says, "Buy, buy, buy! There's a new collection coming out."

What about working with Prodip? I know you collaborated on the alien figure and the book, which were really cool. Are there other people or friends that you collaborate with?
I don't have many friends! Only a few...Jan Lamb. I only do this kind of collaboration with friends that I think are on the same wavelength—so not a lot.

Florance [turns to Michael's wife], can you relate to toys or is it a dude thing?
FLORANCE: Funny thing is, whenever Michael has a new product and I would say, "Oh, this is so cute! I like this!" He will say, "Oh. Then this would not sell." Or if my mom likes it, then he'll say, "Oh, we're in trouble!"

LA

SICK!

The first of many Tattoo vinyls

eyer.

maxx

miss

SQUARE

billy.

ART

JAMES JEAN

The strip malls, suburban sprawl, and insipidness of New Jersey had a way of erasing what little culture was left in my mind, smoothing out my brain with its consummate banality. However, art was a way for me to define a new identity and engrave new pathways in what felt like an overwhelming monoculture. As a child of the 1980s, to be Asian American was to be Asian without any memory of Asia and American without any of its privileges. (I pray that James Baldwin can forgive my shameful appropriation of his words, but his genius resonates.)

On a more granular level, to be an East Coast Asian American was to be at odds with our more confident West Coast counterparts. Fresh out of art school and new to California, I could feel the disconnect when I tried to introduce my work to *Giant Robot* during my first year living in Los Angeles in 2003. I didn't listen to punk rock music, and I didn't skateboard. The dark, baroque, and surreal works in my portfolio didn't mesh with the effortless cool of their coterie of artists. I failed, feeling dejected and invisible as I picked up my portfolio from the Giant Robot store. They were just too cool and out of reach. I remained the outsider, pining for a way inside.

The worlds of Takashi Murakami and Yoshitomo Nara glimmered far away in a different galaxy, but *Giant Robot* magazine created an Einstein-Rosen bridge between worlds and offered rare insights into artists and cultural curiosities that reverberated from the fringes. And there I was, on the fringes of the fringe. Tony Leung (p. 116) looked upon me with pity from the cover of *Giant Robot #5*. It was exceedingly rare to see an Asian man on the cover of an American magazine, but *Giant Robot* did it, and Tony was quietly judging me from a realm beyond time, as if to admonish me that 20 years later, we would be browsing furniture stores and dining together in Tokyo.

My 20-year-old self could never have predicted such occurrences, that I would go on to have many dinners with Takashi Murakami (p. 435) and paint into the night with Yoshitomo Nara (p. 430) in Hokkaido. *Giant Robot* opened the wormhole into those worlds, and captured a moment in time when Takashi and Nara both had jet black hair and were engraving their place into art history. Two decades later, they are now deeply embedded in the firmament of the art world. The sheer effort of their work has sapped the pigment from their hair.

Now both gray, their artistic practices have diverged in opposite directions, and musings on legacy and mortality linger in the air.

When I reread these old interviews, I see the foundations of their respective philosophies, and it's fascinating to see how things have played out. Takashi's production model has turned his studio into a behemoth that both excretes mountains of work and is constantly hungry for resources, while Nara has no assistants and enjoys a good sweet potato shochu. Takashi's monster propels him to ever-greater heights of cultural influence, while Nara's retreat into solitude provides an intoxicating liberation from worldly concerns. Eventually, I did make it inside the magazine, and Eric included me in my first museum show at the Giant Robot Biennale. Meanwhile, I've migrated from the fringes into different territory. I still perceive myself as an outsider, but upon close inspection, I've probably stepped into a blind spot. Now, I realize that I'm the one letting people in, ushering others into the floating world of my work.

James Jean is a visual artist whose body of work traces a path through everything from fine art to film to high fashion.

FABLES 74 DRAWING (2008) | 20" X 30" | Charcoal on Rives BFK.

Step into the Rem Koolhaas-designed Prada stores in Soho or Beverly Hills and you will be greeted by enormous, 17' X 200' murals showcasing the work of James Jean. Prada has also produced a line of shoes, bags, and apparel using the 28-year-old artist's mysterious, dark, and fantastic artwork—but not his name. The fact that the exclusive clothing brand didn't promote the Los Angeles-based artist along with its products has become a common topic of conversation among art-minded folks. Was it because of his youth or soft-spoken demeanor? Or was it an oversight of his artistic merit?

While Jean remains a mystery to much of the couture scene, he is well known among comic book readers. His cover art for Vertigo Comics's *Fables* has earned him the Eisner Award for "Best Cover Artist" four years in a row, from 2004–2007. His work has been featured in other comics, books, ad campaigns, and snowboards, and fellow artist and friend David Choe often says, "He's the best painter in the world." When I visit Jean's modernist residence in Santa Monica, it seems like the perfect place for him to live and work. The sight lines are nice and his art is spread around different rooms. The living room's big windows face a small backyard and let in perfect light for it to function as a painting studio—although he has to paint large pieces in the garage. The space above the garage is a drawing studio and print-packing location. Walking around the premises where he draws, paints, and otherwise runs his business, he tells me how art has taken him everywhere.

JAMES JEAN

COMIC COUTURE

words + pictures | Eric Nakamura
art | James Jean

You're from Taiwan?
JAMES JEAN: I was born there, but moved to the US when I was three. So I am sort of an ABC.

Did you teach yourself drawing from the beginning?
Totally. I was always drawn to photographs of big trucks, robots, and everything. I wanted to translate it all onto paper. **My parents would bring home reams of dot-matrix paper with the holes on the sides, and since it would all fold out, I would do elaborate multi-panel drawings over the perforations.** It was a very broad canvas.

You were the king of drawing in your elementary and junior high, weren't you?
I guess. People were like, "James can draw that." It was nice.

I was that kid in elementary school—the Asian kid who could draw. It's weird. I don't think a lot of the Asian kids keep that up. They're good at drawing and then they're like, "I'm going to be the guy who cleans pools," or something.
My parents wanted me to go to law school or be a doctor—the typical stuff—so I actually stopped drawing for a while. I always drew, but I didn't do it seriously for a long time. In high school, I was really into music. I played the piano, the trumpet...

There is a James Jean who plays music, but it's not you.
It's kind of funny. That's some Christian rock band. At least I beat them on Google. So, yeah, I guess I took a chance and applied to art school. **I wanted to do comics and the School of Visual Arts was the only one with a cartooning**

program, and that was the only school I applied to. My parents were not happy. This was the late '80s or early '90s. I think that was the beginning of Image.

FAUN BLOOM (*Trembled Blossoms* style frame) (2008) | Graphite and digital.

Yeah, with* Spawn *and* Cyberforce. *When Image Comics came out and challenged Marvel and DC, did that influence you at all?
Yeah, I had all those comics. I had *Youngblood*. I started a little bit before with Jim Lee on *The Uncanny X-Men* and *Wolverine*. My first comic was *Wolverine 30*. There was something so attractive about comic books—having all those drawings in a pamphlet, putting them in a bag, and all that. It's good to finally have a hobby when you're a kid and you're lost and don't know what to do. I guess it's almost like something forbidden with its violence and sex. You know, our parents didn't know anything about it. I could draw. I had friends that would bully me and have me make dirty drawings for them when I was in middle school. When I was in the first grade, I drew a hermaphrodite and got in trouble. I drew it during lunch and the lunch monitor took it away and told me I had to talk with the teacher. It was mortifying. I just thought it was hilarious and didn't even know what a hermaphrodite was. I would just draw a naked lady and end up drawing a penis. Then the teacher started giving me a lecture like, "I understand that nudity is appreciated in sculpture and Michelangelo."

When did you come out to LA?
In 2002, I moved out here and got married.

You were in New York before that, right?
Yeah, I went to school there from 1997 to 2001. During my last year there, I shared a loft with Yuko Shimizu. She's a pretty famous illustrator now. We saw the Twin Towers fall from our window. It was definitely an unforgettable watershed moment, and there was a torrid amount of change afterwards. I had an internet job that ended. Around that time, developers were hanging so they had me on a retainer. For a while, that was my only source of income. Then I started doing covers for DC in October 2001. At that point, I was doing one cover a month.

Covers aren't just a gig, but a serious endeavor, right?
I guess. <u>At the time, my art school education had given me these delusions of grandeur. I thought I was going to be a painter doing cover illustrations for big publishing companies. But I couldn't get editorial work</u> because all the paintings I did were too surreal and strange to be commercial. Once I started doing comic book covers for Vertigo, everything started snowballing. It turns out a lot of art directors read comics, so I started to get more assignments. I got regular assignments, bigger advertising jobs, and covers—mostly through word of mouth. After about two years, I was pretty comfortable.

Was it weird to start drawing the covers instead of the insides? Isn't the cover the most prestigious part?
I think it was good timing. They were going to do five issues of *Fables*, so they said, "Alright, how about you do the first five covers?" I think they just wanted to take a chance. *The Sandman* had just ended, and they were looking for a fresh start. It was the editorial art director Mark Turello who recommended me for the job. He seemed to really like the work he saw on my website, and really pushed me for the gig. When *Fables* started to do well, they said, "Let's do another five covers." <u>Vertigo puts out a lot of books, but they don't last.</u> It's an achievement when a book lasts more than 10 issues or a year.

Was it different working at Vertigo compared to DC's main titles or even Marvel?
Fables has nothing to do with superheroes or anything like that, and it was a technical challenge to depict characters in a real space when I was so used to being

a painter, doing whatever I wanted, and playing graphically with things. Instead, I had to make sense and tell a story. It was really difficult. It was good for my chops, that's for sure.

At the time, were you more into drawing something like* The Thing?
No. <u>I read comics by people like Chris Ware and Dave Cooper back then. Charles Burns and Daniel Clowes, too. I loved that stuff. I had no interest in superheroes</u>, but then I ended up doing *Batgirl* covers. I felt like I did interesting stuff with those covers. I could render accurate, attractive-looking anatomy, which was definitely not one of my strengths when I was in school. People loved my drawings and the flat color. Even now it's super popular.

Do you think that your painterly style is getting more popular or making a comeback?

It's hard for me to say because I am not far enough removed to be objective. But I know there are a lot of people like Yuko Shimizu, Tomer Hanuka, and Nathan Fox, even István Bányai, whose work has a comic book look. They have characters that occupy space defined by dark lines and flat color, whereas illustration before was Brad Holland-esque.

It seems there are just so many people jumping in over time.

When I graduated, illustration was dead. Everyone was so depressed. Now everyone wants to be an illustrator. It's crazy. In the last five years, it exploded. I don't know why. Maybe it's the internet. Everyone has a website, everyone is posting on Flickr, and everyone is blogging about their work and putting their work on Myspace. Drawing is a real fun endeavor, and now it is more accessible. When I was growing up, it was hard for me to find art that was interesting. My parents had a collection of Van Gogh books but I was not old enough to appreciate it.

Do you think that a lot of illustrators are getting popular without chops, as you might say?

Oh yeah. There is so much biting out there, it is insane. <u>I have seen my work influence a lot of people in a short amount of time. That's cool, but I feel like my work comes from a place of authenticity.</u> In art school I was absorbing all these different influences and synthesizing them into something that was my own. <u>Now I see people take what I've done and use it without knowing where it comes from. It's superficial.</u>

Where does your subject matter come from? If it's a fantasy world, you must include some of yourself in your paintings.

It references art history, memories from my childhood, gender issues, beauty, ideas of beauty, and the act of drawing and making art. I am drawn to creating windows into a self-contained world, and I try to exploit that. I love all sorts of painting and art, but I feel that my ideas about composition and carving a psychological space are rooted in stuff like Chinese scroll painting and lithography. I like

LEFT TO RIGHT: **MAZE** (2008) | 29″ X 41″ | Mixed media on paper. ● **WILLOW I, IV** (2007) | 30″ X 22″ | Mixed media and digital. ● **CRAYON EATER** (2007) | 12.5″ X 17″ | Mixed media and digital.

to apply traditional skills and use them to do something interesting, beautiful, and maybe unsettling.

Are you constantly looking at books and materials, or do you sketch off the top of your head?

It's a little of both. Sometimes I will wake up with an idea. Like I just woke up one day and I had the idea for *Crayon Eater*. It's a big crayon drawing of a kid eating crayons. When I do large, dirty, narrative pieces, I look at these Chinese erotic books. I also have a book of erotic Japanese woodblock prints, too. You have to think that this was the fantasy or porn of the time.

When did you start looking at things like that or scroll paintings?

I was always drawn to Asian influences. You know how Western paintings are all about atmosphere? There are no edges or the edges are soft. Chinese woodblock prints or scroll paintings have beautiful calligraphic lines. Maybe it's because of the writing, but who knows? I am drawn to line work.

Do you paint and draw daily?

I am always swamped with stuff, and do something every day. Right now,

I'm designing my book for DC. They're collecting my covers, and I'm doing all the typography and design for it. I'm drawing every day. I was just in Iowa on my friend's film set drawing Elliot Page and Keith Carradine. I can show you the sketches.

What movie is it?

It's called *Peacock*, starring Cillian Murphy with Susan Sarandon. My friend Michael Lander was making the movie so I came out for a week and I just hung out around the set for like 10, 12 hours a day, just drawing for myself. The production company wanted to use the drawings for promotion, and were like, "Hey, can you stay longer?" and paid for the rest of my stay.

When you are doing sketches, do they become studies for paintings?

No, the sketches are of the moment. They exist only because I was there for that amount of time. I don't go back and work on them or anything.

So how often do you have the freedom to go to a place and just draw for yourself?

I do it pretty often. Like whenever I go out to lunch, I'll draw my friends eating.

I mean do you ever set out a day where you're like, "I'm going to go to the park and just draw. That's it." Do you ever make time for that kind of stuff?

Not unless I'm traveling. Usually I don't forcibly make time unless it's something special. There's this girl, Sasha Grey. She's an awfully good, um, porn star. I mentioned to Dave Choe that I'd always wanted to draw her, and he said, "Yeah, I might have a friend that knows her." So he called up the friend, and she was like, "I just worked with her last week." So we called her up and set up a date. She just came over and posed. She likes wearing stripes so I worked that in there.

So what do you think about all the collaboration work that's going on? You recently worked with Prada.

I don't know if that was a true collaboration. Basically, I did two huge drawings for them that were really long, like scroll drawings. They were 11 or 12 feet long, and Prada turned them and another drawing I did into wallpaper for a fashion show. Then they took elements and collaged them onto clothes. People edited the drawings and put new stuff on them, but I think the spirit is there.

What's it like working with a very high-end line? Was it like the whole Murakami thing?

I think it's totally different. Louis Vuitton hired him. He's famous. But Prada underestimated my fan base and the allure of the work I had done. Apparently, it is the most popular wallpaper they've ever had. I hear from the stores that people constantly come in and ask about the wallpaper. John Galliano was looking at it and people will come in wanting to take photos. People never wanted to do that for previous wallpaper installations.

Do you think your work is a little dark for Prada?

I feel like Prada's always been dark. They kind of have this dark, hyper-modern sensibility. Even working with Rem Koolhaas—he's a little dark and unconventional. So I feel the aesthetics worked well together, as opposed to their other line, Miu Miu, which is more playful and girly.

Have there been more fashion brands trying to hit you up?

Yeah, but I've declined them.

So there's no interest in doing a true collaboration that actually uses your name from the conception, like, "What do you want to make?" Are there any brands left?

Well, there is. I'm in talks with The Grateful Palate about doing my own wine. I did these three triptychs, initially. It turned into this project with a Southern theme. Now they're basically letting me do whatever

I want. We've brainstormed and it's really cool collaborating with them. They come up with great ideas.

With products like wine or clothing, is it all about art or is it like an integrated business brand thing?

Actually, most of the stuff I've done is due to fortunate conjunctions of events. It's not like I have a business plan or anything, I'm just trying to do what interests me. People want me to do T-shirts and make all this stuff, but in the end I just want to draw and make pictures. I'm not that interested in making products, even though it's cool to do all that stuff and it's like being part of a club. It's like, "Oh, now you're accepted. You're a real artist because you've parlayed your work into all these different products."

I think the bottom line is, are you making a living with your art and drawing?

I've done really well. I have a business manager and accountant that make investments for me and stuff. They do Mike Judge and a lot of entertainment people.

Do they recommend career choices?

Oh, you mean like an agent? No, not at all. I've never had an agent and have never been interested. I've always handled my own business and negotiated my own contracts and rates. I make my own invoices, and I feel like I've done a good job with all that over the years. Sure, an agent can help you get your foot in the door,

POOR THING (2007) | 36" x 22" | Charcoal and digital.

but it's a crime to give someone 30 percent to do stuff that is actually very easy to take care of yourself.

But are there times when you have to be like the good guy and the bad guy at the same time?
Yeah, but it's worked out okay so far. I've been pretty stern and I've been forthright. And it's always worked out okay. As long as you respect the person who you're working with, just ask. If they want to work with you, they'll come back with a counteroffer or something.

Your last name is Jean. What is that really? Is that C-H-I-E-N in Chinese?
Yeah, it is. "Jee-yen" is my Chinese name. So, J-E-A-N.

Who made that spelling?
I think my dad did, or maybe someone on Ellis Island, I don't know.

You didn't go "Oh, I'm just going to be James Jean."
Oh, hell no. I'm telling you, everything that's happened to me has been real fortunate. I didn't know my name was going to be easily memorable. I just grew up with it.

How many people know you're Asian just from your name alone? It must be something like 10 percent.
Yeah, everyone thinks I'm a tall, old, white guy. The truth hurts. What can I say?

ERIC: *James Jean is probably one of the most talented visual artists and to say that about a single person among so many great artists we work with feels unfair, but I'm still willing to say it. Prove me wrong? That said, this interview took place at a time when I knew James less well and he was on the rise. Yes, I rejected him from a GR2 show—his work was just too polished. Think: we were lucky enough to be considered grunge or punk, but then a young Freddie Mercury walks in—the octaves are astounding and studied, but also not a good fit for our less dimensional range. Yet he was growing and art aside, we've become close friends. I've followed him, his family, and his art to the opposite ends of the world a few times now, and I'll keep doing it. I can see why mentioning that can bring a tear, which I saw from him during the Q&A portion of the Giant Robot documentary. I feel that now.*

So much has transpired since this interview, and James's work has changed multiple times—perhaps stemming from outside forces and his willingness to experiment. I was complicit with helping him hide out during a dark part of his life. I watched his paintings morph, and then reform again into something new. James is still not appreciated enough in the "high art" world in North America, and perhaps as a mid-career artist, that time will be here soon. Meanwhile, he's a juggernaut in Asia, packing giant museums with paintings and sculptures in China and Korea. His work appears on luxury brands. It's a matter of time before he shows up on your breakfast cereal boxes in America.

FABLES COVER COLLECTION JACKET DESIGN (2008) | 20" X 31" | Mixed media and digital.

VIRGIN DESTROYER (IPIS NI LUPE) (1995)
60" X 40" | Acrylic on muslin | Collection of Tom Patchett, Los Angeles | Courtesy of Track 16 Gallery, Santa Monica | Photo: William Short

VIRGIN DESTROYER

666

VD

words | Martin Wong
portrait | Wendy Lau
pictures | Lizabeth Oliveria Gallery + Track 16 Gallery

MANUEL OCAMPO

SHEER ART ATTACK

Manuel Ocampo was born in the Philippines in 1965, moved to Seattle in 1986, and attended Cal State Bakersfield before infiltrating the LA art scene in the early '90s. Under the flag of multiculturalism, he has brought to galleries and museums an unflinching and painterly vision of darkness and violence filled with recurring themes of imperialism, Nazism, and the Ku Klux Klan. But Ocampo is neither a regurgitator of goth masturbation, nor a trendy purveyor of outsider imagery; he's a true painter inspired by art history, punk rock, and the colonial past of the Philippines.

After taking part in important exhibitions such as Helter Skelter: LA Art in the 1990s, as well as group shows with the likes of Jean-Michel Basquiat and Don Ed Hardy, Ocampo left his art celebrity status in America to find new inspiration in Rome and Spain. After returning to America and spending a few years in Northern California, Ocampo moved back to the Philippines, where he spends time with young artists and his style has taken a cartoonish turn, kind of like *Cracked* magazine from hell. We met Ocampo when he was visiting his sister in Los Angeles.

CRITICISM WILL HAVE NO EFFECT (2005)
66" X 84" | Oil and acrylic on canvas | Private collection | Courtesy of Lizabeth Oliveria Gallery, Los Angeles, CA | Photo: Anthony Cuñha.

UNTITLED (PINK, BIRD, CROSS SHIT) (2005)
30" X 24" | Oil on canvas | Private Collection | Courtesy of Lizabeth Oliveria Gallery | Photo: Anthony Cuñha.

THE ISLAND

Where do you live in the Philippines?
MANUEL OCAMPO: In Manila. I went back two or three years ago. I hadn't been there since I was a kid, and my first impression was that I'd landed in Hell.

What prompted the move?
My then-wife's dad died, we were getting sick of Berkeley because everything in the Bay Area was so expensive, and there was nothing happening there. So we decided to try Manila. That's when my marriage fell apart. Everything fell apart. I thought, "I hate this place."

Sorry for bringing it up.
That's okay. I like it now.

Is there an art scene in Manila?
Yeah, a handful of people who like reading *Giant Robot* and *Juxtapoz*. I thought they could use some theory. I tried giving them *Artforum,* but they gave it right back.

It seems like a lot of younger artists don't try to change the establishment or be part of it, either. They're in their own world.
The line between graphic design and art has been blurred, and a lot of the kids are trying to fight it from the inside.

You mean like work with Nike or whomever?
Now there are tendencies to collaborate with artists in other fields. There's more of a merging of disciplines and a "team spirit" sort of thing. **A lot of artists are not relying on the mainstream market; they're putting up websites and getting heard and seen and established by themselves. It's a different strategy than "I'm just going to do my own thing."** Before, there were certain valid means of support like big galleries, museums, academies, and big-name critics who would champion you. But that has all fallen apart.

Which era do you belong to?
I'm part of the new one, but I'm out of place. In the Philippines, there isn't

much of an art market. A lot of the newspapers only like nice, traditional stuff like flowers, palm trees on beaches, and colorful patterns. That or abstract things that are very dated.

Maybe the people with money just aren't into the more critical, aggressive stuff?
They're not. I was surprised when <u>I had a show in Manila and it nearly sold out. I thought, "They like my stuff. Is that good or bad? Am I getting benign?"</u> But collectors buy art from my friends who are a lot younger and edgier.

Do you think Filipino collectors perceive and decipher your work the same way collectors do in the US and other countries?
They're probably buying it as an investment, but I can't second-guess them.

Has living in the Philippines changed your approach to art?
Yeah, I think there is a lot of energy in the Philippines right now. I feel there are a lot more possibilities, and <u>it's okay to make mistakes because I'm basically at the bottom of the barrel.</u>

So you think Artforum doesn't care about you anymore?
No, I mean where I am, in the Philippines. I don't give a shit about *Artforum*! It's all an advertisement anyway.

Although, you probably don't make as much money as you used to.
Definitely not, but it's cheap to live there.

A lot of your newer work is text-heavy. Where does that come from?
It just comes from reading too many art mags and picking up quotes from articles or reviews. I pick out the ones that are sometimes true, silly, absurd, pretentious, ridiculous, or offensive, but always have that air of intellectualism. After all, I'm putting it on a $10,000 product that's made of wood, cloth, and some coagulated pigmented muck—I need to make it deep! Like this one: "Contemporary art has abandoned its function as the visual wing of the house of poetry and morphed into a fecklessly transgressive subdivision of the entertainment industry..."

Critics used to describe your art as commentary on colonialism in the Philippines. Now you're trying to kick-start an art scene there. Is there something to that?
Maybe. I don't know. Did I ever say anything about colonialism? I want to be colonized.

Goldilocks and Jollibee are in the US now!
It's reverse colonization: Filipinos colonizing Filipino Americans.

PILIPINAS (O' BATHALA) (1990)
Framed: 22" X 22" | Acrylic paint on canvas | Private Collection | Courtesy of Track 16 Gallery | Photo: William Short.

ALL OF ITS BEAUTY IS IN DENYING ITSELF THE ILLUSION OF BEAUTY (2005)
30" X 24" | Oil on canvas | Private Collection | Courtesy of Lizabeth Oliveria Gallery | Photo: Anthony Cuñha.

WHY I HATE EUROPEANS (1992) | Framed: 74 ³/₁₆ " X 98 ⁷/₁₆ " | Oil paint and collaged paper on canvas | Collection of Tom Patchett | Courtesy of Track 16 Gallery | Photo: William Short.

ARTISTIC ISSUES

Essayists often cite the erotic ideas of French intellectual Georges Bataille, post-Marxist sociology of Jean Baudrillard, and post-colonialism in general when they describe you. How does it feel to be deconstructed like that? Is that what you think about when you're making art?
You can read it as such, but when I'm painting I don't think about those kinds of issues.

Do you read any French situationist writings?
I used to read a lot of theoretical tracts and theory. My favorite is Baudrillard because he's the most nihilistic and the most punk. But if I start to read that kind of critical stuff, I start losing interest.

You think too much about the process?
Or about my role in society. Being an artist is like being a guerrilla.

Is it tough to fuel discussion about your work without flying flags?
I came into the scene at the moment when multiculturalism was a hot topic. In some ways, my art is a reaction to that.

When you see the KKK and swastikas, it doesn't look like I denounce Nazism; I seem to glorify them. I don't know. There was a lot of self-exoticizing coming out of that early multiculturalism movement.

Was it like a Rainbow Coalition back then, or was multiculturalism just a label?
It was just a label made up by academics.

But it got you into shows.
Yeah, it did.

What was it like in the early '90s in LA? Was it full of energy with art shows everywhere?
Not really. It was happening more in academic circles. In art, it's all business.

But it must have been cool to catch that wave.
It was exciting, but back then it was like, "Oh shit!" I felt like an outsider. I'm a fan of artists like Mike Kelley, Paul McCarthy, and Jim Shaw, but a lot of them came from CalArts. I only knew about them through magazines. My style was totally different, so it was weird for me to be there with them. I'm more like the old school, traditional painters, and they're more conceptual.

At that point, did you realize that you wouldn't ever need a real job?
I need one now!

What was the last real job you had?
At a paint store in LA. Before that, I worked at McDonald's, then a photobooth.

You studied art at Cal State Bakersfield?
Yeah, if you could call it studying. **Art school is a weird thing. When you go to art school, you don't really study.** You just try to make connections. Students go to UCLA so they can play the scene. But if you go to Bakersfield, there's nothing there and no good teachers.

Was Central California an inspiration for any of your work?
No, it was just an anecdote of my youth. It's like a desolate nihilism, like *Dawn of the Dead*.

How does it make you feel when you watch the documentary about you, God Is My Co-Pilot?
I cringe. I shouldn't have agreed to it.

Usually, they make those about someone who is senile or dead.
Maybe they should have done it when I was dead! I hate seeing and hearing myself. It's like, "I said that? That's so stupid." When you're in front of a camera, you stiffen up and think, "I want to say something smart or deep or be cool or funny or at least charming."

Were you flattered to be asked?
Actually, I thought it was work! It was produced by Tom Patchett, who was a good friend of mine and also a collector.

One of your pieces at his gallery had your art on the floor and business correspondence on the walls. Were you okay with people walking on your paintings?
I thought it was cool. I wanted to do something nontraditional, but have paintings. And I step on my paintings anyway—to add texture.

When you revisit older pieces, do they stand the test of time?
I feel like I could improve on them. Like, "This would look good in black and white."

What does it mean for you to improve on your art?
I guess one's taste follows what's happening at that time. Now that I'm doing different stuff, I want to modernize old stuff to what's happening now.

And what's happening now?
I don't know! But I notice that a lot of German artists are putting up religious iconography and swastikas.

You were way ahead of them!
Yeah, I got invited to participate in this major group show in 1992 called Documenta in Kassel, Germany. The organizers were Belgian. They picked the paintings with the swastikas, and I was the one who got censored. Now the hottest German artists like Jonathan Meese and Andy Hope have chockablock swastikas in their paintings, and the Europeans are eating it up. Talk about me having sour grapes. In some pop-punk, hip-hop sense, being bad is cool. It's an interesting place, though, because you can buy a lot of art for, like, a dollar.

When you were a student, didn't you copy Catholic paintings?
A priest was looking for artists to copy paintings, icons, and stuff in the church. It was supposedly conservation.

And you sold the pieces to tourists!
Yeah. I'm sure there's someone in New Mexico or Arizona selling them as Mexican. In a way, what I'm doing now is the same thing.

Reinterpreting votive candle imagery?
Selling it as something of value. I think everything now is pop art. Artists are merging boundaries and disciplines.

Is it true that you served dog meat at an art opening?
It was 1993, and I was invited to paint a banner to be exhibited in the lobby of LA's City Hall for the Filipino Arts Festival. The image of a dog on a spit and a monkey turning the spit handle reflected the racist stereotypes of Filipinos: dog-eaters and monkeys with no tails. There were all these symbols, too, like crosses, swastikas, dollar signs, and a Star of David. The ruckus started when FACE (Filipino American City Employees) started protesting, yelling that, "Flips don't eat dogs, only Vietnamese, Koreans, and Chinese do." Eventually, my Flip artist friends and I replaced the banner with a more "pleasant" one, but with the same motifs: the same dog, but in a hot tub, and a monkey-like human manning the barbecue grill with daisies and rainbows under a beautiful LA sunset. As part of the festival, there was a panel discussion, and the banner took center stage. My friends and I decided to cook some ground-up dog meat, put it in lumpia, and serve it to the people attending. We didn't tell anybody that dog meat was inside the lumpia. It was actually delicious!

Do you ever get hate mail or angry confrontations?
Mostly from the Fil-Am community. When that brouhaha about the dog banner happened, a lot of them wanted to kick my ass. **I was the butt of jokes in community papers, like a crossword puzzle had my name as the answer to "gago" (stupid).** There was one Filipino artist who had a website devoted to trashing me, but I don't think it's around anymore.

Although there is a lot of anger and energy in your work, I've always suspected that you're secretly happy.
I don't know. I'm happy doing it. I'd like to be a happy artist.

Do you think your art is pretty?
Yeah, I think it's pretty: the composition,
texture, paints, and all the formalist stuff.

Even though you once said that you use cheap paint!
Cheap paints make the best surfaces. One tube costs
just a dollar, so I can do whatever I want with it.
But if I buy a Sennelier oil paint that costs $35
a tube, I'd use a drop, and say, "That's enough."

Do you skimp on brushes, too?
I skimp on everything.

Is that the Asian in you?
Maybe. I'm pragmatic.

BUSINESS AND PLEASURE

Are there Asian artists you ever get lumped with?
They cluster me with Mexican artists like Frida
Kahlo because of the Baroque handling and
composition. I don't mind. It's all art to me.

**Sometimes people mention you in the same breath
as Jean-Michel Basquiat.**
Ah, Basquiat. He's an early influence of mine. When he died,
his value went up and critics started dissing

him as just a scenester and a jerk who was manipulated by
his dealers and didn't know what he was doing. But in the
latter part of the '90s, the artists who were getting rec-
ognition started citing Basquiat as an influence. Now he
has pretty much been validated within academic circles.

Doesn't that boost the value of your work?
It's okay. I don't care. I try to be invisible anyway.

**Are you the sort of artist who has to paint
or else you get depressed?**
It's more like I'm depressed because I have to
paint. No, I'm happy. I just get bored, so I have
to paint. I have nothing better to do.

Is there such a thing as painter's block?
For me? Yeah. For stimulation, I can just go around
the city and look around, or go to a bookstore,
open a book, and copy somebody else.

**Maybe it's better if an artist doesn't interact
with people.**
Yeah, people don't even see my stuff unless they go
into galleries. I don't show my stuff when it's in the
studio, so the gallerists get surprised or freak out and
say, "This isn't what I was expecting. You don't get shown
next time." That has happened to me several times.

VOMITOS POST-HISTORICUS (1988)
75" X 83" | Oil on unstretched canvas | Collection of Tom Patchett | Courtesy of Track 16 Gallery | Photo: William Short.

**I gather your ex-wife isn't your
manager anymore.**
She used to be a buffer. I had
no chemistry with my dealers
back then, so I didn't want to talk
with them. When I did, I didn't
want to be an artist anymore.
Now I'm doing everything. It's
fun because the gallerists that
I work with in the Philippines,
the States, and Europe are my
friends. I hang out with them.

**Do your shows sell out before
they open?**
No, I've never sold out a show. I
barely sell three pieces at an opening.
But what I like about Europe is that
the gallerists there have parents
who were gallerists or collectors.
It's part of a tradition, and if I don't
sell, it's okay. They know what an
artist's life is like, so they support
me. Here in the United States, if
you don't sell half of your show,
you're never going to show again!

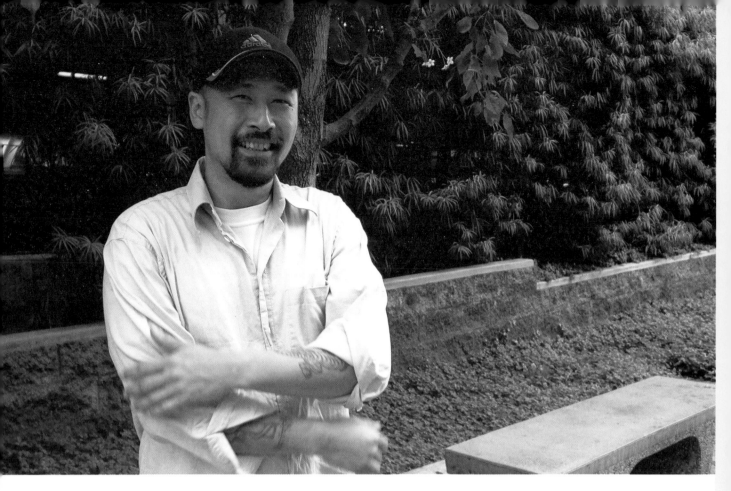

That's a lot of pressure.
It is a different way of doing things. I'm a lot more pressured when I show here than when I show in Europe.

Do you ever get tired of skulls and swastikas and want to paint something like bunnies?
I've painted bunnies. I'm into ducks now.

Are they evil ducks or something?
I don't know. Donald Duck is an evil duck, but he looks harmless! But I see the elements as abstracts anyway. Josef Albers will paint a square his entire life.

What type of kid were you? Were you a good student?
No, I was a recent immigrant. I had problems with the language and stuff like that. So I was a good bad student.

Were there other Filipinos?
The Filipinos in Seattle were into Cameo, Morris Day, and R&B. I was not into that at all. I was really into my music, and that's what got me into art.

Did specific album covers affect you?
I'd buy albums with good covers. Classic ones were by Raymond Pettibon. A lot of the Dead Kennedys album covers were great.

Have you ever painted an album cover?
My painting is on the back of Beck's *Odelay*. I knew him back in the early '90s when he worked at the MOCA bookstore. I used to hang out with a lot of improvisatory musicians at the Onyx Cafe in '88 and '89. A lot of them were on John Zorn's label. I didn't play, but once, I did a live backdrop painting. I always hung out with musicians instead of people in the art scene.

What do you do these days when you're not dealing with art?
I don't know. Hang out and drink San Miguel.

Do you ever drink when you paint?
No, I'm a social drinker.

What's with the tiger and cross tattoos on your forearms? They look like your art.
I wanted generic tattoos.

Where did you get them?
Don Ed Hardy. He's a tattoo god and a good friend of mine. I met him at an art opening in Honolulu. I was going to get more tattoos, but my ex-wife said she wasn't going to sleep with me if I did.

What does that Sanskrit say?
"You owe me money, you bum." It's Tibetan. 🐱

THAT GOOD ALL OVER FEELING...

PIMPLE BAIL BONDS

RAY

RAY FONG

HELLO ERIC. VERY LONG TIME
INDEED. I WAS IN BOSTON AND
CAME ACROSS YOUR MAGAZINE W/
THE NEW GRAPHICS. THAT ISSUE
WILL DEFINE EVERY ISSUE —
AS OLD SCHOOL. I HAV
NEW YORK FOR THE LA
SPRING IS NICE ON TH
SEABOARD. OTHER THAN
HAVE BEEN WELL, AND I
SAME FOR YOU. CALL ME

WARMEST REGARDS

ERIC: This looks like the LACMA parking lot, which has a story of its own. Mike Louie and I went down there, where McGee and Kilgallen were painting murals in the dimly-lit lot as part of the Made in California exhibition (2000). We skateboarded, had them draw in a sketchbook, and ate at Canter's on Fairfax. Later on, it was the ultimate date spot. The lot was open

TWIST OF FATE

words | Eric Nakamura

pictures | Barry McGee + Eric Nakamura

Following the birth of his daughter, Asha, and subsequent tragic death of his wife, Margaret Kilgallen, in 2001, little was heard from Barry McGee. This year, the San Francisco artist (who goes by the name "Twist" when painting in the streets) resurfaced with numerous shows in highbrow venues around the world, such as the Prado Museum, Liverpool Biennial, and MoMA. We thought this would be a perfect time to pay him a visit.

Life in the McGee household is hectic. In addition to what you'd find in any home—family photos, clean dishes, handwritten notes, and toys (a mini-banjo seems to be Asha's favorite)—there are assorted art books, zines, flyers, and dolls. Barry's works in progress sit alongside pieces by his wife, Thomas Campbell, Todd James, and hobo train-hopper Bozo Texino. In a nook sits even more art, a small computer, a printer, and a fax machine. Kitchen space serves as a temporary working area while the home studio is completed.

Asha fights for Barry's attention as he sits on an easy chair that appears to be his designated spot in the living room. When I press "record," he looks uncomfortable. We've known each other for years, but interviewing the soft-spoken Barry is like pulling teeth—although he does tell me funny stories that I'm not allowed to share. I guess he and I both like to talk about stupid things. After a while, we decide to get out of the house.

Barry looks ahead and says, "Wet cement." We're riding bikes through the dirty streets of the Mission District, passing arty-looking warehouses and modest homes. Pedaling an old one-speed hybrid cruiser, I trail Barry and 16-month-old Asha, who's in the kiddie seat. We take a break from running errands (checking Barry's PO box, sending mail, and dropping off film) to inspect a tiny patch of moist gray sidewalk that's been blocked off by a couple cones. It's already been visited by many taggers, but there's plenty of space for more writing.

At our next stop, I step in dog shit in the communal hallway that leads to the front door of Barry's studio. The space is messy, arty, beat-up, and colorful. A graffiti artist named John who lives in the studio's loft shows us digital pictures of him bombing the trains that will transport fans to the World Series at Pacific Bell Park. Then he shows Barry his assigned freelance work: grinding paint off used aerosol cans for later use in an art piece.

The studio is filled with art. There are squiggles on paper by J. Otto Seibold (who rents part of the space), some of Barry's work in various stages of completion, and bits and pieces of work by Margaret. Scattered around Barry's area are pint bottles that he bought for $1 apiece from winos on the street, whose portraits he paints on them.

After Barry looks over his desk, which is covered with little slips of paper, the ride goes on. We look in disbelief at walls once covered by graffiti that have been coated with other tones to make a new mess. We get cheap Chinese food at Jade Cafe No. 2 and then go back to his house.

The next day I return to pick up this issue's cover art. Asha is asleep and Barry is sitting at his kitchen table with a fine brush in hand. One of the faces is giving him trouble, and it's taking him longer than he wants. It all looks good to me—the open mouth, the buck teeth, and the other variations—but he keeps saying "no," repainting the background color, and blow-drying it before painting once more. We chat a little, but I've been tuned out.

In the other room, I read a zine while listening to the blow-dryer go on and off a few times until I finally hear something like "yep." He hands me the artwork and says "Good luck," as if he just messed up.

ASHA'S TIME

How old is Asha?
BARRY McGEE: Sixteen months old. She says a few words, but it's just garble.

How is it raising her on your own?
At first, my family and friends were helping and coming over a couple of times a week. I have her a lot of the time now. When I do art things, my brother and sister come over and help, but if it's just a two-day thing, I'll bring her. It's easier sometimes.

Does that affect your routine?
Sure, everything. I like the challenge. **I don't want her to be raised by nannies and babysitters.** She's my responsibility. I might as well be there. It's what I want.

Your daughter has a fund. How does that work?
I was never looking for help, but someone set it up. It feels a little weird. In the beginning, that fund was set up for breast milk. There's a milk bank in San Jose, but it's like $9 an ounce. It was $1,200 for three weeks' [worth]. It's out of control, but it was one of Margaret's wishes. I would have done it on my own, but people sent checks so I used it for milk. It's a nonprofit place and there are people who donate milk. Everybody raised her.

CREATIONISM

Was it hard to get back into art?
It's something that I can always do. It's getting back into work mode, which was good to do. Finding the time to tinker on things or whatnot. I like working.

ERIC: The Barry McGee fan would trip out on all of this. Some of these pages were actual faxes! Today, Barry

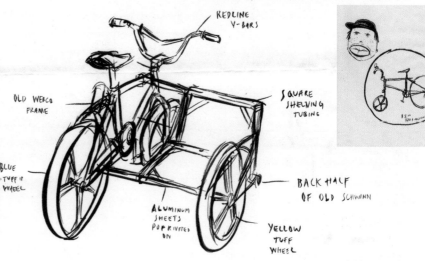

REDLINE
V-BARS

OLD WEBCO
FRAME

SQUARE
SHELVING
TUBING

BLUE
"TUFF"
WHEEL

BACK HALF
OF OLD SCHWINN

ALUMINUM
SHEETS
POP RIVETED
ON

YELLOW
TUFF
WHEEL

KING FOR A DAY

How have things changed for you?
My whole perspective's different on everything, obviously. I don't dillydally around. I don't have patience for it. I think of other things I can be doing. If I have five minutes when someone's watching her, I'll use that five minutes. It's an enormous span of time, and I know what I can do in it. I just use time efficiently.

How about the art? Is it changing?
Not really.

But your style seems to be changing, like with the spray-painted hair on some of your characters.
Those are incremental movements. Different to me is like painting with your left hand.

What do you think about people who say that you're doing the same thing over and over?
I feel bad. I agree with them. **Repetition is part of graffiti, but I don't know if it's part of art.** I would want to see something different every couple of years.

But I think there are many changes!
If you notice them. The thing with [painting on] trucks is bigger for me. Using trucks is new. It's interesting, fun to look at, and fairly easy. I tell [exhibitors] I want a truck, they go to the wrecking yard and take digital photos, and I look at them on the computer. I say, "I like that one," and they get it for me. It's something big and physical; it's a challenge.

How often do you paint?
Hardly at all. If there's a show, I'll just do it, and make things there on the walls.

What happens to the walls after you paint on them?
I used to think they got thrown away. I found out that people are pulling them out of the dumpsters and selling them.

What do you think about the prices for your art, especially on eBay?
It's ridiculous. It's also stolen, too. I can always tell when it's stolen. It has fingerprints, it is smeared, and the wire is [messed up], so it probably got yanked.

Your work looks like folk art. How does it fit into folk art?
That's generous of you; I wish it fit in better. I love it. For some reason, I think about folk art in the best scenario. It's art that hasn't been exploited; it's not in-the-know and definitely not selling on eBay. Don't you get warm and fuzzy when you see good folk art? You get this gut feeling because it's an honest portrayal. That's what I think I see when I see good folk art. It might be art that's discovered when an artist passes away, and you see some grand plans of how the world operates through his eyes. I think folk has something to do with being handmade—it has a human touch to it, crafted with care and love. Things done by hand are refreshing to me.

Do you work at home?
I've done a few drawings. When Asha goes to sleep, I work. It's different entirely. I'm figuring out how to do things in 5 minutes or 10 minutes if I have to. I do it when I can do it.

Are you making less stuff now?
I'm not sure. This year I've done a lot and had a lot of shows. Too many—like a band that won't get down from the stage.

☗ ERIC: Barry has a fascination with bikes—part of his upbringing was BMX bikes. He told me about how his father picked a bicycle for him by the

I like the detail on the doll that was made from your art.
I wanted to make a toy that can get you in trouble. There are thousands of toys, and I like that anyone can make one now. It's a level playing field. It's like anyone can make a movie now.

STATE OF THE ART

Have you noticed that more people have been paying attention to design and art in the last five years?
I think art and design are becoming one. A billboard can be a painted [by an artist] to sell. **It's all cross-contaminated.** People in executive positions are like, "Will you do this ad campaign? It's edgy, it speaks to a certain demographic of kids, and we can make money off of it." And the [artist] is paid to do his or her thing and there's an attachment on the corner about who paid for the billboard. I don't know if it's right, but I don't mind at all.

People are having more art shows these days, too.
I know what you're talking about, but I'm not convinced people are selling paintings in galleries and living off of it. It's more doing art for fill-in-the-blank car commercials.

What commercial work have you done?
I haven't done any commercial work, [although] one billboard will be sponsored by Nike to some degree. Someone's paying for it, but I'm not sure. There's an old guard—the commercial gallery with white walls and the receptionist—that's on the way out. It seems like a stale way of selling art. If you have a store, you sell different things, and you sell art. Don't you think that's more interesting? It's more hybrid and it cuts across who normally buys art. It used to be collectors. Kids buy art now; I don't think they used to do that. And if they can't buy the art, they could buy a magazine or a T-shirt.

Do you still have time to do the Twist stuff?
It still interests me a lot. I still do it even when I'm with Asha, [although] it would be ridiculous to get caught and have a baby with you. I'm not going to take her out bombing or anything.

NONVERBAL COMMUNICATION

What do you say when people ask what your art is about?
I'd hope the buyer is sophisticated enough to understand the visual language instead of asking, "What does it all mean?" **If you see a good painting, you see a good painting. I'm not exactly sure why, and I'd rather not hear anything about it. It's several things that come together at once. My talking about it probably takes away from what I do.**

No way.
Seriously. The less known, the more interesting. It's like these guys [*pointing to a Bozo Texino marking on a piece of metal*]: They have all these things going on because no one knows who they are. People wonder why, people are trying to figure it out. It's amazing. It's the perfect way for the image to communicate.

Is that why I don't read many articles about you?
That's a better sign than ever, don't you think?

Way back, you talked a lot about destruction.
It's what we do as a nation. I'm no different than any other American. [My last show in] England was about that. It was about making huge messes and just leaving. There's no art in it—just destruction.

What about your photography?
They're not art photos; they describe what's going on. What is real art? I'm not convinced that drawing on paper is real art. **I could draw on a mailbox with a pen and a person can be upset about it, [who] then comes into the studio and looks at a drawing on paper and says, "This is really great."** I don't know what's what. I think they're both viable forms of communicating through imagery.

Do you consider photos to be part of your work?
I think they work best when they are grouped with the

quality of welds from the factory, which meant he got a Cook Bros. Racing frame. These are highly coveted today. He later sent me this drawing (left page, "king for a day") of a sidehack bike since I rode one as a young teen.

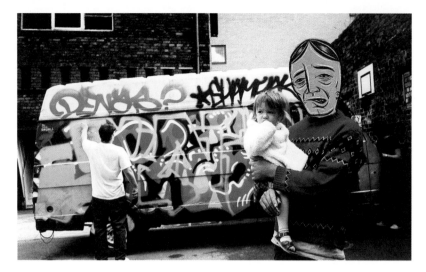

drawings. They help illustrate. I'm not sure what I'm after, but they go together with the drawings.

The photos of homeless folks are interesting without being exploitative.
They're just people sleeping on the street. They're out there on the street with all the other things I like as part of the landscape. It's not that shocking in San Francisco to see someone laid out. People walk right by. The body might be dead and no one will approach it. You get accustomed to it.

Have you seen the audience for your art change at all?
I don't know who my audience is, but kids always find out about it.

STREETLIGHT PEOPLE

How does one stay relevant in gallery art and street art?
I don't want people in the art world to think that people who used to do stuff on the street advance, go into a gallery, and regard their street stuff as, "when I was younger..." There's never going to be that separation with me. I like the idea of running back to the streets. <u>There's a tendency to cleanse the artist from the street and put him safely in the gallery</u>: "We found this guy on the street and he was doing graffiti. Then we brought him into the art world and it's been perfect ever since."

Do you see people do that?
Sure. I've done that.

When did you realize it?
When you're sitting around and talking to a bunch of people you're not interested in, or have no knowledge of what's going on outside.

What do you think about the concept of street art?
It's a catchword. It's like an extreme sport. It probably won't be long until it's a contest, where someone goes out with a backpack...It's already whored out. I went to the JCPenney menswear department and there were puffy jackets with third-generation graffiti on them! I think of it as a gauge of what the public accepts and tolerates. <u>People like this clean version when they're buying clothes: "This is urban. There's graffiti on it." At the same time, a tag on the wall will drive them crazy.</u>

FAMILY BUSINESS

Is it difficult when you get questions and comments about Margaret and her art?
I'm kind of honored if someone wants to say something about Margaret's work or was inspired by it. It's not something I'm trying to hide. It's not something I'm running away from. It's a part of me. It was a special time to be with her. You have to be able to share things with other people who were inspired by her, too. Someone just emailed me a tattoo of one of Margaret's fighting woman pieces. The guy got it to remind him to live life to its fullest, and not be slack. I was like, "Great." It was nice that [Margaret's art] could move someone. I think images have a life of their own.

How is Margaret's art (like what's at the Whitney) being handled?
They needed someone to redo the piece on the wall. Rather than have workers do it, I did it. But I don't think I'd do that again unless it was in a museum setting.

Is her work in storage?
I have a lot of it at the studio. Museums wanted to purchase parts of it at one time, so I'm dealing with that kind of stuff. It's more of an archival setting than in a studio.

Are you okay with making decisions on it?
It's to maintain the longevity of her work. All her slides and all the pieces she sold—all that needs to be cataloged and stuff. She's had an influence on a lot of people—and me, too—in making art. I think it's important.

What about your work?
I couldn't care less about mine. It's about getting rid of mine. 🐱

ERIC: The day I interviewed Barry, we rode to get "junky" Chinese somewhere in the Mission District in San Francisco, his daughter Asha riding along on a seat. We stopped to tag in wet concrete, and he later showed me his old fixed gear bicycles in the garage. Asha's now graduated from UCSB.

The cover of this issue (see p. 451) was painted at his house. There's a photo of him working on it (prev. page, left). I was waiting and waiting, and watched as I missed flight after flight. You'd think he'd have this down and it would be easy, but he repainted one area over and over. It's thicker in that spot, with layers of art that didn't make the final cut beneath. Luckily, I made the last flight out and the original art for the cover was put in a thin paper bag that went through the x-ray at the airport. The piece currently hangs in my bedroom.

Today, you can still meet Barry McGee at an exhibition and he'll be inundated with folks in line trying to get him to tag a book.

🐱 **ERIC:** Margaret Kilgallen's work is featured in a touring solo exhibition—That's Where the Beauty Is. It's currently not on view, but maybe it will be again, someday soon. GR also co-distributed her first monograph, In the Sweet Bye & Bye.

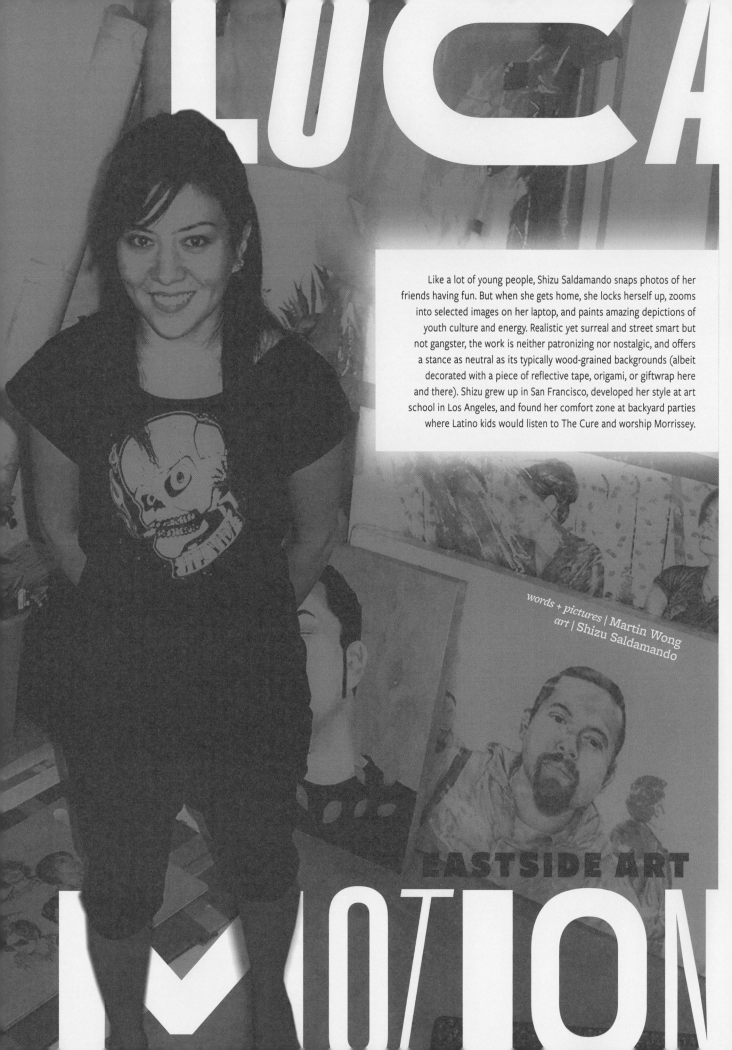

LOCA

Like a lot of young people, Shizu Saldamando snaps photos of her friends having fun. But when she gets home, she locks herself up, zooms into selected images on her laptop, and paints amazing depictions of youth culture and energy. Realistic yet surreal and street smart but not gangster, the work is neither patronizing nor nostalgic, and offers a stance as neutral as its typically wood-grained backgrounds (albeit decorated with a piece of reflective tape, origami, or giftwrap here and there). Shizu grew up in San Francisco, developed her style at art school in Los Angeles, and found her comfort zone at backyard parties where Latino kids would listen to The Cure and worship Morrissey.

words + pictures | Martin Wong
art | Shizu Saldamando

EASTSIDE ART

MOTION

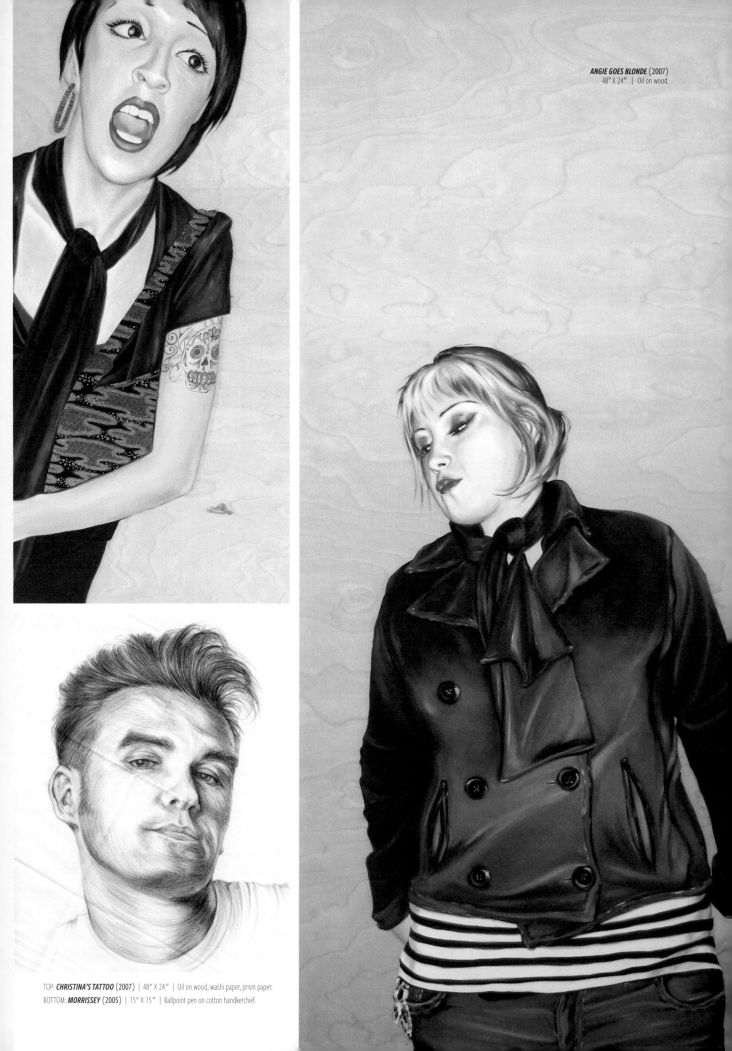

ANGIE GOES BLONDE (2007) | 48" X 24" | Oil on wood.

TOP: *CHRISTINA'S TATTOO* (2007) | 48" X 24" | Oil on wood, washi paper, prism paper.
BOTTOM: *MORRISSEY* (2005) | 15" X 15" | Ballpoint pen on cotton handkerchief.

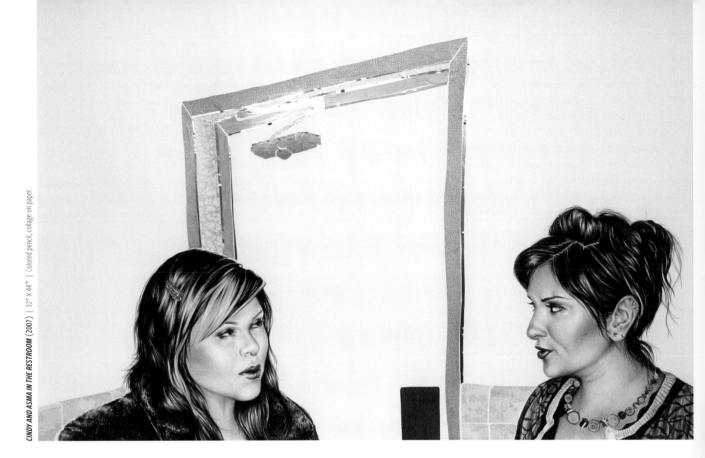

CINDY AND ASMA IN THE RESTROOM (2007) | 32" X 44" | Colored pencil, collage on paper.

What was it like growing up in the Mission?
SHIZU SALDAMANDO: I was born and raised there. It was really urban before the dot-com explosion. Then I had to take the bus out to the Sunset District, which was a horrible experience.

Was this the early '90s? Did you go to Epicenter or Gilman Street?
In high school I was in this all-Asian girl punk band and we used to go to Berkeley on weekends. But I'd still hang out with the Latino kids. I was with both groups, although I dressed more like a chola and wore tons more makeup than I do now. I had baggy clothes and hoop earrings because that was the uniform for the neighborhood. There was this Samoan gang in the Potrero Hill projects and other gangs I'd see when I rode the bus. People would get jumped all the time, so you had to fit in.

When did you move to Los Angeles?
I moved right after high school. I got accepted to UCLA, where I did different types of art, including video and installation.

A lot of people who move down from the Bay Area just complain about how LA has no culture, weather, or public transportation.
Really? I liked LA a lot. My roommate was from Whittier and I'd go home with her to house parties where they'd play punk or The Smiths. It was cool.

There's something about LA, Latinos, and Morrissey.
Yeah, it's great. I wrote a paper about how Morrissey was the son of Irish immigrants and he went to Catholic school in England. He had an immigrant, working-class experience and grew up alienated, like the sons and daughters of Mexican immigrants. A lot of his music is about how he suffers so much, but how virtue can only come through suffering. That's what the church says, too. Poor people are told that they have to suffer in this life so they can reap the benefits in Heaven. That keeps them from rising up against The Man.

Also, being in love but staying chaste.
That's a big part of it as well. He's an alternative to the hypermacho ideal.

His pompadour and suits probably don't hurt.
The whole rockabilly aesthetic and look are the perfect combination.

The subjects of your art touch on that style, too.

I find it fascinating how people spend a lot of time on that sort of thing. It's hard to access that look. **The people that I tend to paint don't get their look from Hot Topic. Being a portrait artist, I'm interested in people and what makes one's self.** It doesn't have to be a punk scene or anything like that. I took photos of my friends on the dance floor and painted a series of them. They weren't done up in crazy style. I just thought it was interesting. It's a documentation of this moment that I'm living.

Is it hard to be a part of something and document it at the same time?

I think everyone goes through that. "Am I authentic?" "Am I a poseur?" **There is no authentic self. We're all mixed up and we're all part of a world that's constantly changing and morphing. There is no "I'm a real Asian" or "I'm a real Mexican."** The experience is so varied. That's the crux of a lot of my work.

Your experience must be interesting. As a Mexican, you're projected as a loca. As an Asian, it's a violin player.

At Lowell High School, I was stereotyped as a Mexican. I was stereotyped more as a girl than anything else in college, like I was some dumbass or a chick.

What sort of art did you like when you were young?

I never really had art books, but my parents always had a lot of prints by Chicano artists. My friend's dad was Juan Fuentes, and I saw him working on a drawing at his house. It was a portrait of three of his cholo friends in pencil and it was really beautiful. I really remember his images and his work is really great.

Your work is really down to earth, but you definitely know the history.

Well, I've been to art school for so long. At CalArts, they really make you position yourself. **If you're going to do painting, you better know why, what the references are, and what new thing you're bringing to make it valid. They're especially mistrustful about painting because it's sellable.** Are you doing it for the gimmick of it or because of the way it functions? Going to CalArts made me more determined to focus on making interesting paintings and prove it can be done.

Did art school change your style?

The painting is pretty much the same as it was when I left UCLA. CalArts changed the way I think about it and talk about it. But I'm open to different things. I made a funeral wreath out of washi paper after going to the Japanese American National Museum and hearing a tour guide talk about funerals that happened at the internment camps. If you look closely at the pictures of funerals, you'll see that they made paper flowers because they didn't have real ones. The piece is an homage to my uncle who went to the camps. All my mom's family was interned in the camps.

Does art run in your family?

My aunt was really into rubber stamps. She'd have stamp parties with origami and glass beads and have Tupperware full of markers. It was this social thing for her, where she'd invite friends over to do crafts together. She and my grandmother go to a craft class every Tuesday. My grandmother also does all this beautiful embroidery and knitting work. My grandfather did lots of really detailed sand painting and carving. He was a great artist but never exhibited or anything. It was for pleasure. Oh, and my uncle is a killer hairdresser.

And your dad's side of your family?

I come from a long line of pharmacists. My dad's dad was a pharmacist and so are my uncles and cousins. My dad's mother's side was involved in the medical field back in Mexico as well. My parents are like the black sheep of their families, which are really conservative and middle class, and work for nonprofits and grassroots activism. They live in a really small house in San Francisco away from everybody. My mom's family is in LA and my dad's family is in Arizona.

HIGHLAND PARK LUAU (2007) | 32" x 64" | Oil paint, gold leaf, origami paper on found screen.

It seems like you usually paint friends. Do you ever paint strangers?

Often, it's a friend's friend. We'll be introduced and I'll snap a picture. But for the most part, I don't feel comfortable painting strangers. I think as time goes on, I'll end up doing that. Recently, I was with this girl at a bar and she had a crazy look. I really wanted to paint her, but she made a face every time I was about to take a picture of her. I think she was feeling unattractive. She was overweight and had blonde hair with black roots, and I thought she looked really cool. She wouldn't have known, but I felt weird about it. **I don't want to just take photos. That's really quick and too easy. When you draw, you really meditate on the image and think about the person. That's a little less exploitative to me. It's translated through my hands and seems more special.**

Your subjects are attractive but not because of movie-star looks.

I painted my friend Martha, and she's really pretty. She had a spread in Parisian *Vogue* when she was 19. When I painted her, I was really bummed out. Her skin is like porcelain. I thought, "I'm never painting you again. You're too attractive and there's nothing I can do." I like to show human qualities that aren't so perfect.

You started out by copying Teen Angel drawings?

That's where the ballpoint-pen-on-handkerchief series came from. I really have no connections to prison culture, so I drew my friends. And Dave Gahan, Robert Smith, Morrissey, and Siouxsie Sioux. Her hair was really hard. Later I thought, why am I doing this on handkerchiefs? Now I do them on canvas and found sheets. It's actually easier than drawing on paper, which doesn't have that give.

What about sticker paper or glitter?

I don't really like making backgrounds, so that makes it more fun and interesting for me. It's like a ready-made signifier. Sticker paper is something pop from a vending machine. Although the subjects aren't Japanese, origami paper is a Japanese reference. **People are very wary of blatant cultural references, thinking that it limits the range of art, but you can't really separate anything from a culture.** Even a minimalist's work makes references to the industrial complexes. I use materials that I was exposed to when I was young, not because I'm making a statement about being a Japanese person, but because I'm familiar with it. 🐱

TOP: *CANDACE AND A FORTY* (2007) | 28" X 18" | Colored pencil, prism paper, glitter on paper.
BOTTOM: *DOWNEY HAPPY BIRTHDAY* (2007) | 50" X 40" | Colored pencil, collage on paper.

GOOD WOOD
CARVER HIGH

words + pictures | Eric Nakamura

There's a mystique around the crafts made by Japanese Americans while incarcerated in concentration camps during World War II, and bird carving is a well-documented example. The Japanese American National Museum in Los Angeles is home to between 150 and 200 pieces, according to curator Karin Higa. "There were classes, and what's interesting is that the art was circulated. People would send them to their neighbors in camp or other camps."

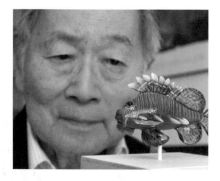

ERIC: The title is a throwback to the *The White Shadow*. We were fans of the television show and it's a very

Perhaps the most stunning examples of the genre are by Yoneguma and Kiyoka Takahashi, who were incarcerated in Poston, Arizona. After being released, they continued to work as a team in Southern California, forming a small and influential company, Takahashi Birds, which placed Japanese American carvings into the psyche of collectors around the world.

When Arnie Fujita was a teenager behind barbed wire in Poston, he rarely saw his mother carve tiny birds out of wood. Collecting scraps from crates behind the mess hall, Toshi Fujita meticulously fashioned delicate and elaborate pieces that looked as real as taxidermy, but were just inches across.

After 45 years in the advertising and graphic arts industries, Arnie decided to try his hand at carving birds. This was 10 years ago, and his subject matter went from birds to fish to just about anything. The self-taught craftsman learned by picking up books about birds, as well as sources on Egyptian art and Inuit art. Making a piece used to take all day, but he's honed it into a science. He carves for one hour, paints for two, and then lacquers. So far, Arnie has carved around 2,000 pieces and sold all but a few.

Samples of his mother's work sit behind glass at his brother's house. Arnie's birds have a smoother look than his mother's birds, which are more detailed. Arnie is still intrigued by his mother's work. **"I can't understand how my mother did it. She was better than me,"** he says. "But she had lots of time."

On a shelf in his Los Angeles home, Arnie has a few examples of mako sharks, fish, turtles, cats, a bear, crosses, and random animals, some of which aren't complete. Health problems—including some that stem from the laborious three-day lacquering process—have forced Arnie to stop churning out pieces. His doctor told him that the lacquer was making him sick. Arnie relates, "It's so bad, I put a mask on." Sawdust has also slowed him down, but he's already planning a comeback.

He starts by drawing a design on a bare block of basswood (the material that architects use to make models, just one step tougher than balsa wood). Then he cuts the shape with a coping saw and uses blades, knives, and sandpaper. Arnie mentions that Swiss Army knives work well for carving, as long as they're sharp.

Arnie can carve some animals by memory. "It's embedded in my head. The hardest are sharks because they're really thin. Tiger sharks are really long, but they almost look like snakes. I used to watch a lot of nature videos."

Other designs are from his niece, an oceanography scientist in Micronesia. He works hard at the details that few notice. He points at a lionfish model and says, "You gotta put exactly 16 feathers in it. The worst is the mako shark—you have to put 32 teeth into each one. I learned a lot about fish; there are thousands of species, and you can't ever stop looking at them."

Arnie says, "In my mind's eye, I'm hoping to get things as close as possible." Yet he won't hesitate to point out how a frog's foot has four toes instead of the three he fashioned, and how the real colors aren't actually as vibrant as some of his depictions are.

He once got a phone call from a woman who asked why the birds are lacquered, since feathers are not glassy. He offered to give her a refund, but she said no. Another call was more of a design problem. "I got a call from the aquarium in Long Beach," he recalls. "The guy who takes care of the fishes told me I got a fin in the wrong place!" He repaired it quickly and now laughs about it.

Locating original carvings by Arnie Fujita might be even tougher than finding signed Takahashi Birds, since they sell so quickly. Don Sakai from Satsuma Imports in West LA has carried Arnie's work for the last few years and has gone through multiple restocks. He elaborates, "Some people buy them because they like a particular fish, like a trout. The bulk buy them as a gift for someone."

Planning his carving comeback, Arnie says that he may unleash "500 or 1,000" pieces next year. He's already carved his own deceased cat, a brother's dog, and two Bruce Lee heads. When I suggest inanimate objects such as cars or bicycles, Arnie agrees and adds, "Maybe monkeys, apes, dinosaurs, or giraffes. And insects—my wife asks for a ladybug." 🐱

ERIC: I feel for those who tried to find a life within the confines of an incarceration camp. Generations later, there's still a lot of anger and trauma, but I think for those folks, it was also a matter of survival and practicality—doing crafts is part of that. I made an effort to collect vintage carvings from Japanese Americans, and although there are tons of remakes, I found a few. The ones pictured in this article by Arnie Fujita are even better than I remembered. He was great and his watch was cool, too. Fujita passed in 2012.

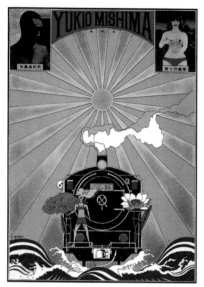

FORKS and FATE

In 1965, an artist designed a poster for a group exhibition in Tokyo that launched him from obscurity to pop-culture icon status. The exhibition, entitled Persona, featured works by various artists on the topic of identity. His was a poster of a man in a black suit hanging from a noose, a single rose in hand, with the caption, "HAVING REACHED A CLIMAX AT THE AGE OF 29, I WAS DEAD." To the left of those words was a picture of the creator at one-and-a-half years old; to the right, a class photo with a hand gesture for sex superimposed over it. Arched above all this was his name in capital letters: TADANORI YOKOO.

In the following years, critical attention to both Yokoo's radical and autobiographical works made him the bad boy of the design world. His notoriety and associations even landed him an acting role in a movie, *Diary of a Shinjuku Thief*, where he played a book thief. Of course, he designed the accompanying poster. He would also design pieces for albums, books, and other high-profile projects.

In 1972, the 36-year-old graphic designer had a one-man exhibition at MoMA. In 2008, he sits in a small room on the second floor of the Japan Society to give a talk about his paintings, which he has worked on exclusively for the last 28 years. Yokoo-san (pronounced Yoko-oh san) has been on New York soil for only two days, and answers a few questions for a local Japanese newspaper alongside an old friend and interpreter. "In a sense, I never fully became a graphic designer," he explains, "because I never took clients' demands all that seriously." Looking at Yokoo-san, you wouldn't guess he is 72 this year. **He has defied the effects of time and maintained his youthful appearance by doing one thing: keeping true to himself. Says Yokoo-san, "I didn't start out by wanting to be a graphic designer. I wanted to be a painter."** Tadanori Yokoo's current show at the Friedman Benda Gallery in Chelsea is his first American gallery exhibition.

words + pictures | Jimmy Cheung *art* | Tadanori Yokoo c/o Friedman Benda

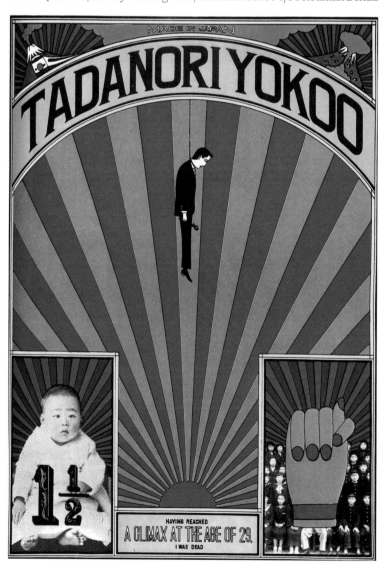

ERIC: I forgot that this transpired—an interview with a legend like Tadanori Yokoo is an amazing thing

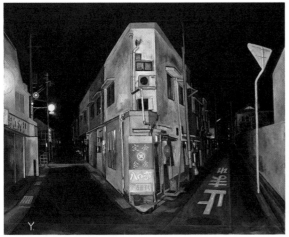

A DARK NIGHT'S FLASHING: N CITY-V (2000) | 130.3 X 162.1 cm | Acrylic on canvas.

Installment at Friedman Benda Gallery, 2008.

Why did you decide to stop graphic design and start painting?
TADANORI YOKOO: <u>I was finished with graphic design because I had nothing left to say with it.</u> Through my painting, I could be loyal to myself.

When you are painting, do your thoughts constantly change or do you stick with a singular goal throughout the process?
The idea for a painting forms in my head as shards of images and shapes. That's where it begins and that's how I enter the process. But, in fact, the notion that you can complete a painting is illusory. **Basically, all my paintings are incomplete because it's impossible to finish one.**

Over the past 40 or so years, has there been a noticeable change in the way you come up with ideas for your works?
It's not a sudden burst of change; it's kind of a gradual change at the pace of everyday life. There have been cases where, say, I've gotten sick or had an accident and there's been a big change, but otherwise it's more like the evolution of human cells on our body: They die, new ones are formed, and it's kind of a much more evolutionary change.

The idea of death is a repeated concept in your paintings. Why is the subject so interesting for you?
As long as you're alive, it's inevitable that you think about death. Death stands in opposition to everything—from beauty to sex to life—so it's kind of an inevitable fascination.

You have done a series of paintings that feature an intersection of two paths. What are you trying to convey with the paths? Maybe life and death?
I encounter my themes rather than plan them in advance. There was a place I used to visit when I was a child. I can't remember if it was a shop or a restaurant, but I went back to see if it was there and it was gone. I photographed the location that night, and when I developed the photograph the next morning, it was a very compelling piece. I decided to make a painting of when the structure had been there. I actually wasn't interested in the fork in the road at all. If people who see it find it a metaphor, that's fine, but I didn't paint it that way.

Would you still make art if there were no spectators?
Absolutely.

Do you have plans to try new media or do anything exciting in the near future?
No plans for the future. **As I said, my works are about encounters, so I don't plan them.** Fate will take care of everything and I don't have to decide.

How do you compare the vibe of New York in the '70s to its vibe today?
I think of New York as a walking city. I have always experienced it by walking around all day. But this time, because of the exhibition and everything, I'm really just seeing it from the inside of a car and it doesn't feel like New York. **The other thing I've noticed is that the dirty New York, the filthy New York that gave me so much energy when it was filled with dog poop and stray papers, now feels so clean. It just...feels like Tokyo.**

If you were to create a painting to represent America, who or what would be a part of that painting?
I don't really want to paint one of America. If I decide I want to paint America, I'll let you know. 🐾

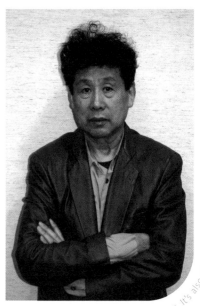

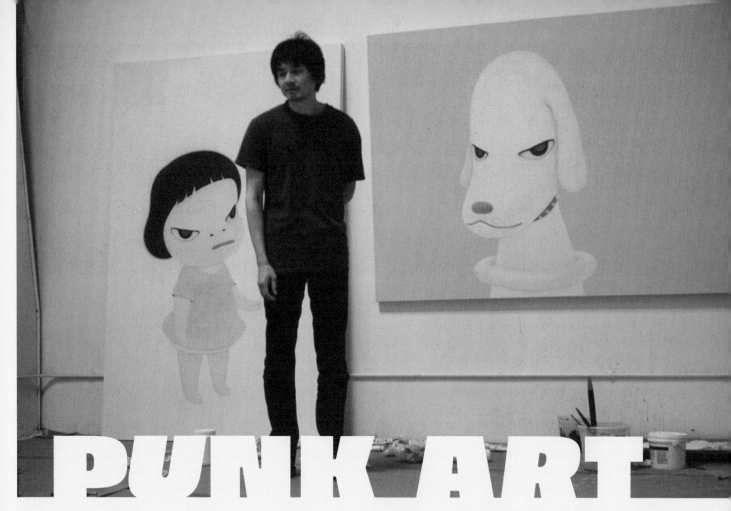

PUNK ART

words | Eric Nakamura

pictures | Eric Nakamura + Pryor Praczukowski

When artist Yoshitomo Nara showed up at the Giant Robot compound, he smiled as he shyly checked out things sitting on our shelves and hanging on our walls. "Our office isn't that interesting," I insisted, so we left for his studio. There, he demonstrated his creative process, which is basically blasting punk CDs and smoking cigarettes. His English is mixed with a Japanese German accent, and he uses tons of thought before each sentence. While he claims his English is bad, he's able to communicate his innermost thoughts, and that's something I appreciate. He's special, and that shows in his artwork and his words.

Why are you always drawing kids?

YOSHITOMO NARA: Oh, it's very difficult to answer. Why don't I draw adults and landscapes or other things? Because I can draw kids and animals. I don't know why, from which ground, which reason...I just want to draw something. Something must be child or animals. I don't know why. Most of the images are coming from my childhood experiences. Difficult!

Why are the kids aggressive with mean faces?

I never thought about whether they're angry or happy. I want to say everyone has every feeling, and children also have their feelings. And when I'm at work, I am sad or angry, and then I can make a good painting. After finishing that, I'm very happy, not ever sad. I don't know why. Maybe the feelings before making paintings were sad, and sad feelings went to the painting. Then, I'm getting happy. But, I think they [*pointing at painting*] are not angry, not so sad, and not

so happy. And they have their own feelings, like you have your own feelings. They have their own feelings. That's why we can't understand children or animals. If you're happy, you think, "Why are you angry? Be happy." When you're sad, you say, "You look so angry, but I'm much more sad or angry."

What makes you angry or sad?

For example, when I watch TV news, wars, or civil wars happen every day, everywhere. But I don't know what is war. I didn't have experience, which is good. But I know just history of war from books and photographs. I didn't see real war scenes. Maybe I can make much more sad and realistic paintings—soldiers with bandages, blood, one eye out—but it's not real for me. But I want to make something. I want to protest, or I want to say something against war or against poverty, against wrong. But with my reality...such paintings came.

You're talking about television, but what about without TV?

I can find it everywhere. When I walked on the street, I saw so many homeless people in LA, in Tokyo, and in Germany, I saw many people from East Europe. I can mix it together with my childhood. I was born in 1959; it was a time of economic development in Japan. Most parents must work for their children or themselves or family. There were many latchkey children. I was one of them.

Tell me about it.

I lived in the countryside in Japan, but my parents had to work like parents everywhere. My house was on top of the hill and there was 300 meters between my house and the next house. There were no children my age. I was alone. But I could play with cats, dogs, sheep, and sometimes cows! They licked my foot—it's very comfortable!

What about when you got older?

When I was teenager, I looked for what is myself. Who am I? Then from my own experiences, I got feeling I was sad. Alone, no friends, and parents were not at home until the night. Oh, sad. But it's interesting. I never thought about being sad when I was a child. I was happy with my cats and dogs and imaginations and made drawings. And when I was back from kindergarten, I made tons of drawings with cats and dogs every day. I made stories like Kamishibai (it was like a puppet show) from '50s or '60s. That was my childhood.

I was a typical teenager. Playing with friends is much more fun than thinking about who I am, or looking for childhood experiences. Before finishing high school, we must decide about going to a university or getting a job. I thought maybe university. At the time, end of '70s, Japanese thought everyone have to have a career, a good university, and a company.

But which department? I liked literature and poems, such things, so I thought, go to department of literature. We have to go to yobiko (after-school study class). I lived in the countryside, so I had to go to Tokyo in the summer for a seminar for a month.

Jugyo was not so good. But for the exam or the test, I never interested in the lesson. Sometimes, I went out and smoked a cigarette. **One day, a guy came to me and said, "Here, I have a ticket for nude sketches." Huh? He thought I was student of seminar for art department. I had long hair like an artist. I was 17, I said, "Nude? Okay!"** I thought maybe I can make good drawings. I got only good marks in art every time in class.

I thought I can. I asked how much. And it was $5 for three hours. I got some materials and sketchbooks and then went into the room and started. But the model was not a young girl, but old lady. Like sumo wrestler. That's why I could concentrate. Then the teacher came to me and asked, "Which university do you want to go?" I said, "I want to go to the department of literature." He said, "No, you're kidding. Why? But you have talent." The things that are the most important to you are inside you. You find it when you don't look for it. But making drawings and art, I never found it because it was too near to me. "Can I go to the art university?" I asked. He said, "Of course." I came from the countryside, I couldn't have such an idea to go to an art university. I could go to the art university, but we got just exercises, very academic. But where am I? This is not art, it's practice and exercise, from Western history. I could make good academic drawings. But I thought about what is my own art or art history. I came from countryside; there's no museums—still none—and I never saw real oil paintings or real sculpture there. But I got many images. People say it's not art from TV, comic books…It doesn't matter. Countryside or big city, I can use such images as my reality.

Then, end of first year, at the art university. I went on a European tour with $3,000 for three months. And I stayed at youth hostels everywhere. Beginning of the trip I visited the museums. Then a few days later, I lost the kind of feeling to go to the museum; it's not my history, I couldn't connect. But at the youth hostel, I could talk to the people from the same generation from all over the world. I can't speak English, but I can say something like favorite bands or filmmakers, or favorite authors. After Europe trip, I thought about art; art must be from my own history or my own experiences, then I began to use such kind of images.

Why did you move to Germany?

End of art university, I have a feeling I was a bad student. I went to the studio at the university not many times. I never made art for teachers. Teachers said, "This is the motif; make a painting." I couldn't make them. So I made many paintings and drawings at home. I showed it to the teacher. End of the university, I thought I want to study and learn, but I'm graduating. I got MA, then there is no university I want to go in Japan. I wanted to go to London to study, and I want to be a good student in Europe. But I couldn't in London; it's very expensive. We have to pay two or three times more because we are not European Union country. In Germany, it's free. That's why I moved to Germany, because I didn't need money.

In one interview you mentioned Kurt Cobain.
I think the music is real music for me. I found reality there. It's not for the audience. It's not for people, it's not a message for the people. My paintings say no message, just a message for me, or from me to me. Kurt Cobain's songs have a similarity I found. I saw him once in Germany. He looked so tired, and they couldn't play good.

What kind of cartoons and shows did you watch?
Typical Japanese animations like *Gigantor* (black and white), *Atom*, and *Speed Racer* was my favorite. Kurt Cobain said he also liked *Speed Racer* and Chim-Chim the monkey. That's why people say, "You have a big influence from Japanese animation." No. I have a big influence from my childhood. The animations gave me influence, but they are not animations you can now watch on TV. The animations I saw before when I was a child. Sometimes, people have kind of nostalgic feelings from my paintings.

How does punk mix with your artwork?
I like punk rock, but not only as music but as sign of independence. Or just their music, simple, straight. They use just what they need, not many elements. Like my paintings, maybe. Very simple. Just one.

What are you listening to now?
NOFX, Guitar Wolf, MxPx, Jon Spencer, Suicidal Tendencies, US Bombs, Eastern Youth.

What about when you do the big sculptures? Do you have the same process as when you're painting?
No, it's different. Painting is much more with spontaneity. Sculpture idea comes spontaneous, but process of making sculptures, not spontaneous. It's kind of master work. It's very hard.

Do you use molding or something?
Yes. I make at first with Styrofoam with some paper or knives, then with plaster, and take the Styrofoam out, then resin and fiberglass.

Does your sculpting give you the same feeling as painting?
Feeling? Yeah. Difference is just process.

Is there a feeling behind your kids walking with their eyes closed?
They are looking for something very important, very real, but they can't give the name. Just something. Everyone has something to find out, they want to find out.

The cups sculpture...I read somewhere that it's like an amusement park ride. Is that the idea?
Yeah, the idea comes also spontaneous. Have you seen Japanese storefront displays? [*He draws a rectangular statue base.*] And when I saw this one, not ramen, but coffee cup, then I got idea. I waited, and I got idea.

A lot of times the character has its eyes kind of closed. Is it tired or is it thinking or...
They are thinking. They are not tired. They are very positive. When they have negative eyes, they are positive. Mentality is positive.

What are they thinking about?
They are thinking about what you are thinking about.

How about the dogs?
Why I make paintings of dogs? Maybe they are intelligent. Cats are not so intelligent. But dogs are very intelligent. That's why they are sometimes sad. "Stay!" Then they stay. "Eat!" "Sit!" It's very sad. Like small children. Maybe that's why I'm using the images of dogs.

When and why are you moving back to Japan?
Reason is very simple. I get bad feeling at the airport in Frankfurt. Customs workers at the airport check me, it takes long time. "This, this, this, this, this...'I bought this one at a discount shop, 1,500 yen,'" They said, "But real cost is 10,000 yen, you have to pay tax for this one." "Why? I am using every time this one." Then, "Please come with me. This room." It's a small room with a sink and mirror, and I thought, "Oh, maybe many drug dealers came here and they check their..." It's a bad feeling, and then I said, "I don't like Germany." I have many good friends in Germany; they are German. But just a few bad Germans made me sad. I didn't do anything bad. But the handling people were, "Come! Stay here! Hidoi, dakara, sugoku o...boku no atama ni kite, moo, anata...doitsu sumanai."

Did they check your butthole?
Sore wa shinakatta. Boku ga [*motions like unbuttoning pants*]. "No, no, it's okay." Three days after, I got letter from owner of building I'm using as a studio. Everybody working there must go in three months. Then I go back to Japan.

What are you going to do in Japan?
My next exhibition in Japan is

September next year in Yokohama Museum. It's a big museum. They can give me money for publication and maybe for studio.

People will say your work is very pop culture. How do you feel about that?
It's true. I saw so many pop culture myself, too. For example, I go to the museum for two hours, another two hours I saw movie, another two hours I read novels, or every time I'm listening to music. We can't escape from pop culture. If you have life in the big city or small city, if you spend your life in countryside, one shop in one village, then something different.

So what's next? Are you going to keep doing this same kind of work?
It's a very difficult question because, can you imagine, there is one tube with ideas. I used already all of the tube for the painting or sculptures everything. And I can see another tube near this older tube which is full of ideas. I can take if I want, but I like this old tube. The last bit in the first tube, maybe, is important. I think, "Maybe I will use this old tube until I die." Because I like this idea, I will change not so quickly, but probably after few years, I will take another tube.

Would your work change if you got married?
I think so. That's why I never like to get married.

Oh really? You said in the car that you wished you were going to get married.
It's like, mom talking, not as an artist. Maybe everybody wants to marry. It's natural, because they want to keep their DNA. **I already made so many children [*points to his art*].** It's DNA for me.

So are you going to have kids one day?
I want to have kids, but not my kids. But maybe I want to have somewhere from Bangladesh or Vietnam. Parentless child.

Oh, I see. Adoption.
Yes, Hindus, Buddhists, Christians,
if I have enough money.

Do people buy your work?
I don't sell, but galleries in LA or
Tokyo do. It's getting expensive.
That's why I made so many books.
Young people can't buy my work.
Ten years ago, this size drawing
(8.5″ X 11″) cost less than $30
with color. Now $800. [*Pointing to
his canvas art*] $1,500 before, but
now, $8,000. Great, yeah, but for
young audience, impossible.

**So do you like to sell your work,
or do you want to keep it?**
Oh yeah. But not sell, I think it's
better to go to a place. 🐱

ERIC: *After decades, an artist
like Yoshitomo Nara is like your
favorite band. When they come
through town, you can try and
catch them, and if you don't, they'll
be back soon with something new.
I wish it was a bit more often with
artists, but it's sort of like that—if
you're lucky, you get to visit them.*

*This visit to Nara's temporary
studio in Venice, California
stands out as an art highlight
today. The paintings you see
in the backgrounds are among
his greatest and now command
eight figures at auctions. All that
aside, Nara is humble, sweet,
and soft spoken. He's into punk
rock—one place among many
where we intersected—which
he listens to decently loud. He
actually stayed close by to the
GR office and dropped in a
couple times. Today his hair is
white, he has his own museum
called N's Yard in Northern
Japan, and he's still willing to
stage dive at a punk rock show.*

*These photos on the right were
taken at my mother's restaurant,
Hakata in Santa Monica.*

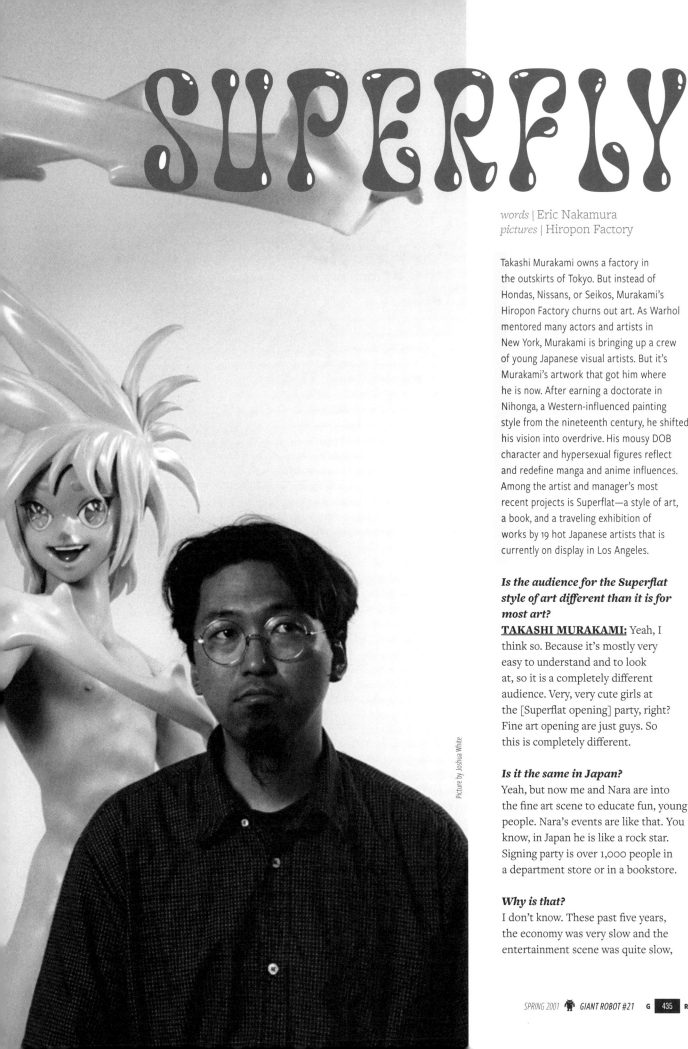

SUPERFLY

words | Eric Nakamura
pictures | Hiropon Factory

Takashi Murakami owns a factory in the outskirts of Tokyo. But instead of Hondas, Nissans, or Seikos, Murakami's Hiropon Factory churns out art. As Warhol mentored many actors and artists in New York, Murakami is bringing up a crew of young Japanese visual artists. But it's Murakami's artwork that got him where he is now. After earning a doctorate in Nihonga, a Western-influenced painting style from the nineteenth century, he shifted his vision into overdrive. His mousy DOB character and hypersexual figures reflect and redefine manga and anime influences. Among the artist and manager's most recent projects is Superflat—a style of art, a book, and a traveling exhibition of works by 19 hot Japanese artists that is currently on display in Los Angeles.

Is the audience for the Superflat style of art different than it is for most art?
TAKASHI MURAKAMI: Yeah, I think so. Because it's mostly very easy to understand and to look at, so it is a completely different audience. Very, very cute girls at the [Superflat opening] party, right? Fine art opening are just guys. So this is completely different.

Is it the same in Japan?
Yeah, but now me and Nara are into the fine art scene to educate fun, young people. Nara's events are like that. You know, in Japan he is like a rock star. Signing party is over 1,000 people in a department store or in a bookstore.

Why is that?
I don't know. These past five years, the economy was very slow and the entertainment scene was quite slow,

so we came up with the subculture scene. Game culture in 1994 was 100 percent, now it is 70 percent. This 30 percent, we can attach to. That's why fine art is popular in Japan.

THE BEGINNING

How did you start your artwork? Did you go to school?
I got my education in Japanese traditional painting first. Do you know Shinro Ohtake? I was very surprised when I saw his show in Tokyo, and I wanted to change my lifestyle to contemporary art. It was about 12 years ago. Then I debuted at a small gallery. I made some classic models, some small dolls, or something like that. It was 1991 or 1992.

Before that, what was your style? Traditional painting? What did it look like?
It looked like a very traditional Western/ traditional Japanese mixed painting style. But it was boring. I really loved the Amazon River. I usually drew big fish. I don't know why, but I really loved the fish, their shape. Almost six years, every day, I drew the big fish.

Would you say your current work, or I guess work after 1990, is more true to yourself?
Now it is completely true. Because this show, the Superflat in Los Angeles, doesn't have my work, right? I just designed the banner. It is maybe my style. I would like to edit the art. I

KIKI WITH MOSS (2000)
TAKASHI MURALKAMI © TAKASHI MURAKAMI HIROPON 2000
600 X 600 mm | Acrylic on canvas | Courtesy of Galerie Emmanuel Perrotin

really like producing, but I don't know why I'm making my pieces.

You don't know why?
Yeah, the creation and editing is very interesting. And then sometimes making my stuff is very stressful. I don't have talent. Mr. [Yoshinori] Kanada has big talent, and Mr. [Koji] Morimoto, too. I'm jealous for these artists. It's true.

Can you tell me about how you make those elaborate statues?
I order the people, the sculptor, and otaku people. I don't touch the art in the process. I paint. I really respect the otaku people, so I give them big money—because of very bad situation in Japan, not much respect for the otaku people. Animation people are employed for very cheap. But this time it is fine art. The figure project is very complicated because many things are in one piece. <u>I would like to know what is otaku culture. I would like to know if I can make a revolution for the marketing of otaku culture and sexuality in fine art.</u> My personality has kind of machinery fetishism. So I would like to satisfy my desire. It's many things in one package.

Where does that come from in yourself?
Everything comes from Mr. Kanada. When I was in high school, I saw the movie *Space Battleship Yamato* for the first time. I'm so impressed when starship explodes. It's very beautiful. I would like to join that.

Why do people in Japan maybe look down on otaku? Almost everybody used to have those toys and grew up the same way, but now some people don't understand. Why?
It's game revolution, right? Don't you think?

Maybe.
Because you know, the Gameboy culture is completely different to our culture. I mean, how old are you now?

I'm 31.
Up to 26–27 years old, people usually play the Gameboy. They listen to the

DOB TOTEM POLE (2000)
TAKASHI MURALKAMI © TAKASHI MURAKAMI HIROPON 2000
600 X 600 mm | Acrylic on canvas | Courtesy of Galerie Emmanuel Perrotin

MiniDisc and play the Gameboy in a train for a long time. It is completely different [than] when I was the same age. I had the Walkman and read manga.

But it's still a subculture, right? What do you think about Japanese pop culture?
Example: SMAP, right? The idol groups. It is very unusual system—the management system wants to get to the big success, the idols don't have talent. Japanese culture, you know, copies US stuff, European stuff, and Western culture for a long time after World War II, right? Each time they have had a fake, fake, fake, fake, fake, fake...Fake history and now it becomes the original. It is an idol culture I think. <u>In US, they are still looking for the true talent like, I don't know, Bob Dylan, or something like that. I don't know the music scene, but we don't need to look for exactly true talent—we can just promote fake talent and it is okay.</u>

Do you think that's more interesting?
I don't know. Because, you know, it is very difficult to explain to the Japanese people because they aren't interested in my issues. It is just everyday. It is

DOB CAMOUFLAGE (2000)
TAKASHI MURALKAMI © TAKASHI MURAKAMI HIROPON 2000 | 1200 X 1200 mm | Acrylic on canvas | Courtesy of Galerie Emmanuel Perrotin

normal. I'm really interested in exact Japanese culture, but in Japan I cannot present art in a very straight way. It is so hard, so I must make a twist.

What do you mean "twist"? So they can understand it?
Do you know that TV show Beat Takeshi created with art? Every week some young artist brings some stuff, like a *Gong Show*, and I usually judge. But very serious art people hate this: "Why is Murakami doing this comedy show?" But the general audience doesn't understand. If I was just in the fine art scene in US and in small market in Japan, nobody would notice what is fine art. I have to go inside the TV industry, so I say "twisted." Because I don't want to very often, but you know I am acting. And then the audience follows me, but when they see my events and I am very serious, they are surprised. Some then start their art education, but very few people understand and they don't come back. So I thought I have to make some textbook. It is Superflat.

DOB

What is your blue mouse character called?
DOB.

What does that mean?
It's like the early '70s, the very popular in gag cartoons. Do you know the baseball manga? I was very big fan. This character said, "Doboshite, doboshite," and I've directly picked it up, and transferred it to the fine art scene. DOB, it's, you know, a very silly thing. But you know, art is a silly thing. And then I attached my character direct to the fine art scene. Some intelligent curators don't understand DOB, but the reviews about DOB are funny, I think.

When did you create that character?
1995.

How did you create that? Is it Illustrator? Computer? Drawing paper?
By myself, I just draw on paper and then I give it to my staff. They make in Illustrator and Photoshop. I don't know how they do it.

Do you have time to do your own artwork?
I wake up at 5:00 in the morning every day. My studio team comes at 9:00, so I draw for two or three hours, but that's it. Just a short time. In a week, you know, maybe I draw for myself about six hours.

What are you drawing now? What kind of things?
It's for sculptures and paintings, kind of small things. They trace it many times, so I choose the exact line, then I give it to the computer people.

Can you explain the eyeball?
It is the concept from when I saw *The Matrix*. Special effects have many cameras, but the Western art, the picture history, tries to get the technique in 3-D. The illusion is in 2-D, but they want to make the illusion in 3-D. *The Matrix* thing is completely flat because there are many camera eyes. So it is very familiar for my feeling with *Ghost in the Shell* creator, Shirow Masamune, who usually draws the manga with very wide range. I think it is very close to *The Matrix* feeling.

You think they're similar?
The Matrix is just one shot, but with many cameras. It is very familiar for me. Manga has one eye, but the next page has a big character. When I see animation stuff, I can see each frame; it is a lot of information. The many-eyeball painting is very didactic, you understand? Many feelings, many eyes.

You're now managing many artists. How do you choose which artists you like?
I choose the very honest person. It's very straight, you know. People I don't like are very proud. I cannot touch those people. Just honest and very true people. So Mr. is quiet and crazy, but looks like an outsider. He is very true and very straight. And Chiho and Aya, too. I can touch their heart, in the core—the core feeling in making fine art. These people I would like to manage.

Do you work with them and talk to them about art?
Very often. You know, when I met Mr. for the first time, his name was Masakatsu Iwamoto, and I interviewed him a lot. At that moment he was creating what looked like Italian art. Art people can understand '60s Italian art. I asked, "What is the favorite thing in your life?" He said, "Erotic manga."

S.M. PK02 A, B, C TYPE 1/1 (2000)
TAKASHI MURALKAMI © TAKASHI MURAKAMI HIROPON 2000
1200 X 1200 mm | Oil, acrylic, fiberglass, and iron | Courtesy of Blum & Poe Gallery, Marianne Boesky Gallery, Tomio Koyama Gallery & Hiropon

And so then, he brought in 300 pieces. I said, "This is your true thing. Why don't you do that?" Then he opened his secret drawing book. "Oh, it is your true thing," and I was very impressed. "It is you." And he said "Really? It is just bad manga." "But it is you. Italian art is not you. This is your true thing, and I recommend it is your way." So he started to do those drawings.

CHARACTERS

Why are characters so popular in Japan?
I cannot explain, but you know sometime I will make a lecture slide show. I have to say some things, but it is not true. So the honest thing is I don't know. Now the big issue in Japan is the kind of mobile phone thing. Mobile now has a camera. It is in a phone to send in an email, one button push. It is kind of characterized, right? Everything is becoming more characterized. The market is big and Japanese people really love to characterize, and so companies make characters again and again.

Every product in Japan has characters.
An art critic in the US said, "I found it looks like the '50s in United States." Bob's Big Boy and many things are characterized, but I'd like to know why

in the US they are slow to characterize everything. Here, *The Powerpuff Girls* are the big thing for the US and Japan characters. <u>Characterized culture will come to the US too, don't you think? Because *Pokémon*'s effect is huge here, too, right?</u>

How is it that you have become the spokesperson about those kinds of things in the media?
I was making the free paper, and now I have a website. I am really active in general. And newspaper people and TV show people used to get my free paper, then they interviewed me.

THE BORDER

In the future, do you want to do more art?
I will make animation stuff in this year, like 20 or 30 minutes, and then I am looking forward to some fun, like John Woo (p. 114). So it's like a border of fine art and commercial film. I would like to create for a new market. Fine art and pop culture.

Do you think art in Japan is getting better? The art scene?
Yeah, this year me and Nara have a very big show in Tokyo and Yokohama. And a big art event will come in the summer. At this moment, it's a big thing.

If you come up quick, you go down quick.
Nara said something like this: "I don't want [to be] very high, you know? To boom in a culture." But he will someday be at the front page of *Esquire* in here, right? And if Chappies start their Japanese TV show this year using the big advertising company, then maybe we start to gain.

What does the name of your company, "Hiropon," mean?
After Second World War, very popular drug, heroin—it was legal. 🐱

ERIC: *Takashi Murakami has been a longtime collaborator and I'm unsure if I met him or if he met me. It turned out he bought the earliest Giant Robot zines in New York in the '90s and supported us along the way. We curated an exhibition together at GR2, and we were among his top sellers for his goods annually. He's invited me to multiple events including Michelin star dinners, art openings, and launches. I've been to his mammoth-sized studio in Saitama, and he's always his old self when we see each other. He sheds the costumed character and he's back to the old Takashi I met in 2001.*

There are only a few people I know of out there who seem to continually top themselves. When you think they've topped out, they keep finding another gear—he might be one of them. Or, maybe it's just me enjoying everything they do—and only a few people can do that as well.

I did interview Murakami more than once, and this is the first of the two. I believe he later mentions that he's become the "Heel" to Yoshitomo Nara's "Hero"—citing a wrestling allegory, yet that's only because of his sophisticated and multi-pronged approach to being huge.

Only a few had the cover twice. I think it's Murakami and Barry McGee, and if we were publishing today, it would be at least a third time each.

words + picture | Eric Nakamura
art | Luke Chueh

CHUEH'S LIFE

Extension (2007)

Since he started showing art in 2003, Luke Chueh has gone from painting small, simple portraits of single characters to making large, elaborate compositions. His signature style employs an instantly recognizable gradation background, and is often used as online avatars by fans. (Listeners of Fall Out Boy saw his art on the cover of the band's 2008 album, *Folie à Deux*.) With little pretension of being a popular or even "lowbrow" artist, the always-smiling 37-year-old resident of Monterey Park, CA, accepts whatever label people put on his work and grows with it. As a result, he has earned a worldwide following of fans and collectors.

So tell me how you started making art.
<u>LUKE CHUEH:</u> I have been making art all my life, but I started doing it professionally in 2003 when I moved to Los Angeles and got involved in the underground art scene, Cannibal Flower art shows, and stuff. Eventually I developed a large-enough portfolio of work to put up a website, get the attention of galleries, and start showing through them. I've slowly worked my way up through the ranks.

I remember seeing your work in 2003 or 2004, and thinking that there were echoes of Yoshitomo Nara in it. Was he an influence?
Oh, absolutely. Takashi Murakami (p. 435), Yoshitomo Nara (p. 430)—all those guys were incredibly influential on my work. I was especially inspired by Nara's sense of minimalism. I am self-taught, so there is no way I would be able to paint like Mark Ryden or Todd Schorr and handle that kind of detail and environment. To see Nara do it with this great comic book kind of flair, but with a fine arts sensibility, was very inspirational to me.

But how did you know what to do? You didn't go to art school, did you?
No, I didn't go to art school, although I have this personal drive to buy as many history books and rent as many art history DVDs as I can. But I did study graphic design at Cal Poly, San Luis Obispo, and I think my designer education has been influential on my painterly, artistic style. One of the things that was hammered into me was the idea that when you're designing advertisements you basically have a window of 2.3 seconds to sell your idea to the audience before they pass it up. And so a lot of my paintings have these sharp narratives that you should be able to catch while you're making your way through a group show. <u>The idea of selling an idea in 2.3 seconds permeates my work, and has definitely worked for me.</u>

Five or six years ago, it seemed like anyone could be an artist. Now it's 2010, and not many have made it without having an art school background. It's like, wow, education actually matters, yet you're one of the very few to make it.
I definitely try to educate myself as much as possible about what's going on out there as well as outside of the genre. <u>You know, I rent those how-to-paint DVDs from Netflix all the time.</u> Hopefully, I'll get something out of it because there's

a lot going on and so many possibilities out there. If I don't open myself up to them, then I'm just screwing myself. I would hope that even artists who went to art school would try to keep that education process going. I mean, they're not going to teach you everything that you can possibly do in five years. You'd be a fool to think you got everything you need.

I know you paint a lot of bears and rabbits. Or is it bears and cats?
I paint cats once in a while, but mostly bears and rabbits.

A lot of blood is part of a narrative, too. Your art didn't have that in the beginning, did it?
No, it didn't, and at first I was kind of nervous because I couldn't imagine most people would want to put images of gory, bloody, mutilated characters on their walls. But I've been putting these kind of cute characters into horrific scenarios and taking it to that level, and I'm pleased that people have been able to accept and embrace it.

Gloomy Bear is another example, right?
Gloomy Bear was definitely a big influence on me. I love the story of the boy finding the little bear in a box, growing up with it, and then the tables turning, followed by the mauling. You always hurt the ones you love.

From early on, a lot of people have used your art as internet avatars. I think that sort of usage spreads out a lot further than you ever intended. How did it happen?
I actually credit that as being instrumental to my success. I'm very grateful for people who have been able to find some sort of personal attachment to my work and then use it for their blogs or Myspace or Facebook pages. Then they go so far as to give me credit. As long as they're not making money off of me, then they can be my guest.

How did that start though? Did you put the image out there so people could download it and use it an icon? Or did people just start doing it?
I think they just grabbed it from my website. And even though I put a lock on my images, people have still been able to find a way around it. But I have no problem with that, and it has really worked out for me in the end. I have been bootlegged by aspiring artists, too, and that's fine. I haven't really seen any bootlegs that make me go, "Wow, that guy is a much better painter than I am," and make me feel small. Actually, I'm flattered by all these activities and the exposure. Any publicity is good publicity.

So how did you turn the corner?
After talking to a couple of galleries, I realized that the cold-call-and-portfolio thing does not work, so I have been kind of just playing it slow. I do let certain galleries know that I'm interested in showing my work with them, and kind of hope that my career and whatever kind of publicity that

I'm able to garner will attract the attention of next-level galleries. They go to my website and contact me online. That's basically how I get in.

I feel like there was a point where things just sped up for you. It's like you had this great exponential leap in the last year or so.
The work evolved a little, and I think that the toys definitely played an important role in my general publicity. <u>The toy thing has definitely been helpful for my career, but I definitely use the format warily because I don't want to be a toy artist.</u>

They're out there.
They're out there and, <u>don't get me wrong, I don't think there's anything wrong with them. But I'm much more interested in painting, and using the toys as a vehicle to help promote that.</u> Recently, I had the release of the black-and-white rabbit toy, and we had people camping out at nine o'clock the night before. It was nuts. I don't think I will ever get those kind of lines for an art show.

That's pretty cool. Has there been anything else?
I've also had certain projects like Fall Out Boy's record. The funny thing is, I still haven't heard the album and still don't have a copy of it. I've never listened to their music before in my life. The only reason why I took the project was because their first run was going to be one million, and <u>how could I dismiss the opportunity to have one million copies of my art distributed around the world? I had artistic control and didn't have an art director going "We want this and this."</u> Of course, I'm sure the editors wouldn't have been very happy if I had bears vomiting blood or shitting green goo on the cover. I took that and the audience into consideration, and it all worked out.

One thing you don't do, or I haven't seen you do much of, is apparel.
A lot of clothing companies contact me about putting my paintings on

Honey Bear (2007)

clothing, but I feel like that just cheapens the work. I have no problem with creating work strictly for apparel, though. <u>The priority just isn't that high because, as I said about becoming a toy artist, there's also "clothing guy."</u>

I think Nara stepped back from products and got back to painting for the same reason.
Once again, they are wonderful tools to help promote the artist. I mean, I still have my old Nara and Murakami shirts but, at the same time, <u>you have to remember what your priority is.</u>

I heard you paint fast. Is that true?
I'm painting faster, but that's only through experience. I like to take a lot of time between steps, step away, and kind of look at a piece to see how it feels and make adjustments if need be. I juggle three or four paintings at the same time.

I notice a lot of your paintings have a gradational background. You've been doing that for a little while.
Yes. Actually, the gradation thing was inspired by Mark Rothko's color fields. In my eyes, one of the more important elements of my work is the color of the background. <u>I create this thing that I call my "color wheel of doom,"</u> where I designate each color with a particular kind of scenario or feeling. Blue, obviously, would be depression. Green could suggest pestilence, but it could also suggest wealth. Red would be like blood, lust, or violence. Orange, being

PROJECT BLACK BOOK

NAME
Luke Chueh

OCCUPATION
Painter / Designer

BLOOD TYPE
?

BIRTHPLACE
Philadelphia

RESIDENCE
Monterey Park / Los Angeles

ASIAN ZODIAC
Ox

WESTERN ZODIAC
Pisces

MOVIE/TV SHOW
Requiem for a Dream / Anthony Bourdain No Reservations

BAND/MUSICAL ARTIST
The Flaming Lips, M83, Mogwai, Beck

WEBSITE/BLOG
www.lukechueh.com

T-SHIRT/ARTICLE OF CLOTHING
Black & Brown

FAVORITE FOOD
Yakatori, Din Tai Fung Pork Dumplings, Ramen (not instant.)

COLLECTION
Luke Chueh Bootlegs

GAME/HOBBY/SPORT
XBox 360, Zombie Farm

TURNING POINT(S)
Moving to Los Angeles

PROUDEST MOMENT(S)
The night I sold my first two paintings, June 2003.

IF I COULD REDO SOMETHING IN LIFE, IT WOULD BE
Thats for me to know, and me to know only.

WHY I EXIST
To Help.

Chueh rhymes with true.

the most, from my understanding, popular color of the criminally insane—I kind of associate it with more insane scenarios. Meanwhile, purple and yellow are almost like wild colors, open to whatever. And then I use grays to suggest coldness or sterility. These colors are the foundation of a painting, and then I use a lot of dark to light gradation to suggest a sense of depth, direction, and environment.

How often do you paint inanimate objects, like still lifes, without a character or figure?

I sketch a lot of inanimate objects to keep myself practicing. One thing I like to talk to other artists about is what kind of techniques they employ. One of the things that a lot of my friends who use oil paint do is take all these photographs of models, or themselves, or their body parts and incorporate them into their paintings. For certain particular paintings that I've done, I would actually do the same thing or download images from the web as source materials—just trying to expand on my abilities and toolkit. The more you have, the better you can be at communicating your ideas. I'm open to trying anything. I've been having fun with denatured wood alcohol lately and the way the alcohol breaks up the pigment into organic, amoeba-like blobs of color.

You've been showing that stuff, too?

It turns up here and there. Obviously, people are familiar with a certain body of work that I do. For a while, I was buying art and I realized that when people buy art—especially when they're new to it—most of them, they want something that is typical of that particular artist. That puts the artist in a bit of a situation, because it locks them down into doing the same thing over and over again. That's something that I struggle with. I've definitely been trying to find opportunities to try different things, but I don't want to divorce myself from what I've built up through the years because that's what people want. We'll see. I'm definitely going to switch things up in a big way.

You mentioned that your art can be taken in by people instantly, and that it's something you struggle with. Is that struggle the actual work or is it having to live with being the "easy-to-get artist guy."

It's definitely personal. I realize what I'm known for and want to grow beyond it. Don't get me wrong; it's a good place to be right now. But, at the same time, when it's no longer a good place to be, you don't want to still be there. I realize I have to keep moving, but the question is, "How am I going to evolve? What direction can I go in without destroying what I already have?" But I've got plans. I'm definitely not going to be letting go of my core idea. My characters have always illustrated very emotional narratives. Now I'm trying to pull them away from that and use them as icons, with more of a contemporary art kind of sensibility. One of the themes I'm going to be working with is communication. In the series, I create the familiar outlines of my characters and fill them

however, and experiment with that. We'll see how it goes. I try to keep an eye on what is going on outside of this entire lowbrow genre. That's one of the things about the lowbrow, pop surrealism scene; it's very incestuous. The artists give the middle finger to the entire contemporary art scene, and I don't think it should be that way. I think that there is a lot of great stuff going on out there that's worth embracing.

You don't hesitate to use the term "lowbrow," but one time you said it half-jokingly, like you were in a lowbrow kind of a show. Do you embrace the label? I know it's somewhat of a bad word for certain artists.
I've grown to accept it. I could go on and on about Robert Williams and the '90s, and how the current crop of artists are very different from that entire hot rod, pin-striping thing. But, at the same time, it's still very illustration-based, and <u>I think that illustration is indeed lowbrow, as opposed to the esoteric, abstract, and insane whatever-the-fuck's-going-on contemporary art.</u> I have a feeling that, at the end of the day, I'm stuck with the lowbrow label, so I might as well come to terms with it.

Is there anything Asian about your art?
Yeah! I grew up reading a lot of manga and watching a lot of anime. Growing up Asian American in Fresno, CA…Let's just say it wasn't easy, and I have found ways of incorporating some of those experiences into my work. Actually, in my last show, I played around with that and did a painting called *Me Play Joke*, which is

a panda standing in front of a Coke can, positioned to look like he has just finished urinating in it. I definitely have fun with that. Being Asian American is unique. You have these two worlds that need satisfying: the Asian part, which usually is tied in with your parents and your family, and the American part, which has a lot to do with your social environment and friends. You have to find a way of balancing those two elements and, of course, that's something you explore in your magazine a lot. I find ways of dabbling with it in my work here and there, too. 🦇

Life n Times of Mecha Sad Bear (2009)

ERIC: *Among all of these comments I get to add in, I think Luke Chueh's entry might be the most difficult. To me, Luke represents Giant Robot changing—he was the cover artist for the final issue, #68, but helped usher me into being a better art curator—and what pushed me along when Giant Robot magazine shut down. Even to this day, when there is doubt or a problem, Luke has a solution, and that alone is as impressive as his art. Fom issue 68 to today, which is roughly a dozen or so years, I can say that we've grown up together.*

This article also represents all who came after the magazine. Luke led the way to the many artists who are now peers, friends, and pillars of the GR Artists community—a hefty list (see pp. 458–463). From Yoskay Yamamoto, Mari Inukai, Katsuya Terada, and Theo Ellsworth; to a younger generation of artists like Felicia Chiao, Maggie Chiang, Kelly Sux, and Rain Szeto; to name a few. Many of them aren't named in this entire publication, but would have undoubtedly been on the cover of an issue of Giant Robot at least once. This would be one of the reasons I wish the magazine were around today. Yet, I'm glad to curate their work in multiple GR settings. Let's keep going.

thank

for contributing to *Giant Robot* magazine

Aaron Brown
Aaron Stewart-Ahn
Abby Armada
Adam Lau
Adam Robezzoli
Adrian Favell
Adrian Tomine
Aileen Son
Akiko Tetsuya
Akio Iida
Alan Williams
Albert Lee
Albert Reyes
Alex English
Alexia Montibon-
 Larsson
Alexis Ching
Alison Kim
Amanda Lovell
Amazing Améziane
Amit Gilboa
Amy Davis
Anderson Le
Andrea Sung
Andrew Lam
Andrew Sun
Andy Wang
Angela Bizzari
Angela Liu
Angelyn Wong
Angie Camacho
Angie Lee
Angie Wang
Anjali Prasertong
Anna Sophie
 Loewenberg
Anne Ishii
Anthony Acosta
Anthony Lew
April Liu
Ara Ashjian
Ara Kim
Audrey Ednalino
Audrey Shiomi
Ava Kaufman
Avery McTaggert

Ayako Fujitani
Barry Hamaguchi
Ben Clark
Beth Accomando
Betty Hallock
Bill Marquez
Bill Poon
Bob Calhoun
Bobby Carter
Bobby Kim
Brandon Kim
Brent Fierro
Brian Houska
Brian Ralph
Brian Rasser
Brian Tse
Bryan McCauley
Candace Mack
Carina Cha
Carla Avitable
Carlos De La Garza
Carmina Ocampo
Caroline Poon
Caroline Suzuki
Carolline Kim
Cate Park
Catherine Lo
Cathy Camper
Cesar Fabello
Chako Suzuki
Chantal Acosta
Charles Song
Charlie Xia
Chi-hui Yang
Chow Ah Beng
Chris Alfaro
Chris Baker
Chris Canuck
Chris Deaner
Chris Hayashida
Christel Leung
Christine Kim
Christine Muzquiz
Clarissa Woo
Claudine Ko
Colin Geddes

Colombene Jenner
Corey Arnold
Corina Fastwolf
Curtis Lin
Cynthia Dea
D.M. Fukuhara
Damon Krukowski
Dan Eldridge
Dan Huang
Dan Lee
Dan Morey
Dan Ryan
Dan-ah Kim
Daniel Lim
Daniel Wu
Danny Smith
Daria Yudacufski
Daryl Chin
Dave Hoang
David Chien
David Choe
David Horvath
David Hyde
David Moss
David Walker
David Weiner
David Yu
Deanne Cheuk
Deanne Oi
Denise Ho
Derek Bevil
Derek Yu
Derral Chen
Deru
DJ Infinity
Dora Quach
Doug Kim
Duke Seino
Eddie Rayden
Elizabeth Kim
Emi Yoda
Emiko Eda
Emilio Santoyo
Emily Ryan
Emmanuel
 Yarbrough

Eric Anderson
Eric Cheng
Eric Elizabeth
Eric Lau
Eric Matthies
Eric Wang
Erica Gee
Erika Ishii
Eros David
Eungie Joo
Evan Mack
Fawn Fruits
Felicia Daniel
Felix Lau
Gabby Cheung
Gabe Soria
Gabie Strong
Gabriel Ritter
Gary Chou
Gary S.H. Lee
Gavin DeGraff
Gayle Peck
Gene Chung
Gerry Mak
Gil Kuno
Giovanni Reda
Glen E. Friedman
Grace Hung
Graham Kolbeins
Grant Kakehashi
Greg Chang
Greg Papazian
Greg Wong
Gregory Han
Hamilton Stephens
Hane C. Lee
Happy Tsugawa-
 Banta
Harry Kim
Heath Row
Heeyeon Chang
Helen Yoshida
Hellen Jo
Herden Daza
Heseon Park
I.H. Kuniyuki

Isis Jara
Izumi Tezuka
J. Grant Brittain
J. Otto Seibold
J. Scott Burgeson
Jai Tanju
Jame Piña
James Baluyut
James Lee
James Leung
Jamie Zawinski
Jane Hseu
Janice Chiou
Jasmine Ong
Jason Jaworski
Jay Babcock
Jay Bain
Jay Jao
Jayson Sae Saue
Jeff Briggs
Jeff Gaskell
Jeff Hong
Jeff Palmer
jeffstaple
Jenn Quinly
Jenny Choi
Jenny Kwok
Jenny Liang
Jenny Yun
Jessica Lew
Jessica Lum
Jessica Sanders
Jessie Mann
Jim Coursey
Jimmy Cheung
Jimmy Lee
Joe Gross
Joe Hahn
Joe Stillwater
Joel Montague
John Matsumura
John O'Conner
John Pham
Jon Campbell
Jon Humphries
Jon Moritsugu

you

Jon Yokogawa	Lawrence Cheung	Michael Zagaris	Pryor	Simon Lei
Jordan Crane	Lawrence Paul	Michelle Borok	Praczukowski	Simon Moran
Joseph Baribeau	Evangelista	Michelle Cabalu	Queena Kim	Singo Hayashi
Joseph Peter	Lawton Chiu	Michelle Loc	Rachel Felstein	Sky Whitehead
Josh Orick	LeRoy Grannis	Mike Fong	Rachel Ng	Sooyoung Park
Josh Spear	Liberty Lidz	Mike Park	Rachel Rinaldo	Sophie He
Joyce Lee	Lilia Kawakami	Mike Pendon	Raghunath Cappo	Souther Salazar
Judy Wang	Linda Tang	Mike Reyes	Raina Lee	Stephanie Carbone
Julie Shiroishi	Ling Wu Liu	Mike Tesi	Ray Barbee	Stephen Chiu
Julienne Lin	Lisa Katayama	Mike Wu	Ray Potes	Steve Khoo
Justin Dean	Lisa Strouss	Mimi Soo-Hoo	Renard Garr	Steve Reeder
Justina Ly	Lizerne Guiting	Ming Tran	Rick Valenzuela	Steven Yi
Kaia Wong	Lori Spears	Minju Pak	Rita Yoon	Sun-Min Kim
Kaori Kasai	Louie Cordero	Mira Lew	Rob Sato	Susan Cho
Kaori Shoji	Louise Chen	Mitch Burman	Rob Schroeder	Tae Won Yu
Karin Anna	Lucy Kim	Mitch Mitchell	Robert Bernal	Tanya O.
Cheung	Luis Rios	Monkmus	Robert Ito	Ted Lai
Karina Santos	Lynn Padilla	Monti Lawrence	Robin Laananen	Teena Apeles
Karol Mora	Mabel Ko	Munkao	Robynn Iwata	Terence Lam
Katie McQuerry	Makoto Nakayama	Myleen Hollero	Roger Snider	Thanh-Thanh Dang
Katie Ryan	Manami Kano	Myles Shioda	Ron Kane	Thao Nguyen
Keiko Takagawa	Manuel Ocampo	Naat Jairam	Ronald J. Saunders	Tim Hugh
Keenan Keller	Maré Odomo	Nancy Mato	Rop Vasquez	Todd Blickenstaff
Keith Saunders	Margaret Cho	Nao Harada	Rotor	Todd Inoue
Kelly O'Sullivan	Margaux Elliott	Naomi Yang	Ryan Randall	Tony Molina
Kelly Roberts	Maria Blackheart	Natasha Bishop	Ryan Wong	Tran Bui
Ken Chen	Mark Nisbet	Nate Shimizu	Ryoko Suzuki	Trang Lai
Ken Kawamura	Mark Schaefer	Nelson Kuo	Saelee Oh	Tricia Lew
Ken Taya	Markus Augustus	Nick Harmer	Sandy Olkowski	Una Kim
Kevin Bolton	Martin Cendreda	Nick Mangkalakiri	Sandy Pae	Vanda Chong
Kevin Kleinhans	Masaki Miyagawa	Nikki Derse	Sandy Yang	Vanessa Cabrillas
Kevin Ung	Matt Gross	Nikki Rodgers	Sarah Ciehomski	Vicki Berndt
Kien Lieu	Matt Kaufman	Nikos Constant	Sarah Glazer	Vicki Tao
Kim Okamura	Matthew Hawkins	Oscar Rios	Sarvi Chan	Vincent Hsia
Kim Riback	Max Wanger	Paco Taylor	Satomi Matsuzaki	Wayne Pan
Kim Suarez	Maya De Forest	Pat Castaldo	Scott Brooks	Wendy Jung
Kim Yutani	Maya Meinert	Pat Tsai	Scott Gibson	Wendy Lau
Kirk Jones	Melanie Phipps	Paula Peng	Scott Larson	Will Khoo
Kiwon Yoon	Melissa Coats	Peter Lee	Selena Ma	Windy Chien
Kiyoshi Nakazawa	Melody Ng	Peter Siu	Senon Williams	Wing Ko
Konrad Ng	Mia Doi Todd	Peter Zaslov	Shad Lambert	Xochitil Oliva
kozyndan	Mia Park	Phil Chen	Shari Sakahara	Yong Kim
Kyle Hertler	Michael Bevry	Phil Nisco	Shaun Fynn	Yuki Ueda
Kyle Kiang	Michael Idemoto	Philip Stone	Shawn Sites	Yvonne Ng
Lana Kim	Michael Kai Louie	Poi Beltran	Sheldon Candis	Zee Burns
Lance Hahn	Michael Kim	Prodip Leung	Shelly Niimi	Zen Sekizawa

the complete set

For the ultimate GR fan, a comprehensive look at *Giant Robot* covers over the years. How many do you own?

Giant Robot
issue no.1 1994 made in the USA $2

Sumo wrestlers sleep after a hefty meal

**Sumo Wrestler Gets 6" Implant in Head!
Filmmaker Disposes of Raw Beef Parts!
Boredoms, Exotica, Twinkies, Fevers,
Trash, TV and More!**

Giant Robot
issue no. 2 - 1995 made in the usa $2.50

**I was Hello Kitty - The Story!
Interviews with Sumo Wrestlers!
Eye Operations, Comics, Anger, Fighting,
Sumo, Hong Kong and More!**

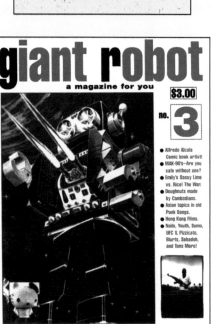

giant robot
a magazine for you
$3.00

no. **3**

- Alfredo Alcala Comic book artist!
- MAK-90's—Are you safe without one?
- Emily's Sassy Lime vs. Rice! The War.
- Doughnuts made by Cambodians.
- Asian topics in old Punk Songs.
- Hong Kong Films.
- Nails, Youth, Sumo, UFC V, Pizzicato, Blurts, Bebadoh, and Tons More!

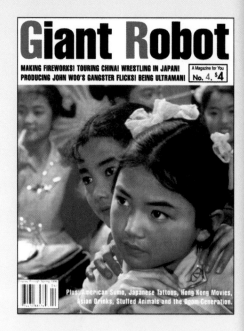

Giant Robot
**MAKING FIREWORKS! TOURING CHINA! WRESTLING IN JAPAN!
PRODUCING JOHN WOO'S GANGSTER FLICKS! BEING ULTRAMAN!**
A Magazine for You
No. 4. $4

Plus: American Sumo, Japanese Tattoos, Hong Kong Movies,
Asian Drinks, Stuffed Animals and the Ogom Generation.

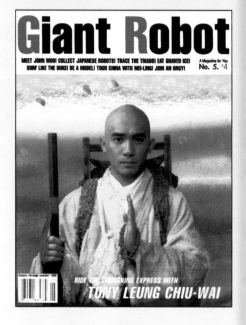

Giant Robot
**MEET JOHN WOO! COLLECT JAPANESE ROBOTS! TRACE THE TRIADS! EAT SHAVED ICE!
SURF LIKE THE DUKE! BE A MODEL! TOUR CHINA WITH MEI-LING! JOIN AN ORGY!**
A Magazine for You
No. 5. $4

RIDE THE CHUNGKING EXPRESS WITH
TONY LEUNG CHIU-WAI

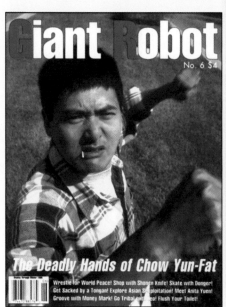

Giant Robot
No. 6 $4

The Deadly Hands of Chow Yun-Fat

Wrestle for World Peace! Shop with Shonen Knife! Skate with Donger!
Get Sacked by a Tongan! Explore Asian Sexploitation! Meet Anita Yuen!
Groove with Money Mark! Go Tribal with Peelco! Flush Your Toilet!

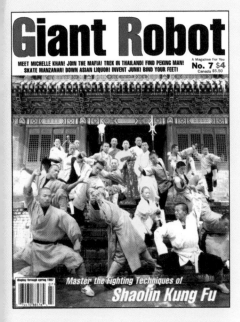

Giant Robot

MEET MICHELLE KHAN! JOIN THE MAFIA! TREK IN THAILAND! FIND PEKING MAN!
SKATE MANZANAR! DOWN ASIAN LIQUOR! INVENT JUNK! BIND YOUR FEET!

A Magazine For You No. 7 $4
Canada $5.50

Master the Fighting Techniques of
Shaolin Kung Fu

Giant Robot

A Magazine For You

TSUI HARK vs JOHN WOO! HELLO KITTY vs GODZILLA! MARGARET CHO vs CIBO MATTO!
STEVE CABALLERO vs ASIAN CAR CLUBS! DJ Q-BERT vs DJ KID KOALA! NUT LIFTING vs SHAOLIN!
SHONEN KNIFE vs SUGARPLANT! MISHIMA vs MIRAN KIM! SUMO PSYCHIATRIST vs YOU!

no.8 $4
Canada $5.50

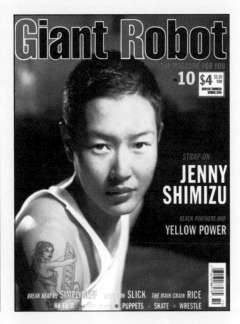

Giant Robot

THE MAGAZINE FOR YOU

-10 $4 $5.50 CON

DISPLAY THROUGH SPRING 1998

STRAP-ON
JENNY SHIMIZU

BLACK PANTHERS AND
YELLOW POWER

BREAK BEAT DJ SIMPLY JEFF · CAPTAIN SLICK · THE MAIN GRAIN RICE
HK FILM · PUPPETS · SKATE · WRESTLE

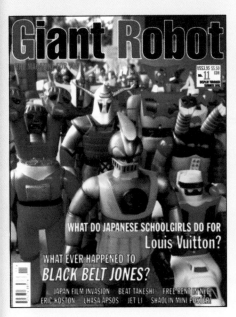

Giant Robot

THE MAGAZINE FOR YOU

US$3.95 $5.50 CON
NO. 11
DISPLAY THROUGH 1998

WHAT DO JAPANESE SCHOOLGIRLS DO FOR
Louis Vuitton?

WHAT EVER HAPPENED TO
BLACK BELT JONES?

JAPAN FILM INVASION · BEAT TAKESHI · FREE RENT IN NYC
ERIC KOSTON · LHASA APSOS · JET LI · SHAOLIN MINI POSTER

MAGIC KINGDOM │ THUG LIFE ★ MURDER CITY ★ KIDS ON COFFEE

Giant Robot

THE MAGAZINE FOR YOU

US $3.95 $5.50 CON
no.12

JET LI
NEW LEGEND
OF SHAOLIN

CHINATOWN'S NOT DEAD
MOB RULES IN CONGO

GIANT ROBOT

THE NEW ISSUE

13

in search of
PYGMIES

QUEST FOR
SUMO
ライフスケイプ

LADIES
MAN in japan

ベタリカン

ASIAN SEXXX ISSUE

Giant Robot

ASIAN POP CULTURE AND BEYOND U.S. $3.95
CDN $5.50

ASIA CARRERA

JAPANESE
SCHOOL
GIRLS

HORNY
ASIANS

LOVE
HOTELS

COVER 2 of 2

SPECIAL FIVE YEAR ANNIVERSARY ISSUE

Giant Robot

ASIAN POP CULTURE AND BEYOND
トコモのケイタイにつなげ

$3.95 $5.50
15

ART/FOOD/KARAOKE

CIBO MATTO · SHU UEMURA · DJ KRUSH
TERMINATOR · BEAT JUNKIES
JAPANESE COVER BANDS

on the road with
世界 **MONEY MARK**

SHAOLIN KUNG FU · MATRIX MAYHEM · TAE-BO FEVER

Giant Robot

16

KICKING FACE
WITH MING TRAN

INSIDE:
TURA SATANA RETURNS
STICK FIGHTERS REVENGE
PARAPPA RAPS

EAT DOGS, EAT BUGS AND BE LACTOSE INTOLERANT

Giant Robot

Asian Pop Culture and beyond

17

RAMEN RANKINGS
BRUCE LEE MUSEUM
CHINESE JAMAICA

MARGARET CHO
LOST AND FOUND

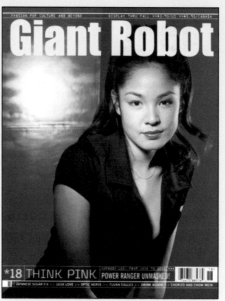

Giant Robot

*18 THINK PINK POWER RANGER UNMASKED!

JAPANESE SUGAR FIX · GEEK LOVE · OPTIC NERVE · TUVAN EAGLES · DRINK BLOOD · CHORIZO AND CHOW MEIN

Giant Robot

PRAY TO PREY

DOOMSDAY CULTS · HAPPY BUDDHAS
THE DALAI LAMA · PURIFIED SOUL
COCK FIGHTS · MOCK MEAT · GODZILLA

19

Giant Robot

>>20

WHEN HUMANS
ATTACK

YOSHITOMO NARA'S KIDS
TOP 25 ASIAN SERIAL KILLERS
FACES OF DEATH

THE BEST KUNG FU MOVIE EVER
GREASY ASIAN JUNK FOOD
TRAINHOPPING
ASIAN HENCHMEN
GIANT ROBOT AWARDS
DESTROYING AMERICA
INDONESIAN SPIRITS
JAPANESE WRESTLERS
CUTE PANDAS
BIG MELONS
MAGGIE CHEUNG
JETS TO BRAZIL
CLOWN TIME

Giant Robot

ISSUE 21

ART
ATTACK!

WONG KAR-WAI, SUPERFLAT MURAKAMI, TONY LEUNG, NAKANASHI'S KAMIKAZES,
GARDENER MICHAEL LAU, MARATHON ESCALATOR RIDING, PSYCHIC CHILDREN,
ASIAN HAIRCUTS, 25 LIFE-ALTERING INVENTIONS, HOT STUFFED ANIMALS

Giant Robot

NEW BLOOD IN JAPANESE ART, INSIDE KOWLOON WALLED CITY, JACKIE CHAN,
BEAT TAKESHI WILL KILL YOU, HONG KONG MOVIE GOD TSUI HARK

MASTER MINDS

NOVELIST HARUKI MURAKAMI
HONG KONG'S COOLEST DESIGNER
HOLIDAY IN THE KILLING FIELDS
THE FUTURE OF ANIME
COLONIC REJUVENATION

issue 22

Giant Robot

CHP

ISSUE 23:
Chappie Science!

Groovisions
Hong Kong's King of Trash
Fashion Freaks in Japan
Scammed in Vietnam
Two Weeks Upside-Down
Hot Tub Monkeys
Orchid Junkies
Money Mark on a Mission
Tiger Balm Gardens
Tomato-Faced Drunks
Armpit Sniffers

CHP

Giant Robot

QUEEN OF MARTIAL ARTS FILMS, GOD OF GLUTTONS
CHINESE TEA ODYSSEY, FILIPINO PRISON CUISINE, GIANT ROBOT AWARDS, RETURN OF THE GINGER, COLOSSAL ASIAN-MAN

ISSUE 24
WHAT YOU MUST KNOW

88
THINGS

Giant Robot

BALLER FROM BEIJING, SUNDANCE SLAM, GEOFF MCFETRIDGE
SPICE GIRL SUPERSTAR, MASTER OF FIGURES, IN CHUNGKING MANSIONS, CAMBODIAN LANDMINE MUSEUM

ISSUE 25
BEST IN SHOW

Giant Robot

Beijing Calling, Manpurse Mania, Ai Yamaguchi

Stephen Chow, Japanese Devils, Dogtown Girl, Fight Club, Make-Out Club

Giant Robot

ISSUE 27
FOLK WAYS

**Barry McGee
Thai Scrabble Champs
The Path of Khan**

Dogtown's Shogo Kubo, Pinoy Superstitions,
Pakistani Truckers, Hell Babies from Japan

Giant Robot

SPORTS TRAGEDIES, SCUMROCK, GIANT ROBOT AWARDS

Golden Age Propaganda
Operation Idol
Junkie Fiction
Chong Hit
Art of War
Scooter Rally
Kozyndan

ISSUE 28
UPRISINGS

Giant Robot

ISSUE 29
UNLEASHED

Photos and Fireworks
Gleaming the Kubrick
Yao Ming
In Afghanistan
Beijing Punks
Snoopy

Giant Robot

ISSUE 30
SUBCULTURED

Master of the Rubik's Cube
Three Gorges Damage
Baby Cart to Hades
Shaolin Dubber
Project Xbox
Ghosts on Film
Plastic Passion

Giant Robot

ISSUE 31
KREATORS

Devil Robots Rising
Red Guard Camera Club
Pharmacy in Cambodia
Bad Guy from Korea
Severed Heads
Hello Kitty

Giant Robot

Ganges Crematoriums
Miss Hong Kong Confidential
Man Makeup
Shafted in China
Future Man
Clare Rojas

ISSUE 32
THE BEHOLDERS

Giant Robot

Space Invasion, Jailed in Japan, Ultimate Fighting Machine, Gangs of Singapore, Hiromix

10
YEAR SPECIAL

ISSUE 33

Giant Robot

Takashi Miike, Tadanobu Asano, Christopher Doyle, Yoko Ono, Dehara
Censored Cinema, Camel Safari, Camp Muay Thai, Machete Core

ISSUE 34
MOVING PICTURES

Giant Robot

ISSUE 35
HEAVY METTLE

KAWS
FLYING DAGGERS
DESIGNING BOBA FETT
MEET THE BEAST
CHINESE HEAVY METAL
MEET MR. VENGEANCE
VIVA LAS VEGAS
BLIND MASSAGE

Giant Robot

ISSUE 36
ICONOCLASH

RYAN McGINNESS

+ GUERRILLA GARDENER / WHEELS OF FORTUNE
MUAY THAI TWIST / INNER SENSES
FERAL CHILDREN / THE LIZARD KING

Giant Robot

ISSUE 37
SUPER ROOTS

MARGARET KILGALLEN

SHOOTING TOKYO THREE PERFECT DAYS
SITAR TREK DESERT IMPS
ALIEN INVADERS CHINESE JAMAICANS

Giant Robot

ISSUE 38
INTERNET YOUTH

SEONNA HONG

BIGFOOT IN ASIA, NATURAL GRAFFITI, KILLER POTATOES
LUNCHBOX STORIES, FRUIT CHAN, PLEASURE VICTIMIZERS
PUSHER MAN, ULTRA MEGA OKINAWA

Giant Robot

ISSUE 39
Examined Life!

SOUTHER SALAZAR

MANUEL OCAMPO, BIRDMAN OF ANAHEIM, KISS MY SNAKE
PRESUMED GUILTY, PICNIC TABLE ASSASSIN, PRISON LIFER

Giant Robot

ISSUE 40
Insettivi

ALIEN EMPIRE

INFERNAL AFFAIRS, MR. BUBBLES, CLAN OF THE DOG PEOPLE
SCARFING FOOD, FLATLAND BMX, DOOM METAL, TYRA BANKS

Giant Robot

ISSUE
41

SUPER NATURAL

GEORGE TAKEI
THE AUTOMATOR
HAMBURGER EYES
MAD WORLD
DENGUE FEVER
IRON MAN

Giant Robot

FEARLESS

Start Your Own Boy Band
Chucky vs. Jet Li
Thunder From The East
Thrilla in Manila
Ricetafarians
Gorgeous China
Uglydolls

42

Giant Robot

ISSUE
43

REINDEER PEOPLE MUTANT ART ZOMBIE
11 WEEKS IN ANTARCTICA FILM FESTIVAL FRENZY
BOY BAND CONFIDENTIAL REVOLUTIONARY OPERA

Giant Robot

THE MONSTERIST, BUDDHA BOX, BIGFOOT IN MALAYSIA, MR. SUDOKU, THE DONUT MAN COMETH

44

Giant Robot

SUPERFLAT FOREVER, NARA A-TO-Z, HARD GAY PRIDE, GARGAMEL'S REVENGE, CRACK HOUSE

issue 45

Giant Robot

Ura-Harajuku Godfather, Gong Li, Towa Tei, Bons Brigade, Thai Cowboys, Gloomy Bear

issue 46

Giant Robot

The Wrong Stuff
Host Story
Rebel Forces
Paradorn Srichaphan
Fighting with Fire
Mountain Mountain

issue 47

Giant Robot

issue 48

Original Syndrome
Unknown Pleasures
Enter the DragonForce
Cornelius
100 Punks
PCP

Giant Robot

ADRIAN TOMINE, REBEL ALLIANCE, DONUTS & CHINESE FOOD
IDOL THREAT, THE COSPLAY SHOW, THE LAST EXECUTIONER
TEN WIMPY ROBOTS, HIGH TEKKON, BIG BANGKOK

issue 49

Giant Robot

A DEFINITIVE HISTORY OF ASIAN POPULAR CULTURE
DAVID CHOE, BLOOD BROTHER, LOCA MOTION
CHTHONIC YOUTH, KAMIKAZE GIRL, SUPER FUTURE

issue 50

Giant Robot

issue 51

Hot Links
Get in the Minivan
Meet John Jay
Blog Jam
Black Arts
Lusty Ladies
Flashers
Feric

Giant Robot

MAID CAFES
HAWAII MODERN
ICED OUT
MACHINE GIRL

ISSUE 52

CARBON SILICON
MUSIC FROM THE MASSES
BLISSED OUT
ALBERT REYES

Giant Robot

issue **53**

Zero Hour
The Last Strand
Pistil Packer
Manila Guerrilla
Stephen Chow
James Jarvis

Giant Robot

Terracotta Connection
Machine Man
James Jean

New Chinese A
Forever No
Cat Hous

54

Giant Robot

issue **55**

Anime Explosion
Angry Management
Shanghai Surprise
The Wanderer
Dirty Hands
Saelee Oh

Giant Robot

FOLD SCHOOL, HOMELESS IN TOKYO
BACK IN BEIJING, BIG BAMBOO
FOXXXY LADY, KAMI

issue **56**

Giant Robot

issue **57**

SLUMDOG STARS
AARON YOO
MAYA SOETORO-NG
FREE THE ROBOTS
THE GOOD, THE BAD,
AND THE WEIRD

**STREET ART
+OBAMA**

Giant Robot

issue **58**

ASIAN JELLO
PET ARCHITECTURE
BOLLYWOOD KUNG FU
KING OF REMAKES
STELLA LAI

Giant Robot

issue **59**

KIYOSHI KUROSAWA • DEPARTURES • CHOCOLATE
TOKYO! TALES • SICHUAN SWEAT • SEVENTIES SMUT
CUTE BENTO • MAFIA MAN • MASAKATSU SASHIE

Giant Robot

issue **60**

15th Anniversary Edition
Star Wars Sites
Peter Saville
Richard Mulder
Charlyne Yi
Quick Gun Murugan
Deth P. Sun
Mono

Giant Robot

Whaling Vigilantes
Gothic & Lolita U.S.A.
Wizards of Gore
Alien Art
Blood Money
Philip Lumbang

issue **61**

Giant Robot

issue **62**

Michael Lau
William Gibson
Ray Barbee
DJ Kentaro
The Dirtbombs
Rob Sato

Giant Robot

John Woo
King of Katamari
Megan Whitmarsh
Kenny Anderson
Nick Cheung
End of the '00s
Yonfan

issue **63**

Giant Robot

Black Rock Shooter
Yellow Fellow Fever
Quest for Kona
Free the Dolphins
Cosplay Days
Carsick Cars
Black Asians

issue **64**

Giant Robot

issue **65**

Save the Sharks
Beijing's Rotten Generation
Hot Summer Daze
The Lost World
Strange Boys
Oriental Flavor
Shintaro Ohata

Giant Robot

issue **66**

Daniel Dae Kim
Bryan Lee O'Malley
The Glitch Mob
Laura Ling
Eye of the Diver
I Want My MSG

Giant Robot

RETURN OF THE QUACK

Big Rigs in Japan
They Called
Him Bruce
Holiday in Mongolia
Jillian Tamaki
Gun Show
Matt Furie

issue **67**

Giant Robot

Luke Chueh
Linkin Park
Haunted Hausu
Dum Dum Girls
Iwai Shunji
Tae Won Yu
Envy

issue **68**

COVER ARTIST CREDITS:

GR #08: Amy Davis
GR #19: Barry McGee
GR #20: Yoshitomo Nara
GR #21: Takashi Murakami
GR #22: Chiho Aoshima
GR #23: Groovisions
GR #24: J. Otto Seibold
GR #25: Geoff McFetridge
GR #26: Ai Yamaguchi
GR #27: Barry McGee
GR #28: kozyndan
GR #29: Snoopy
GR #30: 326 (a.k.a. Mitsuru Nakamura)
GR #31: Devil Robots
GR #32: Clare Rojas
GR #33: Space Invader
GR #34: Yukinori Dehara

GR #35: KAWS
GR #36: Ryan McGinness
GR #37: Margaret Kilgallen
GR #38: Seonna Hong
GR #39: Souther Salazar
GR #40: Jeff Soto
GR #41: Jeana Sohn
GR #42: Uglydoll
GR #43: Rachell Sumpter
GR #44: Pete Fowler
GR #45: Takashi Murakami
GR #46: Mori Chack
GR #47: Kohei Yamashita
GR #48: Heisuke Kitazawa
GR #49: Adrian Tomine
GR #50: Dave Choe
GR #51: Feric

GR #52: Albert Reyes
GR #53: James Jarvis
GR #54: James Jean
GR #55: Saelee Oh
GR #56: Kami
GR #57: Dave Choe
GR #58: Stella Lai
GR #59: Masakatsu Sashie
GR #60—15th Ann. special: Deth P. Sun
GR #61: Philip Lumbang
GR #62: Rob Sato
GR #63: Megan Whitmarsh
GR #64: Ryohei Huke
GR #65: Shintaro Ohata
GR #66: Bryan Lee O'Malley
GR #67: Matt Furie
GR #68: Luke Chueh

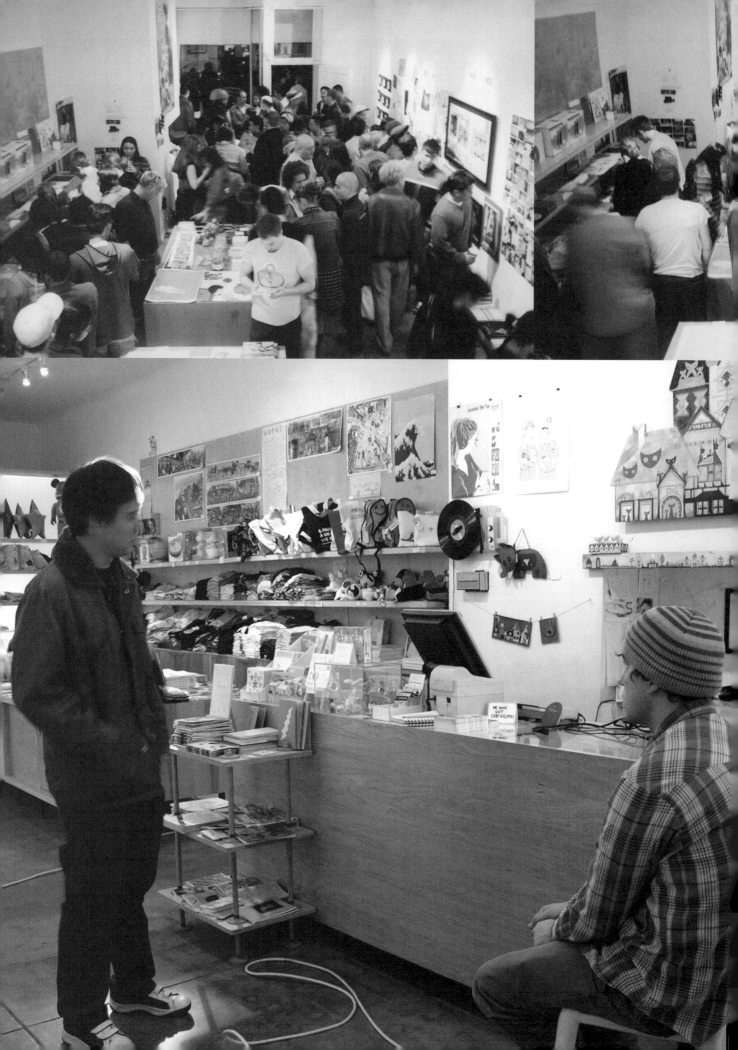

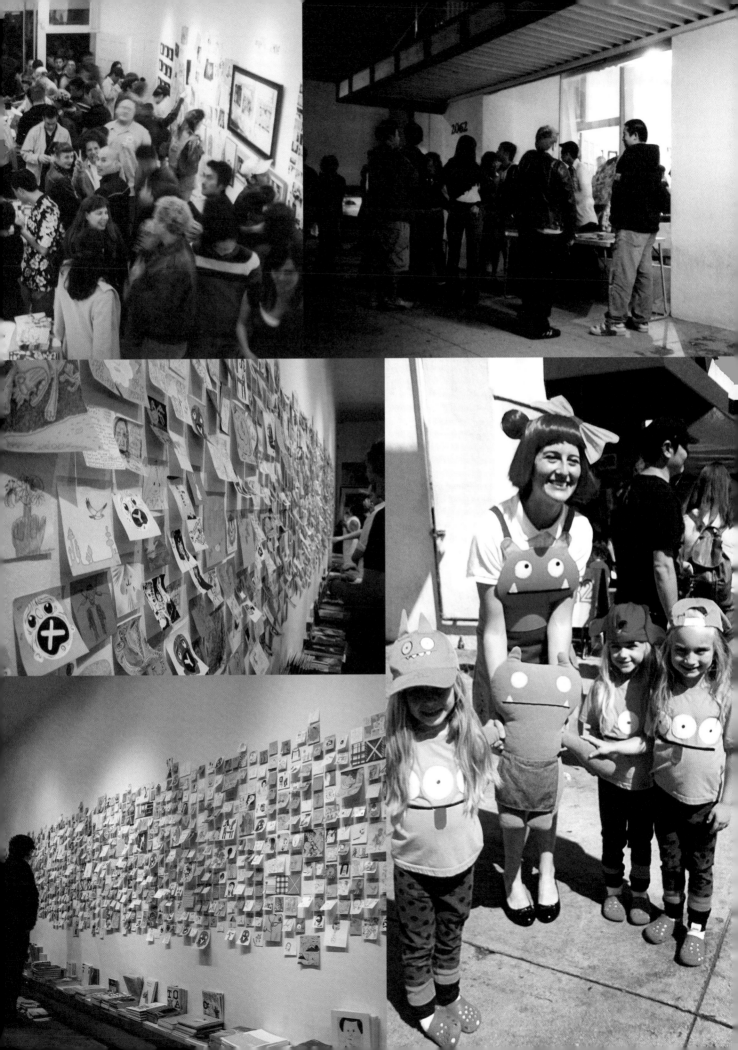

thank

for showing at Giant Robot

Aaron Brown
Aaron Burtch
Aaron Horkey
Aaron K
Aaron Martin
Aaron Martinez
Aaron Piland
Aaron Renier
Abby Aceves
Abby Manock
Abe Lincoln Jr.
Adam Grano
Adam McCauley
Adam Wallacavage
Addeline Griswol
Adrian Tomine
Aeron Alfrey
Ai Yamaguchi
Aiyana Udesen
AJ Fosik
Akiko Stehrenberger
Ako Castuera
Albert Reyes
Aleks Sennwald
Alessandro Gallo
Alex Chiu
Alex Kao
Alex Konstad
Alex Lukas
Alex Meyer
Alex Ostroy
Alexandar Lansang
Alexander S. White
Alexander Shen
Alexander Vidal
Alexia Stamatiou
Alexis Mackenzie
Alfred Liu
Alice Lee
Alicia McCarthy
Alika Cooper
Alisa Yang

Alisha Sofia
Alison Gordon
Allison Bamcat
Allison Cole
Allison Sommers
Alvin Buenaventura
Alycea Tinoyan
Alyssa Mees
Amanda Brown
Amanda Visell
Amelia Giller
Amelie Laurice
Amy Davis
Amy Lockhart
Amy Matsushita-Beal
Amy Ross
Amy S. Kauffman
Amy Sol
Amy Vazquez
An Nguyen
Ana Bagayan
Ana Mouyis
Ana Serrano
Anders Nilsen
Andrea Guzzetta
Andrea Kang
Andrea Wan
Andrew Brandou
Andrew DeGraff
Andrew Hem
Andrew Holder
Andrew Jeffrey Wright
Andrew Lee
Andrew MacLean
Andrew Mar
Andrew Perry
Andrew Schoultz
Andrew Stewart
Andria Robbins
Andrice Arp
Andy Jenkins
Andy Kehoe

Andy Rementer
Andy Smenos
Angela Boatwright
Angela Kongelbak
Angela Ramones
Angela Song
Angie Clayton
Angie Wang
Ann Shen
Anna Anthropy
Anna Hellsgard
Anna Sea
Anne Emond
Anne Figuls
Anne Ishii
Anne-Louise Ewen
Annette Berry
Annie Bissett
Anthony Ausgang
Anthony Macbain
Anthony Russo
Anthony Wu
Apak!
Ariel Lee
Ariel Schrag
Arlo Jamrog
Armando Gonzalez
Armando Veve
Arnaud Loumeau
Arthur Fong
Arthur Jones
Ashira Siegel
Ashkahn
 Shahparnia
Ashley Dreyfus
Ashley Kwon
Ashley Macomber
Aska Iida
Attaboy
Audrey Kawasaki
Austin David Conrad
Austin English

Austin Horton
Autumn Leaflet
Aya Kakeda
Aya Takeda
Ayumi Takahashi
Bagger43
Baron Yoshimoto
Barry McGee
Beast Brothers
Beau Blythe
Beau Stanton
Becca Stadtlander
Beci Orpin
Bella Foster
Ben Chu
Ben Goetting
Ben King
Ben Newman
Ben Wolfingson
Benjamin Clarke
Benjamin Lee
Benjamin Sea
Benjie Escobar
Bennett Slater
Bert Gatchalian
Bertrand Todesco
Beryl Chung
Beth Tacular
Beth Whitney
Bigfoot One
Bijou Karman
Bill Barminski
Bill McMullen
Bill McRight
Bill Zindel
Billy Reynolds
Bjorn Calleja
Blaise Larmee
Blake Jones
Blake Scott
Blinky
Bo Myles

Bob Dob
Bonnie Lui
Brad Mossman
Bradford Lynn
Bree Rawn
Brenda Chi
Brendan Monroe
Brent Harada
Brian Chippendale
Brian Cronin
Brian Ewing
Brian Flynn
Brian Holderman
Brian Luong
Brian Ralph
Brian Rea
Brian Rush
Bridget Henry
Briochecoco
Brittany Douziech
Bronwyn Minton
Brook Caballero
Brooks Salzwedel
Bruce Richards
Bryan Wong
Bubi Au Yeung
Buff Monster
Burlesque Printing
Buster Moody
Bwana Spoons
C.F.
C.K. Wilde
Ca Cooca
Caitlin Anne
Caitlin Keegan
Calamity Cole
Caleb Sheridan
Calef Brown
Calvin Laituri
Calvin Wong
Cam Floyd
Camila Otero

you

Camilla D'Ericco
Camilo Bejarano
Camily Tsai
Candi "Snaggs" Hibert
Candie Bolton
Cantab Publishing
Carl Cahbasm
Carl Dunn
Carleen Cotter
Carlos Donjuan
Carlos Ramos
Carlos Ulloa
Carly Lake
Carmel Ni
Carmen Luceno
Caroline Hwang
Carson Ellis
Casey O'Connell
Casey Weldon
Cassandra Ford
Cassia Lupo
Cassie Ramone
Cat Ferraz
Cat Lauigan
Cate McCleery
Catherine Graffam
Catia Chien
Celeste Byers
Chad Dziewior
Chad Eaton
Chadwick Whitehead
Chaehyung Lee
Chang Park
Chantal deFelice
Charles Chatov
Charles Eckert
Charles Glaubitz
Charles Immer
Charlie Becker
Charlie Powell
Chauney Peck
Chellioh

Chelsea Wong
Chesiel John
Chihiro Torikai
Chiho Aoshima
Chris Buzelli
Chris Cilla
Chris Duncan
Chris Hyoung Lee
 (Chaehyung Lee)
Chris Kerr
Chris Kline
Chris Kuzma
Chris Lindig
Chris Mostyn
Chris Neal
Chris Roberts
Chris Silas Neal
Chris Uphues
Chris von Szombathy
Chris Ward
Chris Wood
Christa Dippel
Christiaan Van Bremen
Christian Leon
 Guerrero
Christian Northeast
Christina Kampson
Christina Margarita
 Erives
Christina Sheppard
Christine Castro
Christine Shields
Christine Vincent
Christine Wu
Christine Young
Christopher Bettig
Christopher Chan
Christopher
 Youssef
Christy Saguanpong
Cindy Suen
Claire Donner

Claire Johnson
Clara Dudley
Clara Winnie
Clare Rojas
Claudia Brandenburg
Clement Hanami
Cleonique Hilsaca
Cody Cochrane
Cody Hudson
Colin Christian
Colin Raff
Conix
Connie Wong
Connor Nguyen
Coop
Corey Arnold
Cortney Cassidy
Cory Schmitz
Courtney
 Wotherspoon
Craig Atkinson
Craig Dransfield
Craig LaRotonda
Crisselle
Crystal Stokowski
Csaba Klement
Cupco
Nanospore
Cynthia Connolly
Dale Raines
Damian J McDonald
Damian Weinkrantz
Damien Correll
Dan Ah Kim
Dan Aycock
Dan Barry
Dan Cordani
Dan Goodsell
Dan Grzeca
Dan May
Dan McCarthy
Dan Moynihan

Dan Quintana
Dan Stiles
Dan Zettwoch
Dan-ah Kim
Dana Collins
Dana Duncan
Daniel Anthony St.
 George 2nd
Daniel Davidson
Daniel Kim
Daniel Lim
Daniel Pagan
Daniel Rolnik
Daniel St. George
Danni Fisher-Shin
Danni Shinya Luo
Danny Espinoza
Dany Paragouteva
Daria Tessler
Darren and Trisha
 Inouye (Giorgiko)
Darth Rimmer
Dash Shaw
Date Farmers
Carlos Ramirez
Dave Bondi
Dave Delaney
Dave Kiersh
Dave Plunkert
Dave Stolte
David Choe
David Choong-Lee
David Chung
David Ellis
David Fair
David Fremont
David Horvath and
 Sun-min Kim
 (Uglydolls)
David Jien
David King
David Mack

David Magdaleno
David Miller
David Monllor
David Olivera
David Ryan
David Sandlin
David Weeks
Davor Gromilovic
Deal Longfish
Dean Gojobori
Dean Kagemoto
Deanne Cheuk
Deborah Kraft
Deborah Lee
Debra Broz
Deerjerk
Defective Pudding
Dela Longfish
Delfin Finley
Dennis Dread
Dennis Tyfus
Derek Albeck
Derek Ballard
Derek Kirk Kim
Derek M. Ballard
Derek Stukuls
Derek Yu
Deth P. Sun
Devin Clark
Devin McGrath
Dewayne
 Slightweight
Diana Georgie
Diana Kwok
Diana Sudyka
Diane Barcelowsky
Dima Drjuchin
DK
DLL Customs
Dollar $lice Bootlegs
Dominique Vitali
Dong Ho Kim

Dora Drimalas
Douglas Gauthier
Drew Beckmeyer
Dustin Benzing
Dutch Door Press
Dylan Griffin
E. Dubois
Eamon Espey
Eddie Martinez
Edel Rodriguez
Edie Fake
Edward del Rosario
Edward Robin Coronel
Edwin Ushiro
Eimi
Eishi Takaoka
EKUNDAYO
Elaine Chen
Elaine Chou
 (Mushinky)
Elaine Wu
Elayne Dixon
Eleanor Davis
Elena Renn
Elisabeth Timpone
Elizabeth Haidle
Elizabeth Huey
Elizabeth Ito
Elizabeth Mamont
Elizabeth Meluch
Elle Michalka
Ellen Surrey
Elliot Brown
Elsa Mora
Elvin Armando
Ely Kim
Emilio Santoyo
Emily Eibel
Emily Wong
Emily Yoshimoto
ENFU
Enkyskulls
EPOCH
Eric Broers
Eric Butler
Eric Fortune
Eric Nakamura
Eric Nyquist
Eric Shaw
Eric White
Erick Martinez
Erik Alos
Erik Bergstrom
Erik Mark Sandberg
Erika Yamashiro
Erin Althea
Erin Rosenthal
Esao Andrews
Esther Pearl Watson
Ethan Hayes-Chute
Etsu Meusy
Eujo

Eunice San Miguel
Eunsoo Jeong
Evah Fan
Evan Harris
Everybody Get Up
Ewa Pronczuk-Kuziak
Faheema Chaudhury
Farel Dalrymple
Fawn Gehweiler
Federico Tobon
Felicia Chiao
Felix Galvan
Femke Hiemstra
Feric (Eric Fung)
Ferris Plock
Filipa Da Silva
Finn Rogers
Fiona Logusch
Flat Bonnie
Flavia Chan
Flo Zavala
Florence Gidez
Foi Jiminez
Fortress Letterpress
Frances Jetter
Francesca Tallone
Francisco Herrera
Franco Zacha
François Vigneault
Frank McLaughlin
Frank Olinsky
Free Humanity
FRENCH
Frieda Gossett
Fumi Omori
Gabe Gonzales
Gabriel Tick
Gabrielle Bell
Gakiya
Garrett Lee
Garrett Morin
Gary Baseman
Gary Benzel
Gary Fogelson
Gary Garay
Gary Musgrave
Gary Panter
Gary Taxali
Gemma Correll
Genevieve Santos
 (Le Petit Elefant)
Geoff McFetridge
Geoff Rockwell
Georganne Deen
George Bates
George Harbeson
Georgie Stout
Germs
Ghostbeard
GHOSTPATROL
GHOSTSHRIMP
Gigi Chen

Gina Zycher
Ginette Lapalme
Ginger Chen
Giorgiko
Girafa
Giselle Potter
Glenn Hernandez
Godeleine
 de Rosamel
Gosha Levochkin
GOSIA
Graham Yarrington
Grant Falardeau
Grant Reynolds
Greenlady/HUGA
Greg Clarke
Greg Gibbs
Greg Mike
Gregory Benton
Gregory Nemec
Grey "Pnut" Galinsky
Gunsho
Gustavo Rimada
Hannah Eddy
Hannah K. Lee
Hannah Stouffer
Hanne Berkaak
Harpoon
Harrison Freeman
Harry Diaz
Hawk Krall
Healeymade
 (David Healey)
Heartslob
 (Savanna Judd)
Heather Cardone
Heather Gross
HeeKyoung Yum
Heeyeon Chong
Heidi Hahn
Heidi Woan
Heisuke "PCP"
 Kitazawa
Hellen Jo
Henny Acloque
Hertz Alegrio
Hilary Florido
Hiro Hayashi
Hiro Kurata
Hiroki Otsuka
Hiroshi Kimura
Hiroshi Mori
Hisashi Kondo
Hollie Mengert
Holly Stevenson
Hooked Hands
Hope Kroll
Hoppip
Hugh D'Andrade
Hugo Morales
Huntz Liu
Ian Adelman

I Heart Guts (Wendy
 Bryan Lazar)
Ian Johnson
Ileana Soon
Ilse Murdock
Indi Ho
Ines Estrada
Ingo Fast
Irene Martino
Isaac Lin
AJ Fosik
Isabel Samaras
Ivan Brunetti
Iwai Shunji
J Salvador
J. Otto Seibold
Jack Long
Jacky Ke Jiang
Jacob Covey
Jacob Goble
Jacob Magraw-
 Mickelson
Jacob McGraw
Jad Fair
Jaga Ichiro
Jaime Herrera
Jaime Soto
Jaime Zollars
Jake Gillespie
Jake Panian
James Austin Murray
James Benjamin
 Franklin
James Chong
James Franklin
James Gallagher
James Haworth
James Jean
James Kirkpatrick
James Kochalka
James Lipnickas
James McShane
James Moore
James Yang
Jamie Rowland
Jamie Wells
Janet Chan
Janice Chang
Jared Andrew Schorr
Jarrett Quon
Jashar Awan
Jasjyot Singh Hans
Jasmine Wigandt
Jason Chalker
Jason Clarke
Jason Fischer
Jason Glasser
Jason Holley
Jason Hsu
Jason Mclean
Jason Polan
Jason Porter

Jason Robards
Jason T Miles
Jasor
Javier Burgos
Jawsh Smith
Jay Horinouchi
Jay Howell
Jay Ryan
Jay Torres
Jay Zehngebot
Jaya
Jayne Hirata
Jeana Sohn
Jeaux Janovsky
Jeff Canham
Jeff Ladouceur
Jeff McMillan
Jeff Quinn
Jeff Soto
Jeff Winterberg
Jeffrey Ashe Meyer
Jeffrey Brown
Jen Corace
Jennifer Lima
Jeni Yang
Jenna Gibson
Jenna Kwon
Jennie Cotterill
Jennifer Davis
Jennifer Jean Lee
Jennifer Lee
Jennifer Nguyen
Jennifer Song Swiney
Jennifer Tong
Jennifer Wang
Jenny Hart
Jenny Kwok
Jenny Ryan
Jenny Yu
Jeremiah Ferrell
Jeremiah Ketner
Jeremiah LaTorre
Jeremiah Maddock
Jeremy Sengly
Jeremy Tinder
Jeremy Wabiszczwicz
Jeremyville
Jermaine Rogers
Jerome Lu
Jeromy Velasco
Jesse Balmer
Jesse Fillingham
Jesse "J*ryu" Yu
Jesse Ledoux
Jesse Lefkowitz
Jesse McManus
Jesse Moynihan
Jesse Olanday
Jesse Reklaw
Jesse Reno
Jesse Tise
Jessica Hong

Jessica Jarvinen
Jessica Seamans
Jessica Ward
Jessicka Addams
Jill Bliss
Jillian Tamaki
Jim Houser
Jim Mahfood
Jim McKenzie
Jim Salvati
Jim Stoten
Jing Wei
Jisoo Kim
Jiyoung Moon
Jo Dery
Joanne Ji Young Kim
Joanne Nam
Jodi Levine
Joe Hahn
Joe Keinberger
Joe Rocco
Joe The Artist
Joe To
Joel Dugan
Joel Nakamura
Joey Chou
Joey Stupor
Johanna Dery
Johanna Goodman
John Banh
John Cuneo
John Freeborn
John Pham
John Porcellino
John Rauchenberger
Johnny Ryan
Johnny Sampson
Jon Burgerman
Jon Ching
Jon Lau
Jon Macnair
Jon Prichard
Jon Vermilyea
Jonatan "Cactus"
 Söderström
Jonathan Edelhuber
Jonathan Hill
Jonathan Petersen
Jonathan Viner
Joon the Goon
 (Juan Alvarado)
Jophen Stein
Jordan Awan
Jordan Crane
Jordan Fu
Jordin Isip
Joseph Buzzell
Joseph Guillette
Joseph Hart
Josh Agerstrand
Josh Cochran
Josie Morway

Josie Portillo
JP Neang
JT Steiny
Juan Muniz
Juan Travieso
Jud Bergeron
Jude Buffum
Juhye Cho
Jules Itzkoff
Julia Rothman
Julia Wertz
JULIACKS
Juliana Brion
Julianna Parr
Julie Manso
Julie Voyce
Juliet Schreckinger
Juliette Borda
Juliette Toma
Jun Inoue
Jun Seo Hahm
Jung Hong
Junko Mizuno
Junko Ogawa
Junyi Wu
Justin "Scrappers"
 Morrison
Justin B. Williams
Justin Fines
Justin Lovato
Justin Morrison
Justin Valdes
Justin Wallis
Justin White
Justine Lin
Justine Thibault
Kaa Yeo
Kaela Graham
Kaeleen Wescoat-
 O'Neill
Kanako Abe
kaNO
Kaori Kasai
Karen Barbour
Karen Hsiao
 (Miso)
Karl Kopinski
Karyn Vogel
Kassia Rico
Kate O'Connor
Katherine Chiu
Katherine Guillen
Katherine Streeter
Kathleen Lolley
Katie Turner
Katie Vonderheide
Katsuya Terada
Katy Ho
Katy Horan
Kaylynn Kim
Kayo Tamaishi
Kazimir Strzepek

Ke Jiang
Keiji Ishida
Keiko Brodeur
Keiko Ogawa
Keira Alexandra
Keith Jones
Keith Shore
Keith Warren Greiman
Kelice Penney
Kelie Bowman
Kellan Jett
Kelly Lynn Jones
Kelly Sux
Kelly Tunstall
Kelly Yamagishi
Kelsey Beckett
Kelsey Bohlinger
Kelsey Brookes
Ken Garduno
Ken Taya
Kenneth Lavallee
Kenneth Srivijittakar
Kenneth Wong
Kent Williams
Kerry Horvath
Kevin Chan
Kevin Christy
Kevin Cornell
Kevin Hooyman
Kevin Huizenga
Kevin Laughlin
Kevin Luong
Kevin Scalzo
Kevin Taylor
Kevin Tong
Keyla Marquez
Keys New
Kiersten Essenpreis
Kii Arens
Killer Bootlegs
Kim Bagwill
Kim Bost
Kim Cogan
Kim Jung Gi
Kim Kelley
Kim Ryu
Kim Scafuro
Kim Schifino
Kim-Hoa Ung
Kimberlie Clinthorne-
 Wong
King Mini
Kinuko
Kio Griffith
Kiyoka Ikeda
Kiyoshi Nakazawa
Kjelshus Collins
KMNDZ
Kohei Yamashita
Koreangry
Korin Faught
Koshin Finley

kozy kitchens/
 kozyndan
Kris Chau
Kristina Collantes
Kristina Reddy
Kristine Evans
Kukula
Kurve
Kwanchai Moriya
Kyle Ng
Kyoka Wakamatsu
L Crowsky
Lala Albert
Lana Kim
Landland
Lap Ngo
Lara Tomlin
Lark Pien
Lart Cognac Berliner
Laura 64 Colors
Laura Bellmont
Laura Levine
Laura Normandin
Laura Planker
Laura Schlipf
Laura Stallion
Lauren Andrews
Lauren Denitzio
Lauren Gardiner
Lauren Kolesinskas
Lauren Redniss
Lauren Tsai
Lauren YS
Lawrence Yang
Le Dernier Cri
Lea Rude
Leah Chun
Leah Goldensohn
Leah Kalotay
Leecifer
Leegan Koo
Leidy Churchman
Leif Goldberg
Leif Parsons
Lena Sayadian
Leo Eguiarte
Leo Frontini
Leon Lee
Leonardo Santamaria
Les Rogers
Leslie Winchester
Levon Jihanian
Lia Tin
Liam Devowski
Lilah Montgomery
Lili Todd
Lilli Carré
Lilly Todd
Lina Yu
Linda Kim
Linda Panda
Lindsey Adelman

Lindsey Balbierz
Linhchi Tang
Linnea Strid
Lionel Maunz
Lisa Congdon
Lisa Hanawalt
Lisa Kogawa
Lisa Perrin
Lisa Vanin
Lisha Tan
 (Lil'Chotchke)
Little Friends of
 Printmaking
Tessar Lo
Little Lazies
littlemoonboy
Liz Lee
Liz McGrath
Liz Riccardi
Lizz Hickey
Lou Pimentel
Louie Cordero
Louise Chen
Louise Jones
Lucas Pincer-Flynn
Lucky Nakazawa
Lukas Geronimas
Luke Chueh
Luke Davis
Luke Ramsey
Luke Rook
Luster Kaboom
Lydia Fong
Lydia Fu
Lynndoodle
M. Velliquette
M. Wandelmaier
Made in Chynna
Madeleine
 Zygarewicz
Madeline Valentine
Maggie Chiang
Mai Ly Degnan
Maia Kobabe
Maiko Kanno
Manny Silva
Mara Isip
Marc Bell
Marc Burckhardt
Marc Johns
Marc Trujillo
Marcellus Hall
Marci Washington
Marco Mazzoni
Mare Odomo
Margaret McCartney
Mari Inukai
Mari Naomi
Mariangela
 Le Thanh
Mariangela Tan
Mariano Ching

Mariel Cartwright
Marika Paz
Marina Caro
Marisa Avila Sayler
Mark A. Miller
Mark Bodnar
Mark Delong
Mark Giglio
Mark Hoffmann
Mark Ingram
Mark Murphy
Mark Nagata
Mark Pedini
Mark Pingitore
Mark Price
Mark Todd
Mark Turgeon
Marlowe
 (Odd Rabbits)
Marrontic
Martha Rich
Martin Cendreda
Martin Hsu
Martin Mazorra
Martin Ontiveros
Martin Wong
Martina Fugazzotto
Mary Delioussina
Mary Hoffman
Masakatsu Sashie
Masato Nakada
Mason Dickerson
Mats!?
Matt Adrian
Matt Burlingame
Matt Furie
Matt Gordon
Matt Haber
Matt Hawkins
Matt Hollister
Matt Johnson
Matt Leines
Matt Lock
Matt Moroz
Matt Nelson
Matt Wood
Matthew Bandusch
Matthew Bone
Matthew Feyld
Matthew Kam
Matthew Lock
Matthew Nelson
Matthew Thurber
Max Bode
Max Kuhn
Max Nagata
Maxwell Loren
 Holyoke-Hirsch
May Ann Licudine
Maya Hayuk

Mayuko Nakamura
McKenzie Fisk
Meatbun
Medar De la Cruz
Meg Hunt
Meg Spectre
Megan Kelso
Megan Otnes
Megan Whitmarsh
Melinda Beavers
Melinda Beck
Melissa Chen
Melissa Kojima
Melissa McGill
Merrily Lupo
Metalnat Hayes
MHAK (Masahiro
 Akutagawa)
Michael Alvarez
Michael Bartalos
Michael Coleman
Michael Comeau
Michael Coughlan
Michael DeForge
Michael Fleming
Michael Hsiung
Michael Mararian
Michael Relth
Michael Slack
Michaela Zacchilli
Michele Carlson
Michelle Borok
Michelle Ku
Michelle Sakai-Hart
Michelle Valigura
Michelle Wanhala
Miho Tomimasu
Mika Mood
Mika Nitta
Mika Oshima
Mike "Le Merde" Kelly
Mike Bellamy
Mike Bertino
Mike Cho
Mike Choi
Mike DeNicola
Mike Dutton
Mike Egan
Mike Hernandez
Mike Hoffman
Mike Kuo
Mike Lee
Mike Park
Mike Perry
Mike Shinoda
Mike Taylor
Mike Wodkowski
Miki Taira
Mimi Chao
Mimi Pond

Minako Iwamura
Ming Ong
Minion Me
Minizakis
Minty Lewis
Miran Kim
Misaki Kawai
Miss Jisu
Miss Muju
Mister Toledo
Moira Hahn
Mollie Goldstrom
Molly Colleen
 O'Connell
Molly Crabapple
Molly Egan
Monica Magtoto
Monkmus
Monyomonyo
Morgan Elliot
Moto Nakaba
Mr. Ed
Mr. Kiji
Mu Pan
Munkao
Mustard Beetle
 (Elizabeth Jean
 Younce)
MWANEL
Mylan Nguyen
Myleen Hollero
N. Takahashi
Nana Aoyama
Nancy Chiu
Nao Harada
Naoki "SAND"
 Yamamoto
Naoshi Sunae
Naoto Hattori
Narangkar Glover
Natalia Miramontes
 (Parakid)
NATALIA RAK
Natalie Andrewson
Natalie Center
Natalie Gamble
Natalie Marks
Natalie Miramontes
Natasha Lillipore
Nate Beaty
Nate Doyle
Nate Williams
Nathalie Roland
Nathan Bagel
 Stapley
Nathan Cartwright
Nathan Doyle
Nathan Fox
Nathan Jurevicius
Nathan Ota

National Forest
Neil Sanders
Nellie Le
Nichole van Beek
Nick Arciaga
Nick Gazin
Nick Kennedy
Nick the Ring
NICO
Nicolas Mahler
Nicolas Nemiri
Nicole Harris
Nicole Momaney
Nicole Schorr
Nicolette Wood
Nidhi Chanani
Nikki Lukas Longfish
Nikki McClure
Nikko de Leon
Nina Frankel
Nina Katan
Niv Bavarsky
Noa
Noel Chanyungco
Noel Claro
Noel Freibert
Noelle Wong
Nola Won
Nomi Chi
Nora Aoyagi
Nozomi Uchida
Obvious Plant
Ofelia Marquez
Ogi
Ogisu
Olaf Ladousse
olive47
Oliver Jeffers
Olivia Pecini
Olivier Schrauwen
Omar Lee
Omocat
Orlando Lacro
OT
Ouizi
Ozabu
P-Jay Fidler
Pam Morris
Pamela Henderson
Panorama Press
Paperobott
Parakid
Pat Roberts
Patricia Wakida
Patrick Burnell
Patrick Hruby
Patrick JB Flynn
Patrick Keesey
Patrick Kyle
Patrick Thai

Paul Donald
Paul Frank
Paul Hornschemeier
Paul Hwang
Paul Lyons
Paul Robertson
Paul Slifer
Paulina Bemu
Pearl Hsiung
Pendleton Ward
Pernille Kjaer
Persue
Pete Fowler
Pete Glover
Peter Arkle
Peter Bagge
Peter Chan
Peter Hamlin
Peter Han
Peter Kato
Peter Kuper
Peter Thompson
Petri Purho
Phil Lubliner
Philip Koscak
Philip Lumbang
Phillip Fivel Nessen
Phillipe Lardy
Phoebe Ko
Phoebe Kobabe
Physical Fiction
Pippi Zornoza
Plants and Chairs
ploopypoopy
Po Yan Leung
PodgyPanda
Polly Becker
Pony Ma
Priscilla Moreno
Prodip Leung
Pryor Praczukowski
Quiralta
R. Biesinger
R. Kikuo Johnson
Ra'yka
Rachel Domm
Rachel Koukal
Rachel Silva
Rachell Sumpter
Rachelle Baker
Ragnar
Rain Szeto
Raina Jia
Rama Hughes
Rami Kim
Ray Fenwick
Ray Fong
Ray Potes
Ray Young Chu
Rebecca Green

Rebecca Wang
Reinier Gamboa
Rembert
Renee French
Restitution Press
RFX1
Rhodora Jacob
Ric Stultz
Rich Jacobs
Rich Stevens
Richard Colman
Richard McGuire
Richard Wilson
Rie Kawashima
Rieko Sakurai
Rina Ayuyang
Rio Yamamoto
Roan Victor
Rob Cham
Rob Corradetti
Rob Leecock
Rob Moss Wilson
Rob Reger
Rob Sato
Robert Bellm
Robh Ruppel
Rodger Stevens
Roger Langridge
Rohitash Rao
Roland Tamayo
Ron Nemec
Ron Regé, Jr.
Ronald J. Llanos
RONDO
Rose Wong
Roxie Vizcarra
Ryan Bubnis
Ryan Cho
Ryan Crippen
Ryan De La Hoz
Ryan Gallagher
Ryan Harris
Ryan Heshka
Ryan Jacob Smith
Ryan McGinness
Ryan McIntosh
Ryan Wallace
Ryohei Tanaka
Ryuji Oguni
S.P. Ehman
Sae-am Lee
Saejean Oh
Saelee Oh
Sakura Maku
Sally Deng
Sam Friedman
Sam Grinberg
Sam Handleman
Sammy Harkham
Sana Park

Sanaa Khan
Sara Antoinette Martin
Sara Saedi
Sara Varon
Sarah Chon
Sarah Lavoie
Sarah Lee
Sarah Lin Mitchell
Sarah Pinner
Sarah Utter
Sas Christian
Sasha Barr
Sashiko Yuen
Sayaka Iwashimizu
Schessa Garbutt
Scott Bakal
Scott Barry
Scott C.
Scott Campbell
Scott Carl
Scott Stowell
Scott Teplin
Scott Tolleson
Scrappers
Sean Boyles
Sean Cassidy
Sean Chao
Sean Hannaway
Sean Keeton
Sean Norvet
Sean Qualls
Selina Alko
Sena Inukai
Seonna Hong
Septerhed
Sergio Jauregui
Seripop
Seth Drenner
Seth Scriver
Shane Geil
Shannon Freshwater
Shark Toof
Shawn Cheng
Shiho Nakaza
Shiho Pate
Shihori Nakayama
Shinjuko
Shino Charlson
Shintaro Kago
Shintaro Ohata
Shirl Sun
Shizu Saldamando
Shu Okada
Sian Keegan
Sidney Pink
Silvio Porretta
Simon Hughes
Simon Kim
Simon Peplow
Sket One

Skinner
Slow Loris
So Youn Lee
Soey Milk
Soner On
SooJin Buzelli
Sophie Mathoulin
Sorie Kim
Souther Salazar
Stacy Javier
Stacy Tan
Stanley Ruiz
Stasia Burrington
Steak Mtn.
Stef Dunlap
Stefanie Le Jeunesse
Stella Im Hultberg
Stella Lai
Stephan Britt
Stephane Prigent
Stephanie Hutin
Stephanie Kubo
Stephanie Leung
Stephanie Wong
Steve Ellis
Steve Weissman
Steven Daily
Steven Weissman
Stevie Shao
Stickymonger
STO
Studio MIKMIK
Sucklord
Sugar Fueled
Sun-Mo Koo
Sunny Den
Superbrothers
Supermundane
Susan Husky
Susie Ghahremani
Suzanne Husky
Sweaty Taxidermy
Sylvia Park
Tad Carpenter
Tae Lee
Taehoon Kim
Takashi Iwasaki
Takashi Murakami
TAMMY
Tanja Rector
Tara Cullen
Tara McPherson
Tasha Kusama
Tatsuro Kiuchi
Taylor Brown
Taylor Lee
Taylor McKimens
Team Macho
Ted McGrath
Tegan Bellitta

Terri Fry Kasuba
Tessar Lo
Tetsunori Tawaraya
Tezh Modarressi
The Chung
The Harpoon
TheLittleLabs
Theo Ellsworth
Thesis
Thinh Nguyen
Thom Lessner
Thomas Allen
Thomas Han
Thomas Lee Bakofsky
Tiffany England
Tiffany Lam
Tiffany Le
Tiffany Liu
Tiffany Tan
Tiffany Wei
Tigerlily Biskup
Tim Biskup
Tim Evans
Tim Furey
Tim Gough
Tim Hensley
Tim Kerr
Tim Le Jeunesse
Timothy Karpinski
Tinna Guo
Tobin Yelland
Toby Tam
Tom Bunker
Tom Eichacker
Tom Forget
Tom Neely
Tom Vadakan
Tomer Hanuka
Tony DePew
Tony Millionaire
Tra Selhtrow
Trace Marshall
Tran Nguyen
Travis Lampe
Travis Louie
Travis Millard
Trevor Alixopulos
Trevor Girard
Trevor Shin
Tricia Keightley
Tripper Dungan
Tristan Eaton
Tru Nguyen
Turtle Wayne
Tury Sandoval
Tyler Parker
Tyler Stout
Tyson Hesse
Ulises Alfonso
 Fariñas

Valerie Pobjoy
Valeriya Volkova
Van Arno
Vanessa Davis
Vanessa Franchi
Vanessa Gillings
Vanessa Ramirez
Vaughan Ling
Viizage Montaraza
Viktor Koen
Vincent Nguyen
Vivian Le
Vivian Marie
 Haworth
Wayne Johnson
Wayne White
Weathermaker Press
Wednesday Kirwan
Wendy Park
William Buzzell
William Schaff
Willian van Roden
Wizardskull
Woodrow White
Xander Marro
Xray Dream
Yasmin Sison
Yasushi Ebihara
Ye Rin Mok
Yejin Oh
Yellena James
Yeo Ka
Yi-Chin Chen
Yong Choe
Yoshi Yoshitani
YOSHI47
Yoshitomo Nara
Yoskay Yamamoto
Yosuke Ueno
Yu Maeda
Yuju Shen
Yuki Mori
Yuki Murayama
Yuki Takahashi
Yukinori Dehara
Yuko Nishigaki
Yumi Sakugawa
Yumi Yamazaki
yumiincolor
Yumiko Kayukawa
Yusei Abe
Yutanpo
Zach Amendolia
Zach Gage
Zachary Rossman
Zachary Zezima
Zack Soto
Zion Rodriguez
Zohar Lazar
ZOUEH

Eric Nakamura would like to thank: Mother and Father; the supporting family; Martin Wong, Wendy Lau, Pryor Praczukowski, Cate Park; and all the staff, writers, and volunteers of the magazine. The Giant Robot stores and gr/eats staff in LA, SF, NY. The current staff at GR: Rachel, Cassia, and Stacy. The GR community, including artists, friends, and visitors who supported over the decades both in person and online. Finally, the competitors who fueled energy and kept me sharp.

Thank you for reading.